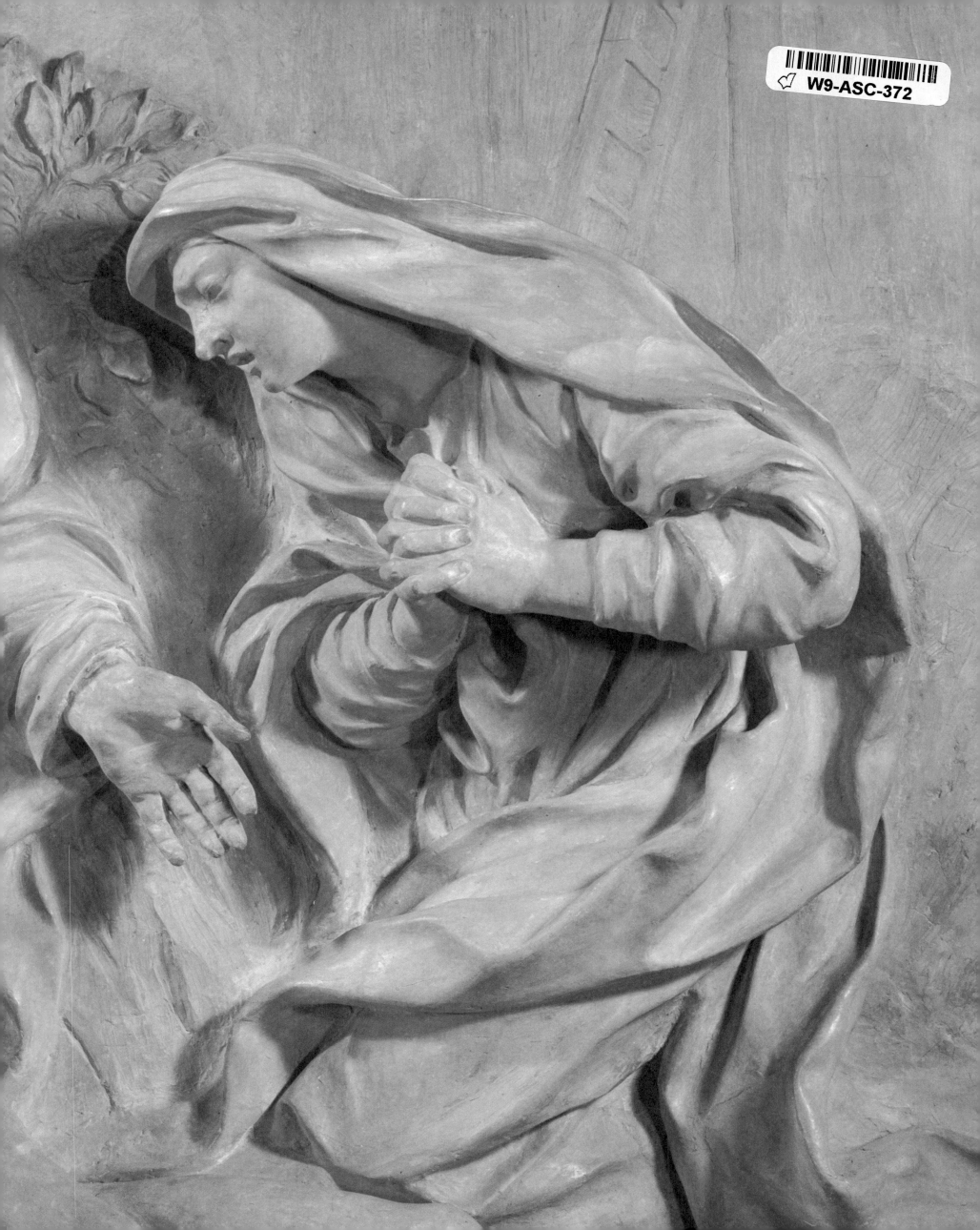

FINGER PRINTS OF THE ARTIST

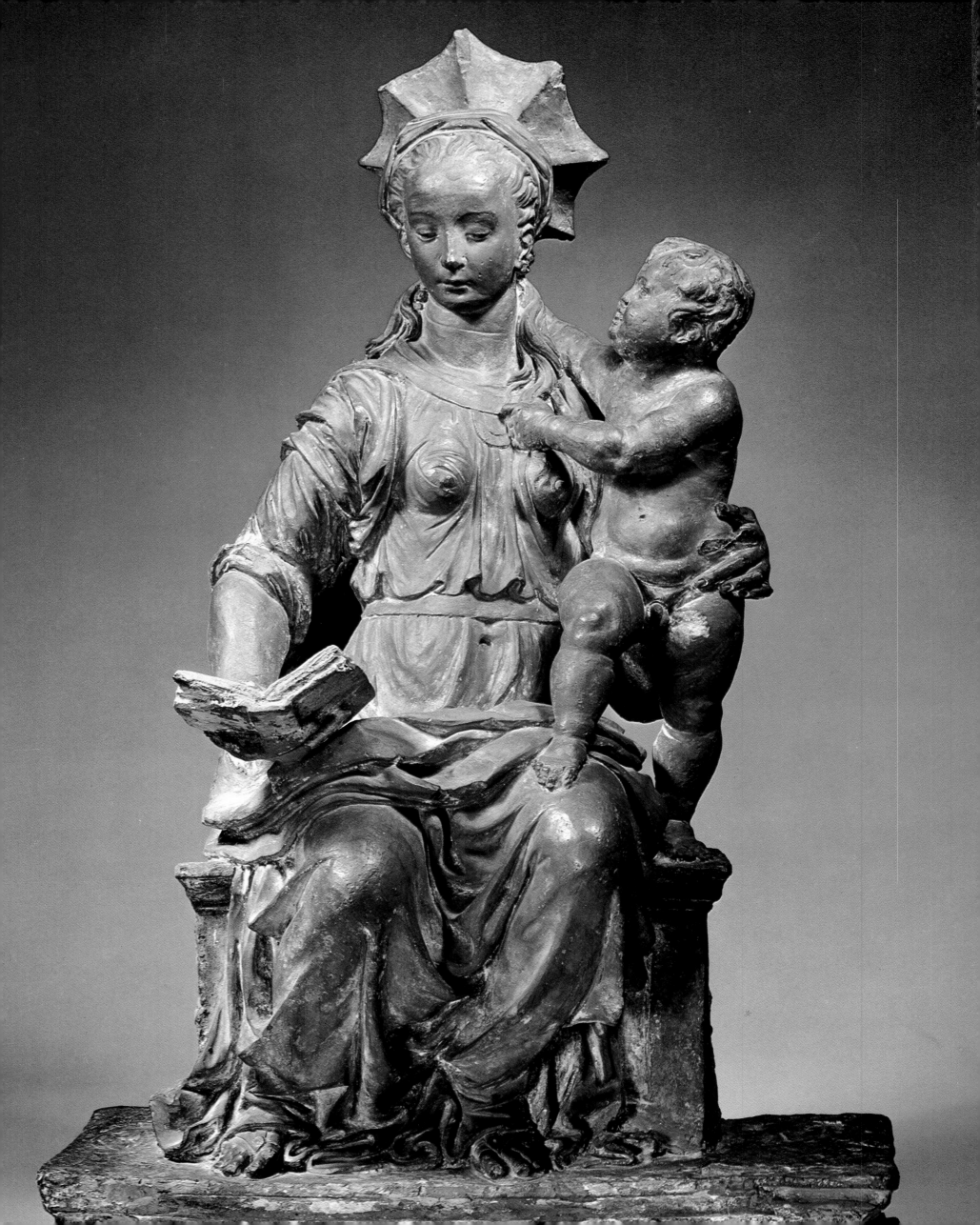

FINGER PRINTS OF THE ARTIST

European Terra-Cotta Sculpture from the Arthur M. Sackler Collections

Introduction and catalogue by

DR. CHARLES AVERY
formerly Deputy Keeper of Sculpture,
The Victoria and Albert Museum, London

Assisted by ALASTAIR LAING

Edited by LOIS KATZ Curator,
The Arthur M. Sackler Collections

THE ARTHUR M. SACKLER FOUNDATION, WASHINGTON, D.C.
AND THE FOGG ART MUSEUM, CAMBRIDGE, MASS.
Distributed by Harvard University Press

EXHIBITION DATES:

The National Gallery of Art, Washington, D.C.
October 25, 1979–October 5, 1980

The Metropolitan Museum of Art, New York,
March 21–September 6, 1981

The Fogg Art Museum, Harvard University, Cambridge,
Fall and Winter, 1981/82

END PAPERS: no. 21, Mazzuoli,
Lamentation, detail

FRONTISPIECE: no. 9, Master of the
Unruly Children, *Virgin and Child*.

Design by Victor Trasoff
Photographs by Otto Nelson
Judith Groppa, Assistant Editor

Typography by Empire Typographers, New York
Printed in the U.S.A. by Rapoport Press, New York

LIBRARY OF CONGRESS CATALOGING IN PUBLICATION DATA
Avery, Charles
 Fingerprints of the Artist:
 European Terra-Cotta Sculpture from the Arthur M. Sackler Collections
 Exhibition held at the National Gallery of Art, Washington;
 The Metropolitan Museum of Art, New York; and the Fogg
 Art Museum, Cambridge, Mass.
 Bibliography: p. 285
 Includes index.
1. Terra-cotta sculpture, European—Exhibitions.
2. Sackler, Arthur M.—Art collections—Exhibitions.
I. Laing, Alastair, joint author. II. Katz, Lois.
III. United States. National Gallery of Art. IV. New York (City).
Metropolitan Museum of Art. V. Harvard University. William Hayes
Fogg Art Museum. VI. Title. VII. Title: Arthur M. Sackler collections.
NB1265.A83 730'.94'074014 80-27821
ISBN: 0-674-30202-8 (clothbound)
 0-674-30203-6 (paperbound)

TABLE OF CONTENTS

LIST OF CATALOGUE ENTRIES 1

ACKNOWLEDGEMENTS 3
Arthur M. Sackler

PREFACE 5
Arthur M. Sackler

AN APPRECIATION 9
Seymour Slive

PROLOGUE 11
John Coolidge

INTRODUCTION 16
Charles Avery

CATALOGUE ENTRIES

The Italian Terra-Cottas, 15th to 20th Century 27
Charles Avery

The French Terra-Cottas, 16th to 20th Century 157
Alastair Laing

The German, English, Netherlandish and
Spanish Terra-Cottas, 16th to 19th Century 243
Charles Avery

APPENDIX 275
Charles Avery

LIST OF FIGURES IN TEXT 281

ALPHABETICAL LIST OF ARTISTS 283

BIBLIOGRAPHY 285

INDEX 291

LIST OF CATALOGUE ENTRIES

1. *Bust of Christ*, late 15th century, circle of Guido Mazzoni (active 1473-1518), accession no. 77.5.47, p. 28.

2. *The Nativity of Christ and Annunciation to the Shepherds*, mid- to late-15th century, North Italian, accession no. 79.1.6, p. 31.

3. *St. Francis*, ca. 1450, attributed to Nicolo Pizolo (active 1421-1453), accession no. 77.5.70, p. 36.

4. *St. Clare*, ca. 1450, attributed to Nicolo Pizolo (active 1421-1453), accession no. 77.5.71, p. 37.

5. *Judith*, late 15th century, attributed to Domenico Boccalaro (documented 1495), accession no. 77.5.56, p. 39.

6. *St. Catherine of Alexandria*, first quarter of 16th century, attributed to Giovanni Minelli (ca. 1440-1528), accession no. 77.5.55, p. 40.

7. *St. Jerome*, ca. 1480-1500, attributed to Andrea Ferrucci (1465-1526), accession no. 77.5.80, p. 42.

8. *David*, late 15th century, Master of the David and St. John Statuettes, accession no. 77.5.5, p. 44.

9. *Virgin and Child*, early 16th century, Master of the Unruly Children, accession no. 77.5.14, p. 46.

10. *Candelabrum-bearing Angel*, ca. 1550, circle of Domenico Beccafumi (1486-1551), accession no. 77.5.17, p. 50.

11. *Bust of a Monk*, late 15th or early 16th century, Bolognese, accession no. 77.5.60, p. 52.

12. *Roman Emperor*, mid-16th century, Italian, accession no. 77.5.8, p. 55.

13. *Pope Julius III del Monte*, ca. 1550-55, attributed to Vincenzo Danti (1530-1576), accession no. 77.5.73, p. 56.

14. *The Deposition of Christ*, ca. 1565, Jacopo Del Duca (ca. 1520-post 1592), accession no. 77.5.34, p. 58.

15. *Head of Doge Leonardo Loredan*, ca. 1572, Danese Cattaneo (ca. 1509-1573), accession no. 77.5.26, p. 60.

16. *Bust of a Cleric*, first quarter of 17th century, Felice Palma (1583-1625), accession no. 79.1.3, p. 64.

17. *Torso of the Resurrected Christ*, first half of 17th century, Alessandro Algardi (1598-1654), accession no. 77.5.4, p. 66.

18. *St. John the Baptist*, first half of 17th century, Alessandro Algardi (1598-1654), accession no. 77.5.3, p. 68.

19. *Two Angel Musicians*, ca. 1636-40, François Duquesnoy (1597-1643), accession no. 79.1.2, p. 70.

20. *Ascension of St. Catherine of Siena*, third quarter of 17th century, Roman, accession no. 77.5.22, p. 73.

21. *Lamentation*, ca. 1695, Giuseppe Mazzuoli (1644-1725), accession no. 77.5.51, p. 75.

22. *Kneeling Angel*, ca. 1695, Giuseppe Mazzuoli (1644-1725), accession no. 77.5.52, p. 77.

23. *Kneeling Angel*, ca. 1695, Giuseppe Mazzuoli (1644-1725), accession no. 77.5.53, p. 77.

24. *The Virgin in Adoration or Annunciate*, late 17th or early 18th century, circle of Mazzuoli, accession no. 79.1.26, p. 80.

25. *Putto Personifying Summer*, 1700-10, Camillo Rusconi (1658-1728), accession no. 77.5.81, p. 82.

26. *Putto Personifying Winter*, 1700-10, Camillo Rusconi (1658-1728), accession no. 77.5.82, p. 82.

27. *St. Peter*, early 18th century, Roman, accession no. 77.5.86, p. 86.

28. *St. Andrew*, early 18th century, Roman, accession no. 77.5.83, p. 86.

29. *St. Peter*, ca. 1708, Pierre-Étienne Monnot (1657-1733), accession no. 77.5.58, p. 89.

30. *St. Paul*, ca. 1708, Pierre-Étienne Monnot (1657-1733), accession no. 77.5.57, p. 89.

31. *Pope Clement XI Albani*, ca. 1700, Roman, accession no. 77.5.12, p. 92.

32. *Hercules Slaying the Nemean Lion*, date uncertain, after Giovanni Baratta (1670-1747), accession no. 77.5.15, p. 94.

33. *Apollo Flaying Marsyas*, date uncertain, after Giovanni Baratta (1670-1747), accession no. 77.5.16, p. 94.

34. *Apotheosis of Grand Master Fra Antonio Manoel de Vilhena*, 1729, Massimiliano Soldani-Benzi (1656-1740), accession no. 79.1.28, p. 98.

35. *Adoration of the Magi*, early 18th century, circle of Soldani, accession no. 77.5.85, p. 101.

36. *Preaching of St. John the Baptist*, early 18th century, circle of Soldani, accession no. 77.5.84, p. 103.

37. *The Continence of Scipio*, first half of 18th century, attributed to Agostino Cornacchini (1686-1754), accession no. 77.5.31, p. 104.

38. *St. Blaise (San Biagio)*, late 17th century, Emilian, accession no 77.5.18, p. 106.

39. *David Triumphant Over Goliath*, 1675-1723, Giuseppe Mazza (1653-1741), accession no. 77.5.49, p. 109.

40. *Walking Cupid*, 1736, Giuseppe Mazza (1653-1741), accession no. 77.5.50, p. 111.

41. *The Virgin Mary (?) Wearing a Veil*, ca. 1700, Giuseppe Mazza (1653-1741), accession no. 77.5.54, p. 112.

42. *The Miracle of the Cranes*, 1733, Ottavio (1695-1777) and Nicola Toselli (1706-post 1782), accession no. 77.5.87, p. 114.

43. *The Education of the Virgin*, 18th century, Bolognese, accession no. 77.5.11, p. 116.

44. *Two Bishop Saints Receiving the Palm of Martyrdom*, 18th century, Bolognese, accession no. 79.1.27, p. 118.

45. *St. Anthony of Padua, St. Lawrence and St. Peter Adoring the Christ Child*, 18th century, attributed to Agostino Corsini (1688-1772), accession no. 77.5.32, p. 120.

46. *Christ on the Road to Emmaus*, ca. 1710-18, attributed to Angelo Gabriello Piò (1690-1769), accession no. 77.5.69, p. 122.

47. *St. Romuald*, mid-18th century, circle of Ubaldo Gandolfi (1728-1781), accession no. 77.5.37, p. 124.

48. *St. Petronius*, mid-18th century, circle of Ubaldo Gandolfi (1728-1781), accession no. 77.5.36, p. 124.

49. *Pope Clement XIV Ganganelli*, ca. 1770, Sebastiano Pantanelli (n.d.-1792), accession no. 77.5.64, p. 126.

50. *Genoese Senator*, late 17th century, attributed to Filippo Parodi (1630-1702), accession no. 77.5.66, p. 128.

51. *Venetian Senator*, second half of 17th century, attributed to Angelo Marinali (1654-1701), accession no. 77.5.48, p. 129.

52. *King David*, ca. 1705, Lorenzo Vaccaro (1655-1706), accession no. 77.5.88, p. 130.

53. *St. Luke*, late 17th or early 18th century, Pietro Papaleo (1642?-1718), accession no. 77.5.65, p. 132.

54. *Sketch-model for a Wall Monument with a Figure of Charity*, mid-19th century, Florentine, accession no. 77.5.19, p. 134.

55. *Sketch-model for a Wall Monument with a Male Portrait-Bust*, mid-19th century, Florentine, accession no. 77.5.20, p. 136.

56. *Virgin and Child*, early 19th century, after Andrea della Robbia (1435-1525), accession no. 77.5.76, p. 138.

57. *Genius of the Papacy*, late 19th century, Ercole Rosa (1846-1893), accession no. 79.1.7, p. 141.

58. *Monument with Angel and Two Mourners*, late 19th century, Ettore Ferrari (1845-1929), accession no. 79.1.9, p. 142.

59. *A Standing Draped Man Representing Fatherland*, 1895, Ettore Ferrari (1845-1929), accession no. 79.1.10, p. 144.

60. *Girl Kneeling and Dressing Her Hair*, early 20th century, Arturo Martini (1889-1947), accession no. 79.1.16, p. 146.

61. *Girl Seated and Drying Her Foot*, early 20th century, Arturo Martini (1889-1947), accession no. 79.1.11, p. 148.

62. *Wrestlers*, early 20th century, Arturo Martini (1889-1947), accession no. 79.1.13, p. 149.

63. *Man on Horse*, early 20th century, Arturo Martini (1889-1947), accession no. 79.1.12, p. 150.

64. *Horse Tamer*, early 20th century, Arturo Martini (1889-1947), accession no. 79.1.15, p. 151.

65. *Pair of Clothed Figures*, early 20th century, Arturo Martini (1889-1947), accession no. 79.1.14, p. 153.

66. *La Vedetta: La Gazzetta del Popolo*, 1884, Mieczylslaw Leon Zawiejski (1856-1933), accession no. 79.1.17, p. 154.

67. *Dead Christ*, ca. 1570, circle of Germain Pilon (1506-1565), accession no. 79.1.21, p. 158.

68. *Nature*, ca. 1679, Louis Lecomte (ca. 1639-1694), accession no. 77.5 41, p. 161.

69. *Virgin and Child*, 1710, Pierre-Jean Hardy (1653-1737), accession no. 79.1.1, p. 163.

70. *A River God and Goddess*, ca. 1699, attributed to Nicolas Coustou (1658-1733), accession no. 77.5.33, p. 164.

71. *Putto Playing a Drum Before Armour*, early 18th century, Jacob-Sigisbert Adam (1670-1747), accession no. 77.5.2, p. 167.

72. *Putti Trying Out Armour*, early 18th century, Jacob-Sigisbert Adam (1670-1747), accession no. 77.5.1, p. 167.

73. *Mourning Woman and Putto*, ca. 1750-60, Louis-Claude Vassé (1716-1772), accession no. 77.5.90, p. 168.

74. *Bust of Henri-Claude, comte d'Harcourt*, 1760, Jean-Baptiste Lemoyne (1704-1778), accession no. 77.5.42, p. 170.

75. *François Boucher*, 1767, Jean-Baptiste Lemoyne (1704-1778), accession no. 77.5.43, p. 172.

76. *Mme. Boucher*, 1767, Jean-Baptiste Lemoyne (1704-1778), accession no. 77.5.44, p. 172.

77. *A Study of a Fallen Man in Agony*, ca. 1700-1715, French, accession no. 77.5.63, p. 174.

78. *Silenus*, ca. 1758, Augustin Pajou (1730-1809), accession no. 77.5.61, p. 176.

79. *Venus Receiving the Apple from the Hands of Love*, 1771, Augustin Pajou (1730-1809), accession no. 77.5.62, p. 179.

80. *Bust of Corbin de Cordet de Florensac*, ca. 1792-94, Augustin Pajou (1730-1809), accession no. 79.1.29, p. 180.

81. *Vestal Bearing Wreaths on a Platter*, ca. 1765-70, Claude Michel, called Clodion (1738-1814), accession no. 79.1.24, p. 184.

82. *Vestal Holding Sacred Vessels*, ca. 1765-70, Claude Michel, called Clodion (1738-1814), accession no. 79.1.25, p. 186.

83. *Mercury*, ca. 1736-39, Jean-Baptiste Pigalle (1714-1785), accession no. 77.5.67, p. 189.

84. *Bust of a High Priest*, ca. 1775, Simon Louis Boizot (1743-1809), accession no. 77.5.21, p. 191.

85. *Equestrian Statuette of the Grand Condé*, ca. 1780, Robert-Guillaume Dardel (1749-1821), accession no. 77.5.40, p. 193.

86. *Lion Supporting an Armorial Cartouche*, ca. 1780-85, Joseph Chinard (1756-1813), accession no. 77.5.28, p. 196.

87. *Phryne Emerging from Her Bath*, ca. 1787, Joseph Chinard (1756-1813), accession no. 77.5.29, p. 198.

88. *Othryades Expiring on His Shield*, ca. 1790-95, Joseph Chinard (1756-1813), accession no. 77.5.38, p. 202.

89. *Bust of a Woman*, ca. 1795-1800, Joseph Chinard (1756-1813), accession no. 77.5.30, p. 204.

90. *Sappho and Phaon*, ca. 1800-10, attributed to Joseph Chinard (1756-1813), accession no. 77.5.27, p. 206.

91. *Venus Comforting Cupid*, ca. 1797, Jacques-Edme Dumont (1761-1844), accession no. 77.5.35, p. 208.

92. *Brutus Lamenting Over the Dead Lucretia*, ca. 1795-1800, François-Dominique-Aimé Milhomme (1758-1823), accession no. 79.1.18, p. 210.

93. *Vestal Holding a Vase*, ca. 1790, attributed to Joseph-Charles Marin (1759-1834), accession no. 77.5.68, p. 212.

94. *Sketch for a Figure of François Chateaubriand*, ca. 1849, Francisque-Joseph Duret (1804-1865), accession no. 79.1.19, p. 214.

95. *Velléda*, ca. 1844, Etienne-Hippolyte Maindron (1801-1844), accession no. 77.5.46, p. 216.

96. *'Flore Accroupie' (Crouching Flora)*, ca. 1863, Jean-Baptiste Carpeaux (1827-1875), accession no 77.5.23, p. 218.

97. *Bacchante Offering a Libation to a Bacchic Term*, ca. 1868-71, Albert Carrier-Belleuse (1824-1887), accession no. 77.5.23, p. 220.

98. *Colombe*, ca. 1870, Albert Carrier-Belleuse (1824-1887), accession no. 79.1.4, p. 223.

99. *Vasque des Titans*, ca. 1880, Auguste Rodin (1840-1917) and Albert Carrier-Belleuse (1824-1887), accession no. 77.5.77, p. 226.

100. *Torso Standing on One Leg*, ca. 1900, attributed to Auguste Rodin (1840-1917), accession no. 77.5.78, p. 233.

101. *Square Vase Adorned with Tahitian Gods*, 1893-95, Paul Gauguin (1848-1903), accession no. 72.10.1, p. 237.

102. *Head of a Young Woman*, ca. 1900-14, Aristide Maillol (1861-1944), accession no. 76.3.17, p. 238.

103. *Maquette for the Tomb of Cardinal de Cabrières*, ca. 1925, Jean-Marie Joseph Magrou (1869-1945), accession no. 77.5.45, p. 241.

104. *Christ Kneeling*, late 15th century, South German, accession no. 77.5.10, p. 244.

105. *Holy Family with St. John the Baptist*, 1634, François Dieussart (ca. 1600-1661), accession no. 79.1.23, p. 246.

106. *Tarquin and Lucretia*, ca. 1650, circle of Artus I Quellinus (1609-1668), accession no. 77.5.13, p. 248.

107. *Bust of a Man Screaming*, mid-17th century, Netherlandish, accession no. 77.5.6, p. 250.

108. *Virgin and Child*, ca. 1700, Flemish, accession no. 77.5.74, p. 253.

109. *St. Joseph Holding the Christ Child*, ca. 1723, Jan-Baptiste Van der Haeghen (1688-1738/40), accession no. 77.5.75, p. 254.

110. *Meleager* or *Hercules*, ca. 1700, Netherlandish, accession no. 77.5.89, p. 256.

111. *Crying Boy*, late 17th or early 18th century, circle of Jan Claudius de Cock (1667-1735), accession no. 77.5.9, p. 259.

112. *Putti Bird's-Nesting*, mid-18th century, attributed to Walter Pompe (1703-1777), accession no. 77.5.72, p. 260.

113. *The Christ Child as Saviour*, 19th century, style of Walter Pompe (1703-1777), accession no. 79.1.20, p. 262.

114. *Father Time Carrying Off Dead Infant*, ca. 1710-20, attributed to Pierre-Denis Plumière (1688-1721), accession no. 79.1.22, p. 264.

115. *Paetus and Arria*, ca. 1770, Joseph Nollekens (1737-1823), accession no. 77.5.59, p. 268.

116. *Melchior and his Page Proffering Frankincense*, late 17th century, Spanish, accession no. 77.5.79, p. 271.

117. *Torero Herido (Wounded Bullfighter)*, late 19th century, Venancio Vallmitjana y Barbany (1828-1919), accession no. 79.1.8, p. 272.

APPENDIX

A. *Virgin Annunciate*, 19th century (?), Italian, accession no. 77.5.7, p. 276.

B. *Pietà*, 19th or 20th century, Italian, accession no. 77.5.39, p. 278.

ACKNOWLEDGEMENTS

Among those to whom I am indebted for their contributions to this collection, its catalogue and its exhibitions, there are a few whom I would like to specifically acknowledge even as I thank the many unnamed whose assistance was deeply appreciated.

For the preparation of this catalogue I must thank my American associates: Lois Katz for her meticulous assistance in the preparation of the text, and Victor Trasoff for his thoughtful and exciting linkage of illustration and text, and for his rewarding exploration of the technologies involved in the execution of the graphics. In English terminology, their "blood, sweat and tears" made this catalogue possible.

In Britain, I would like to acknowledge the contribution of the author of this volume, Dr. Charles Avery, then of the Victoria and Albert Museum, whose writings I had so admired, and Alastair Lang who assisted him.

To the National Gallery of Art and to its remarkable director, J. Carter Brown, I owe a particular debt for having made the first exhibition of part of the collection an event of great joy without pain. I want to thank Dr. Douglas Lewis, whose trip to London to view the newly acquired terra-cottas sparked the enthusiasm which led to the exhibition at the National Gallery, an exhibition so brilliantly conceived and exquisitely executed that I am sure it would have deeply moved the artists who created these terra-cottas. For this achievement I would like to thank Gilbert Ravenal, Gordon Anson, Victor Covey and Mark Leithauser. I want to express particular appreciation to Dr. Carolyn Newmark for her research and commentaries which did so much to enrich the exhibition and place it within its art historical context.

I would like to express my thanks to Professor Seymour Slive, Professor John Coolidge, Professor John Rosenfield and Professor Sydney J. Freedberg and Arthur Beale, Head Conservator, of Harvard and the Fogg Art Museum for their encouragement and scholarship, for the assistance of their staffs as well as for their plans for the presentation and study of all the terra-cottas at the Fogg.

At The Metropolitan Museum of Art I would like to thank Olga Raggio and James Draper for their understanding and appreciation of these sculptures.

For sensitivity and excellence of his photography, I would like to thank Otto Nelson who has photographed objects from my collections for more than twenty years.

I have commented on the remarkable role of Dr. Andrew S. Ciechanowiecki, scholar and friend, without whom this collection would not have been possible. I would also like to thank Cyril Humphris for making available to me a number of exquisite and unique sculptures.

And then, on a personal note, my heartfelt thanks to one closest and most dear, whose participation can never be adequately acknowledged.

ARTHUR M. SACKLER

3

The Medium that Serves the Master

I HAVE MADE a long journey, a spiritual pilgrimage from my roots in the Western arts, a hegira which carried me to the aesthetics of the East. And, as this volume testifies, I am now finding my way back to one of man's great expressions in Western civilization.

The origins of my interest in the arts, or should I say my passions, were rooted in pre-Renaissance painting and in the glories of pre-, post- and Impressionism. With time, I found myself seduced and progressively more intimately involved in the subtleties and nuances and the incredible excitement of the great ritual bronzes of China, the exquisite intimacies and secrets of the greatest carvings in "living" stone, Chinese archaic jades; the inspiring creations of the ceramacist and the soul-fulfilling aesthetics as well as the intimacies and humor of the great painters and calligraphers of China. I found fulfillment in China's early wood sculpture, so close to our modern experience; and then, later, faced the questions aroused by the restrained, oft constricted ritual Buddhistic sculptures in stone and gilt bronze.

When enamoured with so much of the bronze and jade and painting art of China, I wondered if I would ever find my "way back" or whether I had permanently parted from the traditions of which I had originally felt so much a part.

I had remarked that I could not see how, after Shang bronzes, which Malraux rightly epitomized as the peak of that art, I could ever care for Renaissance or Baroque bronzes or the most inspired, exquisitely realized marble sculpture of those periods. Yet, always a doubt remained. Even as I had reservations in respect to Michelangelo's *David,* I never doubted as to what were, for me, that great master's sublimely fulfilled creations, the *Pietàs,* the *Moses,* and the so-called "unfinished" figures now at the Accadèmia in Florence and the Louvre in Paris.

One day just about three years ago I happened to pass a gallery in London. An inner voice—which some call intuition and I prefer to think of as the unconscious integration of stimuli constantly taking place in that massive network of neurones which we so lightly and simply call the brain—that inner voice bade me stop the taxi, enter the gallery, and ask: "Do you have any terra-cottas?"

As fate would have it, I addressed the question to one of the few men in the world who apparently had not only recognized but addressed with passion his conviction as to the aesthetic potentials of this medium, Dr.

Andrew S. Ciechanowiecki. From that point on, Andrew Ciechanowiecki became a fellow companion and in many ways a guide, a friend on my journey back to our Western aesthetics, one without whom this collection would never have come into being. This man, who has won my admiration as connoisseur and scholarly art historian, a "hunter" in search of great art and a unique dealer, sensed the object of my search. I was seeking for something which perhaps I had not even fully articulated in my own mind. I hungered for a Western manifestation of the freedom of aesthetic expression I had found in so many of the paintings of China, the powerful, aesthetic thrust of its bronzes and the dynamic brilliance of its ceramics. In the arts of the Orient I have found virtually complete aesthetic fulfillment in all media except perhaps one—the spatial medium of the sculptor.

I have been asked, what on *earth* are you now doing with terra-cotta sculpture, European terra-cottas? That was a very apt observation, for terra-cottas are truly of the earth. For me, terra-cottas are unique among the plastic arts. I know from my friends in the performing arts—music, and opera, and the dance—how difficult it is for the greatest conductors, singers, actors, musicians and dancers to catch the finest nuances of meaning, the full depth of the message of the composer, the dramatist or the choreographer. It is all too often also true in the plastic arts when the message of the master has to be transmuted through intermediates such as the bronze caster.

For me, terra-cottas have enabled our masters of aesthetics to capture a feeling and an aesthetic at a given point in time and a given point in space. They have taken clay and in a god-like achievement, through their genius, have breathed life into it; so much has life been breathed into this earth as to bring to you centuries later a living message with directness and clarity and present it with the mark of their individuality.

These artists realized in their day what they could do with this medium and now, in our day, and at this point in time and space, in our museums and through these pages they will be speaking to you with a unique intimacy and immediacy.

With terra-cottas I found I was going back, perhaps, to what I have called an ultimate expression of the neuromotor, the tactile and depth-perspective experiences of man; to their expression in the plastic and spatial arts—the joy of the child squishing mud through its fingers, at first maybe "aimlessly" but sensually, then purposefully, ultimately constructively.

Why, I wondered, this sudden turn of aesthetic events in a life which had

gone so far down the road of its Oriental expressions? What a provincial thought that was, as though the neurosensory and neuromuscular systems of man in different parts of the world were so different in origin and its fundamental, intrinsic aesthetic so widely disparate.

I always wanted to experience as close as one can, at first hand if possible, the creative impulse which moves a master. In the field of Oriental art I had savoured the emotional impact as the genius of Tao-chi committed brush to paper, as a man had moulded a camel in wet clay and with what must have been the stub of a brush, fashioned in a thrice the hair on the back of a camel's neck. And from Shang and Chou ritual bronzes and weapons as from the Neolithic through the three-color glazes and even in the early Sung ceramics, I had sensed how the medium had served the master. That relationship of master to medium was, I felt, lost in the later ceramics of the Orient, the porcelains of the Ming and Ching periods, as the discipline of technique seemed to cool the heat and spontaneity of emotional expression. In Western art I had felt that even more so. Despite the beauties of the masterpieces in bronze and marble, I had felt that these two media either imposed too much upon the creative process or had interposed too often between the creator and me, as viewer. Could it be that in the terra-cottas the fullest primacy of the master over the medium still prevailed? That in terra-cotta sculpture the creative impulse of spatial art could come further in direct expression, freer from the restrictions of technique and technology imposed by rigid or unyielding stone or molten bronze?

I have since wondered whether in the plastic arts of the terra-cottas the biologic adage of "ontogeny recapitulates phylogeny" was not paralleled in that a developing individual recapitulates what may have been the multimillenial experience of his forebears in the creative process related to clay, a process whose artifacts today, thousands of years later, provide us with such objects of aesthetic joy as the striking neolithic pots of China, the beautiful sculptures of the goddesses of Anatolia and the fertility figures of Iran.

The free and full aesthetic communication, the spiritual intimacy I sought I believe I have found in these European terra-cotta sculptures. They speak to me with an immediacy undimmed by time, with an intimacy unrestricted by technology, and with a personality as distinctive as what I see them to be—as individual as the *Fingerprints of the Artist*.

ARTHUR M. SACKLER

AN APPRECIATION

THE ARTHUR M. SACKLER COLLECTION OF EUROPEAN TERRA-COTTAS is outstanding in its concentration on this particular medium, and distinctive both for its size and its chronological range. It is a rare occurrence when a museum is privileged to present such an interesting and varied group of terra-cotta sculpture. This is doubly true when one remembers that, because of the risks involved in handling terra-cotta, these works of art are seldom permitted to leave the institutions in which they are permanently housed.

Dating from the fifteenth through the twentieth century, the Sackler sculptures provide an unusually comprehensive historical overview of terra-cotta in post-medieval European art. Moreover, since the collection includes *bozzetti* or sketch-models, as well as finished small-scale and monumental pieces, the various uses of terra-cotta are richly documented. Many of the works in this selection have never before been publicly exhibited. The National Gallery of Art, Washington, D.C. appreciated the opportunity of presenting selections from this collection and the generosity which makes such an exhibition possible.

Terra-cottas are to sculpture as drawings are to paintings. Yet, to the best of my knowledge no one has ever attempted to make a comprehensive collection of terra-cottas, and to the best of my knowledge, there has never been an exhibition of terra-cottas that can begin to match the scope and quality of this collection. Both "firsts" are astonishing.

Why have terra-cottas been "second class" sculptures? Fortunately, there is good reason to believe that this will soon change. The interest in the exhibition of the Sackler terra-cottas at the National Gallery in Washington, at The Metropolitan Museum of Art in New York and the Fogg Art Museum in Cambridge offers excellent proof that we are more than ready to enjoy and study their presentation. These sculptures are not only fascinating as independent works of art, they help even the most experienced scholars discover aspects of sculpture that have been overlooked. This catalogue should also open many eyes to the exciting relationship that terra-cottas have with sculpture in stone and in bronze. Even as both collection and catalogue add to our aesthetic experience, they open a new chapter in the history of art collecting, both private and public, in this country and abroad.

SEYMOUR SLIVE
Director, Fogg Art Museum
Gleason Professor of Fine Arts
Harvard University

PROLOGUE

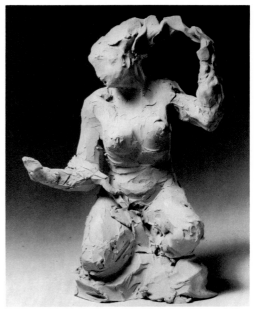

No. 60. Martini, *Girl Kneeling and Dressing Her Hair*.

THE EMINENCE OF AMERICAN MUSEUMS and our art collections are a relatively recent phenomena, an achievement attained only in this century. Baedeker's *United States* vividly suggests how limited were our holdings in 1893. No reference is made to a museum in Washington, D.C. At The Metropolitan Museum of Art in New York, it was noteworthy that "most of the objects are labelled." The starred feature was the collection of more than ten thousand antiquities which General Cesnola had "found" during the six years he was U.S. Consul in Cyprus. This collection was sold to the Metropolitan and its owner subsequently appointed director of the museum. In Boston "the large and excellent" museum collection of plaster casts "was surpassed in importance by those of Berlin and Strassburg only"; their paintings, it was noted, were "on loan and frequently changed." The Art Institute of Chicago possessed "some very interesting and valuable collections," but lacked a building. Philadelphia had no art museum.

Less than a century later, the museums of the United States and our collections are so distinguished that in almost every field of cultural treasures, we are, if not first, then second only to the countries in which those arts are indigenous. We have the finest Chinese art outside China; the finest Mexican art outside Mexico; the finest British art outside Britain. If the Russians surpass us in the Dutch seventeenth century, our modern French paintings are unrivalled.

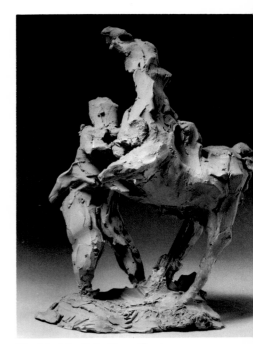

No. 64. Martini, *Horse Tamer*.

This achievement has been privately financed, and it is largely to the credit of private collectors. It is also typically an American expression of farsighted national policy. Private collections have been bold and remarkable achievements, compared to which most museum purchases, controlled by committees, have been unadventuresome.

The Arthur M. Sackler collection of European terra-cottas is a case in point. Several American museums have occasionally bought terra-cotta sculptures. None has recently assembled such a comprehensive group. The Sackler collection illuminates the entire field of old master sculpture, a field in which serious regular collecting was supposed to be no longer possible.

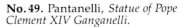

No. 49. Pantanelli, *Statue of Pope Clement XIV Ganganelli*.

Terra-cotta may well be the material that has been most consistently and most widely used for making works of art, which makes it all the more astonishing that it has received so little

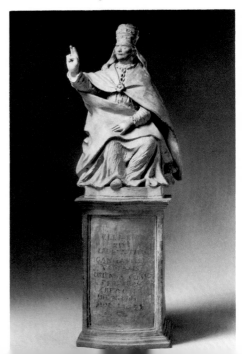

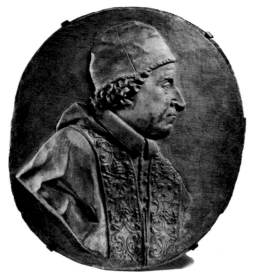

No. 31. Anonymous,
Pope Clement XI Albani.

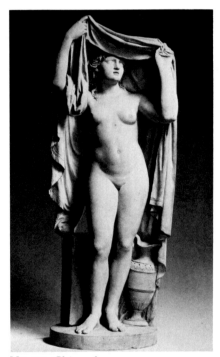

No. 87. Chinard,
Phryne Emerging from her Bath.

No. 71. Adam,
Putto Playing a Drum Before Armor.

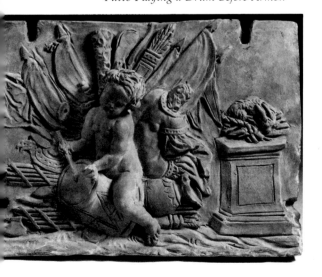

general study. There are no universal collections. Even systematic, limited groupings are rare. Only in Italy or Denmark can one see a comprehensive array of Etruscan terra-cottas. Does a representative assemblage of architectural terra-cottas exist? Is there any place where one can grasp the extent of Clodion's achievement? Suppose drawings were viewed in similar fashion. Adjudged poor relations of statues, paintings or prints, they would be scattered about a collector's house, or dispersed among a museum's departments.

Considering the traditional attitude toward terra-cottas, the very existence of the Sackler collection is remarkable.

To be sure, sculptors' sketches in clay have long been sought—but how sporadically. Bernini was perhaps the most prolific such sketcher. His son wrote that one of the servants cleverly acquired a great many of the clay pieces and supported himself and his family for twenty years by selling them off. Only a few survive. The two largest collections are at the Fogg Art Museum, Cambridge and at the Hermitage, Leningrad. Together they contain less than thirty Bernini terra-cottas. The Berlin/Dahlem museum alone has one hundred thirty drawings by Rembrandt.

Lacking coherent collections we must turn elsewhere for knowledge. Few documents indicate just how terra-cottas were used, but we do have some information about the way sculptors' studios were organized. From this we can deduce that between the fifteenth century and the present day, fired or unfired clay could be used for three-dimensional sketching (nos. 60–65), for presenting the artist's idea to the patron (no. 49), for the sculptor's definitive model which his assistants would translate into marble or bronze (no. 31), for finished works of art (no. 87), or for inexpensive reproductions of popular statues. Frequent examples of this genre, though not represented in the Sackler collection, are portraits of rulers (often at miniature scale) to be acquired by prudent bureaucrats or sold to admiring tourists, much as photographs of the president are sold today.

But a given piece might serve more than one purpose. Thus the Adam reliefs (nos. 71 and 72) may well have been presentation pieces, but it is likely they were also intended for permanent exhibition. Or, the use to which a sculpture was put might change. No material is more difficult to recarve than terra-cotta, few are

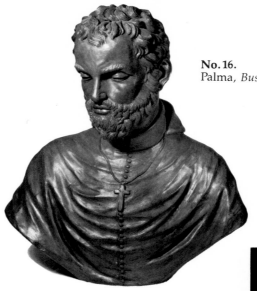

No. 16.
Palma, *Bust of a Cleric.*

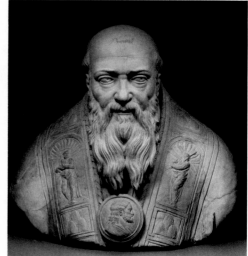

No. 13. Danti (?), *Pope Julius III del Monte.*

easier to extend or alter. By a little smudging of the surface the remodeller can hide his traces almost completely.

Our information as to how terra-cottas have been used is fragmentary. We are only just becoming aware of how often they have been restored. Much that we have read, assumed or proposed now begins to seem simplistic. We welcome the Sackler collection first because it can enlighten us. This wide range of objects makes any number of instructive comparisons easy.

But the collection is no mere assemblage of individual attractions. Artistically and historically it is especially notable for a score of portrait-busts ranging in date from the mid-sixteenth to the late nineteenth century. Even more unusual is a sequence of some twenty narrative reliefs, spanning the same period of time.

The nineteenth century judged human beings in terms of "character." Strong or weak, flighty or determined, character was usually conceived as a God-given attribute, independent of the individual's desires or social position, like red hair. The portrait-bust was an ideal form for depicting character conceived in this way because it included nothing irrelevant. That period developed an enthusiasm for busts which reached an apogee in the work of Rodin. In America that enthusiasm died with the Depression.

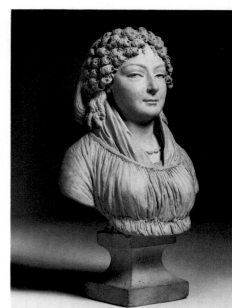

No. 89. Chinard, *Bust of a Woman.*

For our age, primarily concerned with abstract art, the representation of an individual's character in sculpture is inappropriate, even distracting. As art, portrait-busts are dead for most of us. If we take them at all, we take them for granted.

No. 75. Lemoyne, *M. François Boucher.*

How can we rekindle an understanding of this major genre? So varied is the Sackler group, it challenges us to consider the different purposes portraits have served, and how function affected their form. We know from paintings of the period that Italian renaissance busts were placed over doors, and also might crown a fireplace. The appearance of the mid-sixteenth century bust by Palma (no. 16) suggests it was intended for such a location. Since most major rooms had more than one door, such a portrait-bust must have been considered part of a series. First of all, it represented the status of the sitter, for example his religious rank or position as head of the family. In any succession of leaders, only one was likely to be alive at any moment. Was the long-term implication of the over-door location that the sitter was dead? Isolated

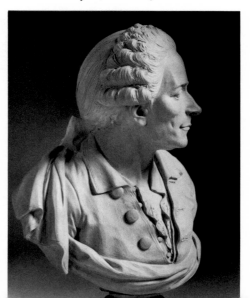

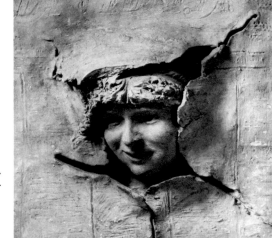

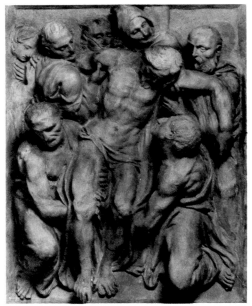

No. 14. Del Duca, *Deposition of Christ.*

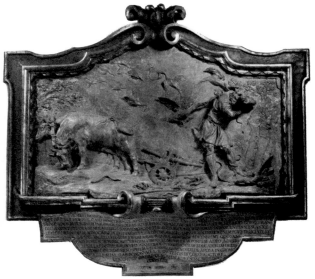

No. 42. Toselli, *Miracle of the Cranes.*

No. 54. Anonymous, *Sketch Model for a Wall Monument with a Figure of Charity.*

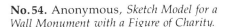

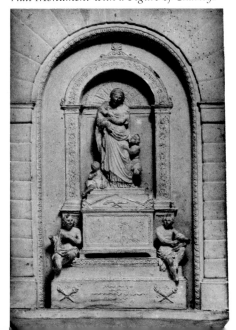

and placed so high, the relation to the viewer could hardly have been intimate.

No. 13, also mid-sixteenth century, is a convincing record of the strong personality of Pope Julius III. It is hardly a representation of such a subtle trait as seductive calculation (as in no. 90); still less a three-dimensional snapshot (such as no. 75, which is only 8 inches high).

Even more remarkable are the narrative reliefs. This genre has played a major role in the history of Western art. But since antiquity, almost every one of the greatest reliefs was intended for a specific location, and most of those which survive remain in the place for which they were made. Original narrative reliefs can rarely be brought together for comparisons, so the expressive possibilities and limitations of this type of sculpture have been insufficiently considered.

The Sackler collection makes such study possible for the period since the Renaissance. Examples range from the late fifteenth century (no. 2) to Zawiejski's delightful nineteenth century newspaper symbol, *The Lookout* (no. 66); from a mid-sixteenth century reflection of a somber composition by Michelangelo (no. 14) to an enchanting Baroque folk narrative, *Miracle of the Cranes* (no. 42). There are the anonymous, tiny representations of wall tombs (nos. 54 and 55) and a full-scale study of children by Duquesnoy, which assistants translated into marble for the Filomarino Chapel in Naples (no. 19). It is hard to imagine a body of material which could be more illuminating to art historians.

Hopefully, a final contribution of this collection and its catalogue will be to make other collectors, as well as museums in the United States, more aware of the importance of terra-cotta sculptures. It would be gratifying if the American collections in this medium ultimately reached the level of distinction we have achieved in other kinds of art.

JOHN COOLIDGE
William Dorr Boardman, Professor of Fine Arts
Harvard University

No.2. Anonymous, *The Nativity of Christ and the Annunciation to the Shepherds.*

No.19. Duquesnoy, *Two Angel Musicians.*

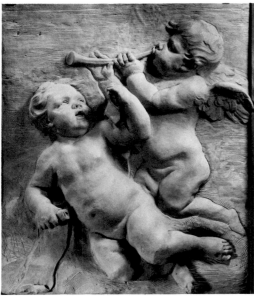

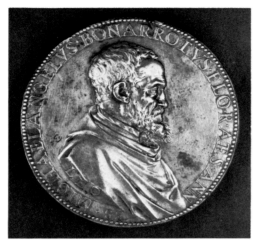

Fig. 1. Leone Leoni, *Michelangelo*,
silver medal, 1563, Victoria
and Albert Museum, London.

"When godlike art has, with superior thought,
The limbs and motions in idea conceived,
A simple form in humble clay achieved
Is the first offering into being brought."

MICHELANGELO, 1545/46, translated by F. Bunnett [1]

INTRODUCTION

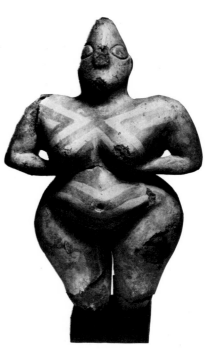

Fig. 2. *Female Figurine*, terra-cotta, Anatolia, ca. 3rd Milennium B.C. the Arthur M. Sackler Collections, New York.

CLAY has since time immemorial been the primary material used by man for modelling images. Left to dry in the sun, or baked in an oven into *terra-cotta* (Italian for "baked earth"), it provided a universally available material which was inert and durable, witness the survival of images made thousands of years ago in Anatolia (fig. 2).

The use of clay in sculpture developed concurrently with its use for pottery vessels, and sometimes performed a dual role, as in pre-Columbian civilizations.

Terra-cotta sculpture, sometimes painted or glazed, has featured in all principal European cultures, although it found particular favour in some, such as the Etruscan (fig. 3), the Italian Renaissance and Baroque periods, and in 18th- and 19th-century France. Terra-cotta was not widely used for sculpture in ancient Greece, apart from the celebrated statuettes made in Tanagra (fig. 4), nor in Rome. Neither was it widely used in antiquity, during the Middle Ages or later in northern Europe, nor has it found particular favour with the modern movement.

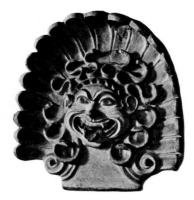

Fig. 3. *Medusa-mask,* decorative terra-cotta roof-tile, Etruscan, 6th century B.C., Museo Nazionale di Villa Giulia, Rome.

In sculpture, clay can be used for two principal purposes: preliminary models—best called sketch-models, from the analogy with preparatory drawings, or *bozzetti,* following Italian usage (*maquettes* in French); and finished sculpture, which may be left plain or, as was more usual, coloured with paints or glazes, for example, the della Robbia technique invented in 15th-century Florence, (see no. 56).

From the High Renaissance, through the Baroque periods in Italy and France, and increasingly toward the present day, connoisseurs have been fascinated by sketch-models as records of the very process of creation at the fingertips of the sculptor. They have, however, rarely survived.[2] In these models his original idea, or successive variations and alternatives, may be preserved for posterity. This enables one, in part at least, to follow the workings of the artist's mind and imagination. These steps are often less clear in a finished sculpture, particularly when executed by carving in stone or marble, where the exacting and lengthy technical processes obviate the spontaneity of a model quickly created in a malleable and responsive medium. As Vasari observed *vis-à-vis* painting, "Many painters . . . achieve in the first sketch of their work, as though guided by a sort of fire of inspiration . . . a certain measure of boldness; but afterwards, in finishing it, the boldness vanishes."

Fig. 4. *Woman,* terra-cotta, Tanagra, late 4th or early 3rd century B.C., Bowdoin College Museum of Art, Brunswick, Maine.

Fig. 5. Giambologna, *Florence Triumphant Over Pisa,* wax, ca. 1565, Victoria and Albert Museum, London.

Fig. 6. Andrea del Verrocchio, *Forteguerri Monument,* terra-cotta, ca. 1476, Victoria and Albert Museum, London.

T HE MAIN RIVAL material for modelling, beeswax, has different properties from clay and, correspondingly, different uses.[3] On the other hand, it is quicker and cleaner to use, for water does not have to be added continually; nor does the model have to be kept damp under wet rags while being worked on, as does one of clay. Beeswax, with various admixtures, such as turpentine and tallow, remains malleable far longer than clay and, even when it has hardened, may be softened again with heat. *"La cera sempre aspetta"*("wax always waits"), wrote the sculptor Sirigatti in 1584, when giving an account of the processes of modelmaking, a topic to which we shall have cause to return.[4] When modelled around an armature, normally of iron wire, wax may be used to create a sculpture that penetrates vigorously into space, for instance, a human with outflung limbs as in Giambologna's *Mercury*,[5] or a horse rearing or galloping, as in Degas' work. Clay is less amenable to such uses, although it, too, may be given greater tensile strength by an armature, usually made of wood. This is to avoid the rust that would be caused by moisture from the clay attacking a metal armature.

On the other hand, however, wax, once it has hardened, is less durable. Thus, a sculptor or collector who wishes to preserve a wax model's design usually has to resort to making a mould from it, which may then be used to cast a bronze version as Giambologna did, or the heirs of Degas. Through the centuries, wax has been used by most sculptors, but their models have rarely survived. However, a unique collection has been built up over the years in the Victoria and Albert Museum in London that includes the best authenticated wax model by Michelangelo, of a slave; a unique tableau of the Deposition in wax on wood by Jacopo Sansovino; and half a dozen sketch-models foreshadowing several of Giambologna's principal compositions (fig. 5).[6]

Once the interest of patrons and collectors had fastened on sketch-models, terra-cotta became the standard material, for example, with Bernini and his followers. Wax seems to have fallen out of favor, probably due to its disadvantage of fragility over the long term. Paradoxically, it was Bernini's boast that he had succeeded in treating his marble sculpture as though it were made of wax, referring, of course, to its daring extensions into space, its bold undercutting, especially of flying drapery, and its glistening surface texture.[7] Naturally, it was to a sculptor's advantage if he could find a ready market not only for a finished work, but for the preparatory stages also. Terra-cotta models served to fire, and then to maintain, a patron's enthusiasm, or to satisfy rich, private collectors who wanted only small representative pieces for their cabinets. Through either channel, the artist's reputation would be spread and enhanced.

The earliest sketch-models in clay or terra-cotta to survive date from the middle of the fifteenth century and were made in or around Florence. They are all connected with important, and more or less public, commissions and were preserved not so much from the

18

point of view of their aesthetic value as from that of visual documentation attached to a legal contract. Models were normally demanded by patrons, especially the corporate committees, which were so important a factor in the emergence of Renaissance sculpture.[8] The earliest examples survive in the Victoria and Albert Museum: Verrocchio's terra-cotta relief design (fig. 6) for the Cardinal Forteguerri monument in Pistoia Cathedral, preserved possibly because there had been an informal competition over the executant, in which Lorenzo "the Magnificent" de' Medici had adjudicated in favour of Verrocchio as against Piero Pollaiolo. This was closely followed by Benedetto da Maiano's sketches for the relief panels on the sides of a polygonal pulpit commissioned by Giovanni Mellini for the church of Santa Croce in Florence.[9]

The deliberate preservation of preliminary sketches for their aesthetic interest by patrons and collectors, whether drawn on paper or modelled in clay and wax, was an innovation characteristic of the High Renaissance, with its new emphasis on the divine inspiration of the creative artist replacing the more traditional dismissal of him as a mere craftsman. Jacopo Sansovino's model, now lost, for his *St. James* in Florence Cathedral was given to Bindo Aldoviti, while his *Deposition* was presented to Giovanni Gaddi.[10] A terra-cotta by Jacopo of *St. Paul* survives in the Musée Jacquemart-André in Paris (fig. 7).[11]

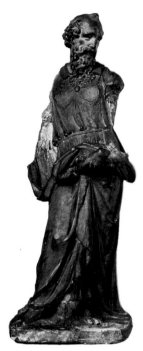

Fig. 7. Jacopo Sansovino, *St. Paul*, terra-cotta, ca. 1515, Musée Jacquemart-André, Paris.

MICHELANGELO often made use of wax or clay models (fig. 8), although few survived his neurotic fits of destruction.[12] Nevertheless, the sonnet quoted earlier attests to his deep respect for the preliminary model, and in it there are clear overtones of the sculptor performing a role analogous to that of God in the Old Testament story of the Creation, when He made man out of a handful of clay. It is recorded that Michelangelo gave his friend and fellow sculptor Leone Leoni a wax model of *Hercules and Antaeus* in gratitude for modelling his portrait on a medal (fig. 1).

Cellini frequently refers to models, although usually wax ones, in his *Autobiography* and *Treatises,* and his preliminary wax model for *Perseus and Medusa* is preserved in the Bargello in Florence.[13] His rival, Bandinelli, was positively obsessed with making models, chiefly in the hope of emulating Michelangelo's success. They feature interestingly in several engravings portraying Bandinelli, which he himself commissioned for publicity purposes (fig. 9).

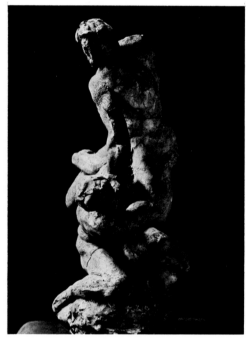

Fig. 8. Michelangelo, *Hercules and Cacus*, terra-cotta, ca. 1525-28, Casa Buonarotti, Florence.

Probably the most dedicated modeller of the late 16th century was, however, Giambologna (1529-1608), a Flemish-born sculptor who made his career under the Medici grand dukes in Florence. We are told by Baldinucci that Giambologna, in his old age, used to love to recount a story against himself: how, soon after his arrival in Rome, he took to show the elderly Michelangelo a laboriously finished model, no doubt hoping for his approbation.[14] Instead, the old master squashed it (it must, therefore, have been in wax, not terra-cotta!), only to remodel it himself, with a few deft strokes, into

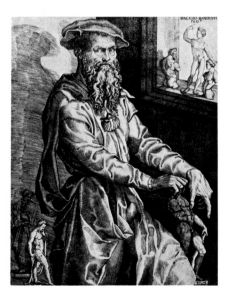

Fig. 9. Niccolò della Casa, *Baccio Bandinelli With Models,* engraving, mid-16th century, Museum of Fine Arts, Boston.

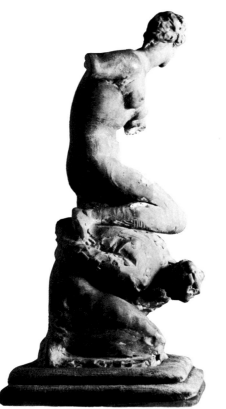

Fig. 10. Giambologna, *Florence Triumphant over Pisa*, terra-cotta, 1565, Victoria and Albert Museum, London.

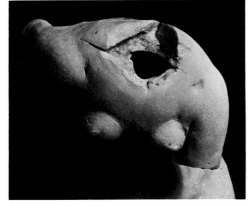

Fig. 11. Detail of statuette in fig. 10, during conservation, showing hollow modelling of torso.

Fig. 12. Detail of statuette in fig. 10, showing imprint of wood-grain on underside.

a vigorous composition, admonishing the newcomer: *"Or va prima ad imparare a bozzare e poi a finire"* ("Now go off and learn to model first, before trying to finish anything").

This was a bitter lesson which Giambologna never forgot, for, as a consequence, he became an assiduous maker of models, apparently preferring to create his compositions in three-dimensional form from the outset, without resorting to drawing.[15] More models by him in wax or clay have survived than by any other Renaissance artist. They are outnumbered only by the wealth of terra-cotta *bozzetti* executed by his great successor, Gianlorenzo Bernini, preserved, for example, in the Fogg Art Museum in Cambridge, Massachusetts,[16] the State Hermitage, Leningrad,[17] etc. Giambologna's sketch-models were preserved by his friend and patron, Bernardo Vecchietti, as well as by Bernardo, a master-mason at the Grand Ducal court, and by the Medici themselves.[18]

GIAMBOLOGNA seems to have adopted the regular procedure of forming his ideas in wax, usually on a wire armature at a height of 10 to 25 centimeters. Three of these "first thoughts," or *primi pensieri*, belong to the Victoria and Albert Museum (fig. 5), while others remain in private hands. Then, using clay, he enlarged and "fleshed-out" his initial idea, roughly doubling the size of the model. Classic examples of this technique are the wax and terra-cotta models executed for his *Florence Triumphant over Pisa* (fig. 10).

The clay model is partly hollowed out to avoid cracking during firing, which could result from differential contraction of the clay (fig. 11). Giambologna's younger Italian contemporary and pupil, Sirigatti, explains the procedure: "Models in clay which are intended to be kept and which are baked in a kiln are produced as follows: clay is dug out of the beds where it is to be found and is softened with water and is well pounded. Then one begins to build up the figure from the legs. They are made solid, as are the arms and the neck. But the torso, and the head, too, are hollowed out. While one is making the figure, parts which stand free may be given supports, as necessary. For shaping one uses an iron tool, with teeth, and pointed tools to get in where the fingers cannot reach, for instance in the hair and elsewhere."[19] Sirigatti then warns against allowing one part to dry out more than another, which will cause cracking, and recommends keeping all the components equally soft under damp rags. "The final polish," he adds, "is given with a soft rag wrapped round the fingers, or, better still, with a sponge."

A terra-cotta such as the *Florence Triumphant over Pisa* was built up in just this way, on a rough wooden board, the grain of which is imprinted on the underside of the model's base (fig. 12). There is an exciting contrast between the rough modelling of the crouching male figure and the voluptuous surface of the female, probably finished, as Sirigatti recommends, with a damp rag or sponge. Vasari (1550)[20] and Sirigatti (1584) give lengthy and more or less consistent accounts of how a full-sized model (in Italian, *modello*)

is produced, emphasizing the necessity of a skeleton (*ossatura*) or armature to support the great weight of clay. The armature is made of wood, with hay or tow bound around it with string, to give a good hold for the damp clay. The latter is mixed with tow or horsehair to bind it together, as well as with baked flour to prevent it from drying out too quickly, thus minimizing shrinkage. The three artists also describe how drapery may be added to a nude figure by dipping real cloth in a liquid slip of clay, and modelling it around the figure as desired.

Fig. 13. Giambologna, *Florence Triumphant over Pisa*, clay with admixtures, 1565, Galleria dell'Accadèmia, Florence.

The full-scale clay model—not terra-cotta, for such a figure was far too large to be baked in a kiln—for *Florence Triumphant over Pisa* (fig. 13), whitewashed to look like marble, actually fulfilled the role of a finished sculpture for some years (1565-1572) in the Palazzo Vecchio in Florence, and this may have helped to ensure its survival. Not until several years later was a sufficiently large block of marble quarried and carved into the final work. The full-scale *modello* for Giambologna's masterpiece, the *Rape of a Sabine,* also survives in Florence, in the Accademia. Both have long been popularly dismissed as being "boring" plaster casts. From such full-scale *modelli,* measurements in all dimensions could be made with the help of various mechanical devices, and then transferred to aid in the carving of the statue from the block of marble.

Some of Giambologna's most excitingly spontaneous sketch-models in clay, with his fingerprints literally preserved on them, were made in connection with his most ambitious, and bizarre, project, the immense garden giant, allegorically representing the mountain range of the Apennines, at the Medici villa of Pratolino (ca. 1585; fig. 14). Here the completed sculpture deliberately lacks "finish" in the conventional sense, in order to stress its intimate relationship with its natural surroundings. The project inspired Giambologna to a burst of spontaneous creativity that has scarcely been equalled. His vigorous attack on the clay most certainly set the stage for the emergence, in the next generation, of Bernini and, still later, of the French Romantics and sculptors such as Arturo Martini (nos. 60-65).

Fig. 14. Giambologna, *River-god,* terra-cotta, ca. 1585, Victoria and Albert Museum, London.

B ERNINI and his followers in Rome (both Italian and French) seem to have transferred their allegiance from wax to clay, probably to satisfy demands of patrons and others that their models be made of a durable material (fig. 15). Correspondingly, the statistical rate of survival of models becomes higher; this is reflected in the present collection, as well as in those of most museums. One may very well be correct in surmising that a "spin-off industry," producing spontaneous sketch-models without a specific commission in mind, soon emerged. These could then be marketed in their own right by sculptors both major and minor to an eager band of collectors. This trend ultimately led to the emergence of sculptors such as Clodion (nos. 81, 82) and Carrier-Belleuse (nos. 97, 98), who directly catered to this market with models which, although freshly modelled,

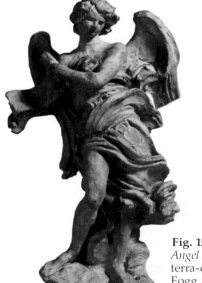

Fig. 15. Gianlorenzo Bernini, *Angel Holding the Scroll,* terra-cotta, ca. 1668, Fogg Art Museum, Harvard University, Cambridge, Mass.

21

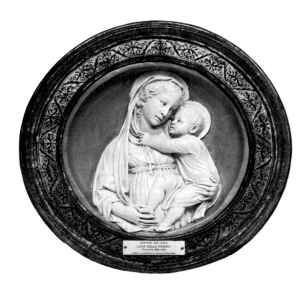

Fig. 16. Luca della Robbia, *Virgin and Child*, tin-glazed terra-cotta, third quarter of the 15th century, Edith A. and Percy S. Straus Collection, Museum of Fine Arts, Houston, Texas.

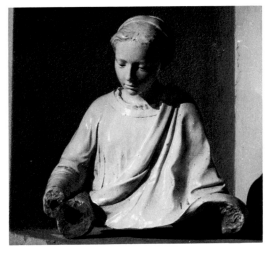

Fig. 17. Luca della Robbia, *Visitation*, detail showing the upper part of the Virgin Mary, tin-glazed terra-cotta, pre-1445, San Giovanni Furocivitas, Pistoia.

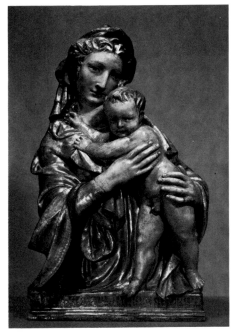

Fig. 18. Florentine School, *Madonna and Child*, terra-cotta, painted and gilded, ca. 1435, Samuel H. Kress Collection, National Gallery of Art, Washington, D.C.

were usually not preparatory in intention. In fact, this market had existed as long ago as the High Renaissance in Florence, where it provided an outlet for the products of sculptors and workshops whose identities are no longer known and who are nicknamed, after the titles of their principal subjects, "Master of the David and St. John statuettes" and "Master of the Unruly Children" (nos. 8 and 9).

Finished sculptures in terra-cotta may be modelled individually, or reproduced by casting from a mould. Both techniques were employed by an artist whose name is indissolubly linked with the medium of terra-cotta: Luca della Robbia (1400-1482).[21] Having begun by modelling clay, perhaps as a preliminary to sculpture carved in marble (he was also a talented marble sculptor),[22] Luca pioneered the use of white tin-glaze to imitate marble, a technique especially useful for sculpture exposed to the weather out of doors (fig. 16). Because it involved a saving in both artist's time and materials, for even in Tuscany a slab of clear white statuary marble was expensive, glazed terra-cotta provided a much cheaper alternative to traditional media. With the discovery of an increasing range of pigments that could withstand the high temperatures necessary to fuse the vitreous glaze, Luca's new medium superseded, at least for public sculptures, the older use of paint over a *gesso* layer. Impervious to rain and ice, the durability of Luca's material is proven by the extremely high survival rate, even in exposed positions, of his and his nephew Andrea's work.

The techniques of modelling to a uniform thickness to avoid cracking, and in component parts that could be easily accommodated in a kiln and subsequently built up into a larger whole, were gradually mastered, as in the group of the *Visitation* in Pistoia, of which one part is shown in fig. 17. The process was then put into mass production by the use of piece-moulds, which served to reduce the unit cost. The details of this technique were a closely guarded trade secret, although della Robbia glazing seems to have been practiced long after the Renaissance, and even into the early 18th century, with its application to late Florentine Baroque sculpture modelled by, for example, Ciro Ferri.

Reliefs and statuettes of the Virgin and Child or other devotional subjects, usually covered with a layer of *gesso* and painted naturalistically, or given a finish resembling bronze or gold, formed a major part of the production of many sculptural workshops in Florence including those of Ghiberti, Donatello, Benedetto da Maiano and Verrocchio (fig. 18). While those great masters occasionally modelled the originals, their shops were occupied in reproducing them by way of commerce, often with variations of size, shape and details, as well as "personalizing" them in some instances with coats-of-arms or emblems, whether of private persons or institutions. Portrait-busts of individuals, once the fashion had been revived following ancient Roman practice, could also be produced in terra-cotta, with the minimum of artistic intervention, by the use of a face-mask, which when it had dried formed a hollow negative mould from which a facsimile of the face could be

cast. This is the probable explanation of the rather "dead" look on the face of Verrocchio's bust of Giuliano de' Medici, now in Washington (fig. 19). An amusing side effect of this process—and one that served to betray when it was employed—is that busts made in this way are anything up to ten per cent smaller than life, owing to the considerable shrinkage that occurs as the moisture is dried out of the clay. If a sculptor wished to achieve a life-size bust in terra-cotta, he could not employ the moulding technique and would have to model the head and shoulders freehand and distinctly larger than life, in order to compensate for the subsequent shrinkage. On the whole, terra-cotta seems to have been held in less esteem in Florence than marble or bronze, which were a good deal more expensive and durable: the feeling that working in terra-cotta was inferior to marble carving— which clearly is much more arduous and demanding—is epitomized by no less a figure than Michelangelo. On the other hand some of the finest Florentine Renaissance sculptures were modelled in clay and fired, not carved.

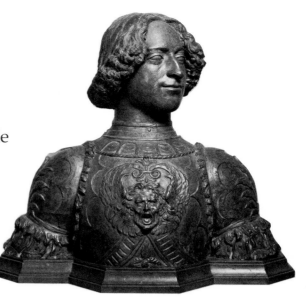

Fig. 19. Andrea del Verrocchio, *Giuliano de' Medici*, terra-cotta, Andrew Mellon Collection, National Gallery of Art, Washington, D.C.

Pietro Torrigiano, a Florentine who was Michelangelo's boyhood rival, and who led a nomadic career all over Europe, also worked largely in terra-cotta. He produced not only life-size statues in Spain, such as his *Virgin and Child* and *St. Jerome*, but also brilliant, veristic portrait-busts in England, for example, *King Henry VII* in the Victoria and Albert Museum (fig. 20) and *King Henry VIII* and *Archbishop Fisher*, both in The Metropolitan Museum of Art, New York.

O UTSIDE TUSCANY the main areas in which terra-cotta was used for finished sculpture were just north of the Apennines, in the alluvial plane of the River Po and its tributaries, which evidently provided an abundant supply of exactly the right type of clay. In Reggio Emilia, around Parma, and in the Marches around Bologna there grew up a whole school of terra-cotta sculpture (see no.1). Figures were frequently modelled life size and composed into vivid tableaux representing scenes from the life of Christ, especially His Birth and Adoration and His Passion. Scenes of the Deposition from the Cross or the Entombment ("Easter Sepulchres") were used for devotions on Good Friday or Easter, when the statue of Christ's corpse would be physically removed from the tableau to symbolize His resurrection (see no. 1, fig. 1). The nearest example in the present collection is a representation of Christ's corpse laid out for burial (no. 67), which, however, probably originated in France.

Fig. 20. Pietro Torrigiano, *King Henry VII*, pigmented terra-cotta, ca. 1510, Victoria and Albert Museum, London.

A series of great sculptors of international repute contributed to this particular tradition, so it should not be lightly dismissed as "folk art" or "devotional statuary" although it subsumes both of these forms. To name only the best of these artists, Niccolò dell'Arca (fig. 21), Guido Mazzoni, Antonio Begarelli and Alfonso Lombardi are principally known for their work in the medium of painted terra-cotta, with careers running from the mid-15th to the late-16th century. This tradition was revived at Bologna in the middle of the 17th century and, cross-fertilized by the new interest in sketch-models and collector's items inspired by

Fig. 21. Niccolò dell'Arca, *Lamentation*, detail showing the upper part of the Virgin Mary, pigmented terra-cotta, 1463, Santa Maria della Vita, Bologna.

Fig. 22. Alessandro Vittoria, *Self-portrait*, terra-cotta, late 16th century, Victoria and Albert Museum, London.

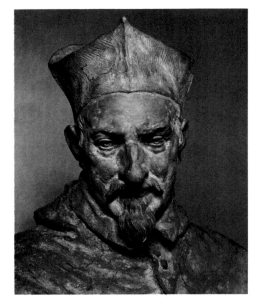

Fig. 23. Alessandro Algardi, *Cardinal Paolo Emilio Zacchia*, detail, terra-cotta, ca. 1652, Victoria and Albert Museum, London.

the success of Bernini, served to produce sculptures of the highest technical and expressive qualities, for example, works by Giuseppe Mazza (nos. 39-41) and others (nos. 42-48).

In late Renaissance Venice, terra-cotta was employed by Jacopo Sansovino and his circle for statues and portraits (see Cattaneo, no. 15). Alessandro Vittoria, on the other hand, exploited the technique in portrait-busts, where the liveliness of the image was enhanced by preserving the spontaneity of the freshly modelled clay, rather than laboriously transferring it into the more elegant and classically inspired marble (fig. 22). Bernini's contemporaries, Algardi and Duquesnoy (members of the triumvirate that pioneered the Baroque style in Rome during the first half of the 17th century), also frequently resorted to terra-cotta. One of Algardi's last works was his expansive portrait of Cardinal Paolo Emilio Zacchia (d. 1605), recently acquired by the Victoria and Albert Museum (fig. 23). His earlier, figurative sculptures are well represented here by a model of *St. John the Baptist* (no. 18) made in connection with a bronze group and by an unusual waist-length, finished statue of *Christ* (no. 17), presumably from a group titled *Christ in Limbo.* Duquesnoy, Flemish by birth, shared the predilection of his countryman Peter Paul Rubens for the lifelike rendering of naked flesh. Particularly in his sculptures of children (*putti*, in Italian), the ductile nature of clay enabled Duquesnoy to reproduce the soft smoothness of infant flesh to perfection (see no. 19). The standards that he set continued to challenge and inspire artists in England, in The Netherlands such as Pompe (no. 112), and Clodion (fig. 24) in France for two centuries afterward, leading up to Carrier-Belleuse and his assistant, the great Rodin.

I N FRANCE, according to Réau,[23] the formality and restraint of the court of Louis XIV was basically unfavourable to the evolution of the freely modelled sketch, fresh in inspiration. But at the end of his reign it came into its own as never before. Indeed, sculptors began to try and preserve some of the spontaneity of a *maquette* in the execution of a finished work, and a laborious finish such as Bouchardon and his compères had striven for fell out of fashion. Something of the contrast remarked by Réau may be observed between examples in the Sackler collection: Louis Lecomte's *Nature* (no. 68), or Adam's *Putti* (nos. 71-72) are less spirited than Vassé's *Mourning Woman and Putto* (no. 73) or the anonymous, *Study of a Fallen Man in Agony* (no. 77).

The collection is also rich in seductively fresh French sketch-models from the Neo-Classic and Romantic periods too—Chinard's *Sappho and Phaon* (no. 90); and little groups by Dumont (no. 91), Milhomme (no. 92) and Duret (no. 94)—while the modern period is well represented by a tiny male sketch ascribed to Rodin (no. 101). The parallel stream of spontaneously modelled, but finished, small sculpture in terra-cotta appears in Clodion's pair of *Vestal Virgins* (nos. 81, 82), in Chinard's *Lion* and *Phryne* (nos. 86, 87), in Maindron's *Velléda* (no. 95) and in Carrier-Belleuse's *Bacchante*, and

Colombe (nos. 97, 98), as well as his *Vase des Titans*, where the young Rodin's powers of modelling were exploited and frozen, so to speak, in a work destined for mass production in ceramic (no. 99).

Modern sculptors such as Arturo Martini (nos. 60-65) have reverted to the use of clay principally for vigorous and spontaneous preliminary models, which combine the additive quality of modelled sculpture with the subtractive effects of carving, by the use of palette-knife or modelling tool to cut into and fashion the moist clay before it hardens.

The appeal of the sketch—be it sculptural, pictorial or literary—was shrewdly judged by Delacroix in his *Journal* to be partly in the fact that its very lack of definition permits everyone to finish it off in his mind's eye: "Perhaps the appeal of a sketch is that everyone can finish it off to his own satisfaction."*

*"*Peut-être que l'ébauche d'un ouvrage ne séduit tant que parce que chacun l'achève à son gré.*"

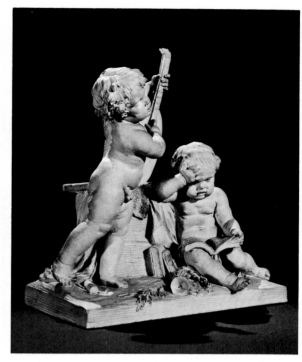

Fig. 24. Clodion, model for *Poetry and Music*, terra-cotta, Loula D. Lasker Fund, National Gallery of Art, Washington, D.C.

NOTES

1. H. Grimm (trans. F. Bunnett), *Life of Michael Angelo*, vol. II, London, 1865, II, p. 284.

2. A.E. Brinckmann, *Barock-Bozzetti*, Frankfurt am Main, 1923; L. Réau, "Les maquettes des sculpteurs français du XVIIIe siècle," *Bulletin de la Société de l'Histoire de l'Art Français*, 1936, pp. 7–28; I. Lavin, "Bozzetti and Modelli," *Stil und Überlieferung in der Kunst des Abendlandes. Akten des 21. Internationalen Kongresses für Kunstgeschichte in Bonn, 1964*, Berlin, 1967.

3. C. Avery, "Bernardo Vecchietti and the wax models of Giambologna," *Atti del I Congresso Internazionale sulla Ceroplastica nella scienza e nell'arte*, Florence, 1975 (1977), II, pp. 461–74; *idem*, "La cera sempre aspetta: wax sketch-models for sculpture," *Proceedings of the Second International Congress on Wax-modelling*, London, 1978 (in press).

4. R. Borghini, *Il Riposo*, Florence, 1584.

5. C. Avery and A. Radcliffe, *Giambologna, Sculptor to the Medici*, London (Arts Council of Great Britain), 1978, no. 13; cf. pp. 48, 49, "The sketch-models of Giambologna."

6. J. Pope-Hennessy, *Catalogue of Italian Sculpture in the Victoria and Albert Museum*, London, 1964, vol. II, nos. 442, 444, 489–494.

7. Lavin, *op. cit.*, p. 104, n. 51.

8. C. Avery, *Florentine Renaissance Sculpture*, London/New York, 1970, p. 3.

9. Pope-Hennessy, *op. cit.*, nos. 131–33, 140.

10. C. Avery, "Benvenuto Cellini's bronze bust of Bindo Altoviti," *The Connoisseur*, 198, May, 1978, p. 67.

11. F. de la Moureyre-Gavoty, *Institut de France-Musée Jacquemart-André: Sculpture Italienne*, Paris, 1975, no. 136.

12. L. Goldscheider, *A Survey of Michelangelo's Models in Wax and Clay*, London, 1962.

13. J. Symonds (trans.), *The Life of Benvenuto Cellini written by himself*, (intro. and illus. J. Pope-Hennessy), London, 1949; C.R. Ashbee (trans.), *The Treatises of Benvenuto Cellini on Goldsmithing and Sculpture*, London, 1898/New York, 1967.

14. F. Baldinucci, *Notizie dei Professori del Disegno*, Florence, 1681–88 (ed. Ranalli, 1846), II, p. 556.

15. C. Avery, "Giambologna's sketch-models and his sculptural technique," in *The Connoisseur*, 199, 1978, pp. 3–11.

16. R. Norton, *Bernini and Other Studies*, New York, 1914; V. Mariani, "Bozzetti Berniniani," in *Bollettino d'Arte*, IX, 1929–30, pp. 59–65; L. Opdycke, "A Group of Models for Berninesque Sculpture," in *Bulletin of the Fogg Museum of Art*, VII, 1938, pp. 26–30

17. Cf. G. Matzulevitsch, "Tre bozzetti di G.L. Bernini all'Ermitage di Leningrado," *Bollettino d'Arte*, XLVIII, 1936, pp. 67–74.

18. See note 3.

19. See note 4.

20. L.S. Maclehose (trans.), *Vasari on Technique*, London, 1907/New York, 1960, p. 150.

21. A. Marquand, *Luca della Robbia*, Princeton, 1914.

22. C. Avery, "Three Marble Reliefs by Luca della Robbia," *Museum Studies 8*, The Art Institute of Chicago, 1976, pp. 7–37.

23. L. Réau, *op. cit.*, in note 2.

The Italian
Terra-Cottas

15TH TO 20TH CENTURY

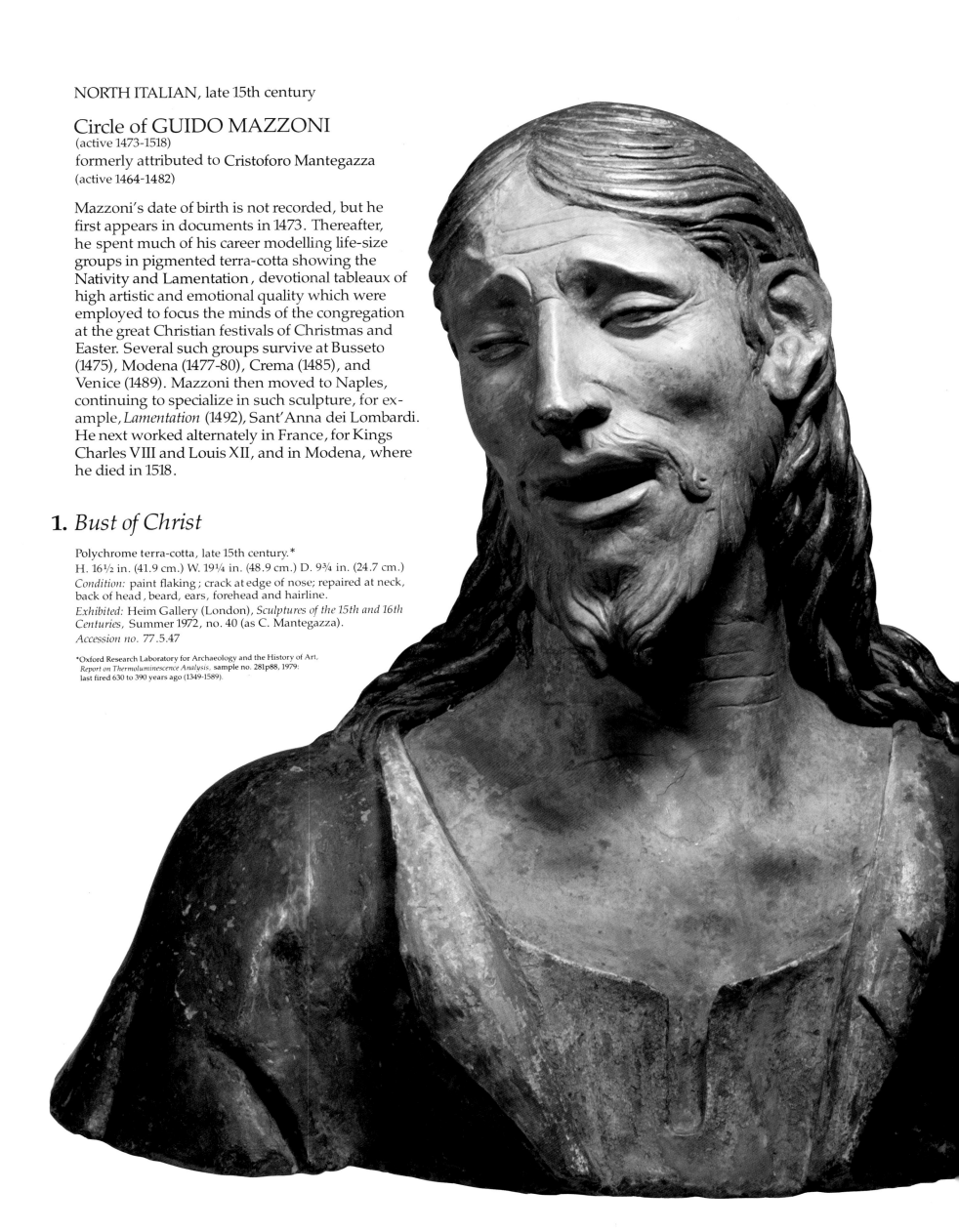

NORTH ITALIAN, late 15th century

Circle of GUIDO MAZZONI
(active 1473-1518)

formerly attributed to Cristoforo Mantegazza
(active 1464-1482)

Mazzoni's date of birth is not recorded, but he
first appears in documents in 1473. Thereafter,
he spent much of his career modelling life-size
groups in pigmented terra-cotta showing the
Nativity and Lamentation, devotional tableaux of
high artistic and emotional quality which were
employed to focus the minds of the congregation
at the great Christian festivals of Christmas and
Easter. Several such groups survive at Busseto
(1475), Modena (1477-80), Crema (1485), and
Venice (1489). Mazzoni then moved to Naples,
continuing to specialize in such sculpture, for ex-
ample, *Lamentation* (1492), Sant'Anna dei Lombardi.
He next worked alternately in France, for Kings
Charles VIII and Louis XII, and in Modena, where
he died in 1518.

1. *Bust of Christ*

Polychrome terra-cotta, late 15th century.*
H. 16½ in. (41.9 cm.) W. 19¼ in. (48.9 cm.) D. 9¾ in. (24.7 cm.)
Condition: paint flaking; crack at edge of nose; repaired at neck,
back of head, beard, ears, forehead and hairline.
Exhibited: Heim Gallery (London), *Sculptures of the 15th and 16th
Centuries,* Summer 1972, no. 40 (as C. Mantegazza).
Accession no. 77.5.47

*Oxford Research Laboratory for Archaeology and the History of Art,
 Report on Thermoluminescence Analysis, sample no. 281p88, 1979:
 last fired 630 to 390 years ago (1349-1589).

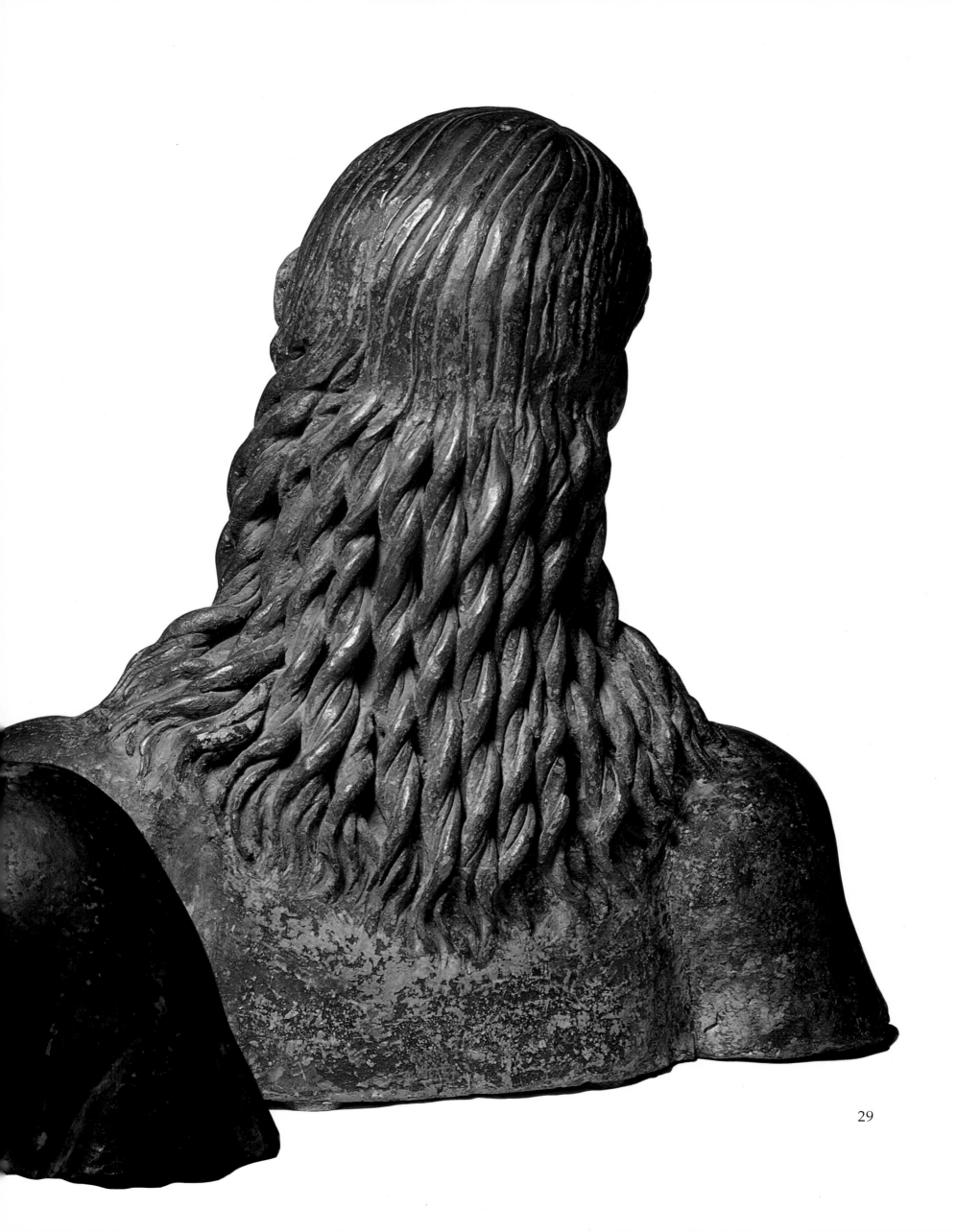

THIS MOVING PORTRAYAL of Christ during His passion is unusual, not only owing to its form as a portrait-bust, but also because in style it does not conform with the principal group of such terra-cotta busts which seem to have originated in the Florentine workshop of Verrocchio.[1] These busts were evidently derived from Verrocchio's bronze statue of Christ from a group showing "Doubting Thomas", Or San Michele, Florence (1466-83), and have a pensive, melancholy expression.[2] It is the look of sheer agony on the Saviour's face, combined with pity for his tormentors, that sets this bust apart: the furrowed brow, eyebrows strained upwards, half-closed eyes, open mouth and tense neck muscles, together with the sharply projecting cheek and collar bones, contribute towards an image of extreme pathos. The facial type is neither Verrocchiesque nor Florentine: it retains the emaciated angularity of Late Gothic sculpture, and this points to north of the Apennines.

When the bust was previously catalogued, analogies with the marble carvings of Cristoforo Mantegazza at the Certosa of Pavia, were suggested,[3] yet the medium of terra-cotta, the scale and the bust form are out of character. The harrowing emotions that are depicted and the vigorous modelling which helps to convey a mood of dramatic tension are characteristic of the school of sculpture modelled at life-size in terra-cotta which was established in the Po Valley in the 15th century and survived well into the 16th century (see Introduction, p. 23). It is therefore preferable to look for the author of the bust in the circle of Niccolò dell'Arca (ca. 1435-1494), who was active in Naples and Bologna, or Guido Mazzoni (active 1473-1518), who worked in and around Modena until 1489, and thereafter in Naples and in France.[4]

The facial type employed for Christ in the present bust is consistent with the head of Mazzoni's once full-length figure of the dead Christ in his great life-size, pigmented group of the *Lamentation* in Sant 'Antonio di Castello, Venice (now in the Museo Civico, Padua).[5] Of this latter group (ca. 1485-1489), only four terra-cotta figures, from a group originally consisting of eight, and the head of the dead Christ remain (fig. 1). This head is closely comparable with the present bust, apart from a realistic difference of expression between the dead, crucified Christ on the one hand and, on the other, the agonized, but still living Saviour of the bust. A very close connection may be remarked between the way passionate grief is registered on the facial features of the bust and its rendering on the countenance of a young, male mourner (probably St. John) from the Venetian group.[6] The bust therefore appears to have originated in the circle of Mazzoni, but must remain anonymous in the present state of knowledge.

1. J. Pope-Hennessy, *Catalogue of Italian Sculpture in the Victoria and Albert Museum*, London, 1964, vol. I, nos. 197, 198, pp. 209–210, and vol. III, figs. 202, 203.
2. J.G. Phillips, "A sculpture by Agnolo di Polo," *The Metropolitan Museum of Art Bulletin*, Oct./Nov. 1971, pp. 80–86.
3. Heim Gallery, *op. cit.* (see *Exhibited* previous page).
4. J. Pope-Hennessy, *Italian Renaissance Sculpture*, London, 1958, plates 120, 121, pp. 342-344, with earlier literature; E. Riccòmini, "Guido Mazzoni," *I Maestri della Scultura*, Milan, 1966, no. 66; T. Verdon, *The Art of Guido Mazzoni*, New York/London, 1978. In 1974, J.-R. Gaborit, Conservateur en chef du départment des Sculptures, Musée du Louvre, referred to a small group of busts of Christ preserved in churches in Emilia with which he associates the terra-cotta *L'Adoration du Christ mort*, in the Louvre (see his "L'Adoration du Christ mort, terre cuite ferraraise du Musée du Louvre," *Monuments et Mémoires*, vol. 59, Paris, 1974, p. 216, footnote 4). He compared a bust in the church of San Spirito in Ferrara with another associated with Guido Mazzoni in the church of San Domenico in Bologna. To these he added a bust in the church of San Domenico in Ferrara which he claimed was extremely close to the bust here. Our thanks to J.-R. Gaborit for bringing this information to our attention.
5. Riccòmini, *op. cit.*, pls. IX-XII.
6. *Ibid.*, pl. XI.

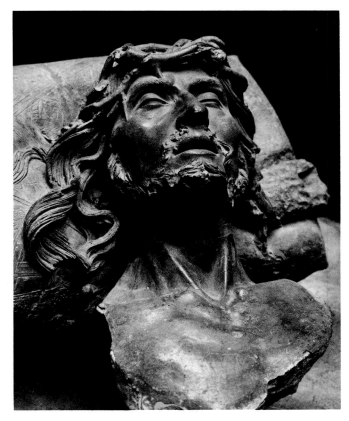

Fig. 1. Mazzoni, Head of Christ, pigmented terra-cotta, fragment from a *Lamentation* for Sant'Antonio di Castello, Venice, 1485-1489, now in the Museo Civico, Padua.

NORTH ITALIAN (VERONA)
mid- to late-15th century

ANONYMOUS
formerly attributed to Michele da Firenze
(active 1436-1441)

2. *The Nativity of Christ and the Annunciation to the Shepherds*

Polychrome terra-cotta.
H. 37¼ in. (94.6 cm.) W. 56½ in. (143.6 cm.) D. 4 in. (10.2 cm.)
Condition: the relief, which was originally modelled in sections and covered with a layer of gesso before pigmentation, appears to have been extensively restored over the years and to have many areas of loss.
Provenance: Istituto dei Buoni Fanciulli, Verona.
Accession no. 79.1.6

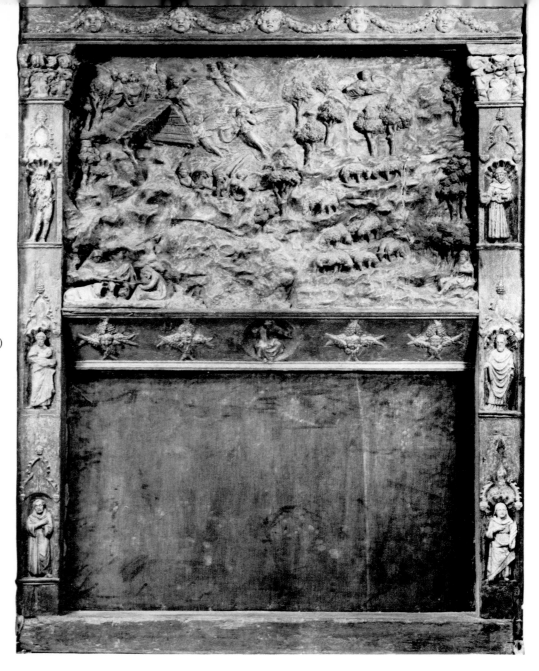

THIS LARGE, narrative relief housed in a wooden frame and mounting, with appliqué sculptural decorations of cherubim and saints in ornate Gothic niches, may be a rare survival of a decorative complex from the middle or late fifteenth century more or less in its entirety. Its function was presumably to frame a window or doorway in the orphanage from which it came. Its provenance from Verona, together with some direct borrowings from Lorenzo Ghiberti (1378-1455), suggested to Giuseppe Fiocco, who first published the piece, an attribution to Michele da Firenze.[1]

Michele da Firenze is the name of a sculptor in terra-cotta that appears in a document of 1436 recording payment for reliefs in the Pellegrini Chapel in Sant'Anastasia, Verona, as well as in another document of 1441 relating to a terra-cotta altar for the Church of Belfiore at Ferrara. The locative surname "da Firenze" (from Florence), combined, in the Pellegrini reliefs, with some obvious stylistic debts to Ghiberti's earlier bronze doors for the Florentine Baptistry, suggested that this secondary sculptor was identical with Michele di Niccolò Dini who was documented among Ghiberti's initial assistants in 1403.[2] Along with the reliefs of the Pellegrini Chapel, the name of Michele has been associated with an elaborate terra-cotta tomb for Dr.

Francesco Rosselli (d. 1430) in San Francesco, Arezzo and the *Altare della Statuine* (fig. 5) in the Cathedral of Modena, as well as numerous reliefs of the Virgin and Child. Minor differences of style suggest the involvement of various workshop assistants on the several projects in question.

The principal debt to Ghiberti here, however, is more direct than in many pieces attributed to Michele. The group Mary, Joseph, the Baby Jesus, ox and ass, in the lower left, almost exactly reproduces the panel of the *Nativity* from Ghiberti's earlier doors for the Florentine Baptistry (fig. 1), though without the subtlety in the drapery, faces and other details. On the other hand, Michele's *Nativity* in the Pellegrini reliefs is entirely different (fig. 2). Moreover, the author of the present relief is quite unashamed by his borrowings from Ghiberti and did not even take the trouble to disguise them by reversing the image, as Michele did in *Adoration of the Magi* (fig. 4), which derives from the corresponding panel by Ghiberti on the Baptistry doors (fig. 3).

The stylization of the landscape as a series of jutting rock formations, the undersides of which are modelled in a series of scooped hollows to accommodate the figures of human beings or sheep, also recalls the panels of Andrea Pisano and Ghiberti, as do the stunted trees. While the

31

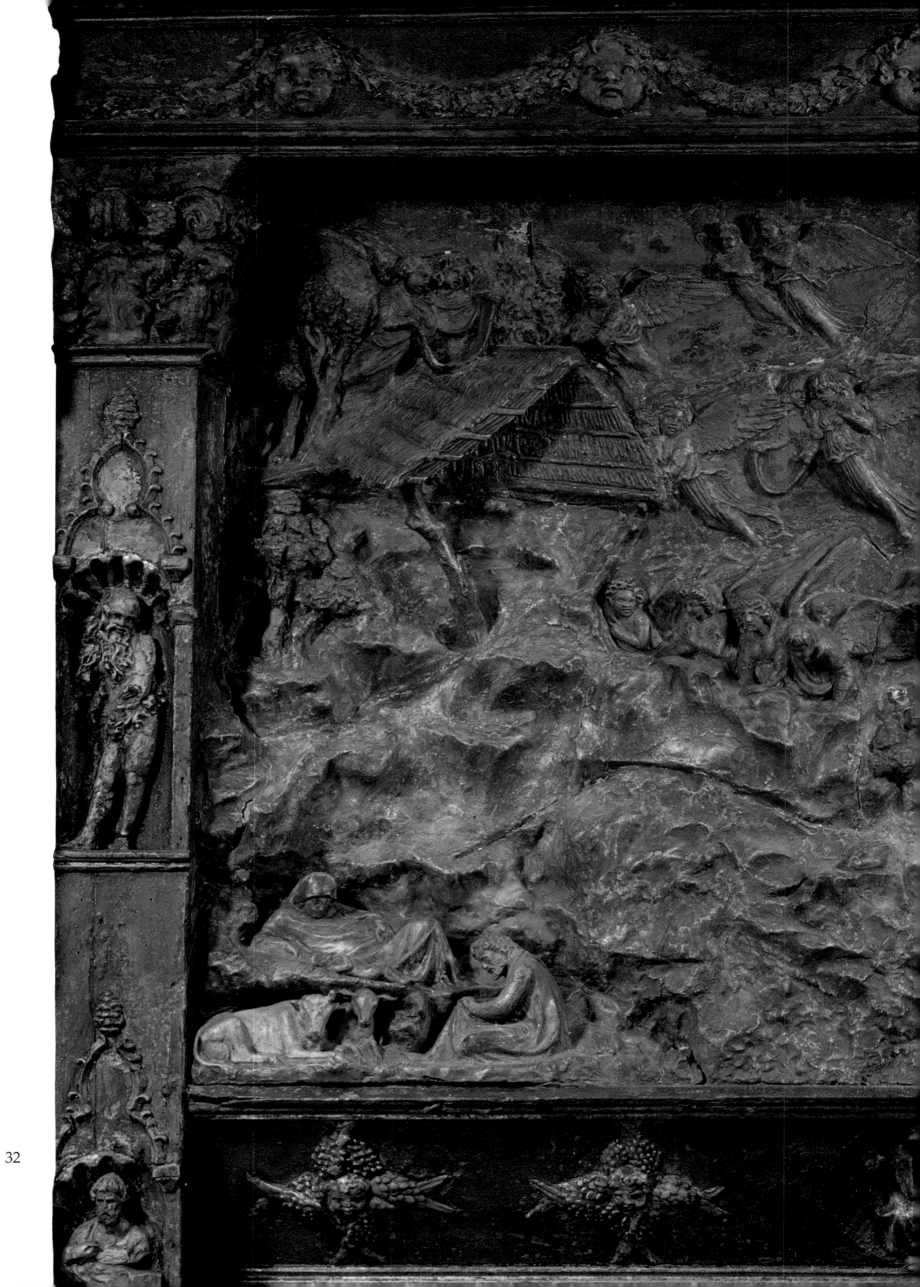

32

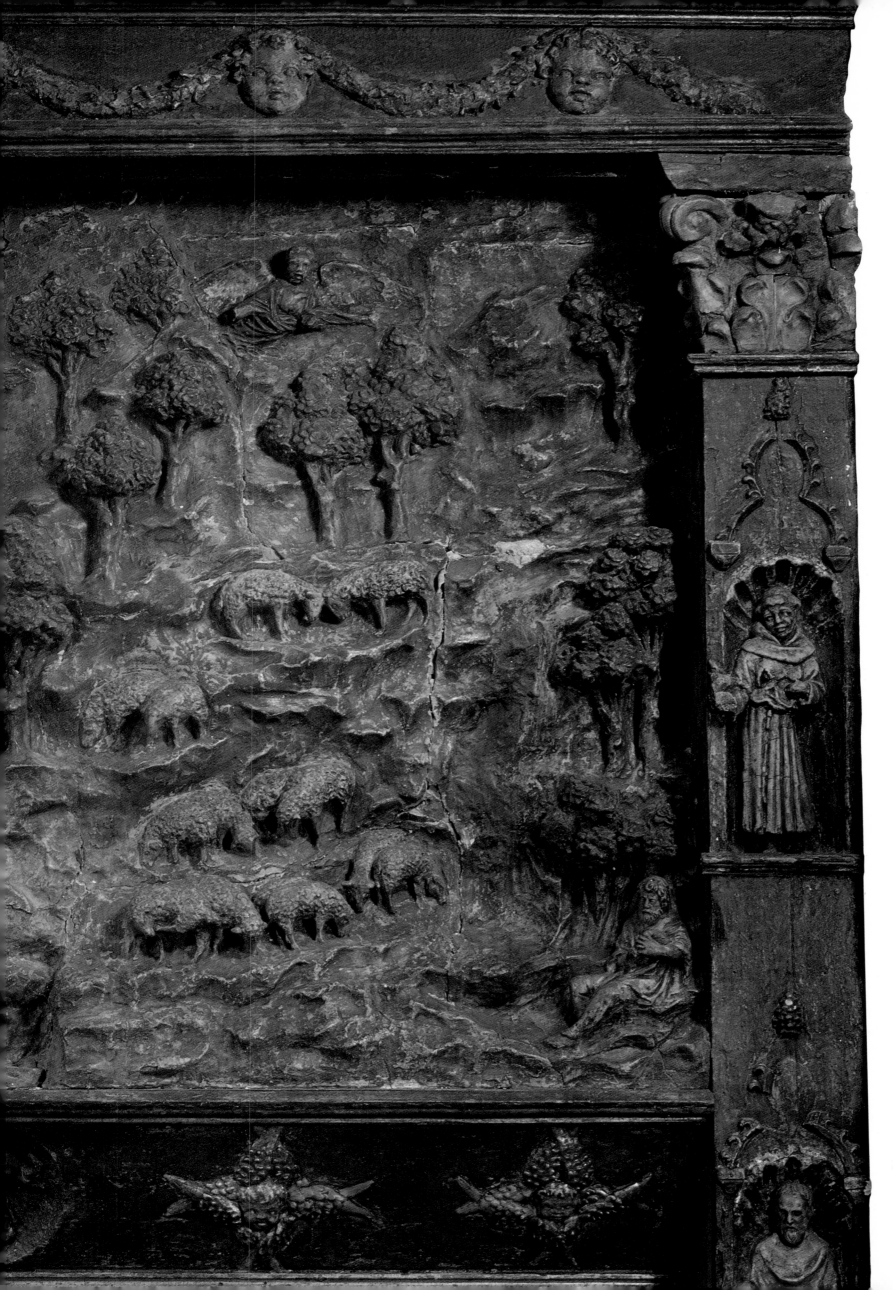

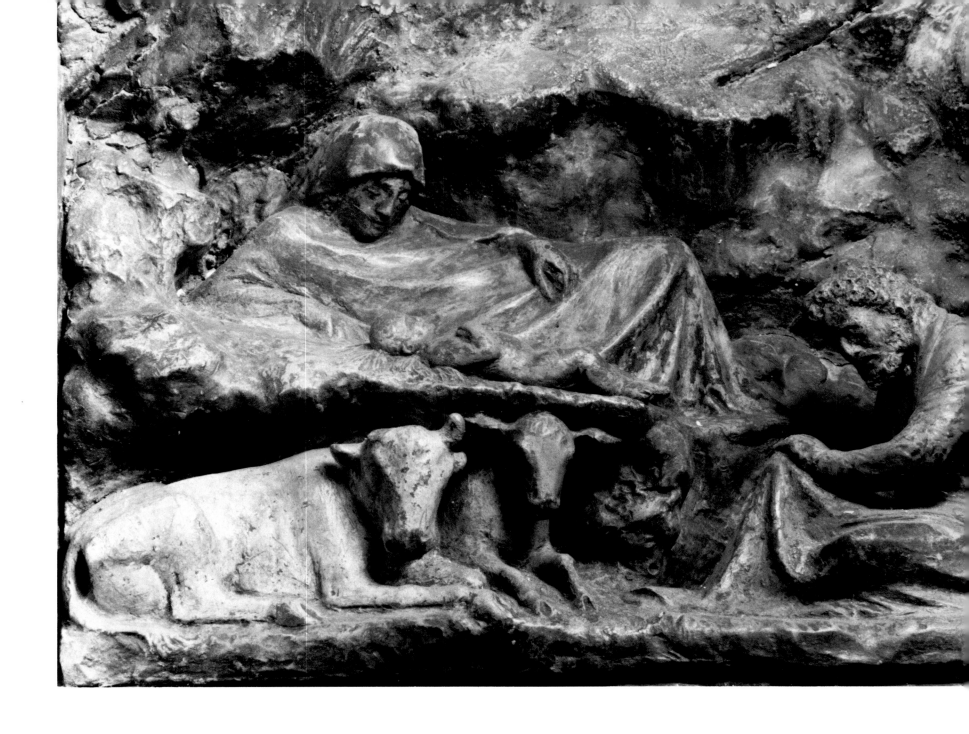

Fig. 1. Ghiberti, *The Nativity of Christ*, bronze, ca. 1410, north door of Baptistry, Florence.

Fig. 2. Michele da Firenze, *The Nativity of Christ*, terra-cotta, ca. 1436, Pellegrini Chapel, Sant'Anastasia, Verona.

same features appear in Michele's reliefs, for example his *Nativity* and *Adoration of the Magi* (figs. 2, 4), they are handled quite differently, and his figures have a naive boldness, even an originality, that is quite distinctive. Legibility and attractiveness of such large terra-cotta reliefs were considerably heightened by pigmentation, which was as important an element in the final effect as the underlying modelling. It should be noted, however, that the original effect of the Pellegrini reliefs has been altered by overcleaning so that hardly any traces of original paint remains. Their naive quality, therefore, not found in the more flowing composition here, may indeed be a function of the loss of their pigmentation.

The statuettes of saints in the shallow niches of the wooden frame of the Sackler relief also distantly recall Ghiberti, although their apparent restoration inhibits using them for comparison.[3] Similar statuettes on the terra-cotta altarpiece, attributed to Michele, in Modena Cathedral (fig. 5) are obviously by a more vigorous imagination and hand. It is clear that Fiocco's attribution, therefore, was overoptimistic and must now be discarded.[4] Nevertheless, connections with the work of Bartolomeo Bellano (ca. 1434–1496/7) and with the early work of Andrea Briosco, called Il Riccio (ca. 1470–1532), which have been suggested since, lack substance, and a proper assessment of the panel and its authorship must await a thorough technical examination and complete conservation.

1. G. Fiocco, "Michele da Firenze," *Dedalo*, XII, 1932, pp. 542-562; J. Pope-Hennessy, *Catalogue of Italian Sculpture in the Victoria and Albert Museum*, London, 1964, no. 56; idem, *Italian Gothic Sculpture*, London, 1955, p. 216.
2. Michele di Niccolò Dini was also listed as Michele di Niccolò dello Scalcagna, son of lo Scalcagna, as if the two names referred to two distinct persons (see Fiocco, *op. cit.*, p. 549). This mistake resulted from a transmission error in the documents which list two Micheles although they were indeed one and the same person. (See G. Vasari, *Le vite de' più eccellenti pittori scultori ed architettori scritte da Giorgio Vasari pittori Aretino con nuove Annotazioni e commenti di Gaetano Milanesi*, vol. II, Florence, 1906, p. 135, and vol. IX, p. 255, 344, ftnt. 1, and 351).
3. Preliminary examination by Arthur Beale at the Fogg Art Museum, Cambridge, Mass., is in progress at this time.
4. Vivian Gordon, a doctoral candidate in the Department of Art History and Archeology, Columbia University, New York, who is currently completing a dissertation on *The Master of the Pellegrini Chapel—Michele da Firenze* has concluded for her thesis, after careful examination of this terra-cotta, that it is not a work by Michele da Firenze or his workshop.

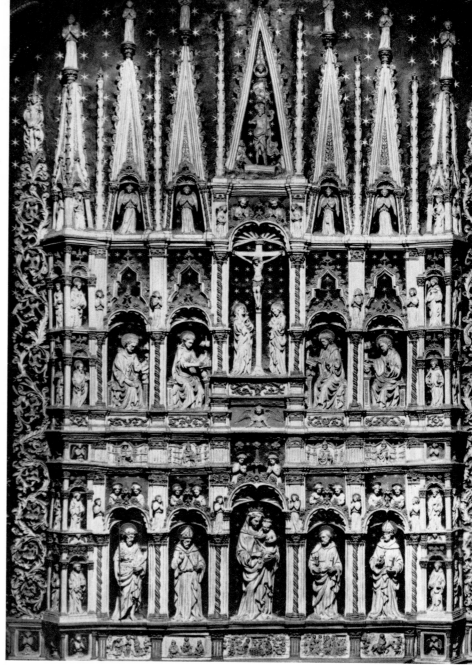

Fig. 5. Michele da Firenze, *Altare delle Statuine*, terra-cotta, ca. 1441, Cathedral, Modena.

Fig. 3. Ghiberti, *Adoration of the Magi*, bronze, ca. 1410, north door of Baptistry, Florence.

Fig. 4. Michele da Firenze, *Adoration of the Magi*, terra-cotta, ca. 1436, Pellegrini Chapel, Sant' Anastasia, Verona.

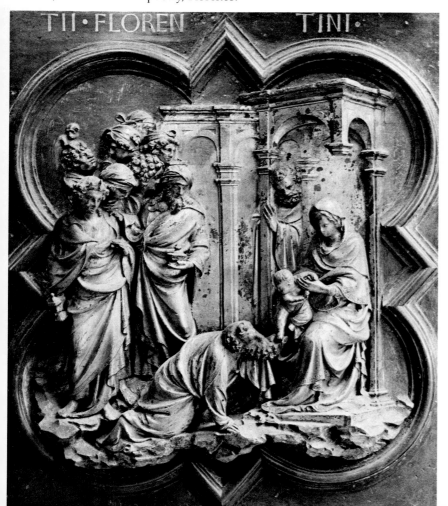

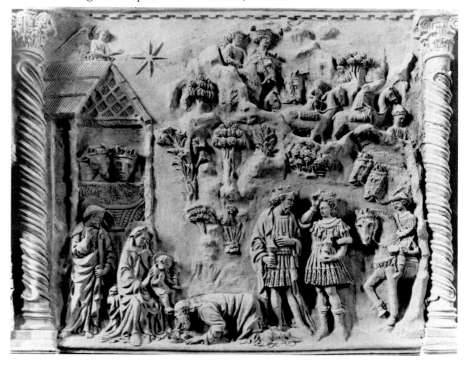

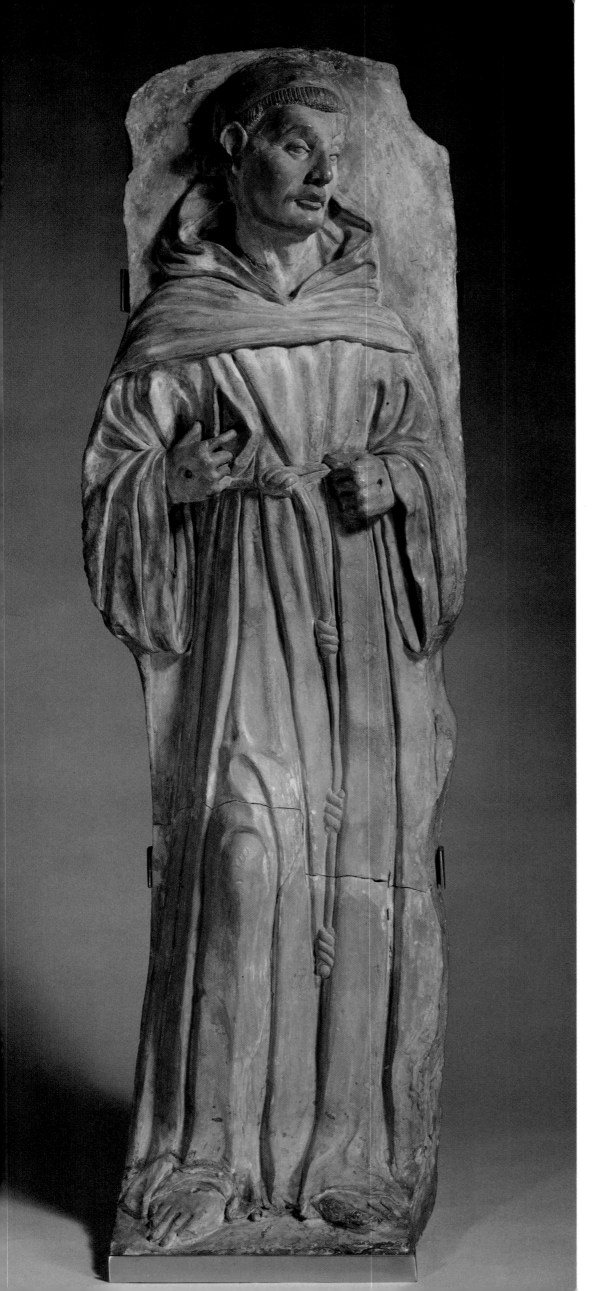

PADUAN, middle of the 15th century

Attributed to NICOLÒ PIZOLO
(active 1438–1453)

Painter and sculptor and pupil of Ansuino da Forli, Pizolo first appears about 1437, working in the Cappella del Podestà alongside Filippo Lippi. Both of these painters were the main formative influences on Pizolo's early work. He soon took up sculpture as well under the guidance of Donatello, and is documented in 1447 (together with others, including Giovanni da Pisa) as having made ten cherubs for the high altar in the Basilica of the Santo (Sant'Antonio, Padua). Predictably, Donatello's influence was decisive for Pizolo's sculpture. By 1448 he had become one of the leading painters in Padua, working with Mantegna, Vivarini and Giovanni d'Alemagna on the Ovetari Chapel in the Church of the Eremitani. Pizolo was assassinated in 1453, and after his death Donatello collected eleven marble blocks from his studio, on five of which Pizolo had begun to carve figures in relief.

3. *St. Francis*

Terra-cotta, ca. 1450.[1]
H. 44⅝ in. (113.4 cm.) W. 14¼ in. (36.2 cm.) D. 5½ in. (14.0 cm.)
Condition: cracked laterally at knee level; repairs at ankles, neck, tip of nose and hands; traces of polychromy, surface abraded.
Exhibited: Heim Gallery (London), *Sculptures of the 15th and 16th Centuries,* Summer 1972, no. 25.*
Accession no. 77.5.70

THESE RELIEFS belong to a dismantled altar, two other panels of which, representing *St. Catherine of Siena* and *St. Catherine of Alexandria* (figs. 1 and 2), are in the Musée des Arts Décoratifs in Paris, there attributed to Giovanni Minelli.[2] Stylistically they relate very closely to fragments of the reliefs of two other altars: one with St. John the Baptist and St. Francis in the Acton collection, Florence,[3] the other also with St. John the Baptist in a private collection in Florence. These three altars, even in their present fragmentary form, constitute a coherent group stylistically. The long, tubular folds, mixed with clinging ones, of the draperies, the striking similarity of the linear edging design on the garments of *St. Catherine of Alexandria* (fig. 2) and that of the Sackler *St. Clare,* the poses of the figures, the treatment of the faces and hands, and the general elegance and delicacy relate the group of reliefs closely.

*The information in this entry is based in part on that provided by the author for the Heim Gallery catalogue.

4. *St. Clare*

Terra-cotta, ca. 1450.[1]

H. 38⅝ in. (98.1 cm.) W. 11½ in. (29.2 cm.) D. 6 in. (15.2 cm.)

Condition: old repairs at neck, waist, above knees and feet; traces of polychromy, surface abraded.

Exhibited: Heim Gallery (London), *op. cit.*

Accession no. 77.5.71

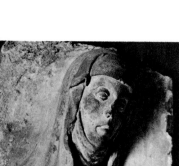

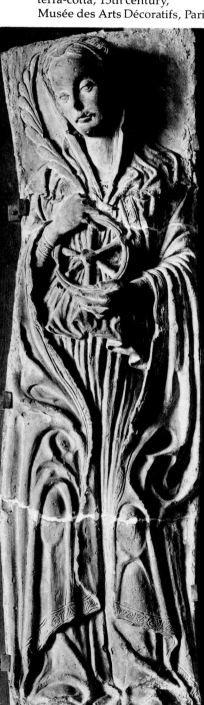

Fig. 1. Attributed to Minelli, (but probably by Pizolo) *St. Catherine of Siena*, terra-cotta, 15th century, Musée des Arts Décoratifs, Paris.

Fig. 2. Attributed to Minelli, (but probably by Pizolo) *St. Catherine of Alexandria*, terra-cotta, 15th century, Musée des Arts Décoratifs, Paris.

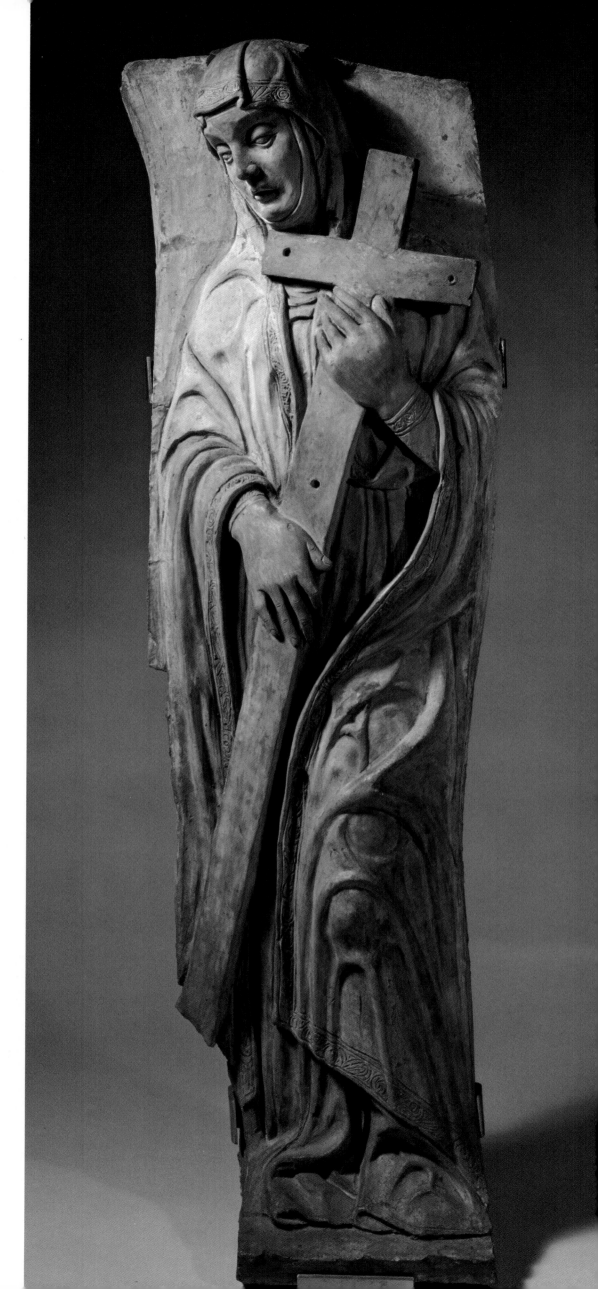

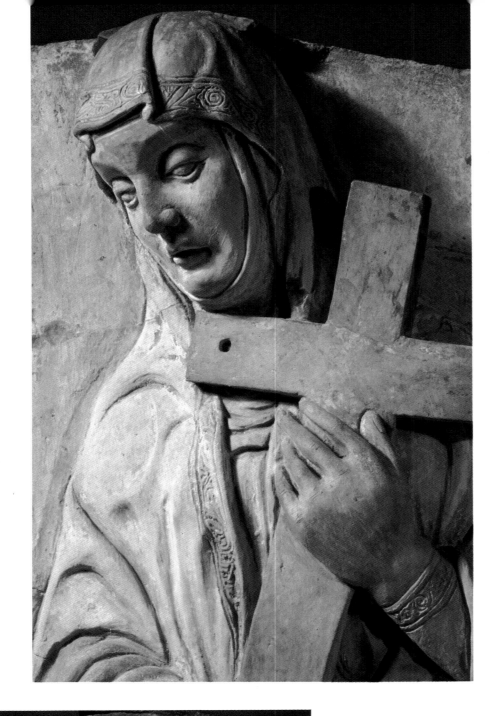

Although all have been attributed to Minelli, they bear little relation to documented works by that sculptor, such as the *SS. Prosdocimo, Antonio* and *Giustina* of 1513 on the facade of the chapel of the Santo.[4] On the contrary, this group of altar reliefs relate to the terra-cotta altar in the church of the Eremitani in Padua (fig. 3), which was intended for the Ovetari Chapel.[5] This altar was begun in July 1448 by Giovanni da Pisa; it was still unfinished on September 27, 1449, when Pizolo was commissioned to finish and gild it.[6] G. Fiocco believes the figures to be by Pizolo and the predella and frieze by Giovanni da Pisa, a view now generally accepted.[7] The influence of Donatello's altar for the Santo on the Eremitani altar, both in form and in the drapery is the result of Pizolo having worked on the Santo altar with Donatello two years before taking on the Eremitani commission. His influence is also evident in the Sackler *St. Francis*.

The analogies between the present *St. Francis* and the *St. Anthony of Padua* on the left of the Eremitani altar are particularly striking, while the face of the *St. Catherine of Alexandria* in the Musée des Arts Décoratifs is remarkably close to that of the Eremitani *Virgin*, thus corroborating the attribution of the group of reliefs to Pizolo.

1. Oxford Research Laboratory for Archaeology and the History of Art, *Report on Thermoluminescence Analysis* (for cat. no. 3), sample no. 281q50, 1979: last fired between 570 and 420 years ago (i.e. 1410–1560); (for cat. no. 4) sample no. 281p47, 1979: last fired between 575 and 375 years ago (i.e. 1405–1605).
2. Nos. 7762-A and B.
3. L. Planiscig, *Andrea Riccio*, Vienna, 1927, figs. 123-124.
4. *Ibid.*, fig. 140.
5. *Ibid.*, fig. 4.
6. E. Rigoni, "Il pittore Nicolò Pizolo," in *Arte Veneta*, II, 1948, p. 143 (trans. and ed. Creighton Gilbert, "The Painter Niccolò Pizolo," in *Renaissance Art*, New York, 1970, pp. 69–91).
7. G. Fiocco, *L'Arte di Andrea Mantegna*, Venice, 1959, p. 81.

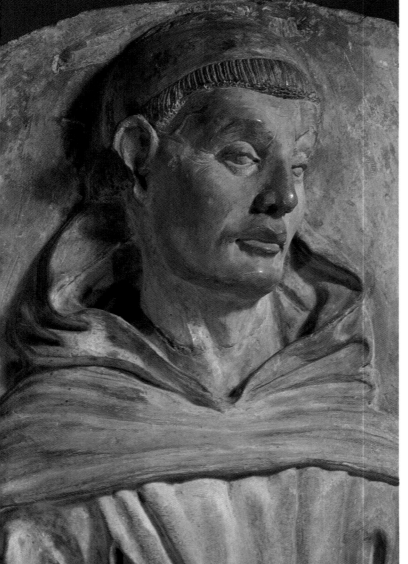

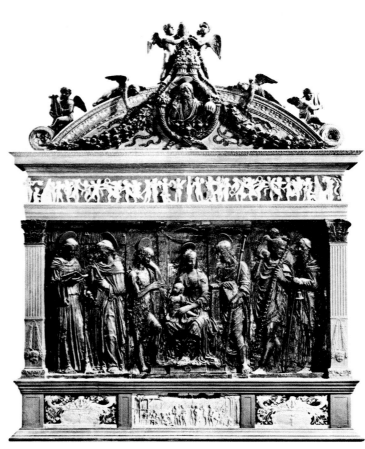

Fig. 3. Pizolo, *Altar Relief,* terra-cotta, ca. 1450, Ovetari Chapel, Church of the Eremitani, Padua.

PADUAN, late 15th century

Attributed to
DOMENICO BOCCALARO
(documented 1495)

Domenico Boccalaro is a terra-cotta sculptor of
secondary importance in the Paduan *ambiente*. He
is documented as having modelled the statues on
the altarpiece of San Nicola da Tolentino in the
Church of the Eremitani, Padua, in 1495. Related
to this altarpiece in style are two statues, *St. John
the Evangelist* and *St. Peter*, which come from the
bishop's palace (*Vescovado*) in Padua and are now
in the Museo Civico. These were formerly
attributed to Giovanni Minelli.[1]

5. *Judith (?)*
Terra-cotta, late 15th century.[2]
H. 46¾ in. (118.7 cm.) W. 13½ in. (34.3 cm.) D. 8¼ in. (20.9 cm.)
Condition: extensively cracked and repaired; both hands missing.
Accession no. 77.5.56

THIS STATUE, which is unpublished and has
no known provenance, clearly belongs
to the problematic group of terra-cottas
modelled in Mantua and Padua in a style derived
from Mantegna during the latter half of the 15th
century.[3] The features of their faces are heavily
incised and the knuckles of their fingers and toes
are emphasized, while the drapery is modelled
into complex patterns of crinkly folds, swathing
the anatomy beneath. The main sculptor involved
was Giovanni Minelli, whose name, until
recently, has been applied in a generic sense to
the whole group, without further distinction,
despite the fact that there are within the group
wide divergencies of style and facture, as well as
a number of named minor sculptors who can be
associated with occasional statues. Of these
sculptors, Domenico Boccalaro is the one whose
works bear the most similarity to the present
terra-cotta. His masculine saints, *John the
Evangelist* and *Peter*, with whom the present
statue may be associated, are thicker set, but the
mannered elongation of this figure is consonant
with the ideal of femininity represented by the
Old Testament Jewish heroine Judith, if it is she
who is represented here. The position of the
arms is consistent with portrayals of Judith,
whose most common attributes are a sword in
the right hand and the decapitated head of
Holofernes in the other.

1. **Palazzo della Ragione**, *Dopo Mantegna* (exhibition catalogue), Padua, 1976, no. 87
(entry by C. Semenzato).
2. Oxford Research Laboratory for Archaeology and the History of Art, *Report on
Thermoluminescence Analysis*, sample no. 281q37, 1979: last fired between 610 and 450
years ago (1389-1529).
3. G. Paccagnini, "Il Mantegna e la plastica dell'Italia settentrionale," *Bollettino d'Arte*,
1961, p. 65 f.

PADUAN, late 15th or early 16th century

Attributed to GIOVANNI MINELLI
(ca. 1440-1527)

Son and pupil of a Maestro Antonio, his first documented works date from circa 1480, and in 1482 he was awarded the contract for the marble choir screen in the Santo. Strongly influenced by the art of Pietro Lombardo, with whom he had worked in his youth, most of the artist's activity is connected with the Santo at Padua, where in 1500 he was entrusted with the construction of the Chapel of S. Antonio after his own and not Riccio's design, as has been proved by E. Rigoni.[1] He worked on this commission until 1521.
As a sculptor he worked both in marble and reputedly also in terra-cotta, the traditional Paduan medium.

6. *St. Catherine of Alexandria*

Terra-cotta, first quarter of the 16th century.[2]
H. 45 in. (114.3 cm.) W. 13½ in. (34.3 cm.) D. 7½ in. (19.1 cm.)
Condition: toes of left foot broken off; repairs throughout figure.

Exhibited: Heim Gallery (London), *Sculptures of the 15th and 16th Centuries,* Summer 1972, no. 26.

Accession no. 77.5.55

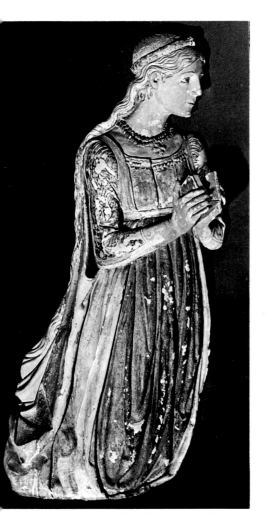

Fig. 1. Minelli, *Entombment of Christ with Carlotta of Lusignan,* painted terra-cotta, 1483-87, The Isabella Stewart Gardner Museum, Boston.

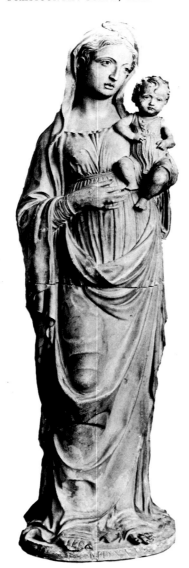

Fig. 2. Anonymous, *Virgin and Child,* terra-cotta with traces of paint, ca. 1525, Philbrook Art Center, Tulsa.

THIS STATUE is a beautiful example of a Paduan terra-cotta of the Renaissance period, the head showing the influence of Classical sculpture and the drapery being more suavely modelled than in the earlier, deeply Mantegnesque phase, with its emphasis on complex patterns of angular, crinkly folds. The slim proportions and closed contours of the statue suggest that it formed part of a retable and stood in a niche, perhaps flanking a group of the Virgin and Child. An attribution to Giovanni Minelli, the principal sculptor in terra-cotta of the period, was discussed at length, when the statue was first exhibited in London in 1972, and rejected in favour of one by an anonymous master, dubbed "Pseudo-Minelli."[3]
However, distinct analogies with a terra-cotta group republished in 1977 as the work of Minelli, the *Entombment of Christ, with Carlotta of Lusignan* (1483-1487) formerly on the altar of S. Salvatore in the Dominican church of S. Agostino in Padua, but now in the Gardner Museum, Boston (fig. 1),[4] suggest that the present statue is actually rather close to Minelli's personal style (always supposing that the attribution of the Boston terra-cotta is correct). *St. Catherine* shares with *Carlotta* a classical nobility of countenance, with high arching eyebrows, straight nose and square chin, framed in symmetrically waving hair, centrally parted. The similar handling of the sharp, straight edge of the hairline to form an inverted V-shape from the central part is an idiosyncratic feature which argues either for the same artist, or for the same workshop. Their quite large but well proportioned hands protruding from tight cuffs are similar, as are the long, smooth curves of folds in their drapery.
Nevertheless, a note of caution should be sounded. The *St. Catherine* also presents some analogies with a terra-cotta statue of the *Virgin and Child,* dated 1525, from the Samuel H. Kress collection (fig. 2).[5] Their closest parallel is, perhaps, in the handling of the draperies in both images; the stylization of the hair presents another, although the faces and hair of the *Virgin and Child* were completely gone over and the entire image restored in 1963, obviously making comparison difficult. Moreover, the author of the latest Kress catalogue categorically denies the attribution of the Philbrook *Virgin and Child* to Minelli, while mentioning instead some similarities with early terra-cotta sculptures by Andrea Riccio.[6] Final judgment must await further serious, scholarly research into the complex and gravely neglected field of Paduan terra-cotta sculpture.

1. E. Rigoni, *L'Arte Rinascimentale in Padova,* Padua, 1970, p. 255 ff.
2. Oxford Research Laboratory for Archaeology and the History of Art, *Report on Thermoluminescence Analysis,* sample no. 281q.23, 1979: last fired between 470 and 320 years ago (*i.e.,* 1509-1659).
3. See discussion in Heim Gallery, *op. cit.,* no. 26, referring to the *St. Catherine* terra-cotta in Königliche Museen zu Berlin, first attributed to Minelli by C. von Fabriczy, "Giovanni Minello," *Jahrbuch der Königlich Preuszischen Kunstsammlungen,* Berlin, 1907, p. 75, fig. 5 and p. 76, with which the Sackler *St. Catherine* has close analogies.
4. R. van N. Hadley, *Sculpture in the Isabella Stewart Gardner Museum,* Boston, 1977, no. 167, pp. 134-136.
5. Gift to the Philbrook Art Center, Tulsa, Oklahoma.
6. U. Middeldorf, *Sculptures from the Samuel H. Kress Collection: European Schools, XIV-XIX Century,* London, 1976, no. K1935, p. 64, fig. 112. Middeldorf is careful to indicate that the Philbrook *Virgin and Child* is *not* by Riccio, even questioning the Riccio attribution of the works he cites as comparison.

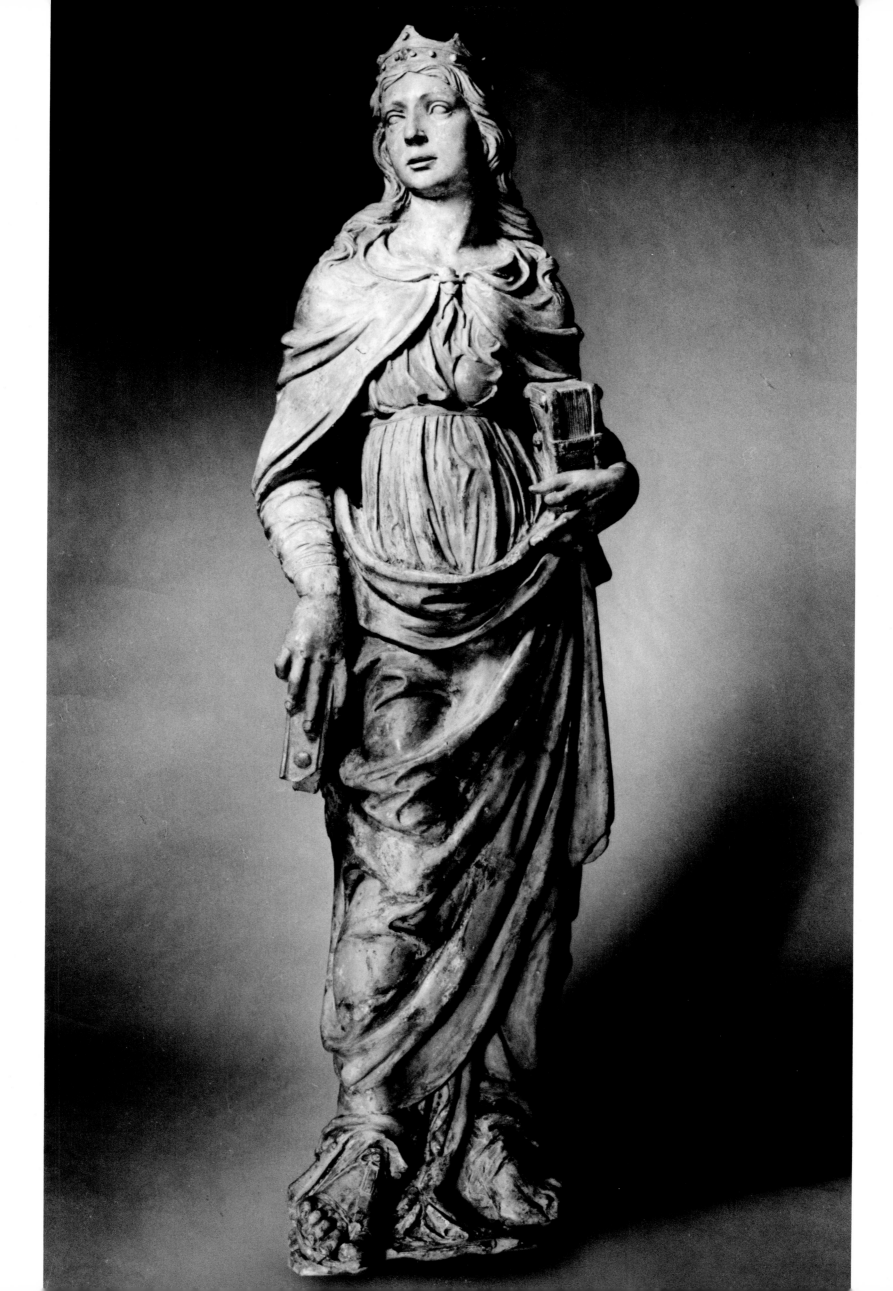

FLORENTINE, late 15th century

Attributed to ANDREA FERRUCCI
(1465-1526)
formerly attributed to Antonio Rossellino[1]

Born at Fiesole, Andrea Ferrucci is best known for his large, decorative complexes, including the font in Pistoia Cathedral and an altar in Fiesole Cathedral. His principal statue is *St. Andrew* (1517) in Florence Cathedral.

7. *St. Jerome*

Terra-cotta, ca. 1480-1500.
H. 22 in. (55.9 cm.) W. 8½ in. (21.6 cm.) D. 5½ in. (14.0 cm.)
Condition: left arm broken off above elbow; repairs to right hand at wrist, head at neck and nose; repairs on right knee and ankle as well as left leg.
Exhibited: Heim Gallery (Paris), March/April, 1974, *Le choix de l'amateur,* no. 6.
Accession no. 77.5.80

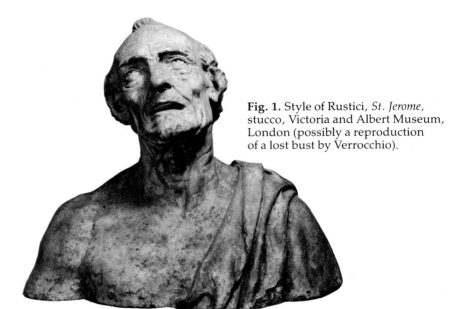

Fig. 1. Style of Rustici, *St. Jerome,* stucco, Victoria and Albert Museum, London (possibly a reproduction of a lost bust by Verrocchio).

STYLISTIC ANALOGIES with the sculpture of Antonio Rossellino, noted by Middeldorf and cited in the catalogue of the Heim Gallery exhibition, are not convincing. The statuette is undoubtedly Florentine, but seems to date from the last quarter of the 15th century, and probably originates from the periphery of the circle of Verrocchio.

The present statuette is more starkly delineated and less subtly modelled (as, for example, the back of the saint's right hand, or the folds of his garment) than was normal in Verrocchio's immediate circle (e.g., in the works of Giovanni Francesco Rustici, 1474-1554). The emaciated features of this *St. Jerome* however are probably modelled in a similar way to those of the lost bust of the saint by Verrocchio, recorded by Vasari, which seems to have inspired a stucco reproduction, perhaps by Rustici (fig. 1).[2] That statues of St. Jerome were popular subjects in Verrocchio's circle is further attested to by a terra-cotta variant on Verrocchio's bust,[3] a terra-cotta statue of St. Jerome in meditation (fig. 2),[4] and one of St. Jerome kneeling (fig. 3),[5] all associated with the style of Verrocchio. There are indeed analogies to be found between an Andrea Ferrucci marble statue of St. Jerome, ensconced in a niche on an altarpiece now in the Victoria and Albert Museum (fig. 4),[6]

and the present statuette. The marble was carved in the 1490s for the Martini and Salviati families for the Church of San Girolamo (St. Jerome) at Fiesole, near Florence. While Ferrucci did not employ such a Verrocchiesque facial type in his marble statue, its general pose, the position and treatment of the saint's right hand and the fall of the drapery, looping from shoulder to waist and then knotted so that a fold falls vertically between the legs, are similar to those in the present statuette, although the disposition of weight and the drapery in the two works are in mirror image.

1. Heim Gallery, *op. cit.* (see under *Exhibited* above).
2. J. Pope-Hennessy, *Catalogue of Italian Sculpture in the Victoria and Albert Museum,* London, 1964, vol. II, no. 420, as "Style of Rustici" and illustrated in vol. III, fig. 417.
3. *Ibid.,* vol. II, no. 422 and vol. III, fig. 418.
4. *Ibid.,* vol. I, no. 141 and vol. III, fig. 163.
5. Heim Gallery, *op. cit.,* no. 9, is attributed to the Master of the David and Saint John Statuettes (see catalogue number 8 for the discussion of this anonymous master) and associated with a series of St. Jerome statues in terra-cotta of which one is in Berlin (Staatliche Museen), a second in the Museo Horne, Florence, and a third in the art market. The kneeling St. Jerome in the Heim Gallery catalogue is very close to the St. Jerome in Berlin which was first attributed in 1913 by Frida Schottmüller to the Master of the St. John Statuettes (see Frida Schottmüller, *Die italienischen und spanischen Bildwerke der Renaissance und des Barock,* Königliche Museen zu Berlin, Berlin, 1913, p. 92, no. 232) but in the 1933 edition of the Schottmüller catalogue was identified with the sculptor Baccio da Montelupo b. 1469, d. 1535? (*Ibid.,* 1933 edition, p. 146, no.171). In 1967 the Museo Horne Catalogue offered the suggestion of Agnolo di Polo for their kneeling St. Jerome although confirming the influence of Verrocchio. (F. Rossi, *Il museo Horne a Firenze,* Milan, 1967, p. 152 and pl. 93).
6. Pope-Hennessy, *op. cit.,* vol. I, no. 151 and vol. III, fig. 173.

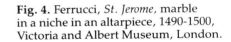

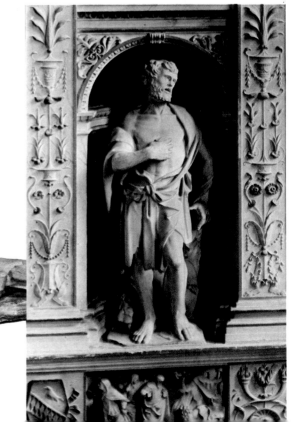

Fig. 4. Ferrucci, *St. Jerome,* marble in a niche in an altarpiece, 1490-1500, Victoria and Albert Museum, London.

Fig. 2. Style of Verrocchio, *St. Jerome,* terra-cotta, Victoria and Albert Museum, London.

Fig. 3. Master of the David and St. John Statuettes, *St. Jerome,* terra-cotta, Heim Gallery, Paris.

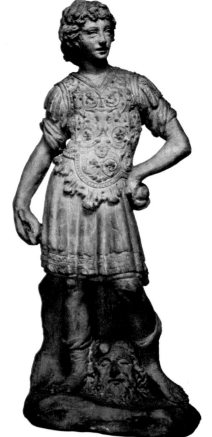

Fig. 1. Master of the David and St. John Statuettes, *David*, terra-cotta, Victoria and Albert Museum, London.

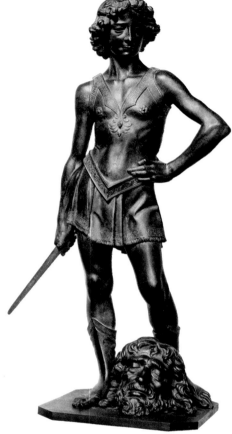

Fig. 2. Verrocchio, *David*, bronze, before 1469, Museo Nazionale, Florence.

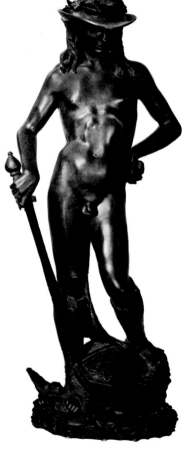

Fig. 3. Donatello, *David*, bronze, Museo Nazionale, Florence.

Fig. 4. Master of the David and St. John Statuettes, *St. Sebastian*, terra-cotta, Victoria and Albert Museum, London.

44

FLORENTINE, late 15th century

Master of the David and St. John Statuettes

Conventional name for the sculptor of two stylistically coherent groups of statuettes produced in terra-cotta in some numbers under the influence of Verrocchio.

8. *David*

Terra-cotta.
H. 21⅝ in. (54.9 cm.) W. 6½ in. (16.5 cm.) D. 5⅜ in. (13.7 cm.)
Condition: surface deteriorated, fractures repaired.
Provenance: Messrs. Colnaghi, London.
Accession no. 77.5.5

THE MAJORITY of the statuettes of David in the group are clad in elaborately decorated, pseudo-Roman armour reminiscent of that shown on Ghiberti's *Gates of Paradise*. They have the left elbow bent, and the right arm hanging down, with a sword in the hand (fig. 1).[1] They are derived from Verrocchio's bronze statue of *David*, which was made for the Medici prior to 1469, and is now in the Museo Nazionale (Bargello), Florence (fig. 2).[2]

The present statuette, while clearly belonging to the same group, differs from them in showing David nude (which recalls Donatello's bronze statue, fig. 3) and posed in mirror image to Verrocchio's (and Donatello's) version. It lacks attributes to specify the subject, such as Goliath's head and a sword, or a sling, but in the left hand there is a stone from which a sling may be inferred. The subject may also be inferred from the figure's undoubted relationship to Florentine images of the hero. It is unusual in its nudity and may have been produced as a studio property for teaching anatomy and composition, or as a collector's item.

A clearer relationship to the style of the Master of the David and St. John statuettes is seen by comparison with a *St. Sebastian* figure in the Victoria and Albert Museum (fig. 4).[3] The latter appears nude and demonstrates a very similar handling of anatomy, particularly the soft curves suggesting the youthful fleshiness of the breasts, the musculature of the upper arms, the ovals of the lower abdomen, the groin and testicles, the modelling of the thighs and the lower legs—even allowing for the obvious repairs to the section between ankles and knees of the *David* here—and the very similar handling of feet and toes.

The faces of the present *David* and that of the *David* in fig. 1 clearly demonstrate a similar hand, with the shape of the faces, mouths, noses, eyes and brows almost interchangeable. The features of the face of *St. Sebastian* conform as well, although the nose is damaged and the position of the head differs.

1. J. Pope-Hennessy, *Catalogue of Italian Sculpture in the Victoria and Albert Museum*, London, 1964, vol. I, nos. 169, 170 and vol. III, figs. 180, 181.
2. C. Avery, *Florentine Renaissance Sculpture*, London/New York, 1970, fig. 104 and p. 132.
3. Pope-Hennessy, *op. cit.*, vol. I, no. 172, vol. III, fig. 182.

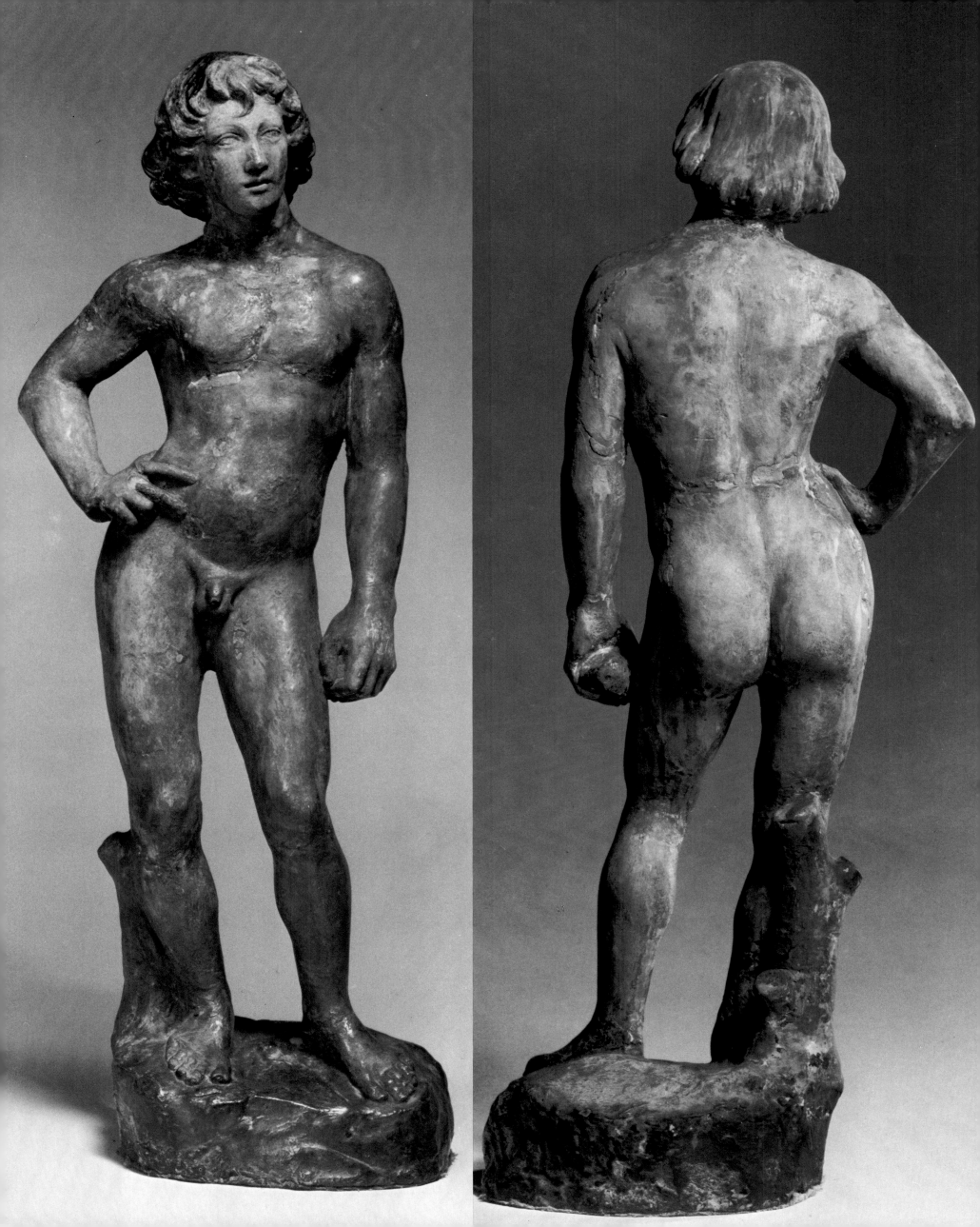

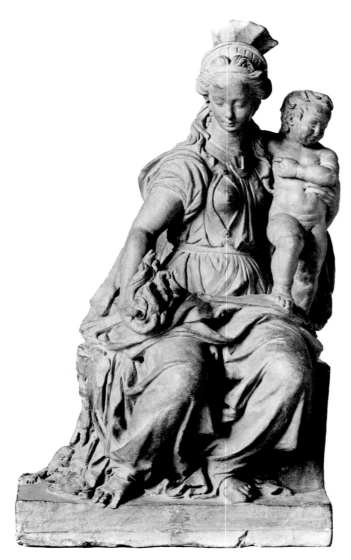

Fig. 1. Master of the Unruly Children, *Charity*, terra-cotta, formerly Kaiser-Friedrich Museum, Berlin.

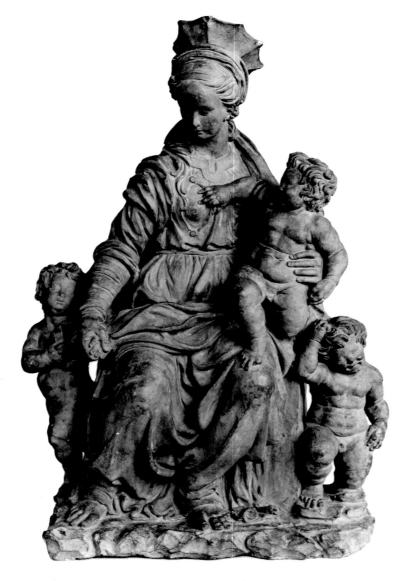

46

Fig. 2. Master of the Unruly Children, *Charity*, terra-cotta, Victoria and Albert Museum, London.

FLORENTINE, early 16th century

Master of the Unruly Children

Conventional name invented by Wilhelm von Bode for an anonymous sculptor much influenced by Verrocchio and Benedetto da Maiano, who produced a stylistically coherent group of statuettes in terra-cotta, the common feature being one or more mischievous children.

9. *Virgin and Child*

Terra-cotta, with traces of gesso and pigmentation (e.g., blue on the Virgin's robe), early 16th century.
H. 28¾ in. (73.0 cm.) W. 19 in. (48.3 cm.) D. 8⅛ in. (20.6 cm.)
Condition: repairs to the Virgin's neck, hair ornament, wrist of left arm, legs, nose and forehead; forefingers of left hand broken off; repairs to child's body throughout; chips on base and edge of headdress.
Provenance: Arcade Gallery, London (1957); Peter Ward-Jackson; Messrs. Cyril Humphris, London.
Exhibited: Arcade Gallery, *Sculpture*, London, November, 1957, no. 7.
Accession no. 77.5.14

T HE STATUETTE is a classic example from a group of variant compositions modelled by an anonymous, but readily recognizable, Florentine sculptor whose work was first integrated by von Bode in connection with examples in the former Kaiser-Friedrich Museum in Berlin (see fig. 1).[1] The most recent discussion at length was based on a *Charity* in London (fig. 2).[2] The terra-cottas ascribed to the Master of the Unruly Children are composed with complete assurance and convey a sense of movement and physical presence which bespeak a good sculptor.

The sculptor executed a series of variations on the basic theme of a seated woman with children about her; some examples

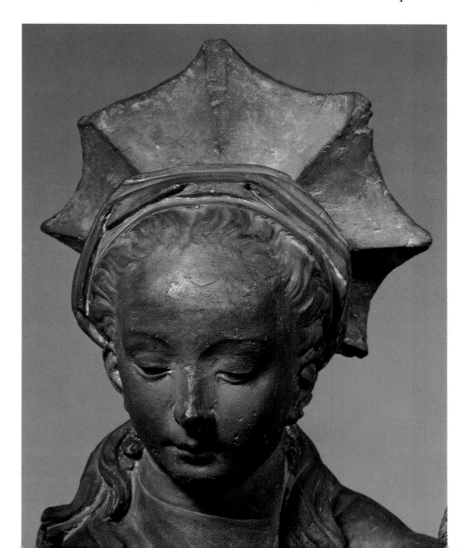

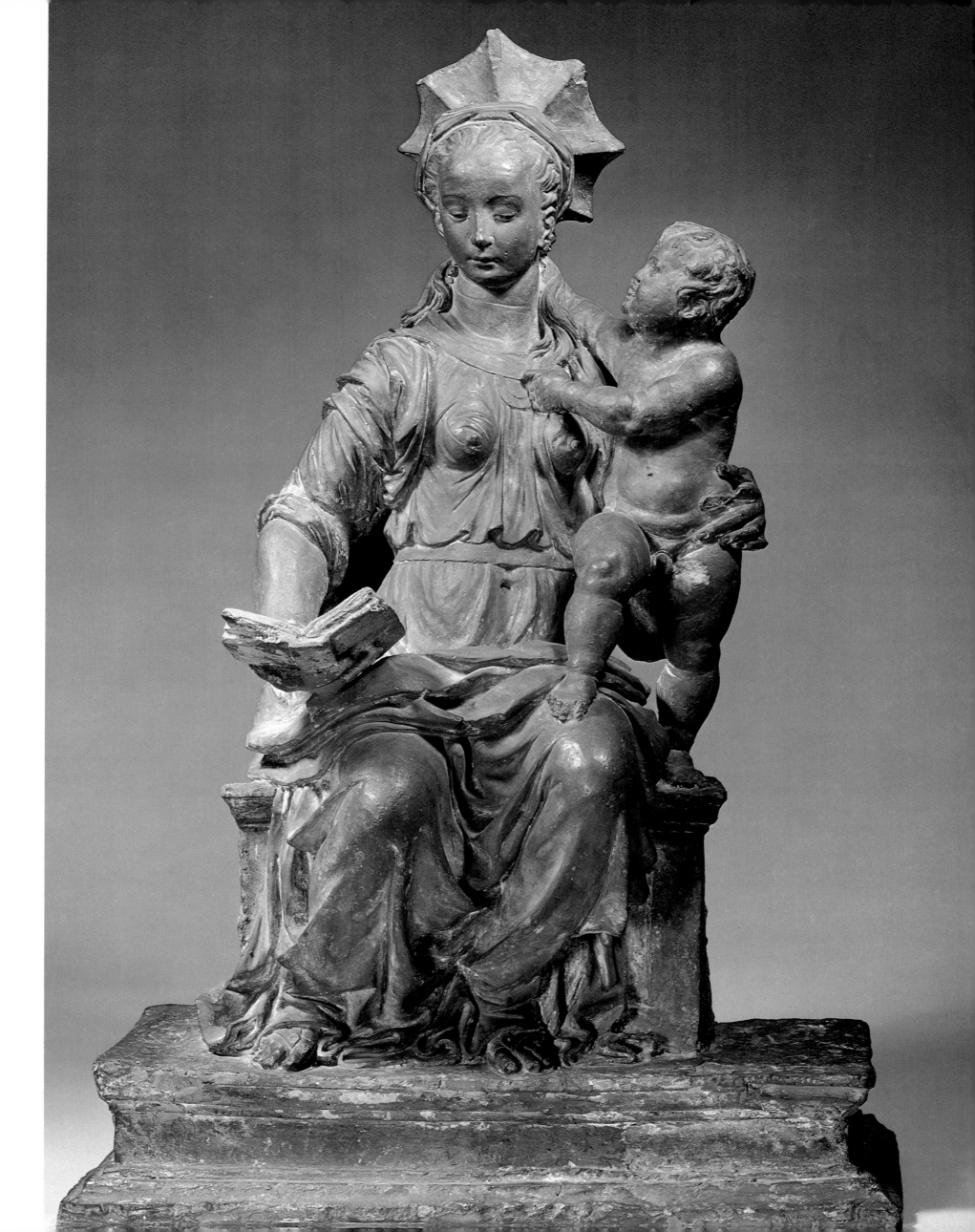

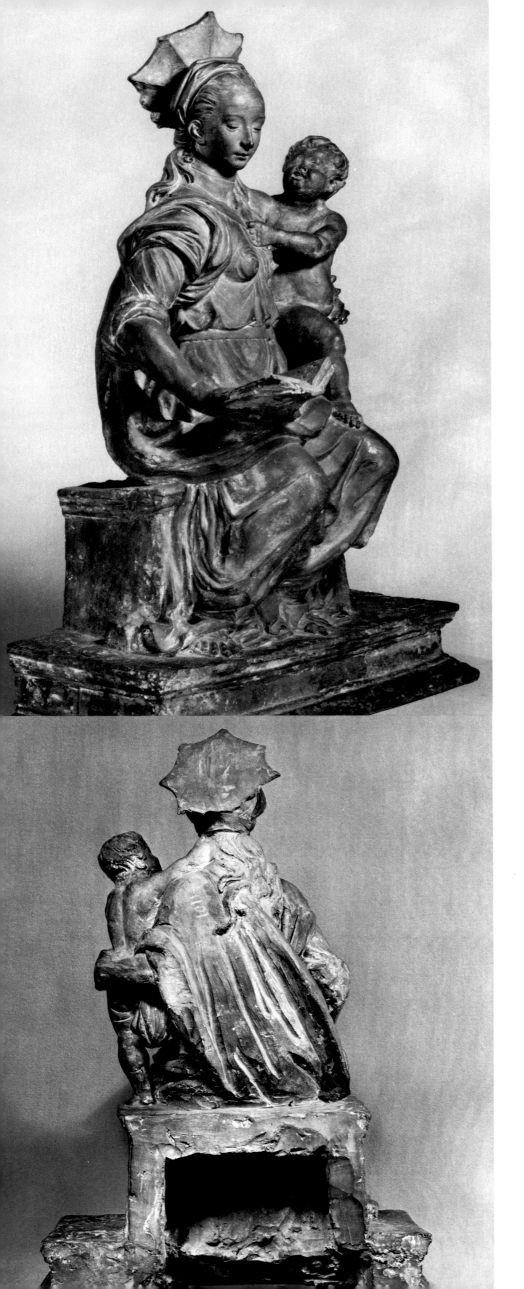

with three children conform to the standard iconography of the Christian virtue of Charity (fig. 2); while others, with only one boy, apparently represent the Virgin Mary with the Christ Child. In some of the variants of the latter theme (fig. 3),[3] the Child playfully reveals one of his mother's breasts as she reads, although in the present, more decorous, rendering He is looking up at her and fondling her hair. The similar facial features of the women, the disposition of their feet with legs directed to the proper left, the loose robes and ample cloaks they wear, and the treatment of their drapery folds, especially across their knees and across their feet along the bases, relate all of them to the same master. Just so, the modelling of the children with the layered fleshiness of their cheeks, necks, arms, legs and abdomen, as well as their facial expressions and swirling curls of hair relate them to the same hand. The infant figures in a group in London entitled *Two Boys Quarreling*, also attributed to the Master of the Unruly Children,[4] are indeed consistent with the modelling of the child in the present statuette as well as the children in the other groups of works associated with this master. The rocky base allies it closely to the base under the *Charity* (fig. 2), while its hollowed out seat is consistent with the *Charity* as well as the *Virgin and Child* (see detail).

Close in style and subject to the statuettes by the Master of the Unruly Children are the glazed, terra-cotta figures of the Christian Virtues, especially the *Charity,* made for the frieze of the *Seven Corporal Works of Mercy* on the external loggia of the Ospedale del Ceppo in Pistoia.[5] The curious ribbed and pointed halo, like an umbrella blown inside out, seen here and in figures 1 and 2, also appears on the *Charity* in Pistoia. Santi Buglioni is credited with glazing the Pistoia figures between 1526 and 1528, but it is not known whether he actually modelled them as well.

It is unlikely that a sculptor as competent as the Master of the Unruly Children restricted himself to producing such a limited range of subjects, and the particular group from which he derives his nickname is probably only one facet of a more extensive activity. Two other distinct series of statuettes in terra-cotta at much the same scale and in a similar style should perhaps be added to his *oeuvre*: both manifest a tendency to produce a series of variations on a particular theme, and are clearly not sketch-models, but finished sculptures made for collectors.

One series shows a *mêlée* of soldiers fighting around a horseman (fig. 4). This was first published by Charles Loeser in 1928 as a series of four groups attributed to Gianfrancesco Rustici (1474-1554).[6] Each of the four include "horsemen, and footmen in armour, or partially clad, or nude, fighting savagely . . . the horses seem maddened into beasts of prey, as they gnash at the limbs of the victims. The riders perform acts yet more bestial, while their faces express well-nigh inhuman savagery."[7] The idea and certain details of contorted facial expression in all four are reminiscent of Leonardo da Vinci's sketches for his fresco, *Battle of Anghiari* in the Palazzo della Signoria, Florence (ca. 1503-1504). Actually two of the four groups in this series, the one in the Museo Nazionale

(Bargello) Florence and the one in the Louvre, Paris, are more specifically Leonardoesque and may be associated with Leonardo himself, or following Loeser, with Leonardo's close friend Rustici.[8] Indeed, according to Vasari, Rustici "was a great lover of horses" and "formed them in clay and in wax... in high and in low relief; and in every manner imaginable." Moreover, "his horses, in terra-cotta, with men astride them, and others under their hoofs," were given by Rustici "as presents to his friends" and there "are many in the houses of Florentine nobles."[9] Thus there was ample evidence for Loeser to have attributed the series of soldiers fighting around a horseman to Rustici. However, two of the series Loeser published, though close in theme, appear, after further analysis, to be by a different hand and more consistent with that of the Master of the Unruly Children (fig.4).[10] There is a particularly familiar rendering of form and movement as well as flesh, hair and drapery folds of the figures. The base in figure 4 is also comparable to that of the *Charity* in figure 2.

The other series that is related in style is illustrated by A. E. Brinckmann and consists of reclining male figures with various attributes, often upturned urns signifying that they are river gods.[11] Again, there are the familiar characteristics of form and movement, facial expression, rendering of flesh, hair and drapery folds. Examples are in the Museum of Art, Rhode Island School of Design (fig. 5); Detroit Institute of Arts; and with J. Böhler, Munich, 1977; etc. These have sometimes been connected with Jacopo Sansovino (1486-1570), on the strength of their similarities with his Venetian works, especially the statuettes of the four *Evangelists* on the altar rail in St. Mark's, Venice, and the terra-cotta sketch-model for the *St. John* in the Staatliche Museen, Berlin.[12]

In the present state of knowledge it is difficult to decide identity from among the several candidates, including Sansovino and Rustici, one of whom may ultimately prove to be concealed behind the anonymity of the Master of the Unruly Children.

Fig. 4. *Group of Warriors*, terra-cotta, Donazione Loeser, Palazzo della Signoria, Florence.

Fig. 5. *River God*, terra-cotta, Italian 16th century, Museum of Art, Rhode Island School of Design, Providence.

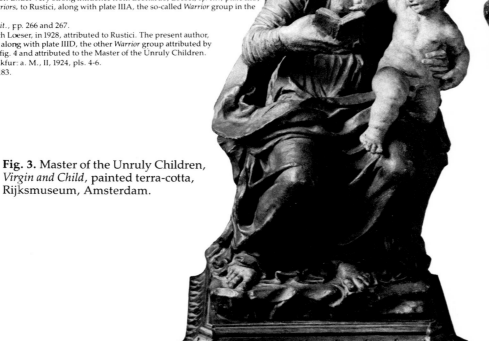

Fig. 3. Master of the Unruly Children, *Virgin and Child,* painted terra-cotta, Rijksmuseum, Amsterdam.

1. F. Schottmüller, *Bildwerke des Kaiser-Friedrich-Museums. Die italienischen und spanischen Bildwerke der Renaissance und des Barock*, I, Berlin/Leipzig, 1933, nos. 1583, 5558.
2. J. Pope-Hennessy, *Catalogue of Italian Sculpture in the Victoria and Albert Museum*, London, 1964, vol. II, no. 425, p. 406 and vol. III, fig. 422.
3. J. Leeuwenberg and W. Halsema-Kubes, *Beeldhouwkunst in het Rijksmuseum*, Amsterdam, 1973, no. 604, fig. 3.
4. Pope-Hennessy, *op. cit.*, vol. II, no. 426, p. 407 and vol. III, fig. 423; see also *Saint John the Baptist as a Child*, (vol. II, no. 427, pp. 408 and 409, and vol. III, fig. 426) attributed to the Master of the Unruly Children, although it is described as "an old terra-cotta squeeze moulded from a superior original."
5. A. Marquand, *Benedetto and Santi Buglioni*, Princeton, 1921, cat. 190, pp. 165-75.
6. C. Loeser, "Gianfrancesco Rustici," *The Burlington Magazine*, vol. LII, June, 1928, pp. 260-272: plate IIIA, *Warrior*, in the Louvre Museum, Paris; plate IIIB, *Warrior* in the Museo Nazionale (Bargello), Florence; plate IIIC, *Warrior*, formerly in Casa Rudolfi, via Maggio, Florence and later in the Charles Loeser collection; plate IIID, *Warrior*, formerly in the Palazzo Ruscellai, Florence and later in the Charles Loeser collection.
7. *Ibid.*, pp. 271-272.
8. C. Avery, *Florentine Renaissance Sculpture*, London/New York, 1970, p. 148 and p. 152, fig. 117, *Fighting Horseman*, for the group in the Museo Nazionale (Bargello), Florence, which the author associates with Leonardo da Vinci: "...there exists a series of terra-cotta groups of fighting horsemen of great complication and vivacity, some of which may be by his hand [i.e. Leonardo's] rather than by Rustici, to whom they are normally attributed [117]" (p. 148), although I refer to the same group as by Rustici (p. 151), but the figures are so Leonardoesque in character that if Rustici invented them, he must have been under very strong influence from Leonardo; Loeser, *op. cit.*, plate IIIB, attributes the group, which he titles *Warriors*, to Rustici, along with plate IIIA, the so-called *Warrior* group in the Louvre, Paris.
9. Vasari as quoted by Charles Loeser, *op. cit.*, pp. 266 and 267.
10. *Ibid.*, plate IIIC, the *Warrior* group which Loeser, in 1928, attributed to Rustici. The present author, however, assigns it to a different hand, along with plate IIID, the other *Warrior* group attributed by Loeser to Rustici but appearing here in fig. 4 and attributed to the Master of the Unruly Children.
11. A. E. Brinckmann, *Barock-Bozzetti*, Frankfur: a. M., II, 1924, pls. 4-6.
12. Schottmüller, *op. cit.*, no. 2611, illus. p. 183.

Circle of DOMENICO BECCAFUMI
(1486-1551)

10. *Candelabrum-bearing Angel*

Terra-cotta, with traces of gilding, ca. 1550.
H. 27¾ in. (70.5 cm.) W. 8¼ in. (20.9 cm.) D. 13½ in. (34.3 cm.)
Condition: repairs at point where drapery meets base, at waist, wrists, ankles, arm, neck, bottom and sides of back drapery and on candlestick.
Accession no. 77.5.17

E VIDENTLY INSPIRED by the candelabrum-bearing angels (ca.1497) by Francesco di Giorgio in Siena Cathedral,[1] this more distinctly masculine figure manifests a degree of mannerism in its exaggerated *contrapposto,* which is closely analogous to that of the eight bronze angels made for the chancel of Siena Cathedral by Domenico Beccafumi between 1548 and 1551 (fig. 1). These were the last works of an artist celebrated for his paintings but little known as a sculptor.[2] The statues are characterized by the nervous modelling of drapery and boldly unconventional poses. The rounded facial type and the treatment of curly hair in the present figure, combined with the slightly "wind-swept" drapery of the tunic which parts over the thighs to reveal the well-turned legs, link it closely to Beccafumi's bronze statues. Close analogies may also be found with an angel in gilded wood (fig. 2), now in the Opera del Duomo, Siena.

1. J. Pope-Hennessy, *Italian Renaissance Sculpture,* London, 1958, plate 97, fig. 101, p. 324.
2. D. Sanminiatelli, *Domenico Beccafumi,* Milan, 1967, cat. no. 79, **p. 122 and pl. 79, 79a, 79b.**

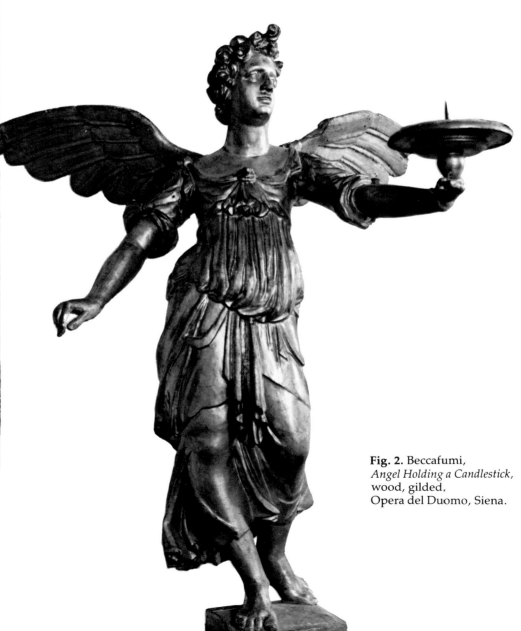

Fig. 1. Beccafumi, *Angel Holding a Candlestick,* bronze, 1548-1551, for chancel of Siena Cathedral, Siena.

Fig. 2. Beccafumi, *Angel Holding a Candlestick,* wood, gilded, Opera del Duomo, Siena.

50

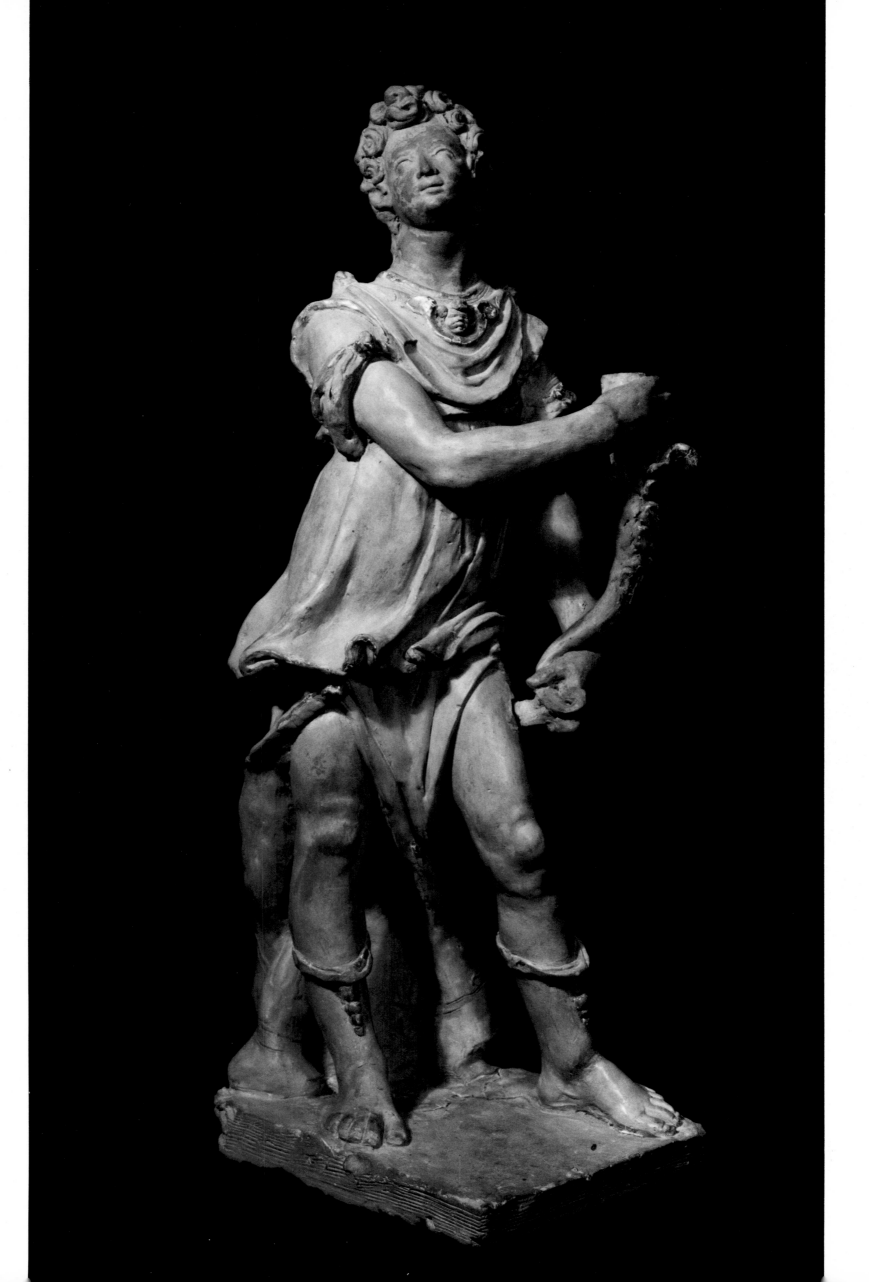

BOLOGNESE, late 15th or early 16th century

ANONYMOUS

11. *Bust of a Monk*

Polychrome terra-cotta.[1]
H. 12⅝ in. (32.0 cm.) W. 12½ in. (31.7 cm.) D. 9 in. (22.9 cm.)
Condition: old repairs at shoulders, around back of head and neck, nose, forehead. Paint flaking generally about face.
Accession no. 77.5.60

THIS POLYCHROME BUST of a monk is probably a devotional image and not a portrait. Its realism and sweetness of mood point towards the Emilian and Marchigian school of terra-cotta. It recalls the work of Francesco Francia, for example his bronze portrait relief of Cardinal Alidosi in the Louvre, and of Vincenzo Onofri, for example his bust of Beroaldo in San Martino, Bologna (fig. 1).[2] In the absence of satisfactory reference works about this important and complex school of terra-cotta, precise attribution is out of the question.

1. Oxford Research Laboratory for Archaeology and the History of Art, *Report on Thermoluminescence Analysis*, sample no. 281p50: last fired between 500 and 330 years ago, (1479-1640).
2. A. Venturi, *Storia dell'Arte Italiana*, VI, Milan, 1908, figs. 534, 537.

Fig. 1. Vincenzo Onofri, *Beroaldo*, terra-cotta, San Martino, Bologna.

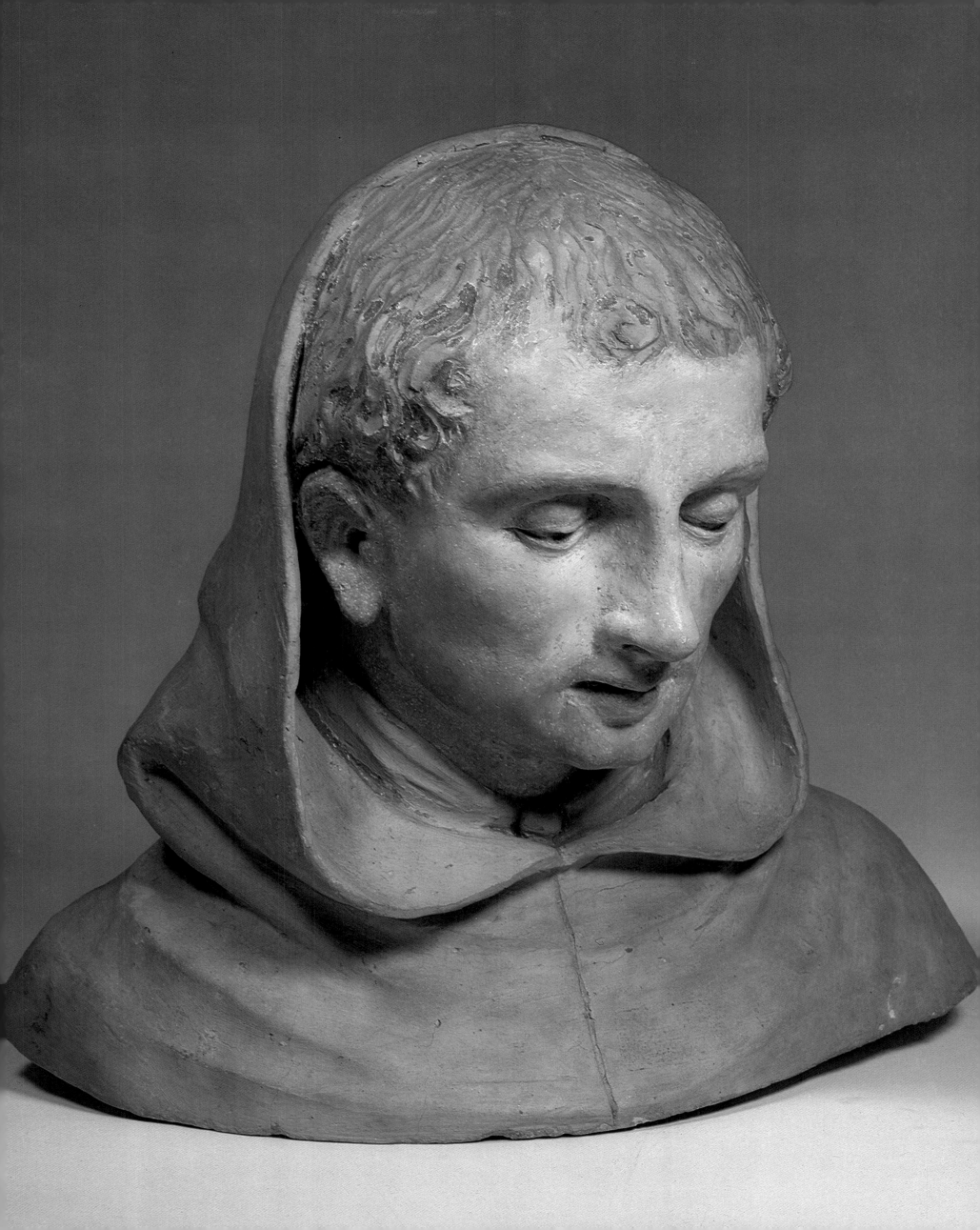

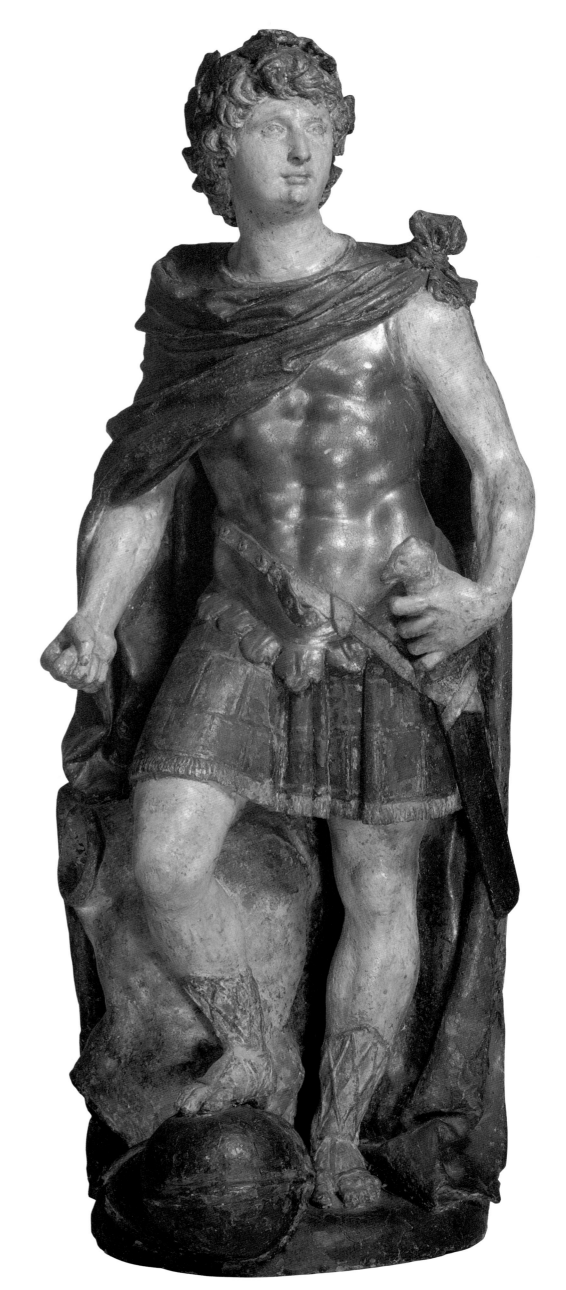

54

ITALIAN, mid-16th century

ANONYMOUS

12. *Roman Emperor*

Polychrome and partly gilded terra-cotta.
H. 27¼ in. (69.2 cm.) W. 9 in. (22.9 cm.) D. 8¾ in. (22.2 cm.)
Condition: repairs at wrists, neck, ankles, right forearm and left
upper arm. Back unfinished. Chips in paint; gilding worn in spots.

Exhibited: Heim Gallery (London), *Sculptures of the 15th and 16th centuries,*
Summer 1972, no. 16, and Heim Gallery (Paris), *Le choix de l'amateur,*
March/April, 1974, no. 11.*

Accession no. 77.5.8

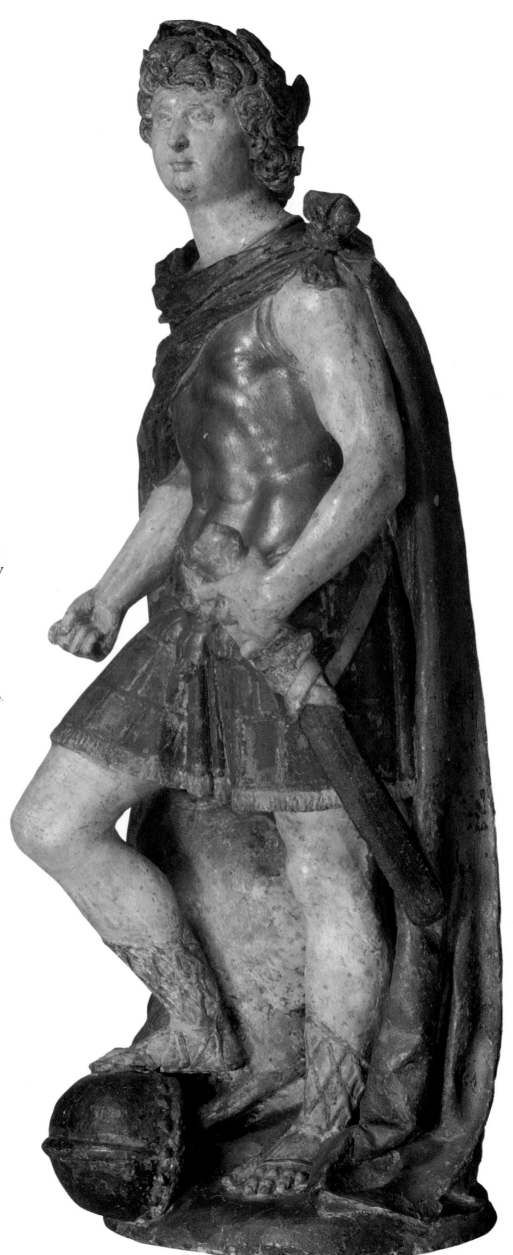

WHEN FIRST PUBLISHED in 1972, the statuette was
regarded as Florentine, third quarter of the 16th
century, analogies being drawn with Bandinelli's
statue *Duke Cosimo I de' Medici* in the Palazzo Vecchio
(1540s) and with one by Vicenzo Danti for the facade of
the Uffizi (ca. 1568-72), now in the Museo Nazionale
(Bargello), Florence. Dating by thermoluminescence
analysis offers a range of dates between 1529 and 1679
for the statuette, though on grounds of style it is likely
to fall within the 16th century.[1]

The statuette, judging from its polychromy and gilding, is
a finished work rather than a sketch-model, and appears to
represent an idealized Roman *imperator,* not a contemporary
ruler *all'antica.* The figure stands in strong contrapposto
and was presumably destined to fill an ornamental role
on a mantelpiece or dresser. It need not have originated in
Florence, however, and may have been made in the
Bolognese or Marchigian terra-cotta schools.

1. Oxford Research Laboratory for Archaeology and the History of Art, *Report on Thermoluminescence Analysis,*
 sample no. 281p52: last fired between 450 and 300 years ago (1529–1679).

*The information in this entry is based in part on that provided by the author for the Heim Gallery catalogue.

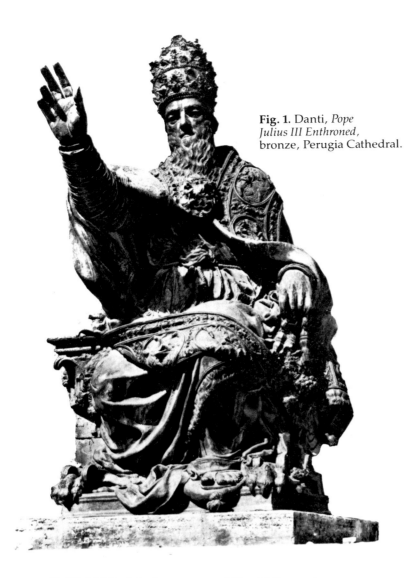

Fig. 1. Danti, *Pope Julius III Enthroned,* bronze, Perugia Cathedral.

ROMAN, third quarter of the 16th century

Attributed to VINCENZO DANTI
(1530-1576)
formerly attributed to Guglielmo della Porta

Vincenzo matriculated as a goldsmith in his native Perugia in 1548. His earliest major sculpture is the monumental bronze figure of *Pope Julius III Enthroned* (fig. 1), outside Perugia Cathedral (1553-1556). From 1557 until 1573 he worked as a sculptor at the court of Cosimo I, Grand Duke of Florence. His masterpiece there was a bronze group on the Baptistry, depicting the *Beheading of St. John the Baptist* (1571): these and all his other figures are gracefully elongated and set in balletic poses characteristic of sculpture in the Age of Mannerism. In 1567 Vincenzo published a treatise on proportion and retired from Florence to Perugia in 1573, where he was appointed Public Architect and was a founder member of the academy there.[1]

13. *Pope Julius III del Monte*
(1549-1555)

Terra-cotta bust, ca. 1550-1555.
H. 23¼ in. (59.1 cm.) W. 24½ in. (62.2 cm.) D. 14 in. (35.6 cm.)
Condition: crack across forehead extending around head; repair at vents and in crack line in beard; cracks on both shoulders.
Provenance: Locko Park collection, Captain P. J. B. Drury-Lowe; sold, Sotheby, London, November 16, 1972, no. 68 (with a bill to Mr. Drury-Lowe dated February 11, 1864); Messrs. Cyril Humphris, London.
Accession no. 77.5.73

THE ELDERLY, LONG-BEARDED POPE is shown wearing an embroidered cope held together with a clasp (morse) showing a bust of Christ in profile to the right. The cope is decorated with panels containing superimposed mounds that are the heraldic device of the del Monte, and two figures of saints standing in architectural niches—one on the spectator's right identified by a cross as St. Andrew and the other without a distinctive attribute.

The medallion of Christ (fig. 2) conforms to the image which was popular in Italy during the 15th and 16th centuries on religious medals: indeed, G. F. Hill remarks that "the regular series of Papal medals with the bust of Christ seems to begin with the Jubilee of 1550," i.e., the year of Pope Julius' accession.[2] Its appearance on the clasp indicates that it had a special significance for him, and may perhaps indicate that the present bust was made to celebrate the occasion.

The bust has been dated to between A.D. 1471-1569.[3] It is therefore likely to have been made during the papacy of Julius III. Three major sculptors were associated with the Pope: Guglielmo della Porta (ca. 1515-1577), whom he commissioned jointly with Michelangelo to make the tomb of his predecessor, Pope Paul III, as well as his own tomb (never completed); Bartolomeo Ammanati (1511-1592), who, also involved with Michelangelo and with Vasari in creating the del Monte family chapel in San Pietro in Montorio (1550 ff.), made portrait effigies of the Pope's relatives; and Vincenzo Danti (1530-1576), whom the Pope commissioned jointly with his father to execute the bronze statue in Perugia.

It is likely that the present, powerful portrait-bust of Julius is by one of these three sculptors, but the choice of author is problematic. It is perhaps closer in style and feeling to Danti's monumental bronze portrait of Julius in Perugia than to Ammanati's del Monte effigies in San Pietro in Montorio or della Porta's portraits of Pope Paul III , such as that in the Capodimonte Museum, Naples. The sketchy but telling delineation of the saints on the cope is consistent with Danti's technique of modelling.[4]

1. D. Summers, "The chronology of Vincenzo Danti's first works in Florence," in *Mitteilungen des Kunsthistorischen Institut in Florenz,* XVI, 1972, pp. 185-198.
2. G. F. Hill, *The Medallic Portraits of Christ,* Oxford, 1920, p. 66.
3. Oxford Research Laboratory for Archaeology and the History of Art, *Report on Thermoluminescence Analysis,* sample no. 81m 101: last fired between 400 and 500 years ago or A.D.1520 ± 49 years.
4. Summers, *op. cit.,* particularly fig. 12, Sportello for Cosimo I de'Medici, Museo Nazionale (Bargello), Florence.

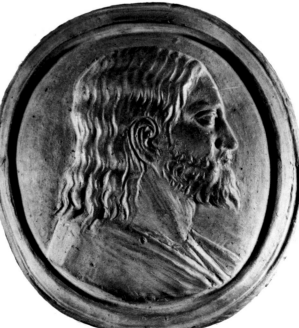

Fig. 2. Detail of clasp with profile of Christ.

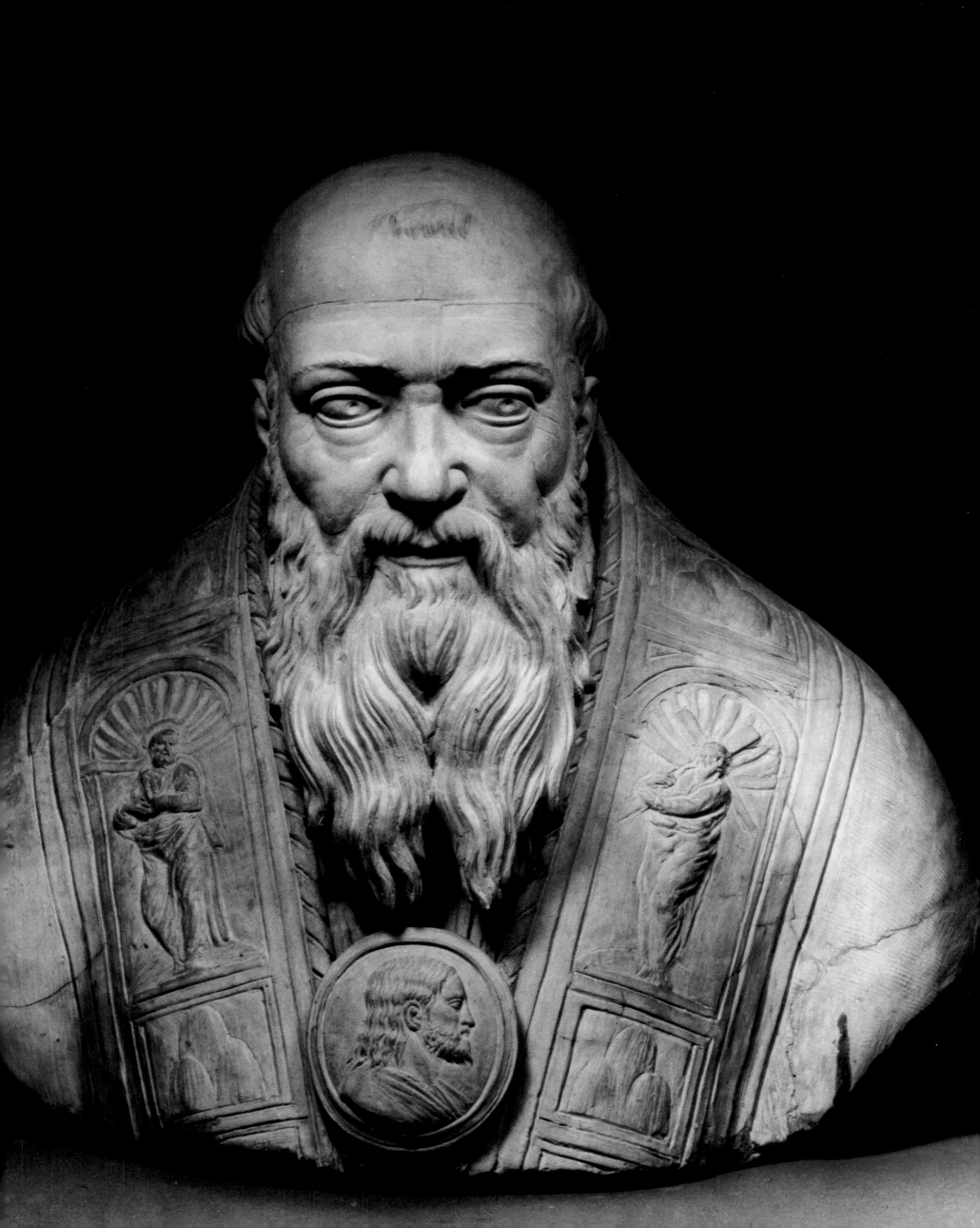

ROMAN, 16th century

JACOPO DEL DUCA
(ca. 1520- post 1592)

Born at Cefalù in Sicily, Jacopo first appears in a document of 1542 working on Michelangelo's tomb for Pope Julius II. He witnessed in 1564 the posthumous opening of Michelangelo's strongbox, and in the following year wrote to Leonardo Buonarotti that he was working on the realization in bronze of a model left by Michelangelo for a sacramental tabernacle for Santa Maria degli Angeli. Now in the Museo di Capodimonte, Naples, this is the principal work for which Jacopo is known (fig. 1). In 1577 he was negotiating to sell it to King Philip II of Spain for the Escorial, but without success. Thereafter (1577-1592) he was in charge of works at Santa Maria di Loreto in Rome.[1]

14. *The Deposition of Christ*

Terra-cotta, ca. 1565.
H. 11 in. (28 cm.) W. 8½ in. (21.5 cm.) D. 2¼ in. (5.7 cm.)
Condition: extensively cracked in the firing and repaired.
Provenance: Anna Maria, Lady Jones and by bequest and descent to Augustus Hare, sold October 13, 1908, St. Leonard's-on-Sea, no. 843: "A Valuable Terra-Cotta Relief, representing 'The Descent from the Cross' mounted in an ebonized and glased (*sic*) case (this has been in the Hare family for very many years, and is said to have formed part of an altar front by Michael Angelo, the rest being in Florence)." Bought by Jane Adeane. Coll. The Lord Adeane. Messrs. Cyril Humphris, London.
Accession no. 77.5.34

THE TRADITIONAL ASCRIPTION to Michelangelo for once has some foundation, inasmuch as the relief is directly related in composition to the corresponding panel on del Duca's bronze tabernacle, now in Naples (figs. 1, 2), which he claimed was derived from a model by his master. The modelling of nude anatomy is, however, not sufficiently well articulated to be by Michelangelo himself and clearly reflects the intervention of his devoted follower.

On March 15, 1565, del Duca wrote from Rome to Leonardo Buonarotti, Michelangelo's nephew and heir, that, as he had not been involved with the project for his master's tomb, he was engaged in making a "tabernacle of metal twenty *palmi* high, following Michelangelo's model." No such original model survives and the dependence of some of the eight narrative reliefs of the Passion on designs by Michelangelo is tenuous. However, the nucleus of the composition for the *Deposition*, as shown in the present terra-cotta with the corpse of Christ supported frontally and upright by two kneeling and two standing figures, is derived from Michelangelo's ideas, which have survived in drawings.[2] A cartoon of a *Pietà* with nine figures (now lost) was recorded in Michelangelo's inventory and may have been Jacopo's source.

The close focus and crowded mass of participants gives the relief a direct, emotional impact that was dissipated when the composition was adapted to the disproportionately high rectangle available on the bronze tabernacle (fig. 2). There, the cross and ladders above and the additional mourning figures tend to distract the eye. The possibility does exist however, given the post of the cross still visible, that there once was an upper section of the terra-cotta as in the bronze tabernacle relief. A relationship in theme and style may be noted with the more or less contemporary project, never completed, by Guglielmo della Porta for a cycle of Passion reliefs with a vertical, rectangular format.[3] An apparently autograph gilt bronze cast from Guglielmo's preliminary model for the *Flagellation* (fig. 3) has been purchased recently by the Victoria and Albert Museum, London.

1. A. Venturi, *Storia dell'Arte Italiana*, X, 2, Milan, 1936, pp. 161-177.
2. C. de Tolnay, *Michelangelo*, V, *The Final Period*, Princeton, 1960, no. 239, figs. 211-213, pp. 216-218.
3. W. Gramberg, *Die Düsseldorfer Skizzenbücher des Guglielmo della Porta*, Berlin, 1964, no. 59, pp. 54-56.

Fig. 1. Del Duca, *Sacramental Tabernacle*, bronze, Museo di Capodimonte, Naples.

Fig. 2. Detail of fig. 1 with panel depicting the deposition of Christ.

Fig. 3. Della Porta, *Flagellation*, bronze cast from a preliminary model, Victoria and Albert Museum, London.

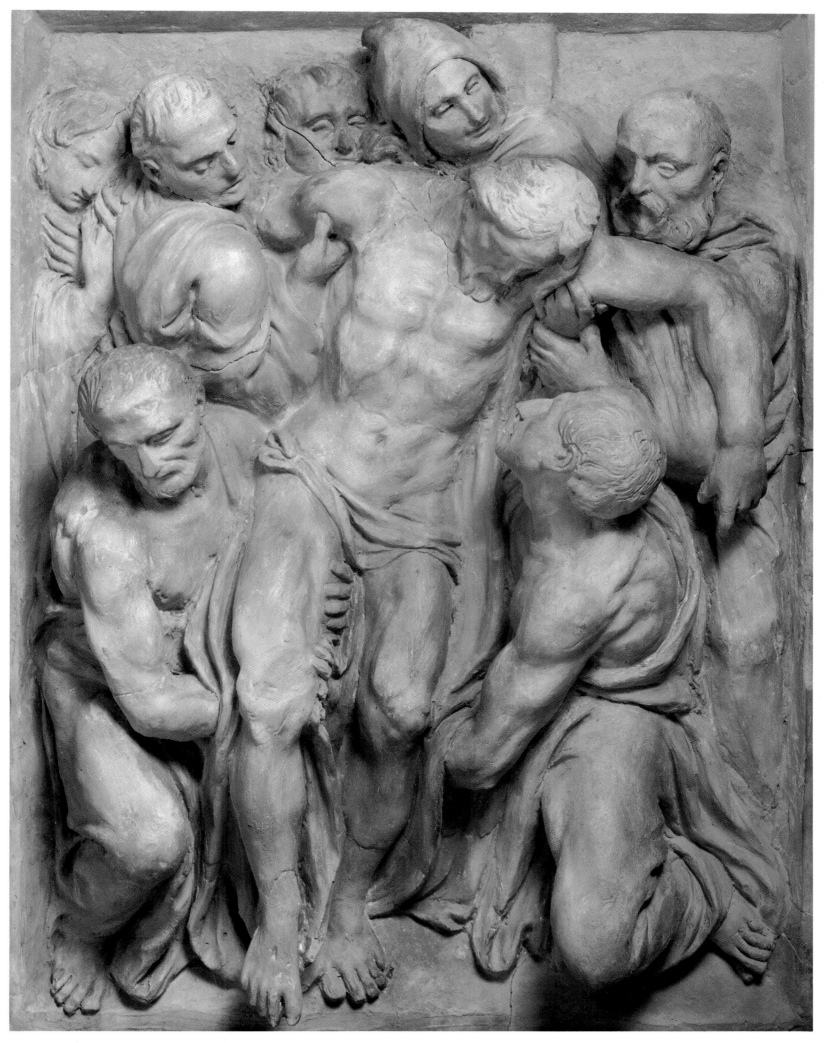

VENETIAN, 16th century

DANESE CATTANEO
(ca. 1509-1573)

Trained under Jacopo Sansovino in Rome, he accompanied his master to Venice in 1527, working with him on the Library of St. Mark and on the Loggetta. He was later active also in Padua (Cappella del Santo, tomb monuments) and Verona, although he continued to work in Venice (the Loredan monument). His considerable *oeuvre* consists of portrait-busts, tomb sculpture, monuments and large-scale reliefs. He is also known for his bronzes.

15. *Head of Doge Leonardo Loredan*
(1436-1521; elected Doge 1501)

Terra-cotta, painted, with traces of gilding, ca. 1572.*
H. 17¼ in. (43.8 cm.) W. 11¼ in. (28.5 cm.) D. 9½ in. (24.1 cm.)
Condition: repaired damages, e.g. to the nose, collar and lower periphery of the bust.
Exhibited: Heim Gallery (London) *Sculptures of the 15th and 16th Centuries,* Summer 1972, no. 30.
Accession no. 77.5.26
*Oxford Research Laboratory for Archaeology and the History of Art, *Report on Thermoluminescence Analysis,* sample no. 281p43, 1979; last fired between 500 and 350 years ago (1479-1629).

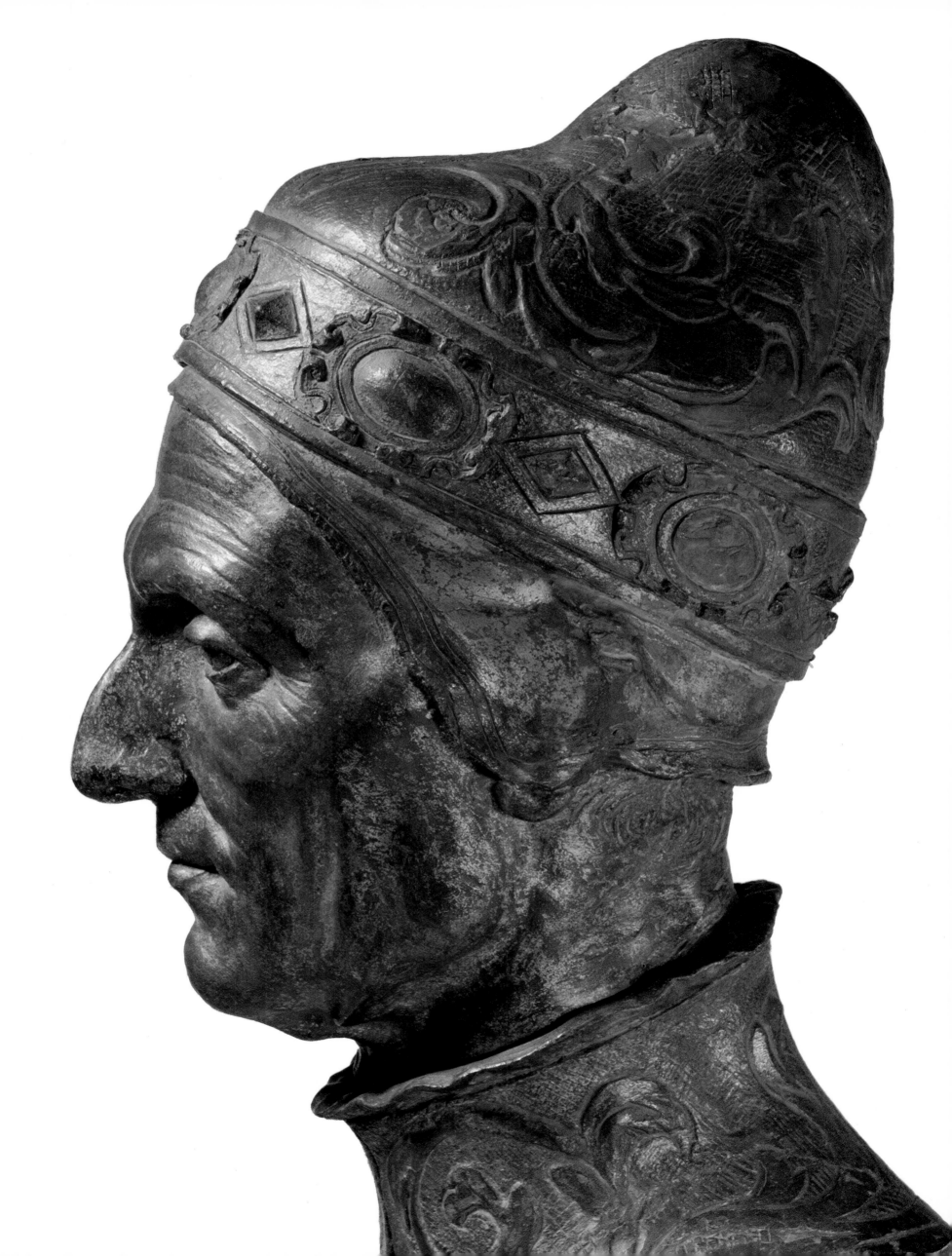

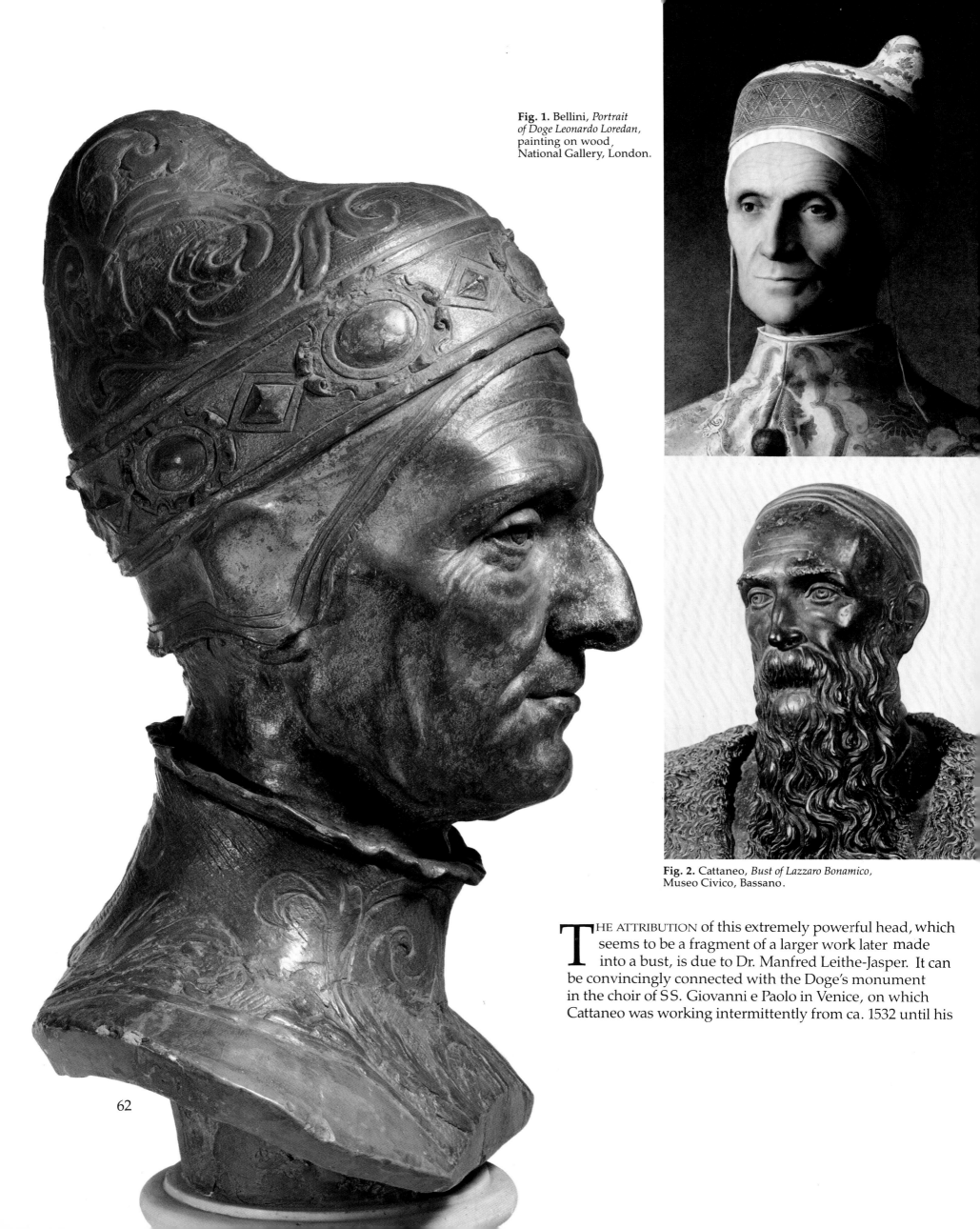

Fig. 1. Bellini, *Portrait of Doge Leonardo Loredan*, painting on wood, National Gallery, London.

Fig. 2. Cattaneo, *Bust of Lazzaro Bonamico*, Museo Civico, Bassano.

T HE ATTRIBUTION of this extremely powerful head, which seems to be a fragment of a larger work later made into a bust, is due to Dr. Manfred Leithe-Jasper. It can be convincingly connected with the Doge's monument in the choir of SS. Giovanni e Paolo in Venice, on which Cattaneo was working intermittently from ca. 1532 until his

62

death in 1572. By that time he had completed only the figures of *Venezia armata*, *Peace* and *Dovizia*, while that of *The League of Cambrai* remained unfinished. The figure of the Doge was finally executed and signed by Cattaneo's pupil, Girolamo Campagna. This happened considerably later, since, in a letter to Francesco Maria II, Duke of Urbino (dated June 19, 1604), Campagna writes: "The statue of the Doge Leonardo Loredan...which is at present unfinished."[1] This clearly gives a *terminus post quem* to the head.

The head of Campagna's statue follows the terra-cotta so closely as to suggest that the latter may have been part of a full-length *modello* done by Cattaneo shortly before his death and then used by his pupil when carving the statue many years later.[2] In his will, the artist left Campagna, who was his favourite pupil, all his drawings and models *(gessi)*.[3] The attribution to Cattaneo is based on stylistic affinities with other documented busts by the sculptor, such as that of Lazzaro Bonamico (d. 1532) in the Museo Civico in Bassano (fig. 2),[4] of Fracastoro (?) in the Kunsthistorisches Museum, Vienna,[5] of Cardinal Pietro Bembo in the Santo at Padua (1547), and of Alessandro Contarini (1555), also in the Santo.[6] It is the lines of the forehead, the modelling of the brow, and the thin bony structure of the face that create a relationship between this head and the one in fig. 2. Especially close is the rendering of the eyes with clearly incised cornea and retina and the shape and style of the eyelids. Clearly, the bony structure of the face and the handling of the eyes relate it as well to the bust of Fracastoro whose "pie-crust" collar is also similarly modelled.

As the present bust was executed posthumously, Cattaneo may have used as its iconographical source the portrait by Bellini, now in the National Gallery in London (fig. 1).[7] The possible influence of Bellini was hinted at by Venturi, who—mistakenly considering the statue of the Doge an early work of Campagna—wrote of the head: "...it has an almost Bellinesque expression of well-being...."[8] There were, however, other iconographical sources available too, such as the profile medallion on the central flagpole in the Piazza San Marco in Venice by Alessandro Leopardi (1505), particularly interesting for the similar, heavy jewelling of the *còrno*,[9] or the medal in the manner of Camelio.[10]

1. *"La státua del Doce Leonardo Loredan...che hora ho in casa non finita..."* G. Gronau, *Documenti Artistici Urbinati*, Florence, 1936, p. 244; P. Rossi, "Vicende biografiche di Girolamo Campagna," *Vita Veronese*, vol. XIX, March/April 1966, pp. 96-97; E. Rigoni, *L'Arte Rinascimentale in Padova*, Padua, 1970, p. 233.
2. A. Venturi, *Storia, dell' Arte Italiana*, X, 3, Milan, 1937, fig. 160; J. Pope-Hennessy, *Italian High Renaissance and Baroque Sculpture*, London/New York, 1970, pl. 120, and fig. 112; G. Timofiewitsch, *Girolamo Campagna*, Munich, 1972, cat. no. 24, pp. 278-281, pls. 88, 89.
3. Rigoni, *op. cit.*, p. 223.
4. L. Planiscig, *Venezianische Bildhauer der Renaissance*, Vienna, 1921, fig. 445, p. 421.
5. *Ibid.*, fig. 448, p. 425.
6. Venturi, *op. cit.*, figs. 6 and 11.
7. M. Davies, *The Earlier Italian Schools*, London, 1961, cat. no. 189, p. 55-56.
8. *"...ha un'a espressione quasi belliniana di bontà mite..."* Venturi, *op. cit.*, p. 212.
9. Venturi, *op. cit.*, X, 1(1935), fig. 308.
10. G. F. Hill, and G. Pollard, *Renaissance Medals from the Samuel H. Kress Collection at the National Gallery of Art*, London, 1967, no. 152.

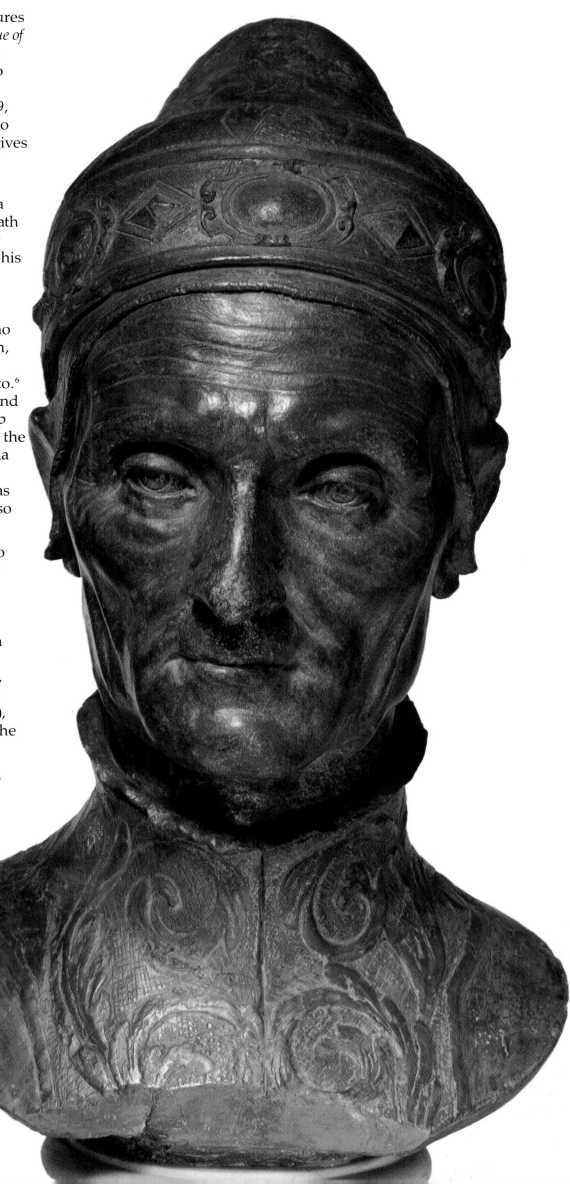

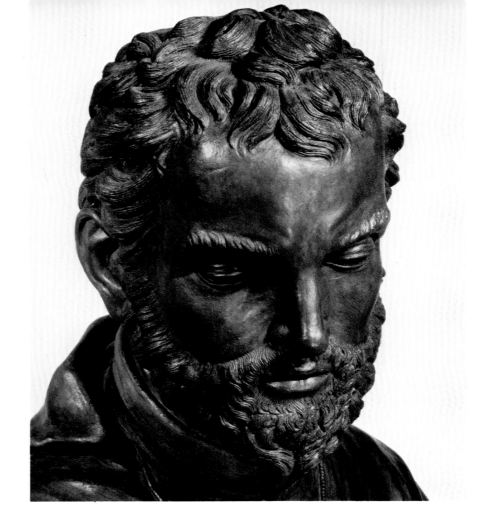

FLORENTINE, first quarter of the 17th century

Attributed to FELICE PALMA
(1583–1625)

Taught in the local school of Carrara, Palma was already formed as a marble sculptor when he came to Pisa in 1605 and entered the studio of Tiziano Aspetti (1565-1607). From Aspetti, he learned the Veneto-Paduan skills of bronze-casting. Around 1610-1611 he executed his sole work of architecture, the Villa Capannori for his and Aspetti's patron Camillo Berzighelli. In 1612 he was summoned to Florence by Cosimo II to execute the monumental marble figure of *Jupiter Tonans* for Poggio Imperiale. Among other works that he executed in Florence were a bronze crucifix and the marble *Bust of Bishops Pietro* and *Usimbardo Usimbardi* in the chapel in S. Trinità, for which Aspetti had made the bronze antependium. Proposed by Pietro Tacca, he was elected to the Accademia del Disegno in 1614. Between 1616 and 1618 he made a statuette of *Noah* and a relief of the *Baptism* in bronze, and a finial figure of the *Risen Christ* in marble, for the font of the Baptistry of Pietrasanta. He was invited back to Pisa to execute the bronze finials of *Christ* and *John the Baptist* for the holy water stoups of Pisa Cathedral. In 1620 he executed two exquisite marble angels for the Madonna di Fonte Nuova at Monsummano. In 1623, Palma was summoned to Massa to execute sculpture for the gardens of the Villa dei Massoni, built by the new Duke (Cosimo II having died in 1621).

Fig. 1. Palma, *Ecclesiastic*, marble,
Victoria and Albert Museum, London.

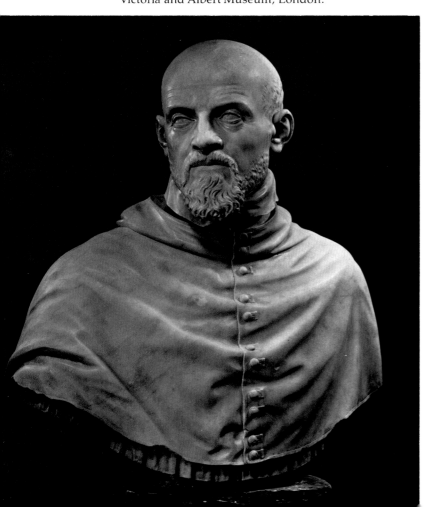

16. *Bust of a Cleric*

Terra-cotta with wax patination.
H. 27½ in. (69.9 cm.) W. 24½ in. (62.3 cm.) D. 11¼ in. (28.5 cm.)
Condition: extensive repairs throughout.
Exhibited: Heim Gallery (London), *The Baroque in Italy,* Summer 1978, no. 31.*
Accession no. 79.1.3

THOUGH EXECUTED in terra-cotta, the handling of this bust, above all of the tight locks of hair and beard, strongly suggest that it is the *modello* for a bronze designed to be placed high up, probably over a tomb or in a family chapel. It seems Florentine, yet has a presence and vigour that recall Venetian masters such as Vittoria and Cattaneo (see no. 15).

The Florentine sculptor in whose work such Venetian traits are to be found is Felice Palma, to whom they were doubtless transmitted via Tiziano Aspetti.[1] Thus far only one other terra-cotta bust, *Portrait of a Cleric*, has been attributed to Palma.[2] Most of the busts by him, which have been published, are in marble, and are in the austerely Florentine tradition.[3] Typical is one showing an unidentified *Ecclesiastic* now in London (fig. 1),[4] which has been convincingly attributed to Palma by comparison with his Usimbardi busts, ca. 1612, in their tomb in Santa Trinità, Florence. If, however, one can imagine the hand that made the heads of the Pietrasanta bronzes shaping a life-size terra-cotta *modello*, something closely akin to this bust would result. Research into Felice Palma and indeed into his Florentine contemporaries in the first quarter of the 17th century is still in its infancy, but this bust strongly merits consideration as a work of Palma's in a hitherto unfamiliar medium.

1. A. Parronchi, "Felice Palma: Nascita del Barocco nella Sculptura Toscana," *Festschrift Luitpold Düssler*, 1972, pp.290-291.
2. The bust is 38 cm. high, waxed and colored, and belongs to the Museo Nazionale (Bargello), Florence, no. 468. The attribution to Palma is made by U. Middeldorf in the catalogue of the exhibition *La Civiltà del Cotto Arte della terra-cotta nell' aria Fiorentina dal XV-XX secolo*, Impruneta, May–October, 1980, no. 2.28. Our thanks to Professor John Coolidge, Harvard University, for bringing this terra-cotta bust to our attention.
3. Parronchi, *op. cit.*
4. A.2-1950: J. Pope-Hennessy, *Catalogue of Italian Sculpture in the Victoria and Albert Museum*, London, 1964, vol. II, no. 604, vol. III, fig. 592.
*The information in this entry is based in part on that provided by the author for the Heim Gallery catalogue.

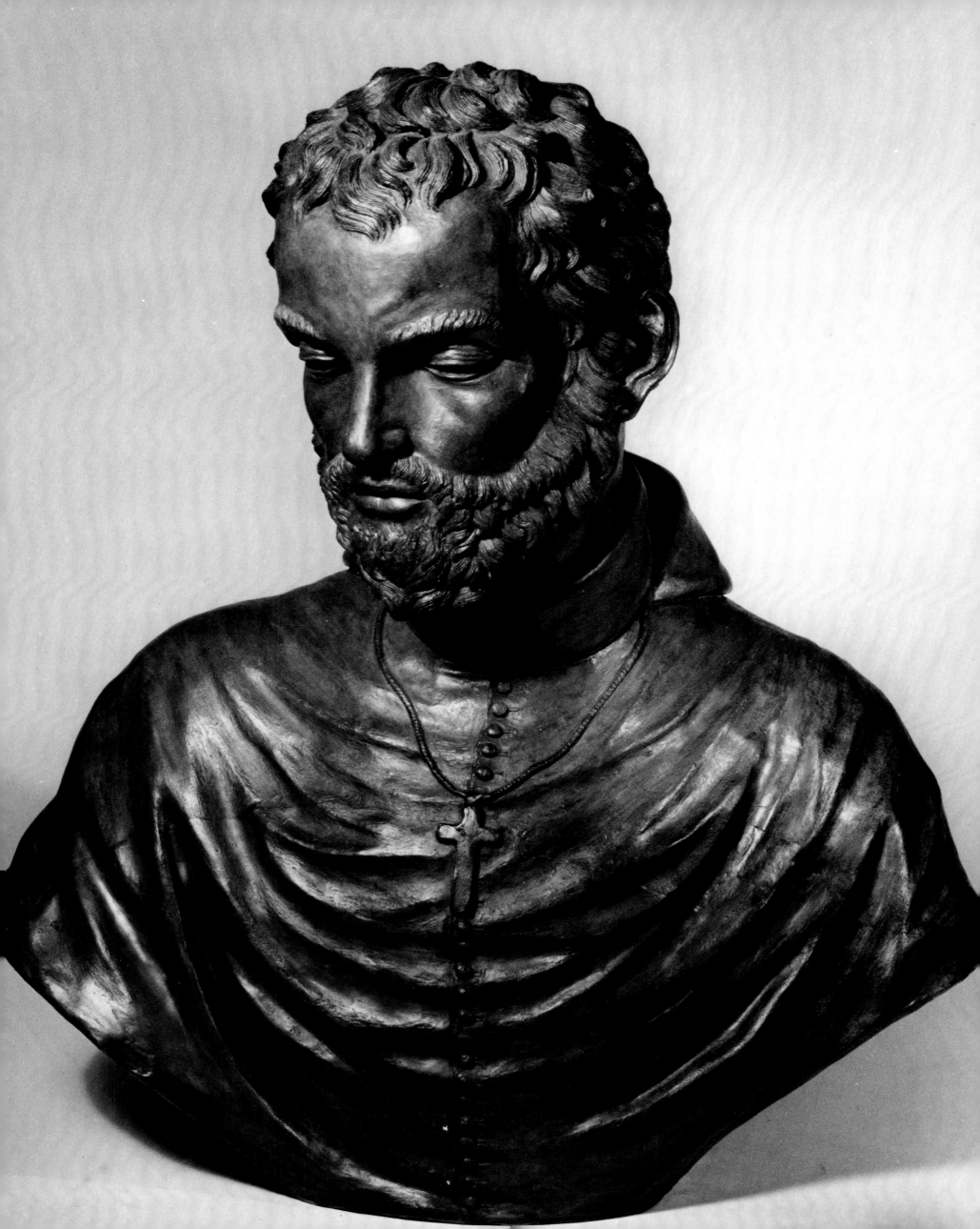

ROMAN, first half of the 17th century

ALESSANDRO ALGARDI
(1598-1654)

Born at Bologna and trained in the academic
tradition of the Carracci, Algardi spent some
years at Mantua and then went to Rome in 1624,
where he was employed as a restorer of ancient
statuary and produced small-scale sculpture.
Algardi's style was more austere and classical
than Bernini's, as is evident in his monumental
tomb of Pope Leo XI in St. Peter's (1634-1644).
During the pontificate of Innocent X (1644-1655),
a large number of official commissions were
awarded to Algardi, and he outshone Bernini for
that decade. The most famous were the great
marble relief of the *Meeting of Attila and Pope Leo
the Great* in St. Peter's (1646-1653) and the bronze
commemorative statue of Innocent X in the
Palazzo dei Conservatori (1645-1650). Algardi also
specialized in portrait-busts.

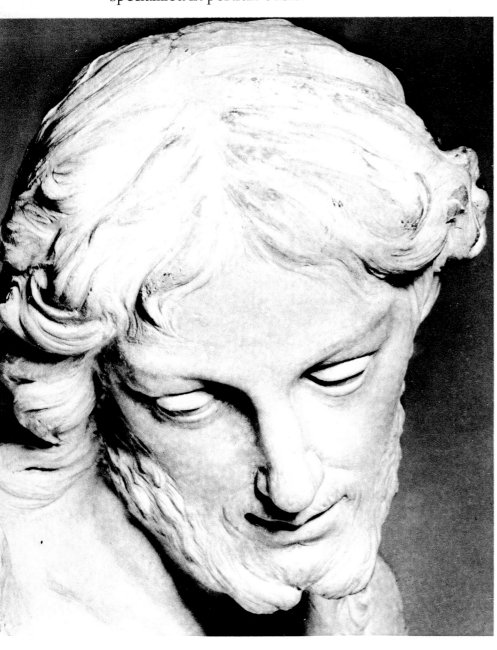

17. *Torso of the Resurrected Christ*

Terra-cotta.
H. 20¼ in. (51.4 cm.) W. 11 in. (27.9 cm.) D. 9½ in. (24.1 cm.)
Condition: across shoulders at both front and back runs a curved
division, filled with plaster, which may be a joint between
separately modelled components of head and torso. Repairs to
back of the head; some losses caused by the fireskin flaking off
over the back and around the groin; right arm, left forearm,
and both legs from the level of the groin are missing.
Accession no. 77.5.4

THE FIGURE, which is clearly a fragment from, or partial
study for, a larger composition—probably involving
another participant—is quite enigmatic. The facial
features and, more particularly, the wound in the right
breast, inescapably denote Christ after the Resurrection.
His downward look and raised right arm suggest one of
two appearances: either to St. Mary Magdalene on Easter
morning, when she mistook Him for a gardener;[1] or to
St. Thomas, who doubted the veracity of the Resurrection
and was not satisfied until he had actually touched the
wound in Christ's side made by a centurion's spear.[2] The
total nudity of all the parts of Christ included in the present
fragment, especially around the loins, is unusual in repre-
sentations of either episode, although it is perhaps more
consonant with the latter, that of the "Doubting Thomas."

The curving division, running around the shoulders just
below the collarbone and the locks of hair that fall down
behind, is most unusual. If it were a joint between two
component parts that were modelled and fired separately, a
point in the neck would have been far preferable and more
normal from a technical point of view. More probably, the
head and shoulders were modelled as a bust-like study
of facial features and expression, and, as the sculptor's
conception developed, the torso was afterwards modelled
to fit on to it.

As remarked by Dr. Jennifer Montagu, "The attribution of this
terra-cotta rests exclusively on style: the flow of the hair,
partly modelled freely in waving masses, partly incised with
the modelling tool; and the sweet expression in a face con-
structed in large and simple planes."[3] She notes a qualitative
discrepancy between the head and the torso, which she
does not feel fit well together in movement or proportion,
although they were apparently both made of the same clay
and presumably in Algardi's studio. While the head and
shoulders are autograph work, it is possible that the torso
was worked up by a studio assistant.

1. John, 20:11-17.
2. *Ibid.*, 24-29.
3. I would like to thank Dr. Montagu for generously making available to me the text of an entry in the *catalogue
raisonée* of her forthcoming monograph on Algardi.

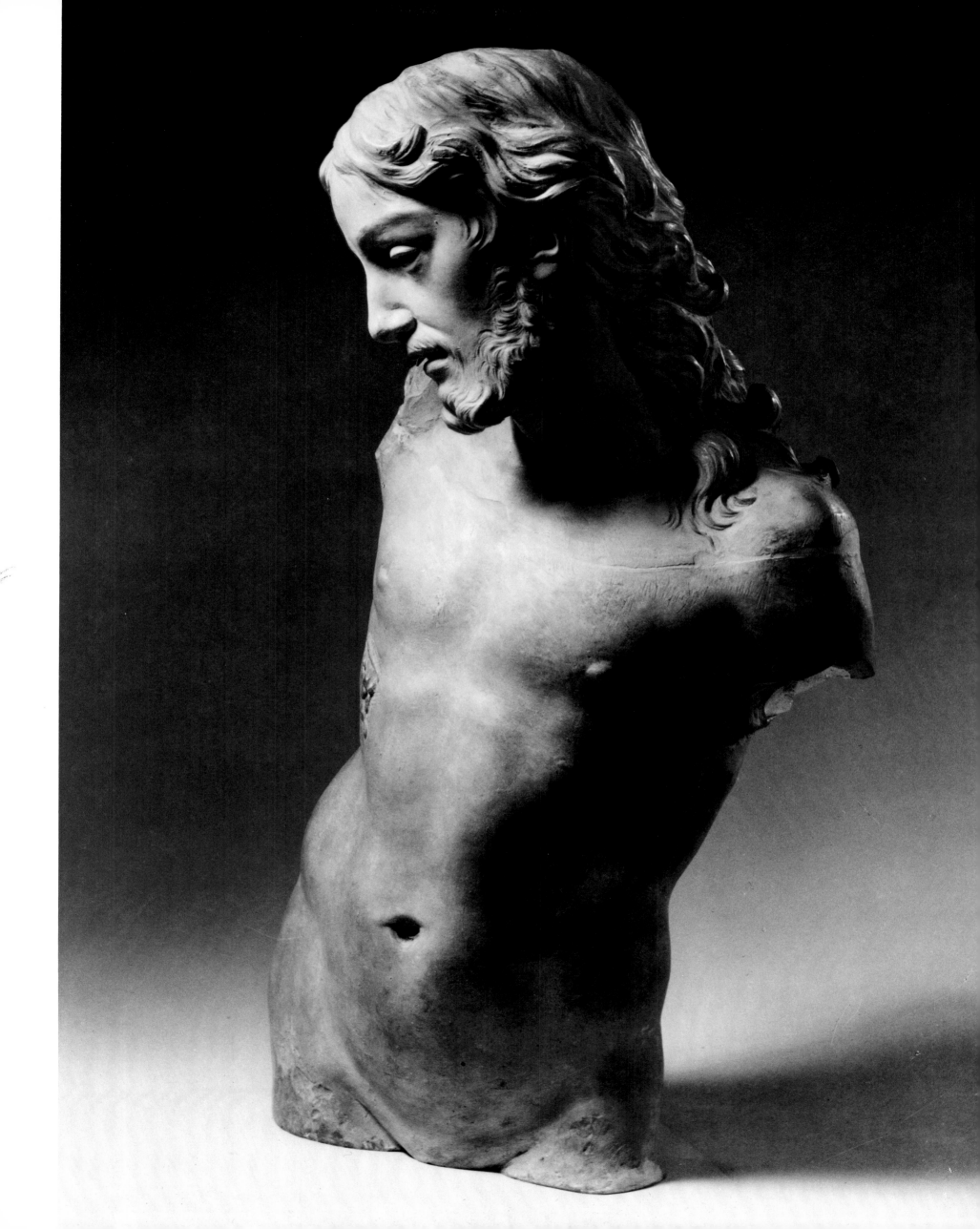

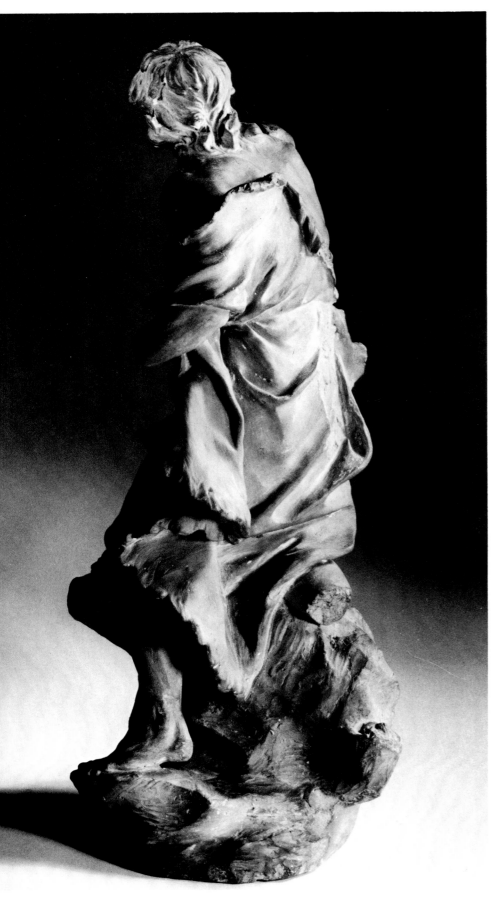

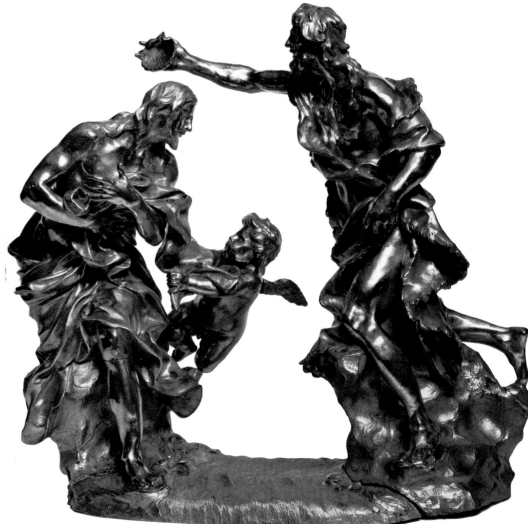

Fig. 1. Algardi, *Baptism of Christ*, gilt bronze, The Arthur M. Sackler Collections.

18. *St. John the Baptist*

Terra-cotta, first half of the 17th century.

H. 16½ in. (41.9 cm.) W. 6 in. (15.2 cm.) D. 7½ in. (19.1 cm.)
Condition: right arm broken at shoulder; left arm broken in midforearm; chips off edge of goatskin; fireskin of terra-cotta flaking throughout; left foot formerly broken at ankle and repaired; right leg broken off at midcalf.
Accession no. 77.5.3

THE TERRA-COTTA appears to be a study for the figure of the Baptist in a small-scale group showing the *Baptism of Christ*, of which a number of casts in bronze are known—the best being one in the Cleveland Museum of Art, but the exceptionally fine version in the Sackler collection is the first in gilt bronze to come to light (fig. 1). Algardi characteristically composed this group out of three detached figures which could be assembled in slightly different ways. This method of composition partly accounts for the differences in the various bronze versions. The terra-cotta here is just such a detached figure. In the Vatican Museum there is a terra-cotta model of the whole group (not including the baby angel), while in the National Museum in Valletta, Malta, there is a model showing just the figure of Christ, painted to resemble bronze.[1]

The bronzes, with the exception of the Sackler gilt bronze, have been discussed by Dr. Jennifer Montagu.[2]

1. J. Montagu, *"Le Baptême du Christ d'Alessandro Algardi,"* *Revue de l'Art*, 15, 1972, pp. 64-78, figs. 2, 4.
2. *Ibid*. The Sackler gilt bronze is discussed in Heim Gallery (London), *From Tintoretto to Tiepolo*, Summer 1980, no. 33 and illustrated.

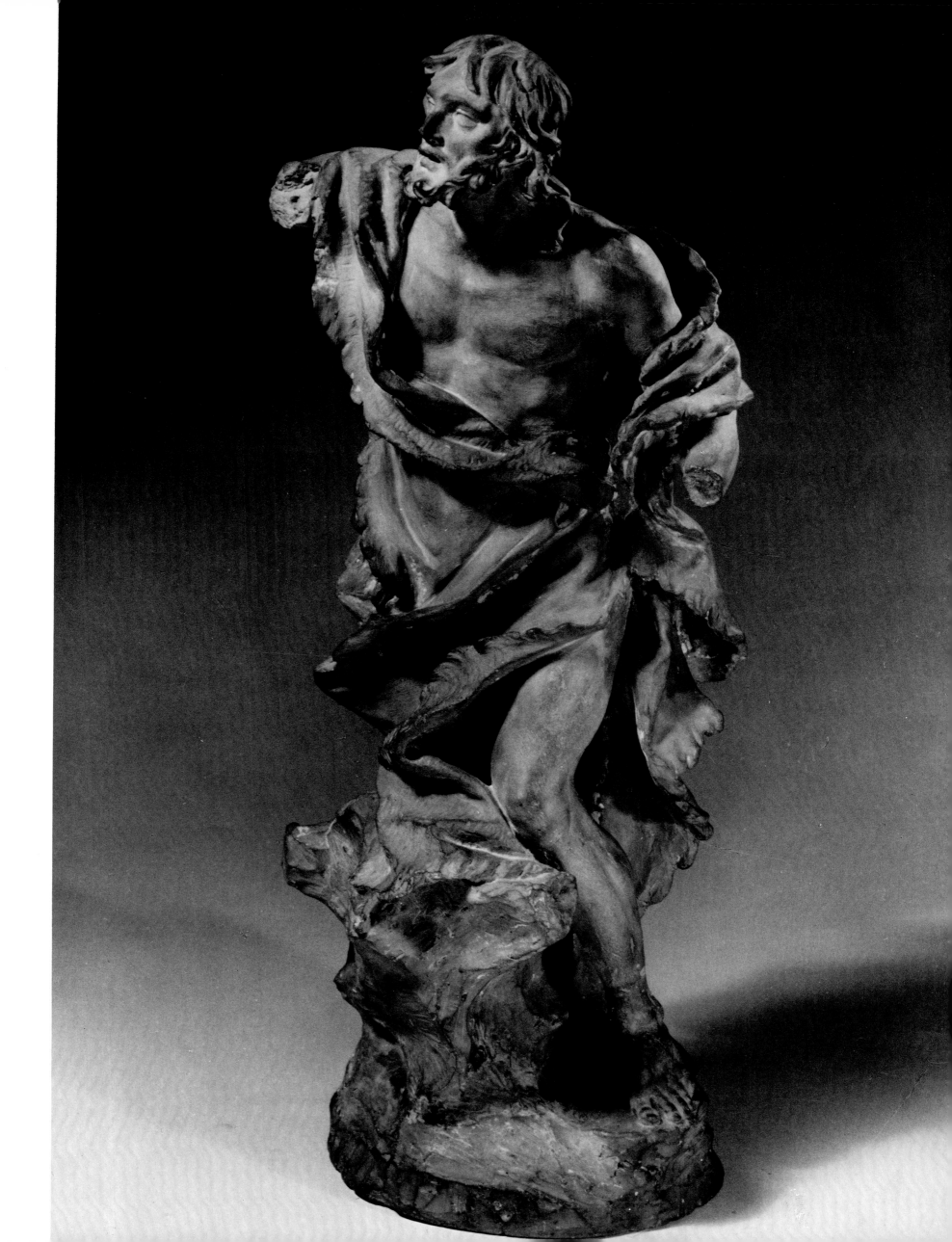

ROMAN, first half of the 17th century

FRANÇOIS DUQUESNOY, called *Il Fiammingo*
(1597-1643)

Son of the Brussels sculptor Jérôme Duquesnoy the
Elder (ca.1570-1641/2)— best known for his *Manneken-
Pis*—François, like his younger brother Jérôme,
was trained in the paternal studio, before leaving
for Rome in 1618. There, like Poussin (with whom
he shared a house), he drew antiquities for Cassiano
dal Pozzo, and between 1627 and 1628 provided
sculpture for Bernini's *Baldacchino*. His name made,
he was asked to carve the *St. Andrew* for the crossing
of St. Peter's (1629-40), and a *St. Susannah* (1629-33)
for S. Maria di Loreto. This work, indebted to both
classical sculpture and Bolognese painting, established
a new sculptural canon for female sainthood and
beauty. His *putti,* executed in every kind of medium—
from terra-cotta and bronze to the marble Vryburch
(1629) and Van den Eynde (1633-40) tombs in S. Maria
dell' Anima—revealed new possibilities of their
quasi-pictorial representation in sculpture, inspired
above all by Titian's *Bacchanals*. He died on the way
to France, where he had been invited by Louis XIII.

19. *Two Angel Musicians*

Terra-cotta, ca. 1636-1640.

H. 33⅓ in. (84.7 cm.) W. 27½ in. (69.9 cm.) D. 5¼ in. (13.3 cm.)
Condition: old repairs throughout; genitals missing on both
angels; fingers of lower angel's left hand broken off; entire
background and surface of relief appears to have been restored.
Provenance: Cardinal Imperiali (?).
Exhibited: Heim Gallery (London), *The Baroque in Italy,*
Summer 1978, no. 32.
Accession no. 79.1.2

*The information in this entry is based in part on that provided by the author for the
Heim Gallery catalogue.

Fig. 1. Altar of Filomarino Chapel, SS. Apostoli, Naples, marble, 1640-1642.

THIS NEWLY DISCOVERED RELIEF is a unique example
of a full-size terra-cotta *modello* by Duquesnoy. It
is for the left-hand group of the marble relief above
the altar of Filomarino chapel in SS. Apostoli, Naples,
which also includes above it G.B. Calandra's mosaic
altarpiece of the *Annunciation*, copied from Guido

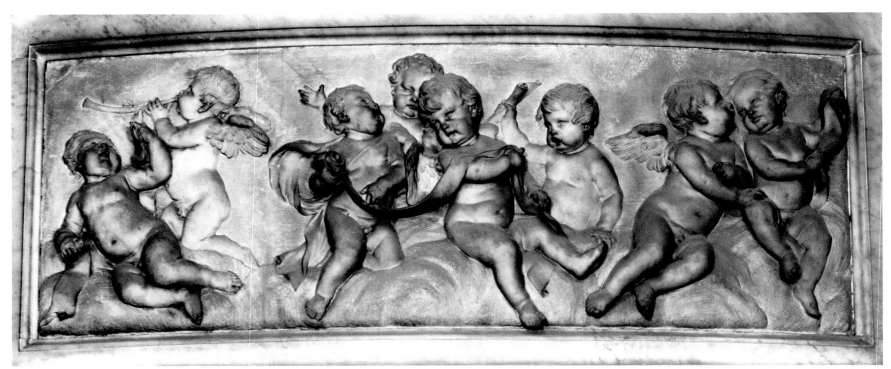

Fig. 2. Duquesnoy, detail of marble relief above the altar of Filomarino Chapel.

70

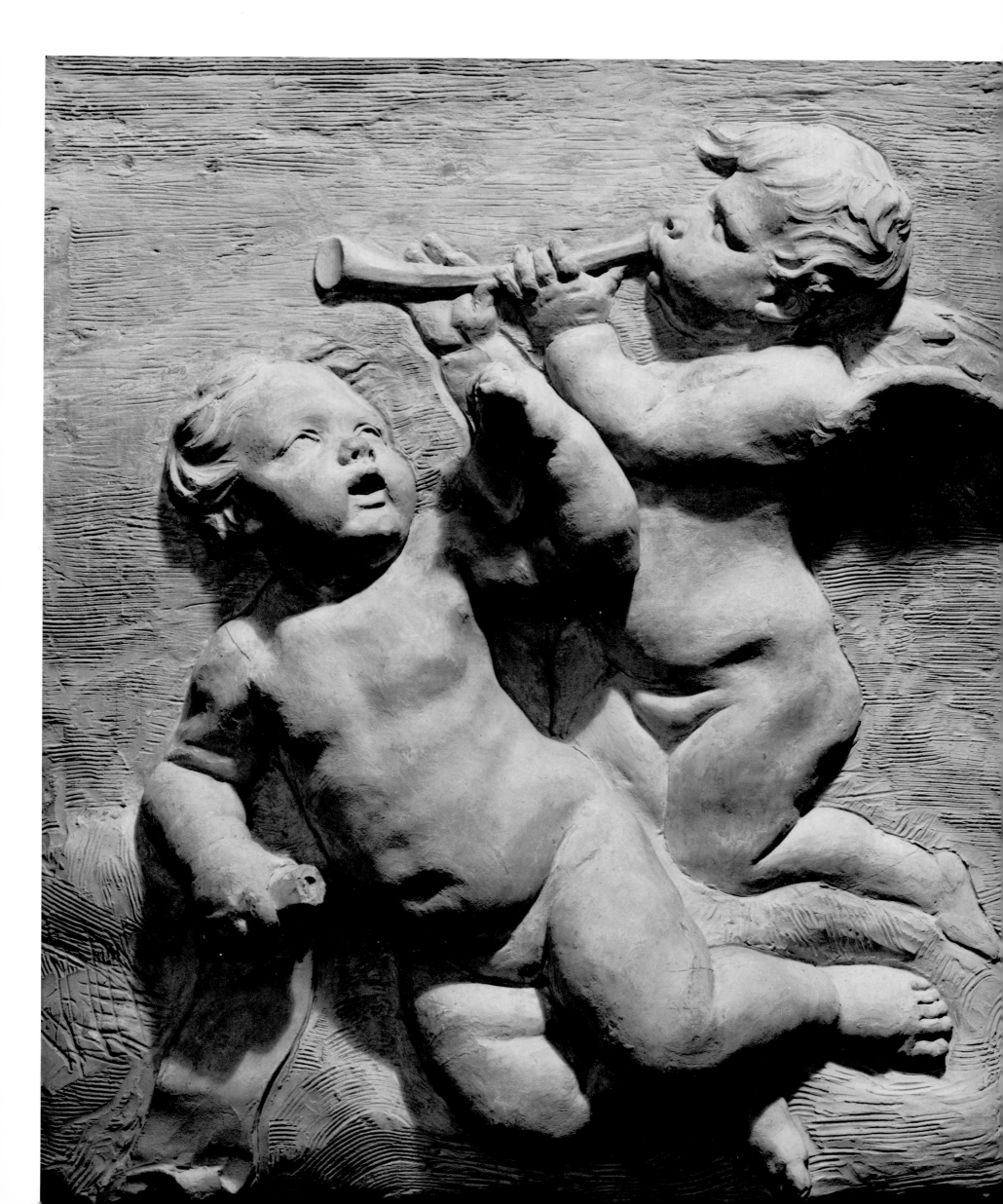

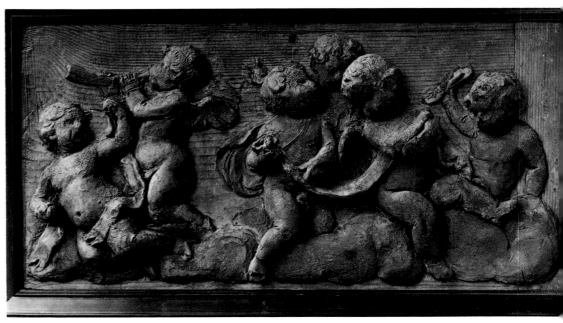

Fig. 3. Monari, Detail of a still life, oil on canvas, ca. 1700, private collection.

Fig. 4. After Duquesnoy, *Study Relief,* wax on figwood, Staatliche Museen Preussischer Kulturbesitz, Berlin.

Reni's painted altar in the Quirinal (figs. 1, 2). The commission is recorded in the accounts of Duquesnoy's career by Baldinucci and by Bellori: "...he carved yet another relief, a long one with naked baby angels singing from a score; it was for the chapel of Cardinal Filomarino, Archbishop of Naples, which had been built with great splendour in the church of the Holy Apostles in Naples, and the marble panel was set above the altar." [1]

The present relief has been published by Antonia Nava Cellini, who points to the subtle differences of perspective and detail that reveal it as a *modello* and not a reproduction.[2] She also publishes a still life by Cristoforo Monari which shows it among a clutter of artistic bric-à-brac (fig. 3).[3] Monari was working in Rome for Cardinal Imperiali around 1700, and it may have been in the cardinal's own collection that he saw the present relief, which would account for its fine carved wood frame.

A small relief modelled in yellow wax on figwood (fig. 4; H. 15.5 cm., L. 33 cm.), given to the Deutsches Museum, Berlin, in 1911 and now in the Staatliche Museen Preussischer

Kulturbesitz, Berlin, had until recently been regarded as an original sketch-model (*bozzetto*) for the left-hand part of the Filomarino relief. However, Ursula Schlegel now definitively rejects the idea that it is a *bozzetto* by Duquesnoy and suggests that it is a study model made from the marble relief in the early 18th century.[4]

The marble relief for which the terra-cotta is a *modello* shows three groups of music-making angels and forms part of an altar that subtly combines architecture, sculpture and mosaic. The altar was designed by Borromini in 1636, and finally consecrated in 1647. Duquesnoy's *putti* are designed to complement those in the top part of Calandra's mosaic altarpiece. This relief is the final demonstration of Duquesnoy's use of *putti* to reveal new possibilities in the pictorial handling of sculpture.

1. G. P. Bellori, *Le Vite de' Pittori, Scultori et Architetti Moderni,* Rome, 1672, p. 276: "*ne scolpì ancora un' altro (mezzo rilievo) lungo con Angioletti ignudi, li quali cantano sù le note, per la Cappella del Cardinale Filomarini Arcivescovo di Napoli edificata magnificamente nella chiesa de' Santi Apostoli in quella Città, dov' è collocato il marmo sopra l'altare.*"
2. A. Nava Cellini, "Per il Borromini e il Duquesnoy ai SS. Apostoli di Napoli," *Paragone,* no. 329, 1977, pl. 31 and pp. 32, 36.
3. *Ibid.,* pl. 32, 33.
4. U. Schlegel, *Die italienischen Bildwerke des 17. und 18. Jahrhunderts,* Berlin, 1978, no. 8.

ROMAN, third quarter of the 17th century

ANONYMOUS

20. *The Ascension of St. Catherine of Siena*

Terra-cotta, gilded.
H. 11 in. (27.9 cm.) W. 9 in. (22.9 cm.) D. 4½ in. (11.4 cm.)
Condition: right hand of St. Catherine broken off; repairs
to necks of figures; gilding flaked and worn throughout.
Accession no. 77.5.22

IN COMPOSITION AND FEELING , this terra-cotta
sketch-model is closely related to the great relief
of St. Catherine by Melchiore Caffà (ca.1631-1667)
in the apse of Santa Caterina a Monte Magnanapoli
in Rome, completed in 1667. It is also close in style
to Caffà — compare the *bozzetto* of *Charity* in
the Staatliche Museen, Berlin-Dahlem.[1]

1. U. Schlegel, *Die italienischen Bildwerke des 17. und 18. Jahrhunderts*, Berlin, 1978, no. 16.

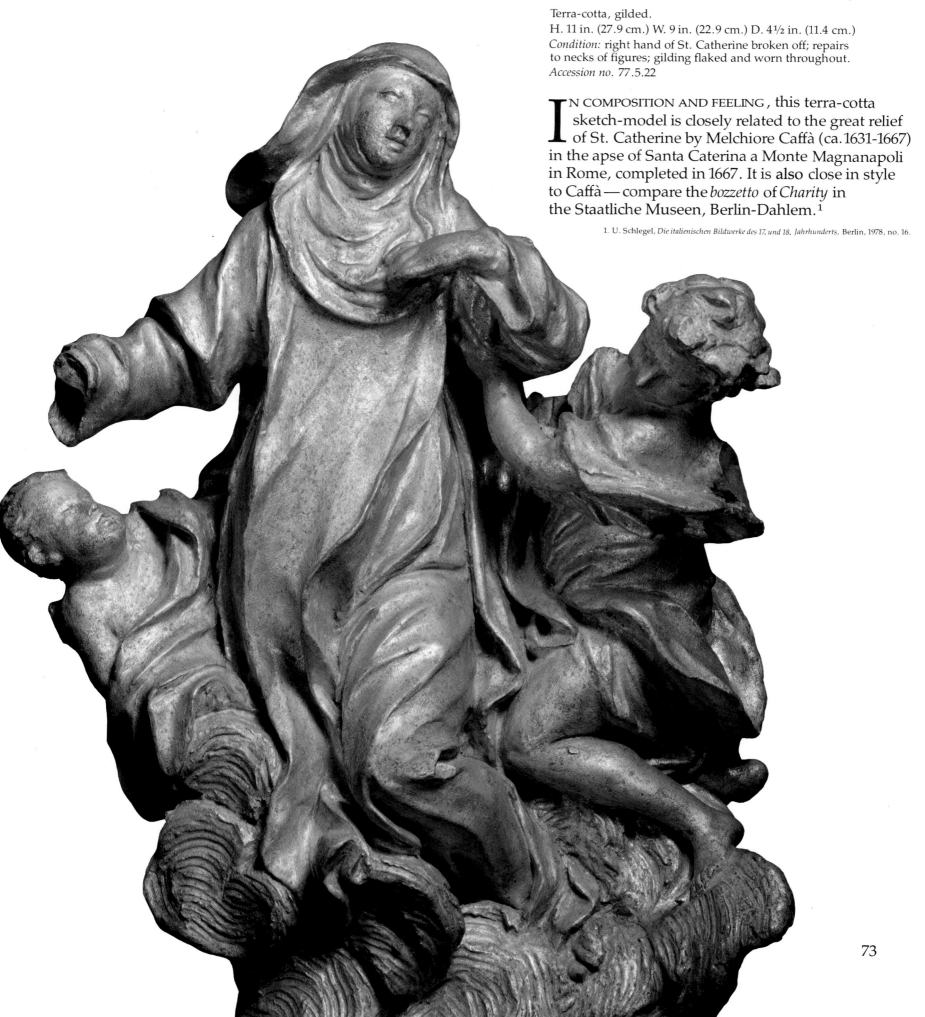

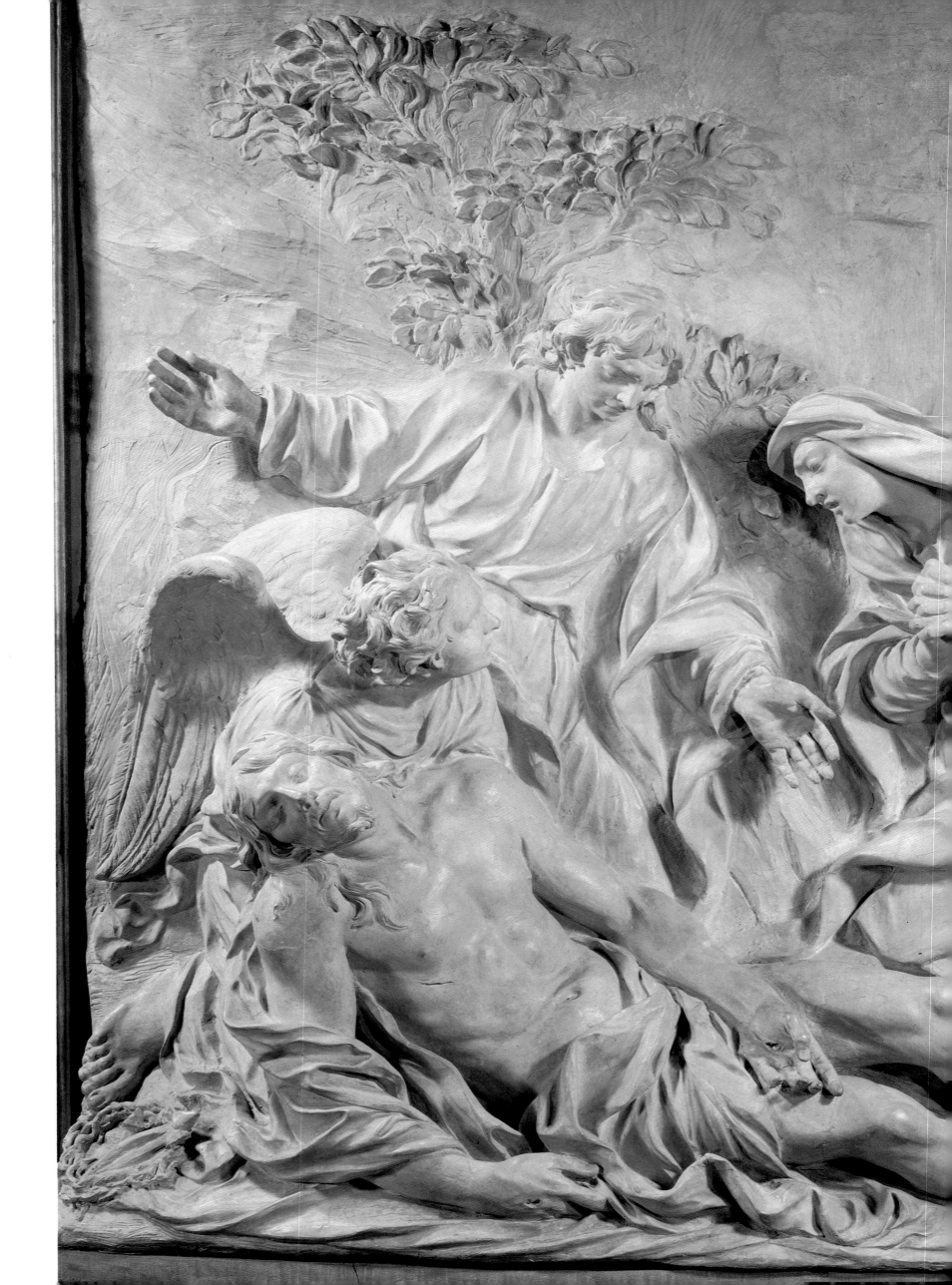

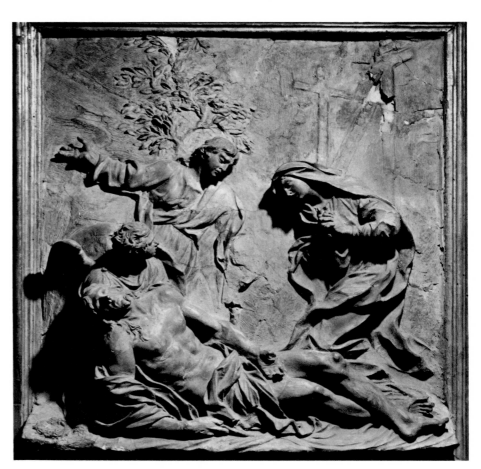

Fig. 1. Mazzuoli, preliminary model for the *Lamentation*, clay, Kunsthistorisches Museum, Vienna.

SIENESE, late 17th century

GIUSEPPE MAZZUOLI
(1644-1725)

One of five sculptor brothers, Giuseppe grew up in Siena and studied in Rome under Ercole Ferrata and Caffà. He later worked with Bernini, and it is his influence that is most visible in Mazzuoli's sculptures. His first work, the *Dead Christ* on the antependium of S. Maria della Scala in Siena (1670-71), was part of a commission undertaken by his elder brothers. He took up residence in Rome after executing the *Charity* on Bernini's tomb of Alexander VII in 1673, but the commission for statues of the *Twelve Apostles* for Siena Cathedral (now in the Brompton Oratory, London) in 1679 caused him to divide his time between Siena and Rome until the end of the century. Mazzuoli was a prolific artist, and particularly in demand for funeral monuments—the most distinguished being perhaps the Pallavicini-Rospigliosi tombs in S. Francesco a Ripa in Rome (1713-14).

21. *Lamentation*

Terra-cotta, ca. 1695.
H. 54 in. (137.2 cm.) W. 51½ in. (130.8 cm.) D. 10½ in. (26.7 cm.)
Condition: repairs throughout .
Provenance: Montegufoni Castle, Tuscany (removed by its 19th-century owners). Private Collection, England.
Exhibited: Heim Gallery (London), *Italian Paintings and Sculptures of the 17th and 18th Centuries*, Summer 1976, no. 31.*
Accession no. 77.5.51

*The information in this entry is based in part on that provided by the author
for the Heim Gallery catalogue.

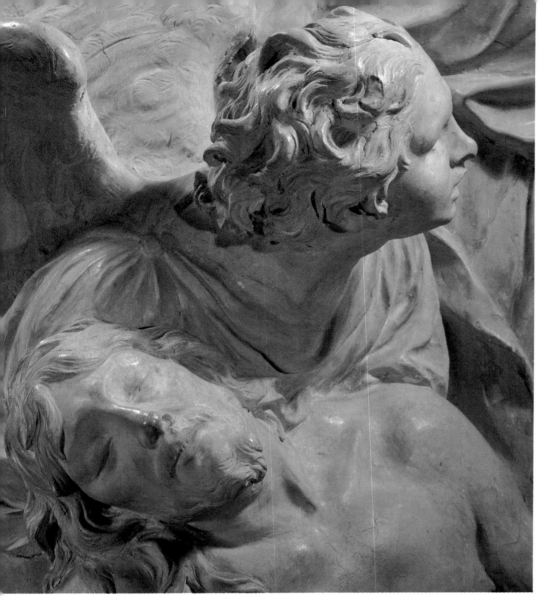

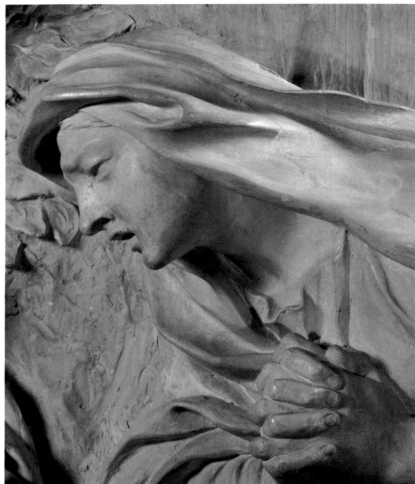

THIS RELIEF comes from the chapel of Montegufoni in Tuscany. According to Pompeo Litta, it was Donato Acciaioli (1622-1704) who "was an extremely pious and wise man. At Monte Gufoni he restored the chapel with great splendour and enriched it with sacred relics."[1] Litta is somewhat ambiguous on the subject, but it would appear to have been in 1691 that Donato inherited Montegufoni by a lot drawn among the male members of his family, in accordance with the will made by Roberto di Donato di Acciaioli in 1538. The relief must therefore have been produced between 1691 and 1704, the date of Donato's death. The only sculptor known to have worked at Montegufoni around this period is Lorenzo Merlini, but his autobiography makes it clear that his work was architectural and done for Donato's successor, Ottaviano.[2]

Montegufoni lies between Florence and Siena: therefore, it is appropriate that this relief exhibits the strongest connections with Mazzuoli's first recorded work, the *Dead Christ* on the antependium of the altar of S. Maria della Scala, Siena (1670-71). Significantly, however, it is even closer to the *bozzetto* for the *Dead Christ* in the Chigi-Saracini collection, Siena, than to the finished work. The legs of the dead Christ in both the *bozzetto* and the relief here are crossed, with the left arm coming to rest on His thighs; and in both there are indications of landscape in the background. On the other hand, this relief adopts the throwing back of Christ's head from the finished work in the altar of S. Maria della Scala.

Another group of works indebted to the antependium are: the *Dead Christ* in marble in the Palazzo Sansedoni in Siena; the two terra-cotta *bozzetti* for it in the Chigi-Saracini collection; and a terra-cotta exhibited at the Heim Gallery, London in 1966.[4] The musculature of Christ's body and the modelling of the drapery in the Montegufoni relief in the Sackler collection are more sensitively executed than in this other group of works. The *Dead Christ* in marble in the Palazzo Sansedoni is closely related to two other works in the same palazzo that were unfinished at Giuseppe Mazzuoli's death and assigned to his nephew, Bartolomeo, to complete.[5] The two terra-cotta *bozzetti* for it in the Chigi-Saracini collection are now regarded as sketches made by Bartolomeo in the process of arriving at the composition of the marble.[6] Further research is still needed to clarify the individual *oeuvres* of the members of the Mazzuoli family, but all indications are that the Montegufoni *Lamentation* seen here represents Giuseppe Mazzuoli returning to and elaborating on his own ideas for the *Dead Christ* of S. Maria della Scala, rather than a work of synthetic derivation by his nephew Bartolomeo.

A modelled clay panel measuring H. 73.5 cm., W. 68 cm., now in storage in the Kunsthistorisches Museum, Vienna (fig. 1), appears to be a preliminary model for the present composition. While the general arrangement of the figures is similar to that of the finished relief, in the model they are placed more diffusely within the field.

1. "Era uomo di molta pietà e saviezza. A Monte Gufoni ristauro magnificamente la capèlla, e la arricĥi di reliquie." *Celebre Famiglie Italiane,* I, 1819, *sub voce* Acciaioli di Firenze, Tav. VII.
2. K. Lankheit, *Florentinische Barockplastik,* Munich, 1962, doc. 50, p. 239.
3. F. Pansecchi, "Contributi a Giuseppe Mazzuoli," in *Commentari,* X, 1959, p. 35 and Tav. XVIII, fig. 1.
4. Heim Gallery (London), *Italian Paintings and Sculptures of the 17th and 18th Centuries,* Summer, 1966, no. 72.
5. Pansecchi, *op. cit.,* p. 41.
6. U. Schlegel, "Per Giuseppe e Bartolomeo Mazzuoli: Nuovi Contributi," *Arte Illustrata,* V, no. 47, 1972, pp. 6-8.

Pair of Kneeling Angels

22. Terra-cotta, gilded, ca. 1695.
H. 15⅝ in. (39.7 cm.) W. 7½ in. (19.1 cm.) D. 8¼ in. (20.9 cm.)
Condition: broken fingers on both hands; broken right wing tip; repairs to neck and above knees; chips in gilding.
Provenance: De Vecchi, Siena.
Exhibited: Heim Gallery, London, *Paintings and Sculpture of the Italian Baroque,* Summer, 1973, nos.30, 31 (not illus.).
Accession no. 77.5.52

23. H. 15⅞ in. (40.3 cm.) W. 9¼ in. (23.5 cm.) D. 7 in. (17.8 cm.)
Condition: repairs to wings, neck, waist and at level of thighs; chips in gilding.
Accession no. 77.5.53

THESE STATUETTES are sketch-models for the pair of large, marble angels flanking the high altar in San Donato, Siena (figs. 1 and 2). They must have been produced shortly before 1695, when the marble versions were recorded as in place.[1] Stylistically, the angels are related to the altar relief of the *Vision of the Blessed Ambrogio Sansedoni* (ca. 1694), in the chapel in Palazzo Sansedoni, Siena. They form part of a series of such angels carved by Mazzuoli throughout his career,[2] beginning with those carved for Sant' Agostino, Siena, in 1677-79,[3] followed by those in San Donato and, later still, those of about 1700 in the Roman churches of Santa Maria in Campitelli[4] and Santa Maria della Vittoria.

1. V. Suboff, "Giuseppe Mazzuoli," *Jahrbuch der Preuszischen Kunstsammlungen,* XLIX, 1928, pp. 33-47, recorded p. 47.
2. F. Pansecchi, "Contributi a Giuseppe Mazzuoli," *Commentari,* X, 1959, pp. 38-39, n. 26.
3. U. Schlegel, "Per Giuseppe e Bartolomeo Mazzuoli: Nuovi Contributi," *Arte Illustrata,* V, no. 47, 1972, fig. 8, p. 6f.
4. *Ibid.,* figs. 16-17.

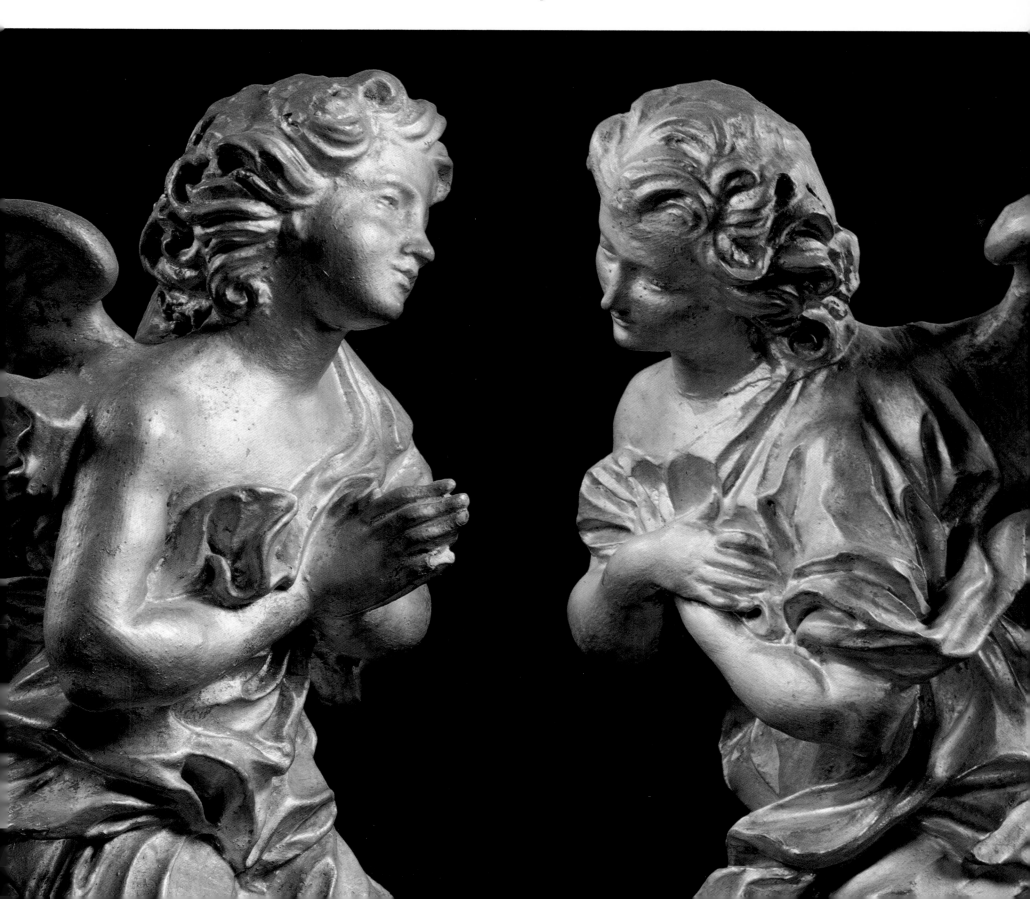

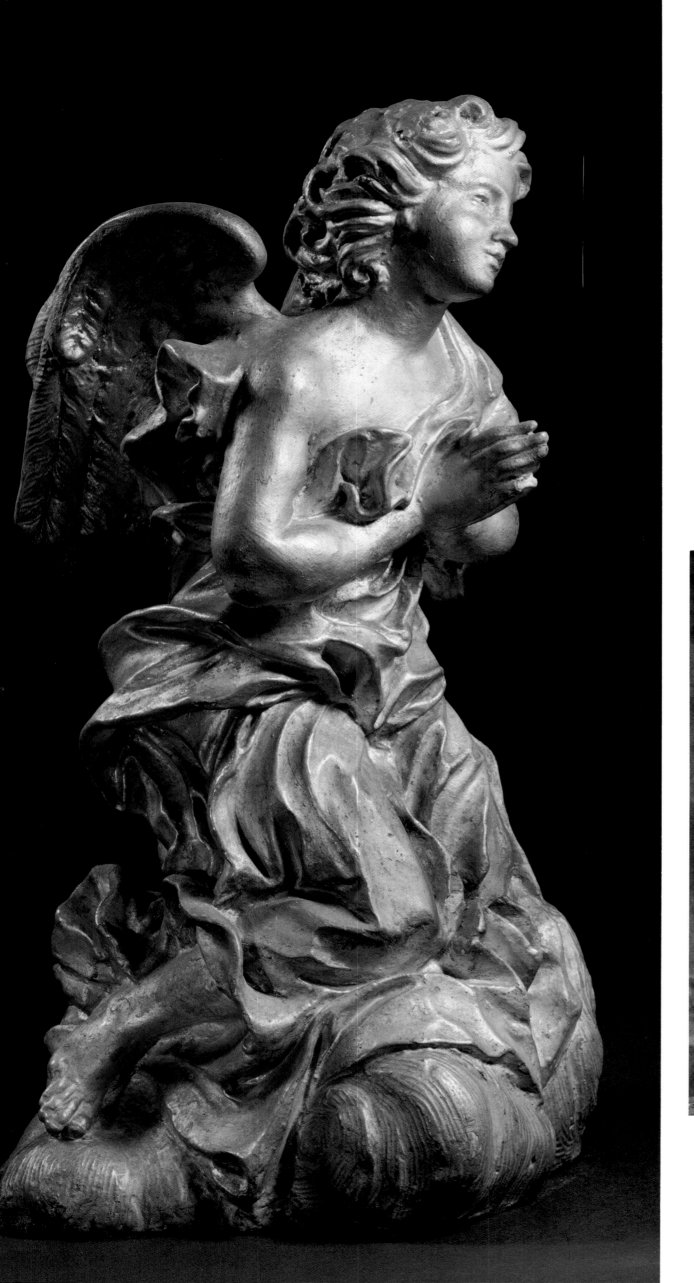

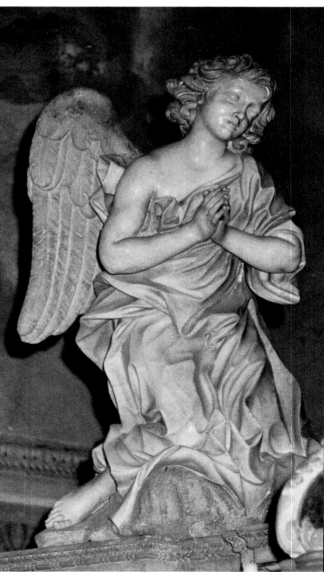

Figs. 1 and 2. Mazzuoli, *Angels*, marb

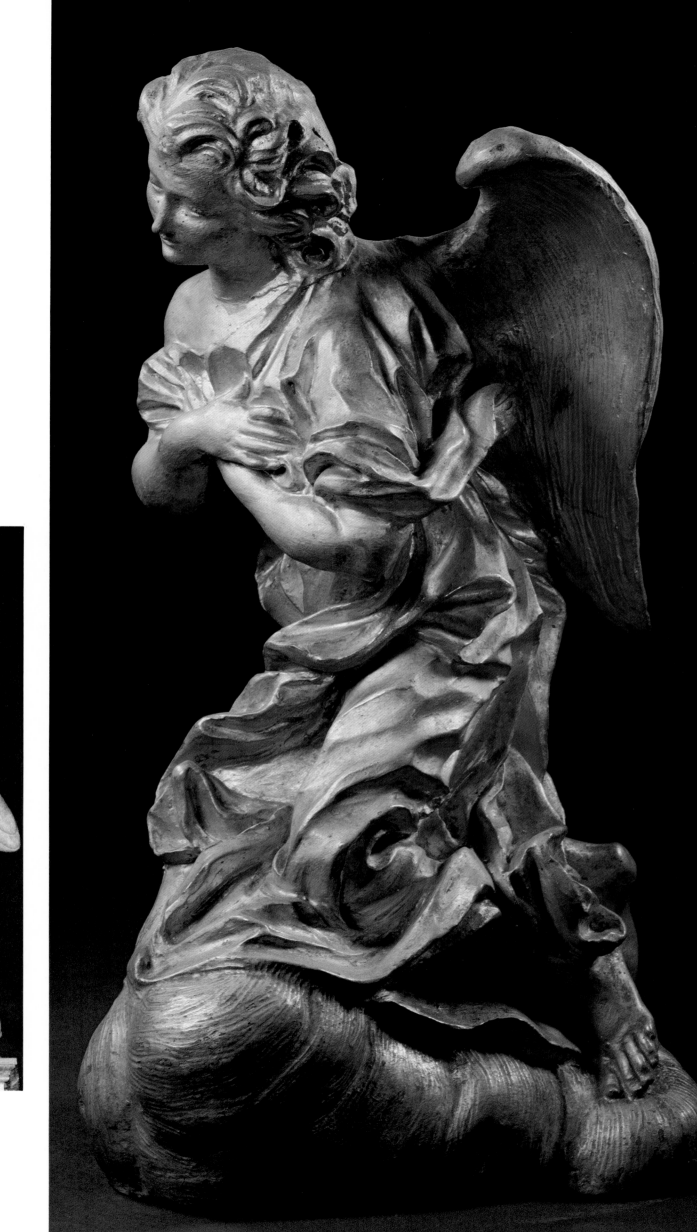

1695, altar of San Donato, Siena.

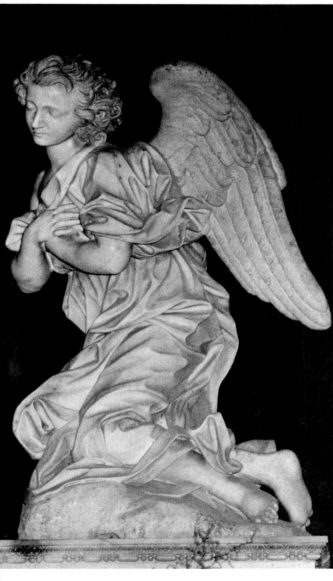

SIENESE or ROMAN, late 17th or early 18th century

Circle of GIUSEPPE MAZZUOLI
(1644-1725)

24. *The Virgin in Adoration, or Annunciate*

Terra-cotta.
H. 21⅛ in. (53.8 cm.) W. 9⅛ in. (23.3 cm.) D. 10⅛ in. (25.7 cm.)
Condition: the Virgin's extended left hand, originally modelled
separately and dowelled on, is missing.
Accession no. 79.1.26

THE STATUETTE, although its exact subject is not clear, is clearly a component of a larger ensemble. The heavily draped, fresh-faced young woman is the Virgin Mary, either adoring the Christ Child, towards whom she extends her (missing) hand; or responding meekly to the message of the annunciatory angel Gabriel.

The little pointed chin, plump cheeks and demurely lowered eyelids of the Virgin correspond with a facial type popular with Italian Baroque sculptors from Bernini onwards, and particularly favored in the circle of Giuseppe Mazzuoli. A direct comparison may be made with the face of the Virgin in an oval relief of *Joseph's Dream*, in Palazzo Sansedoni, Siena.[1] The slightly angular breaking of the folds in the drapery is also consistent with such an origin. The statuette may be not so much a sketch-model as a finished sculpture for a devotional group, especially if its subject is the Adoration, when it would conform with the normal pattern of Christmas crib groups.

1. U. Schlegel, 'Per Giuseppe e Bartolomeo Mazzuoli: Nuovi Contributi,' *Arte Illustrata*, V, no. 47, 1972, p. 6 f., fig. 18.

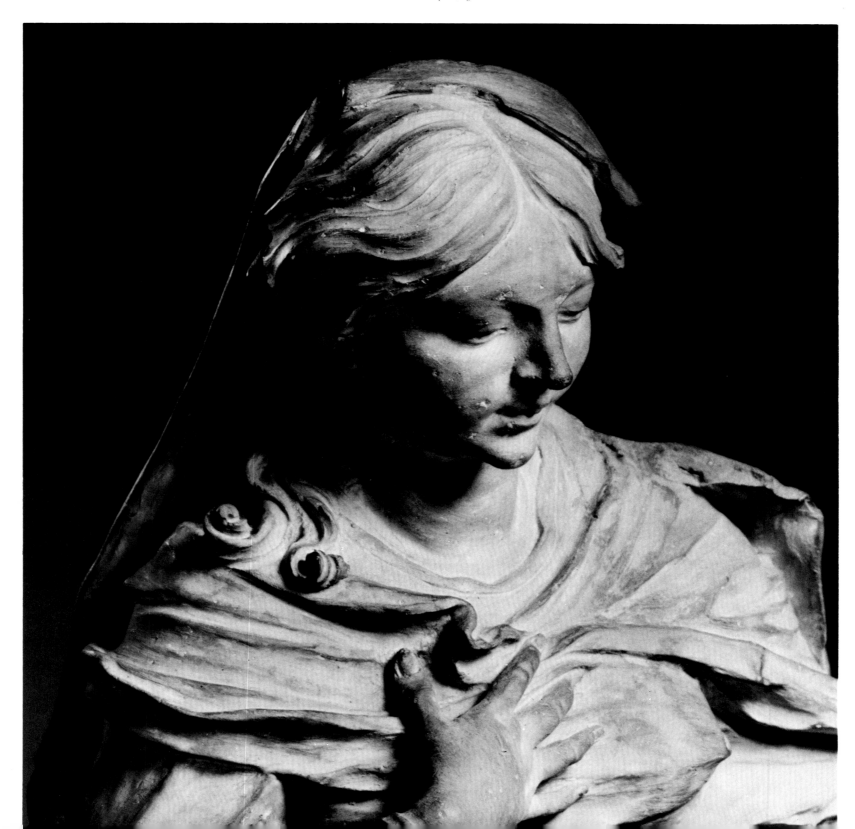

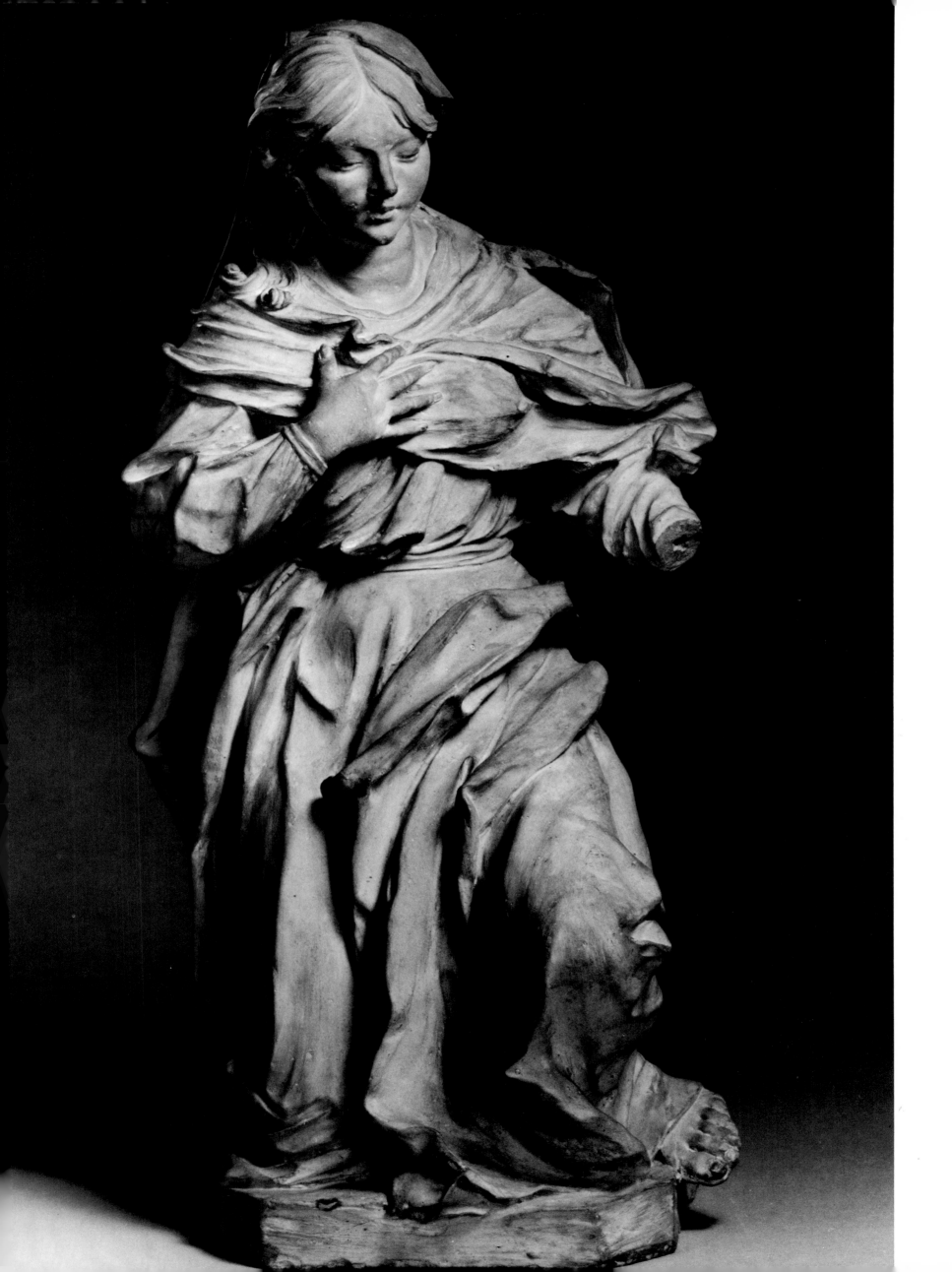

ROMAN, early 18th century

CAMILLO RUSCONI
(1658-1728)

Rusconi was the strongest personality among Roman sculptors of the first quarter of the 18th century. A pupil of Ercole Ferrata, his first works, such as the *Cardinal Virtues* (1685) in the Cappella Ludovisi of S. Ignazio, are almost Rococo, but he soon developed a personal synthesis of the Baroque of Bernini and the classicism of Algardi and Duquesnoy. At the same time, he was also being influenced by the many French sculptors then working in Rome and by Carlo Maratta. His importance can be measured by the fact that he was given four of the twelve statues of the *Apostles* in S. Giovanni Laterano (1708-18) to execute—the major sculptural commission of the century in Rome.

25. *Putto Personifying Summer*

Terra-cotta, 1700-1710.
H. 20 in. (50.8 cm.) W. 15½ in. (39.4 cm.) D. 15 in. (38.1 cm.)
Condition: old repairs throughout.
Exhibited: Heim Gallery (London), *Paintings and Sculptures of the Baroque,* Autumn 1970, no. 79.
Accession no. 77.5.81

26. *Putto Personifying Winter*

Terra-cotta, 1700-1710.
H. 21⅛ in. (53.7 cm.) W. 15 in. (38.1 cm.) D. 15 in. (38.1 cm.)
Condition: old repairs throughout.
Exhibited: Heim Gallery (London), *op. cit.,* no. 80.
Accession no. 77.5.82

Fig. 1. *Spring*

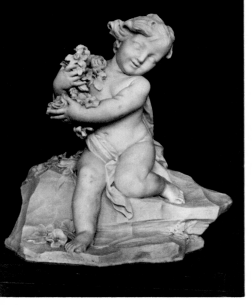

Fig. 2. *Summer*

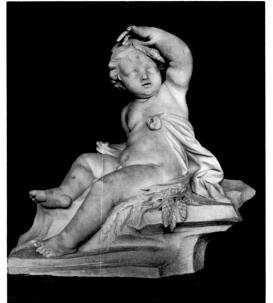

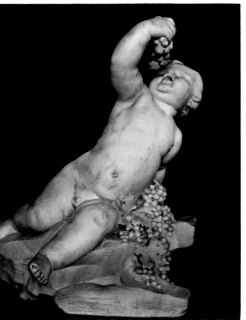

Fig. 3. *Autumn*

Fig. 4. *Winter*

Rusconi, *Putti Personifying the Four Seasons*, Royal Collection in Windsor Castle, by gracious permission of Her Majesty, the Queen.

THESE TERRA-COTTAS are models for two of a series of four marble statues representing the *Seasons*, now in the Royal Collection at Windsor Castle (nos. 173-6), where they have traditionally been attributed to Rusconi (figs. 1-4). This attribution can be substantiated on both historical and stylistic grounds. Pascoli mentions a commission from one of the sculptor's patrons and friends, Marchese Niccolò Maria Pallavicini, for "four putti, representing the four seasons,"and places it just before 1711.[1] He continues by recording that, together with other works by Rusconi executed while he was engaged on the tomb of Gregory XIII, the *putti,* after Pallavicini's death,"were sold for a high price and transported to England."[2]

Pascoli's account is corroborated by Filippo della Valle (1698-1768), a practicing sculptor, in a letter about the career of the recently deceased Rusconi, addressed to Monsignore Giovanni Bottari from Rome on January 10, 1732.[3] Della Valle places the episode after a heart attack which took place when Rusconi was about forty, but which he survived:

"He then made of clay as an exercise a beautiful child playing with some bunches of grapes. Carlo Maratta inspected it and praised it highly, as did all the painters and sculptors who saw it, indeed they positively besieged the artist with demands that he carve it in marble. This he did and it turned out so well that Marchese Niccolò Maria Pallavicini, a connoisseur of rarities and remarkable works of art, wanted it for himself and commissioned from Rusconi a further three representing the three other Seasons. After the death of the Marchese they were all taken to England, and are now in the royal cabinet, having cost four thousand ducats."[*]

Della Valle's account is detailed and trustworthy: evidently Rusconi worked up the *putto* with bunches of grapes in clay

* "*Allora fece di terra per suo studio un bel putto che scherzava con alcuni grappoli d'uva, che visto da Carlo Maratta ne fece grande stima, e lo stesso confermarono tutti, sì pittori e sì scultori che lo videro, talchè gli fecero un assedio intorno perchè lo scolpisse in marmo, come fece, e gli riuscì tanto bene che il marchese Niccolò Maria Pallavicini, amantissimo di queste rarità e delle produzioni più singolari di queste arti, il volle per sè e ne ordinò tre altri al Rusconi che rappresentassero le tre altre Stagioni. Questi poi furono dopo la morte del detto marchese trasportati in Inghilterra, e sono adesso nel regio gabinetto mediente il prezzo di scudi quattro mila.*"

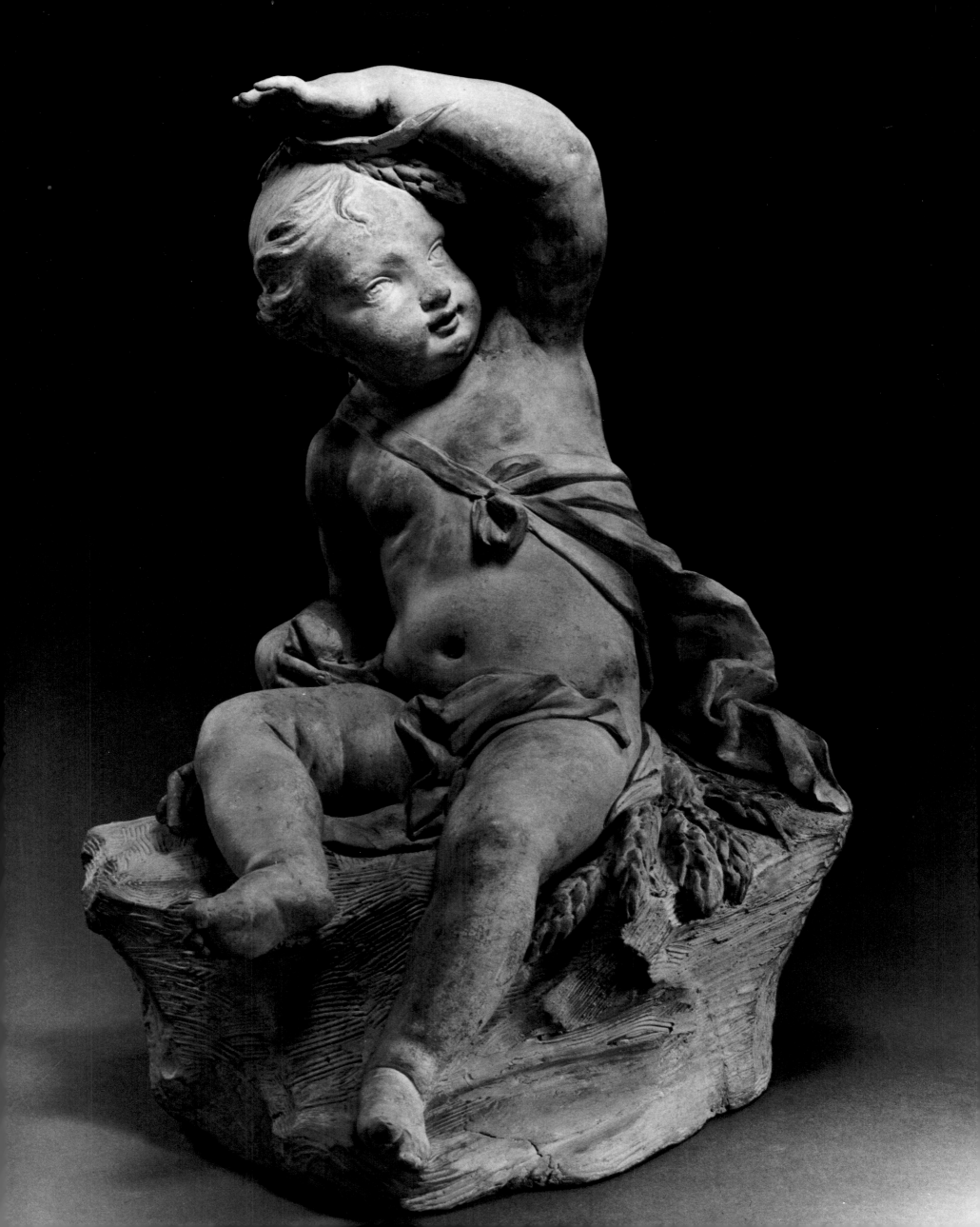

for his own satisfaction (later regarded as *Autumn*, fig. 3). The groups now at Windsor are first recorded in Kensington Palace prior to 1828; their earlier whereabouts are not documented, nor is the identity of their original purchaser (possibly King George II, or an intermediary).

In the light of Pascoli's and della Valle's accounts, which state categorically that the marbles had been transported to England—as well as the latter's additional remark that they were in the royal collection (by 1730/32)—speculation that they might have been sold to the "Old Pretender" (James III Stuart, who from 1719 until his death in 1766 was resident in Rome), and later inherited by King George III, after the death of the last Stuart, the Cardinal of York, in 1808 seems otiose.[4]

In his life of Rusconi, ca. 1735, F. S. Baldinucci embroiders the factual accounts of Pascoli and della Valle with a detailed literary description of the *Seasons*, which he must have seen in either the marbles before they left Rome, or perhaps the models, which are, except for minor variations in detail, substantially the same in composition : "Rusconi made a little model as an exercise showing a child with a bunch of grapes in one hand and sitting on a rock, where there were several other bunches. He modelled it both gracefully and appropriately and on the advice of Carlo Maratta and other experts, who had praised it highly, he carved it in marble at the size of four *palmi* (handspans). So charming was it that the Marchese Pallavicini insisted on having it at any price: as it could be taken to symbolize Autumn, he commissioned Camillo to carve three other similar groups to represent the other seasons. So Rusconi carved another child also sitting upon a rock, frozen stiff with the cold and caught in the act of wrapping itself up in a cloth with a marvellous expressiveness; the cloth covered half the head, fell about the

shoulders and covered most of the body. To define the season yet more clearly, a water bird symbolic of Winter was set by its side. After this he made Summer in the guise of a girl, who is holding daintily in her left hand some ears of corn with which she is pretending to crown herself. A pretty piece of drapery and some other ears of corn on the ground provide a setting. Spring was likewise depicted by Rusconi as another sweet and playful baby girl holding some flowers in her hands, while others which she seems to have missed are strewn on the ground. Her loins are girded with a little bit of drapery which is attached to her belt by a brooch and which serves both to cover her decently and to adorn her."[5]

That the terra-cottas are models for the marbles and not copies after them is evident from noticeable variations in detail, especially in the conformation of the rocks on which the *putti* are seated. Particularly striking are the differences in the position of the bird in *Winter*, and the removal in the marble version of much of the drapery from the groin of the little girl representing *Summer*. Another terra-cotta study for *Winter*, in the collections of the Hermitage, Leningrad (catalogued as a Duquesnoy), exhibits substantial differences from the present composition as well as from the final marble version. A terra-cotta in the Palazzo Venezia in Rome may be a later copy. This would not be surprising, for these groups were very popular during the 18th century in Italy and were even copied in porcelain.[6]

The attribution to Rusconi, who was well known to his contemporaries for his *putti* in many Roman churches, commissioned as separate items and not as incidental elements of larger groups, is completely convincing[7] For instance, the *putti* that hold the coat of arms on the Fabbretti monument in S. Maria Sopra Minerva (1700) are close replicas of those at Windsor, both in type and in the handling of the marble.

1. E. Pascoli, *Vite de Pittori, Scultori ed Architetti Moderni*, vol. I, Roma, 1730, p. 261.
2. *Ibid.*, p. 263.
3. G. Bottari and S. Ticozzi, *Raccolta di lettere sulla pittura, scultura ed architettura . . .*, Milan, 1822, II, no. XCVI, pp. 310-323 (esp. pp. 314-315).
4. Thieme-Becker, *Allgemeines Lexikon der Bildenden Künstler*, Leipzig, 1935, s.v. Rusconi; A. Ciechanowiecki, in the Heim Gallery catalogue cited above; and R. Enggass, *Early Eighteenth Century Sculpture in Rome*, University Park and London, 1976, vol. I, pp. 92-93.
5. "*Avendo poi fatto un modelletto per suo studio rappresentante un Putto con un grappolo d'uva in mano e sedente sopra un masso, dove posati erano più grappoli della medesima, il tutto fatto con molta grazia e proprietà, consigliato da Carlo Maratta e da altri virtuosi che con somma summa lo veddero, lo [il Rusconi]scolpi in proporzione di quattro palmi in marmo, e così graziosamente che veduto dal detto Marchese Pallavicino, lo volle ad ogni prezzo; e perche questo poteva figurare l'autunno, ordino al medesimo Cammillo il trarne fuori da marmi altre tre gruppisimili, che le tre altre stagioni rappresentassero. Indiscolpi un altro putto sedente anch'esso sopra un masso, tutto abbrividato dal freddo in atto di rinvoltarsi con espressione meravigliosa in un panno, che (coprendogli mezza la testa) calandogli sopra le spalle quasi tutto il corpo gli ricopre e per maggior espressione della stagione vi e posto allato un uccello aquatile simbolo dell'inverno. Dopo a questo fece l'estate figurata per una femmina, la quale graziosamente tenendo nella sinistra mano alcune spighe di grano finge cingersi con essa la testa mentre molte altre per terra insieme con un bel pannicino servono per campo della medesima. La Primavera venne da esso rappresentata parimente in un'altra vaga, e scherzosa donzelletta che tenendo fra ambe le mani alcuni fiori pare ne trascuri altri che sparsi per la terra si vedono, da fianchi suoi pendere un pannicello che legato con un nastro alla cintola bastantemente l'adorna e la ricopa.*" F. S. Baldinucci, "Camillo Rusconi, Scultor Milanese," in *Archivi d'Italia*, edited by S. Ludovici, series 2, no. 17, 1950, pp. 209-222.
6. For identical porcelain reductions after the marbles, see G. Morazzoni , *Le Porcellane Italiane*, Milan, 1960, pl. 342,there unconvincingly given to Spain.
7. Pascoli, *op. cit.*

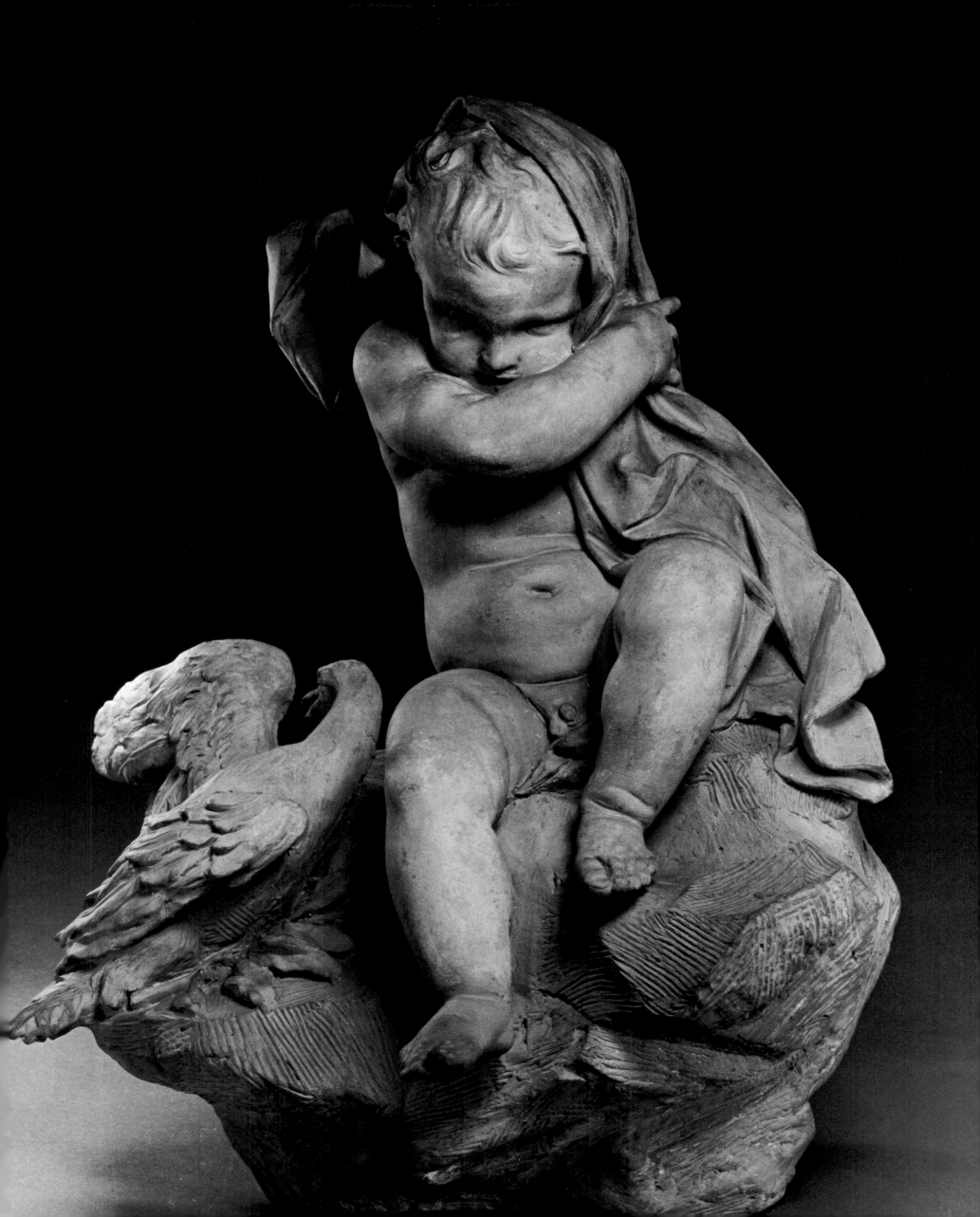

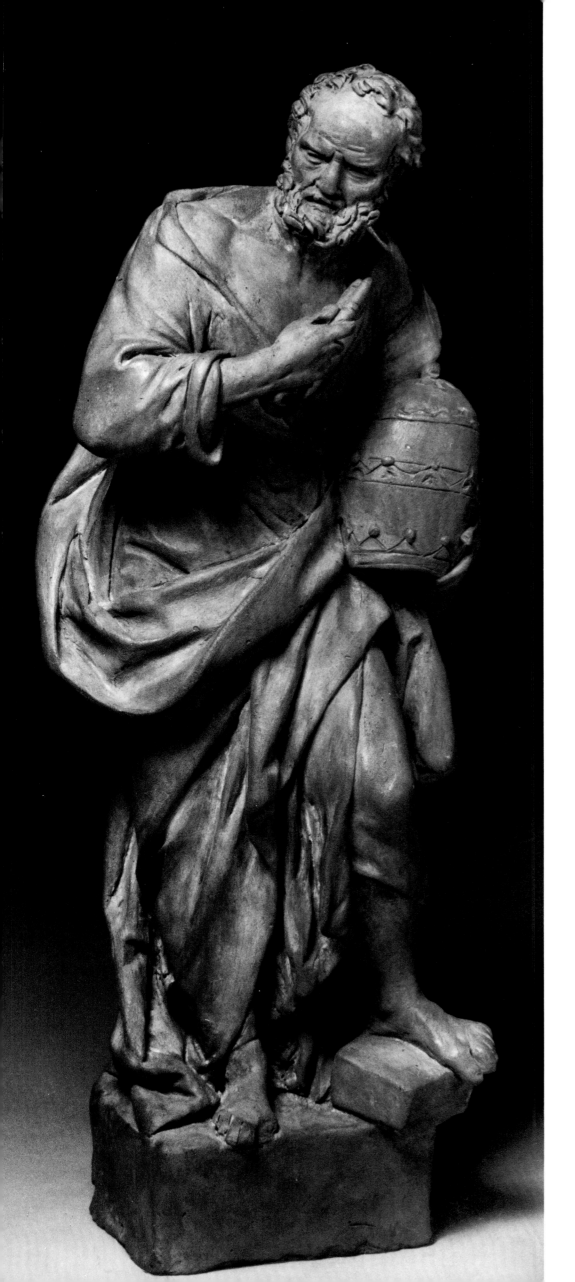

ROMAN, early 18th century

ANONYMOUS

27. *St. Peter*

Terra-cotta, with traces of gilding.

H. 13¾ in. (34.6 cm.) W. 5¼ in. (13.3 cm.) D. 4¼ in. (10.8 cm.)

Condition: repaired break in right ankle with still apparent crack; forefinger broken on left hand; possible old repair to nose.

Exhibited: Heim Gallery (London), *The Baroque in Italy,* Summer, 1978, nos. 33.

Accession no. 77.5.86

28. *St. Andrew*

Terra-cotta, with traces of gilding.

H. 13½ in. (34.3 cm.) W. 5 in. (12.7 cm.) D. 4¾ in. (12.1 cm.)

Condition: toe on right foot broken off, crack in right ankle.

Exhibited: Heim Gallery (London), *op.cit.*, no. 34.

Accession no. 77.5.83

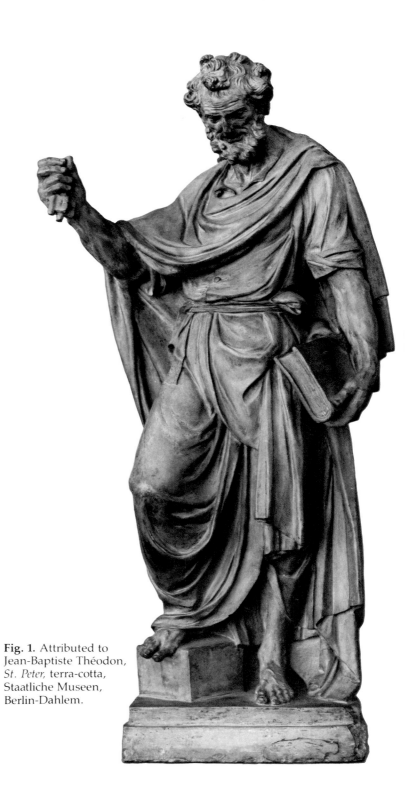

Fig. 1. Attributed to Jean-Baptiste Théodon, *St. Peter,* terra-cotta, Staatliche Museen, Berlin-Dahlem.

THIS PAIR of sketch-models has no established provenance. When they were first published and exhibited in London in 1978,[1] an attempt was made to differentiate between the handling of the statuettes and to allocate them to different sculptors. Subsequent study suggests that this theory is untenable, for the style and handling are so close as to be indistinguishable.

It was, however, suggested in 1978 that they may have been sketch-models for two of the celebrated series of 18th century marble statues of Apostles for the Basilica of St. John Lateran, the *St. Andrew* by Camillo Rusconi, and *St. Peter* assigned at first to Jean-Baptiste Théodon. The series, "the major sculpture commission in eighteenth century Rome," was put in hand about 1701, with original designs provided by the painter Carlo Maratta for Cardinal Benedetto Pamphili.[2]

The present statuette of *St. Andrew* however, carrying fish in his right hand and a fish hook (?) in his left, bears no specific relationship with the Lateran statue by Rusconi and cannot be by him. *St. Peter* the apostle who became the first Pope and is seen here holding the symbols of Papal office, a large key in his right hand and a Papal tiara in his left, was originally attributed to Théodon, a French sculptor, also initially assigned to make a model for the *St. Peter* from Maratta's design for the Lateran commission.[3] There is no secure evidence for Théodon's style as a modeller of clay. Indeed, a rival candidate for his sketch-model of *St. Peter* recently emerged in West Berlin (fig. 1), paired with one for a *St. Paul.*[4] It too is attributed only on hypothetical stylistic criteria, but is nevertheless more convincing as a candidate. Anyway, the final marble of *St. Peter* for the Lateran commission was executed by Théodon's fellow countryman, Pierre-Etienne Monnot (1657-1733),[5] possibly to his own rather than Maratta's (or Théodon's) design and bears no resemblance to the *St. Peter* here.

There are no grounds remaining for differentiation between the hands that produced the present pair of models, and none of the sculptors who participated in the Lateran commission seems a very likely candidate. Indeed, the closed silhouettes of both figures, with their attributes held tightly to the body, are unlike the dramatically open compositions in the Lateran which tend deliberately to defy their containing niches with centrifugal movements.

1. Heim Gallery, *op. cit.* (see *Exhibited* above).
2. F. den Broeder, "The Lateran Apostles," *Apollo*, May, 1967, p. 362, and R. Enggass, *Early Eighteenth Century Sculpture in Rome*, University Park and London, 1976.
3. The result, however, was criticized by the sculptural community, which wanted to escape the restriction of working from a painter's two-dimensional project. In 1703 Théodon was ordered to make small, and full-scale, models for consideration, but by 1705 he had abandoned the commission and left for France, to escape from Maratta's aesthetic monopoly.
4. U. Schlegel, *Die italienischen Bildwerke des 17. und 18. Jahrhunderts*, Staatliche Museen Preussischer Kulturbesitz, Berlin, 1978, nos. 23-24.
5. For a discussion of Monnot, see nos. 29 and 30.

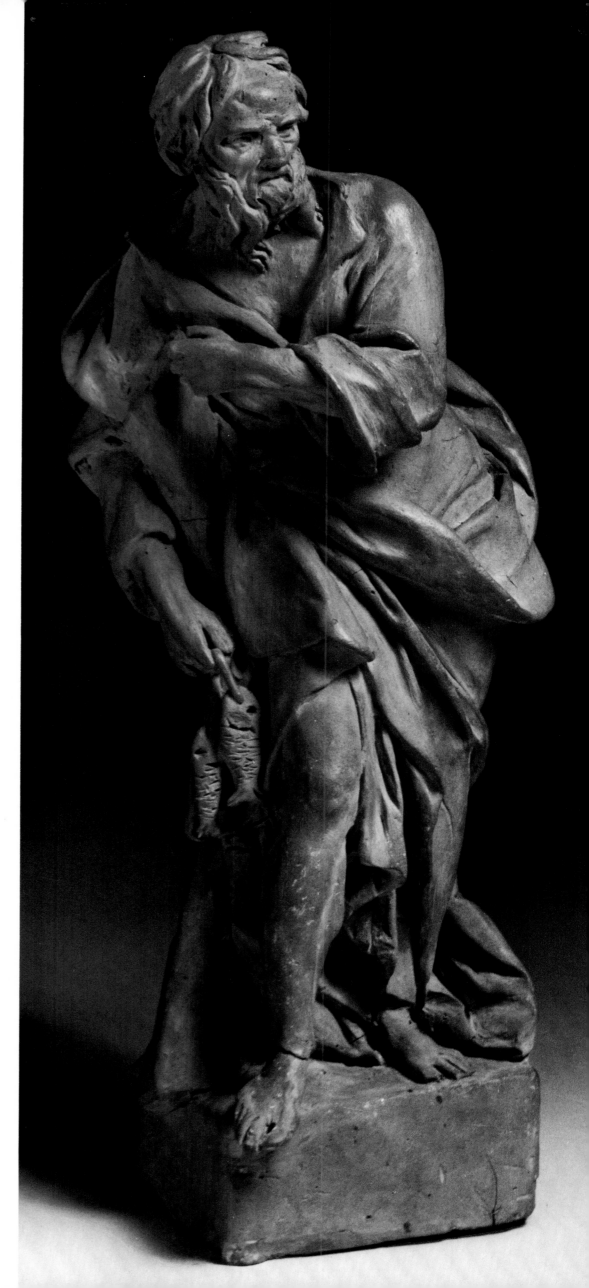

ROMAN, early 18th century

Attributed to
PIERRE-ETIENNE MONNOT
(1657-1733)
formerly attributed to Ercole Ferrata
(1610-1686)

Monnot was a French sculptor who
worked mainly in Rome, and is there-
fore normally classified under that
school. He decorated the Marmorbad
in Kassel, supplying reliefs and figures
until about 1728. He supplied marble
sculptures in Burghley House for the
Earl of Exeter, as well as a monumental
tomb in St. Martin's, Stamford, England.[1]
In Rome, his masterpieces were the
statues of *Saints Peter* and *Paul* for the
Basilica of St. John Lateran.

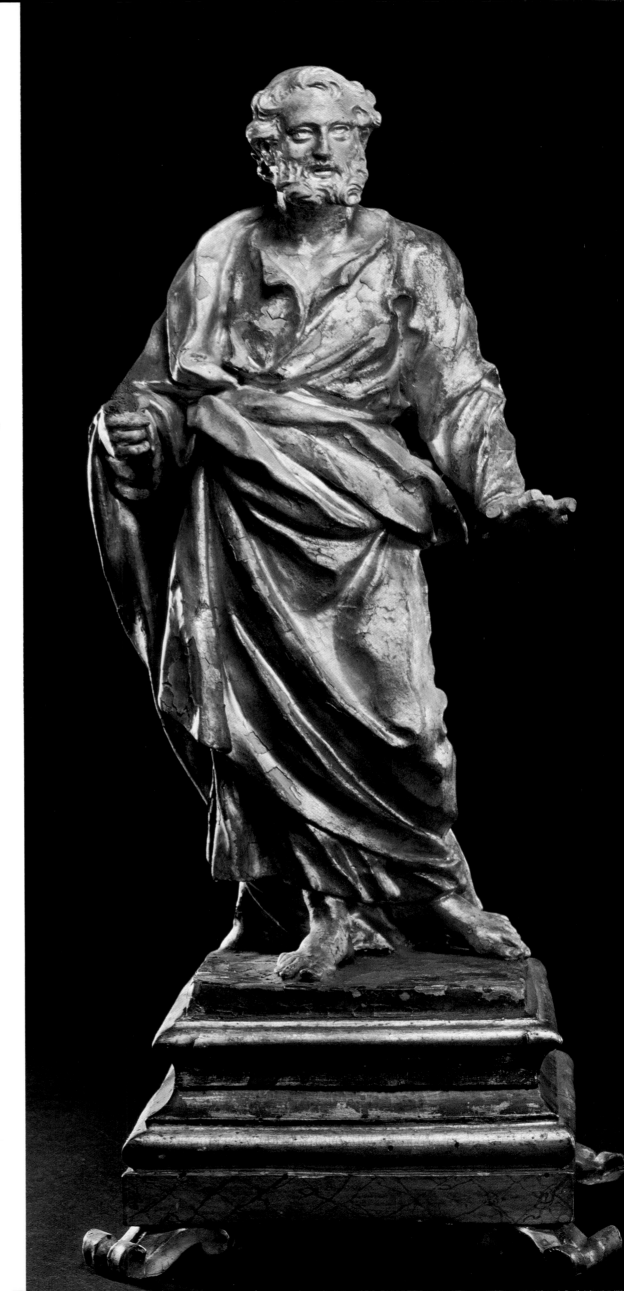

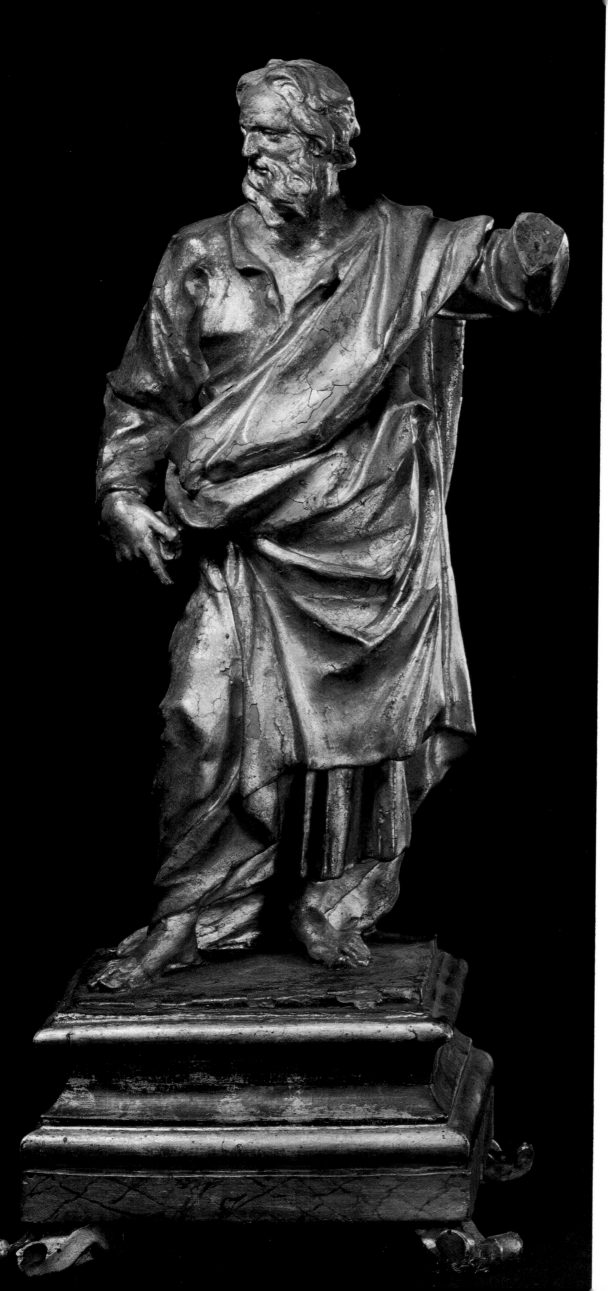

29. *St. Peter*

Terra-cotta, gilded, ca. 1708.
H. 19¼ in. (48.9 cm.) W. 8¼ in. (20.9 cm.) D. 8¼ in. (20.9 cm.)
Condition: old repairs throughout; fingers missing on
both hands; paint and gilding chipped throughout.

Exhibited: Heim Gallery (London), *Paintings and
Sculptures of the Baroque,* Autumn, 1970, no. 66.
Accession no. 77.5.57

30. *St. Paul*

Terra-cotta, gilded, ca. 1708.
H. 19¼ in. (48.9 cm.) W. 8¼ in. (20.9 cm.) D. 8¼ in. (20.9 cm.)
Condition: left forearm and hand missing; old repairs at ankles,
right wrist, neck, and nose; gilding flaking throughout.

Exhibited: Heim Gallery (London), *ibid.*, no. 67.
Accession no. 77.5.58

89

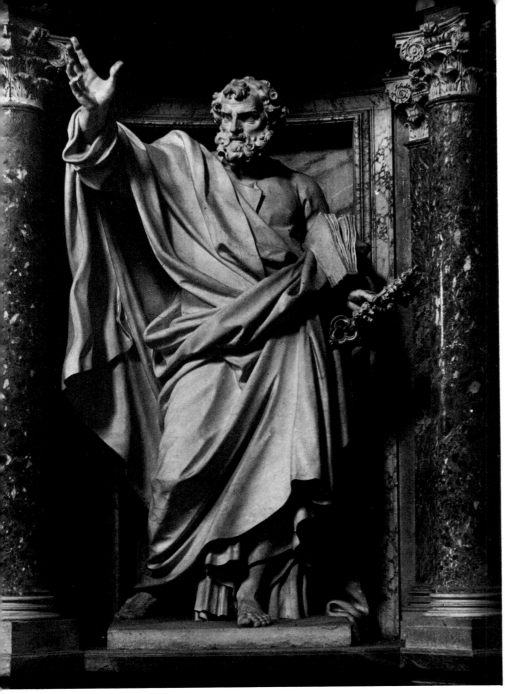

Fig. 1. Monnot, *St. Peter,* marble, St. John Lateran, Rome.

Fig. 2. Monnot, *St. Paul,* marble, St. John Lateran, Rome.

THIS PAIR OF STATUETTES has been convincingly attributed to Pierre-Etienne Monnot by Dr. Michael Conforti, who sees them as early studies for the *Saints Peter* and *Paul* that Monnot was invited to execute for the niches of St. John Lateran in Rome.[2] The statue of *St. Paul* is signed and dated 1708 and *St. Peter* was completed by 1713 (figs. 1, 2), both being paid for by Pope Clement XI Albani (1700-1721).[3] The finished marble statues both have the right arm raised high with the hand open, as though the saints were preaching dramatically, and the left lowered to hold the traditional attribute: twin keys for *St. Peter*, the sword for *St. Paul*. *St. Peter* has the shorter, curlier hair and beard and *St. Paul* the longer, more straggly one—again traditional typology. Otherwise, the disposition of each figure's weight and their drapery are more or less in mirror-image.

Neither of the present sketch-models, however, has its right arm raised, though one holds up its left. By analogy with the finished sculpture, the one which holds up its left arm also has longer hair and beard and consequently should represent St. Paul. It is preferable therefore to regard the statuette with its left hand raised as St. Paul and the other, with left hand lowered, as St. Peter, who might originally have held keys in his clenched right hand. The general pattern of folds on both terra-cotta models when so identified corresponds well with their supposed marble counterparts, though the drapery on *St. Peter* is in mirror-image to the marble. The handling of drapery in broad swathes, creating strongly diagonal linear patterns, seems to correspond well with Monnot's style. The relatively unmodelled backs of the statuettes confirm that the compositions were destined for display in niches as were the Lateran statues. The gilding and mounting on ornate wooden bases indicates that they were preserved for display after their purpose had been served.

An interesting connection with some rare Meissen porcelain statuettes of *Saints Peter* and *Paul* has recently been noted.[4] They were manufactured by J. J. Kaendler in

90

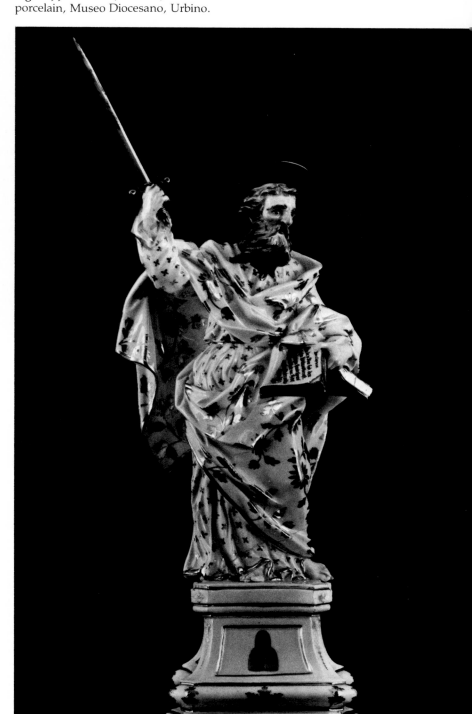

Fig. 3. J.J. Kaendler, *St. Peter*, porcelain, Museo Diocesano, Urbino.

Fig. 4. J.J. Kaendler, *St. Paul*, porcelain, Museo Diocesano, Urbino.

1735, probably on the basis of drawings, as part of an altar garniture presented by Augustus III of Saxony to Cardinal Annibale Albani and now preserved in the Museo Diocesano in Urbino (figs. 3, 4). Cardinal Annibale, the recipient, was a nephew of Pope Clement XI who had instigated the Lateran sculptural program. The Meissen statuettes, though they vary quite considerably from the marble statues, are nevertheless closer to them than the present sketches. Both, for instance, hold up their right hand. Indeed, the *St. Paul* is made to brandish his sword in it, suggesting a possible way the attribute might have been accommodated in the present sketch, where the raised hand is missing.

1. H. Honour, "English Patrons and Italian Sculptors," *The Connoisseur*, June ,1958, p. 220.
2. Information supplied by Heim Gallery, London.
3. For discussion of this major commission, see cata.ogue nos. 27, 28, and F. den Broeder, "The Lateran Apostles," in *Apollo,* May, 1967, pp. 360-365; also R. Enggass, *Early Eighteenth Century Sculpture in Rome,* University Park and London, 1976, vol. I, pp. 85-87; vol. II, figs. 30-32, 35-39.
4. T. H. Clarke, " 'Die Römische Bestellung'—the Meissen altar garniture presented by Augustus III to Cardinal Annibale Albani in 1736," *Keramos,* October, 1979, pp. 3-52. My thanks to the author for kindly drawing my attention to this interesting parallel.

ROMAN, early 18th century

ANONYMOUS

31. *Pope Clement XI Albani*
(1649-1721; elected Pope in 1700)

Terra-cotta oval relief, with recessed edge for mounting in a frame, ca. 1700.
H. 23¾ in. (60.3 cm.) W. 19¾ in. (50.1 cm.) D. 2½ in. (6.4 cm.)
Condition: minor chips and repairs around edge; surface colouring slightly worn; firing crack around left contour of figure.
Provenance: Chigi Collection, Chigi Palace.
Accession no. 77.5.12

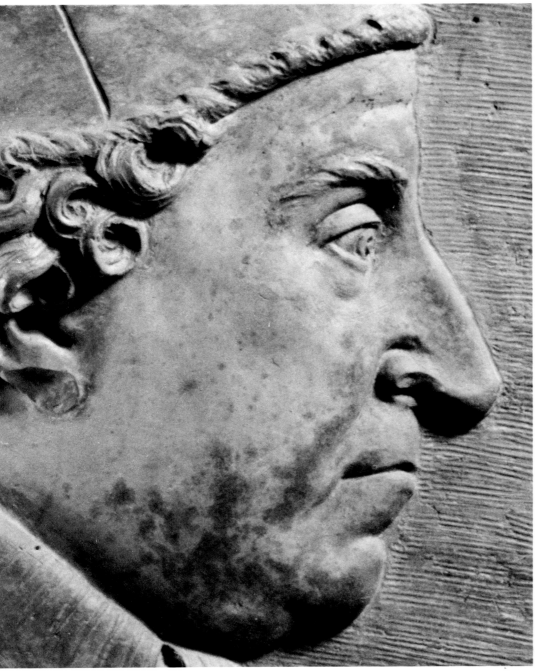

Fig. 1. Detail of head, actual size.

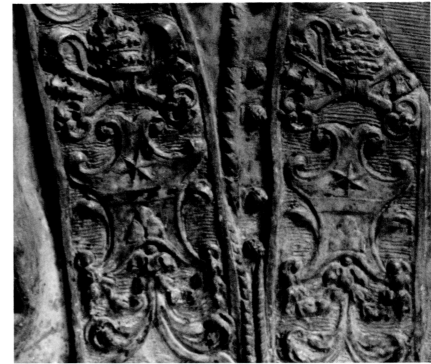

Fig. 2. Detail of Albani coat of arms on border of cope.

THE POPE, Gian Francesco Albani, is shown life-size in profile to the right, wearing the fur-trimmed *berréttíno* and a cope with embroidered borders bearing the Albani arms (fig. 2). The contours are very emphatic and the detailing is incisive, which suggests that the author may have been a medallist as well as a sculptor by profession.

The present relief is noted, without attribution, by Dr. Ursula Schlegel in connection with a sketch-model in Berlin for an honorific statue of Clement by Angelo de Rossi.[1]

A number of sculptors portrayed this art- and culture-loving pope: Cornacchini, Baratta, Mazzuoli and Pierre II Le Gros (1666-1719). Of these, the last is a possible candidate for the authorship of the present relief.[2]

1. U. Schlegel, *Die italienischen Bildwerke des 17. und 18. Jahrhunderts*, Staatliche Museen Preussische Kulturbesitz, Berlin, 1978, p. 98.
2. For Baratta's bust see H. Honour, "Count Giovanni Baratta and His Brothers," *The Connoisseur*, 1958, p. 175, fig. 9; for Cornacchini, see W. Hager, *Die Ehrenstatuen der Päpste*, Leipzig, 1929, no. 66, p. 70 and fig. 36.

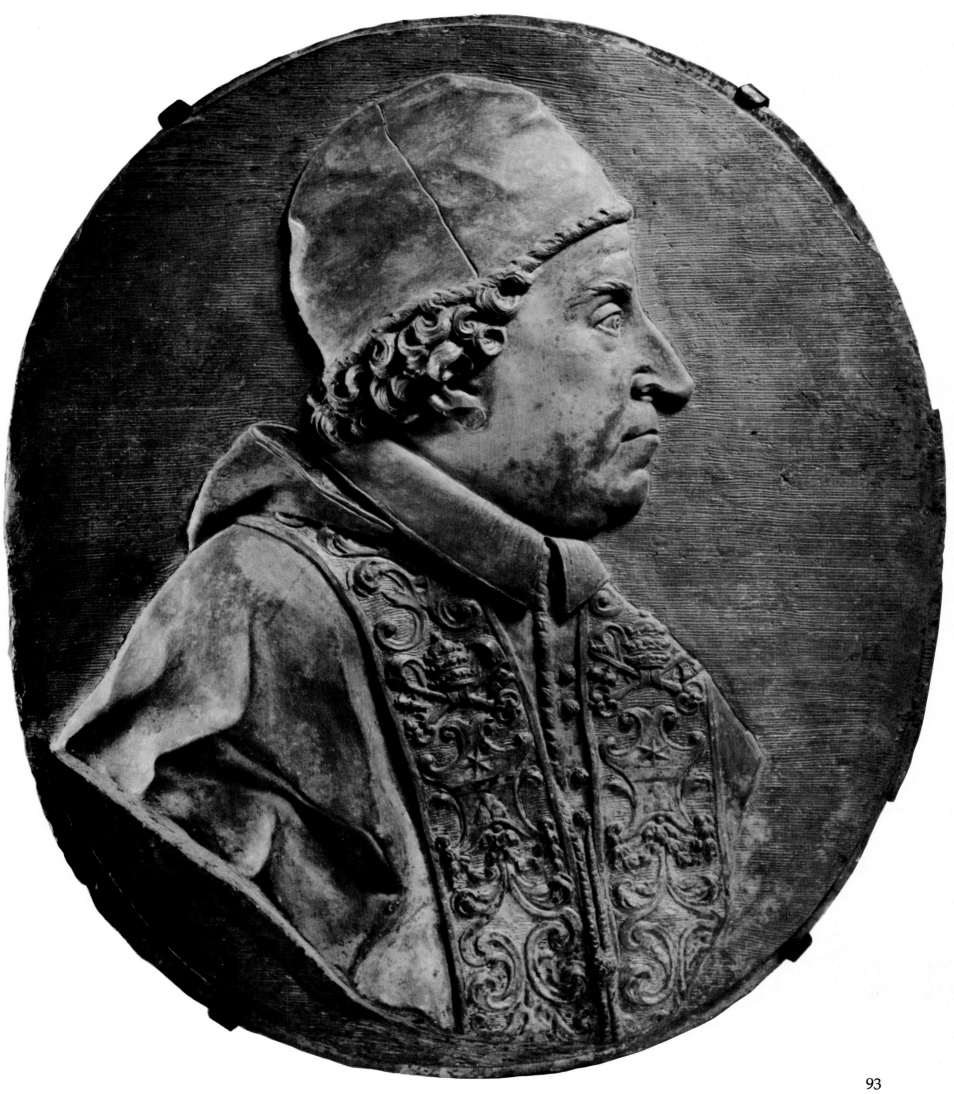

93

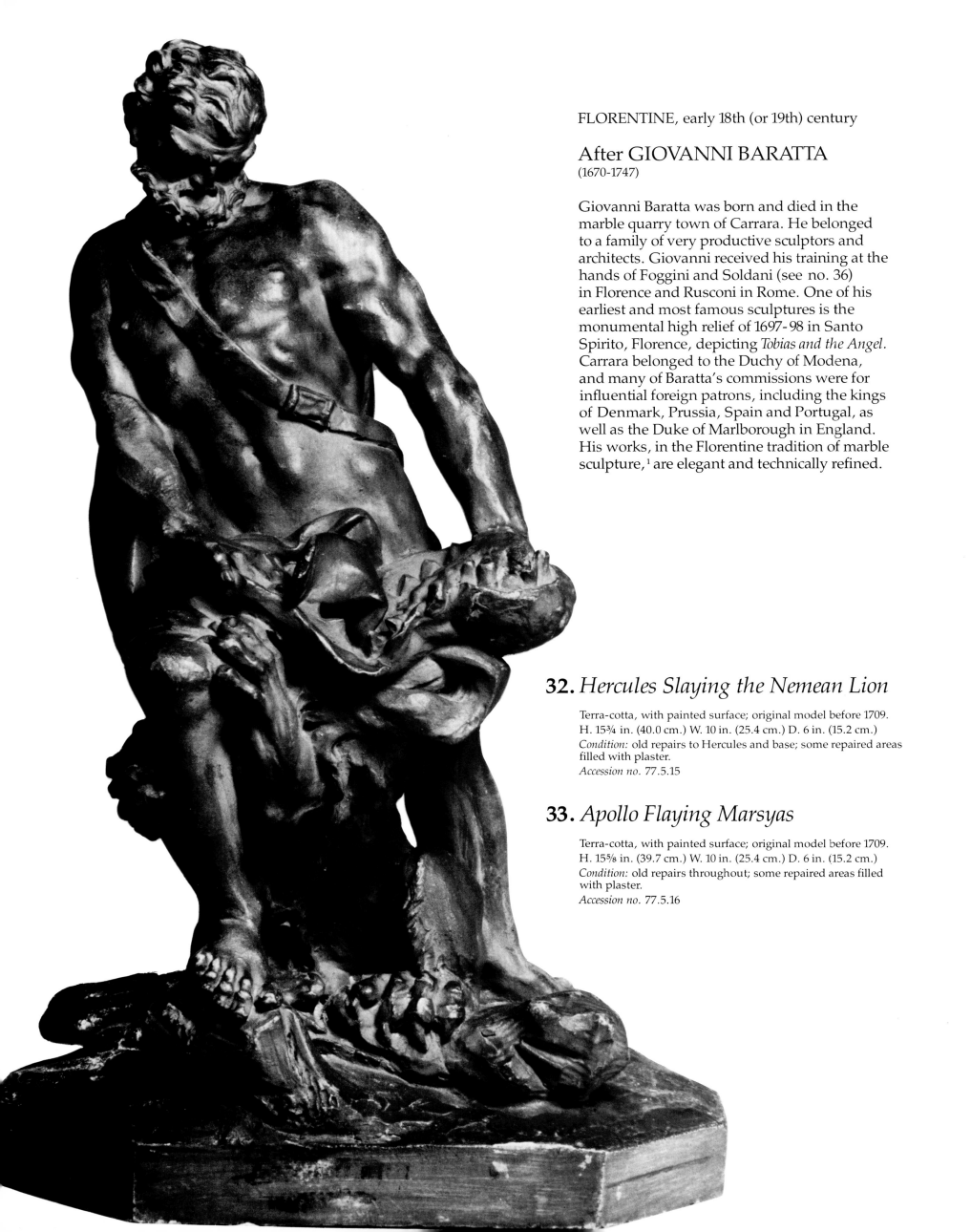

FLORENTINE, early 18th (or 19th) century

After GIOVANNI BARATTA
(1670-1747)

Giovanni Baratta was born and died in the marble quarry town of Carrara. He belonged to a family of very productive sculptors and architects. Giovanni received his training at the hands of Foggini and Soldani (see no. 36) in Florence and Rusconi in Rome. One of his earliest and most famous sculptures is the monumental high relief of 1697-98 in Santo Spirito, Florence, depicting *Tobias and the Angel*. Carrara belonged to the Duchy of Modena, and many of Baratta's commissions were for influential foreign patrons, including the kings of Denmark, Prussia, Spain and Portugal, as well as the Duke of Marlborough in England. His works, in the Florentine tradition of marble sculpture,[1] are elegant and technically refined.

32. *Hercules Slaying the Nemean Lion*

Terra-cotta, with painted surface; original model before 1709.
H. 15¾ in. (40.0 cm.) W. 10 in. (25.4 cm.) D. 6 in. (15.2 cm.)
Condition: old repairs to Hercules and base; some repaired areas filled with plaster.
Accession no. 77.5.15

33. *Apollo Flaying Marsyas*

Terra-cotta, with painted surface; original model before 1709.
H. 15⅝ in. (39.7 cm.) W. 10 in. (25.4 cm.) D. 6 in. (15.2 cm.)
Condition: old repairs throughout; some repaired areas filled with plaster.
Accession no. 77.5.16

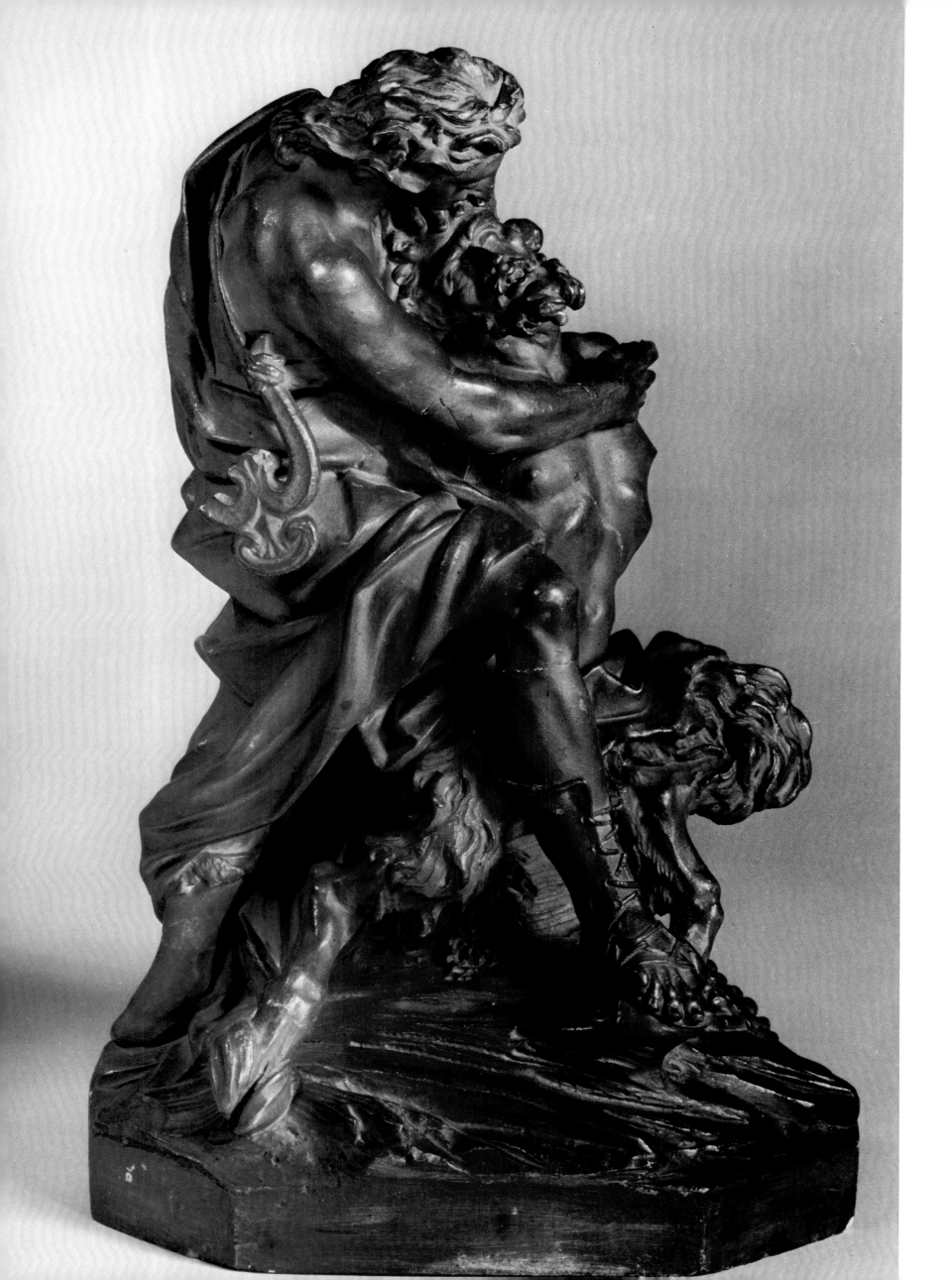

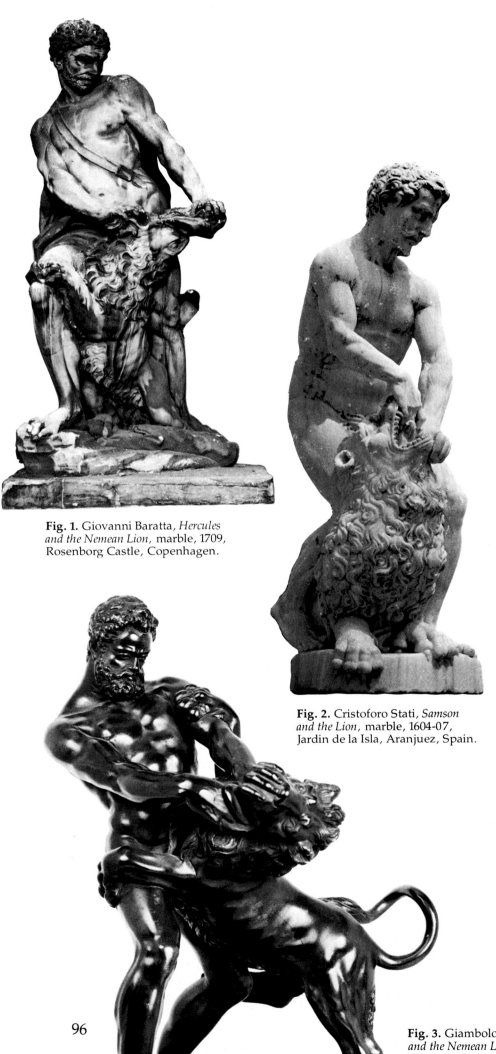

Fig. 1. Giovanni Baratta, *Hercules and the Nemean Lion,* marble, 1709, Rosenborg Castle, Copenhagen.

Fig. 2. Cristoforo Stati, *Samson and the Lion,* marble, 1604-07, Jardin de la Isla, Aranjuez, Spain.

Fig. 3. Giambologna, *Hercules and the Nemean Lion,* bronze, National Gallery of Ireland, Dublin.

96

THE TWO GROUPS, although uniform in size, shape of base, general composition, and surface treatment, do not form a proper pair in their iconography: one shows the first of the Labors of Hercules, and the other the punishment by flaying alive of the satyr Marsyas, who had imprudently challenged Apollo to a musical contest—his pan-pipes versus the god's lyre. Both were favorite subjects with painters and sculptors in an age devoted to classical mythology. The arrangement of the figures in both groups is so compact as to suggest that the compositions were designed to be carved in marble, as indeed one of them was.

The group of *Hercules Slaying the Nemean Lion* appears to be a model for a marble statue which is now in a pavilion in the park of Rosenborg Castle, Copenhagen (fig. 1). This was bought, together with two medium-sized statues of *Orpheus* and *Eurydice,* by King Frederick IV of Denmark on a visit to the sculptor's studio in 1709.[2] A bronze cast of the Hercules group of smaller size (24.8 cm.) was bought in 1935 in Paris for the Berlin Museums and is now in the Bode Museum, East Berlin.[3] The treatment and composition of the Hercules group recall a marble statue by Cristoforo Stati (1556-1619), now in the Jardin de la Isla, Aranjuez (fig. 2);[4] a bronze statuette by Giambologna (fig. 3);[5] and a terra-cotta by Stefano Maderno, dated 1622, in the Ca d'Oro, Venice.[6]

No mention is made of a composition of *Apollo Flaying Marsyas,* and yet clearly the present statuettes were intended to form, if not a pair, at least part of a series. Dr. Jennifer Montagu of the Warburg Institute has remarked that in an exhibition of the Accadèmia di San Luca in 1767, Marchese Alessandro Capponi showed a marble group of *Marzia Scorticato da Apollo* ascribed to the "*Squola* [sic] *del Baratta,*" paired with a group by Baratta, *Mercurio, Che Uccide Argo (Mercury Killing Argus).*[7] This early reference corroborates the connection of the subject of *Apollo Flaying Marsyas* with Giovanni Baratta, already suggested by its pairing with a composition that is demonstrably by him. In both subject and composition, the *Apollo Flaying Marsyas* recalls the treatment of Baratta's master, Foggini, in his bronze group, now in the Victoria and Albert Museum, London (fig. 4).

The present terra-cottas have been shown by thermoluminescence dating techniques to be posthumous.[8] If these data are correct, one can only infer that they are casts in terra-cotta of original models by Baratta which have disappeared. Even so they are clearly of great art-historical interest. Alternatively, it may be that the many later repairs which the groups have undergone were effected in clay and refired, a process which would inevitably have obviated the scientific evidence for their original date of manufacture. Thus the date obtained by testing may prove to be that of a relatively recent refiring.

1. U. Schlegel, *Die italienischen Bildwerke des 17. und 18. Jahrhunderts,* Staatliche Museen Preussischer Kulturbesitz, Berlin, 1978, pp. 156-157.
2. H. Honour, "Count Giovanni Baratta and his Brothers," *The Connoisseur,* 1958, pp. 170-177, cat. no. 17.
3. Inv. no. 8492; and Schlegel, *op. cit.*
4. Sent in 1607 by Ferdinando I of Tuscany to the Duke of Lerma, Prime Minister of Spain, cf. Anthony Radcliffe, "Two bronzes from the circle of Bernini," *Apollo,* December 1978, pp. 418-423.
5. C. Avery and A. Radcliffe, *Giambologna, Sculptor to the Medici,* (exhibition catalogue), London, 1978, no. 75.
6. A.Nava Cellini, "Stefano Maderno", *I Maestri della Scultura,* no. 60, Milan, 1966, pl. XVII.
7. Personal communication with the author.
8. Oxford Research Laboratory for Archaeology and the History of Art, Report on Thermoluminescence Analysis, sample 281p60 (from Apollo and Marsyas): "less than 100 years old." Further study is intended in order to determine if repairs undertaken in the last 100 years may have prevented a proper dating by thermoluminescence analysis.

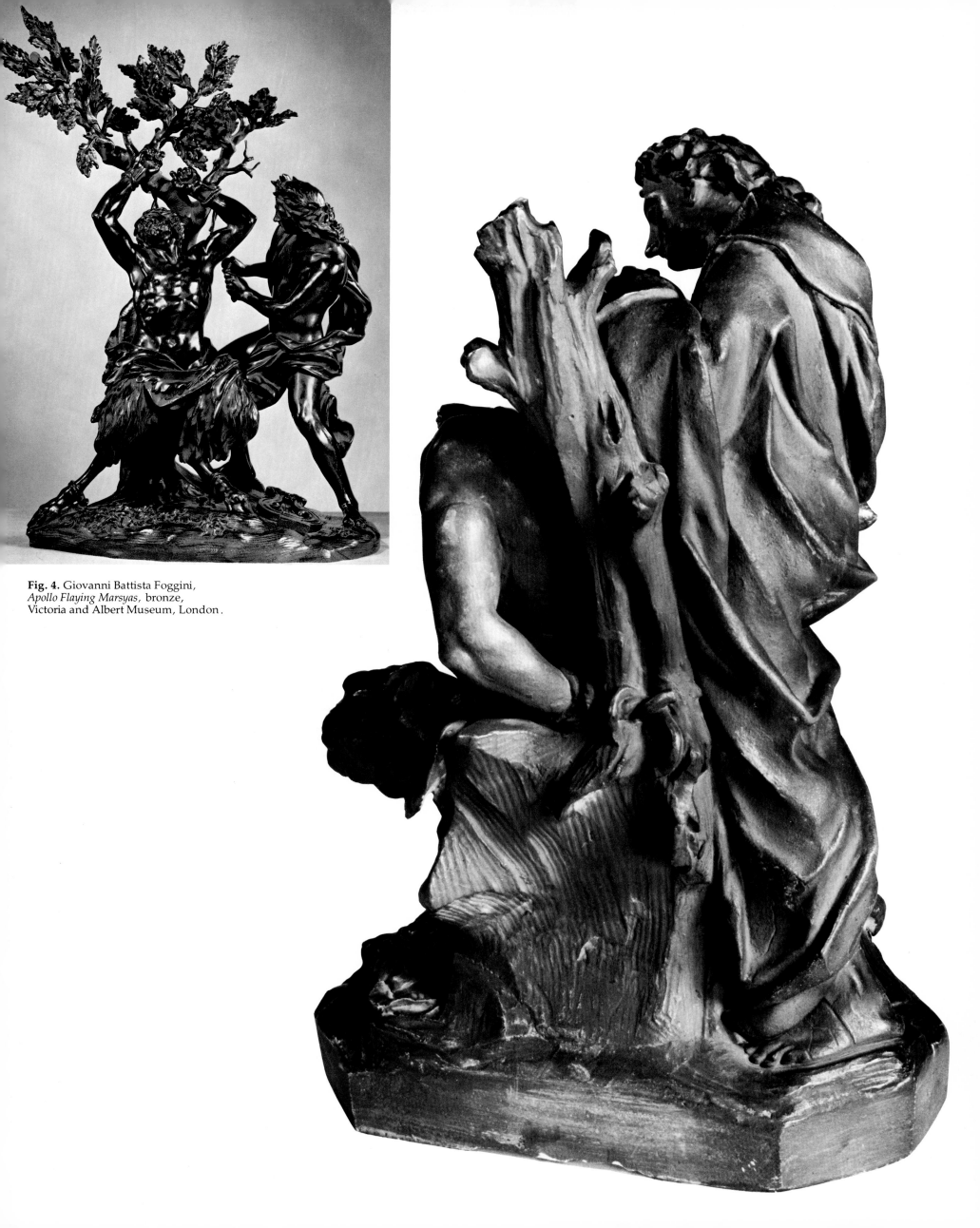

Fig. 4. Giovanni Battista Foggini,
Apollo Flaying Marsyas, bronze,
Victoria and Albert Museum, London.

FLORENTINE, early 18th century

MASSIMILIANO SOLDANI-BENZI
(1656-1740)

After attending the Grand Ducal drawing-school in Florence, Soldani spent four years, from 1678, at the Florentine Academy in Rome. He quickly established himself as a leading designer of medals, working for Pope Innocent XI, Queen Christina of Sweden and numerous cardinals. To further his specialization he was sent to Paris, where he also won recognition. He finally returned to Florence from Rome in 1682. Although he was initially active as a medallist—and from 1688 was in charge of the Grand Ducal Mint—he soon turned to sculpture, particularly in bronze, working for the Medici, the Order of Malta, Prince Liechtenstein and many other distinguished foreign clients, including the Duke of Marlborough. In this field Soldani achieved great fame, both as a modeller and as a virtuoso in the handling of bronze.

34. *The Apotheosis of Grand Master Fra Antonio Manoel de Vilhena*

Terra-cotta.
H. 23½ in. (59.7 cm.) W. 14⅞ in. (37.8 cm.) D. 4¼ in. (10.8 cm.)
Condition: repaired throughout.
Exhibited: Heim Gallery (London), *The Baroque in Italy,* Summer 1978, no. 36.*
Accession no. 79.1.28

SOLDANI SPENT THE YEARS 1727-29 making the second of his bronze tombs for Manoel de Vilhena, a Grand Master of the Order of Malta, during the latter's lifetime, for the Church of St. John in Valletta.[1] When Soldani dispatched the tomb to Malta in October 1729, he announced that he was also sending a medal and a wax group, together with an explanation of their symbolism.[2] The Grand Master wrote to Soldani in December acknowledging the safe arrival of the tomb, and thanking him for the gift of forty specimens of the medal, together with the original wax model for it, as well as the wax bas-relief. He expressed especial delight in their *"vaste ed erudite Idee"* and *"misteriose rappresentanze."*[3]

Two wax casts are known. One, in a collection of the Marchese Ginori Lisci, was probably purchased with other waxes by Marchese Carlo Ginori from Soldani's son in 1744.[4] The other, formerly in the collection of Cardinal Alpheran, a nineteenth century French cardinal who was

himself a member of the Order of Malta, was recently acquired from his heirs by the Black-Nardeau Gallery, Monaco. An earlier date is assigned to it than to the one in the Ginori Lisci collection, and it may indeed be the one sent to Manoel de Vilhena in 1729.[5] Another terra-cotta version is in the Victoria and Albert Museum.[6] This is in fragile condition and shows signs of having had certain protuberant parts, especially heads and limbs, removed to facilitate the taking of piece moulds and then replaced. It is identical in composition to the present relief, differing only in minor details. In the relief here, as in the Ginori wax as well, the head of the allegorical figure of *Eternity* is turned, hiding more of the face than in the Victoria and Albert Museum version, and her body accordingly turns more pronouncedly. The wax relief from the Cardinal Alpheran collection, however, also differs in details, as in the placement of the sword below the figure of *Cybele* in the lower right corner, and in the existence of a trident held in Neptune's left hand, and missing from all the other versions. From the dispatch of the wax model for the medals along with the medals themselves, and from similar tactics in his dealings with Prince Liechtenstein, it is evident that Soldani hoped by sending a wax cast taken from a terra-cotta relief to prompt the Grand Master to have it cast in bronze, retaining the original models to work from should he receive the commission. In any event, Manoel de Vilhena merely reciprocated his gift with that of a monkey and a *"gatto Affricáno"* (an "African cat"), from which, he assured Soldani, he could obtain civet.[7]

The complex, allegorical content of the relief is closely related to that of the Grand Master's tomb: his bust is borne aloft by an eagle to *Eternity* (the shrouded figure of a woman with the coiled snake behind), while *Time* (holding his sickle and hourglass) is repelled. A *putto* supports the *Stocco e Cappello* (ceremonial sword and helmet) presented to the Grand Master by the Pope, while *Eternity* points to the stricken figure of *Neptune* (with his rearing horse behind him and his foot on a dolphin, symbolizing the Order's policing of the seas), and *Cybele* (with her lion and armour, symbolizing the Order's terrestrial power).[8] At the right edge, on a palm (for victory) and an olive sprouting fresh branches (renewed peace) hang shields embellished with the cross of the Order and devices taken from the Vilhena coat of arms. In the lower left two *putti* quarrel over a relief plan of the most notable construction in Malta, Fort Manoel.

1. K. Lankheit, *Florentinische Barockplastik*, Munich, 1962, pp. 157-160.
2. *Ibid.*, doc. 520, pp. 313, 314.
3. *Ibid.*, doc. 522, p. 314.
4. *Ibid.*, figure 107, and J. Pope-Hennessy, "Foggini and Soldani: Some recent acquisitions," *Victoria and Albert Museum Bulletin*, III/4, 1967, p. 142, fig. 8.
5. Black-Nardeau Gallery, Monte Carlo, *Sculpture and Works of Art 1500 to 1900*, Monaco, 1980, no. 21, illus. Our thanks to James Draper, Associate Curator, Department of European Sculpture and Decorative Arts, The Metropolitan Museum of Art, for bringing the Alpheran wax to our attention.
6. A. 13-1967. Pope-Hennessy, *op. cit.*, p. 143, fig. 9.
7. Lankheit, *op. cit.*, doc. 523, p. 314.
8. In 1967 Pope-Hennessy, *op. cit.*, p. 144, no. 19, called this figure *Valletta.*

*The information in this entry is based in part on that provided by the author for the Heim Gallery catalogue.

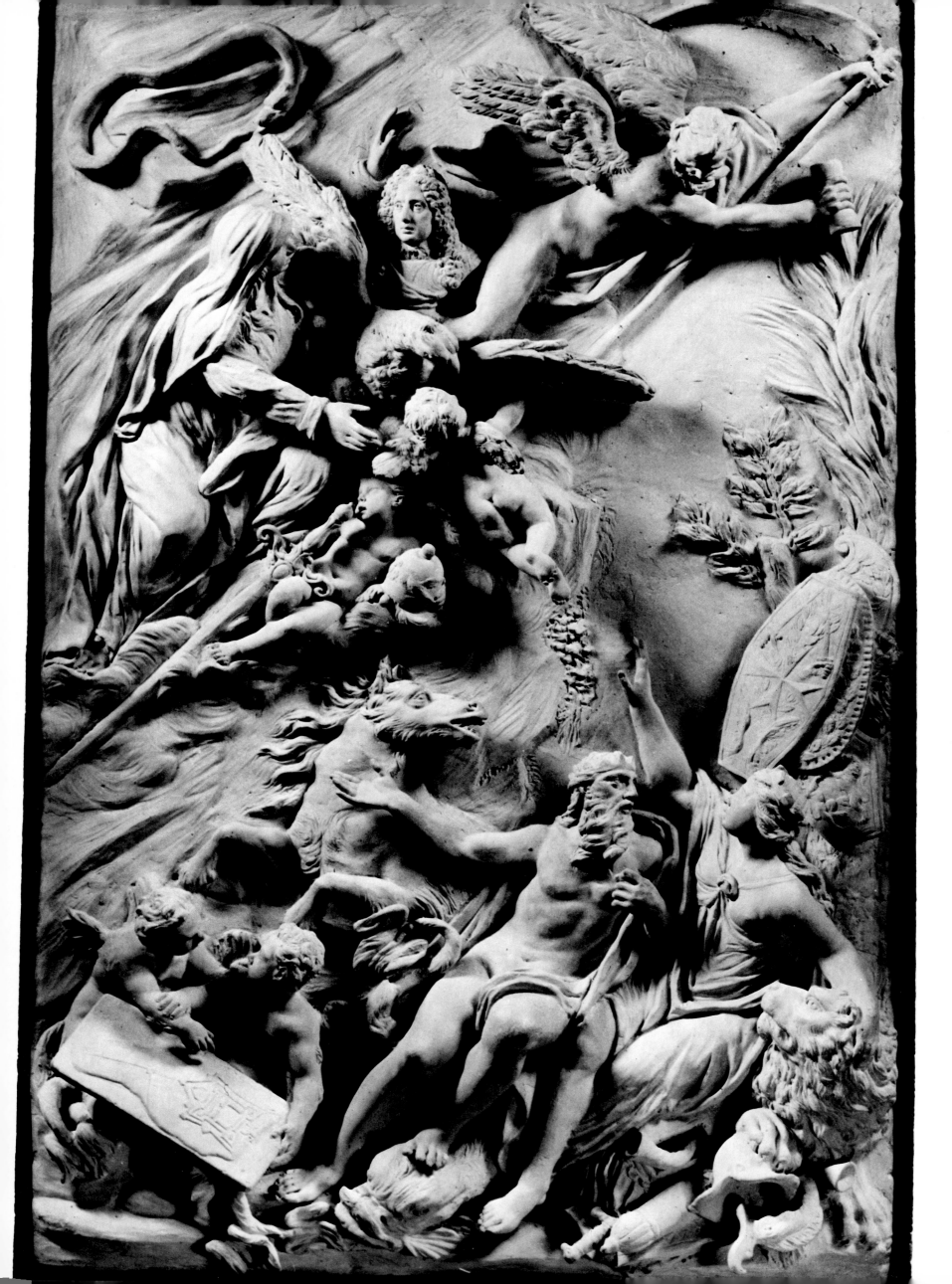

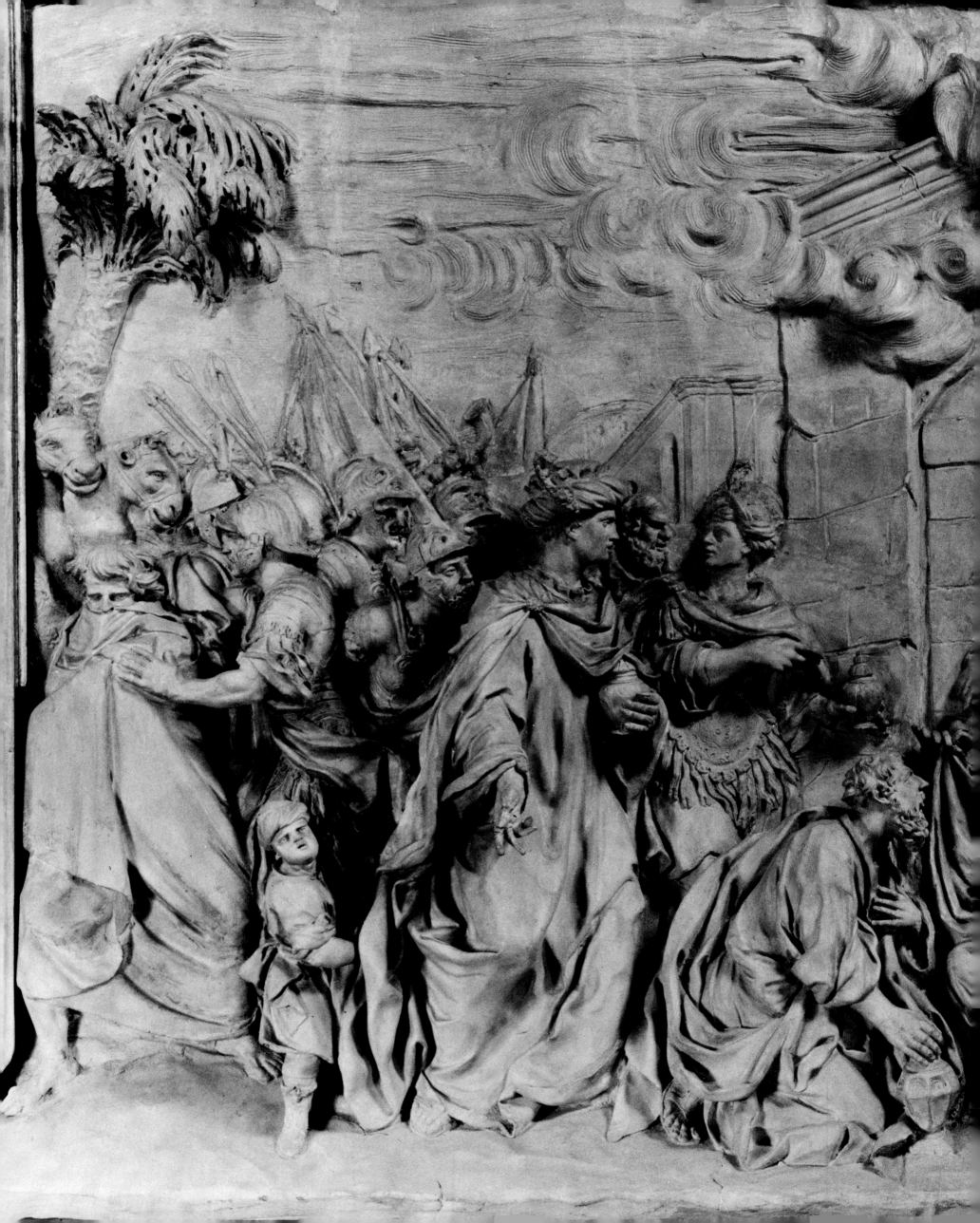

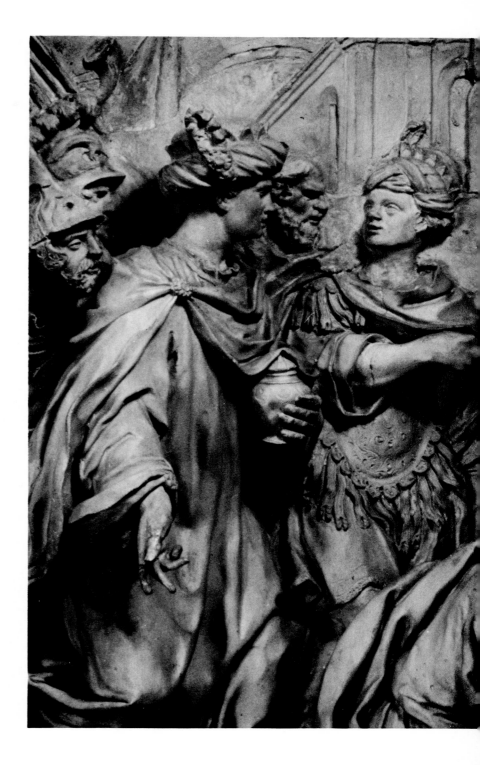

FLORENTINE, early 18th century

Circle of SOLDANI

35. *Adoration of The Magi*

Terra-cotta.
H. 28 in. (71.2 cm.) W. 31 in. (78.8 cm.) D. 8½ in. (21.6 cm.)
Condition: predictably in such a complex panel, there are numerous minor damages to projecting parts, such as heads, arms, fingers and the foreground.
Provenance: Conte degli Alessandri, Empoli; Heim Gallery, London.
Exhibited: P. & D. Colnaghi & Co., Ltd., *Exhibition of Seventeenth and Eighteenth Century Italian Sculpture*, London, February/March, 1965, no. 12, pl. XI.
Accession no. 77.5.85

101

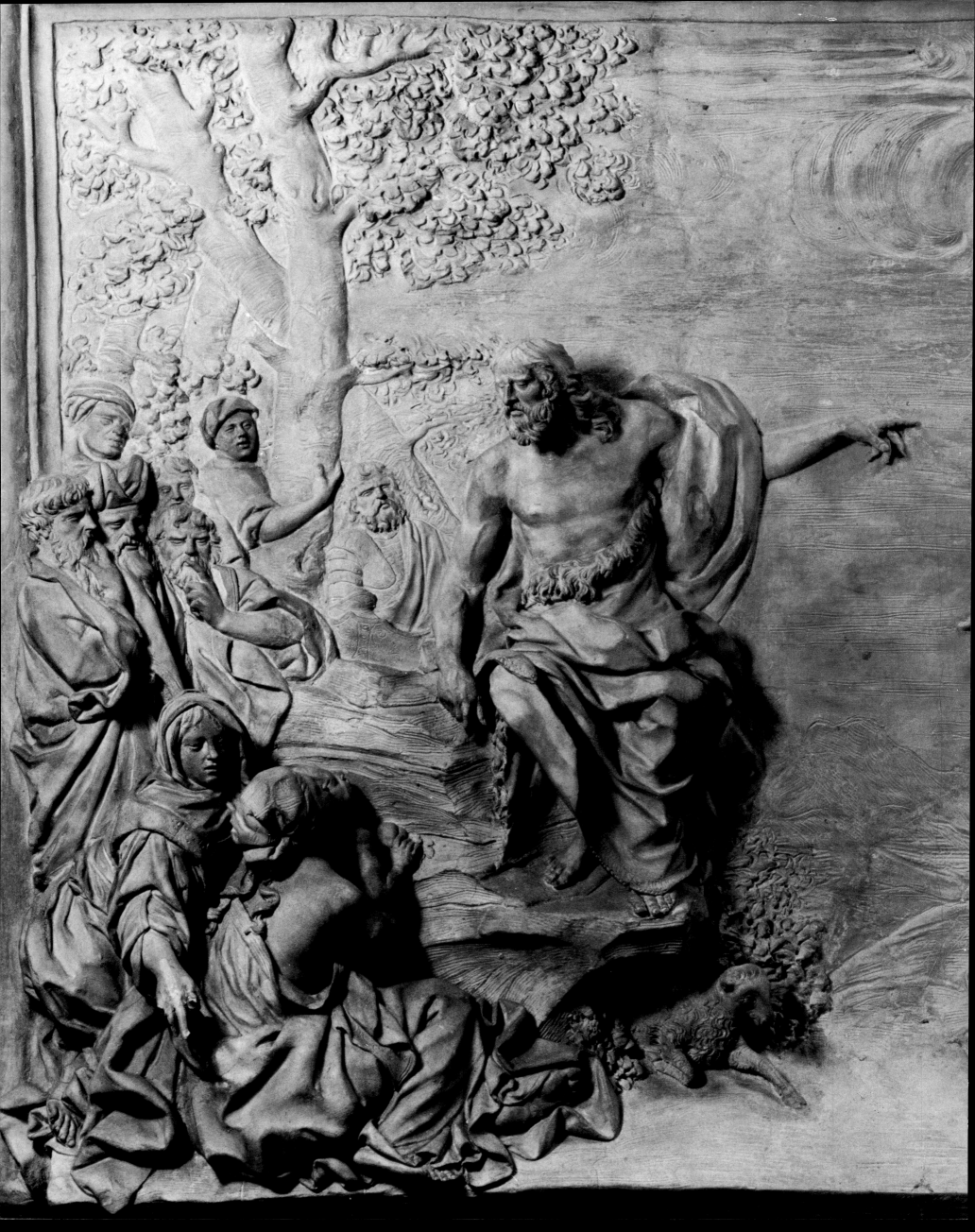

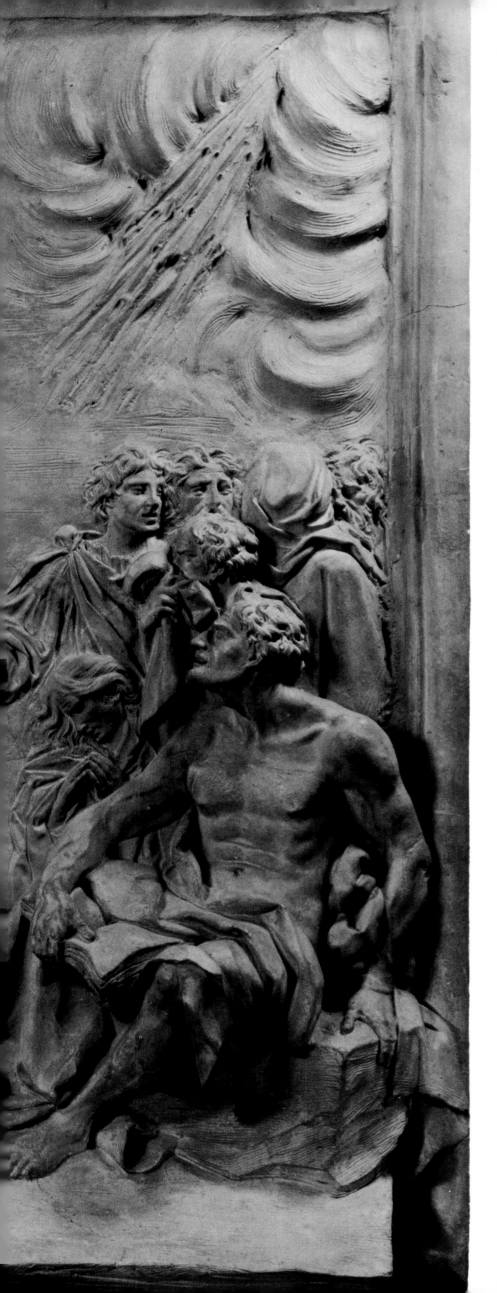

36. *Preaching of St. John the Baptist*

Terra-cotta, early 18th century.
H. 28½ in. (72.4 cm.) W. 32¾ in. (83.2 cm.) D. 6 in. (15.2 cm.)
Condition: same as no. 35.
Provenance: same as no. 35.
Exhibited: Colnaghi, *op. cit.,* no. 11, pl. X.
Accession no. 77.5.84

THE STYLE, facture and facial type of these reliefs are not identical. If they are by the same hand, they were not done at the same time. Nor are they now considered to be by the same hand as the two slightly smaller terra-cotta panels with which they were associated in 1965.[1] The latter, of similar style, have since been identified as sketch-models by Giuseppe Piamontini for two of his large stucco reliefs in the church of SS. Michele e Gaetano degli Antinori in Florence.[2]

Piamontini is associated with the late Florentine Baroque sculptors from the circle of Soldani. The two reliefs here and the two smaller panels trace back to a 19th-century Florentine provenance from a villa near Empoli belonging to a prominent patrician family, the degli Alessandri. This provenance, taken together with the positive identification of the Florentine sculptor Piamontini for the formerly related smaller panels, also points authorship of the Sackler reliefs towards one of the late Florentine Baroque sculptors from the circle of Soldani, who so far has defied identification.

The biblical subjects depicted in the two Sackler reliefs do not constitute a normal pair, suggesting that these panels formed part of a larger cycle devoted to the early life of Christ. It may, of course, be that only these two episodes were allocated to a particular anonymous sculptor, while the intervening ones were done by yet other hands.

1. P. & D. Colnaghi & Co., Ltd., *Exhibition of Seventeenth and Eighteenth Century Italian Sculpture,* London, February/March, 1965, nos. 13 *(The Judgment of an Unknown Saint)* and 14 *(The Martyrdom of an Unknown Saint),* not illus.
2. J. Montagu, "Some small sculptures by Giuseppe Piamontini," *Antichità Viva,* 3, 1974, fig. 31 (bozetto for *The Martyrdom of Sts. Simon and Judas Thaddeus),* fig. 32 *(The Martyrdom of Bartholomew),* pp. 17-18, and Heim Gallery (London), *From Tintoretto to Tiepolo,* Summer 1980, no. 39 and 40.

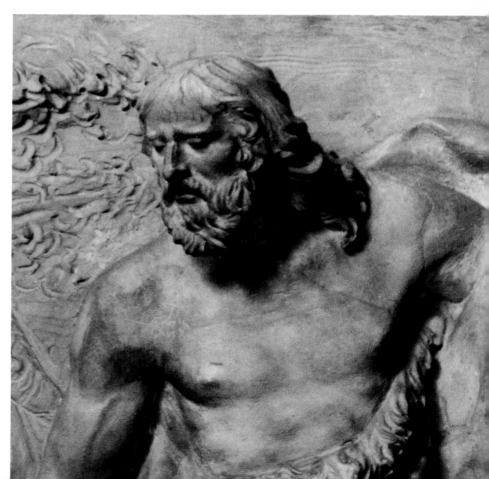

FLORENTINE, first half of the 18th century

Attributed to
AGOSTINO CORNACCHINI
(1686-1754)

Born in Pescia, near Pistoia, Agostino, at the age of eleven, was taken to Florence and apprenticed to Giovanni Battista Foggini, the Grand Ducal sculptor. He was next patronized by Francesco Gabburri (1675-1742), who later wrote a detailed biography of him.[1] In 1712 he and his patron moved to Rome, where Camillo Rusconi was at the height of his success, and Cornacchini worked in collaboration with him; for example, on the Corsini Chapel in San Giovanni in Laterano, where he carved statues of *Prudence* and *Fortitude*. When Gabburri returned to Florence, he placed Agostino under the protection of Cardinal Carlo A. Fabbroni, for whom Cornacchini carved small marble groups of the *Nativity* and *Deposition*. These were bequeathed to the Biblioteca Fabbroniana in Pistoia, while a terra-cotta model of the former piece is now in the Victoria and Albert Museum, London.[2] Cornacchini's most famous commission was the equestrian *Charlemagne* (ca. 1718-1725), which stands at one end of the atrium of St. Peter's, Rome, opposite Bernini's *Constantine*.[3] Apart from other statues and portrait-busts located in Rome, Cornacchini modelled a spectacular bronze group of *Judith and Holofernes* for the Electress Palatine, Anna Maria Luisa de' Medici, now in the City Museum and Art Gallery, Birmingham, U.K.[4] He also carved a number of angels elsewhere.

37. *The Continence of Scipio (?)*

Terra-cotta, on contemporary gilt-wood stand.
H. 19½ in. (49.5 cm.) W. 17¼ in. (43.9 cm.) D. 13½ in. (34.3 cm.)
Condition: numerous small repairs to this very fragile terra-cotta, which is modelled in five separate component parts.
Provenance: Baron Friedrich von Stumm, Villa Rusciano, Florence.
Exhibited: Heim Gallery (London), *Faces and Figures of the Baroque*, Autumn 1971, no. 77.
Accession no. 77.5.31

THE PROBABLE SUBJECT of this complex, multifigure group is a famous episode from ancient Roman history. The celebrated Roman general Publius Cornelius Scipio (called Africanus, from his conquest of Carthage) having conquered Spain for the Romans, "refused to see a beautiful princess who had fallen into his hands after the taking of New Carthage, and he not only restored her inviolate to her parents, but also added immense presents for the person to whom she was betrothed."[5]

The group belongs to what is now defined as the Florentine Late Baroque style, when sculpture became more and more pictorial and less "statuesque." The complicated building up of figures into a dramatic tableau with many incidental details is characteristic of the artists who were followers of Giovanni Battista Foggini and Massimiliano Soldani-Benzi, who initiated these traits. Of these, Cornacchini is a likely candidate for the authorship of the present group, owing to analogies in style and in type of figure with his two major groups in marble, the *Nativity* and *Deposition* for Cardinal Fabbroni, now in Pistoia.

1. H. Keutner, ed., "The Life of Agostino Cornacchini by Francesco Maria Gabburri," *North Carolina Museum of Art Bulletin*, II, Summer, 1958, no. 1, pp. 37-42.
2. J. Pope-Hennessy, *Catalogue of Italian Sculpture in the Victoria and Albert Museum*, London, 1964, vol. II, no. 652, vol. III, fig. 647, incorrectly attributed to Pierre-Etienne Monnot; the correct identification was made by Olga Raggio in her review of this catalogue in *The Art Bulletin*, vol. L, March, 1968, pp. 104-105.
3. Keutner, *op. cit.*, p. 38 (and footnote 7), fig. 3, p. 39; and Keutner, "Critical Remarks on the Work of Agostino Cornacchini," *North Carolina Museum of Art Bulletin*, I, Winter, 1957-1958, nos. 4-5, pp. 15-17.
4. Keutner, ed., "The Life of . . ." *op cit.*, p. 40; and Detroit Institute of Art, *The Twilight of the Medici*, Detroit/Florence, 1974, no. 2, p. 40, entry written J. Montagu.
5. J. Lemprière, *A Classical Dictionary*, new edition, New York, 1949, p. 565.

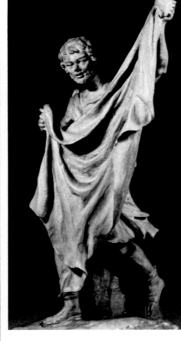
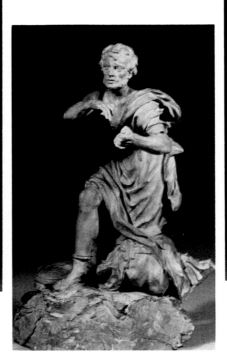

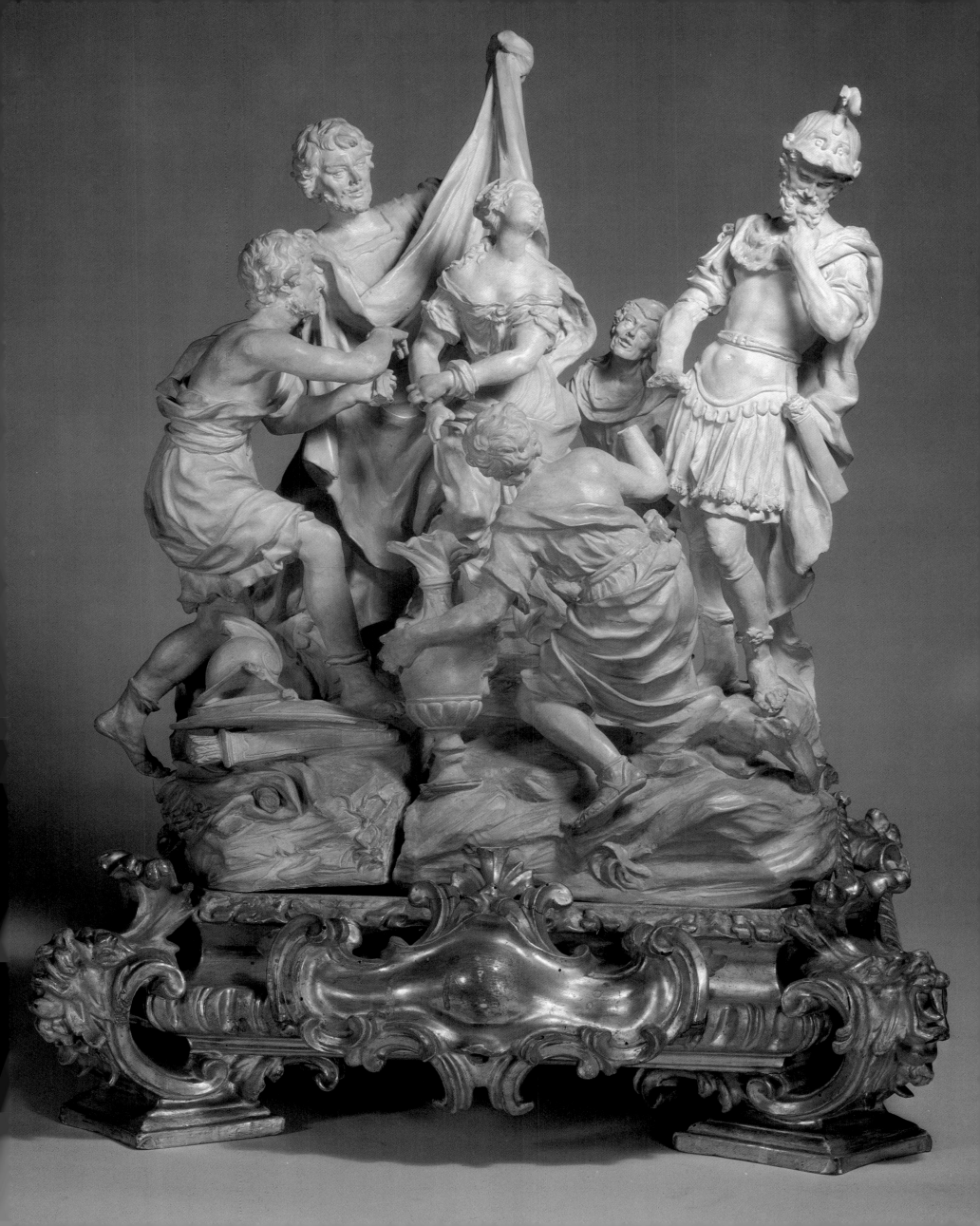

EMILIAN, late 17th century

ANONYMOUS

38. *St. Blaise (San Biagio)*

Terra-cotta polychromed, ca. 1690-1700.
H. 44¼ in. (102.2 cm.) W. 21¾ in. (55.3 cm.) D. 11⅜ in. (28.9 cm.)
Condition: repairs throughout figure and base.
Accession no. 77.5.18

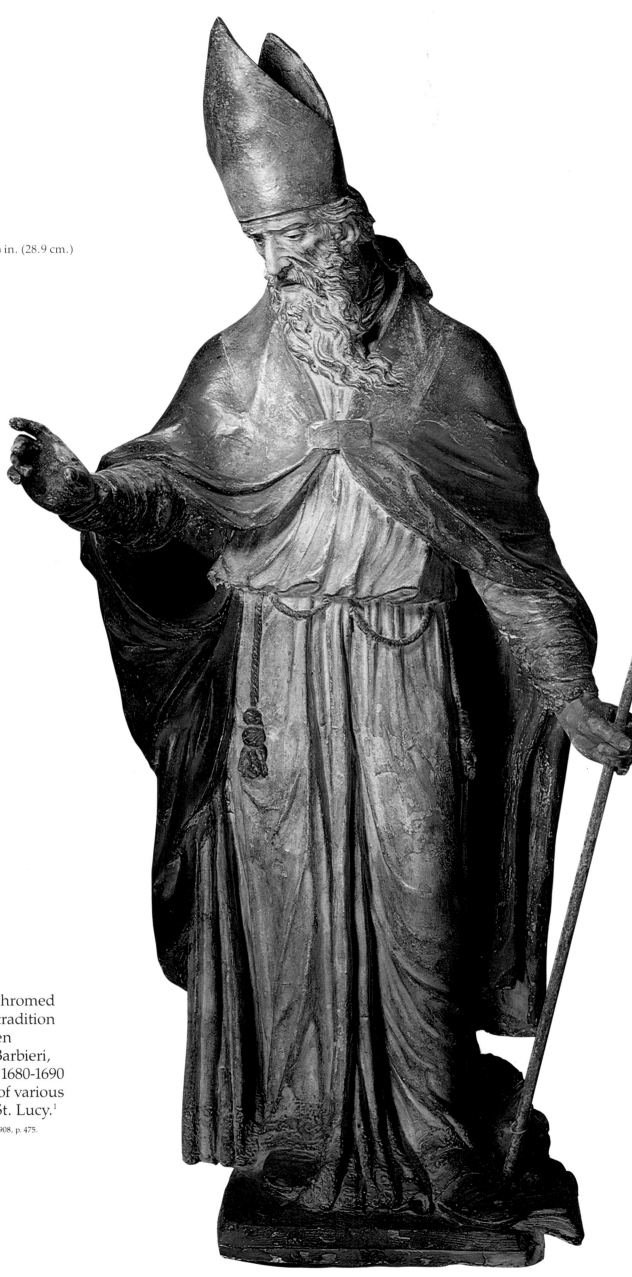

THIS IMPRESSIVE, finished and polychromed devotional statue stems from the tradition of Emilia and Romagna. It has been suggested that it may be by Giacomo Barbieri, a sculptor who was active between ca. 1680-1690 in Parma, where he produced statues of various saints on the facade of the Oratory of St. Lucy.[1]

1. Thieme-Becker, *Allgemeines Lexikon der Bildenden Künstler*, II, Leipzig, 1908, p. 475.

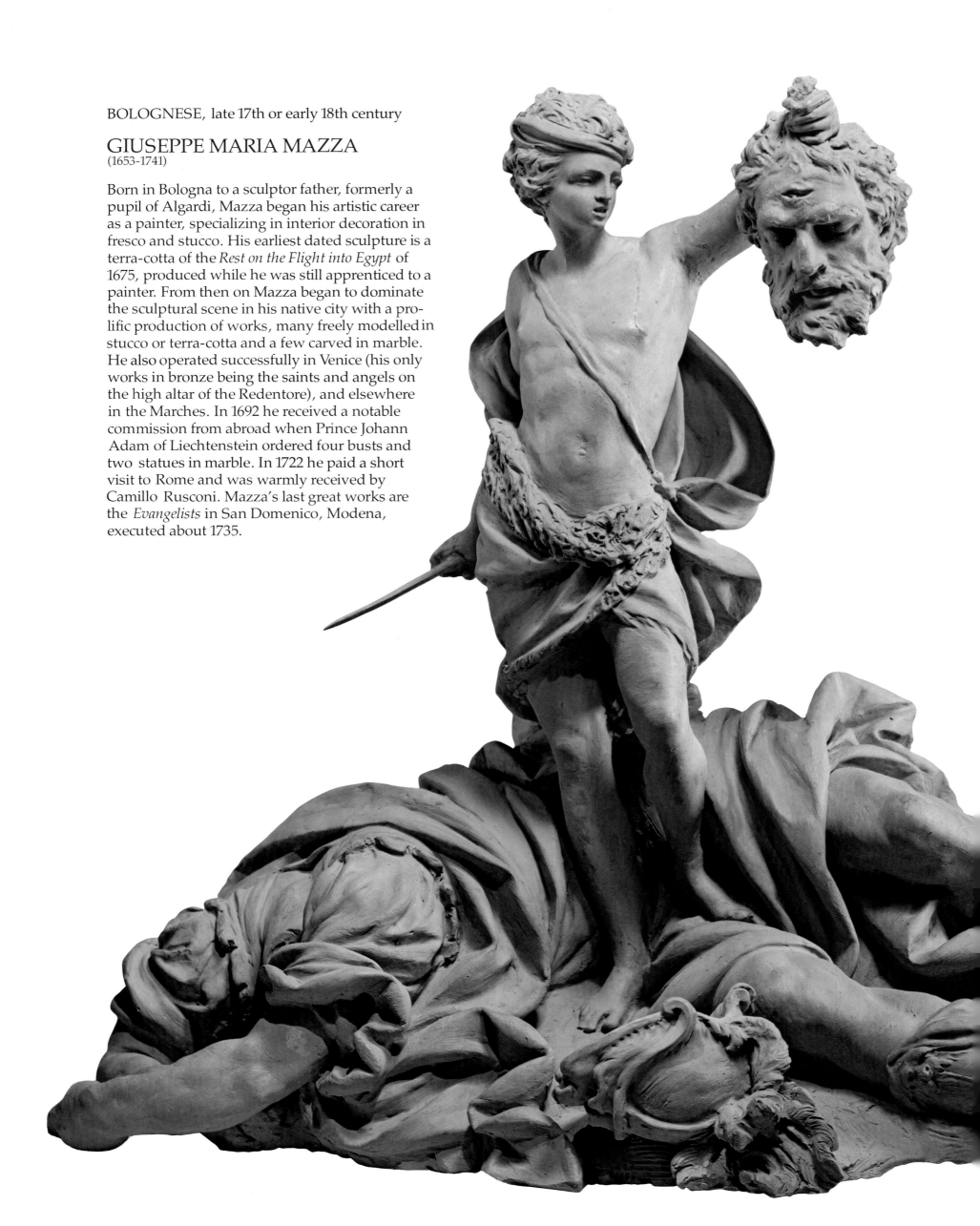

BOLOGNESE, late 17th or early 18th century

GIUSEPPE MARIA MAZZA
(1653-1741)

Born in Bologna to a sculptor father, formerly a
pupil of Algardi, Mazza began his artistic career
as a painter, specializing in interior decoration in
fresco and stucco. His earliest dated sculpture is a
terra-cotta of the *Rest on the Flight into Egypt* of
1675, produced while he was still apprenticed to a
painter. From then on Mazza began to dominate
the sculptural scene in his native city with a pro-
lific production of works, many freely modelled in
stucco or terra-cotta and a few carved in marble.
He also operated successfully in Venice (his only
works in bronze being the saints and angels on
the high altar of the Redentore), and elsewhere
in the Marches. In 1692 he received a notable
commission from abroad when Prince Johann
Adam of Liechtenstein ordered four busts and
two statues in marble. In 1722 he paid a short
visit to Rome and was warmly received by
Camillo Rusconi. Mazza's last great works are
the *Evangelists* in San Domenico, Modena,
executed about 1735.

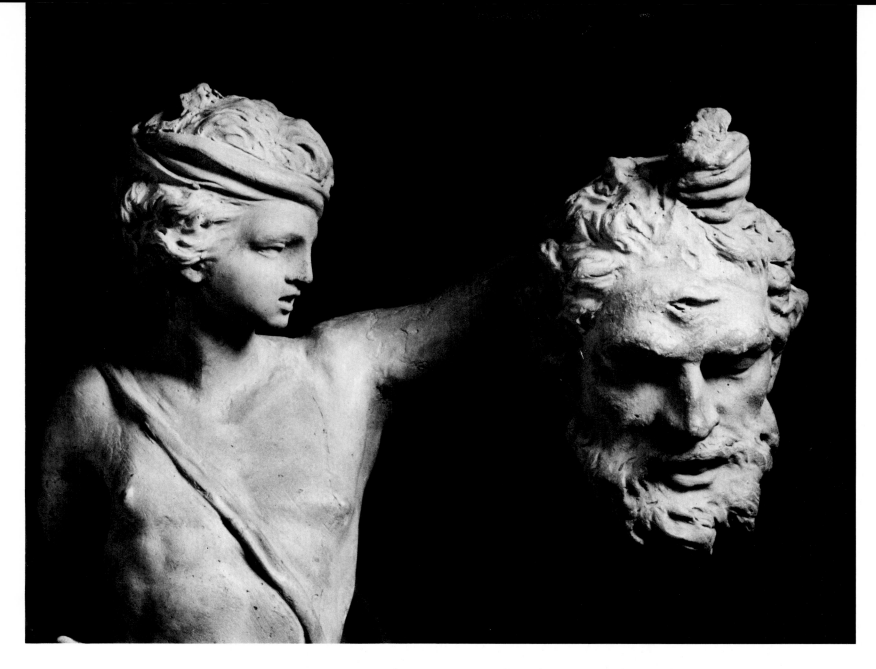

39. *David Triumphant over Goliath*

Terra-cotta, after 1675 and before 1723.
H. 18¾ in. (47.6 cm.) W. 20¾ in. (52.7 cm.) D. 11 in. (27.9 cm.)
Condition: repairs throughout both figures.
Accession no. 77.5.49

T
HIS STRIKING GROUP was recognized and published
by Eugenio Riccòmini, as a youthful work of
Mazza's.[1] It appears to have been the inspiration
behind Foggini's better known group (executed about
1723 in terra-cotta, bronze, and porcelain) of the same
subject, which it certainly preceded, and which employs
a similar, pyramidal composition.[2]

1. E. Riccòmini, *Ordine e Vaghezza: La Scultura in Emilia Nell' eta Barocca*, Bologna, 1972, no. 110, p. 98.
2. Detroit Institute of Arts, *The Twilight of the Medici* (exhibition catalogue), Detroit and Florence, 1974, no. 11, p. 48, entry written by Dr. Jennifer Montagu, who concurs with the present attribution.

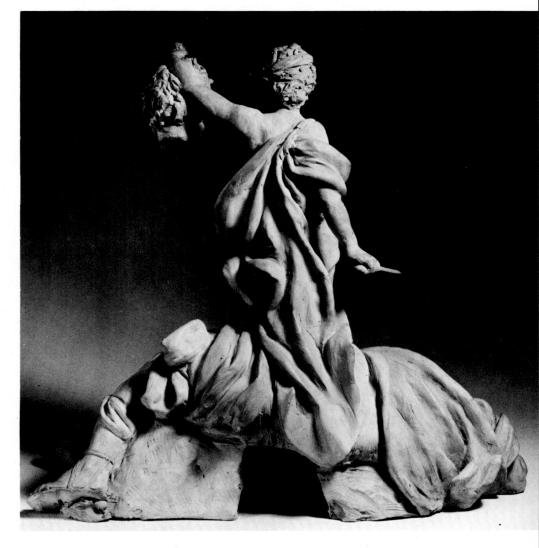

BOLOGNESE, early 18th century

GIUSEPPE MARIA MAZZA
(1653-1741)

40. *Walking Cupid (?)*

Terra-cotta, 1736.
Signed: "1736 G.M." incised on back of socle.
H. 11½ in. (29.2 cm.) W. 4 ⁵⁄₁₆ in. (10.9 cm.) D. 3½ in. (8.9 cm.)
Condition: head has been broken off and repaired at top of neck;
possible repair to left upper arm and left leg at ankle; nose pre-
viously broken and repaired, with faked paint on tip of nose.
Accession no. 77.5.50

THIS CHARMING STUDY of a little boy walking
along, clasping a cloak around him with both
hands, is identifiable as Cupid only from
the quiver full of arrows that lies between his feet.
It bears Mazza's initials on the back of the socle,
incised rapidly with a stylus in the damp clay in
his usual manner, as well as the date 1736. The soft
modelling of the infant flesh, the gently curling
locks of hair, and the delicate suggestion of facial
features are characteristic of Mazza's style at its
most informal and relaxed.[1]

1. See Mazza babies in C Semenzato, *La Scultura Veneta del Seicento e del Settecento*,
Venice, 1966, figs. 52-53, decorations for the Palazzo Widmann, Venice, and p. 33.

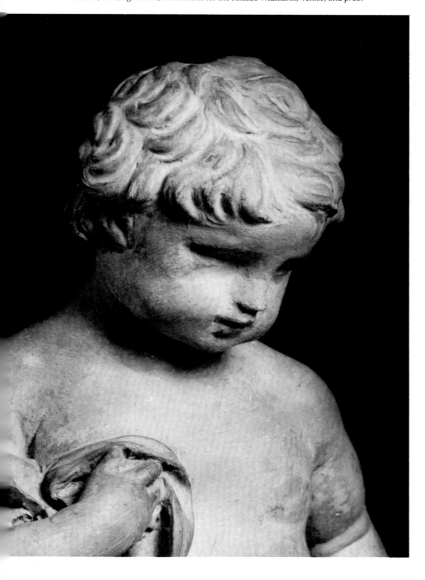

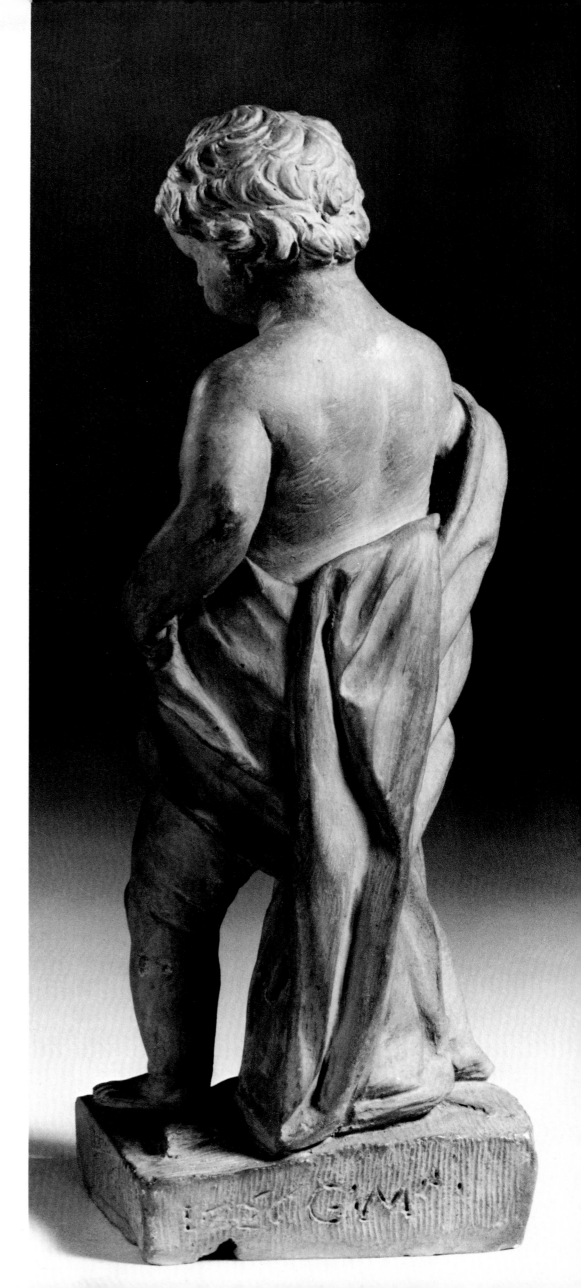

BOLOGNESE, late 17th or early 18th century

Attributed to GIUSEPPE MARIA MAZZA
(1653-1741)

41. *The Virgin Mary(?) Wearing a Veil*

Terra-cotta, ca. 1700 (?).
H. 20¾ in. (52.7 cm.) W. 19½ in. (49.5 cm.) D. 10 in. (25.4 cm.)
Condition: possible repairs to neck, tip of nose and edge of veil.
Exhibited: Heim Gallery (London), *Baroque Sketches, Drawings & Sculptures*, Autumn 1967, no. 85 (as Giuseppe Mazzuoli).
Accession no. 77.5.54

ANALOGIES with the work of Mazzuoli (no. 21), cited when the bust was first exhibited, are not compelling. The modelling of the drapery in tiny, rippling folds is basically unlike Mazzuoli's technique, in which broader, scooped folds in the manner of Bernini predominate. The serenity and warmth of the expression, as well as the modelling of the features, point to Mazza—or at least to Bologna rather than Rome or Siena.[1]

1. See Mazza's *Madonna col Bambino* in the Agostini collection, Bologna (E. Riccòmini, *Ordine e Vaghezza: La Scultura in Emilia Nell'eta Barocca*, Bologna, 1972, cat. no. 91, fig. 268) for the same treatment in the head covering as it folds on the top of the head, the rounded cheek and chin, the softly curving strands of hair; also Mazza's stucco relief with *Vergine Annunciata* (*Ibid.* cat. no. 137, fig. 254), and his terra-cotta *Madonna Immacolata col Bambino* from the A. Boschi collection, Bologna (*Ibid.*, fig. 153, p. 112).

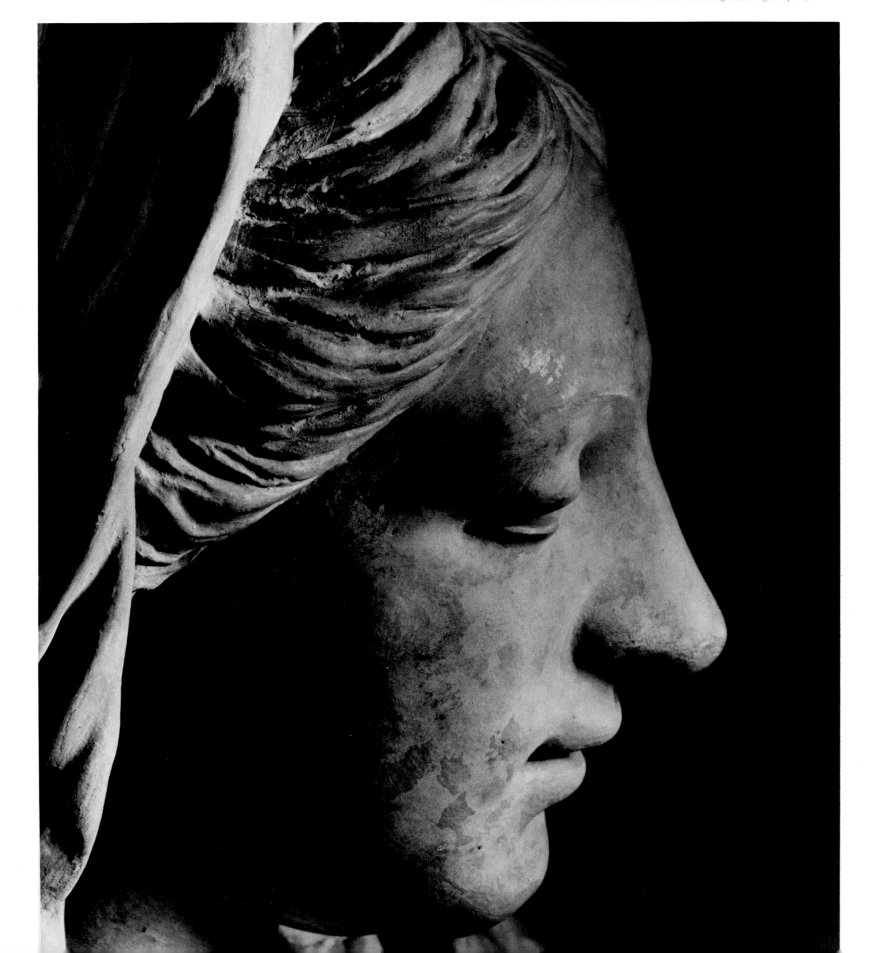

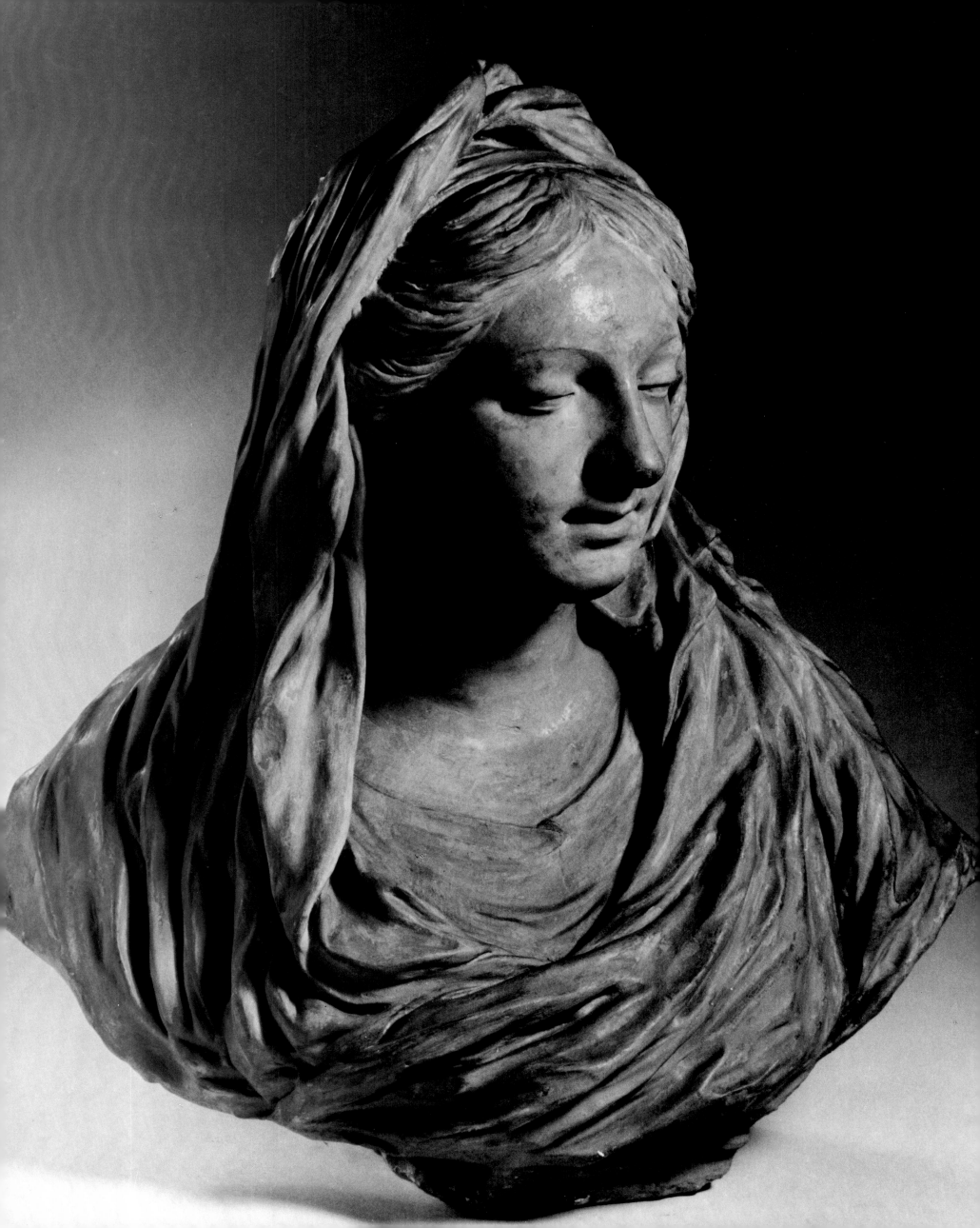

BOLOGNESE, middle of the 18th century

OTTAVIO and NICOLA TOSELLI
(1695-1777) (1706-post 1782)

Ottavio and Nicola were sculptor brothers who
worked in partnership from an extensive and
many-sided artistic family in Bologna.[1] They
produced sculpture in marble, wood, wax, etc.,
as well as in the time-honoured Bolognese
medium of terra-cotta.

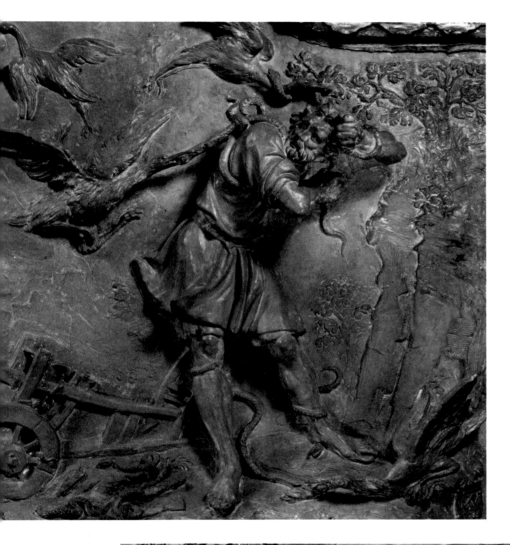

42. *The Miracle of the Cranes*

Terra-cotta, 1733 (on shield with monogram, lower right)
in contemporary, carved, gilded and inscribed frame.

H. 23¼ in. (59.1 cm.) W. 36 in. (91.4 cm.) D. 3¾ in. (9.5 cm.)

Inscribed on frame: AGELLUM IN ORA JULAE VERSUS THUSCIAM ARATRO SCINDENTE
GLANDONE BUBULCO, QUI DE CAVA VOMERE CASU PENETRANTE APERTA, PRODIERUNT
ANGUES, MISELLUM EX SUBITO IMPETU ITA SUNT ADORTI HOMINEM INJURIAM
CREDERES AD REFERENDAM PRO EXTURBATA QUIETE, QUOD CITO STRANGULASSENT
ETIAM, IPSE NISI MISEROS SPISSISSIMOSQUE PER EDITOS CLAMORES FORTE
DEPASCENTES SUFRA COLLEM GRUES IN OPEM ADVOCASSET: QUOT EMINUS
IMPETITUM AB ILLIS CONSPICIENTES HOMINEM, EOVE TRUCI VEL MOTAE SPECTACULO,
VEL EDULIORUM MEMORES PER EUM CUM ADVENIRENT QUOTANNIS PORRECTORUM,
AUT DEMUM UBERI ALLECTAE ESCA FORTEM ADEO ADVERSUS ILLAS INSTITUERUNT
PUGNAM, QUOD POSTREMO PIUM EDUCATOREM DE EXICIOSO DISCRIMINE SOSPITEM
REDEMISSE, LUMINOSUS DE APOSA IN GRON: VERB: MEMORAB: BONON: AD A. S. 727
TESTIS EST QUO AUCTORE LOCO ITEM GRUARIA NOMEN ADVENISSE CONSTAT.
FACTA 1733 OᵀN*

Condition: extensive restoration throughout.

Accession no. 77.5.87

THIS HISTORICALLY FASCINATING RELIEF records an extra-
ordinary, rustic miracle which took place in 727 A.D.
at Gruaria near Bologna, when a ploughman was saved
from a nest of snakes, which he had accidentally disturbed,
by a flight of cranes, which attacked and carried them off.[2]
The lengthy, contemporary inscription on the frame records
the circumstances. The monogram "ONT 1733 F" on the
shield at the lower right-hand corner of the terra-cotta consti-
tutes the joint signature of the brothers and is repeated
below on the frame, at the end of the narrative inscription.
The devices on the coat of arms in the lower left-hand corner
have not been identified, but are presumably those of the
artists or of their patron.

The exciting story is brilliantly evoked by the contrast be-
tween the oxen, uncomprehendingly straining at the yoke
of the abandoned plough and their wretched master
who struggles desperately to free himself from the snakes.
The opposed diagonal flight paths of the several cranes
in midair increase the sense of dramatic commotion. Here,
sculptural relief is seen at its most pictorial.

1. Thieme-Becker, *Allgemeines Lexikon der Bildenden Künstler,* Leipzig, XXXIII, 1939, pp. 314-315; and E. Riccòmini,
 Mostra della Scultura Eolognese del Settecento (exhibition catalogue), Museo Civico, Bologna, 1965-66, pp. 112-115.
2. Dr. Carolyn Newmark, Associate Curator of Sculpture, National Gallery of Art, Washington, D.C., has pointed
 out that the relief may have been commissioned for the millenium of the event.

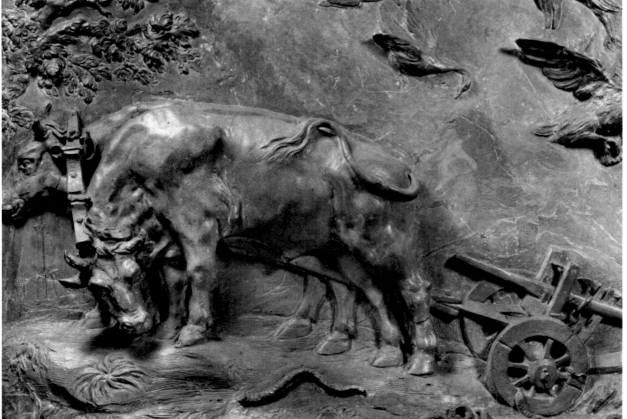

* As a ploughman by the name of Glardo was tilling a
small plot of land in the region of Jula, facing Thuscia,
some snakes, whose nest had accidentally been torn
open by the ploughshare, quite suddenly sprang out
and attacked the poor fellow as if to avenge themselves
on him for having disturbed their rest. And they would
quickly have choked him to death, too, had he not, by
his frequent and pitiful cries, summoned to his aid
certain cranes which were, by chance, foraging atop a
hill. Those of the cranes which could see in the distance
the man under attack by the snakes, either moved to
pity by the spectacle of such an assault, or recalling the
food which the ploughman had given them when they
came every year, or, finally attracted by the tasty
morsels, boldly attacked the snakes until, at length, they
rescued their grateful caretaker from dire distress.
A splendid eyewitness from Aposa provides a record
of this story in the Chronicles of Memorable Accounts
in Bologna, in the year of our Saviour 727; and, by his
authority, the name attributed to the place is Gruaria.
Fashioned in 1733 by Ottavio and Nicola Toselli.
Translated by William J. McCarthy, Department of Greek
and Latin, Catholic University of America, Washington, D.C.

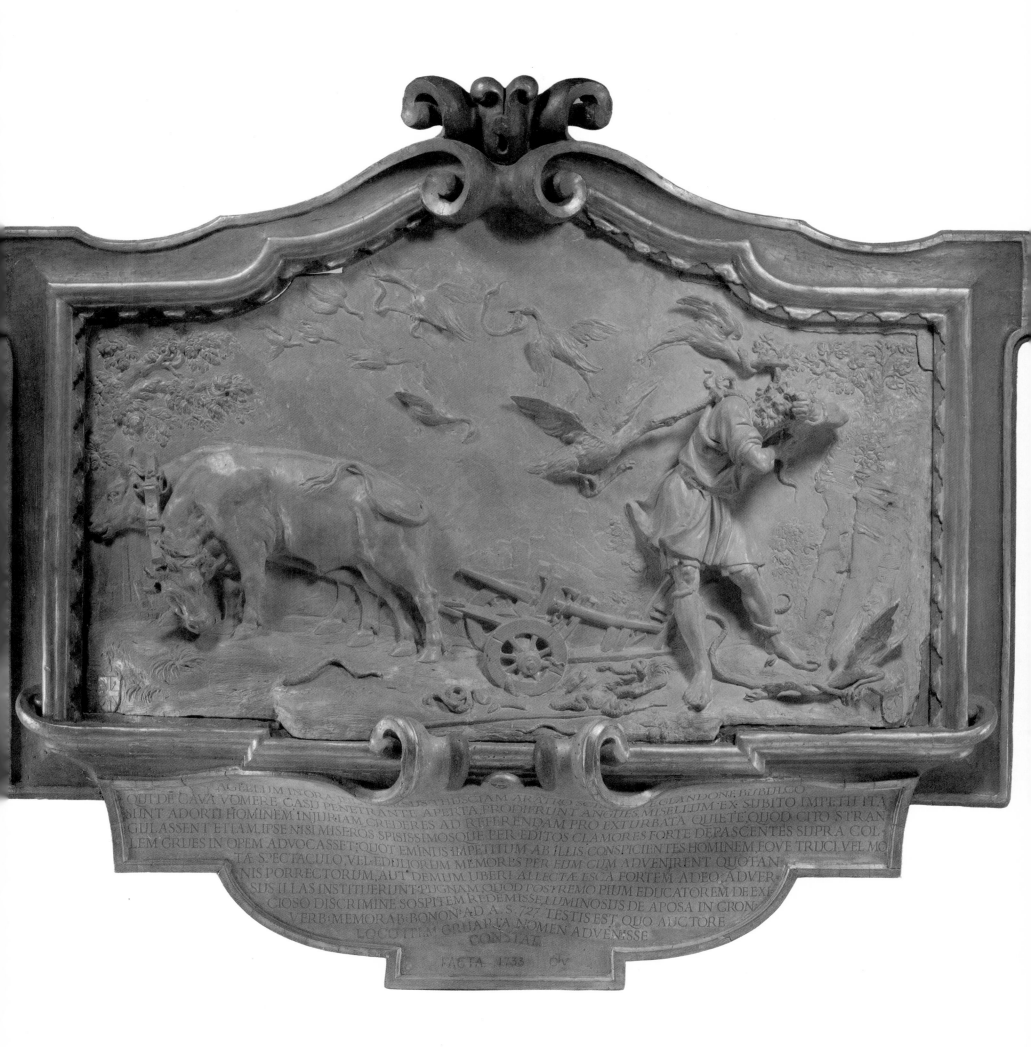

AGELLUM IN ORA [...] THESCIAM ARATRO SCI [...] EGLANDONE BUBULCO
QUI DE CAVA VOMERE CASU PENETRANTE, APERTA PRODIERUNT ANGUES, MISELLUM EX SUBITO IMPETU ITA
SUNT ADORTI HOMINEM INJURIAM, CREDERES AD REFERENDAM PRO EXTURBATA QUIETE, QUOD CITO STRAN
GULASSENT ETIAM, IPSE NISI MISEROS SPISISSIMOSQUE PER EDITOS CLAMORES FORTE DEPASCENTES SUPRA COL
LEM GRUES IN OPEM ADVOCASSET; QUOT EMINUS IMPETITUM AB ILLIS CONSPICIENTES HOMINEM EOVE TRUCI VEL MO
TA SPECTACULO, VEL ED ILIORUM MEMORES PER EUM CUM ADVENIRENT QUOTAN
NIS PORRECTORUM, AUT DEMUM UBERI ALLECTAE ESCA FORTEM ADEO, ADVER
SUS ILLAS INSTITUERUNT PUGNAM, QUOD POSTREMO PIUM EDUCATOREM DE EXI
CIOSO DISCRIMINE SOSPITEM REDEMISSE, LUMINOSUS DE APOSA IN CRON
VERB: MEMORAB: BONON: AD A. S. 727 TESTIS EST QUO AUCTORE
LOCO ITIAM GRUARIA NOMEN ADVENISSE
CONSTAT.

FACTA 1733 OV

115

ANONYMOUS

43. *The Education of the Virgin*

Terra-cotta, 18th century.
H. 35½ in. (90.2 cm.) W. 20 in. (50.8 cm.) D. 15 in. (38.1 cm.)
Condition: broken and repaired below waist; old repairs
to neck, wrists, edge of Virgin's foot, left and right arm
below shoulders, possibly edges of draperies and at knees.
Accession no. 77.5.11

THE SUBJECT of St. Anne teaching the Virgin Mary to read had been popular during the Middle Ages in Northern European wood sculpture, but is less frequent in Italian sculpture of the Renaissance and Baroque periods. Its use here may have been the result of a revival of the Marian cult in the aftermath of the Counter-Reformation. The epoch is indicated partly by the elaborate three-dimensional curves of the throne on which St. Anne is seated and partly by the elongation of the figures. The group is well conceived and united by the play of drapery folds on mother and daughter, as well as by Anne's right arm encompassing the charming, barefooted figure of Mary. The style and handling are probably Bolognese, though no precise parallel for the idiosyncratic facial types, particularly of St. Anne, has so far been adduced.

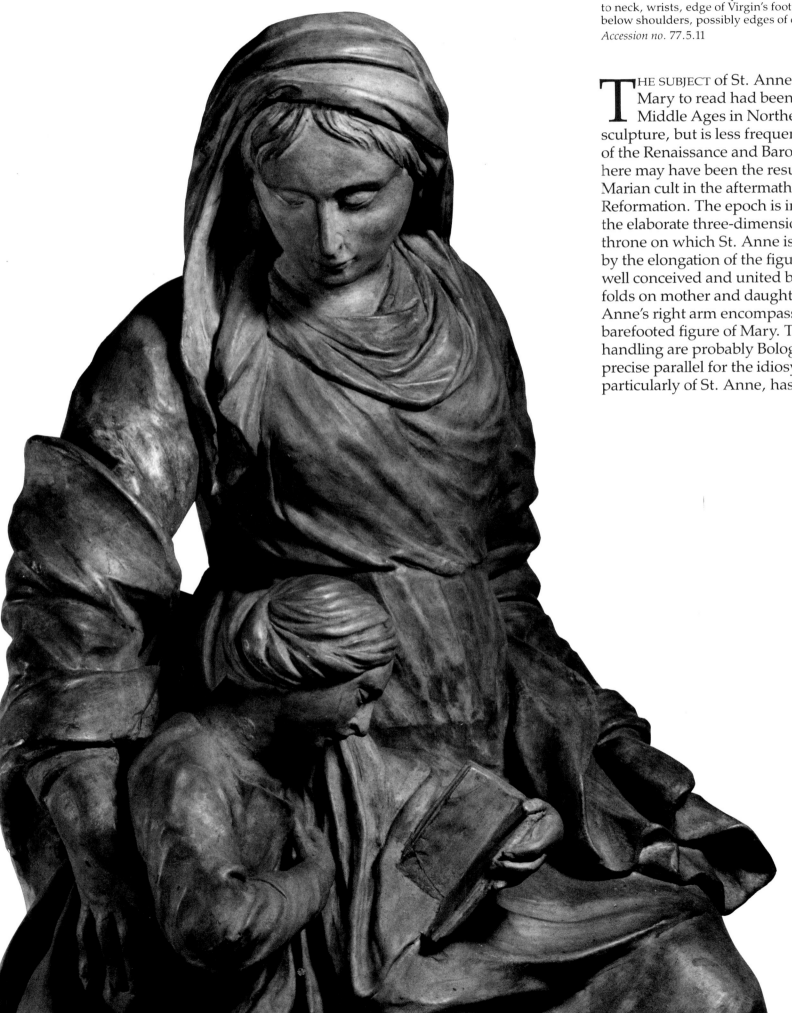

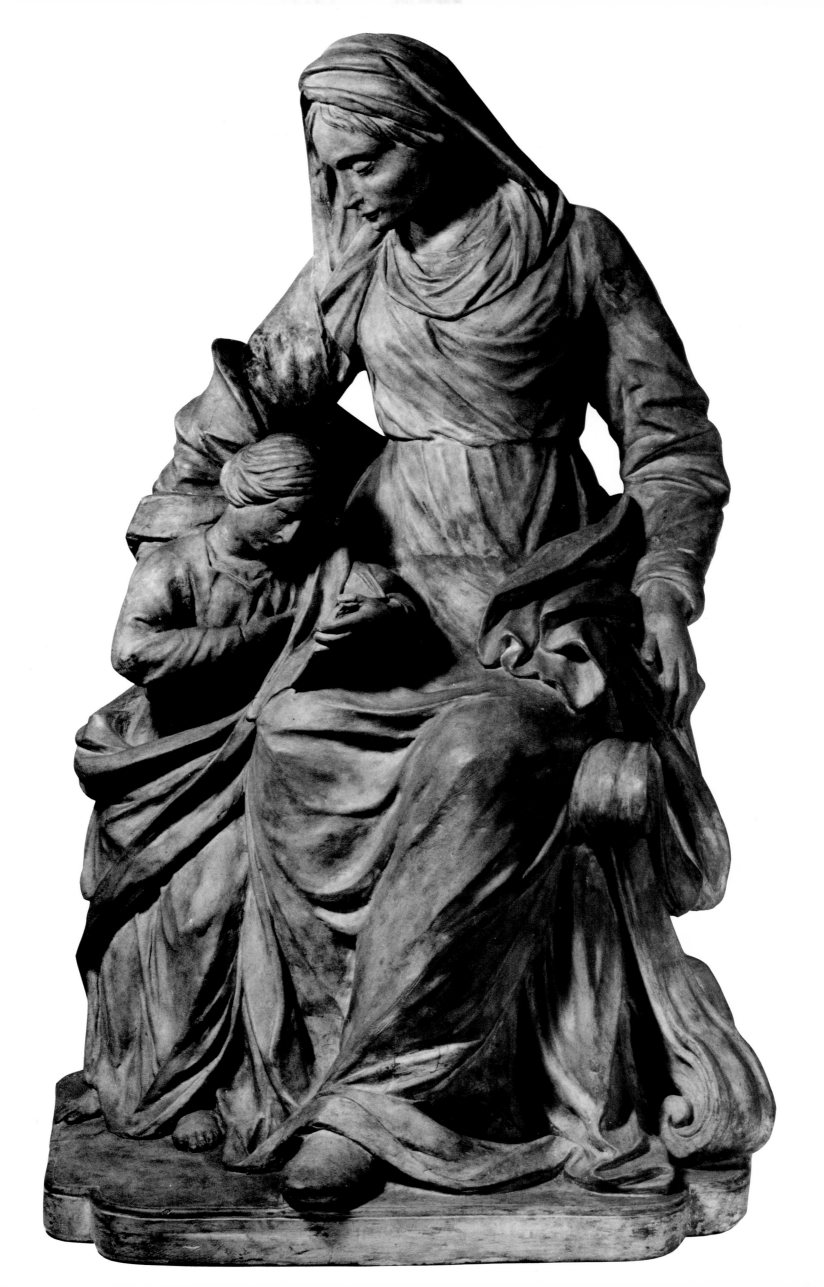

BOLOGNESE or ROMAN, 18th century

ANONYMOUS

44. *Two Bishop Saints Receiving the Palm of Martyrdom*

Terra-cotta relief.
H. 18¾ in. (47.8 cm.) W. 13⅜ in. (34.0 cm.) D. 4⅝ in. (11.8 cm.)
Condition: repairs to edge of base; bishop with back to viewer
repaired at neck and elbow; repair at top of relief, from head of
standing bishop, through *putti,* and head and wings of angel.
Accession no. 79.1.27

THE BISHOPS clad in mitres and copes, kneel at lower
right, one holding a crozier. An axe, a possible
instrument of martyrdom, appears in the lower left-
hand corner. Above, two *putti* (possibly representing their
souls) hover under the outspread wings of a guardian
angel who extends a palm branch, symbolic of martyrdom,
downwards with his left hand.

The curved top and bottom of the panel, indicating archi-
tectural mouldings, suggest that this is a sketch-model
for a relief set in the wall of a church or chapel, dedicated
to the two bishop saints who may be identified as the
illustrious St. Cyprian (ca. 200-258), bishop of Carthage, the
first African bishop to obtain the martyr's crown, and
Cornelius, elected Pope in Rome in 251.[1] St. Cyprian, a
wealthy patrician and teacher of rhetoric in Carthage, was
converted to Christianity about 246. Subsequently, he
devoted his wealth to the relief of the poor and other pious
uses and was made head of the Carthaginian church about
248. Both he and Cornelius suffered during the persecution
of Christians under the Roman Emperors.

Cornelius, under the Emperor Gallus, was imprisoned and
condemned to exile in Civitavecchia where he died in 253.
St. Cyprian, first banished to Curubis in 257 by the Emperor
Valerian, was later recalled to Carthage and beheaded in
258. The two martyrs had been friends, St. Cyprian
supporting the views of Cornelius during the Novatian
schism in Rome in 251. Both share the same feast day,
September 16, and would likely be depicted together in a
commemorative plaque receiving the palm of martyrdom.

The modelling here is fluent and vigorous. Particularly
arresting is the way in which the banks of clouds are
allowed to overlap the sides of the frame and thus protrude
physically into the spectator's space.

1. Our thanks to James Draper, Associate Curator, Department of European Sculpture and Decorative Arts, The
Metropolitan Museum of Art, New York, for suggesting this identification. For a discussion of Pope Cornelius
and St. Cyprian, see *Biblioteca Sanctorum,* Istituto Giovanni XXIII della Pontifica Università Lateranense, Rome,
vol. III, 1963, pp. 1260-1274 and vol. IV, 1964, pp. 182-190, respectively.

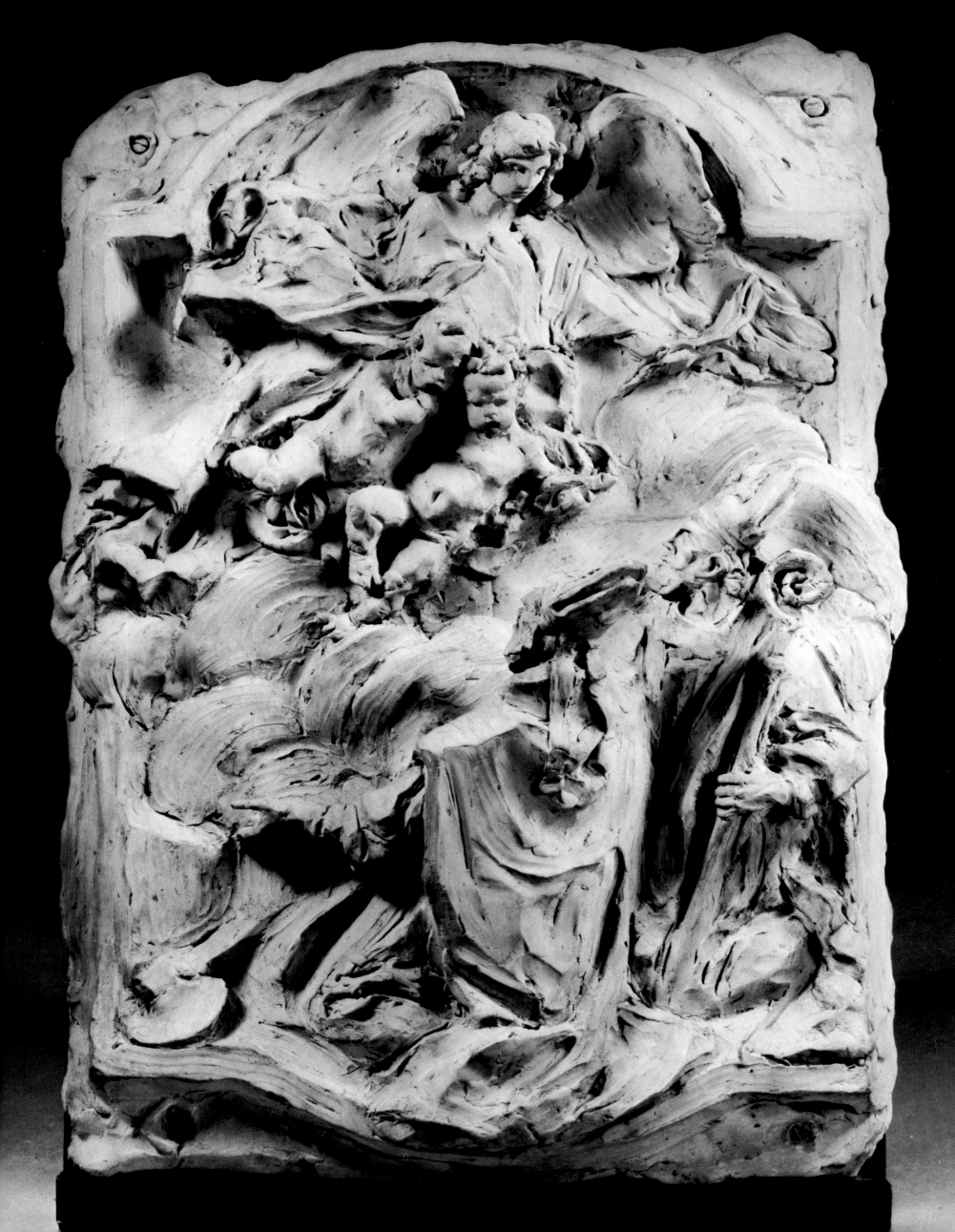

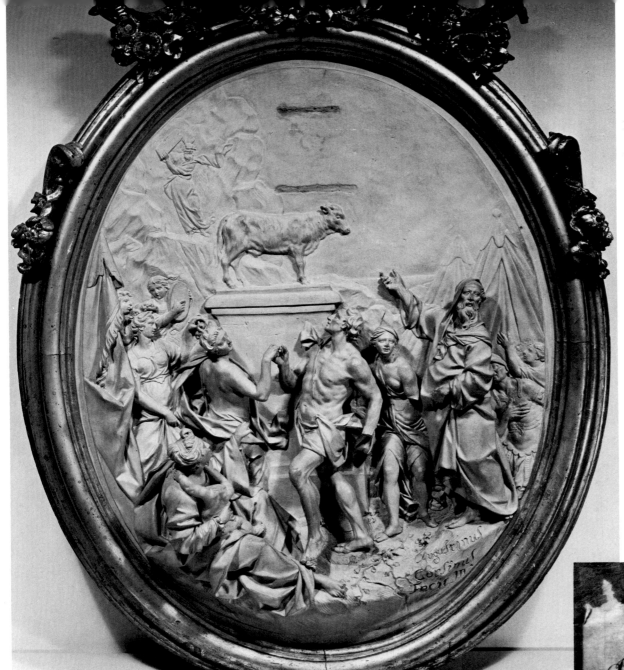

BOLOGNESE, 18th century

AGOSTINO CORSINI
(1688-1772)

Born in Bologna, Corsini worked principally in his native city and in Rome, where he modelled a figure for the Trevi Fountain (1735). In Bologna he was responsible for a statue of St. Peter on the facade of the Cathedral and for the facade sculpture of the Monte di Pietà.

45. *St. Anthony of Padua, St. Lawrence and St. Peter Adoring the Christ Child*

Terra-cotta, in contemporary, gilded wooden frame.
H. 15½ in. (39.4 cm.) W. 13 in. (33.0 cm.) D. 3 in. (7.6 cm.)
Condition: repairs on top left side of oval and lower right side; heads in relief broken and repaired at necks; extended finger of right hand of St. Lawrence repaired; chip at top of oval.
Exhibited: Heim Gallery (London), *Baroque Art for the Collector,* Autumn 1969, no. 68.
Accession no. 77.5.32

120

A CONTEMPORARY ATTRIBUTION on the back of the frame reads: "Low relief by the famous Bolognese sculptor Agostino Corsini who made—among other works in his native city and outside—the great statue of *St. Peter...* on the facade of the Cathedral and the *Immaculate Conception* now in San Petronio. He died at Naples in the 12...84 (?)."* This is consistent with the style of the relief—which shows all of the characteristics of Corsini's composition, and precise, if rather dry, execution—as revealed in his signed but not dated terra-cotta relief showing the *Worship of the Golden Calf* (fig. 1).[1]

The particular choice of saints is unusual and presumably reflects the names of one or more patrons, or a joint dedication of a chapel. The comparatively small scale suggests a domestic, devotional context.

**"Bassorilievo del celebre scultore Agostino Corsini, bolognese, che fra diversi lavori operati in patria e fuori fece la gran statua di S. Pietro... va la facciata della Metropolitana e la Concezione ora esistente in S. Petronio. Mori in Napoli nel 12...84."*
1. J. Pope-Hennessy, *Catalogue of Italian Sculpture in the Victoria and Albert Museum,* London, 1964, vol. II, p. 660, no. 705, vol. III, fig. 695.

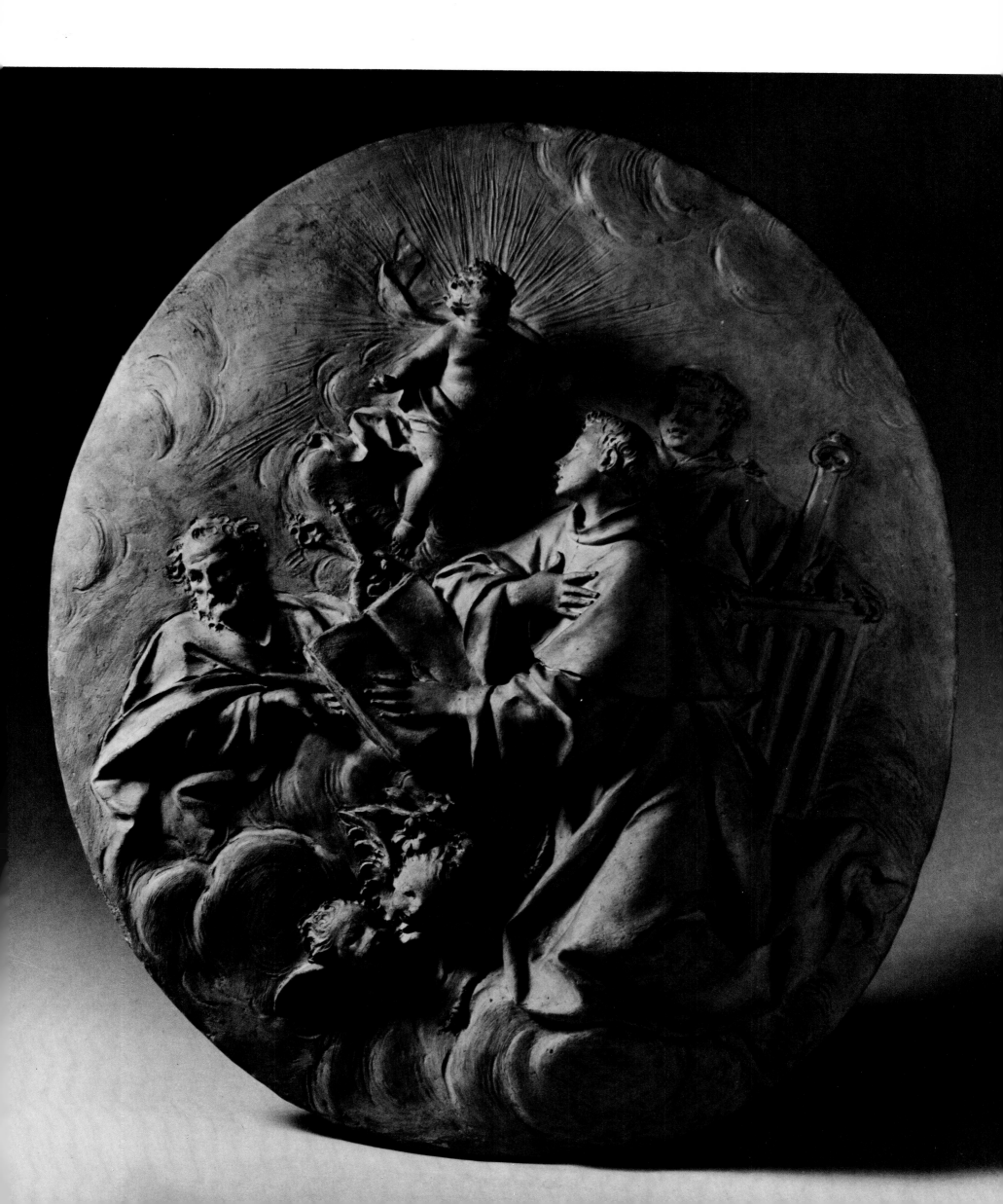

BOLOGNESE, 18th century

ANGELO GABRIELLO PIÒ
(1690-1769)
Bolognese sculptor, known also for his wax portraits.

46. *Christ on the Road to Emmaus*

Terra-cotta, ca. 1710-1718.
H. 14⅛ in. (35.9 cm.) W. 12 in. (30.5 cm.) D. 1 in. (2.5 cm.)
Condition: good, apart from minor flaking round edge, probably
caused by contact with a frame. Little finger of Christ's left
hand broken off.
Exhibited: Heim Gallery (London), *Italian Paintings and
Sculptures of the 17th and 18th Centuries*, Summer 1966, no. 74.
Accession no. 77.5.69

THE RELIEF SHOWS an episode in the New Testament story of how Jesus, after the Resurrection, made himself known to two of his disciples as they were journeying to Emmaus, a village some seven miles outside Jerusalem. He joined them incognito as they were discussing the Crucifixion and Resurrection and gave an interpretation of these events. When they reached Emmaus, Jesus appeared to be going further, but the disciples persuaded him to stop and eat with them: "When he was at table with them, he took the bread and blessed and broke it, and gave it to them. And their eyes were opened and they recognized him; and he vanished out of their sight. They said to each other, 'Did not our hearts burn within us while he talked to us on the road, while he opened to us the scriptures?'"[1]

The artist employs dramatic irony by giving Christ a halo, which can be seen only by the spectator, for according to the biblical narrative, the disciples did not recognize their master until he broke the bread at table. The moment depicted is when he appeared to be about to continue his journey and they are inviting him to join them for supper: the disciple at the left has his arm around Christ's shoulders and points to a wayside inn indicated at the left edge of the oval.

This relief would seem to belong to the artist's youth, before his stay in Rome (1718). It is closely related to similar works in the Collegiate Church of S. Giovanni in Persiceto, Bologna.[2]

1. Luke, XXIV, vv. 13-35.
2. E. Riccòmini, *Mostra della Scultura Bolognese del Settecento* (exhibition catalogue), Museo Civico, Bologna, 1965-66, pl. 56, 57.

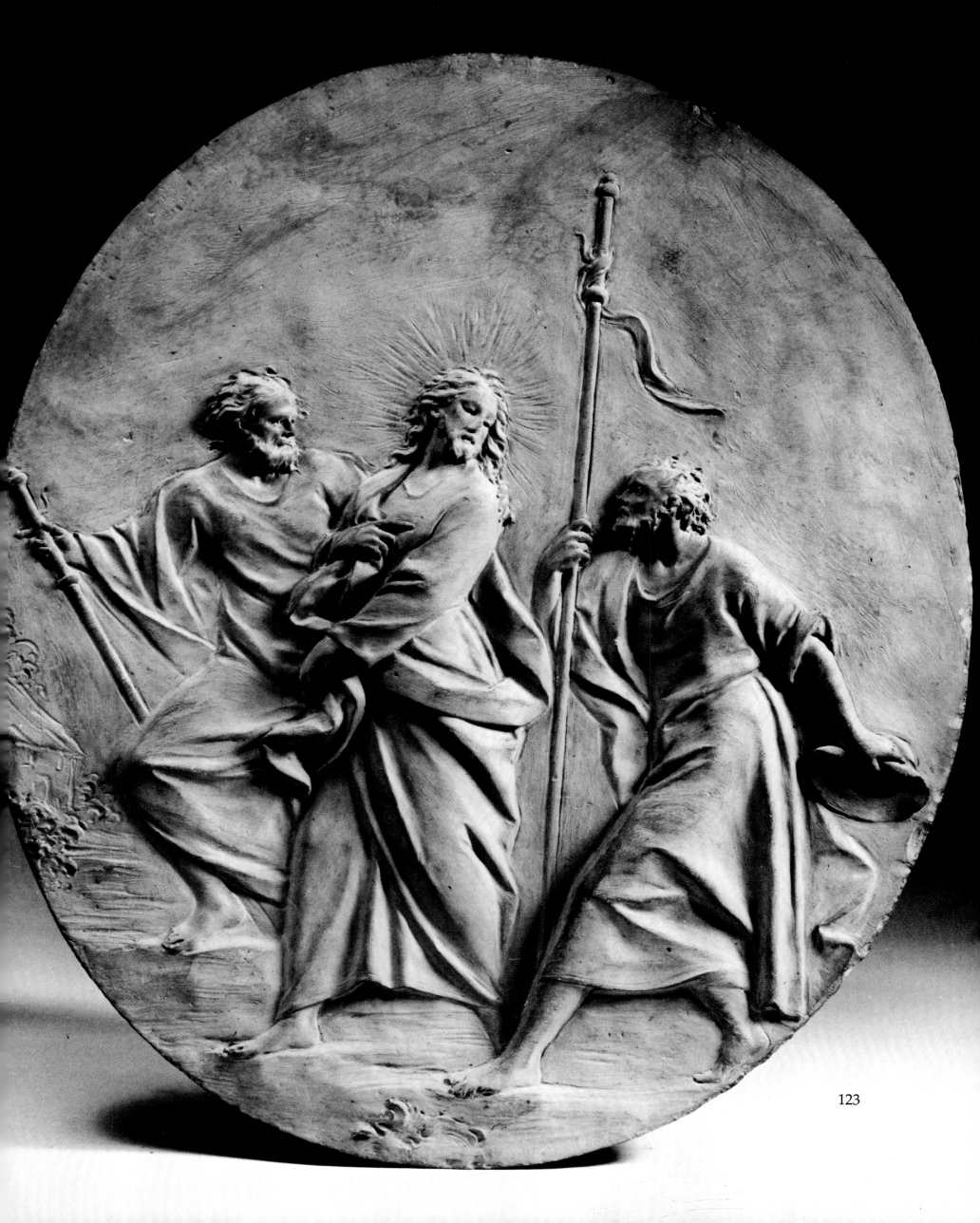

123

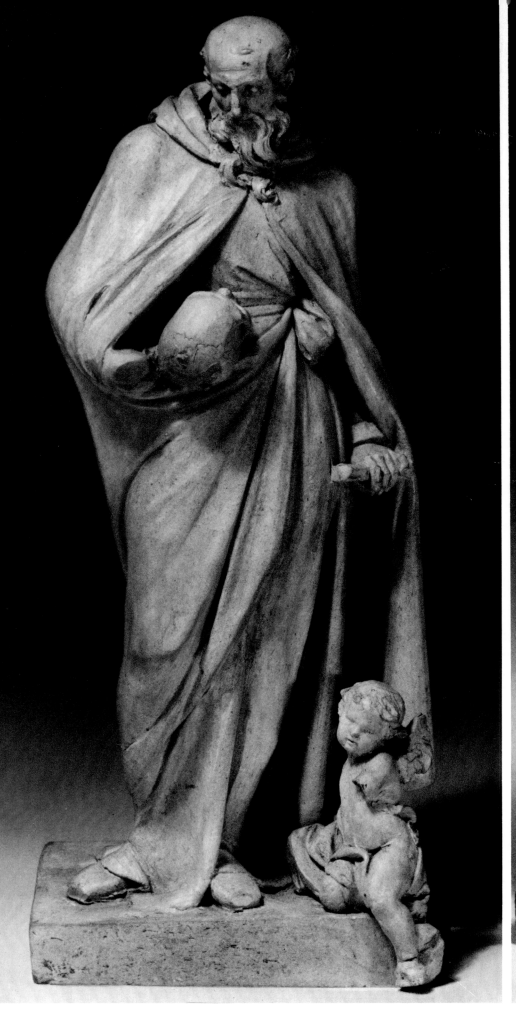

BOLOGNESE, middle of the 18th century

Circle of UBALDO GANDOLFI
(1728-1781)

124

47. *St. Romuald (?)*

Terra-cotta, middle of the 18th century.
H. 10 in. (25.4 cm.) W. 4¼ in. (10.8 cm.) D. 3¾ in. (9.5 cm.)
Condition: wing and left arm of angel broken; right hand
of the saint broken off beneath the skull.
Accession no. 77.5.37

48. *St. Petronius (?)*

Terra-cotta, middle of the 18th century.
H. 10 in. (25.4 cm.) W. 4½ in. (11.4 cm.) D. 3½ in. (8.9 cm.)
Condition: vent hole in back of neck; right foot of angel broken off;
little finger and thumb of Saint's left hand broken off.
Accession no. 77.5.36

NOTHING IS KNOWN of the provenance of this elegant pair of statuettes, which are, presumably, sketch-models for larger statues in niches (judging from their neutral backs), though they are carefully finished in themselves. Even the identity of the Saints is ill-defined: one, wearing a cope and with a mitre held by a baby angel, may be St. Petronius, Bishop of Bologna; the other, con-templating a skull and with the remains of what may be a crutch in his left hand may be St. Romuald, a Camaldolese (Benedictine) monk (ca. 952-1027), whose symbolic attributes these are. The style of the figures is suave, but monumental, and points to a Bolognese origin. Indeed, it is similar to that of Ubaldo Gandolfi,[1] as well as to that of one of his pupils, Giovanni Lipparini.[2]

1. Cf. E. Riccòmini, *Mostra della Scultura Bolognese del Settecento* (exhibition catalogue), Museo Civico, Bologna, 1965-1966, **figs.** 115, 116, 117, 118.
2. *Ibid.*, figs. 112, 113.

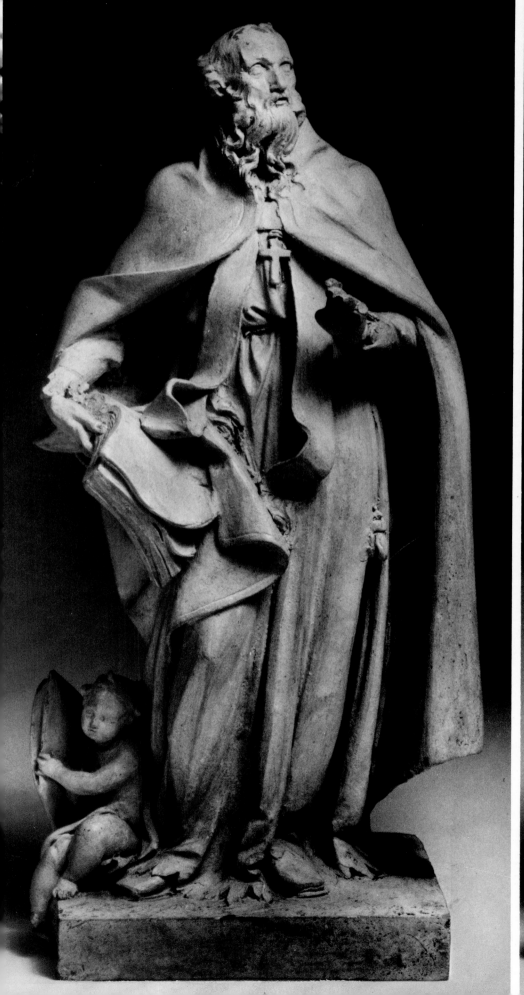

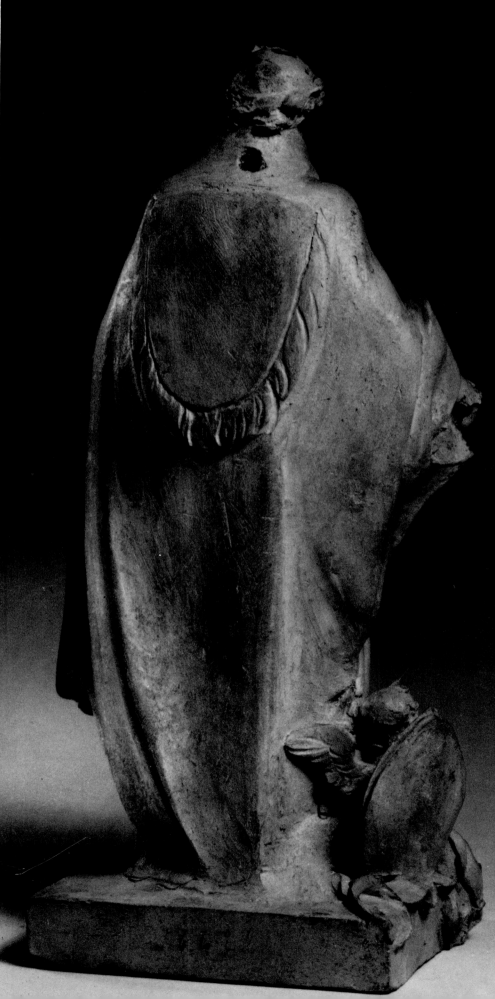

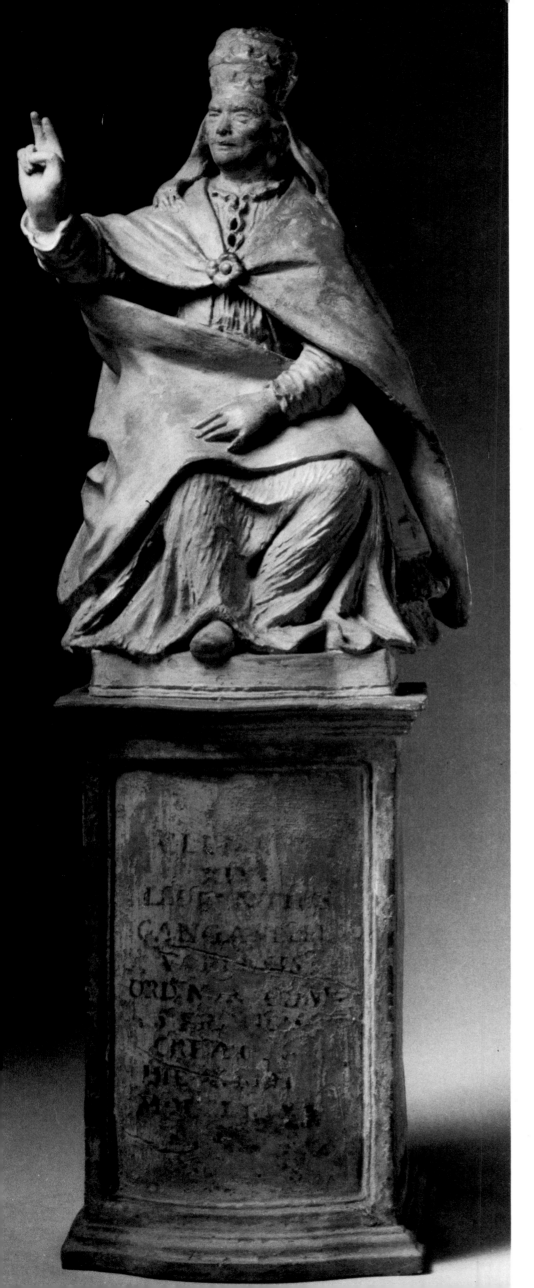

NORTH ITALIAN, second half of the 18th century

SEBASTIANO PANTANELLI
(n.d.-1792)

Pantanelli was born in Pesaro at an unknown date, and among his few recorded works is a portrait-bust of Conte Annibale degli Abati-Olivieri Giordani in the Biblioteca Olivieriana there. He produced four busts for the anatomical lecture theatre in Modena, the city where he died.

49. *Statue of Pope Clement XIV Ganganelli*
(1769-1774)

Terra-cotta, painted and partially gilded, ca. 1770.
H. 19¾ in. (50.1 cm.) W. 16¾ in. (42.5 cm.) D. 6 in. (15.2 cm.)
Condition: the raised right hand and the head have been broken and repaired; paint and gilding are flaking.
Accession no. 77.5.64

THE STATUETTE appears to be a sketch-model for the commemorative statue erected after the death of the pope in the Piazza del Municipio of S. Angelo in Vado, near Urbino, the pope's home town.[1]

1. W. Hager, *Die Ehrenstatuen der Päpste*, Leipzig, 1929, no. 72, p. 74.

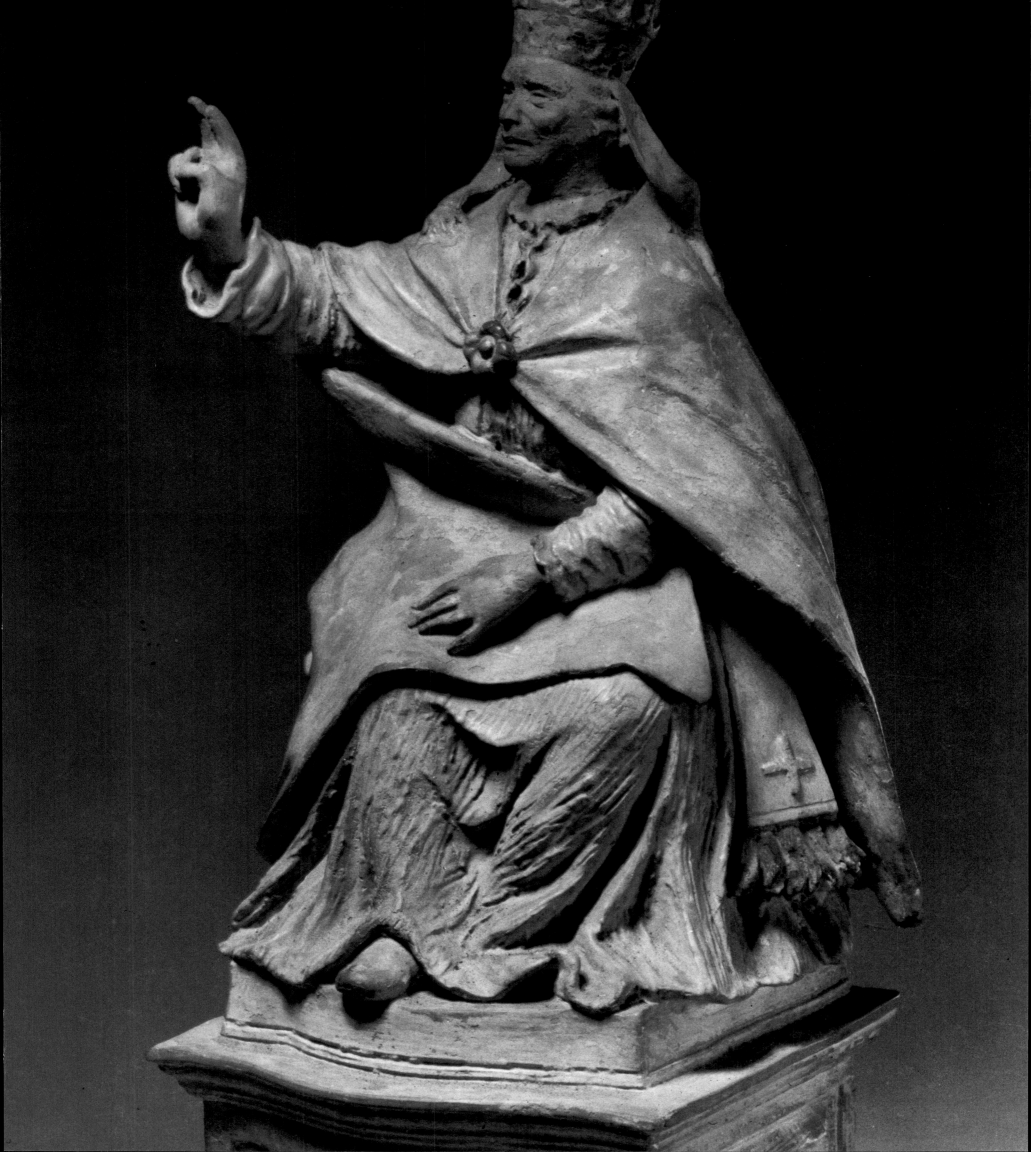

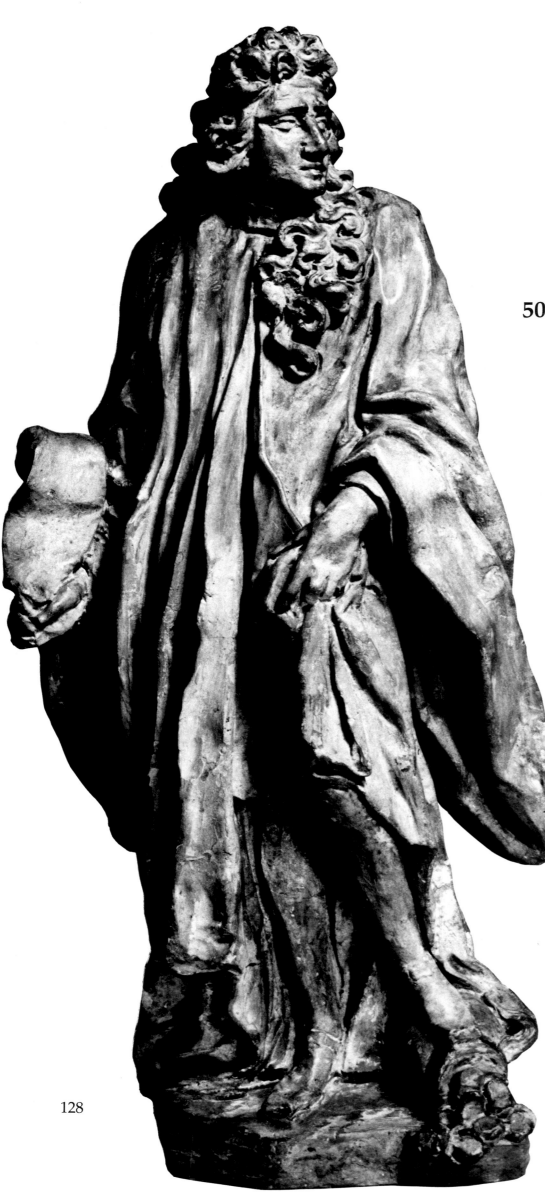

ITALIAN, second half of the 17th century

Attributed to FILIPPO PARODI
(1630-1702)

Son of a Genoese wood-carver, Filippo was a follower of Bernini. He worked in Genoa, Venice (1683) and Padua (1686-90). His masterpieces of marble carving in Padua are the Cappella del Tesoro in S. Antonio, and the Altar of the Pietà in Santa Giustina. He also produced many statues for his native city.

50. *Genoese Senator*

Terra-cruda (unfired clay) with gray paint, late 17th century.
H. 20⅜ in. (51.7 cm.) W. 9 in. (22.9 cm.) D. 5½ in. (14.0 cm.)
Condition: old repairs at neck, shoulders, below chest, across drapery and legs below knees, left and right sleeves, lower legs, wrists, ankles and base.
Accession no. 77.5.66

T HE STATUETTE, which is freely modelled in unbaked clay and has been much repaired with plaster, is presumably a sketch-model for a life-size allegorical, portrait statue. The bewigged patrician, who wears the ruff and robes of political office—in Genoa, it has been suggested—rests his left foot on an upturned cornucopia disgorging coins. Such abundance is presumably proclaimed as the result of whatever treaty or legislation is inscribed on the scroll which he is holding in his right hand. The name of Filippo Parodi (1630-1702) has been tentatively proposed as a possible author, but the statuette has certain affinities of line and sweep of pose with sculptures of the Veneto of the later 18th century. James Draper of The Metropolitan Museum of Art has suggested that although the costume and air of the figure are 17th century, the flaccid horizontal working of the clay hints at Neoclassical training.[1] It might therefore result from the generation of Antonio Canova's teachers in the late 18th century. A project in Padua to supply scores of commemorative figures in period dress for the park known as the Prato della Valle involved several sculptors of the Veneto in the 1770s and 1780s.

1. Personal communication to the author.

VENETIAN, second half of the 17th century

Attributed to ANGELO MARINALI
(1654-1701)

Angelo was a member of a family of sculptors with whom he collaborated. They were active in and around Bassano.[1] He worked also in Venice, Verona, Udine and Vicenza. He joined the sculptors' guild at Vicenza in 1681, remaining an active member until 1698.

51. *Venetian Senator*

Terra-cotta, pigmented surface.
H. 21⅝ in. (54.9 cm.) W. 11 in. (27.9 cm.) D. 9½ in. (24.1 cm.)
Condition: extensively cracked and repaired.
Exhibited: Heim Gallery (London), *Baroque Paintings, Sketches & Sculptures for the Collector,* Autumn, 1968, no. 75.
Accession no. 77.5.48

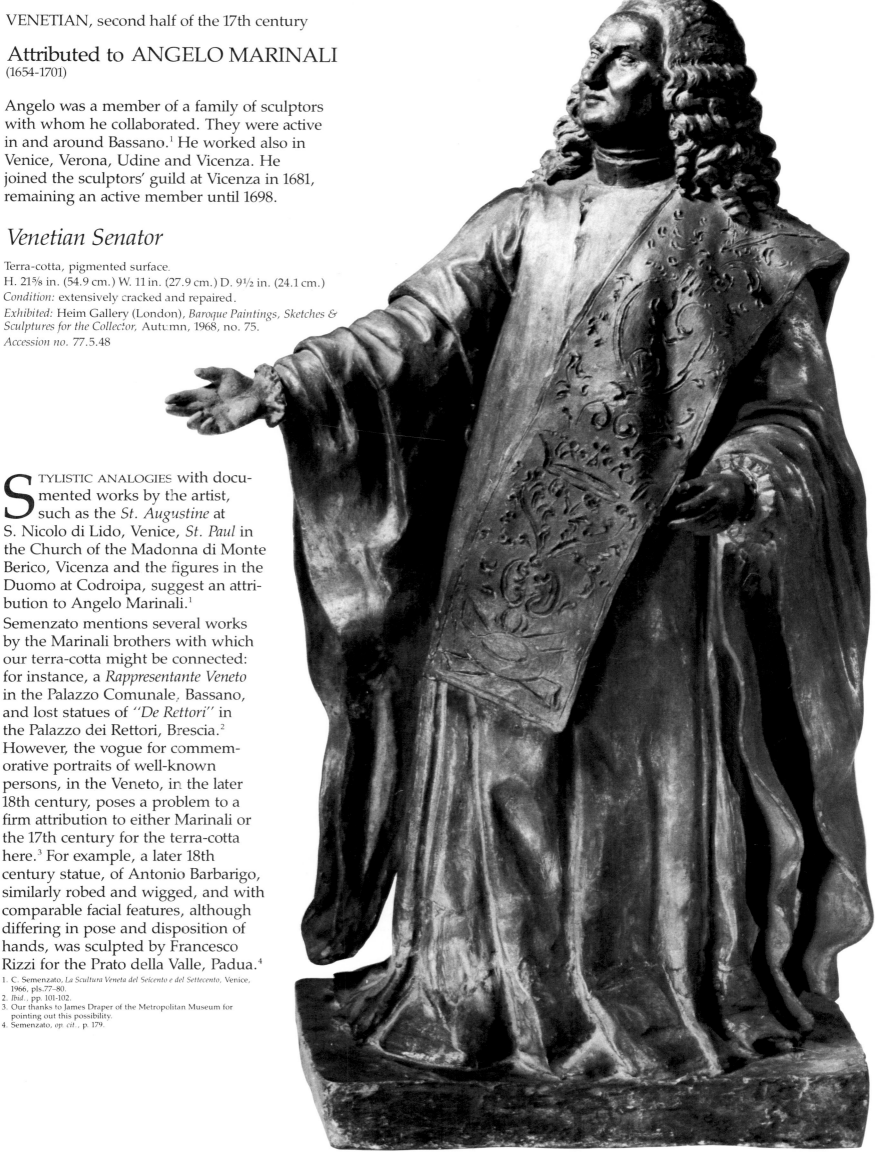

STYLISTIC ANALOGIES with documented works by the artist, such as the *St. Augustine* at S. Nicolo di Lido, Venice, *St. Paul* in the Church of the Madonna di Monte Berico, Vicenza and the figures in the Duomo at Codroipa, suggest an attribution to Angelo Marinali.[1]
Semenzato mentions several works by the Marinali brothers with which our terra-cotta might be connected: for instance, a *Rappresentante Veneto* in the Palazzo Comunale, Bassano, and lost statues of "*De Rettori*" in the Palazzo dei Rettori, Brescia.[2] However, the vogue for commemorative portraits of well-known persons, in the Veneto, in the later 18th century, poses a problem to a firm attribution to either Marinali or the 17th century for the terra-cotta here.[3] For example, a later 18th century statue, of Antonio Barbarigo, similarly robed and wigged, and with comparable facial features, although differing in pose and disposition of hands, was sculpted by Francesco Rizzi for the Prato della Valle, Padua.[4]

1. C. Semenzato, *La Scultura Veneta del Seicento e del Settecento,* Venice, 1966, pls.77–80.
2. *Ibid.,* pp. 101-102.
3. Our thanks to James Draper of the Metropolitan Museum for pointing out this possibility.
4. Semenzato, *op. cit.,* p. 179.

NEAPOLITAN, late 17th to early 18th century

LORENZO VACCARO
(1655-1706)

Son of a Neapolitan lawyer, Vaccaro turned from studying law to architecture. He became the pupil of the most outstanding sculptor-architects in Naples, Cosimo Fanzago and Dionisio Lazzari, although he preferred monumental statuary to decorative, architectural work.

Most noteworthy are his monument of Francesco Rocco in Naples Cathedral; the over-life-size stucco figures of the *Emperor Constantine* and *St. Helena* in San Giovanni Maggiore; *St. Jerome* and the *Blessed Pietro da Pisa* (1687-1702) in S. Maria delle Grazie at Caponapoli; four marble statues (1687) in the Congrega dei Morticelli at Fogga; and the *Divine Grace* and *Providence* (1705-06) in the Certosa di San Martino. Vaccaro also produced models for silversmiths, such as the *Four Continents* in Toledo Cathedral (1692-95), worked often in stucco and made an equestrian bronze statue of King Philip V of Spain. His chief inspiration was his close friend and contemporary, the painter Francesco Solimena (1657-1747), for whom he made many models to paint from. In exchange, Solimena gave him painted sketches, which influenced Vaccaro in his eloquent poses, gestures and ample draperies.

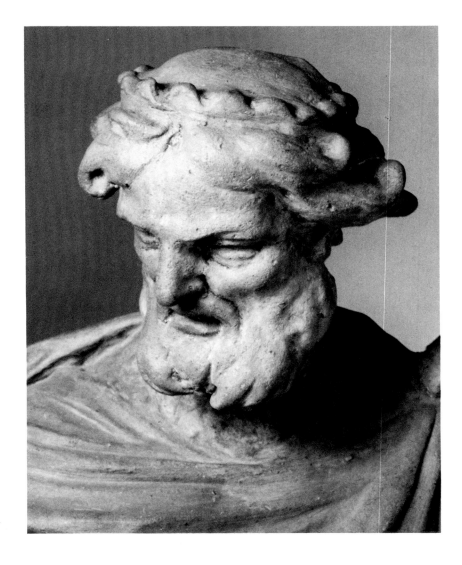

Fig. 1. Vaccaro, *King David*, marble, San Ferdinando, Naples.

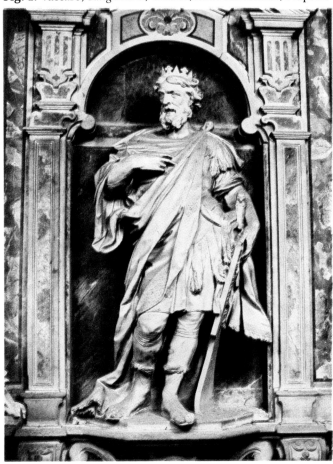

52. *King David*

Terra-cotta, ca. 1705.
H. 16¾ in. (42.6 cm.) W. 8¼ in. (20.9 cm.) D. 4¾ in. (12.1 cm.)
Condition: repaired breaks at neck, right arm and wrist, and left arm.
Exhibited: Heim Gallery (London), *Faces and Figures of the Baroque*, Autumn 1971, no. 74 (as Rusconi).
Accession no. 77.5.88

As HAS BEEN recently demonstrated by Dr. Andrew Ciechanowiecki, the statuette is a sketch-model for the splendid marble statue of *King David* in the church of S. Ferdinando in Naples (fig. 1).[1] The story of this commission is complex but well documented.[2] It was awarded to Vaccaro by the Jesuits, and when he was murdered on August 10, 1706, the *David* was nearing completion. Lorenzo's patrons turned to his 25-year-old son, Domenico Antonio, to finish the statue, and it turned out so successfully that the latter was entrusted with the pendant figure of *Moses*. The finished marble is about 265 cm. high and differs from this sketch in its degree of elaboration, in the angle of the head, and in details such as the clothing of the legs and the harp resting on the ground at the figure's left side.

1. A. Ciechanowiecki, "A Bozzetto by Lorenzo Vaccaro," *The Burlington Magazine*, CXXI, 1979, figs. 81, 82, pp. 252-253.
2. B. de' Dominici, *Vite de' Pittori, Scultori, ed Architetti Napoletani*, III, Naples, 1742, p. 482.

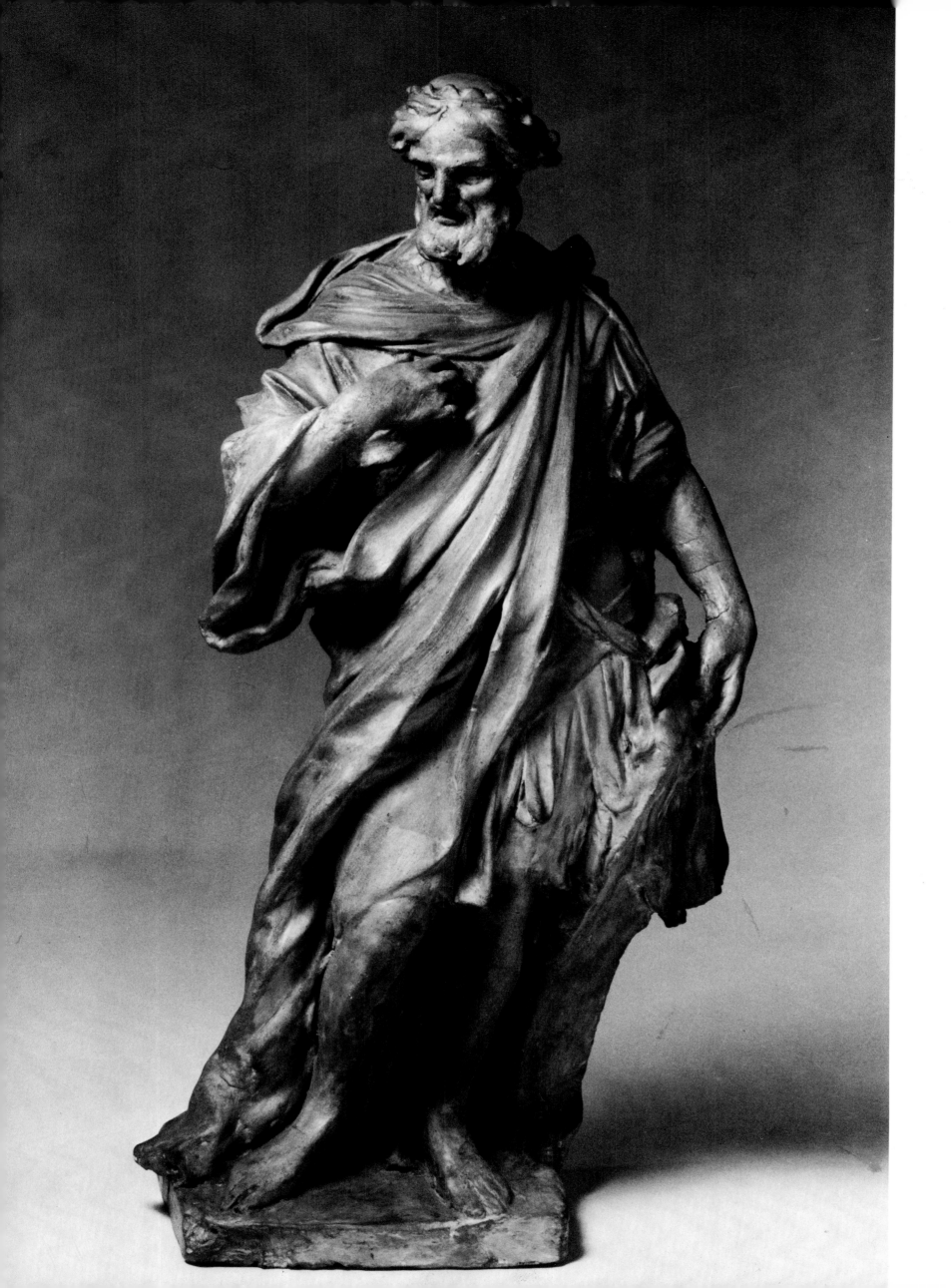

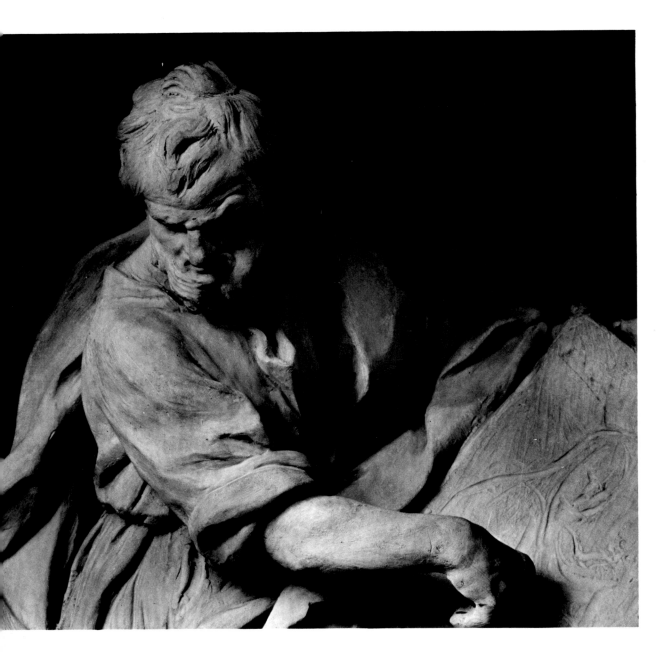

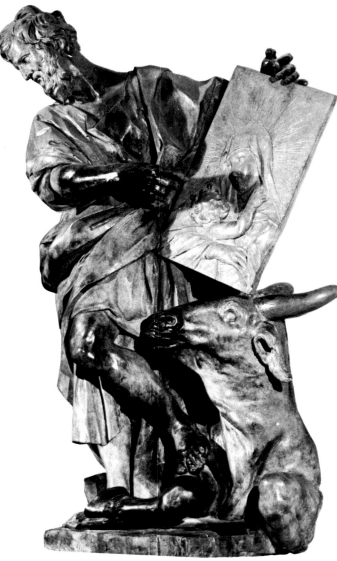

Fig. 1. Papaleo, *St. Luke*, carved wood, National Museum, Valletta, Malta.

SOUTH ITALIAN, late 17th century

PIETRO PAPALEO
(ca. 1642-ca. 1718)

Pietro Papaleo was a sculptor and medallist born in Palermo, Sicily, but active in later life chiefly in Rome, where he became a member, in 1695, of the Academy of St. Luke and, in 1707, of the Congregazione dei Virtuosi. Statues by him are recorded in Santa Maria della Scala (*St. John of the Cross*) and in San Sebastiano fuori le mura (*St. Fabianus*), as well as stucco decorations in S. Maria di Montesanto and in the Vatican (Galleria delle Carte Geografiche). In 1699 he delivered a model of angels to decorate the Chapel of St. Ignatius in the Gesù di Roma.[1]

53. *St. Luke*

Terra-cotta, prior to 1695.
H. 19½ in. (49.5 cm.) W. 12¼ in. (31.1 cm.) D. 9¾ in. (24.7 cm.)
Condition: repaired breaks at both wrists and several fingers; the saint's neck; right foot and corner of base; the bull's horn and ears.
Accession no. 77.5.65

THIS VIVACIOUS and brilliantly modelled sketch depicts the Evangelist St. Luke (with his symbol, the bull) showing a panel on which he has painted the Virgin and Child. St. Luke was traditionally supposed to have been a painter and was normally chosen as the patron of guilds of artists, as in the case of the Roman Academy of St. Luke.

The statuette was identified recently by Dr. Jennifer Montagu[2] as a sketch-model for a monumental wooden statue now in the National Museum, Valletta, Malta (fig. 1). According to John A. Cauchi, formerly curator at the National Museum, the latter was commissioned for St. Paul's Grotto in Rabat. This is documented in the archives of the Valletta Cathedral as having been carved by a sculptor with the surname Papaleo.[3]

1. Thieme-Becker, *Aligemeines Lexikon der Bildenden Künstler*, Leipzig, XXVI, 1932, p. 217; R. Enggass, *Early Eighteenth Century Sculpture in Rome*, University Park and London, 1976, vol. I, pp. 73-76, citing earlier literature.
2. Personal communication to the author.
3 Canon Reverend John Azzopardi of Malta "Il-Krisja Ta' S. Pawl tar-Rabat fis-1680," *Il Festa Taghna*, 1980 (footnote 7), mentions the terra-cotta here as correctly attributed to Pietro Papaleo who is identified in document no. 2 in the article as the sculptor of the wooden statue (fig. 1 above). Our thanks to Dr. Carolyn Newmark for making this information available.

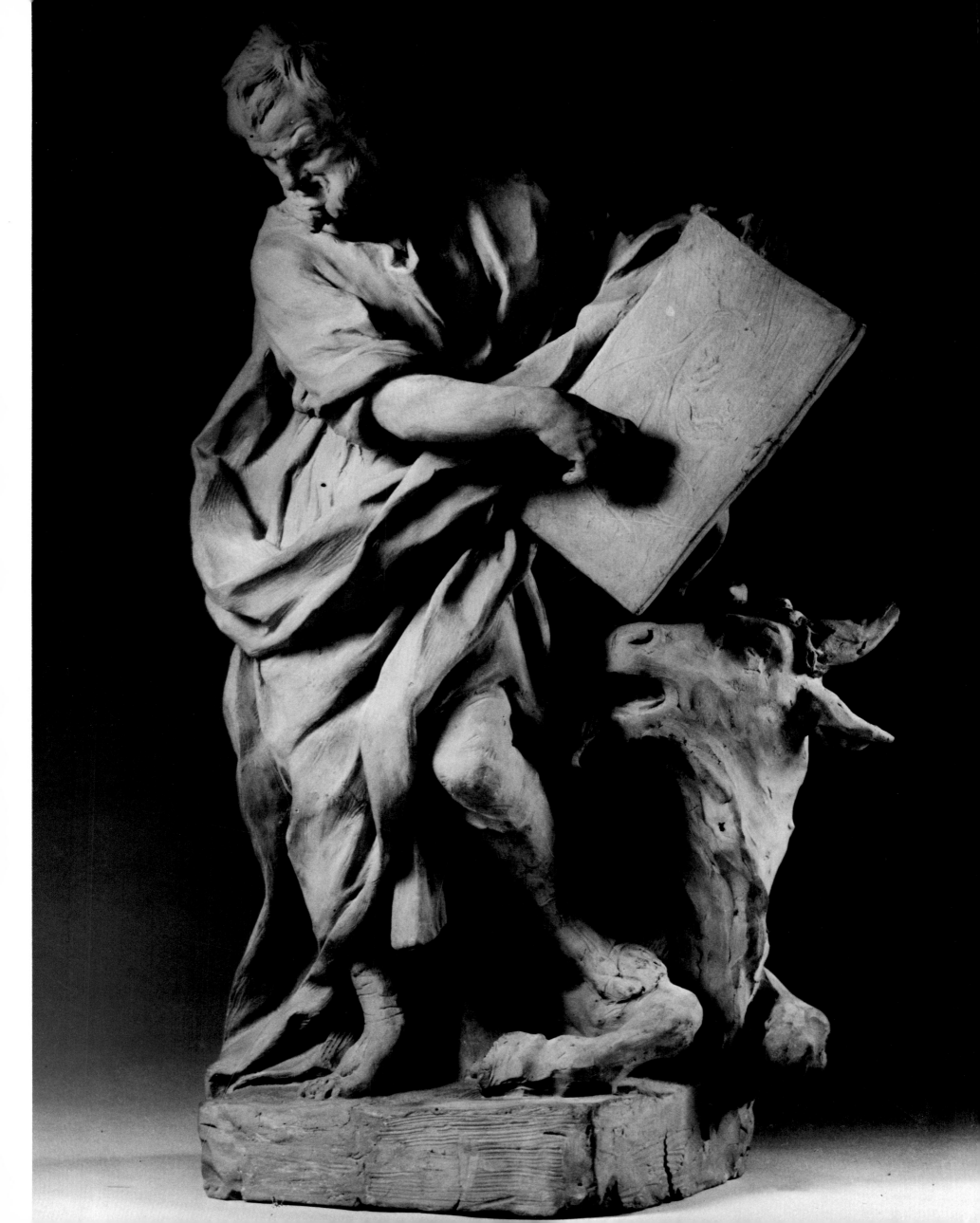

ANONYMOUS

54. *Sketch-Model for a Wall Monument with a Figure of Charity*

Terra-cotta with slip.
H. 13⅝ in. (34.6 cm.) W. 8¾ in. (22.2 cm.) D. 2⅞ in. (7.3 cm.)
Condition: side of baby's face at *Charity*'s shoulder broken off. Feet and right hand of attendant figure in lower right of niche broken off; right foot and left hand of left niche figure broken off.
Accession no. 77.5.19

THE STYLE of the figures and the design of the sarcophagus are distinctly Neo-Classical and recall the work of the Florentine sculptor Lorenzo Bartolini (1777-1850). The focal group, an allegory of *Charity*, indeed recalls Bartolini's *La Carità Educatrice* of 1817-24 for which a plaster survives in the Gipsoteca of Prato and a marble in the Galleria Palatina in the Pitti Palace, Florence.[1] However, the integration of distinctly Renaissance motifs into the design of the tomb is not characteristic of Bartolini and suggests a later phase in the evolution of Italian 19th century sculpture: the round-headed arch with flanking pilasters, all covered with foliate ornament, combined with plain rectangular panels behind the principal figure, recalls Florentine "humanist" tombs by Desiderio da Settignano, Bernardo Rossellino or Mino da Fiesole.[2] The outer frame of rusticated masonry also recalls the Quattrocento, but is derived from the external architecture of a typical Renaissance *palazzo*. The combination of such disparate elements is skilfully managed and bespeaks a well-educated and sensitive designer, probably with a Florentine background in the circle of Bartolini.

1. Palazzo Pretorio, *Lorenzo Bartolini* (exhibition catalogue), Prato, 1978, no. 10.
2. C. Avery, *Florentine Renaissance Sculpture*, London/New York, 1970, figs. 75, 80, 85 and 96.

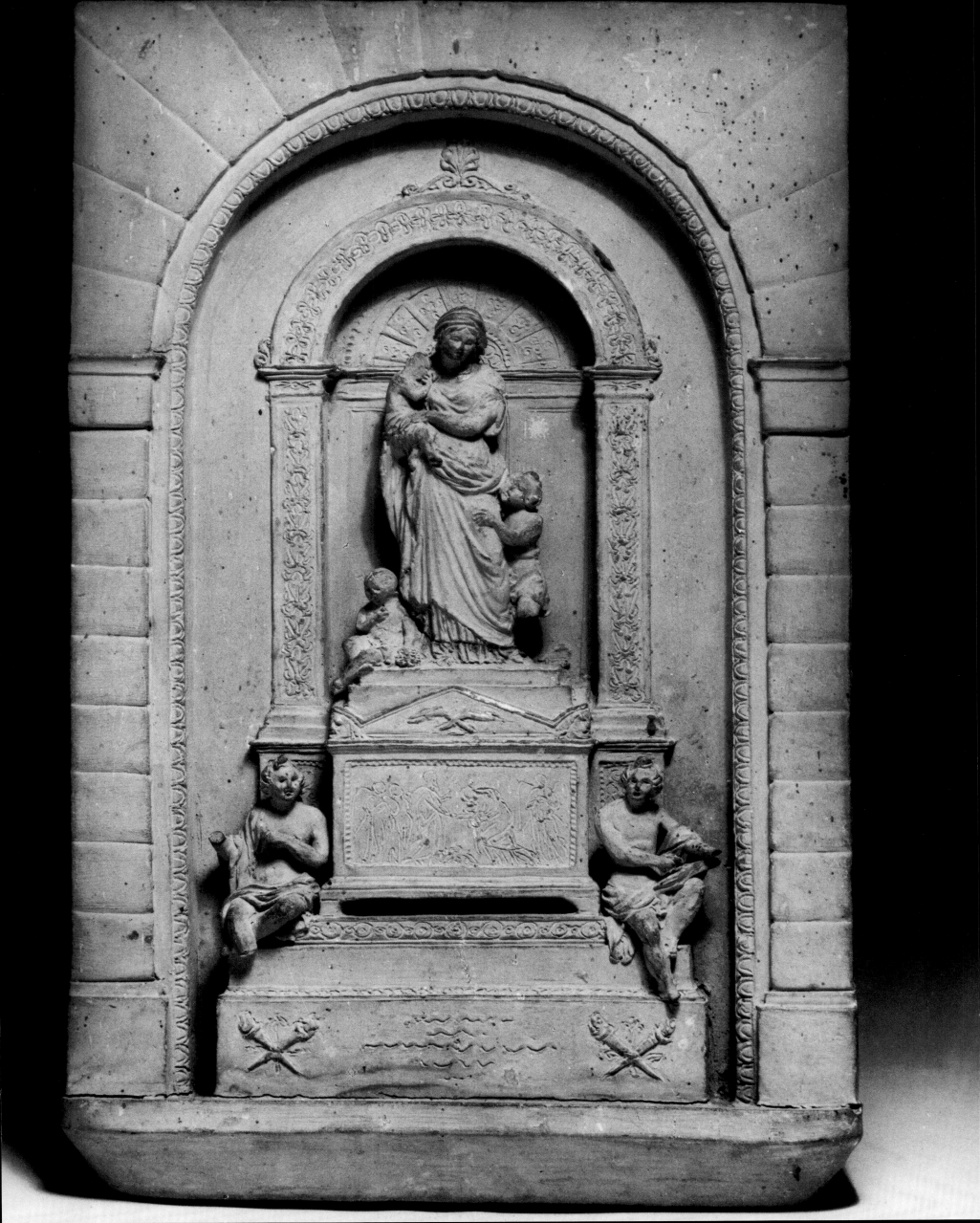

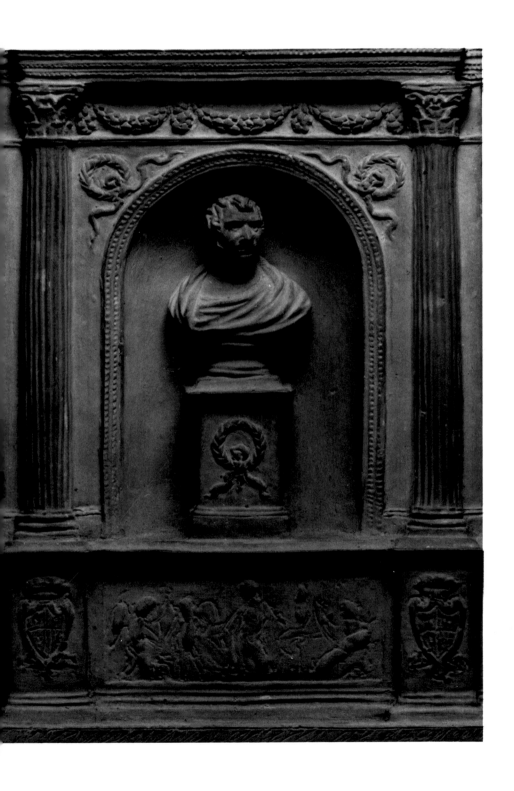

FLORENTINE, mid-19th century

ANONYMOUS

55. *Sketch-Model for a Wall Monument with a Male Portrait-Bust*

Terra-cotta with slip.
H. 13⁵⁄₁₆ in. (33.8 cm.) W. 7⅞ in. (20.0 cm.) D. 2½ in. (6.4 cm.)
Condition: chips to top of roof of niche, top left edge and
left edge of base.
Accession no. 77.5.20

THIS SKETCH-MODEL is a companion piece to no. 54 and is patently by the same hand.[1] It is less obviously eclectic in inspiration, consisting of a classical aedicula interpreted in the late 18th century manner, without many signs of Grecian, or indeed Italian Renaissance, motifs. Most of Bartolini's wall-monuments are close to Athenian funeral *stelae* (tombstones) in design and spirit. The hairstyle of the deceased with a central lock of hair falling over the forehead is to be found in many of Bartolini's portraits,[2] as is the asymmetrically draped toga round the shoulders.[3] The subject was aristocratic, judging from the coats-of-arms surmounted with coronets, and interested in music and/or poetry, judging from the lyre which decorates the pediment. The narrative or allegorical relief below is rendered so sketchily as to be hard to interpret.

1. For an indication of its authorship, see cat. no. 54.
2. Palazzo Pretorio, *Lorenzo Bartolini* (exhibition catalogue), Prato, 1978, nos. 1, 3, 4, 5, 9, 12, etc.
3. *Ibid.,* no. 3.

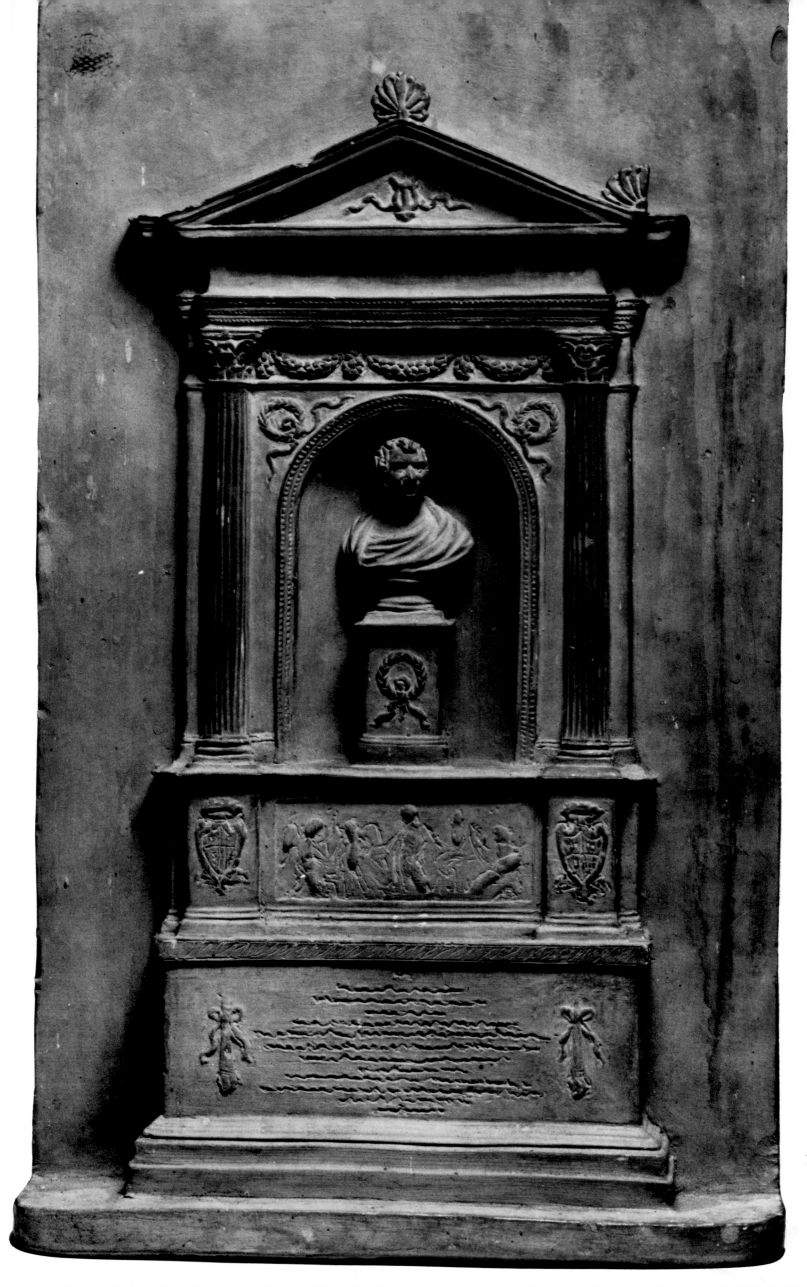

137

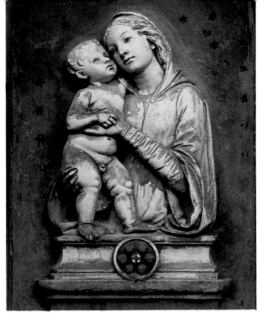

Fig. 1. Luca della Robbia, *Via della Scala Madonna*, glazed terra-cotta, Florence.

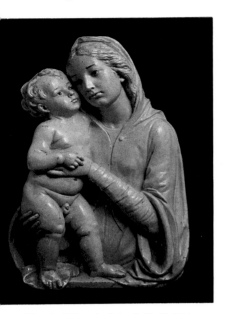

Fig. 2. School of A. della Robbia, *Madonna and Child*, terra-cotta, white glaze, Museum of Fine Arts, Boston.

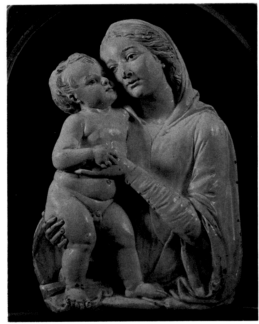

Fig. 3. Replica, terra-cotta, white glaze, Wallace Collection, London.

FLORENTINE, early 19th century (?)[1]

After ANDREA DELLA ROBBIA
(1435-1525)

Andrea, a nephew of Luca della Robbia, who had invented the medium of tin-glazed terra-cotta, trained under him, matriculating in the Guild of Stonemasons and Carpenters (*Arte dei Maestri di Pietra e Legname*) in 1458. Luca died in 1482 and, subsequently, Andrea took over the manufactory, employing several brothers. The bulk of Andrea's work is to be found in Florence and Tuscany, where he was particularly patronized by the Franciscan Order.[2]

56. *Virgin and Child*

Relief in tin-glazed terra-cotta.
H. 19 in. (48.3 cm.) W. 14¼ in. (36.2 cm.) D. 4¼ in. (10.8 cm.)
Condition: the relief has been repaired below the Virgin's left elbow, at the level of the Christ Child's knees and the index finger of her right hand. Otherwise it is in excellent condition.
Accession no. 77.5.76

138

THIS TERRA-COTTA is only partially glazed, with the flesh parts and hair left bare. The Virgin's cloak is the traditional blue, with an apple-green lining revealed inside the sleeves and hood, yellow trimmings at cuffs and neck, a yellow button and a purple tunic. The glaze is thick and homogeneous. As is normal, the relief is hollowed out behind to achieve a relatively uniform thickness to assist even firing. The composition is known as the *Via della Scala Madonna*, from a primary example located in Florence (fig. 1).[3] That example is mounted as a street tabernacle on the corner of Via della Scala and the Via Oricellari in the wall of a palace built in 1498 for Bernardo Rucellai, who had married Nannina, a sister of Lorenzo ("the Magnificent") de' Medici. It bears on its elaborate plinth, also of glazed terra-cotta, the arms of the Medici combined with the Croce del Popolo (the arms of the Republican party).

A. Marquand states: "In composition this Madonna follows the one in the Piazza dell' Unità, but is farther removed from the master's hand. The single button, the absence of slashes on the sleeves, and at least the upper portion of the base or pedestal are preserved in replicas at Duveen's, Castro, Boston Museum (fig. 2), Wallace collection (fig. 3), Cambridge and Faenza."[4]

Of these, the majority are glazed white all over, with only touches of violet in the eyes and eyebrows, while some have haloes added. The last one, however, in the Pinacoteca Comunale at Faenza, is glazed with colours identical to those in the present example (fig. 4).[5] Another similar, partially glazed, example was formerly in the Raoul Tolentino collection.[6] The introduction of a wider palette of colours and the technique of partial glazing, leaving flesh areas to be painted more naturalistically than was feasible by glazing them white, is generally regarded as characteristic of the workshop and followers of Andrea della Robbia, during the first quarter of the 16th century.

1. Oxford Research Laboratory for Archaeology and the History of Art, *Report on Thermoluminescence Analysis*, sample no. 281q80: less than 120 years old. Further study is intended in order to determine if repairs undertaken in the last 100 years may have prevented a proper dating by thermoluminescence testing.
2. J. Pope-Hennessy, "Thoughts on Andrea della Robbia," *Apollo*, CIX, March, 1979, pp. 176-197.
3. A. Marquand, *Andrea della Robbia and His Atelier*, Princeton, 1922, II, no. 302, p. 166f.
4. *Ibid.*, I, no. 87, fig. 97. pp. 128-129.
5. *Ibid.*, II, no. 308, p.170; personal communication, Dott. Arch., Ennio Golfieri, honorary curator, Pinacoteca Comunale, Faenza, February 6, 1979.
6. H. Townsend, cataloguer, *The Rare Artistic Properties Collected by the Connoisseur Signor Raoul Tolentino* (auction catalogue), American Art Association, New York, April 21-24, 26, 27, 1920, Lot 869, formerly in the Wilkins collection, Florence.

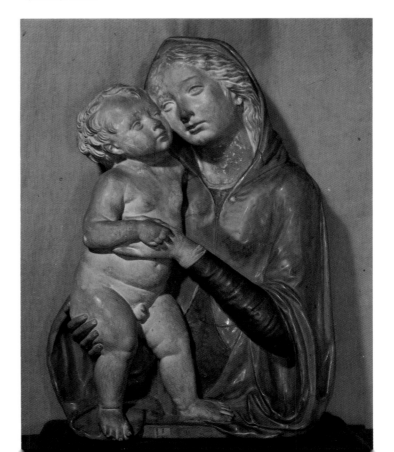

Fig. 4. Replica, polychrome terra-cotta, Pinacoteca Comunale, Faenza.

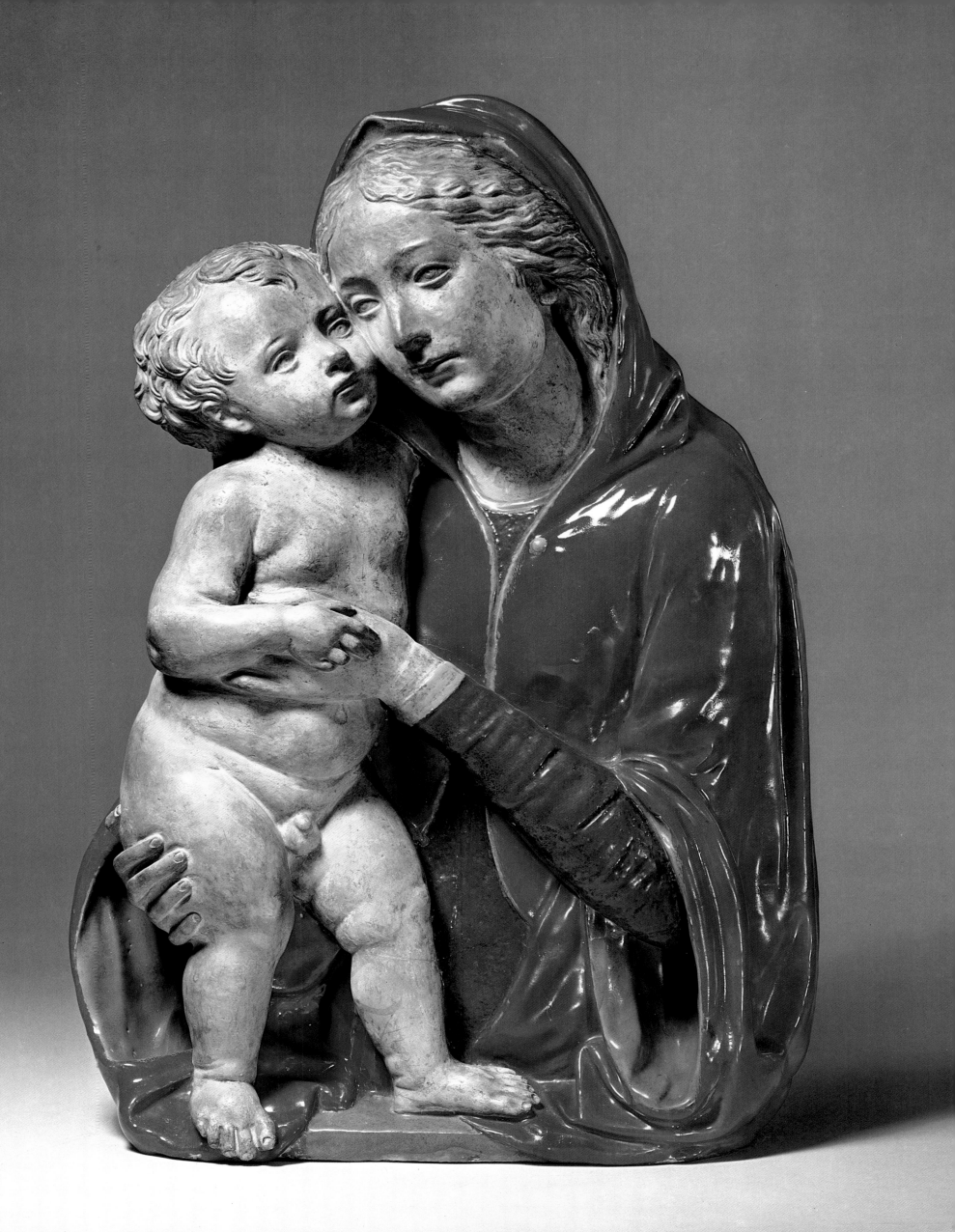

ROMAN, late 19th century

ERCOLE ROSA
(1846–1893)

Son of a *scalpellino* (stone-mason), Rosa learned the art of sculpture first from his father, modelling figures for Christmas cribs in terra-cotta. Later he went to Rome and worked in various studios, being particularly influenced by Vincenzo Vela and Giovanni Dupre. His first success was a monument to the Carioli brothers on the Pincian (1873–1883); he then provided narrative reliefs for the equestrian monument by Ettore Ferrari to King Vittorio Emanuele II in the Cathedral Square, Milan (1879–93); Rosa also produced a number of other portraits, monuments and allegorical statues.[1]

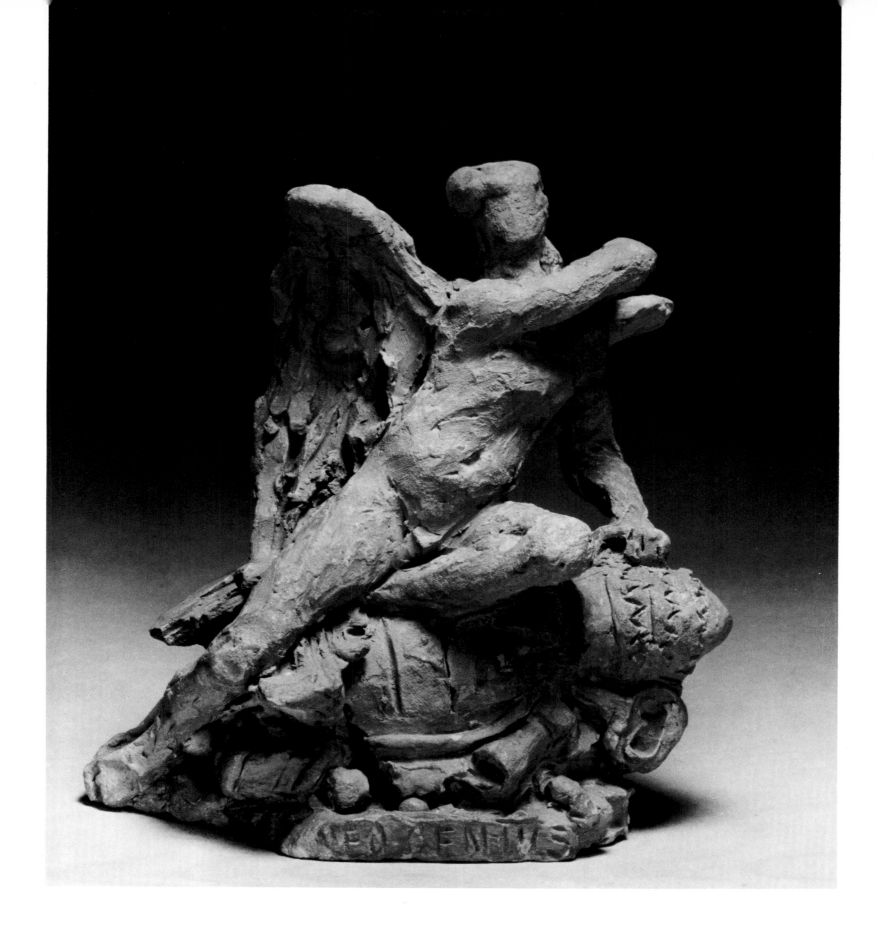

57. *Genius of the Papacy*

Terra-cotta, late 19th century.
Signed: "LEO GENIUS" inscribed on base.
H. 7⅛ in. (18.2 cm.) W. 6 3/16 in. (15.8 cm.)
D. 4 ⅜ in. (11.1 cm.)
Condition: minor repairs throughout; piece of lower left wing broken off.
Accession no. 79.1.7

THE COMPOSITION shows a winged nude male figure in a dynamic pose seated on a trophy consisting of emblems of the papacy, including at the right the triple tiara and symbolic keys of St. Peter. On the shaped architectural plinth below are inscribed the words 'LEO GENIUS', presumably referring to a Pope of that name.

The type of composition suggests that the sculpture was destined to decorate a monument, or perhaps the roof-line of a building.

1. Thieme-Becker, *Allgemeines Lexikon der Bildenden Künstler*, XXVIII, Leipzig, 1934; *Enciclopedia Italiana*, XXX, Milan, 1936.

141

ROMAN, late 19th century

ETTORE FERRARI
(1845–1929)

Born in Rome, son of the sculptor Filippo Ferrari (1819-1897), Ettore learned the rudiments of painting and sculpture from his father. He then went to university, later joining the Academy of St. Luke, winning a scholarship with his *Return of the Prodigal Son* in 1869. He won a prize at Turin in 1880 with his tragic group entitled *Cum Spartaco Pugnavi.*

Thereafter he received many official commissions from the court of Savoy. He produced many public monuments, such as the equestrian monument to King Vittorio Emanuele II in Venice (1887), the statue of Giordano Bruno in Campo dei Fiori, Rome (1883), and Garibaldi memorials in Rovigo (1897), Ferrara, Macerata, Pisa, Cortona and Vincenza. He also produced numerous portrait-busts and monuments for private patrons. For the United States he carved the marble statue of President Lincoln, in The Metropolitan Museum of Art, New York, a monument to Giuseppe Verdi in Philadelphia and to A. Meucci on Staten Island, N.Y. (1923). He held important official posts in the fine arts "establishment" in Rome, as well as being Professor of Sculpture and President of the Academy of Fine Arts.

Ferrari was also politically active as a socialist in the Chamber of Deputies between 1882 and 1892; was a councillor and assessor of the City of Rome and, from 1904 to 1918, Grand Master of the Freemasons of Italy. These public activities exposed his sculpture to exaggerated praise and criticism.[1]

58. *Monument with Angel and Two Mourners*

Terra-cotta, late 19th century.
Signed: monogrammed ₤2650 on the left of base on which angel is standing.
H. 12½ in. (31.8 cm.) W. 9⁷⁄₁₆ in. (24.1 cm.) D. 5½ in. (14.0 cm.)
Condition: extensive repairs throughout.
Provenance: said to have come from the sculptor's studio.
Accession no. 79.1.9

THE MONUMENT is in the late Neo-Classical style with massive architectural elements of abstract shape and three idealized, allegorical figures set off against it, framing a brief inscription in the centre. The angel above is self-explanatory, while the more active and earthly figures below might be taken to represent Industry with cogwheel (left), and Commerce resting on a roped bale (right).

1. Thieme-Becker, *Allgemeines Lexikon der Bildenden Künstler,* XI, Leipzig, 1915, *Enciclopedia Italiana,* XV, Milan, 1932.

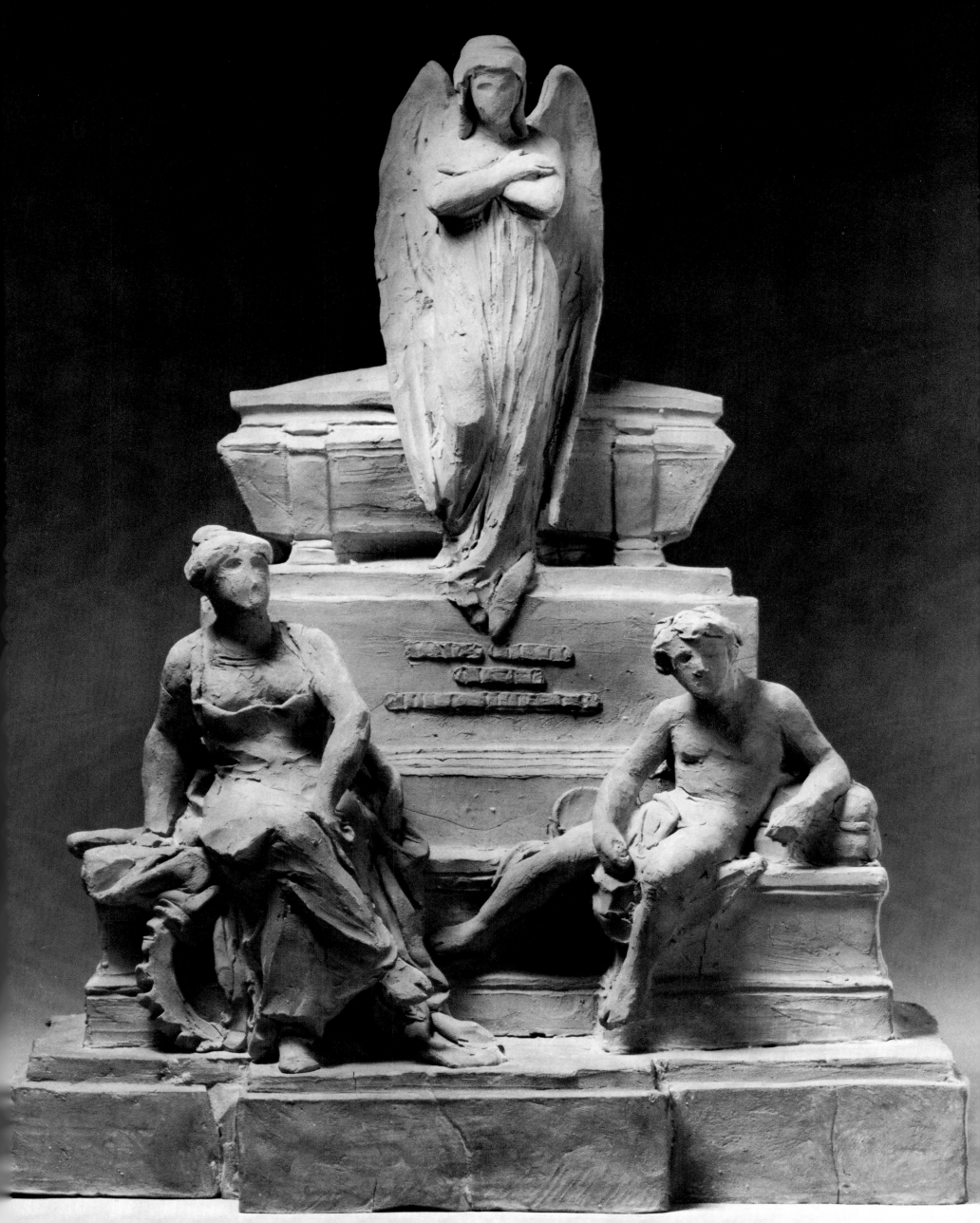

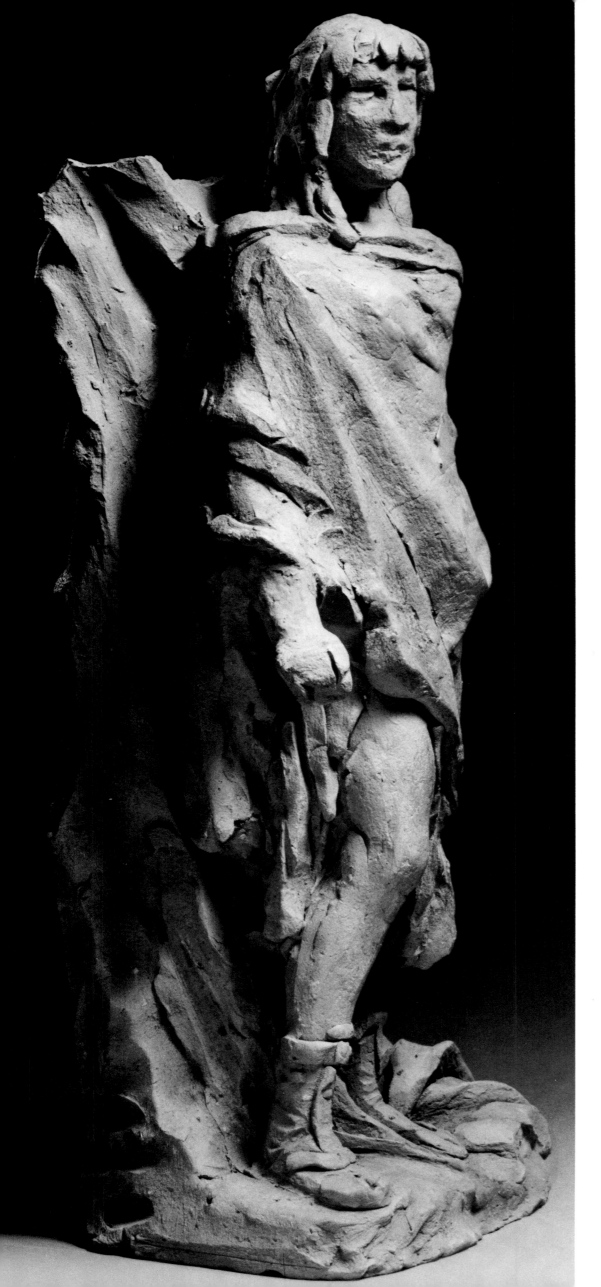

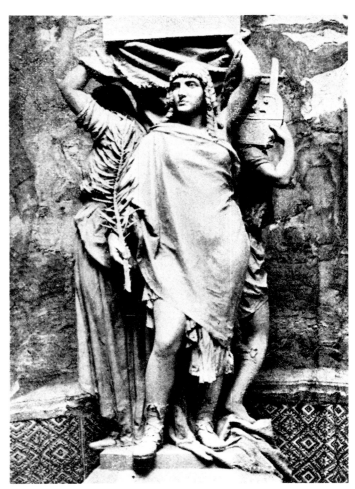

Fig. 1. Ferrari, *Monument to Terenzio Mamiani della Rovere*, full-size model for bronze caryatids, Pesaro.

59. *Standing Draped Man Representing Fatherland*

Terra-cotta, datable to 1895.
H. 13⅞ in. (35.3 cm.) W. 5⅝ in. (14.4 cm.) D. 4½ in. (11.6 cm.)
Condition: minor repairs throughout; left arm missing at shoulder.
Provenance: said to have come from the sculptor's studio.
Accession no. 79.1.10

THE VIGOROUS STANCE and upward glance give a heroic feeling to the figure. It is a sketch-model for one of the three bronze caryatid figures on the monument to Terenzio Mamiani della Rovere in the Piazzale della Stazione at Pesaro.[1] Mamiani (1799–1885) was a politician, professor of philosophy and writer from Pesaro. The caryatids represent Poetry, Philosophy and Fatherland, and each has one arm raised to support a bust of Mamiani.[2] The only male figure, for which this is the model, probably represents Fatherland (*Patria*). He carries a branch in his right hand, while the female caryatids carry a lyre and a book, respectively. The Sackler terra-cotta model for the male figure is missing the symbol included in the Pesaro monument.

1. G. Vaccaj, *Pesaro*, Bergamo, 1909, pp. 135–136 including one illustration of the finished monument and two views of the full-size models for the bronze caryatids.
2. Touring Club Italiano, *Guida d'Italia: Marche*, Milan, 1962, p. 138.

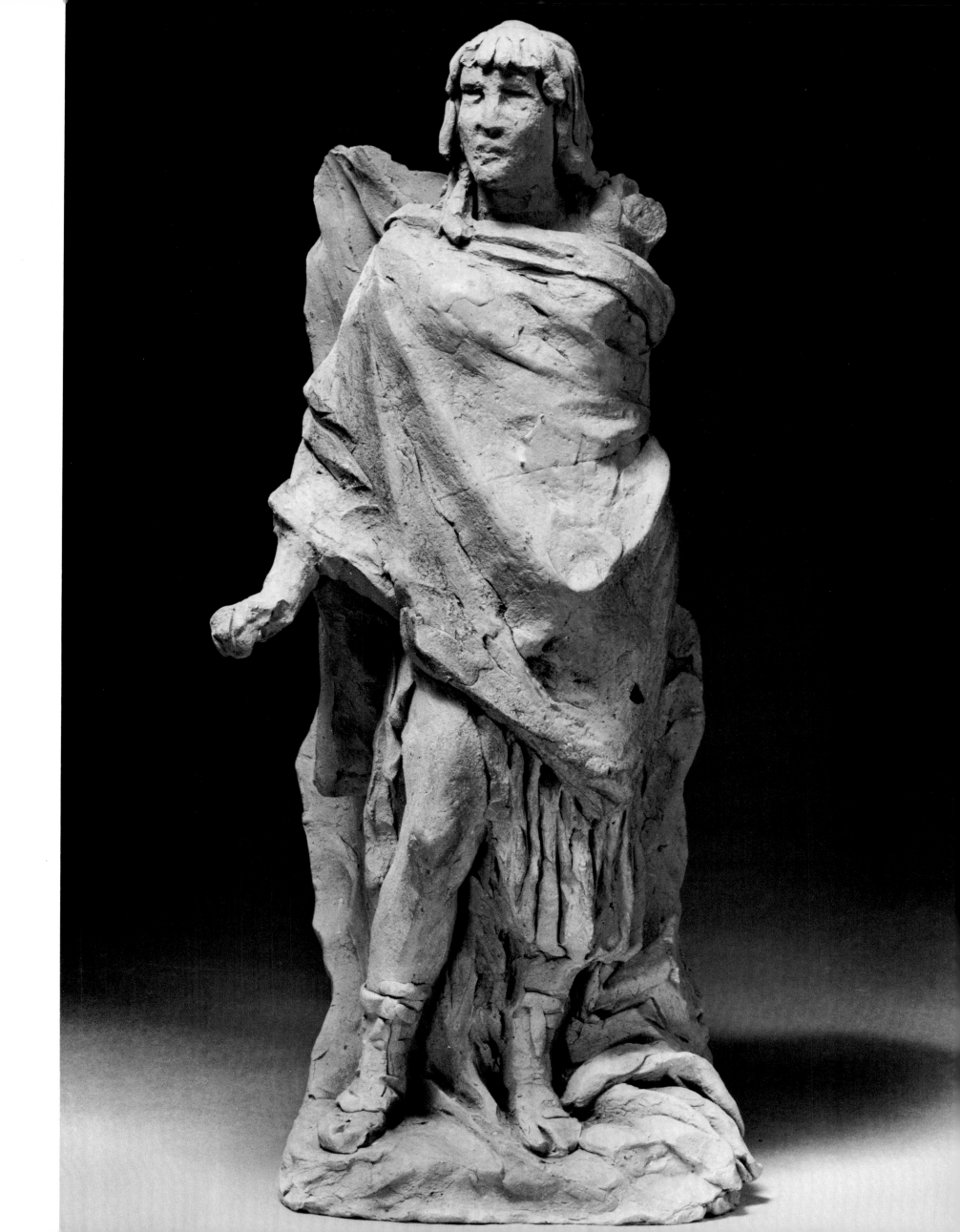

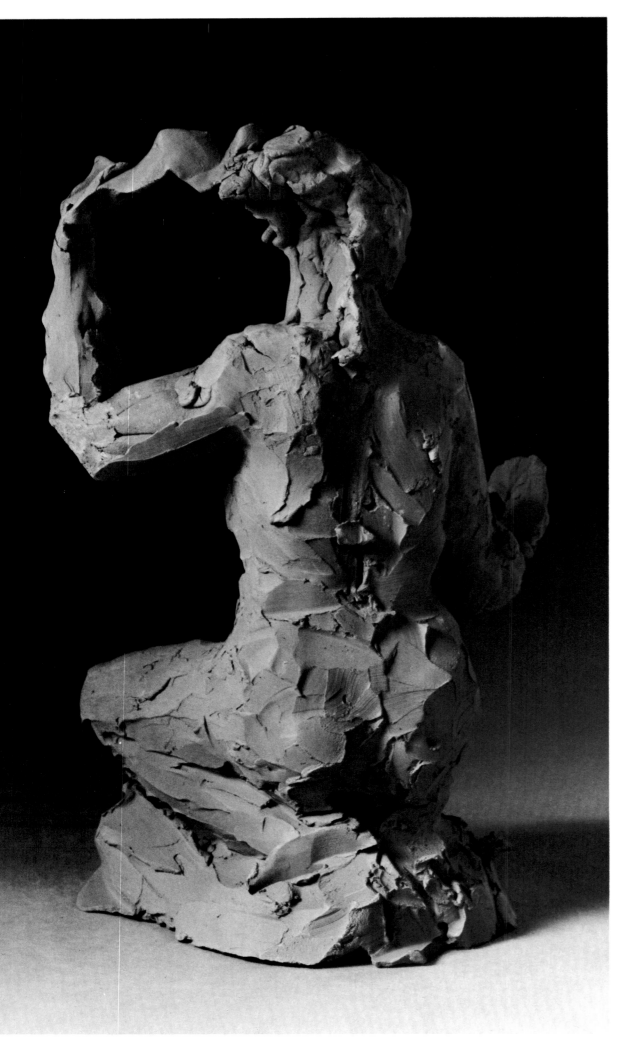

ITALIAN, early 20th century

ARTURO MARTINI
(1889-1947)

Martini was born and initially trained in ceramics
in Treviso (northern Italy), while he attended the
free life-study classes of the Accademia di Belle
Arti in Venice (1906-1907). A visit to Munich in
1909, financed by his employer, brought him into
contact with the celebrated sculptor Adolf von
Hildebrand. Martini first exhibited a work at the
Ca' Pesaro in Venice in 1908, but by 1911 had a
whole room to himself, and in 1920 received his
first one-man show in Milan. He exhibited fre-
quently during the inter-war years, moving
about within Italy, following commissions and
exhibitions from Rome to Carrara to Milan, and
elsewhere. At the Biennale exhibition in Venice in
1942 he showed some work in a completely
changed style, and from then until his death in
1947 he was very productive.[1]

60. *Girl Kneeling and Dressing Her Hair*

Terra-cruda.

Signed: traces of initials inscribed in wet clay with stylus
on back of base.
H. 10⅛ in. (25.7 cm.) W. 6½ in. (16.5 cm.) D. 4⅞ in. (12.3 cm.)
Condition: some minor repairs throughout.
Provenance: Istituto Italia-Oriente di Cultura, Rome.
Accession no. 79.1.16

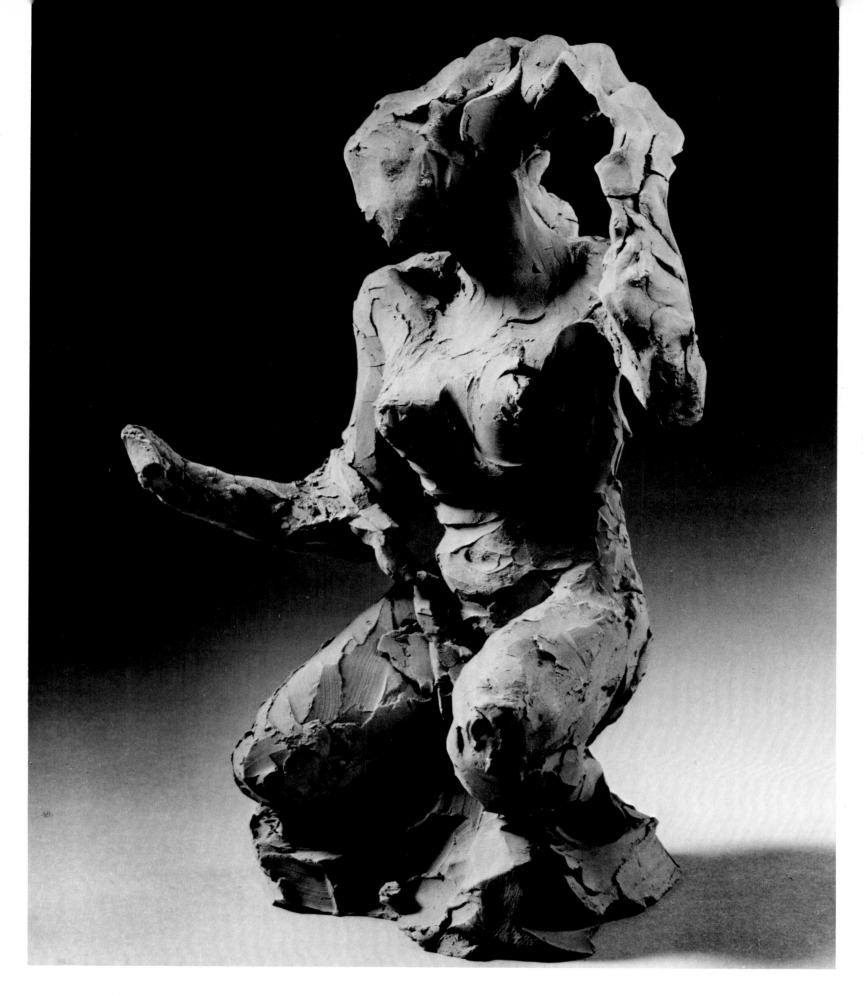

ONE OF A GROUP of six sketch-models acquired from the same source, all of which show a remarkably free and exciting handling of moist clay. The figure is built up rapidly with the fingers and modelling tools, the traces of which are everywhere apparent.

The influences of Degas' wax studies of figures and horses in movement is apparent and it is probable that these unfired clay models are early essays by Martini, for they do not relate closely to his later, more abstract and static sculpture, with its debt to cubism and its deliberate rotundity of form.

This composition is engagingly spontaneous, for all its background in "old master" sculpture, both Greco-Roman and more modern, for example, *Crouching Aphrodite* by Doidalsas (3rd century, B.C.), *Fiducia in Dio* by Bartolini (1835), as well as Degas' *Dancers* (1872 on).

1. G. Perocco, "Arturo Martini," *I Maestri della Scultura*, Milan, 1966, no. 68.

61. *Girl Seated and Drying Her Foot (?)*

Terra-cruda, early 20th century.
Signed: traces of initials inscribed in wet clay with stylus on back of base.
H. 9⅜ in. (23.8 cm.) W. 4¼ in. (10.8 cm.) D. 6⅞ in. (17.5 cm.)
Condition: right hand broken off, minor cracks throughout.
Provenance: as for no. 60.
Accession no. 79.1.11

THIS CHARMING STUDY, less extrovert in mood than the *Girl Kneeling and Dressing Her Hair* (no. 61), shows the sculptor's knowledge of earlier examples of beautiful young girls depicted more or less nude as they perform their toilet. Three sources spring to mind for the present composition: a series of small bronze statuettes formerly classed as "Italo-Flemish", but now regarded as French and possibly associable with Barthélémy Prieur (1536-1611);[1] Falconet's marble statuettes of *Baigneuses* (also reproduced on a smaller scale in *biscuit de Sèvres*); and Degas' freely modelled statuettes of dancers in repose.

1. Cf. R. R. Wark, *Sculpture in the Huntington Collection*, San Marino (Calif.), 1959, nos. XV, XVI.

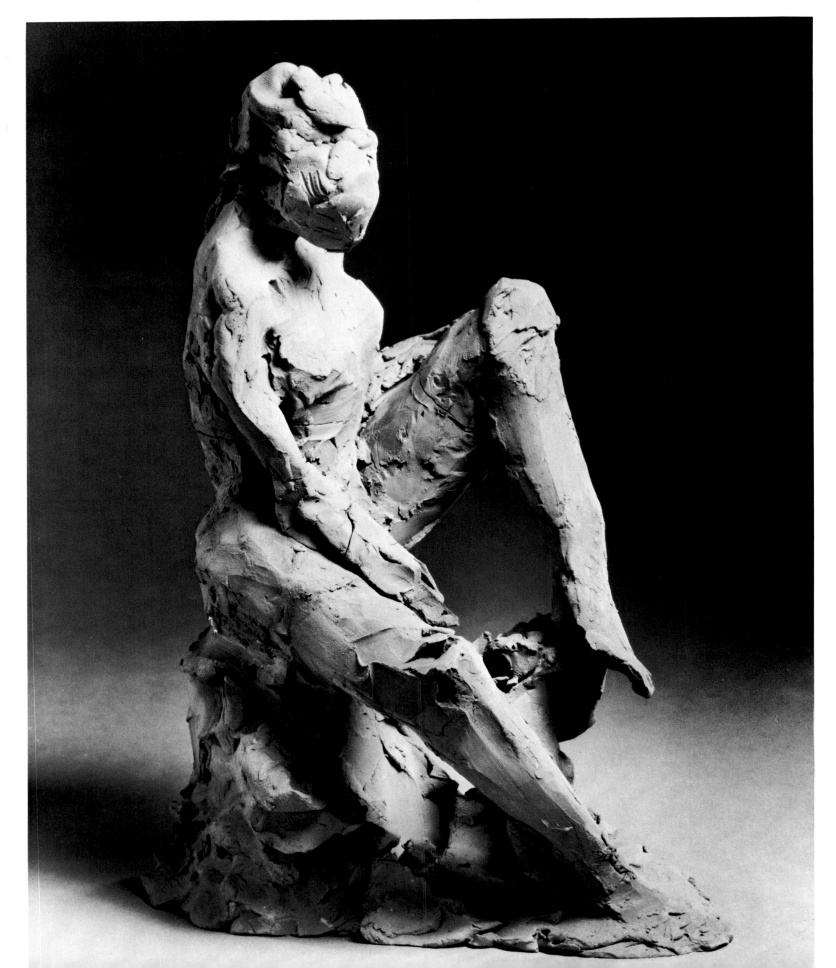

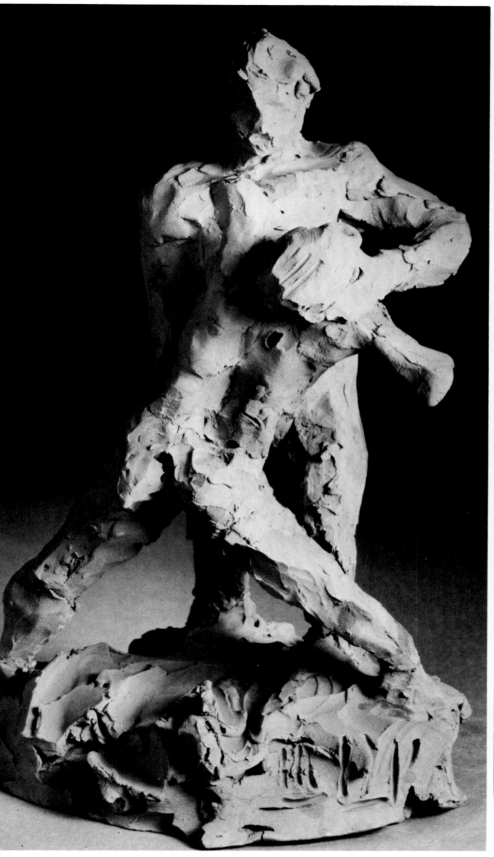
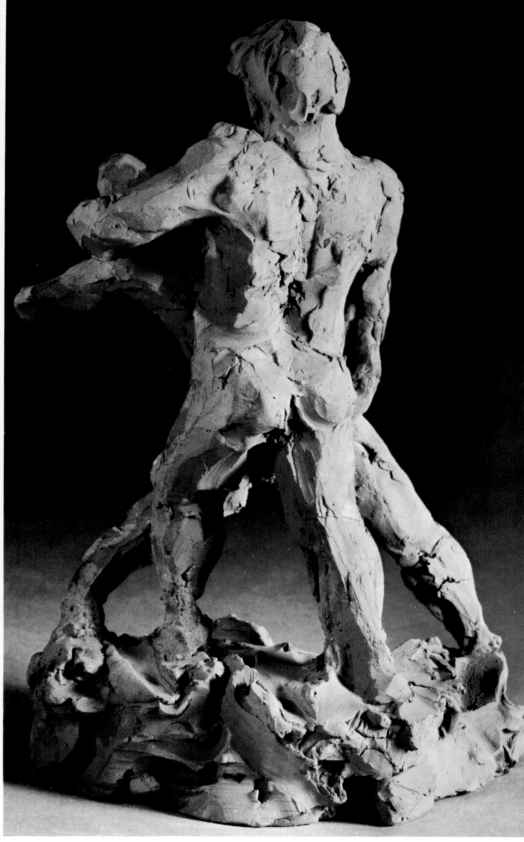

62. *Wrestlers*

Terra-cruda, early 20th century.
Signed: initial "M" and possible date inscribed with stylus in wet clay on base.
H. 8¾ in. (22.2 cm.) W. 5¾ in. (14.7 cm.) D. 5⅛ in. (13.1 cm.)
Condition: left foot of lower wrestler broken off, minor repairs throughout.
Provenance: as for no. 60.
Accession no. 79.1.13

THE THEME OF wrestling figures recalls Hellenistic Roman sculpture, as well as a number of bronze statuettes from the Italian Renaissance and later. Martini here used the deliberate roughness of finish on the vigorously modelled figures to an expressive end. For instance, the unnaturally deep hollowing around the spine of the lower figure suggests the spent energy of the less powerful antagonist, who appears to be suffocating.

149

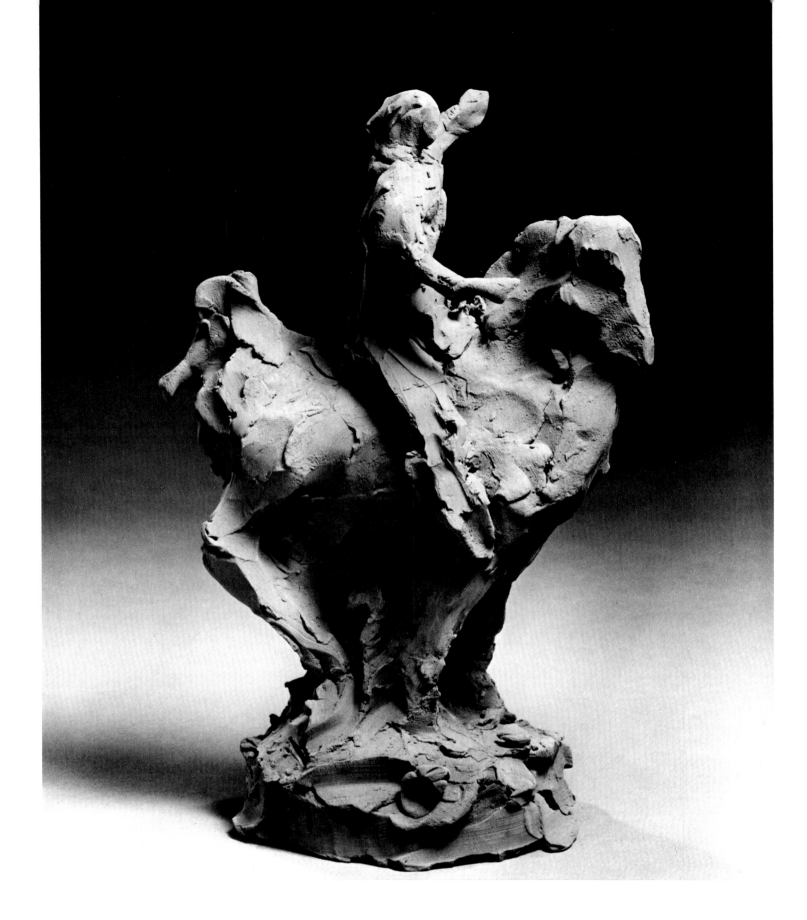

63. *Man on Horse*

Terra-cruda, early 20th century.
H. 8 in. (20.3 cm.) W. 3⅝ in. (9.3 cm.) D. 5⅛ in. (13.0 cm.)
Condition: cracked through legs of horse, rider's right foot missing.
Provenance: as for no. 60.
Accession no. 79.1.12

THIS CURIOUS little study of an equestrian figure
indicates an unusual pose, with the four legs of the
horse rather close together, the front pair braced,
the hind ones being brought forward, as though the horse
were landing from a jump, or abruptly stopping in its tracks.

64. *Horse-Tamer*

Terra-cruda, early 20th century.
Signed: initials "AM" inscribed with stylus in wet clay on top of base.
H. 9³⁄₁₆ in. (23.4 cm.) W. 7¼ in. (18.6 cm.) D. 4¼ in. (10.9 cm.)
Condition: some drying cracks and minor repairs throughout; parts of both front legs of horse broken off.
Provenance: as for no. 60.
Accession no. 79.1.15

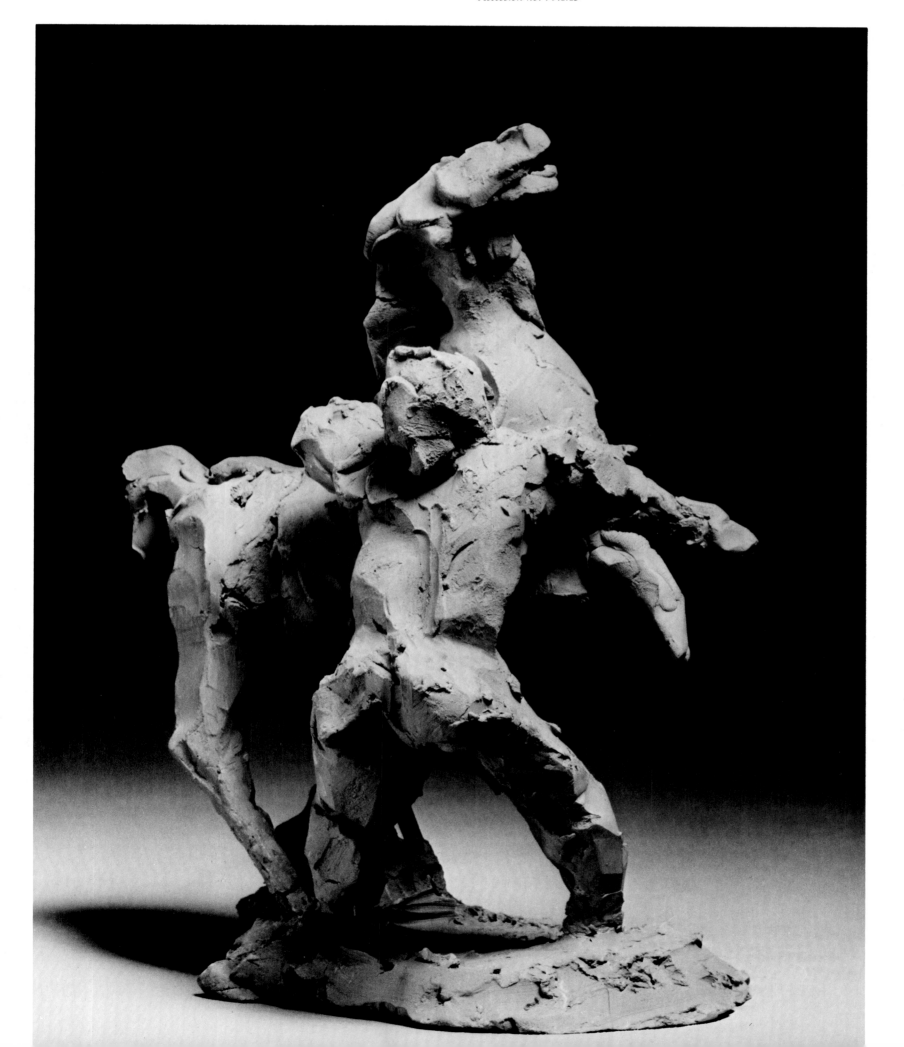

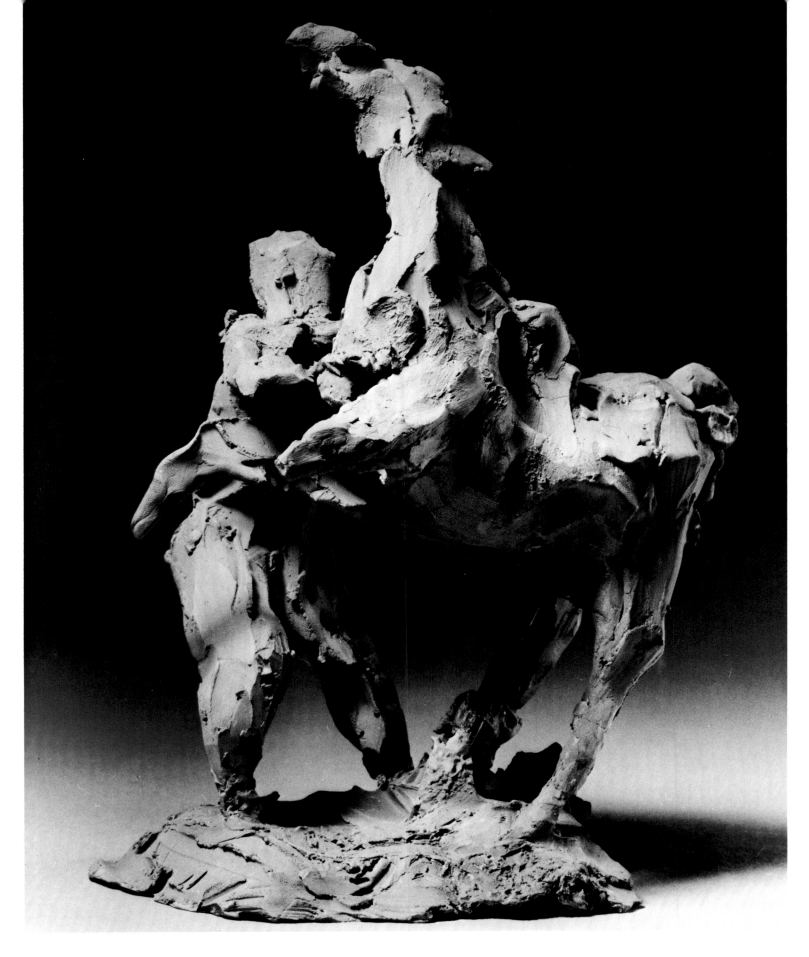

THE SUBJECT recalls the celebrated pair of ancient Roman marble groups of *Horse-Tamers* on the Esquiline Hill in Rome and Bertoldo di Giovanni's (ca.1420–1491) bronze statuette of *Bellerophon and Pegasus* in the Kunsthistorisches Museum, Vienna. Degas' interest in depicting the horse in action may have inspired Martini to produce this brilliantly evocative sketch of a man attempting with all his weight and strength to restrain the excited animal. The thrust downwards of the man's buttocks, which form a sharp angle between his spread legs and straining torso, is opposed to the rising motion of the horse, suggested by its front hooves flailing in midair, its raised head and open mouth, and its arched tail.

65. *Pair of Clothed Figures*

Terra-cruda, early 20th century.
H. 8¼ in. (20.9 cm.) W. 4⅞ in. (12.5 cm.) D. 3³⁄₁₆ in. (8.2 cm.)
Condition: some drying cracks and repairs throughout.
Provenance: as for no. 60.
Accession no. 79.1.14

AN EMPATHY between these two human beings—who are so broadly
sketched and so heavily clad as to be barely distinguishable
as a man and a woman—is suggested both by the merging
of their forms in a solid lump of clay and by the relationship of their
heads, which are skillfully indicated by modelling the planes with a
spatula. The monumentalizing of a human form by the use of heavy
drapery recalls the work of Rodin, especially his statues of Balzac.

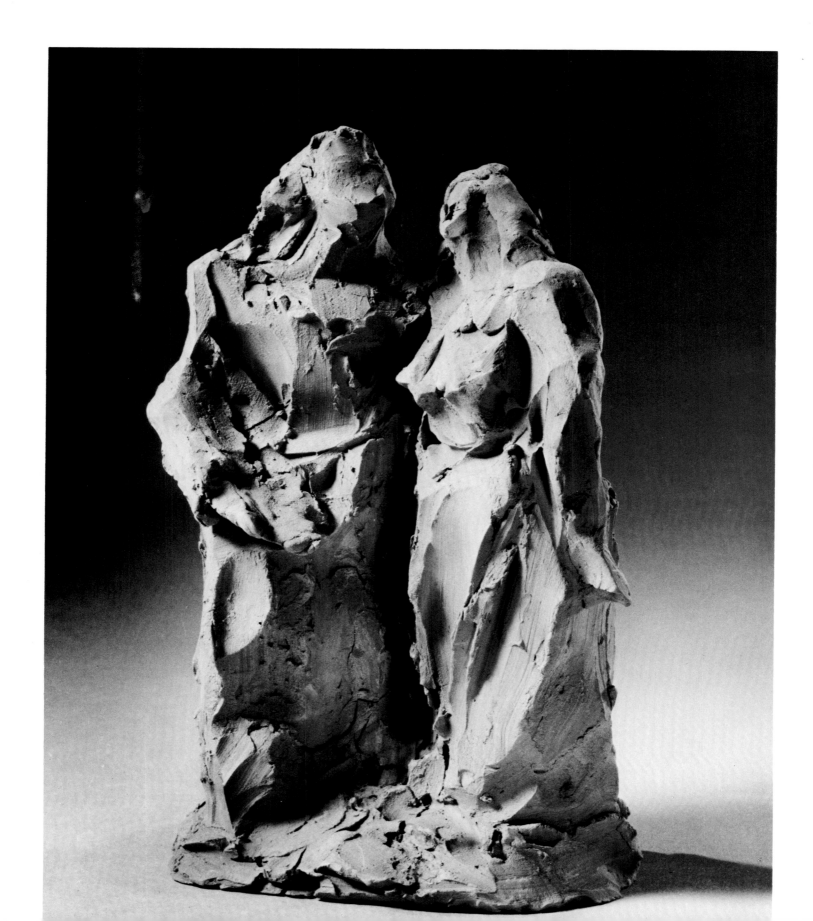

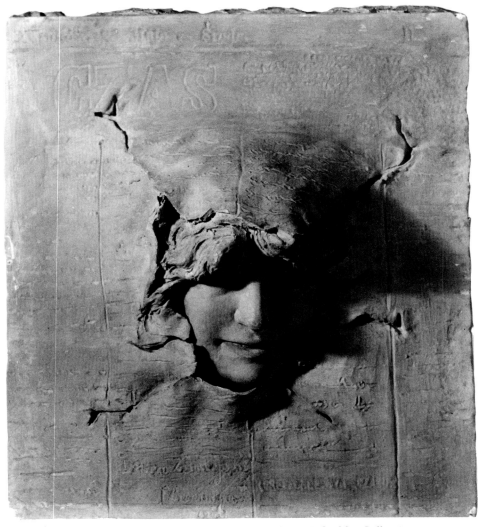

Fig. 1. Zawiejski, *Czas*, terra-cotta, the Arthur M. Sackler Collections.

ITALIAN, late 19th century

MIECZYLSLAW LEON ZAWIEJSKI
(1856-1933)
Born in Cracow, active in Florence and Poland.

66. *La Vedetta: La Gazzetta del Popolo*
The Lookout: The People's Gazette

Terra-cotta, 1884.
Signed: L. Miecz Zawiejski/Firenze/1884
H. 10½ in. (26.7 cm.) W. 9³⁄₁₆ in. (23.3 cm.) D. 3½ in. (8.9 cm.)
Condition: excellent.
Accession no. 79.1.17

STYLISTICALLY RELATED to contemporary Italian *genre* sculpture, this whimsically punning piece is inscribed with newspaper captions referring to the recent unification of Italy. It is interesting in being a political sculpture, though on a small scale. The "shock effect" of the human image projecting through a printed page of text is analogous to the contemporary posters of Toulouse-Lautrec.

A similar relief but with a masthead of the Polish newspaper *Czas* (fig. 1), originally a pendant to the present piece, is also in the Arthur M. Sackler collections.

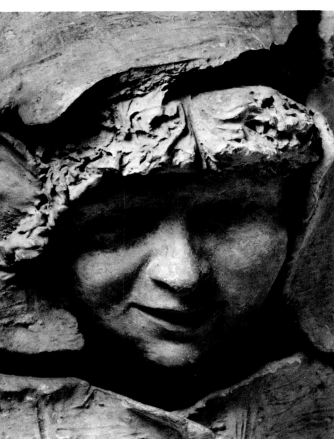

154

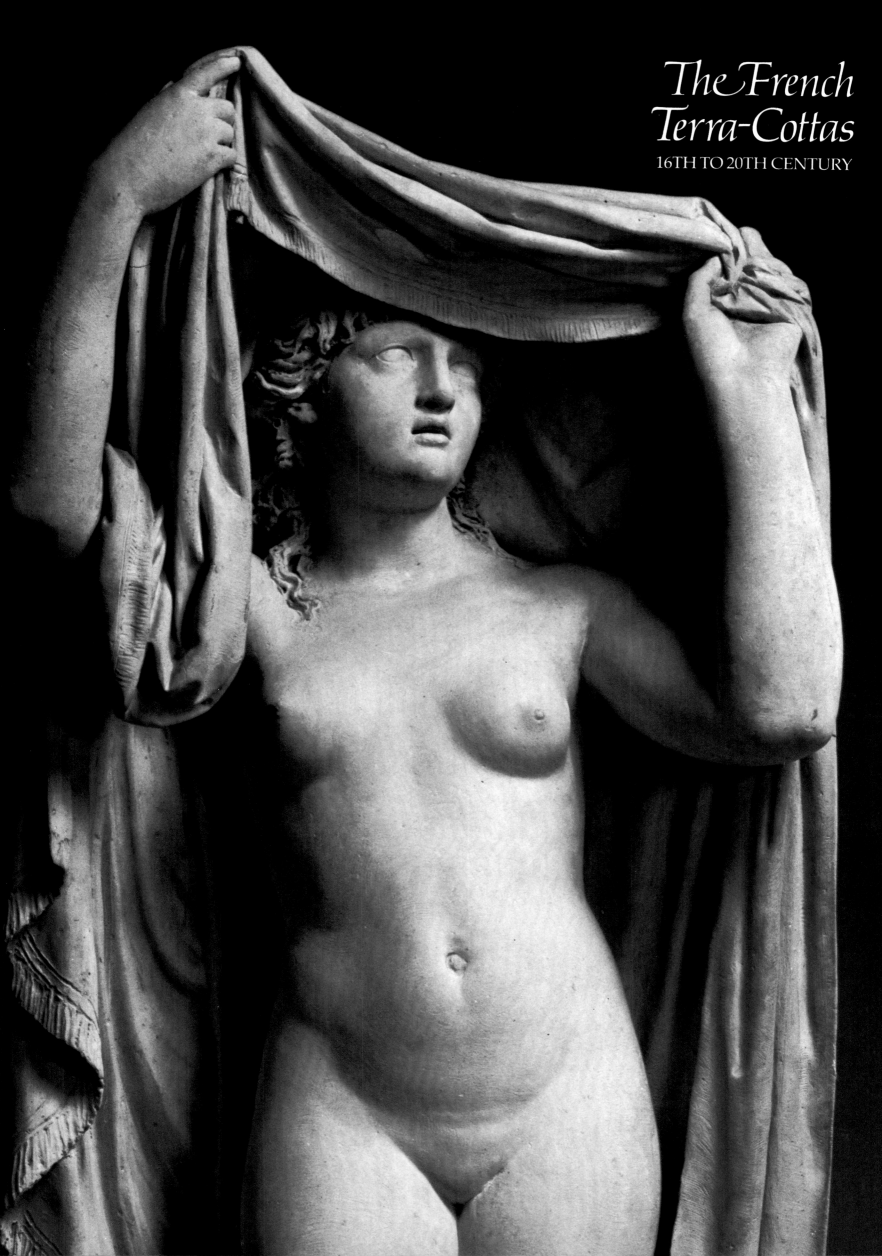

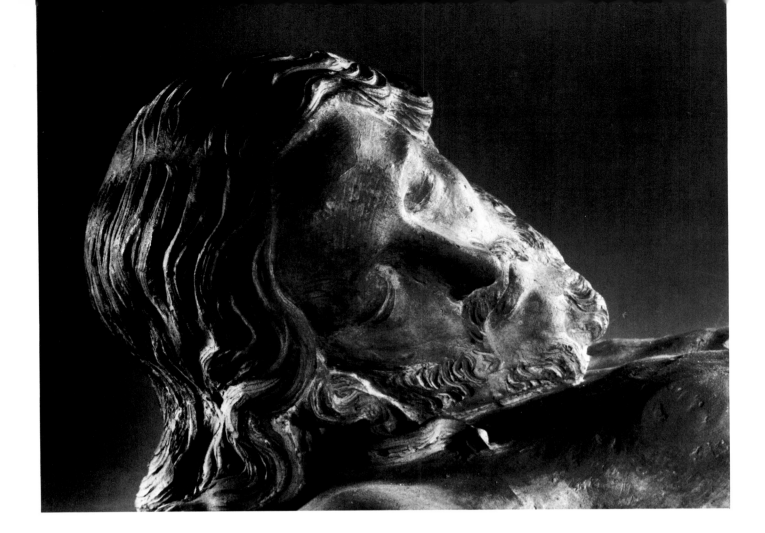

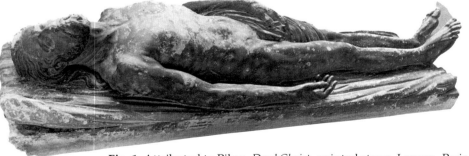

FRENCH, late 16th century

Circle of GERMAIN PILON (1528-1590)

Son of a stonemason, Pilon was a prolific sculptor talented in various media. Student of, and collaborator with, Pierre Bontemps in the 1550s, he later worked under Francesco Primaticcio and Pierre Lescot. In 1571, he was referred to as sculptor to King Charles IX. His works included figures for a monument to Henri II (1561), sculptures for the funerary chapel of Catherine de Medici, Abbey of St. Denis (1565/70 and 1583), the garden of Fontainbleau, the Louvre, Palace of Justice, and churches of Paris.

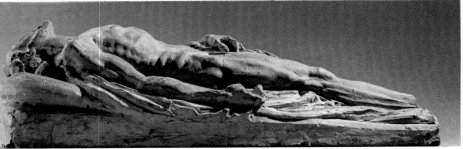

Fig. 1. Attributed to Pilon, *Dead Christ*, painted stone, Louvre, Paris.

Fig. 2. Pilon, *Sketch for Tomb of Henri II*, terra-cotta, Louvre, Paris.

67. *Dead Christ*

Terra-cotta, ca. 1570 (?).
H. 12⅜ in. (31.4 cm.) W. 33 in. (83.8 cm.) D. 10⅝ in. (27.0 cm.)
Condition: many superficial abrasions, owing to the fireskin of terra-cotta becoming detached.
Accession no. 79.1.21

THE SUBJECT of the dead Christ is normally found in connection with the so-called Easter Sepulchers in churches, which consisted of statuary tableaux, often life size. They were particularly popular in the Marches of Italy and the region around Troyes in France, although there are examples all over Europe. The present statuette, if it was intended as a finished work, is of an unusual scale, and may rather have been a highly worked model. In style and treatment it is very close to the *Dead Christ* in painted stone attributed to Pilon now in the Louvre (fig.1).[1] That, in turn, is related to Pilon's *gisant* of King Henri II of about 1570 on the royal tomb in St. Denis[2]—for which there is a terra-cotta sketch-model of roughly half-size (57cm.) in the Louvre (fig.2).[3] The extremely competent rendering of nude anatomy and the handling of the drapery in the present model relate it intimately to these analogous works by Pilon. The delicately delineated facial features and wavy locks of hair may be paralleled in his life-size marble statue of the *Risen Christ,* now in the Louvre.[4] This was originally intended to form part of a tableau of the *Resurrection*, with three life-size marble statues (*Christ* and two *Soldiers*), on an altar in Notre-Dame-la-Rotonde at St. Denis, executed about 1583. Terra-cotta models for these statues existed in St. Etienne-du-Mont until about 1806.

1. P. Vitry, *Musée National du Louvre. Catalogue des sculptures du moyen age, de la renaissance et des temps modernes,* I, Paris, 1922, no. 437: W. 200 cm.; J. Babelon, *Germain Pilon,* Paris, 1927, no. 7, and pl. XVIII, p. 62.
2. Babelon, *op. cit.,* pl. VII.
3. *Ibid.,* no. 5, p. 61; and pl. XI, Vitry, *op. cit.,* no. 415.
4. Babelon, *op. cit.,* no. 20, p. 65, and pl. XXV; P. Vitry, *Catalogue des sculptures,* Supplément, Paris, 1933, p. 52, H. 2.22 m.

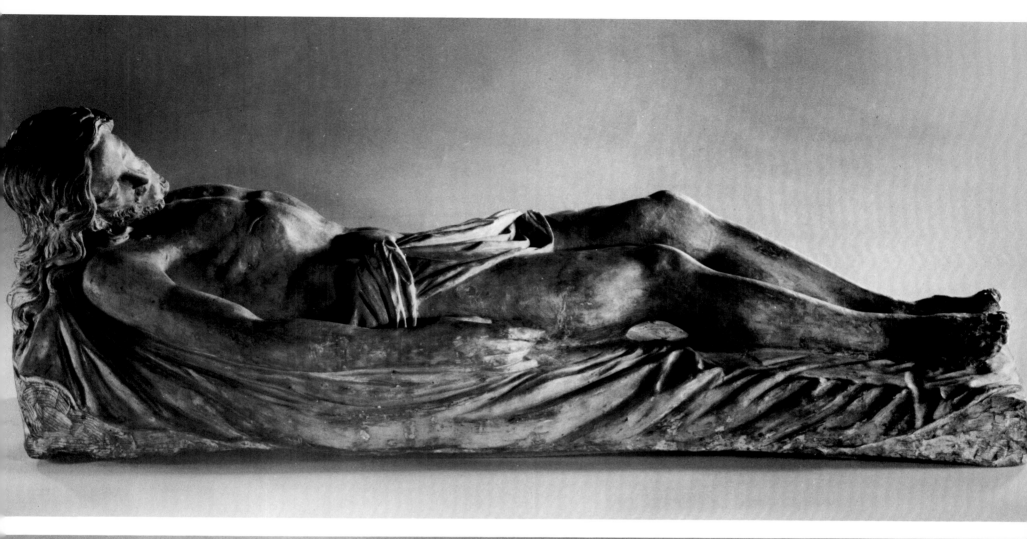

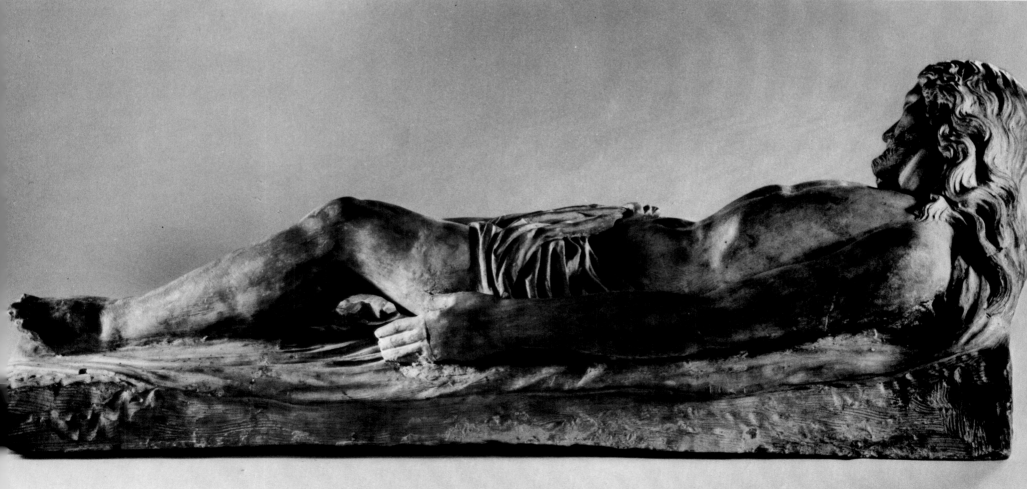

159

FRENCH, late 17th century

LOUIS LECOMTE
(ca. 1639-1694)

Born in the village near Paris called Boulogne, Louis Lecomte was *agréé* by the Académie royale de peinture et de sculpture in 1675, and received into full membership in 1676, on presentation of a marble medallion relief of *St. Bartholomew* now in Nôtre-Dame de Versailles, Chapel of St. Roch; in 1693 he was made assistant professor. Lecomte was almost exclusively occupied in working for the Crown, largely at Versailles, but also at Marly and the Invalides. Among his rare independent works of sculpture was a *Louis XIV Trampling Heresy Underfoot*, carved in marble for the courtyard of the *hôtel* of the King's *valet de chambre*, M. du Bois-Guérin, in 1689. He is not to be confused with another sculptor of the same name, who also worked at Versailles, and who, to distinguish himself from this Lecomte, was known as Lecomte Picard (1650-1681).

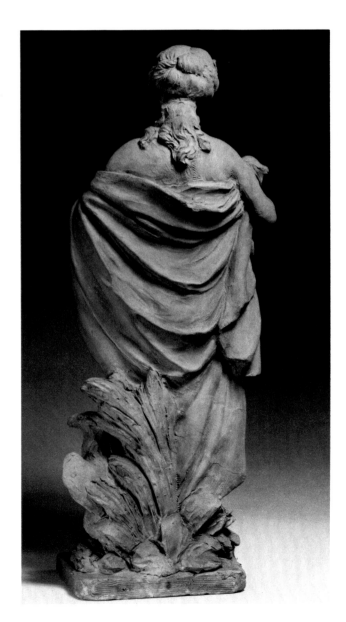

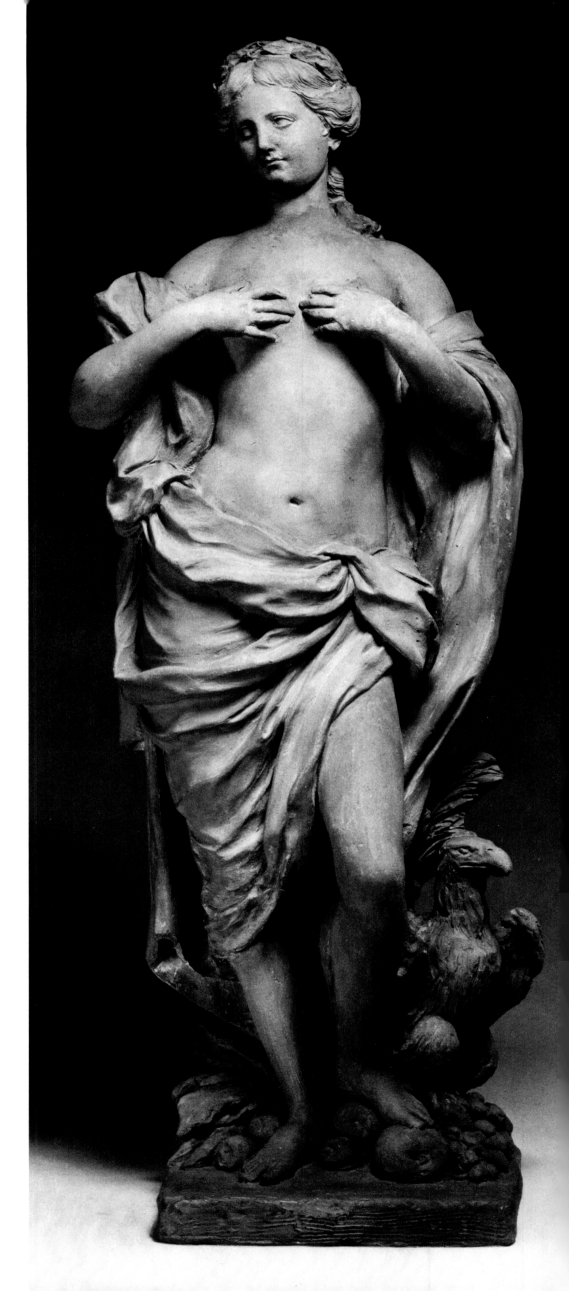

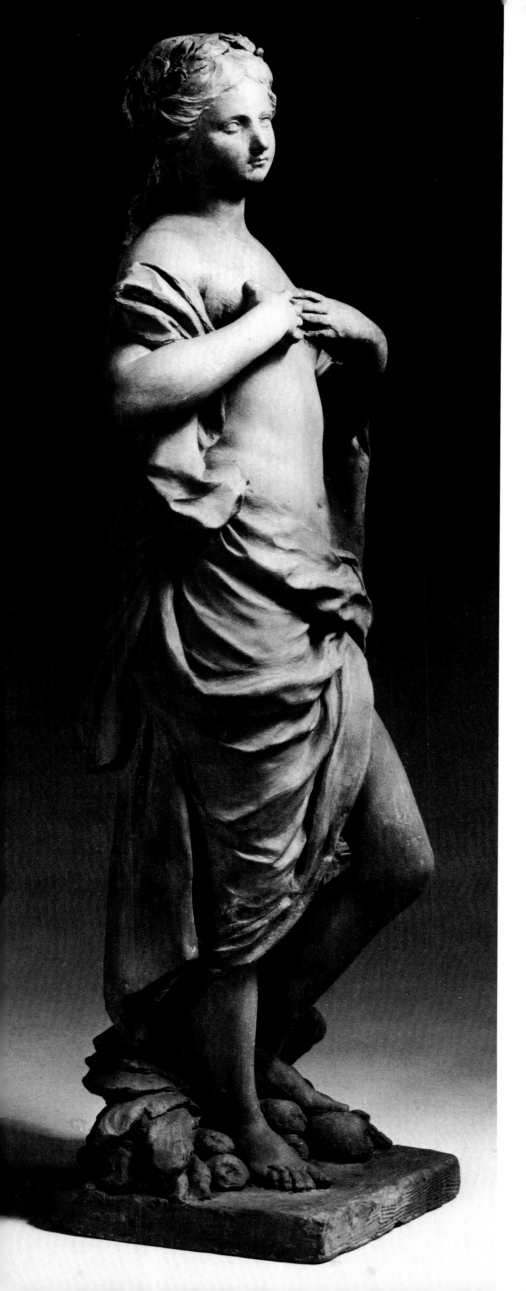

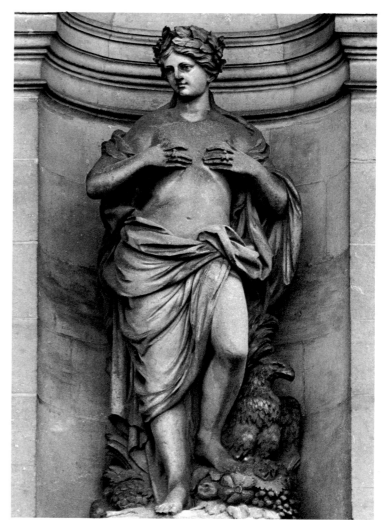

Fig. 1. Lecomte, *Nature*, marble, Versailles.

68. *Nature*

Terra-cotta, ca. 1679.
H. 21½ in. (54.6 cm.) W. 7½ in. (19.1 cm.) D. 5 in. (12.7 cm.)
Condition: old repairs throughout.
Accession no. 77.5.41

THIS IS THE MODEL, identified by François Souchal, for one of the two statues (*Nature* and *Art*) carved by Lecomte in 1679-1680 for the two first-floor niches in Hardouin-Mansart's remodelled central *corps de logis* on the garden front of the château de Versailles (fig. 1).[1]

The goddess stands on the fruits of the earth, hands on her breasts, an allusion to the fecundity of nature. A vulture beside her, *"oiseau fort glouton,"* symbolizes Nature's inevitable tendency to devour everything it engenders. Evidently the sculptor, or probably Charles Le Brun (1619-1690) in a supplied drawing, had recourse to Cesare Ripa (fl. 1600) for the imagery of Nature.[2] The image, which Ripa took from a medal of Hadrian's, showed Nature with a large vulture impossibly perched on her outstretched arm, and with her breasts engorged with milk.[3] Ripa's image was modified, both to make it easier to execute in the round and for the sake of propriety. Here, the vulture is more suitably placed beside her, and she puts her hands on her breasts, thus implying their fertility while concealing them.

1. F. Souchal, "Les statues aux façades du château de Versailles," *Gazette des Beaux-Arts,* 79, February, 1972, figs. 36 and 37, p. 77.
2. A new edition of J. Baudouin's translation of Ripa's *Iconologia* had just come out in 1677.
3. Milk is seen flowing over the fingers of the hands of the *Nature* in Versailles, as it is just barely seen here on the fingers of this figure's left hand. See Souchal, *op. cit.,* for the description of *Nature* pressing her breasts to extract the milk. Souchal also describes the allegorical nature of the images reflecting the philosophy of Versailles. On one side is *Nature,* the other *Art,* two ideas united in the conception of classicism and monarchy and used to consecrate the glory of the king.

PIERRE-JEAN HARDY
(1653-1737)

Born in Nancy, Hardy presented himself in 1680
to the Académie in Paris, to which he was admit-
ted in 1688 on presentation of a relief depicting
Religion Crushing Idolatry now in the Louvre.
Before this, however, he had already been creating
statues to designs by Le Nôtre for the Grand
Degré at Chantilly, as well as providing wooden
sculptures for the prince de Condé's apartments
in his châteaux, in 1684. In the same year, Hardy
initiated what was to become a lifelong activity
as an ornamental sculptor on the royal châteaux
by supplying a plaster model for one of the *pièces
d'eau* at Versailles and carving two vases. He also
worked at Meudon, the Trianon, and Marly,
not only as a sculptor but also as a specialist in
rocailles. One of his chief responsibilities was the
upkeep and repair of sculpture at Versailles and
Marly, a task that included, in 1726, the provision
of seven vine leaves to cover various *nudités,*
including *une double sur la grande figure d'Hercule.*

162

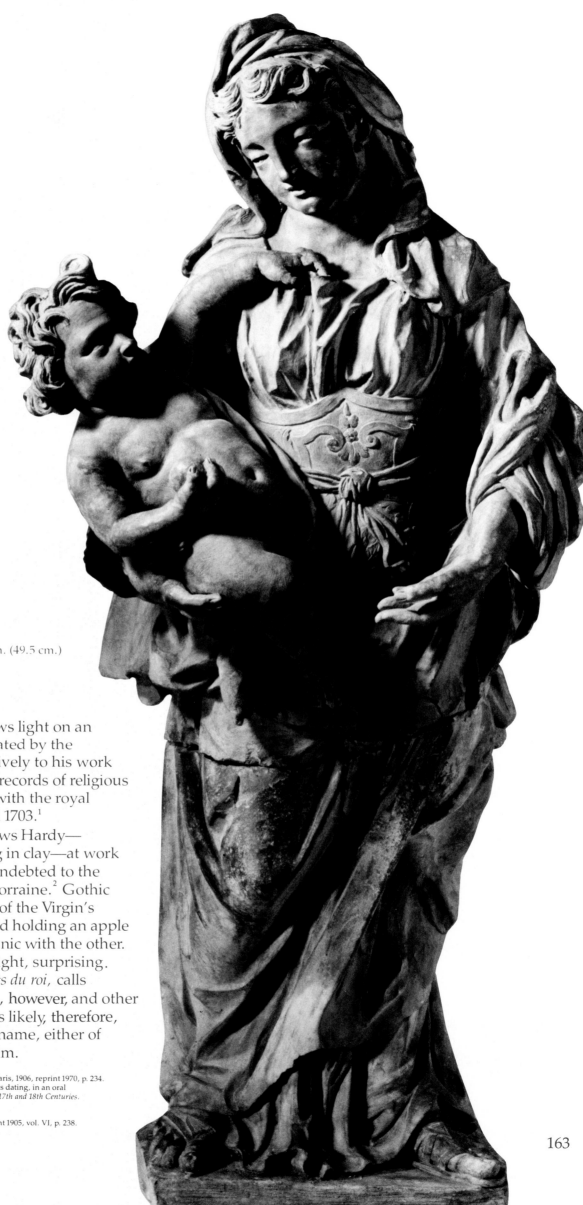

69. *Virgin and Child*

Terra-cotta, 1710.
H. 60¼ in. (152.9 cm.) W. 30½ in. (77.5 cm.) D. 19½ in. (49.5 cm.)
Signed on base: P. HARDY 1710.
Condition: both Virgin and Child repaired extensively.
Accession no. 79.1.1

THIS PREVIOUSLY UNKNOWN statue throws light on an aspect of Hardy's activity little illuminated by the documents, which refer almost exclusively to his work for the French Crown. Hitherto, the only records of religious sculpture from his hand were connected with the royal church of the Invalides, between 1692 and 1703.[1]

This terra-cotta is interesting in that it shows Hardy— away from the court milieu and modelling in clay—at work in a less academic vein, and in a manner indebted to the popular religious sculpture of his native Lorraine.[2] Gothic reminiscences are still there—in the sway of the Virgin's body, and in the gesture of the Christ Child holding an apple in one hand and tugging at the Virgin's tunic with the other. The initial "P" of the signature is, at first sight, surprising. Lami, drawing on the *Comptes des bâtiments du roi,* calls the sculptor only "Jean."[3] George Nagler , however, and other early writers refer to him as "Pierre." [4] It is likely, therefore, that Hardy had more than one baptismal name, either of which might have been used to refer to him.

1. S. Lami, *Dictionnaire des sculpteurs de l'école française sous le régne de Louis XIV,* Paris, 1906, reprint 1970, p. 234.
2. Professor François Souchal confirms the authorship of the statue and accepts its dating, in an oral communication. It will be included in vol. II, F. Souchal, *French Sculptors of the 17th and 18th Centuries. The Reign of Louis XIV.*
3. Lami, *op. cit.*
4. G. K. Nagler, ed., *Neues Allgemeines Künstler-Lexikon,* Munich, 1835-1852, reprint 1905, vol. VI, p. 238.

FRENCH, late 17th to mid-18th century

NICOLAS COUSTOU
(1658-1733)

Son of François Coustou, a wood-carver from Lyons, Nicolas and his brother Guillaume I, thanks to the dominance of their sculptor uncle, Antoine Coysevox, enjoyed a favoured position as sculptors to the French Crown during the later years of Louis XIV. After receiving his first training from his father in Lyons, Nicolas went to Paris in 1677 to perfect his craft under his uncle. In 1682 he won the *prix de Rome* for sculpture, and set out for Italy in 1683. He remained there for three years, carving the inevitable statue after the Antique, *The Emperor Commodus as Hercules*, for the park of Versailles. On his return to France in 1686, he spent some months in Lyons and arrived back in Paris in 1687.

From that time on he was continuously employed in providing sculpture for the royal palaces of Versailles, Marly, and the Trianon, and for the royal church of the Invalides, most notably the two groups of *Meleager,* and *The Seine and the Marne.* He also collaborated on the imposing, though since dismantled, tombs of François de Créqui and the prince de Condé, and carved statues and busts of such important figures as Villars and Colbert, as well as the *Descent from the Cross* for the *Voeu de Louis XIII* in the choir of Nôtre-Dame set up in 1725. Admitted to the Academy in 1693 on the strength of his relief of *The Recovery of Louis XIV,* now in the Louvre, he became a full professor in 1702, rector in 1720, and chancellor in 1733.

70. *A River God and Goddess*

Terra-cotta, ca. 1699.
H. 10½ in. (26.7 cm.) W. 15 in. (38.1 cm.) D. 3½ in. (8.9 cm.)
Condition: extensive repairs throughout.
Accession no. 77.5.33

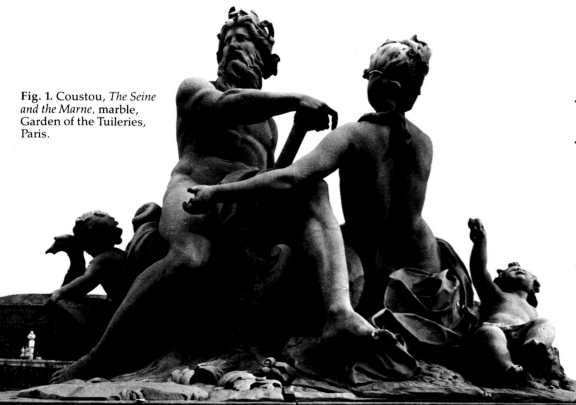

Fig. 1. Coustou, *The Seine and the Marne,* marble, Garden of the Tuileries, Paris.

IT SEEMS most probable that this terra-cotta can be identified as Coustou's original *maquette* for his marble group of *The Seine and the Marne* in the Tuileries gardens, which was originally carved for Marly; it has more affinity with this group than with Corneille van Clève's balancing group of *The Loire and the Loiret.*[1] The two groups of *Rivers* were originally planned as part of a sculptural complex adorning the piece of ornamental water called *Les Nappes* at Marly, created in 1699.[2] On his visit to Marly in May 1699, Louis XIV gave orders that the sculptures of *Les Nappes* and the *Grand Pièce d'Eau* should provisionally be executed in plaster covered with stucco

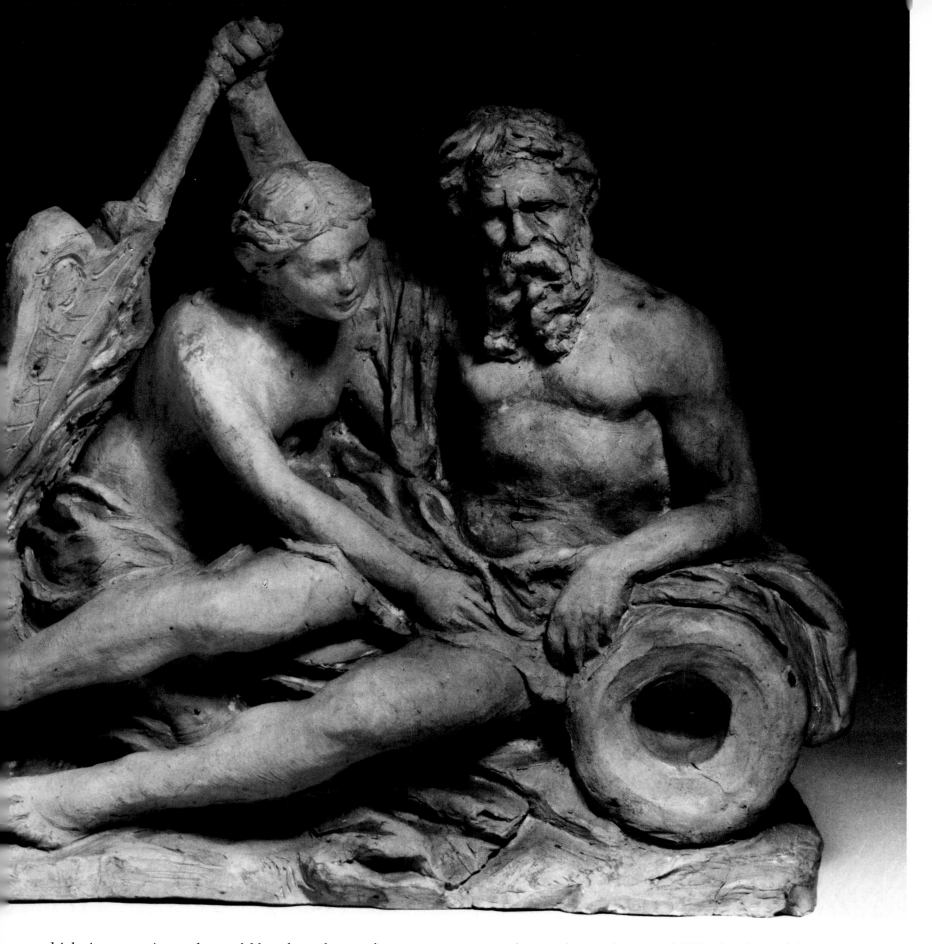

which, it was estimated, would last from four to five years, so that their artistic effect could be judged and they could act as substitutes during the inevitably lengthy carving of the marble. At one point, in August 1708, Louis even had these plasters painted in bronze, in anticipation that, for greater speed, they would be executed in metal instead; but he quickly reverted to his original intention. Ultimately, only Coysevox's equestrian figures of *Fame* and *Mercury*, the two pairs of *River Gods*, and Flamen and Hurtrelle's *Nymphs* reached execution in marble. Coysevox's figures were set up in 1702, but payments for the carving of the rest of the

sculpture dragged on until 1712, the date of Coustou's signature on his group. The summariness of the present sketch clearly suggests that it was made by the sculptor at an early stage, when he was still elaborating his ideas. In 1701, he was paid for a wax model, reportedly executed in 1699, which evidently embodied the final solution that he presented for approval.[3] In this first sketch the sculptor had not yet arrived at the idea which was so successfully to link the group with its garden context on every side: that of turning the figures of the *Seine* and the *Marne* so that they faced in opposite directions, with a *putto* at either end.

1. J. and A. Marie, *Marly*, Paris, 1947, figs. 125 and 127.
2. B. Rosasco, "New Documents and Drawings Concerning Lost Statues from the Château of Marly," *Metropolitan Museum Journal*, 10, 1975, pp. 79-96.
3. *Ibid.*, no. 28, p. 85.

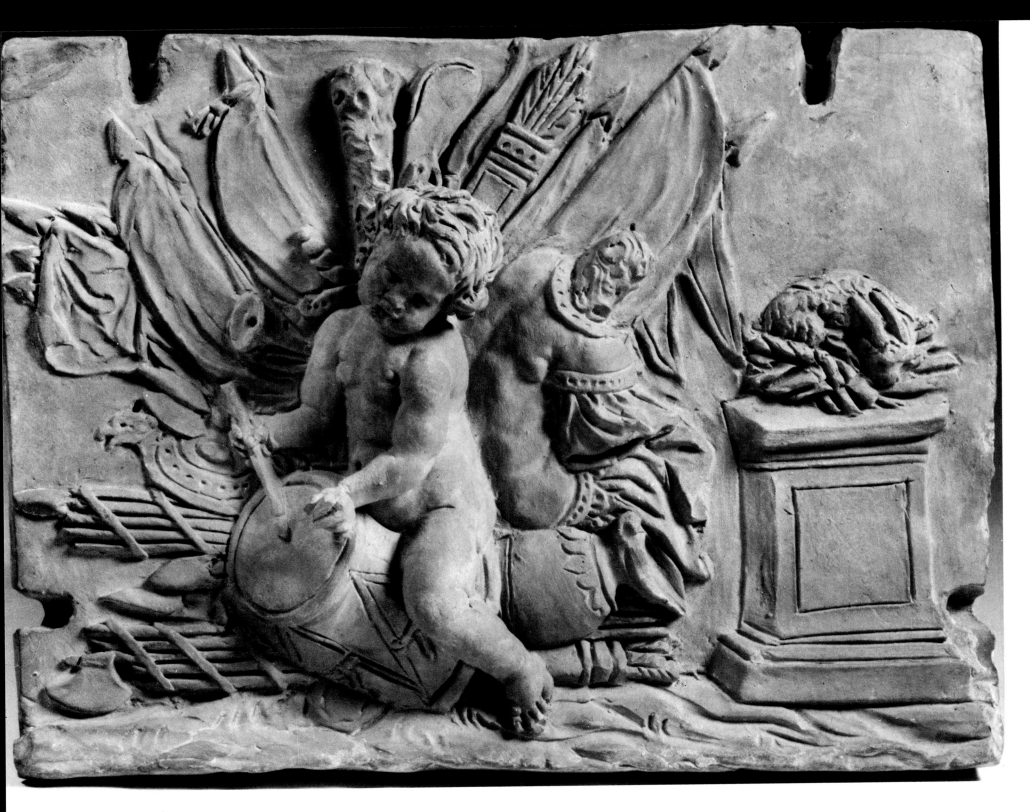

FRENCH, late 17th to mid-18th century

JACOB-SIGISBERT ADAM (1670-1747)

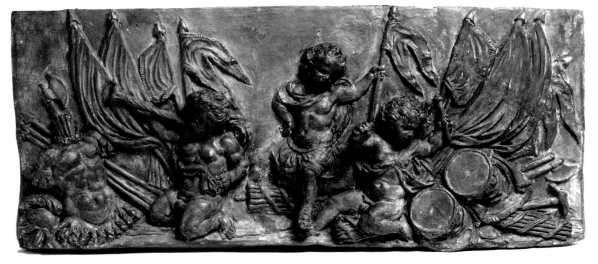

Fig. 1. Adam, *Putti with Military Trophies,* terra-cotta, Heim Gallery, London.

Son of Lambert Adam, a brass-founder of Nancy, Jacob-Sigisbert instead followed the avocation of his uncle Sigisbert, and studied sculpture under César Bagard. After working for a dozen years in Metz, Jacob-Sigisbert had returned by 1699 to Nancy, where he became Court Sculptor to Leopold, Duke of Lorraine, for whom he executed a variety of works in stone, bronze, and terra-cotta. Towards the end of his life he spent six years with his sons in Paris, but returned to Nancy before his death. He was father of the sculptors Lambert-Sigisbert, Nicolas-Sébastien, and François-Gaspard Adam, and grandfather of Claude Michel (Clodion). According to Mariette and Dom Calmet, he modelled mostly in terra-cotta and was clearly accustomed to work on a small scale, as can be seen in the sculpture on the facade of the house that he built for himself in the rue des Dominicains at Nancy.

71. *Putto Playing a Drum Before Armour*

Terra-cotta, early 18th century.
H. 8 in. (20.3 cm.) W. 10 in. (25.4 cm.) D. 2⅝ in. (6.7 cm.)
Condition: old repair at top running horizontally near top and down both sides of relief and at neck of figure in high relief.
Accession no. 77.5.2

72. *Putti Trying Out Armour*

Terra-cotta, early 18th century.
H. 6½ in. (16.5 cm.) W. 12¾ in. (32.4 cm.) D. 2⅜ in. (6.0 cm.)
Condition: repairs and cracks running in vertical line from left of center, across top of relief and neck of figure on proper right.
Accession no. 77.5.1

THESE TWO terra-cottas belong to a group of five reliefs, of which two others are in the Musée Historique Lorrain at Nancy (fig. 2) and a fifth with the Heim Gallery in London (fig. 1).[1] All show *putti* with military accoutrements and trophies. Although the slots on the sides indicate that these pieces were exhibited in their own right, their fragmentary state suggests that they were originally *maquettes* for larger-scale reliefs intended to be applied to architecture, most probably, in view of their theme, to a triumphal arch. There is, indeed, a possible reminiscence of them in Joseph Soentgen's reliefs celebrating the French alliance with America on the Porte Désilles of 1784, and the detail of the *putto* trying on the helmet is recalled in Jacob-Sigisbert's grandson Clodion's relief on the facade of 22, rue Saint-Dizier at Nancy.[2]

1. A further relief from the group was included in the sale of the Emile Straus Collection, Galerie Georges Petit, Paris, June 3-4, 1929, lot 81 (illus.); L'abbé Choux intends to devote a short article to these reliefs in a forthcoming issue of *Le Pays Lorrain*.
2. A. Jacquot, "Les Adam, Les Michel et Clodion," *Réunion des Sociétés des Beaux-Arts des Departements*, Paris, 1897, pl. XXXVII, p. 674.

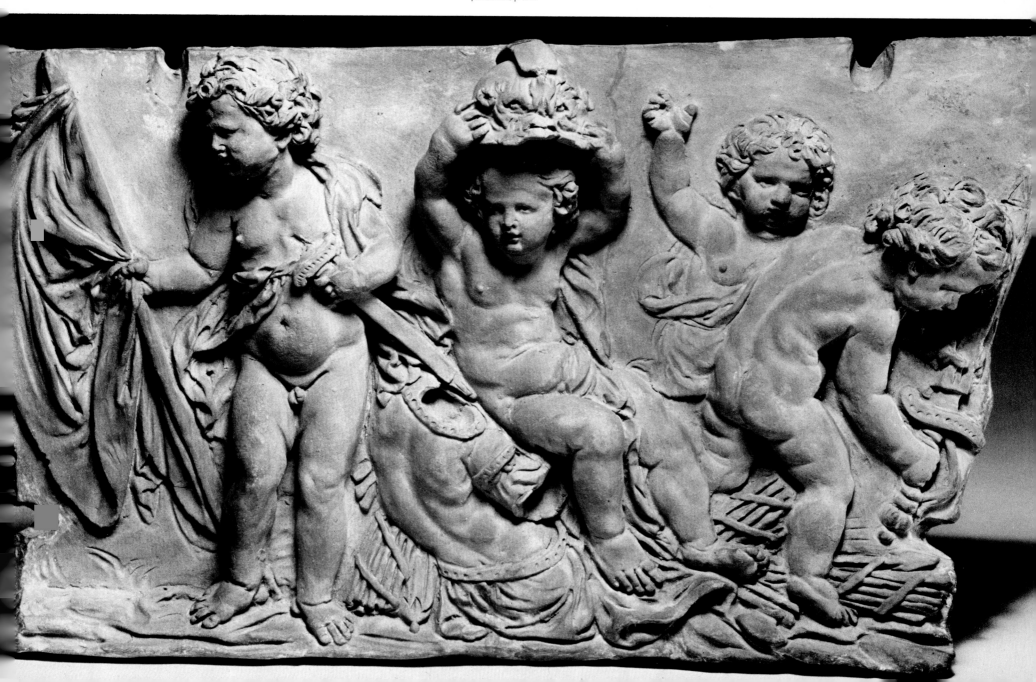

FRENCH, mid-18th century

LOUIS-CLAUDE VASSÉ
(1716-1772)

Louis-Claude trained in Paris under his father, the ornamental sculptor François-Antoine Vassé. After his father's death in 1736 he entered the atelier of Bouchardon. In 1739 he won the first prize for sculpture, and from 1740-45 studied at the French Academy in Rome. *Agréé* by the Académie royale, in 1748, he became a member in 1751 on presentation of a marble statuette of a *Sleeping Shepherd* now in the Louvre; in 1761 he became a full professor.

He regularly exhibited at the Salons from 1748 to 1761, and was a protege of the Comte de Caylus. His *oeuvre* included sculpture for Madame de Pompadour's dairy at Crécy and Madame du Barry's pavilion at Louveciennes *(Venus Directing the Darts of Love)*, for Frederick the Great of Prussia *(Diana)*, as well as for Russian magnates. Vassé's last work was the monumental mausoleum of Stanislas Leszczynski in Nôtre-Dame de Bonsecours at Nancy, which, after his death, was finished by his pupil Félix Lecomte. He also executed reliefs and busts, notably of children. A most successful sculptor, even though personally disliked by many of his contemporaries, Vassé died in his lodgings in the Louvre in 1772.

73. *Mourning Woman and Putto*

Terra-cotta, ca. 1750-1760.
H. 7 $^{15}/_{16}$ in. (20.2 cm.) W. 7⅝ in. (19.4 cm.) D. 4⅝ in. (11.7 cm.)
Condition: putto's right foot and forearm and left arm at shoulder broken off; large toe of woman's left foot broken off.
Accession no. 77.5.90

THIS TERRA-COTTA is clearly a *maquette* for the figure of a *pleureuse* (mourner) to be placed alongside a tomb. It recalls the figure of *Sorrow* in the Louvre, which probably originally came from the 1771 tomb of Feydeau de Brou in Saint-Merry.[1] It is quite possible that the sketch was executed without any particular tomb in mind, for as Ingersoll-Smouse and Réau remarked, Vassé's *Woman Weeping Over an Urn*, which he made for the Galitzin monument in 1763, derived from a plaster model that he had exhibited as far back as the 1748 Salon, and *pleureuses* appear to have been something of a stock-in-trade with him.[2]

1. J. Coural, "Note sur le Tombeau de Paul-Esprit Feydeau de Brou par Louis-Claude Vassé," *Revue de l'Art*, 40/41, 1978, fig. 2 and pp. 203-204.
2. F. Ingersoll-Smouse, *La sculpture funéraire en France au XVIIIe siècle*, Paris, 1921, pp. 189-190; and L. Réau, "Un sculpteur oublié du XVIIIe siècle: Louis-Claude Vassé, 1716-1772," *Gazette des Beaux-Arts*, sixth series, vol. IV, 1930, pp. 44-48.

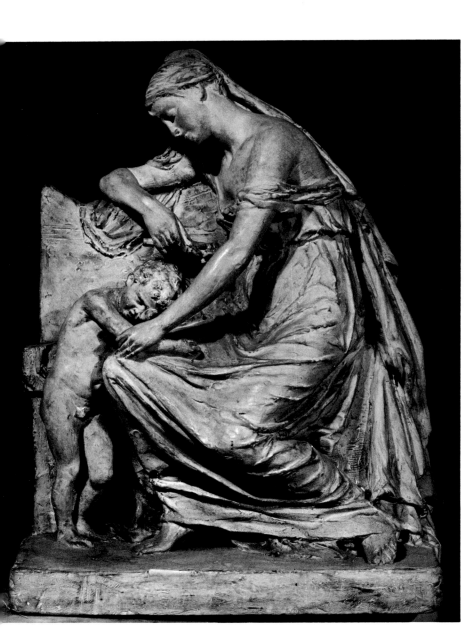

Fig. 1. Vassé, *Sorrow*, plaster, study for figure on tomb of Feydeau de Brou, Saint-Merry.

Detail of signature and date on bust

FRENCH, 18th century

JEAN-BAPTISTE LEMOYNE
(1704-1778)

Son of the sculptor Jean-Louis Lemoyne, Jean-Baptiste studied under his father and Robert le Lorrain, and in 1725 won the first prize for sculpture. Because he had to help his nearly blind father, he did not go to Italy to further his studies, as would have been expected. Admitted to the Royal Academy in 1728, he became a full member ten years later; he moved on to assistant professor in 1740, professor in 1744, deputy rector in 1761, rector in 1768, and, finally, in 1769, he became director of the Academy. He was also a member of several provincial French academies and exhibited regularly at the Salons from 1737 to 1771. Lemoyne's first known works involved completion of sculptures by his uncle, Jean-Baptiste I Lemoyne, left unfinished at the time of the latter's death. He then worked on numerous monumental commissions for Versailles, various Paris churches, and for private patrons. However, Jean-Baptiste is particularly remembered for his statues and busts of Louis XV, whose official portraitist he was. As one of the leading sculptors of the period, his splendidly vivid busts—of courtiers, magistrates, writers, actors, and many sitters still anonymous—were sculpted during a long and brilliant official career and portray a wide range of 18th-century French society.

74. *Bust of Henri-Claude, comte d'Harcourt*

Terra-cotta, 1760.
Signed: "par J-B Lemoyne 1760." under right shoulder.
H. 23¼ in. (59.1 cm.) W. 16 in. (40.6 cm.) D. 13 in. (33.0 cm.)
Condition: possible old repair to nose; crack on edge of mantle.
Accession no. 77.5.42

LEMOYNE'S POSITION as sculptor to Louis XV inevitably meant that he was also the first choice as sculptor of leading members of the court. As Réau has said: "One could illustrate the Memoirs of the duc de Luynes...with the busts of Lemoyne, who recreates before our eyes all the brilliant and lively world of marshalls and of ministers, of favorites and grand ladies, who peopled the court of Versailles."[1]

One of the court families to whom Lemoyne became almost a *"sculpteur attitré"* was that of the d'Harcourt. He modelled the senior member of the family Anne-Pierre, 4e duc d'Harcourt (1701-1784), Governor of Normandy, in terra-cotta in 1760.[2] He repeated this in marble, having perhaps already modelled him, in a more spirited way, in plaster;[3] and he also sculpted the maréchal's daughter-in-law, née d'Aubusson de la Feuillade, in marble in 1777.[4] In the same year that he sculpted the maréchal d'Harcourt, Lemoyne modelled the present terra-cotta bust of his younger brother, comte Henri-Claude d'Harcourt (1704-1769), *lieutenant-général des armées du Roi:* "A very ordinary warrior who was not distinguished for any brilliant deed in his profession or for his country."[5]

Interestingly enough, Henri-Claude's widow, Marie-Magdeleine Thibert de Martrais, comtesse de Chiverny (who was herself modelled in plaster by Lemoyne),[6] turned first to Berruer and then to Pigalle for the emotional tomb in Nôtre-Dame (1771-1776) of herself as a "new Artemisia" being reunited with her Lazarus-like husband in his sarcophagus. *L'Espion Anglais* related that she was so grief stricken at his death that she kept a clothed effigy of him seated beside his sickbed, with whom (or with which) she used to converse for several hours a day. But when, content with neither tomb nor effigy, she also wanted a posthumous marble bust of her husband, she again turned to Lemoyne.[7] There could have been no higher tribute to his gifts as a portraitist. The posthumous bust was evidently based on the present terra-cotta, but with the torso enlarged and elaborated, no doubt so that it could hold its own with Lemoyne's bust of the maréchal. It is signed and dated 1773 and is in château de Saint-Eusoge. One in plaster is in the château de Thury.[8]

1. "On pourrait illustrer les Mémoires du Duc de Luynes,...avec les bustes de Lemoyne, qui font revivre sous nos yeux tout ce monde brillant et spirituel de maréchaux et de ministres, de favorites et de grandes dames qui peuplait la cour de Versailles." L. Réau, *Une dynastie de sculpteurs au XVIIIe siècle; Les Lemoyne*, Paris, 1927, p. 89.
2. *Ibid.*, p. 91 for a description of the terra-cotta bust of the maréchal which, in 1927, was in the Ph. Weiner Collection, Paris.
3. *Ibid.*, no. 78, figs. 61 and 63 and pp. 91 and 147; neither the marble nor plaster bust is dated.
4. *Ibid.*, no. 95, fig. 64 and pp. 95 and 148.
5. *"Guerrier très ordinaire qui ne s'est signalé par action aucune d'éclat dans son métier et envers sa patrie"* (*L'Espion Anglais*).
6. Réau, *op. cit.*, no. 94, pp. 91 n. 2 and 148.
7. Réau, *J.-B. Pigalle*, Paris, 1950, pl. 24 and pp. 99-104 and 162-163.
8. Réau, *Les Lemoyne, op. cit.*, no. 79, fig. 62, and pp. 91 and 147.

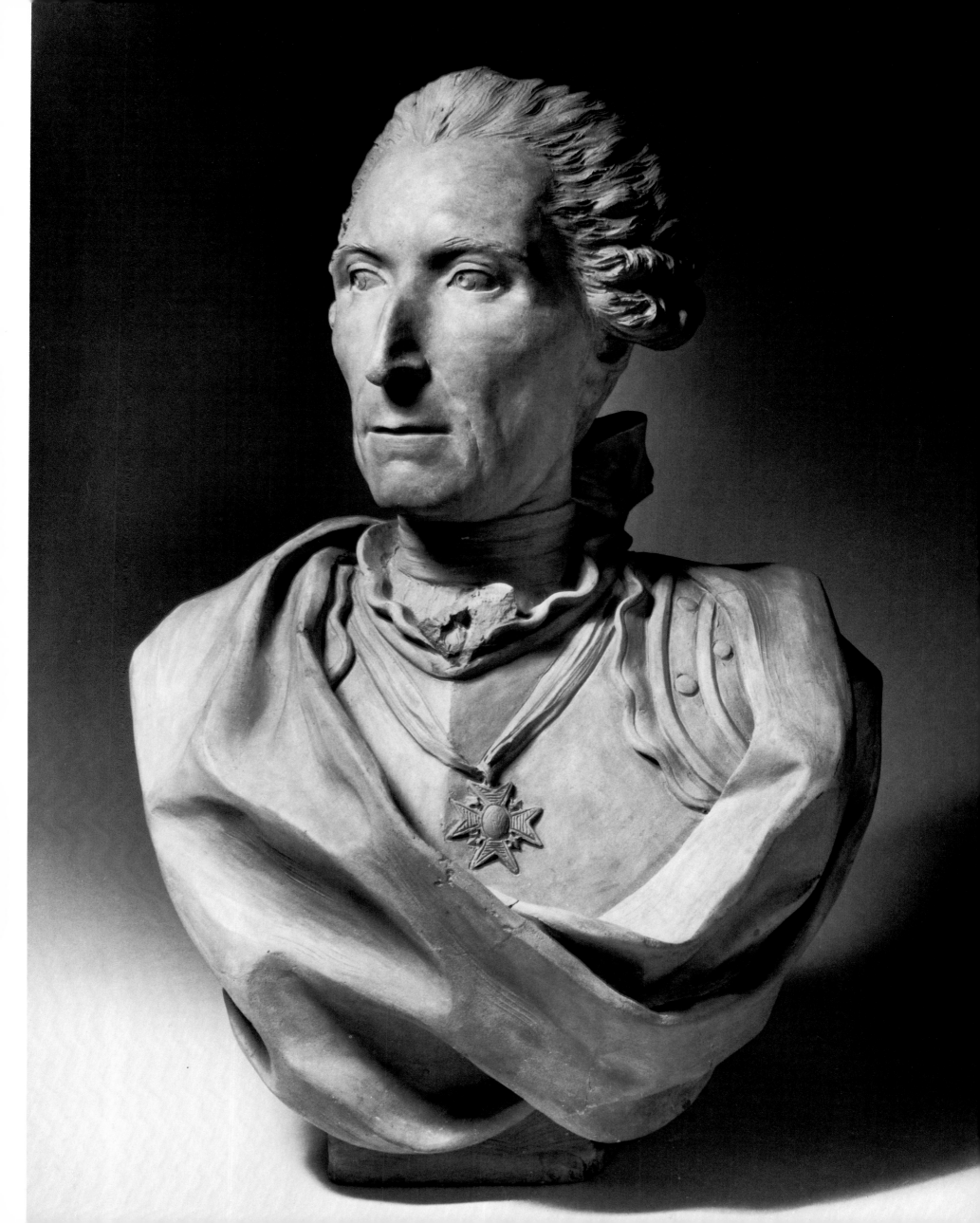

75. *M. François Boucher*

Terra-cotta, 1767.
Inscribed: Monsieur François Boucher peintre ordinaire du Roy et de Mme. la marquise de Pompadour. Par J. B. Lemoyne. 1767.
H. 8½ in. (21.6 cm.) W. 8¼ in. (20.9 cm.) D. 3⅝ in. (9.2 cm.)
Condition: no apparent repairs or damages.
Accession no. 77.5.43

76. *Mme. Boucher*

Terra-cotta, 1767.
Inscribed: Madame François Boucher. J. B. Lemoyne. 1767.
H. 9¾ in. (24.8 cm.) W. 7⅛ in. (18 cm.) D. 4⅜ in. (11.2 cm.)
Condition: excellent, with no apparent repairs or damages.
Provenance: Christie's, July 1, 1976, lot 10 (pair).
Accession no. 77.5.44

Fig. 1. Detail of inscription on back of busts.

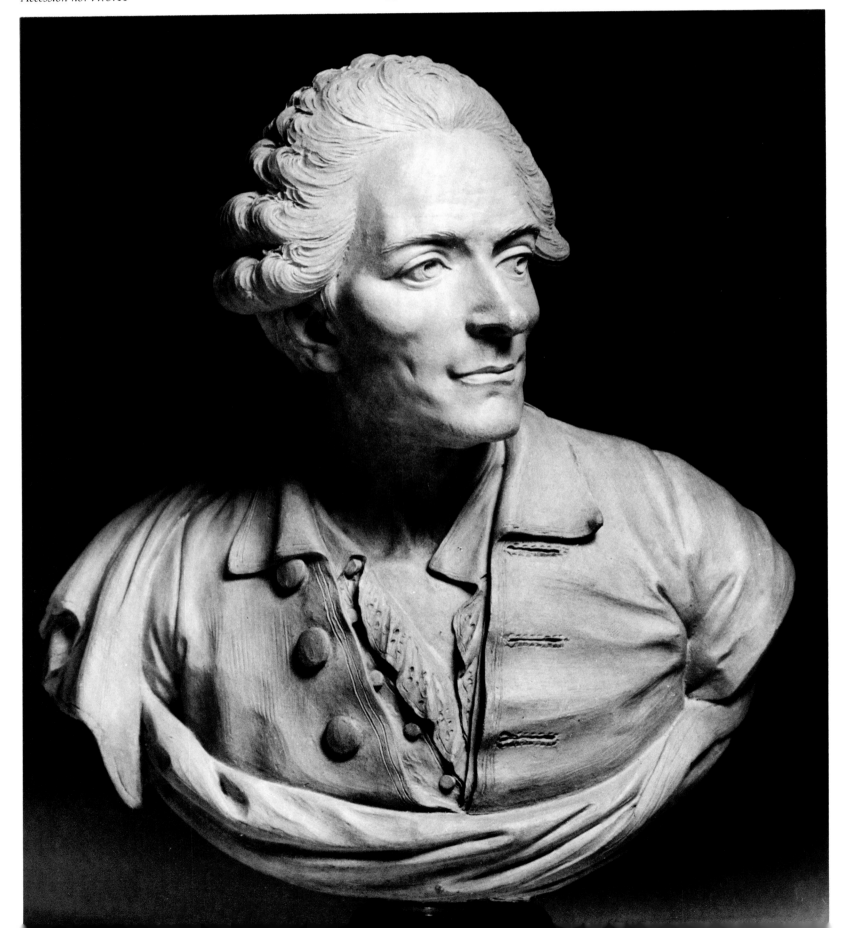

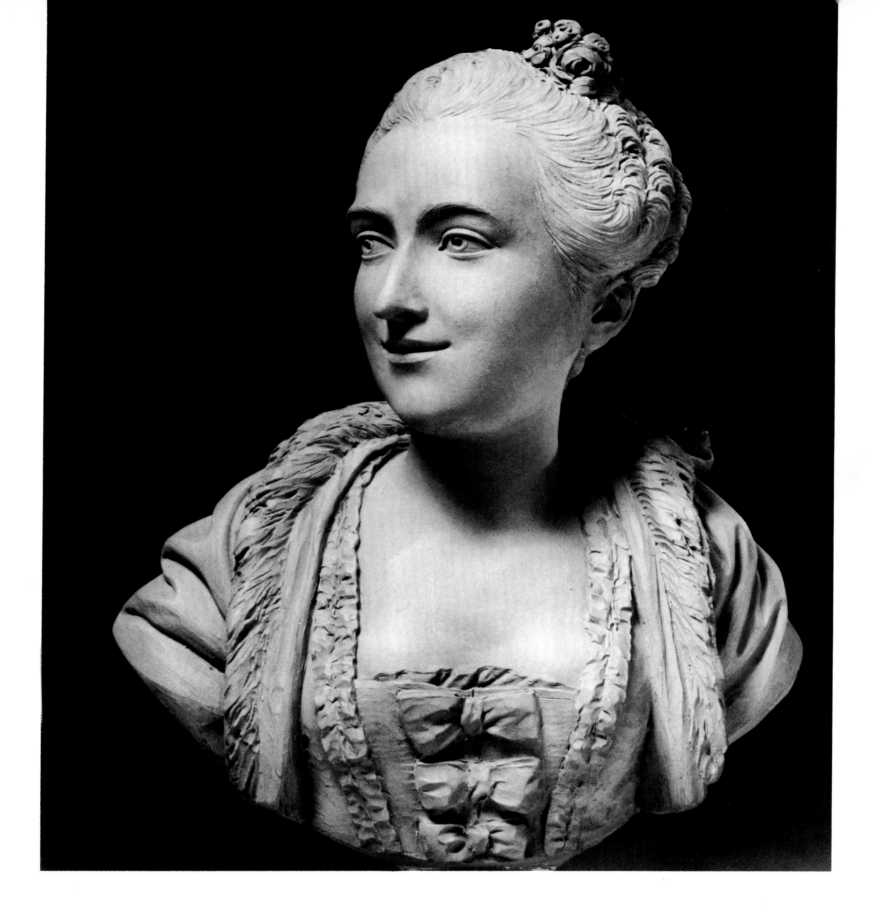

BUSTS OF BOUCHER and his wife by Lemoyne are not recorded in the earlier literature, and both the *petite nature* format and the use of everyday dress are unusual in Lemoyne's *oeuvre*; nonetheless, the features of the man are clearly Boucher's and the inscription (fig. 1) seems trustworthy.

It is indeed strange that until now no bust of Boucher by Lemoyne should have been known, for their relationship was closer than that of merely professional colleagues.[1] Not only were Boucher and Lemoyne First Painter and First Sculptor, respectively, to the king, but when Boucher stepped down from the directorate of the Academy in

July, 1768, he was succeeded by Lemoyne. One need not doubt that he had a significant say in the choice of his successor.[2] The present pair of busts was modelled in 1767, the year before this handover of the directorate. Given this, what could be more natural than, as a delicate gesture anticipating and encouraging the fall of Boucher's mantle onto his own shoulders, Lemoyne should sculpt the painter and his wife on this small and intimate scale?

Another bust of Boucher by a sculptor colleague is a terracotta attributed to Caffieri.[3]

1. A drawing by Boucher, of the sculptor's eldest son at the age of three, which had previously been in the P.-H. Lemoyne sale of 1828, appeared in the Yves Le Moyne sale of February 5, 1912, lot 33, see L. Réau, *Une dynastie de sculpteurs XVIIIe siecle: Les Lemoyne*, Paris, 1927, p. 158.
2. *Ibid.*, p. 131.
3. Heim Gallery (London), *Aspects of French Academic Art: 1680-1780* (exhibition catalogue), Summer 1977, no. 35.

FRENCH, first quarter of the 18th century

ANONYMOUS

77. *Study of a Fallen Man in Agony*

Terra-cotta, ca. 1700–1715.
H. 6¾ in. (17.1 cm.) W. 9¾ in. (24.7 cm.) D. 6¼ in. (15.8 cm.)
Condition: broken and repaired on right side of base.
Accession no. 77.5.63

T HIS SMALL sketch-model combines the appearance of an 18th century terra-cotta with an emotionalism and freedom of handling more characteristic of the romantic era. The key to this seeming incongruity is to be found in some observations made by François Souchal about the reception-pieces required of French sculptors by the Académie royale de peinture et sculpture: "The intention was primarily to put the artist's technical skill to the test, by confronting him with tricky problems....It is for the same reason that the great majority of reception-pieces produced at the end of the 17th and throughout the 18th century depict figures that are victims of some drastic fate or compelled to make a violent effort. With but few exceptions, reception-pieces thus present a more febrile, agonised appearance than [public] statues and bas-reliefs of the same period."[1]

Souchal goes on to note that there almost seems to have been a tacit understanding towards the beginning of the century that these reception-pieces should present a series of variations on the theme of "falling."

The present terra-cotta certainly seems to belong to this group of falling or agonizing figures produced as reception-pieces in the early years of the century, a group which includes Guillaume Coustou the Elder's *Hercules on the Funeral Pyre* (1704), François Dumont's *Falling Titan* (1711–12), and Jean-Baptiste Lemoyne the Elder's *Death of Hippolytus* (1715).[2] The spiritual ancestor of most of the sculpture produced in this vein was Pierre Puget (1620–1694), and it is indeed with a terra-cotta generally attributed to him, the *Resting Mars* in the Musée des Arts Décoratifs (fig. 1), that the present sketch-model displays most affinity in the handling of the clay.[3] There is, however, no sculpture by Puget himself for which the present terra-cotta could have been a preliminary sketch. Its pose and depiction of agony are, on the other hand, very close to those of another reception-piece of 1713, the *Death of Meleager* by René Charpentier (1680–1723), now in the Louvre (fig. 2).[4] There are certain differences of pose, and the figure faces in the opposite direction, so that in the absence of any other sketches in this medium by the sculptor it would be overbold to attribute this terra-cotta to Charpentier. But this was surely the context in which it was created, and the subject of Charpentier's marble statuette, the *Death of Meleager,* could well have provided the occasion for the depiction of the inner torments from which the terra-cotta figure appears to be in agony.[5]

The vivid technique of this *maquette,* with the clay built up in small patches and strips, and the figure in vigorous action, reveals a verve and spontaneity which further dramatizes the study of a struggling man. The summariness of the technique adds to the impression of agony.

1. "On entendait avant tout éprouver l'habilité technique de l'artiste en le soumettant à des problèmes délicats....C'est pour la même raison que la grande majorité des morceaux de réception, des la fin du XVIIe et pendant tout le XVIIIe siècle, représentant des personnages victimes d'un sort tragique ou obligés de fournir un effort violent. A quelques exceptions près, les morceaux de réception offrent donc une image de la sculpture plus tourmentée, plus enfiévrée que statues et bas-reliefs de la même époque." F. Souchal, *Les Slodtz,* Paris, 1967, pp. 201–202.

2. For Guillaume Coustou the Elder's reception piece for the Académie royale, October 25, 1704, *Hercules on the Funeral Pyre,* marble (H. 74 cm.), a terra-cotta version (H. 53 cm.) and another terra-cotta version (H. 27 cm., W. 40 cm.), see F. Souchal, *French Sculptors of the 17th and 18th Centuries. The Reign of Louis XIV,* vol. A-F, Oxford, 1977, cat. no. 7a, cat. no. 7b¹, p. 130 and cat. no. 7b², p. 358, respectively; for F. Dumont's *Falling Titan* and Lemoyne's *Hippolytus,* see Souchal, *op. cit.,* 1967, pl. 17b and pl. 17c, respectively.

3. K. Herding, *Pierre Puget,* Berlin, 1970, cat. no. 60, pp. 53-54 & 201 and figs. 299 & 300; hôtel de la Monnaie, *Louis XV: un moment de perfection de l'art français,* (exhibition catalogue), Paris, 1974, p.72 (illustrated in error in place of Caffieri's sketch for his reception-piece of a *River God* now in the Louvre).

4. Souchal, *op. cit.,*1977, cat. no. 9, pp. 88-89, illus., although not cited by Souchal in his 1967 publication in the context described in footnote 1 (above).

5. In greek legend, Meleager was the son of Oeneus, king of Calydon. When he was seven days old, the Fates told his mother, Althaea, that he would live until a log of wood then on the fire was completely consumed by the flames. Althaea immediately snatched the burning brand from the fire, quenched it, and hid the charred remains. Many years later, during the hunt for the Calydonian Boar, in which some of the greatest warriors of Greece joined in the chase, Meleager killed two of his mother's brothers in a dispute over the prize of the boar's hide and tusks. He killed two more of his uncles in a battle defending Calydon from an attack by the Curetes. His mother, maddened by the death of all her brothers by her son's hand, took the half-burned brand which she had snatched from the fire so many years before and hurled it into the flames. As it was consumed, Meleager felt a fiery breath scorch him and died. A celebrated warrior, Meleager held his ground when Heracles visited Hades and frightened the spirits of the dead into fleeing before his sword.

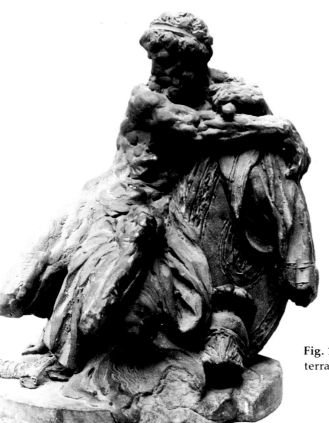

Fig. 1. Attributed to Puget, *Resting Mars,* terra-cotta, Musée des Arts Décoratifs, Paris.

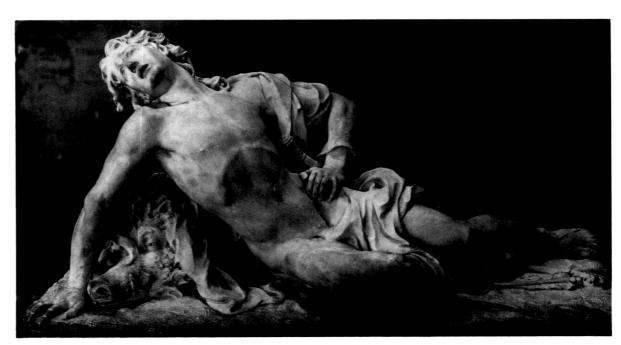

Fig. 2. Charpentier, *Death of Meleager,* marble, Louvre, Paris.

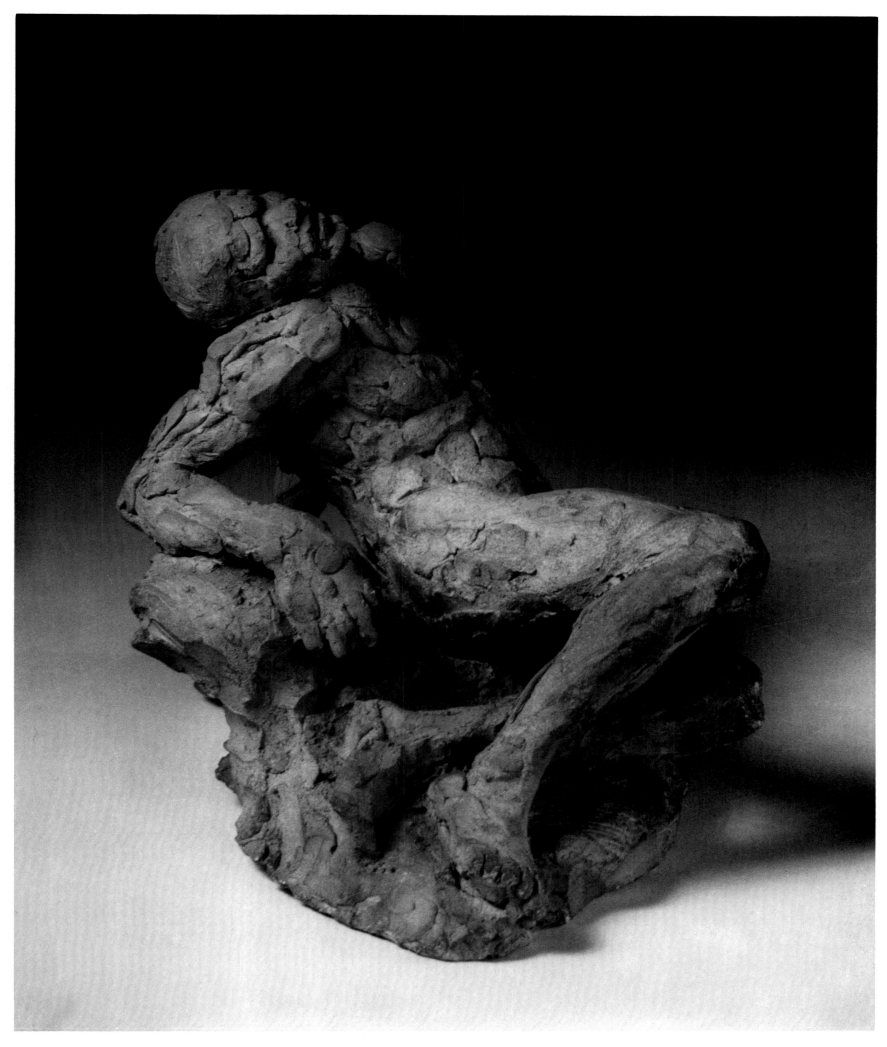

FRENCH, 18th century

AUGUSTIN PAJOU
(1730-1809)

Artistically very precocious, the Parisian Pajou began to study under Jean-Baptiste Lemoyne at the age of fourteen. Four years later, he won the first prize for sculpture, and after three further years spent at the Ecole des élèves protégés, arrived in Rome in 1752. He stayed in Italy until 1756, studying both sculpture and drawing. In 1760 he became a member of the Académie royale, an assistant professor in 1762, full professor in 1770, deputy rector in 1790 and, finally, rector in 1792. His commissions for the Court under Louis XV and Louis XVI were of major importance, but he also became the sculptor of Madame du Barry, working for other patrons as well. Exhibiting regularly at the Salons from 1759 to 1802, he held the post of Keeper of Antiquities at the Louvre. After the Revolution he was elected Membre de l'Institut and received the Legion of Honour. Pajou's *oeuvre* is very considerable, ranging from monumental sculpture, through numerous busts, to small decorative groups and figures—all of the highest artistic merit. In addition, he was a superb draughtsman.

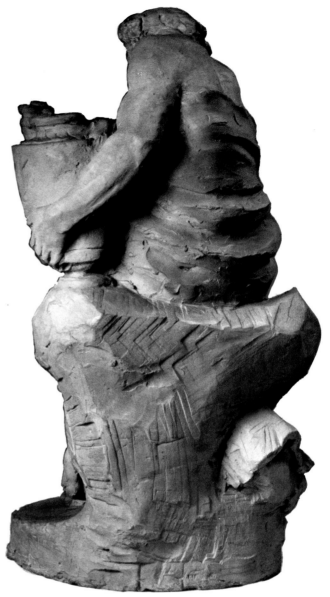

78. *Silenus*

Terra-cotta, ca. 1758.[1]
H. 17⅜ in. (44.1 cm.) W. 9 in. (22.9 cm.) D. 10 in. (25.4 cm.)
Condition: old repairs at neck, left shoulder, right wrist and legs.
Exhibited: Heim Gallery (London), *Aspects of French Academic Art: 1680-1780,* Summer 1977, no. 37 *
Accession no. 77.5.61

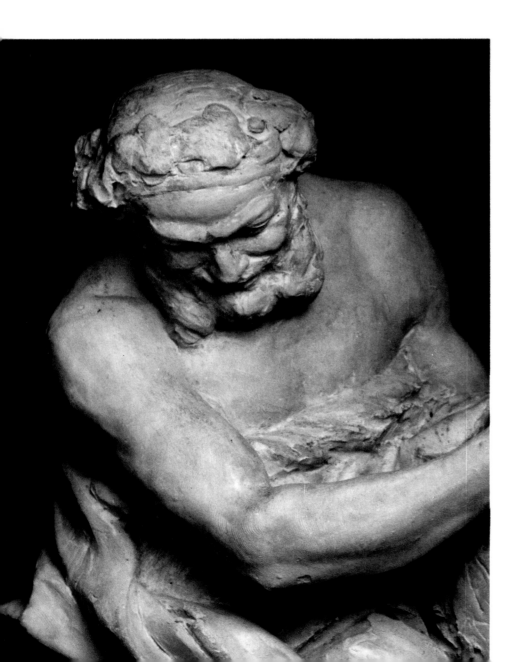

A LIFE-SIZE PAIR of plaster statues of *Silenus* and of a *Satyr Playing the Flute* were executed by Pajou in 1758, but it is not known for what these were originally destined. These signed and dated statues were later placed in niches in a *treillage garni de figures* in the extensive grounds of the Folie Saint-James at Neuilly— built by Bélanger for the inordinately rich financier, Baudard de Vaudésir, baron de Saint-James, from about 1778 onwards. When the Folie became a lunatic asylum, after passing through several hands, the plaster statues were sold, becoming the property of the poet and aesthete comte Robert de Montesquiou.[2] The present terra-cotta is the sketch-model for a plaster statue of *Silenus,* which is not known to have been executed in any other medium.

1. Oxford Research Laboratory for Archaeology and the History of Art, *Report on Thermoluminescence Analysis,* sample no 281q80: less than 120 years old. Further study is intended in order to determine if repairs undertaken in the last 100 years may have prevented a proper dating by thermoluminescence testing.
2. H. Stein, *Augustin Pajou,* Paris, 1912, pp. 15-17, 396.
*The information in this entry is based in part on that provided by the author for the Heim Gallery catalogue.

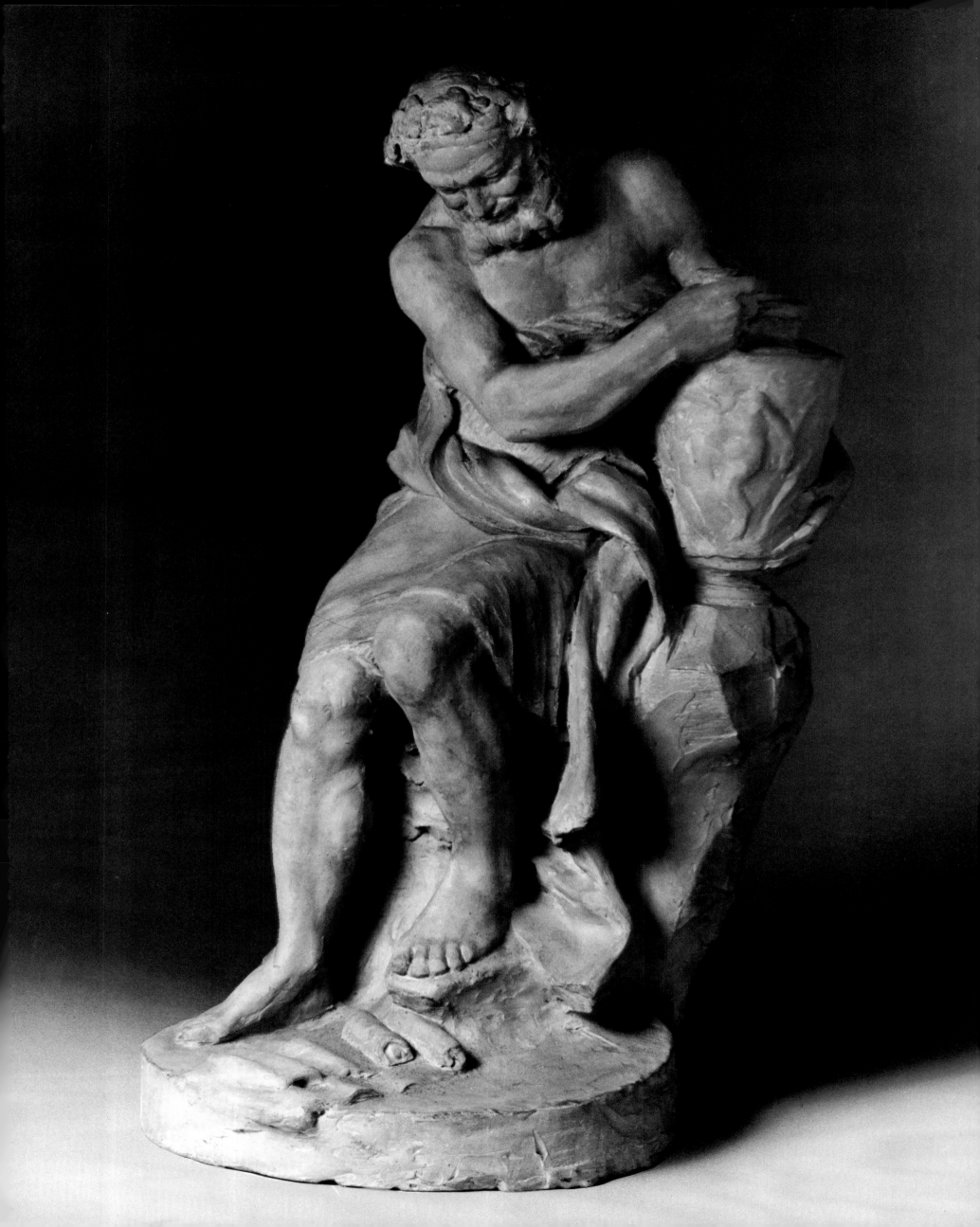

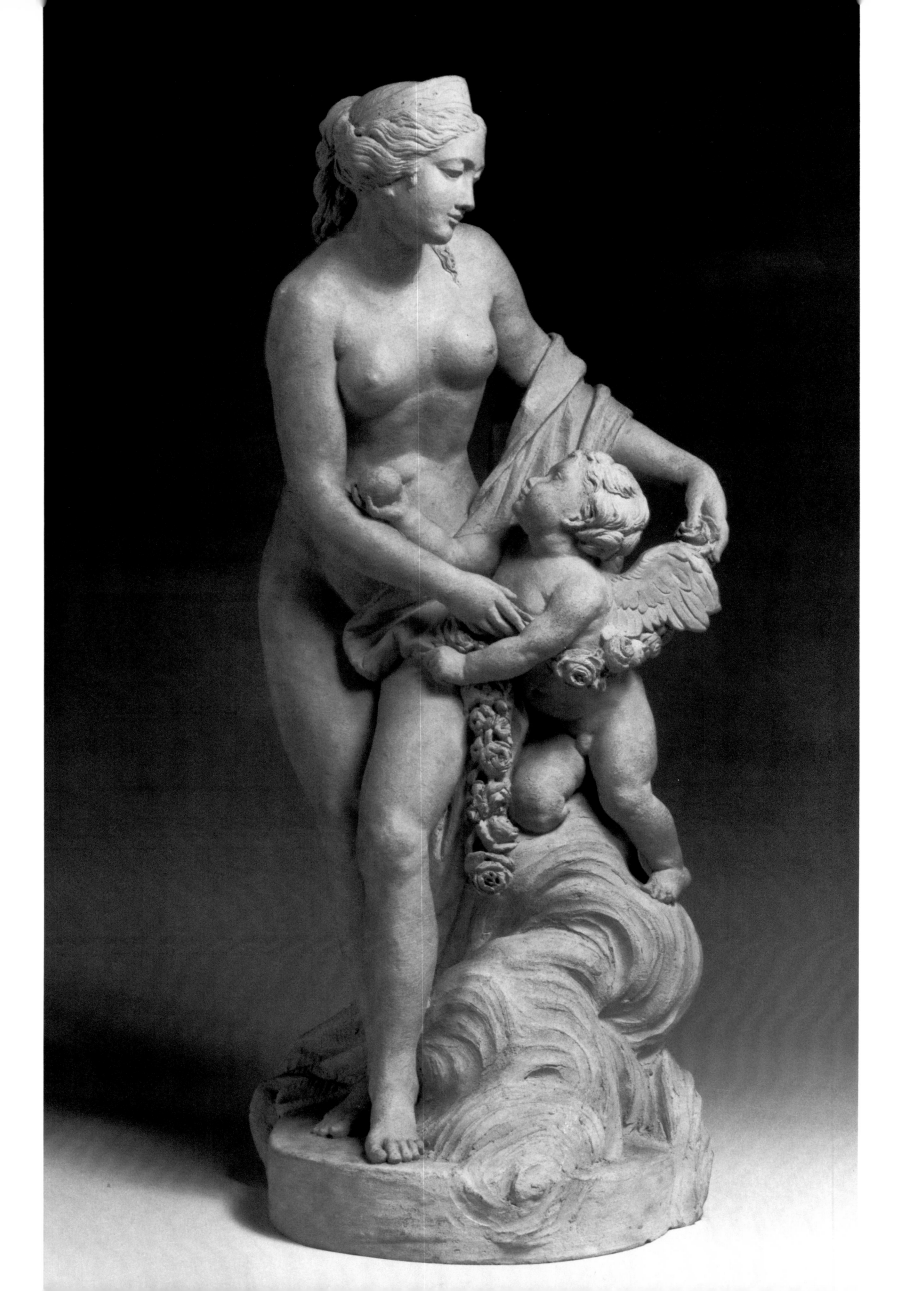

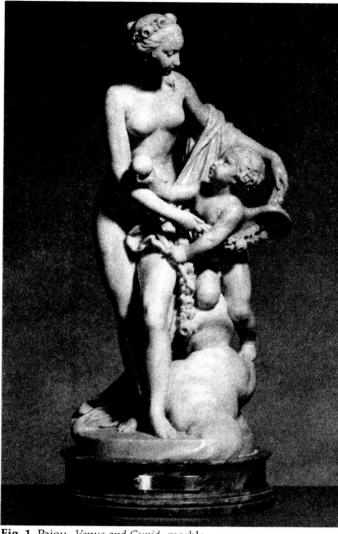

Fig. 1. Pajou, *Venus and Cupid*, marble, formerly in the Rothschild Collection.

79. *Venus Receiving the Apple from the Hands of Love*

Terra-cotta, 1771.
H. 18⅝₆ in. (46.5 cm.) W. 7⅝ in. (19.4 cm.) D. 5¼ in. (13.3 cm.)
Condition: old repairs at wrists, neck, arm with drapery, flowers in female's left hand, and wings of Cupid.
Exhibited: Paris, Salon of 1771. Heim Gallery (London), *Aspects of French Academic Art: 1680-1780,* Summer 1977, no. 39.
Accession no. 77.5.62

VENUS IS SEEN HERE enchaining Love with a rose garland. The fruit being offered to her by Love has been variously described as an apple, the *fruit du péché* (fruit of desire or sin), or the prize given her for her beauty.[1] The arrow he originally held in his left hand is broken off.

This terra-cotta is purportedly one of two sketches of Venus and Cupid submitted by Pajou to the Salon of 1771,[2] and to have served as the model for a marble exhibited in the Salon of 1787.[3] The marble, formerly in the Rothschild collection, Vienna, passed into other hands and was subsequently sold in New York (fig. 1).[4] One of two drawings for the composition is now in

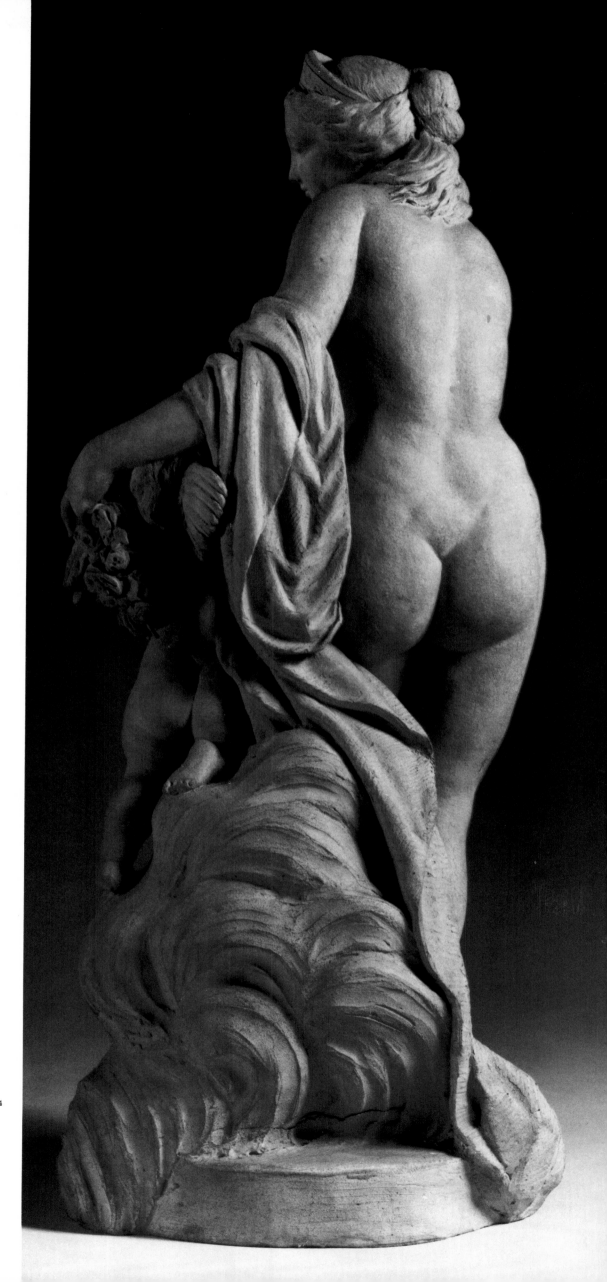

the Sackler collection (fig. 2).[5] A full-size statue in *pierre de Tonnerre* was described in the Salon of 1806 and appeared in the Sardou collection, Marly-le-Roi.[6]

The question of title for this statuette has created some confusion. The 1771 Salon descriptions enumerate three sketches in *terre* by Pajou: *Vénus, ou la Beauté qui enchaîne l'Amour; Vénus recevant de l'Amour le prix de la Beauté; Hebé, Déesse de la jeunesse.*[7] The two referring to Venus are the problem. Obviously, the terra-cotta here is the same subject as the marble statuette of 1787 specifically designated in the Salon of that year as *Vénus recevant la pomme des mains de l'Amour.* It is also identical with the group in the drawing and the full-size statue in *pierre de Tonnerre.* In all, Venus is seen enchaining Love with a garland of roses as Love offers her a fruit, by whatever name. Therefore, the image in its various versions can, in fact, be associated with either of the works described in the 1771 Salon. Traditionally, however, it was Paris, not Cupid, who awarded Venus a golden apple, the prize for surpassing the other goddesses in beauty, and such a subject, with Cupid, would indeed be unusual.

In publishing this terra-cotta in 1977, however, the Heim Gallery titled it *Venus Receiving the Prize of Beauty from the Hands of Love,* while referring to Diderot's 1771 Salon comments praising the idea of *Venus Enchaining Love.*[8] Diderot allegedly wrote: "The idea of Venus enchaining Love is an ingenious and excellent notion; it appears from the group that the point is not that he [Love] wishes to escape, since he does not make an effort to oppose his bondage, but only that she enchains him to forestall desire which would emanate from him. *Venus who receives from Love the prize of beauty* presents a pleasing pose although the idea of it is not new...."[9]

The implication in Diderot's comments is that in one image Venus enchains Love but in the other Love is simply offering her the prize for beauty. Diderot's Salon reviews, however, were intended to be read outside of France and were not available in print until the end of the eighteenth century (1795).[10] There is even a question of whether, in fact, what he said was transmitted entirely accurately or even whether Diderot actually wrote the notes attributed to him, particularly for the 1771 Salon.[11] Therefore, comments ascribed to him merely compound the confusion.

1. "La pomme des mains du l'Amour" in the description of the 1787 marble version by Pidansat de Mairobert who continued the *Mémoires secret par Bachaumont* after Bachaumont's death in April, 1771 (see H. Stein, *Augustin Pajou*, Paris, 1912, p. 215 and 403, and J. Seznac, ed., *Diderot Salons*, vol. IV, Oxford, 1967, p. 125); "fruit du péché" in Stein, *op. cit.*, p. 216; "le prix de la beauté" in Stein, p. 214, and Seznac, ed., *op. cit.*, p. 154 and 219; "la pomme, prix de sa beauté," in *Le Pausanias français ou Description de Salon de 1806*, Paris, 1808, p. 470.

2. Seznac, ed., *op. cit.*, p. 154 and 219.

3. Stein, *op. cit.*, p. 214-216. Stein says, "Il existe...un groupe charmant en marbre, dont l'esquisse fut exposée au Salon de 1771 et eut l'heur de plaire-chose rare-à Diderot lui-même..." (p. 214), but adds to the confusion when he writes, "Et lorsqu'en 1787 le *plâtre* [ed. italics] tranformé en marbre..." (p. 215).

4. Parke-Bernet Sales Catalogue, November 1, 1958, no. 302, mistitled *Cupid and Psyche.*

5. Stein, *op. cit.*, pl. IX, p. 246.

6. *Ibid.*, p. 217. Stein describes finding it in the Sardou collection, but disagrees with the opinion in *Le Pausanias français, op. cit.*, that the image in *pierre de Tonnerre* was begun by Pajou, completed by Boizot for M. Le Voyer, and then sold to a porcelain manufactory in 1806 before finding its way into the Sardou collection. He is convinced Boizot had nothing to do with this work, nor is there an example of it in Sèvres (p. 217, footnote 3).

7. Seznac, ed., *op. cit.*, p. 154.

8. See under *Exhibited* above.

9. Seznac, ed., *op. cit.*, p. 219, "L'idée de Vénus qui enchaîne l'amour est une idée ingénieuse et fine; car il parait par le groupe que si elle enchaîne, ce n'est point qu'il veuille s'échapper, mais seulement pour prévenir le désir qui pourrait lui en venir, puisqu'il ne semble pas faire d'effort pour s'opposer à son esclavage. *Vénus qui reçoit de l'Amour le prix de la beauté* offre une pose agréable quoique l'idée n'en soit pas neuve...(Esquisses jolies)"

10. W. G. Kalnein and M. Levey, *Art and Architecture of the Eighteenth Century in France*, Harmondsworth, 1972, in Notes to Part One, chapter 2, footnote 1, p. 364.

11. Seznac, ed., *op. cit.*, p. xiv-xv.

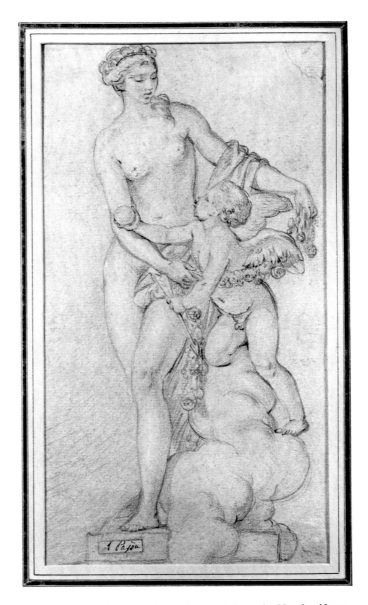

Fig. 2. Pajou, *Venus Receiving the Apple from the Hands of Love.* Drawing, ink on paper, from the Arthur M. Sackler Collections.

80. *Bust of Corbin de Cordet de Florensac*

Terra-cotta, ca. 1792-1794.
H. 21¼ in. (54.0 cm.) W. 18½ in. (47.0 cm.) D. 11¾ in. (29.8 cm.)
Condition: repairs to edge of nose, right shoulder, lower edge of chest and collar; some repair to chin.
Provenance: purchased from descendants of the sitter in 1969.
Exhibited: Heim Gallery (London), *Recent Acquisitions: French Paintings and Sculptures of the 17th and 18th Centuries,* Summer 1979, no. 27.
Accession no. 77.1.29

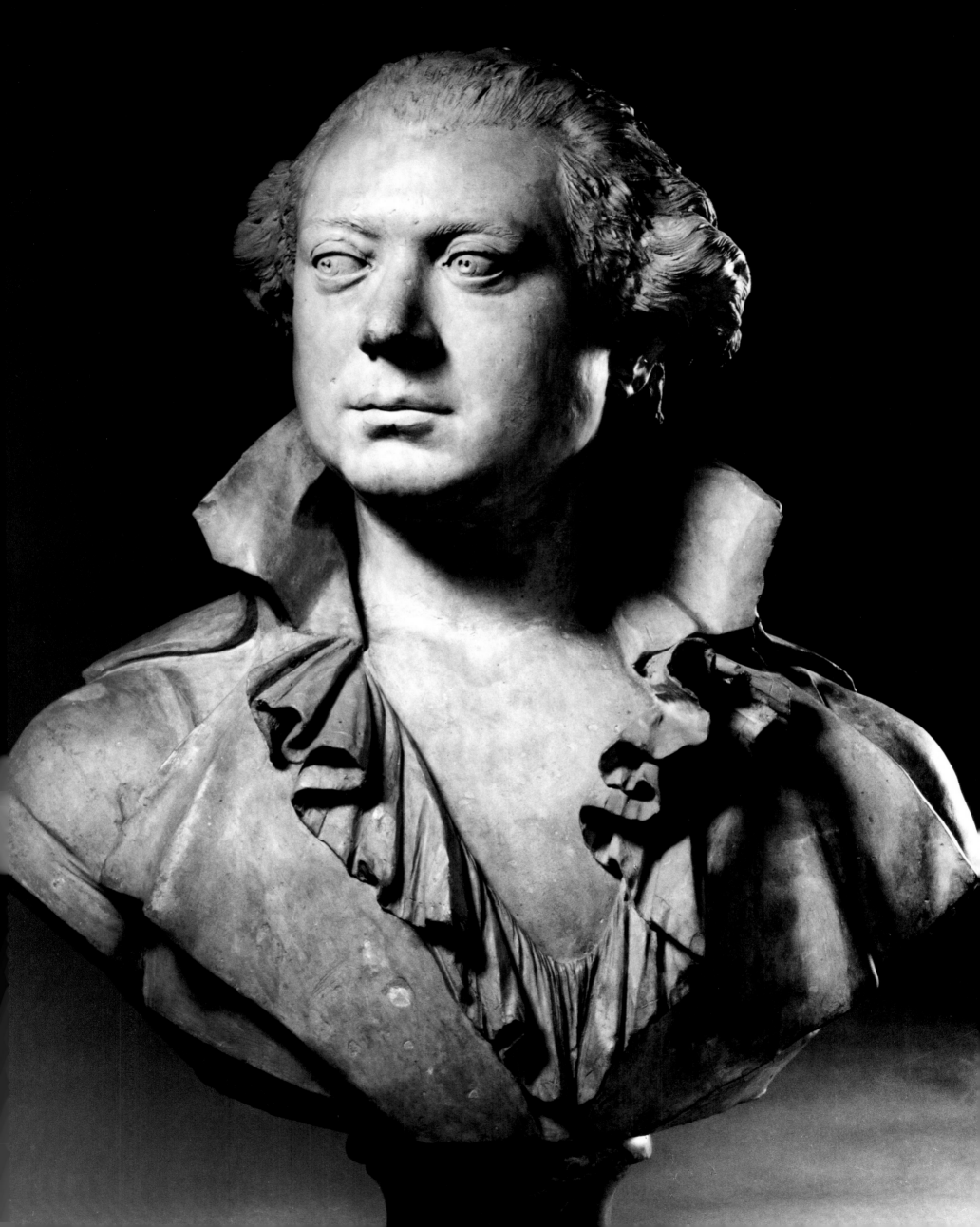

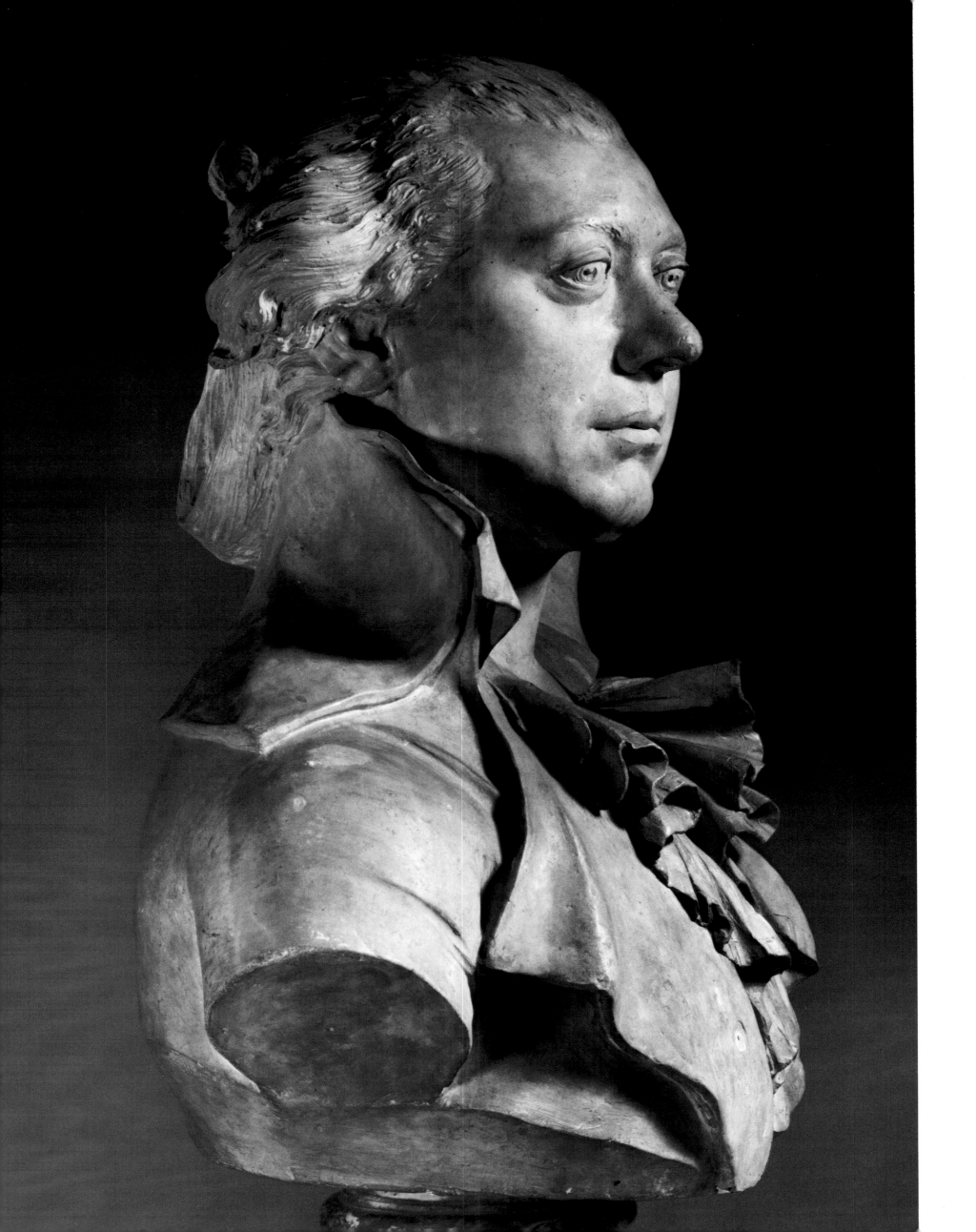

82. *Vestal Holding Sacred Vessels*

Terra-cotta, ca. 1765-1770.
Signed: CLODION, incised on base.
H. 16¾ in. (42.6 cm.) W. 5 ¹/₁₆ in. (14.5 cm.) D. 5⅜ in. (13.7 cm.)
Condition: some minor repairs throughout.
Provenance: see no. 81.
Exhibited: Heim Gallery (London), *op. cit.*, no. 31.
Accession no. 79.1.25

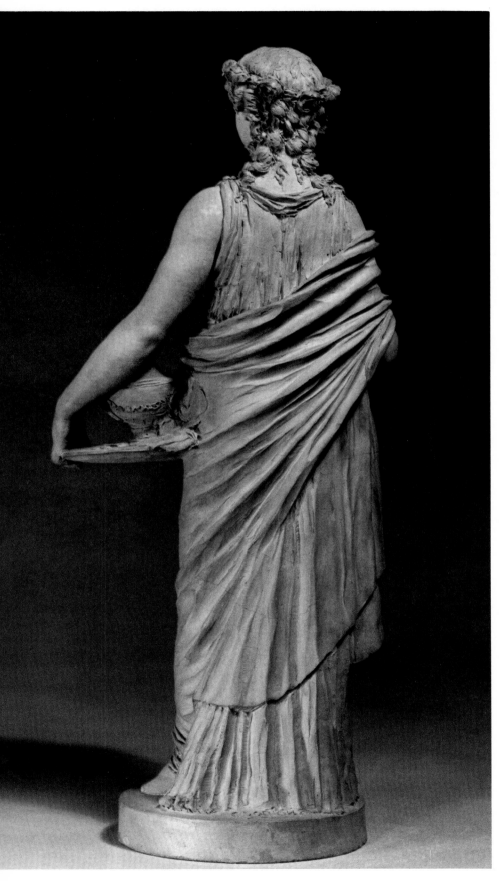

Attempts at cataloging the work of Clodion have been made by different authors, who include vestals of various heights and poses.[8] Unfortunately, the cataloging is uneven—some of it lacks dimensions for the images described, while the descriptions are often mere titles. Without adequate illustrations or definitive cataloging, it is difficult to determine the number of variant compositions of vestals that Clodion produced, or to trace their specific provenance.[9] Using a process of elimination by height and subject or other distinguishing characteristics for those vestals already catalogued, and if the records describe the pose accurately enough, there are a number of vestals with one or other of which the two here may be associated.

Some possible candidates were formerly recorded as distinct pairs, for example those described as *Deux belles vestales ajustées dans le genre antique*, at Natoire's *vente ápres décès*.[10] Natoire was director of the French Academy in Rome while Clodion was a student there, strongly suggesting that these were made in Rome. However, their sizes and poses are not described.

Another pair described as *Deux belles figures debout representant de Vestales: I. L'une portant des vases pour le sacrifice. II. L'autre est aussi debout et bien drapée* was sold on March 15, 1785.[11] The catalogue gives their sizes, with bases, as 18 pouces (ca. 45 cm.). While they are close in size to the Sackler pair—even though the Sackler figures no longer have gilt bronze bases set in marble—the latter are signed and it seems unlikely that such an important fact would be ignored in the sales catalogue. Lami also mentions two vestals in terra-cotta made as a pair in the collection of M. Lucien Desmarais, Paris.[12] While he notes that they are signed, he gives no indication of size or pose. A signed, standing vestal holding a plate which contains a wreath or crown of flowers in the Eugène Tondu sale in Paris, April 3-29, 1865, is referred to by Thirion.[13] The size indicated (44 cm.) and the description makes this closest of all to our no. 82.

1. L. Réau, *Houdon —sa vie, son oeuvre*, vols. III/IV, Paris, 1964, cat. no. 3 and pl. II.
2. Françoise Boucher sale, Paris, February 18-March 9, 1771. F. Lugt, *Repertoire des catalogues de ventes publiques, 1600-1825*, vol. I, The Hague, 1938, no. 1895 (hereafter given as Lugt no.): "Une Vestale, terre cuite 15 pouces de haut, faite a Rome d'après l'antique. C'est la même que celle qui a étée copiée par Le Gros pour le jardin des Tuileries.".
3. Sale of M. de Fortier, avocat (Lugt no.1822): "Une Vestale couronnée de fleurs, tenant d'une main un vase appuyé sur un trépied, de l'autre une patère. Statuette en terre cuite. Haut, 13 pouces 6 lignes (quoted from S. Lami, *Dictionnaire des sculpteurs de l'école française au dix-huitième siècle*, vol. II, Paris, 1911, p. 144).
4. French & Co. sale at Parke-Bernet, November 14, 1968, lot 135 and T. Hodgkinson, "A Clodion statuette in the National Gallery of Canada," *National Gallery of Canada Bulletin*, 24, 1974, pp. 20-21 and fig. 12.
5. U. Middeldorf, *Sculptures from the Samuel H. Kress Collection*, London, 1976, pp. 106-108 (entry by Charles Avery) and fig. 182. This marble was formerly in the David-Weill collection.
6. Sale of M. de Julienne, Paris, March 30-May 22, 1767 (Lugt no. 1603), among the terra-cottas, lot 1304: "Deux figures de femme, l'une avec sa torche allume le feu sacré de l'Autel, l'autre, qui est une Prêtresse couronnée, verse sa patère sur l'Autel: groupes de 10 pouces 6 lignes de haut par M. Clodion, sur un socle de bois doré." Both H. Thirion (*Les Adam et Clodion*, Paris, 1885, p. 387) and Lami (*op. cit.*, p. 144), incorrectly refer to the first vestal as "...allume le feu....de l'Amour."
7. Exhibited in Galerie Cailleux, *Autoure de Néoclassicisme*, Paris, 1973, no. 57. This terra-cotta may be the one formerly in the David-Weill collection, Paris. The Cailleux catalogue, however, creates confusion by referring to this terra-cotta as the model for a marble executed in 1765, formerly in the David-Weill collection. The 1765 date is actually an error since the marble vestal from the David-Weill collection was dated 1770 and is, in fact, the marble now in the Kress collection, Washington, D.C. It is the 1770 marble which was exhibited at Wildenstein Gallery in 1940 (see Wildenstein & Co., *French XVIIIth Century Sculpture*, formerly of the David-Weill collection, New York, April, 1940, p. 16, no. 35 for the terra-cotta vestal and no. 37 for the marble).
8. Lami, *op. cit.*, and Thirion, *op. cit.*
9. See the entry written by C. Avery in Middeldorf, *op. cit.*
10. Lami, *op. cit.*, p. 146 (Lugt no. 2928), Henri Thirion adds to this information that the pair was sold to Paillet (see Thirion, *op. cit.*, p. 391).
11. Sale of Mme. de B(oynes), Paris, March 15-19, 1785 (Lugt no. 3845), lot 125, and in Thirion, *op. cit.*, p. 397. Sold to Desmarest.
12. Lami, *op. cit.*, p. 158. These were ostensibly in the Desmarais collection at the time of Lami's publication in 1911 and were works personally known to him.
13. Lot 205. See Thirion, *op. cit.*, p. 406 (Lugt vol. III, no. 28424).

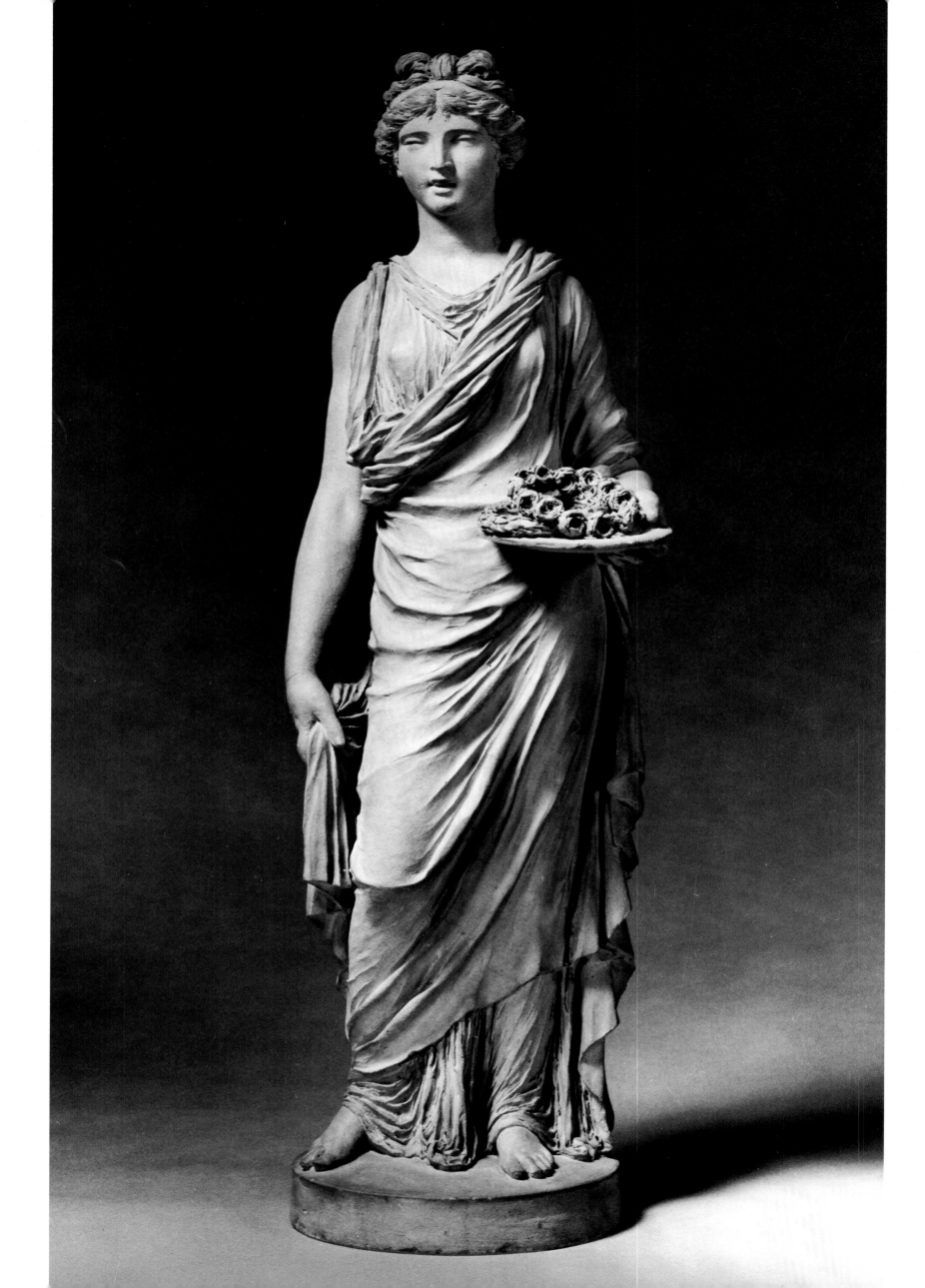

FRENCH, mid-18th to early 19th century

CLAUDE MICHEL, called CLODION
(1738-1814)

A nephew of Lambert-Sigisbert Adam, under whom he
studied until the latter's death, Clodion completed his
apprenticeship under Pigalle. He won the first prize for
sculpture in 1759 and, after spending three years at the
Ecole des élèves protégés, went to Rome, where he
stayed until 1771. There he worked for several important
patrons, including Catherine II of Russia. After returning
to Paris, he became an associate of the Royal Academy
in 1773 and exhibited regularly at the Salons. He did not
seek official commissions, as he was swamped by the
demands of private clients, who fought for the small,
sensuous and decorative terra-cotta statuettes that he
produced in large quantities. Nevertheless, Clodion
also sculpted several monumental pieces and worked on
the decoration of some *hôtels particuliers* in Paris. The
Revolution, with its complete change of taste, ruined the
artist, but he managed to model figures for Niederwiller
in Nancy between 1795 and 1798. He then collaborated on
some of the great sculptural commissions of the Empire
(Colonne de la Grande Armée, L'Arc de Triomphe du
Carrousel), but died in poverty and obscurity only two
decades before his sculptures were again to become
sought after. Clodion was the greatest 18th-century
French master of sculpture on a small scale, and his
works have an originality and vivacity all their own.

81. *Vestal Bearing Wreaths on a Platter*

Terra-cotta, ca. 1765-1770.
Signed: CLODION, incised on back of figure.
H. 16½ in. (41.9 cm.) W. 4⅞ in. (12.4 cm.) D. 4⅜ in. (11.2 cm.)
Condition: some minor repairs throughout.
Provenance: French & Co., New York.
Exhibited: Heim Gallery (London), *Recent Acquisitions–French Paintings
and Sculptures of the 17th and 18th Century,* Summer 1979, no. 30.
Accession no. 79.1.24

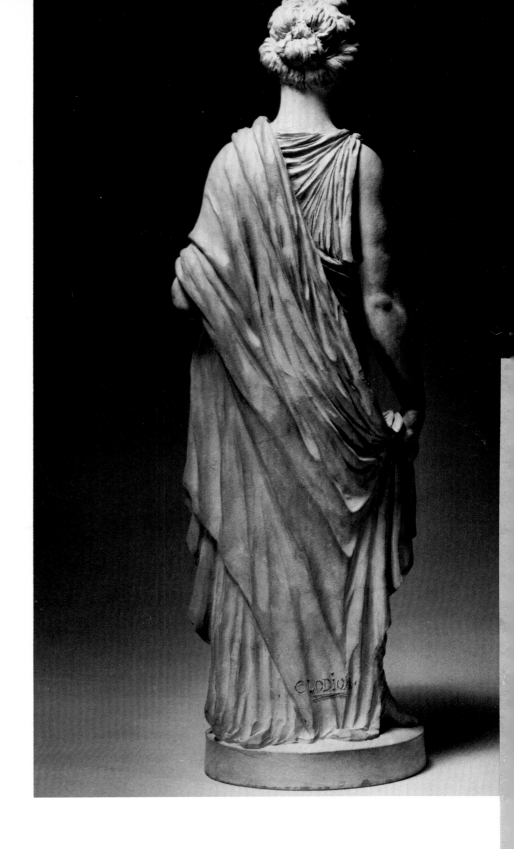

STATUETTES OF YOUNG VESTAL VIRGINS were one of
Clodion's earliest and favorite themes. Inspired,
like his fellow student Houdon[1] by an Antique
statue of a *Priestess Carrying a Vessel* in the Capitoline
Museum, Rome, and another in the Uffizi Gallery,
Florence, he started to make terra-cotta statuettes of
vestals while still studying at the French Academy in
Rome. A terra-cotta *Vestal* after the Antique by Clodion
featured in François Boucher's *vente après décès* in 1771.[2]
In another composition of his own, Clodion modelled
a vestal holding a vase in one hand and a patera in the
other and introduced a fashionable tripod *athénienne.*
This is recorded as bearing the signature *Clodion Roma
1766,* and was included in a sale in 1770.[3] He then
apparently made a terra-cotta variant of the 1766 figure:

this time with the vestal tipping the contents of her patera
into the sacrificial fire of the tripod altar. Such a vestal is
one of a pair of figures signed and dated *M: Clodion in Roma
1768,* in the Carnegie Institute in Pittsburgh.[4] The Carnegie
Vestal is essentially identical with, and may have been the
model for, a marble statuette which Clodion carved in
Rome for Catherine the Great of Russia in 1770, now in
the Kress collection, National Gallery of Art, Washington,
D.C.[5] Perhaps an earlier terra-cotta example of this version
of Clodion's priestess is one from a smaller pair of vestals
(10 pouces 6 lignes or 26.5 cm.), sold in 1767. She is de-
scribed as *Une pretesse couronée verse sa patère sur l'autel.*[6]
Another, larger in size, in a pose which is in reverse of
the Carnegie terra-cotta and the Kress collection marble,
is now in the Cailleux collection.[7]

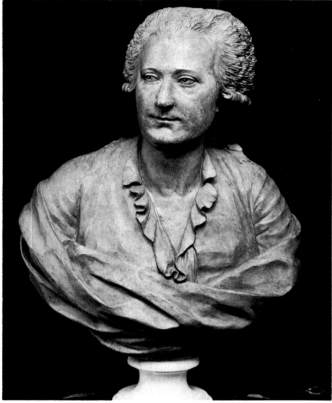

Fig. 1. Pajou, *Bust of the marquis de Montferrier,* terra-cotta, ca. 1781-82, Montreal Museum of Fine Arts.

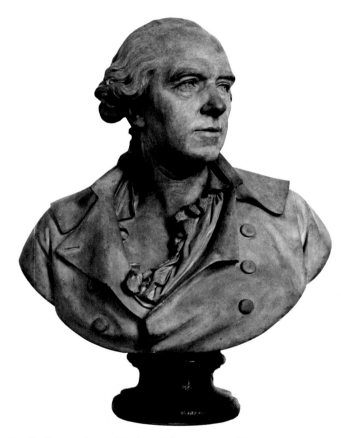

Fig. 2. Pajou, *Bust of Hubert Robert,* terra-cotta, Ecole des Beaux-Arts, Paris.

THIS UNPUBLISHED and unsigned terra-cotta bust can be dated to Pajou's period in Montpellier (1792-1794), where he had fled from the "Terror" raging in Paris. Although it shows stylistic similarities with earlier portrait-busts like the one of the well-known Languedoc parliamentarian, the marquis de Montferrier (fig. 1), dating from ca. 1781-1782[1] and now in the Montreal Museum of Fine Arts, Canada, it comes nearer to works which date from a decade later. It can, in fact, be closely compared with the portrait bust of Hubert Robert, shown at the Salon of 1789. Its directness, lifelike quality and expressiveness of face suggest a keen understanding or knowledge of the subject, as in the Robert portrait (fig. 2).[2]

The closest stylistic analogies can be established with the busts of J. B. Riban[3] (with whose father Pajou was staying at Montpellier, and who had properties in the Hérault), and with that of Antoine-Louis-François Viel de Lunas, marquis d'Espeuilles, dating from 1794 and also executed in Montpellier.[4] Both are in terra-cotta and show the same treatment of draperies, of the eyes and the hair. This stylistic evidence is corroborated by an historical element: namely, that the sitter came from the Hérault and was closely connected with the circle in which Pajou moved during his stay in the South of France.

1. H. Stein, *Augustin Pajou,* Paris, 1912, pp. 159-160, illus. p. 161; and exhibited in Heim Gallery (London), *French Paintings and Sculptures of the 18th Century,* Winter, 1968, no. 64, p. 17.
2. W. G. Kalnein and M. Levey, *Art and Architecture of the Eighteenth Century in France,* Harmondsworth, 1972, p. 104 and fig. 106, in Ecole des Beaux Arts, Paris.
3. Stein, *op. cit.,* illus. p. 277.
4. *Ibid.,* illus. p. 287.

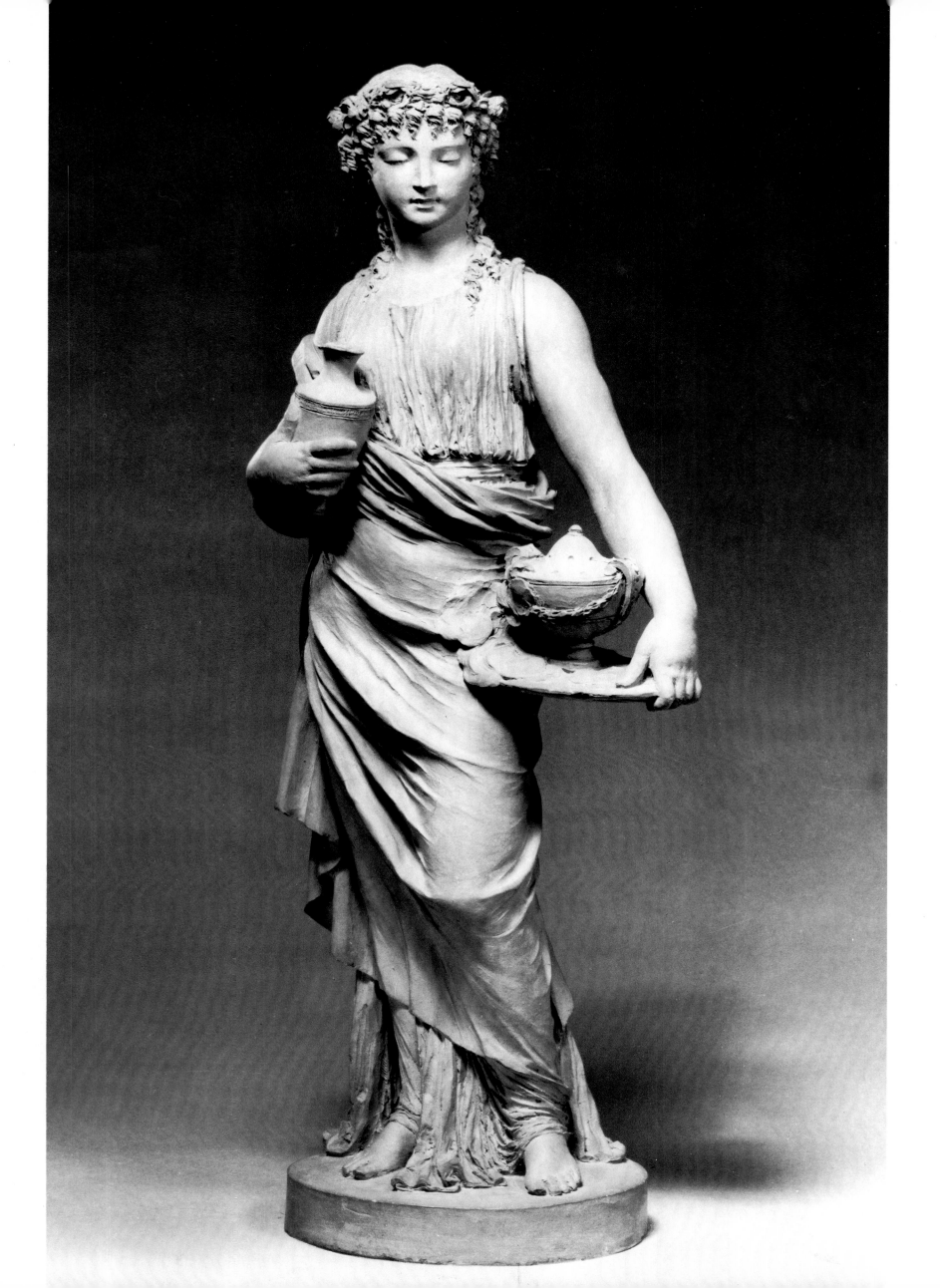

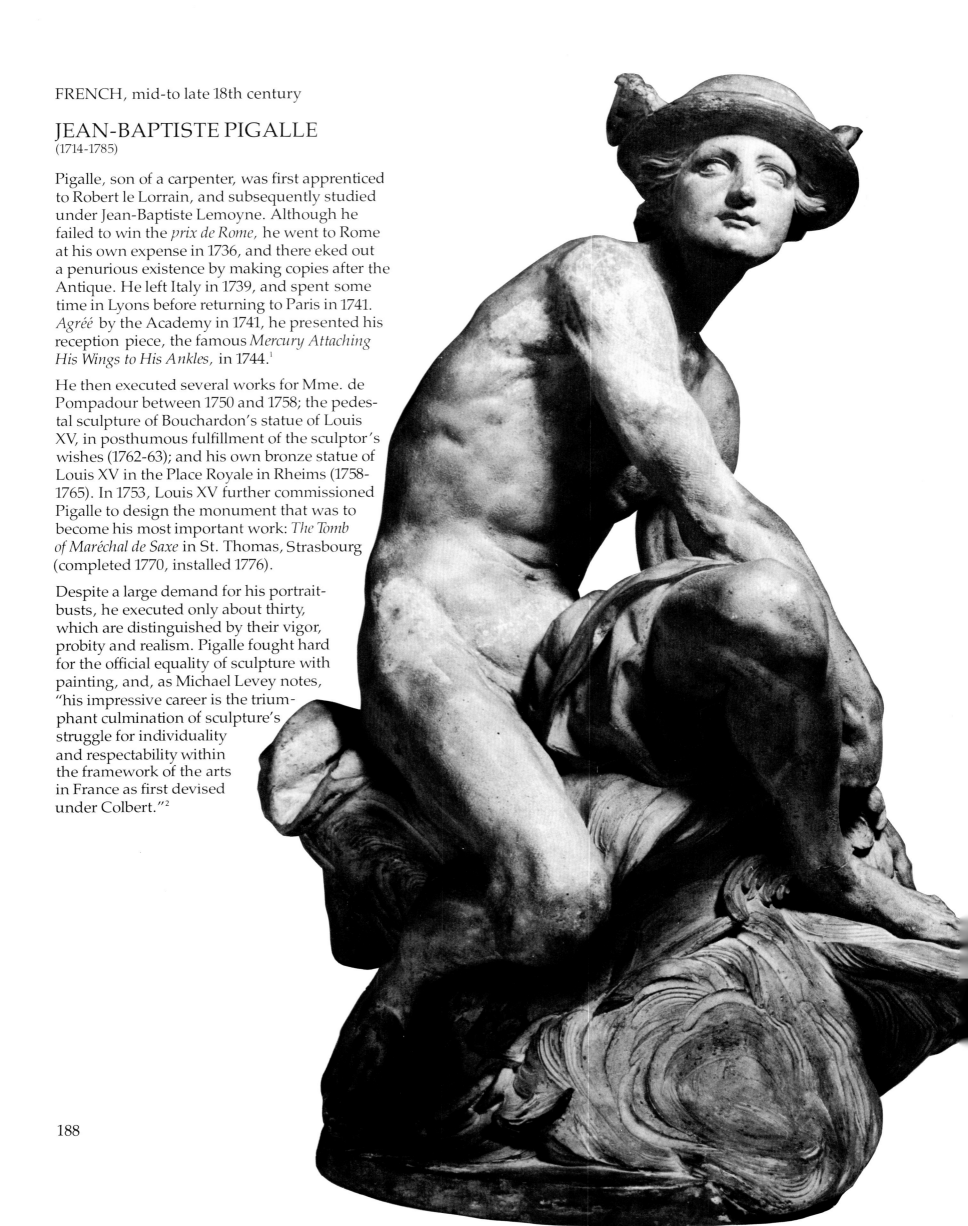

FRENCH, mid-to late 18th century

JEAN-BAPTISTE PIGALLE
(1714-1785)

Pigalle, son of a carpenter, was first apprenticed
to Robert le Lorrain, and subsequently studied
under Jean-Baptiste Lemoyne. Although he
failed to win the *prix de Rome,* he went to Rome
at his own expense in 1736, and there eked out
a penurious existence by making copies after the
Antique. He left Italy in 1739, and spent some
time in Lyons before returning to Paris in 1741.
Agréé by the Academy in 1741, he presented his
reception piece, the famous *Mercury Attaching
His Wings to His Ankles,* in 1744.[1]

He then executed several works for Mme. de
Pompadour between 1750 and 1758; the pedes-
tal sculpture of Bouchardon's statue of Louis
XV, in posthumous fulfillment of the sculptor's
wishes (1762-63); and his own bronze statue of
Louis XV in the Place Royale in Rheims (1758-
1765). In 1753, Louis XV further commissioned
Pigalle to design the monument that was to
become his most important work: *The Tomb
of Maréchal de Saxe* in St. Thomas, Strasbourg
(completed 1770, installed 1776).

Despite a large demand for his portrait-
busts, he executed only about thirty,
which are distinguished by their vigor,
probity and realism. Pigalle fought hard
for the official equality of sculpture with
painting, and, as Michael Levey notes,
"his impressive career is the trium-
phant culmination of sculpture's
struggle for individuality
and respectability within
the framework of the arts
in France as first devised
under Colbert."[2]

188

83. *Mercury Attaching His Wings to His Ankles*

Terra-cotta, ca. 1736-1739.
H. 21¼ in. (54.0 cm.) W. 12 in. (30.5 cm.) D. 9½ in. (24.1 cm.)
Condition: old repairs to neck, ankles, wrists, right knee,
shoulders, wings of helmet, tip of nose.
Accession no. 77.5.67

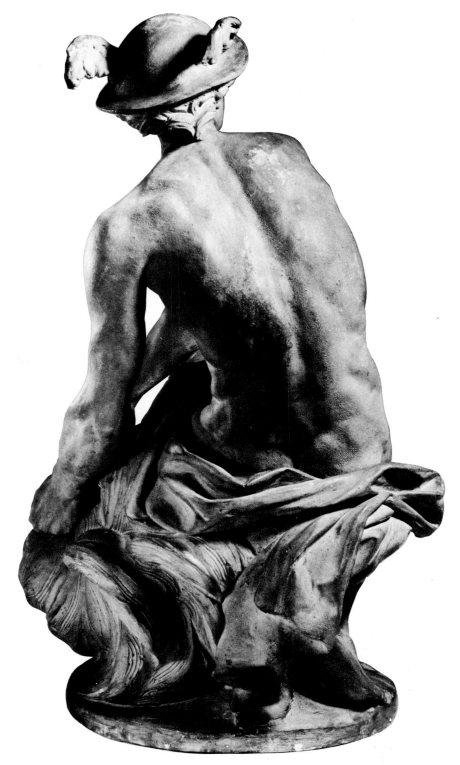

PIGALLE HAD THE good fortune to strike the imagination of the public with the very first work that he exhibited after his return to Paris in 1741: the *Mercure attachant ses talonnières.*[3] He is reputed to have made a *maquette* of this while still in Rome (which he was forced to pawn in Lyons). He exhibited a plaster model of the *Mercure* in the Salon of 1742.[4]

In September of the following year he was supplied with a block of marble out of which to carve a life-size version for the king, and in 1746 received the commission for a *Venus* as a pair to it. He completed both statues in 1748, and in 1750 Louis XV gave them to Frederick the Great, who placed them on one of the terraces of Sans Souci, at Potsdam. Removed in 1844, they stood, until 1940, at the foot of the main staircase of the Kaiser-Friedrich Museum, and are now in the Staatliche Museen in West Berlin.[5] Louis XV compensated himself for the gift by commissioning from Pigalle a group of *Venus Charging Mercury With the Education of Love*, with Mercury in the same pose.[6] In 1744, Pigalle presented a marble statuette of the *Mercury* to the Academy as his reception piece.

The *Mercury* became one of the most reproduced sculptures of the century. The rich *fermier-général* Bouret owned replicas of both it and the *Venus* in 1762.[7] Versions of both in stone were ordered by baron d'Oigny for the château de Millemont around 1765, and a lead version from the château d'Anet was placed in the Luxembourg Gardens, before entering the reserves of the Louvre in 1872.[8] It was also reproduced in *biscuit de Sèvres*, bronze, and Wedgwood basalt-ware. In Chardin's *l'Etude du Dessin*, exhibited in the Salon of 1748, a half life-size plaster already appeared — perhaps the same as the *épreuve*, repaired in Pigalle's own studio and sold in the posthumous sale of m. de Selle in 1761. A propos this, the abbé Gougenot remarked that the choice of this sculpture, rather than an Antique, for the student to draw from *"fait connaître que notre Ecole peut fournir les modèles les plus purs de la correction du dessin."* By 1766 Chardin, who was a friend of the sculptor himself, owned a smaller plaster version, which is mentioned in his *inventaire après décès*. It became the focus of his *Les attributs des Arts et les Récompenses qui leur sont accordées*, painted for Catherine the Great in that same year, along with a *répétition* for Pigalle himself: again the sculpture appears as a paragon.[9]

The prime terra-cotta version is the 22-inch-high model that was reputedly bought back from the de Jullienne sale by the sculptor in 1767, although the carefully annotated copy of the catalogue in the Victoria and Albert Museum states that this "original terra-cotta" was bought for the Czarina, and it ultimately formed part of the Altman bequest to The Metropolitan Museum of Art, New York, in 1913.[10]

The present terra-cotta comes somewhat closer to the marble statuette than to either the Metropolitan Museum terra-cotta or the full-scale marble, especially with regard to the position of the *caduceus*. Yet in psychological impact there is more of an affinity with the full-scale marble: here, *Mercury* has a more intent expression and lacks the slightly mischievous anticipatory smile that distinguishes the Metropolitan Museum terra-cotta.

1. Now in the Musée du Louvre. See L. Réau, *J.B. Pigalle*, Paris, 1950, p. 151, cat. 1, no.3, pls. 2 and 3 (H. 58 cm.), Musée du Louvre, no. 1442.
2. W. G. Kalnein and M. Levey, *Art and Architecture of the Eighteenth Century in France*, Harmondsworth, 1972, p. 190.
3. Michael Levey has pointed out that the pose may be derived from an engraving by S.A. Bolsvert after Jacob Jordaens' painting *Mercury and Argus*. See M. Levey, "The Pose of Pigalle's Mercury," *The Burlington Magazine*, October, 1964, fig. 32 and pp. 462–463.
4. Identified by Réau with the plaster in the collection of Doctor Dagencourt in Paris. L. Réau, *op.cit.*, p. 151, cat. 1, no.2, not illustrated.
5. *Ibid.*, cat. 1, the marble *Mercury*, formerly in Kaiser-Friedrich Museum, mentioned but not illustrated, p.152. Marble reductions of it and the *Venus* paired with it are at Waddesdon.
6. Ultimately never executed in marble. *Ibid.*, cat. 5, pl. 11, a group of three figures in plaster commanded in 1750 for the gardens of Choisy or La Muette and listed by Réau as residing, in 1950, at Château de Sassy, Orne.
7. M. Charageat, "Vénus donnant un Message à Mercure," *Revue des Arts*, 1953, p. 222.
8. Réau, *op.cit.*, cat. 1, mentions the stone and lead versions but they are not illustrated.
9. Grand Palais, *Chardin* (exhibition catalogue) Paris, 1979, nos. 94 and 125.
10. Clare Le Corbeiller, "Mercury, Messenger of Taste," *The Metropolitan Museum of Art*, Summer 1963, p. 23.

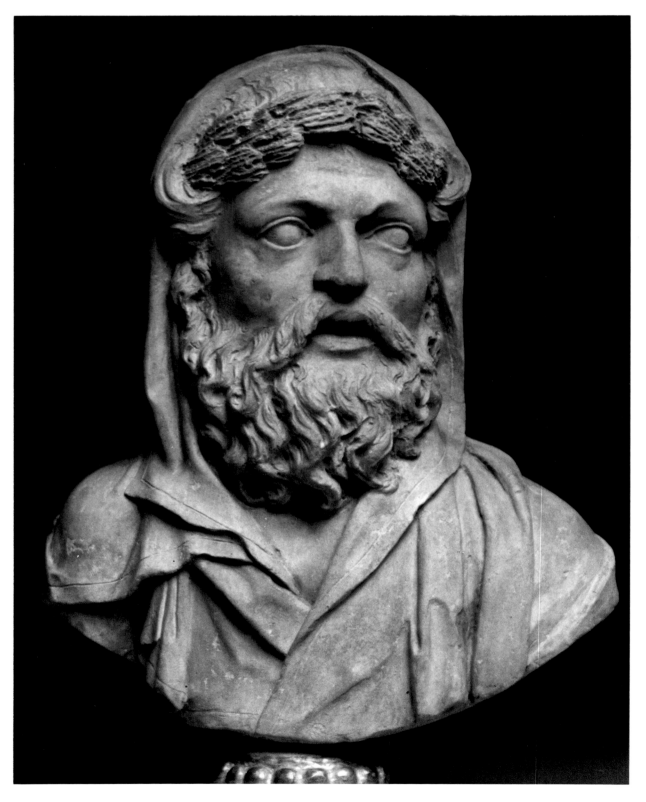

190

SIMON-LOUIS BOIZOT
(1743-1809)

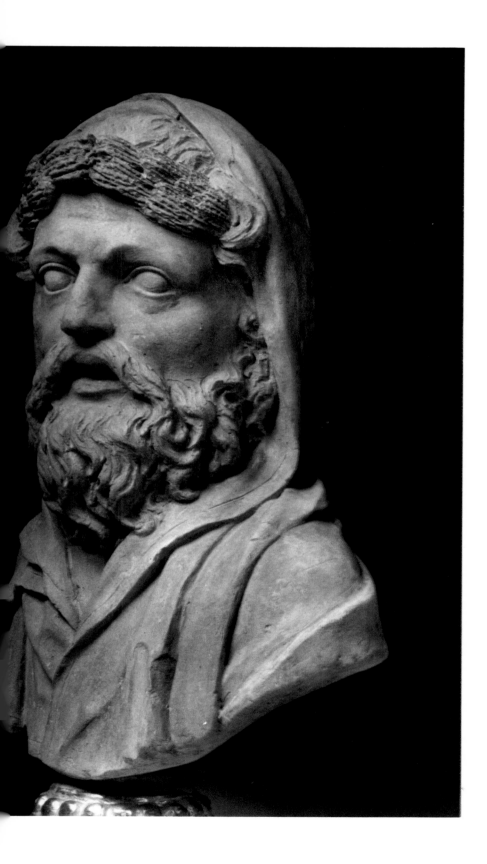

Son of the painter Antoine Boizot, Simon-Louis studied under Michel-Ange Slodtz and, in 1762, obtained the first prize for sculpture, which enabled him to go to Rome. He stayed there from 1765 to 1770. Soon after his return to Paris he was appointed to succeed Falconet and Bachelier as director of the sculpture atelier at the Sèvres manufactory, remaining in charge from 1774-1800, and continuing to supply models after his retirement. He became a member of the Académie royale in 1778 and an assistant professor in 1785. He exhibited regularly at the Salon from 1773 to 1806. One of the most prolific and popular sculptors of his time, his *oeuvre* consisted of both small and monumental decorative sculptures, as well as busts.

84. *Bust of a High Priest*

Terra-cotta, ca. 1775.
H. 6¾ in. (17.1 cm.) W. 6 in. (15.2 cm.) D. 3⅛ in. (8.0 cm.)
Condition: repair to back of head, tip of nose; chips in fold of cloth along right shoulder and hood on head; some flaking of surface.
Exhibited: Mallett at Bourdon House (London), *Sculptures in Terracotta*, 1963, no. 64; Heim Gallery (London), *French Paintings and Sculptures of the 17th and 18th Centuries*, Winter 1968, no. 78.*
Accession no. 77.5.21

DURING HIS DIRECTORSHIP of the sculpture atelier at the manufactory of Sèvres, Boizot modelled many small figures and busts. The close analogies between this terra-cotta and a similarly treated small *Bust of a High Priest*, executed for Sèvres in 1774, suggest an attribution to the artist and a similar dating.[1] The following year, Boizot made the *Bust of a High Priestess* as a pendant,[2] and a further, more emotional, *Bust of Calchas*, the soothsayer of the Greeks at Troy.[3]

1. Emile Bourgeois, *Le Biscuit de Sèvres*, vol. I, Paris, 1913, no. 328, pl. 26.
2. *Ibid.*, no. 329, pl. 26.
3. *Ibid.*, no. 121, pl. 51.
*The information in this entry is the same as that provided by the author for the Heim Gallery.

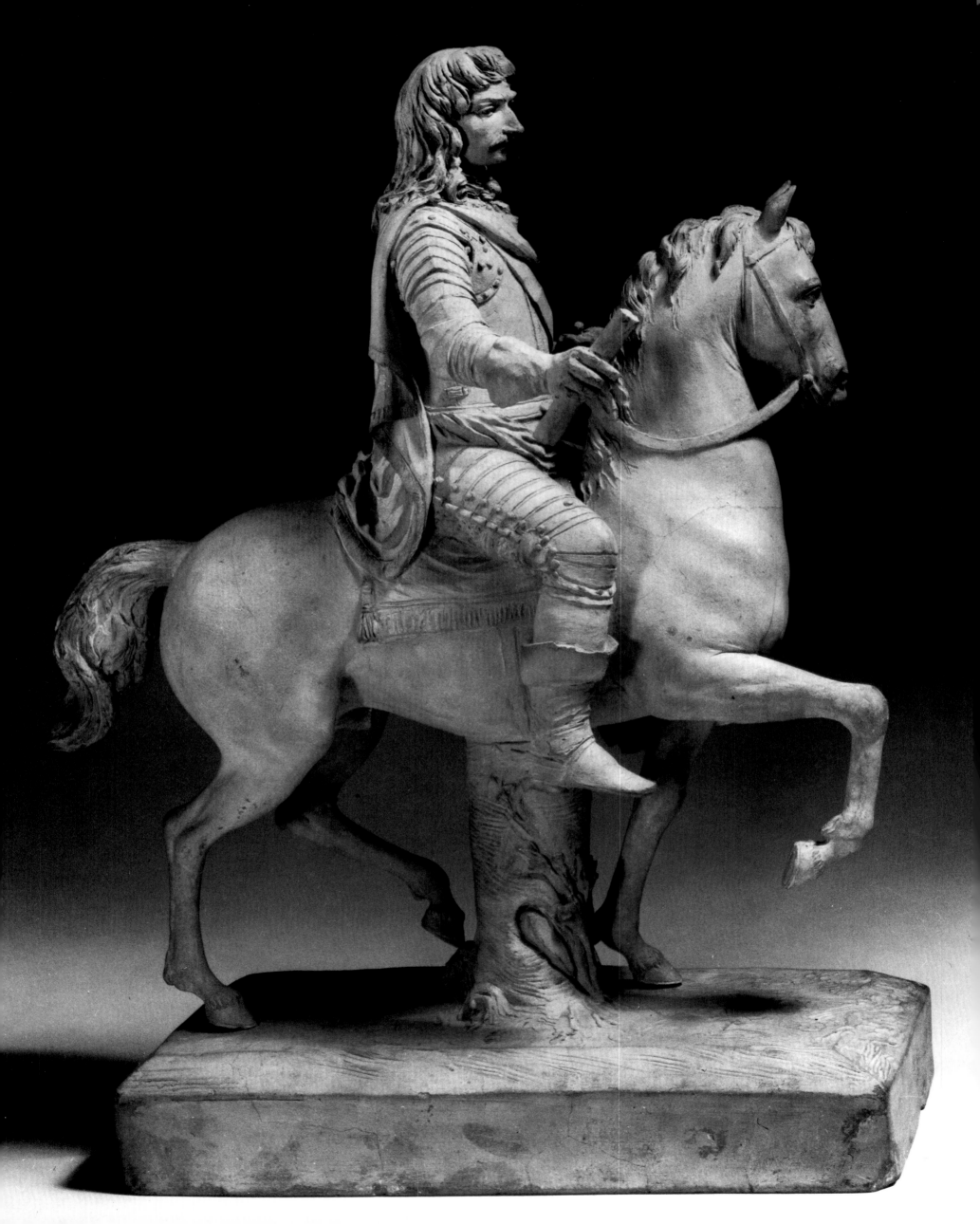

FRENCH, late 18th to early 19th century

ROBERT-GUILLAUME DARDEL

(1749-1821)

formerly attributed to Félix Lecomte
(ca. 1737- 1817)

Born in Paris in 1749, Dardel was a pupil of Pajou.
He competed unsuccessfully for the *prix de Rome*
for sculpture in 1771 and 1773, and, failing to
gain admittance to the Academy, was forced
to exhibit at the Salons de la Correspondance
from 1781 to 1787, until the main Salon was
thrown open to all in 1791. *Charity,* signed Dardel,
1785 (fig. 1), is from those years.

From 1780 until the Revolution he worked for the
prince de Condé, but, protected by David, far
from suffering from these links with the *Ancien
Régime,* he was appointed to the Commission
Temporaire des Arts and to the board of the
National Museum in 1793, and elected president
of the selection committee of the Concours after
it turned itself into a Revolutionary club. In 1796
he was made administrator of the Musée de
Versailles, and in 1800 became a professor at the
Versailles Academy. In the same year, he won a
prize in the competition for a monument to
commemorate the Peace of Amiens, and in
1807-1808 contributed a statue of a *Grenadier* to the
Arc du Carrousel. He signalled his adhesion
to the Restoration by a complex group of *The
Grand Condé, Louis XIV, and the Ashes of Louis XIII*
in the Salon of 1814. Dardel's originality and
forte lay in his allegorical terra-cottas and histor-
ical statuettes, several of which are in the
Musée Condé at Chantilly.

85. *Equestrian Statuette of the Grand Condé*

Terra-cotta, ca. 1780.
H. 14 in. (35.6 cm.) W. 11¼ in. (28.5 cm.) D. 6 in. (15.2 cm.)
Condition: repairs to tail, left hind leg, joints of front legs and
right hoof of horse. A pin behind rider's right foot indicates
missing attachment.
Accession no. 77.5.40

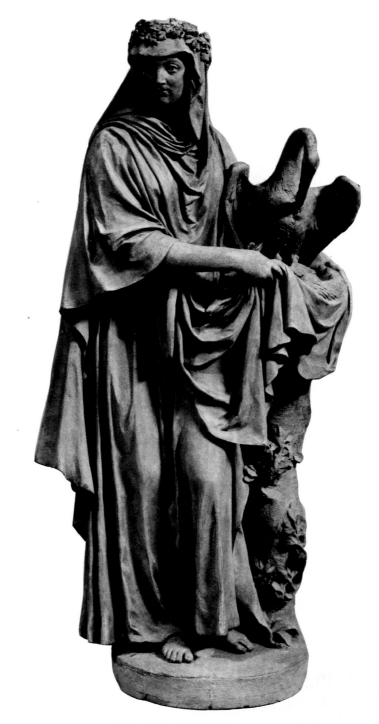

Fig. 1. Dardel, *Charity,* terra-cotta,
1785, Heim Gallery, London.

EQUESTRIAN MONUMENTS have always represented one
of the sculptor's greatest challenges. And paradoxi-
cally, because the theme is one of those that offers the
least scope for variation, and because, if the artist does
succeed in forging an imaginatively new image, the glory
is more often reaped by the subject than by the sculptor.
Undeniably, equestrian monuments were, from the time
of Giambologna's equestrian statue of Cosimo I onwards,
one of the most potent visual means of establishing the
image of the absolute prince.[1]

Precisely because equestrian statues had this unique
power to convey authority in the Age of Absolutism—the

seventeenth and eighteenth centuries—they were almost
exclusively reserved for the depiction of rulers.[2]

Bouchardon and the Academy never forgave the former's
pupil Laurent Guiard for his act of *hubris* in daring to ex-
hibit a model of Louis XV on horseback *"vêtu à la gauloise,"*
in the annual exhibition of works of the pupils of the Ecole
royale des élèves protégés in the royal apartments of
Versailles in 1754. In the whole of Lami's *Dictionnaire des
sculpteurs français* there appears to be mention of only one
18th-century equestrian figure which is not of a ruler,
and that is the statuette of the young prince de Bourbon,
from the house of Condé — and thus a member of the

193

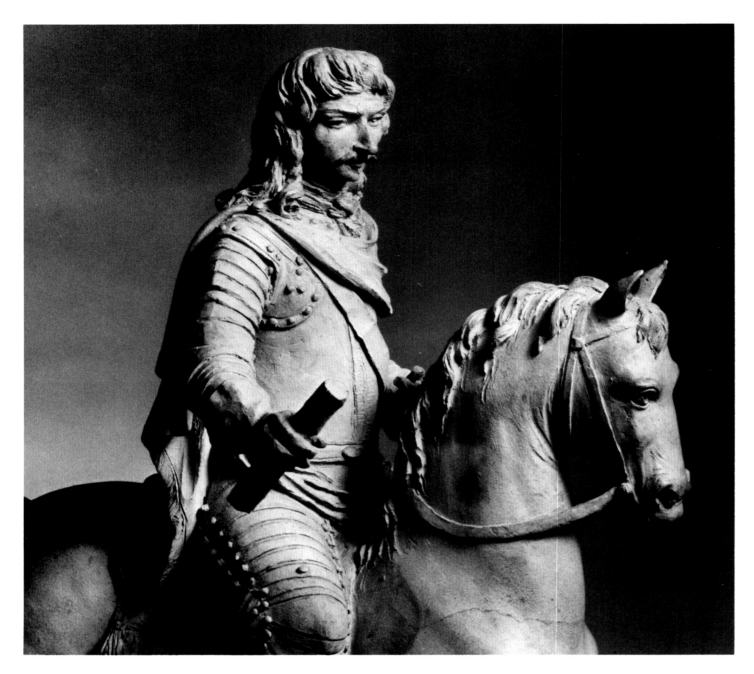

Blood Royal— exhibited by Louis-Jacques Pilon in the annual showing of pupils of the Académie royale in 1769. The present equestrian statuette is, appropriately, of an ancestor of the prince de Bourbon, the Grand Condé (1621-1686), the greatest military commander in France in the seventeenth century. From the presence of the awk-ward central tree stump (see the equestrian statue of Louis XIII in the Place des Vosges), it would appear to have been the model for an intended statue in marble, in which this stump would have been necessary to take the main weight of the stone. No project for such an equestrian statue is known, but Dardel is documented as having depicted the Grand Condé on at least three occasions: in a bronze bust in 1780, in a statue in 1782, and in a group in 1814.[3]

None of the representations of the Grand Condé by Dardel or others was equestrian because of the contexts for which they were for the most part intended. Dardel was, however, prince Louis-Joseph de Condé's (1736-1818) accredited sculptor until the Revolution, not only sculpting the prince's distinguished ancestor, but also making

sketches and statuettes of several other historical figures, chiefly military commanders of the 17th century. These were, with the d'Angiviller commissions for the series of *Great Men of France*, among the earliest historicizing sculptures. It seems very possible that at one point the prince de Condé also contemplated erecting an equestrian monument to his ancestor, for which this would have been the model. In type, the attitude of horse and rider appears to have been inspired by Andreas Schluter's equestrian monument to the Great Elector in Berlin (1703). But it is clear that Dardel, who leaned toward allegorical depictions, for example, *Descartes Piercing the Clouds of Ignorance*, 1782,[4] was not at home with equestrian figures—the reason why, perhaps, no monument was ever executed.

1. U. Keller, *Reitermonumente absolutischer Fürsten*, Munich, 1971.

2. P. Patté, *Monumens érigés en France à la gloire du roi Louis XV*, Paris (1765), is largely concerned with the distinguished series of monuments by Pigalle, Bouchardon, and Lemoyne raised to honour the king, and with their distinguished prototypes. Plates 7 and 13 depict equestrian monuments.

3. Félix Lecomte, to whom this statuette was previously attributed, carved a statue of the Grand Condé for the Ecole Militaire in 1773. Roland also carved him for the series of *Great Men of France* in 1785-87, and made the sketch of a statue of him for the Pont de la Concorde, a commission which was taken over by his pupil David d'Angers after his death. (D'Angers' depiction of the *Condé Throwing His Bâton into the Enemy's Lines* significantly took its inspiration, via Roland, from Dardel's statue of 1782.)

4. The facial features and hair treatment of the *Descartes* image are closely comparable to Dardel's handling of the Sackler terra-cotta. See J.G. Mann, *Wallace Collection Catalogues: Sculpture*, London, 1931, pl.16.

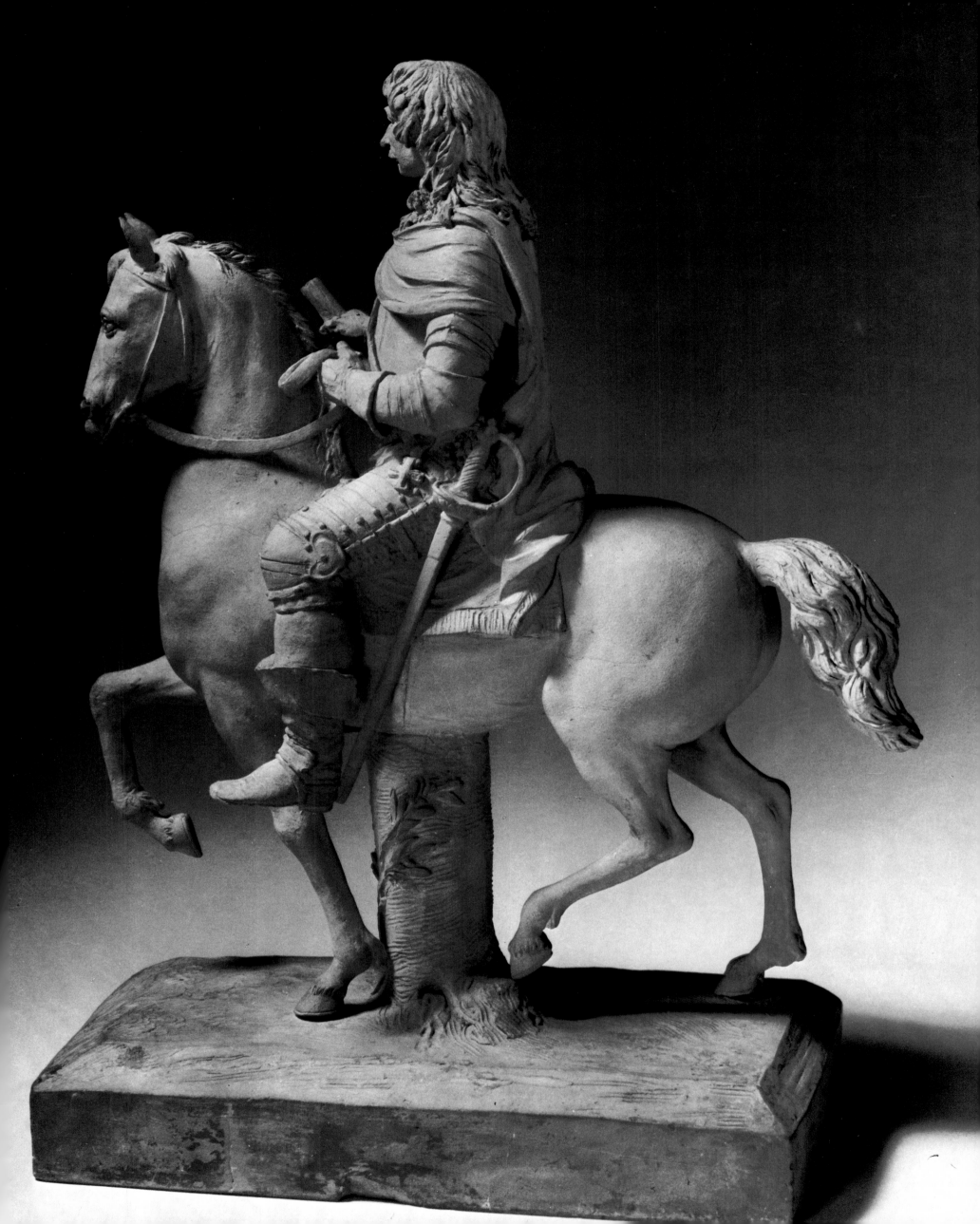

FRENCH, late 18th to early 19th century

JOSEPH CHINARD
(1756-1813)

Son of a silk-weaver, Chinard was born in Lyons, where he began by making confectionery figurines. In 1770 he was admitted to the Ecole de dessin, followed by a period in the atelier of Barthélemy Blaise. He travelled in 1784 to Rome, where he was given numerous commissions to copy Antique statues. There, in 1786, he won the Balestra prize at the Accadèmia di San Luca with his *Perseus and Andromeda*. Returning to Lyons in 1787, he soon found himself in fashion and made the first of a series of lively portraits. During a second visit to Rome (1791-92), he executed two allegorical Revolutionary compositions, which led to his arrest. Freed after a short time he returned to Lyons in triumph, only to find himself imprisoned again in 1793, this time accused of counter-revolutionary implications in his sculpture. Acquitted and released (after modelling a plea of *Innocence Taking Refuge in the Bosom of Justice* in terra-cotta) in 1794, he designed decorations for the popular celebrations in Lyons and Revolutionary monuments, as well as numerous portrait medallions and busts. In 1795 Chinard became an Associate of the Institut de France. He made a third visit to Italy in 1800, and subsequently moved between Carrara, Lyons, Marseilles and Paris, where he produced numerous busts of Napoleon and his family, an important bust of *Madame Récamier,* decorations for the Arc du Carrousel, and began several large projects, including the reliefs for an Arc de Triomphe in Bordeaux. As Michael Levey notes, Chinard was "easily the most distinguished sculptor working outside the capital" in France in the years of the Revolution and the Empire.[1]

196

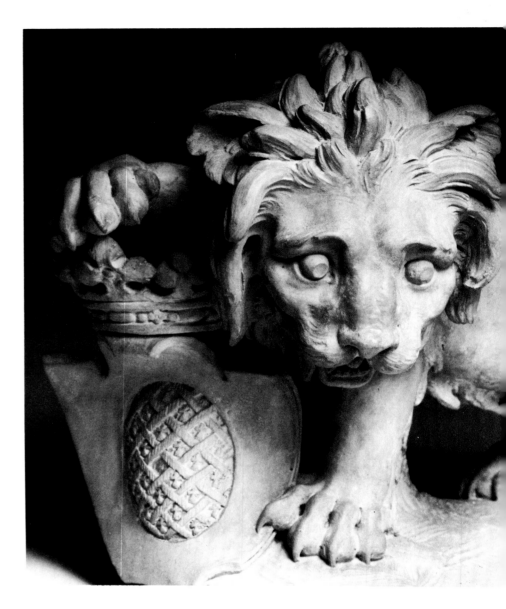

86. *Lion Supporting an Armorial Cartouche*

Terra-cotta, ca. 1780-85.
Stamped: CHINARD SCULPTEUR
H. 7¼ in. (18.4 cm.) W. 10½ in. (26.7 cm.) D. 5½ in. (14.0 cm.)
Condition: corner of base with tail broken; repairs to right foreleg, ornaments on crown and top right of shield.
Accession no. 77.5.28

THIS LION is an interesting document of Chinard's earliest manner. Its pose and expression, the summary treatment of its shaggy mane, and the asymmetrical cartouche slipping off the pedestal, are all still Rococo in feeling. That it stems from before the Revolution, and indeed from before Chinard's sojourn in Rome, is evident not only from the shield and marquis' coronet, but also from the stamp (fig. 1), which is of a kind that Chinard did not use after 1787.

This lion was doubtless a model for a stone lion on the gatepost of the entry to an *hôtel* or *château,* of the kind that Chinard executed for the Porte Saint-Clair in Lyons in 1789. The arms—*de gueules fretté d'or, les clairevoies semées de fleurs-de-lis du même*—are those of the Auvergnat family d'Alzon, but it has not been possible to discover for which member of the family, or for what location, this lion was intended.

1. W. G. Kalnein and M. Levey, *Art and Architecture of the Eighteenth Century in France*, Harmondsworth, 1972, p. 170.

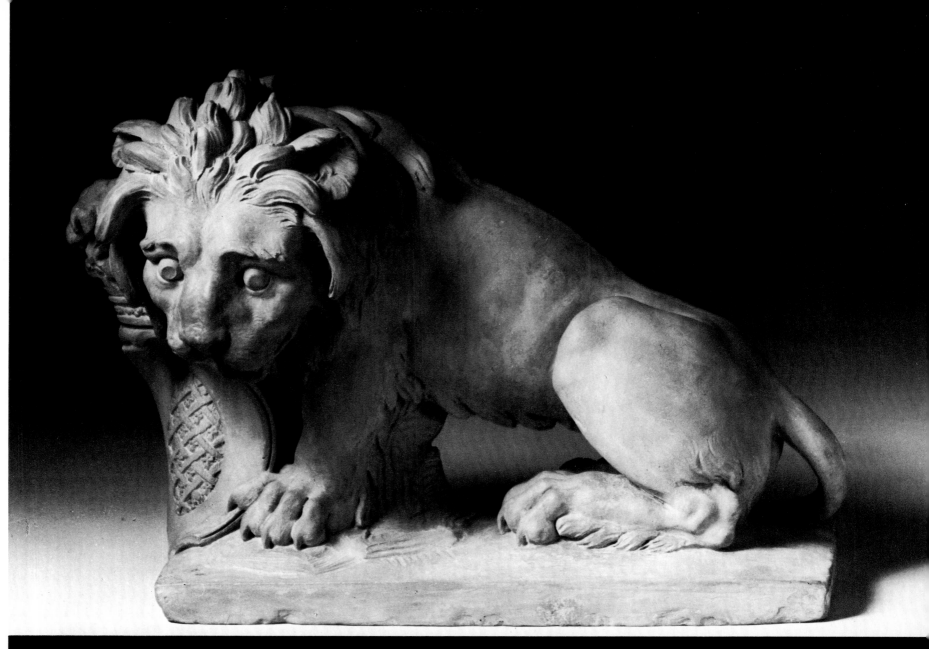

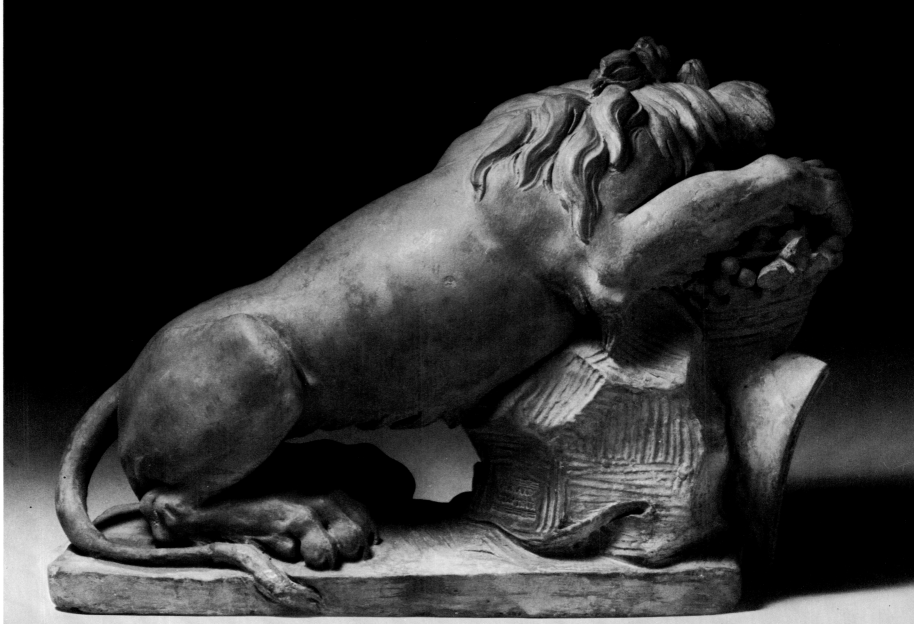

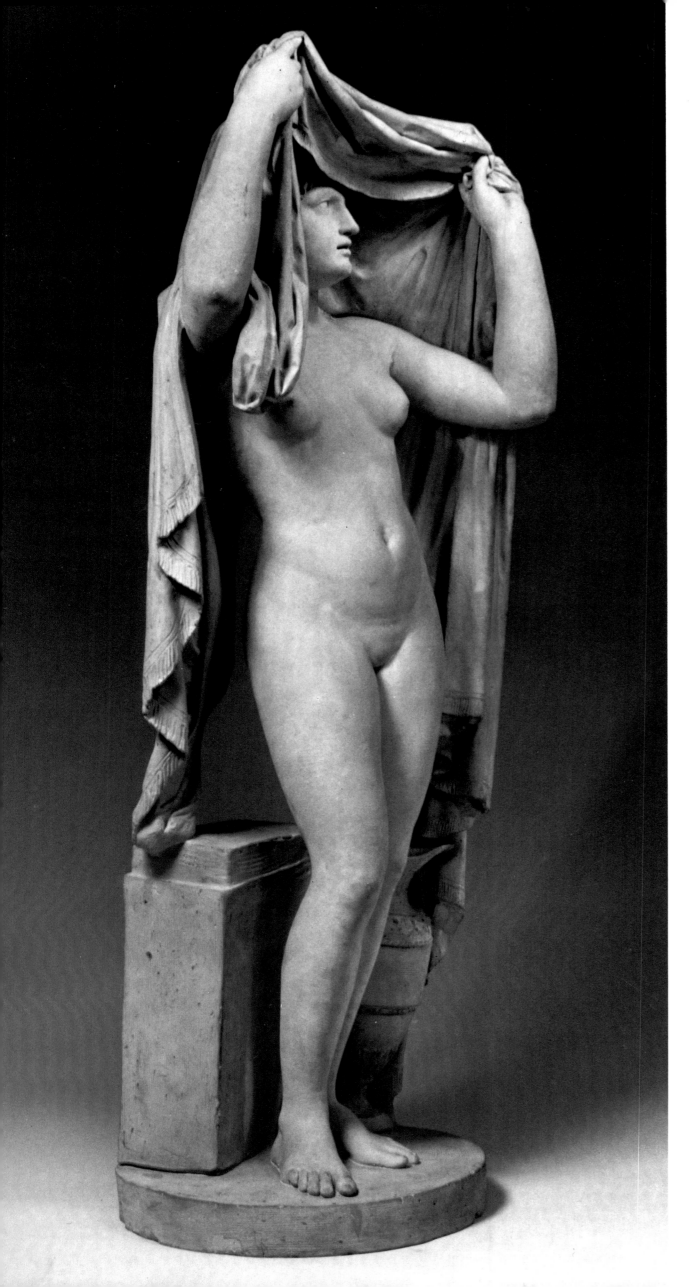

87.

Phryne Emerging from Her Bath

Terra-cotta, ca. 1787.
Stamped: CHINARD SCULPTEUR
H. 28⅛ in.(71.4 cm.) W. 10⁷⁄₁₆ in.(26.5 cm.) D. 8½ in. (21.6 cm.
Condition: repairs to legs, wrists, neck, nose and to drapery.
Provenance: M. Villard, Lyons.

Exhibited: Musée Napoléon, Paris, Salon of 1810, no. 945,
Phriné sortant du bain, p. 112.
Accession no. 77.5.29

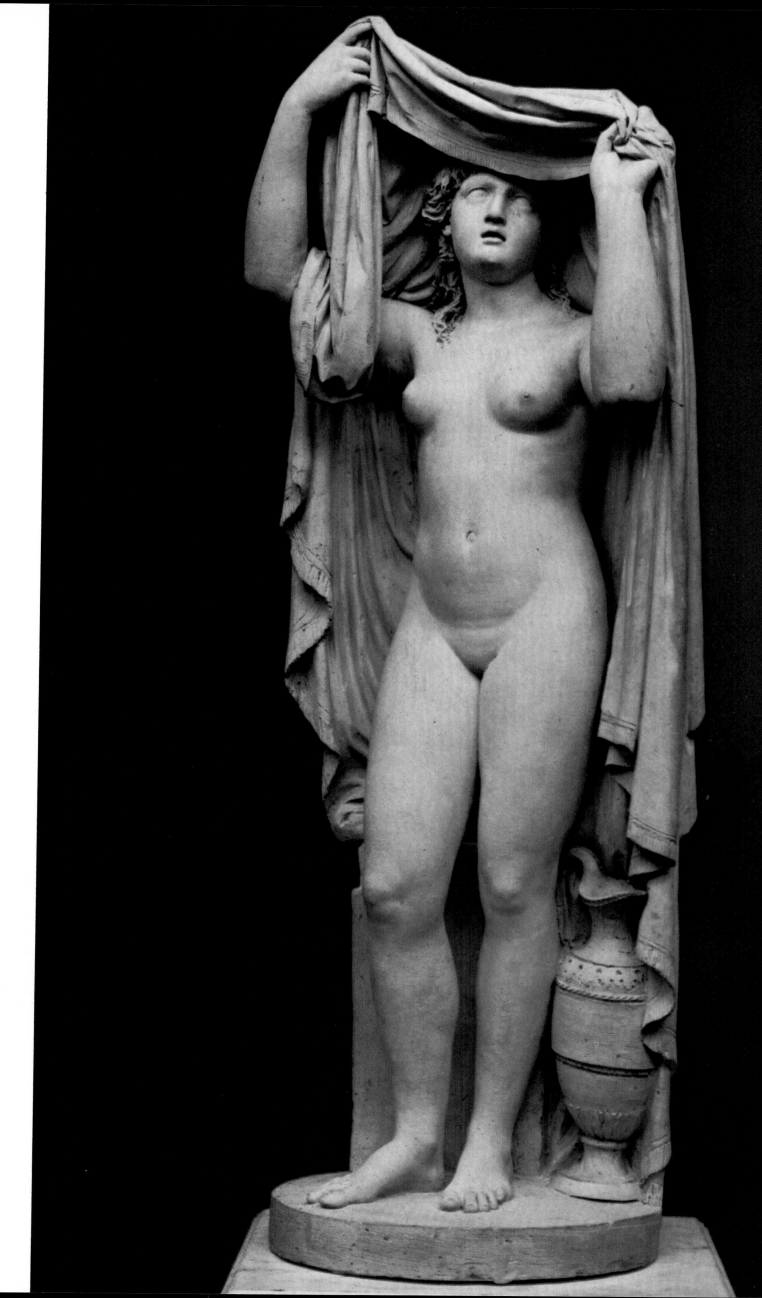

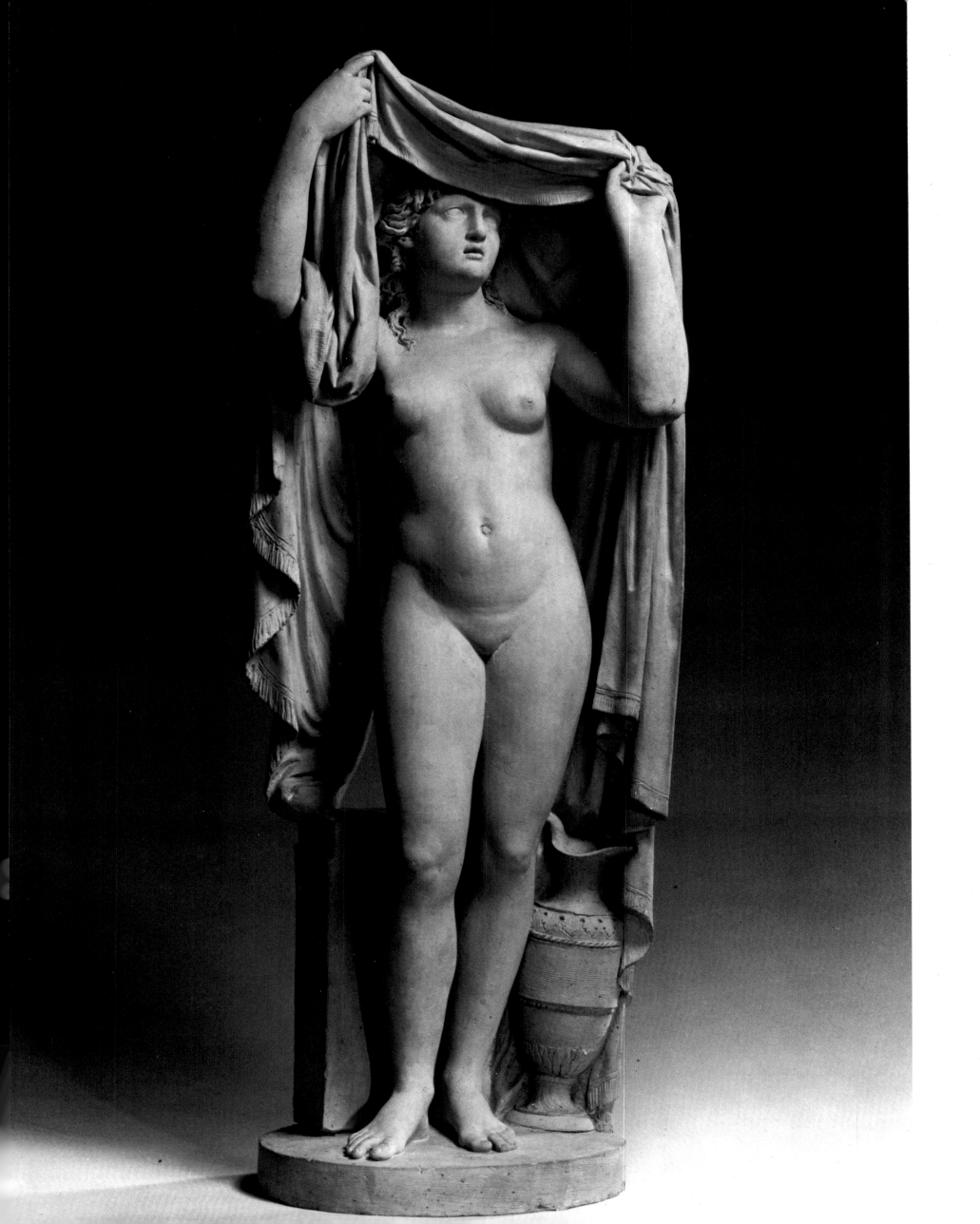

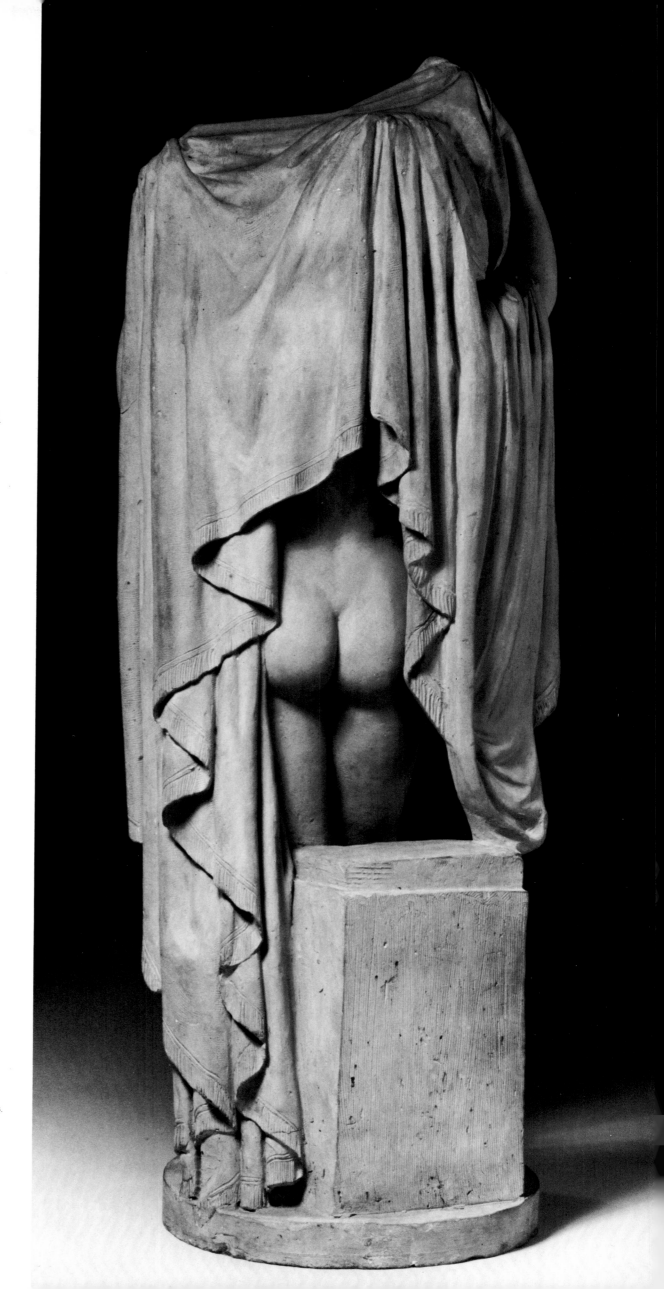

WHEN THIS statuette was first published by Salomon de la Chapelle,[1] he described it in detail, but called it *Galatea*. This was one of a number of pieces of erroneous information derived from its owner.[2] It was variously said to be *"pas entièrement finie,"* which is untrue; to have been the *maquette* for a statue at Marseilles, of which neither de la Chapelle nor any other source makes mention; and to have been paired formerly with a *Pygmalion,* of which there is no other record, and whose inherent improbability is demonstrated by the fact that the present figure shows a woman draping herself after a bath (hence the ewer beside her), and not a statue in the process of becoming flesh. There seems little doubt that this is, rather, a terra-cotta figure of the famous courtesan, *Phryne Emerging from Her Bath,* which Chinard exhibited at the Salon of 1810. Confirmation of this is provided by a marble statuette of the same subject in The Allen Memorial Art Museum, Oberlin College, Ohio, purportedly done in imitation of one executed by Jean Jacques Pradier (1792-1852) in 1845.

Although exhibited in 1810, Chinard's terra-cotta was executed earlier. The Salon of 1810 was partially retrospective and we know at least one of the works exhibited at this time, *Perseus Delivering Andromeda,* was a composition dating back to the very outset of his career. Furthermore, the stamp on this statuette is one that Chinard did not employ after 1787 (see no. 88), and the style of the work suggests Chinard's recent exposure to classical sculpture in Rome. Stylistically, there are affinities with his early terra-cotta statuette of *Philosophie,* signed "CHINARD AUX AICLUSES" and executed at the time of his incarceration in 1792 in Lyons.[3] Moreover, it is evident that the direct inspiration for this statuette—a woman with her head half veiled in drapery exposing her lower parts— was Houdon's immensely popular *Frileuse,* modelled in 1781, and exhibited in various media between that date and 1796. Chinard had heavy commitments as a portrait sculptor by the end of his life, but when exhibiting in the nation's capital in 1810, he would not have wanted to be written off as a mere provincial portraitist.

1. S. de la Chapelle, "Catalogue des oeuvres de Chinard," *Revue du Lyonnais,* XXIII, 1897, p. 143.
2. A *Femme Couvert de Draperies* by Chinard was also in his collection.
3. M. Tourneax, "La collection de M. le comte de Penha Longa: busts, médaillons et statuettes de Chinard," *Les Arts,* vol. VIII, no. 95, November. 1909, fig. on p. 15.

88. *Othryades Expiring on His Shield*

Terra-cotta, ca. 1790–1795.

Inscribed: partially effaced inscription on upper base appears to read *(O)trianidas.*[1]

H. 17⅜ in. (44.1 cm.) W. 21½ in. (54.6 cm.) D. 12 in. (30.5 cm.)

Condition: old repairs throughout figure; surface recently cleaned revealed inscription noted above.

Exhibited: Musée Napoléon, Paris, Salon of 1810, no. 941, *Otriades mourant sur son bouclier,* p. 111.

Accession no. 77.5.38

IN THE SECOND HALF of the eighteenth century, students at the French Academy in Rome, aided by the organization of the Papal museums, were again taking as keen an interest in Antique sculpture as their counterparts had in the later part of the 17th century. The themes *Dying Gaul* or the Spartan *Othryades Dying* were among those popular at the time. The celebrated *Dying Gaul* in the Capitoline Museum, Rome (fig. 1), served as the Antique prototype.[2]

Othryades was the subject of a well-known composition executed in 1778 by the Swedish sculptor Johan Tobias Sergel (1740-1814).[3] The French sculptor, Pierre Julien (1731-1804), submitted his successful *morceau de réception,* the marble *Dying Gladiator,* to the Academy in 1779.[4] Although his figure, raised to lean forward, departs from the Antique prototype, the inspiration, in the essentials of the pose, the shield beneath, and the matted hair, is nevertheless the same.

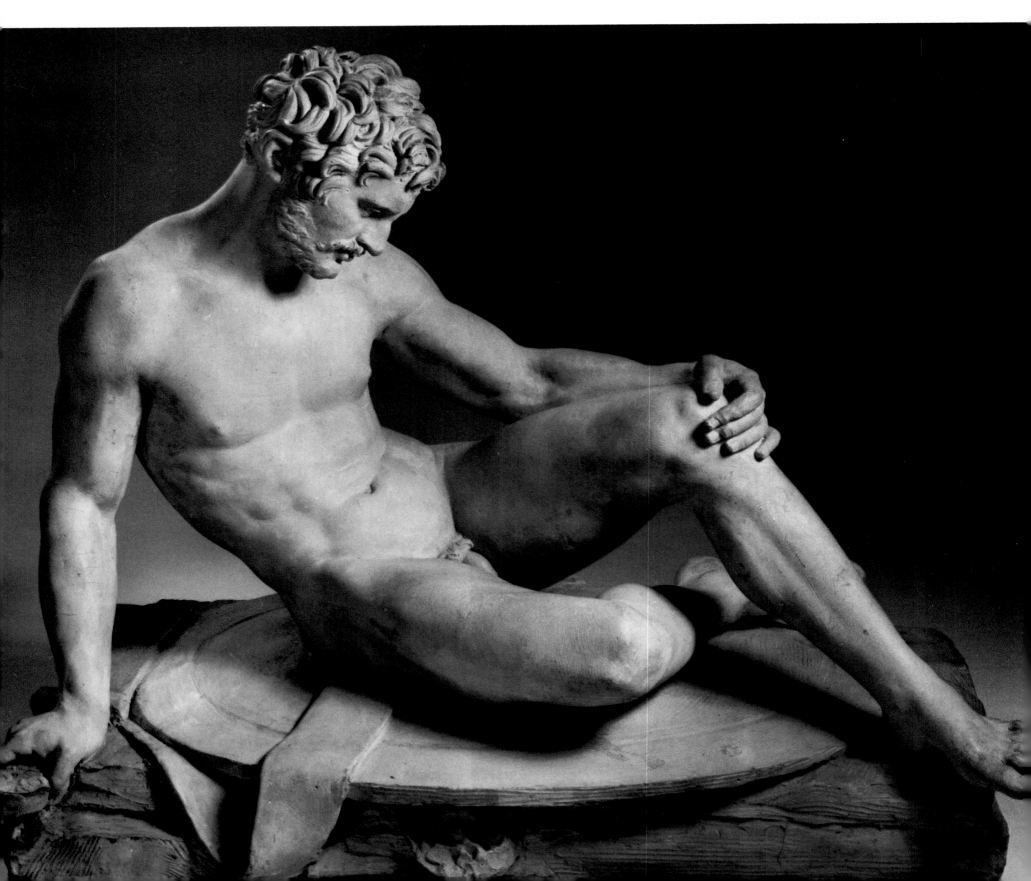

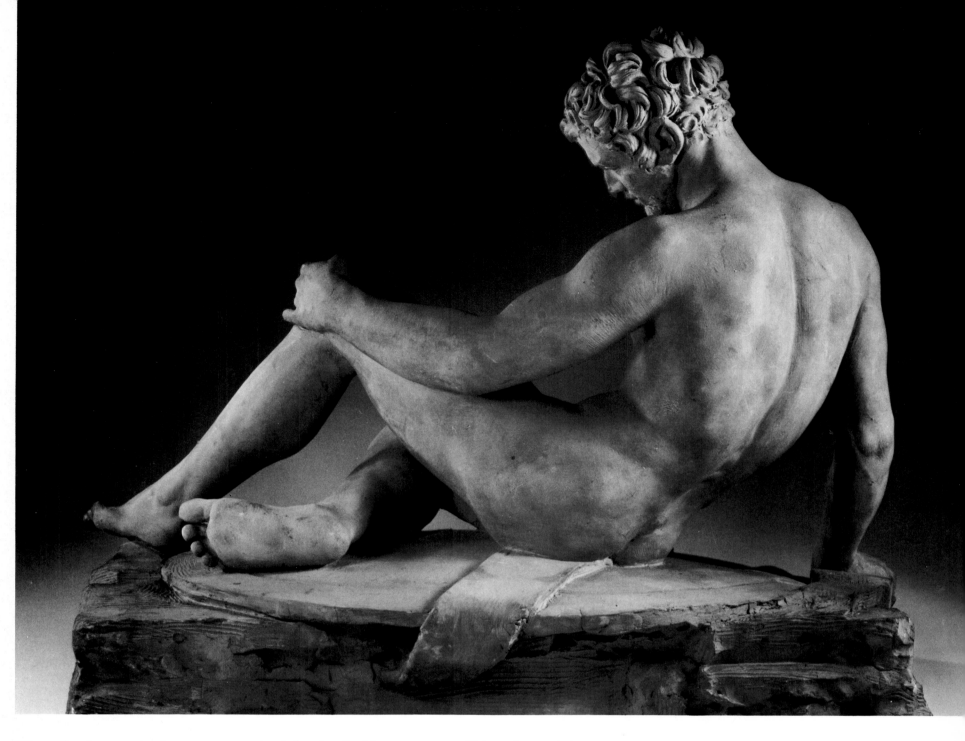

When the terra-cotta here was acquired for the Sackler collection, it was attributed to Julien. Considered a first idea for his marble, it was identified as a terra-cotta version of it sold in Paris in 1814.[5] James Draper of the Metropolitan Museum and Jean-René Gaborit of the Musée du Louvre pointed out, however, that, apart from the difference in pose, the bland surface texture of the terra-cotta here differed from other known sketches by Julien.[6] Moreover, in the course of cleaning this terra-cotta, the inscription, which was previously hardly visible, became much more legible and identified the figure as *Othryades*.

It was James Draper who subsequently pointed out that the inscription (although misspelled) is in Chinard's characteristic handwriting with its curled back 'd', and that the figure should indeed be identified with Chinard's lost *Othryades Expiring on His Shield* which he exhibited in the Salon of 1810. Mr. Draper also pointed to the similarity of handling between the hair of this figure and that of Chinard's self-portrait in terra-cotta in the Musée Girodet, Montargis, datable to ca. 1790-95.[7]

In 1810, the theme *Mort d'Othryades* was proposed to candidates in the Concours de Rome and undoubtedly inspired Chinard to exhibit his *Otriades* in that year's Salon. When he was in Rome in 1784-86, he had in fact executed a copy of the Antique *Dying Gaul* for the baron de Bézenval and must have drawn on it when he executed his *Otriades*.

An 1810 date, however, seems a little late for this terra-cotta and like *Phryne Emerging from Her Bath* (no. 87), although exhibited in 1810, was probably executed earlier.

1. Othryades or Otriades refers to the Spartan Othryades described in Herodotus as a survivor of three hundred Champions who fought with the three hundred Argives for the possession of Thyria. Being left on the field as dead, he was afterward ashamed to return to Sparta as the only survivor and slew himself on the spot.
2. It stood in the center of the *Salone* there until its removal to Paris in 1797, and now stands in a room named after the former designation of the statue the *Stanza del Gladiatore*. H.S. Jones, *The Sculptures of the Museo Capitolino*, Oxford, 1912, pl. 85, fig. 1 and pp. 338-340.
3. Jean-René Gaborit of the Musée du Louvre, Paris, in a personal communication to the author, November 14, 1979, notes that Sergel's *Othryades* was intended as a *morceau de réception* never presented to the Academy in Paris. A plaster cast, however, was exhibited in the Paris Salon of 1779. See Hamburg Kunsthalle, *Johan Tobias Sergel* (exhibition catalogue) Hamburg, May 22–September 21, 1975, p. 32 for an illustration of the piece in the Nationalmuseum, Stockholm.
4. Julien's *morceau de réception*, now in the Louvre, no. 749.
5. Hôtel de Bullion, Paillet sale, June 2, 1814, lot 92.
6. J. Draper, "New terracottas by Boizot and Julien," *Metropolitan Museum Journal*, 12, 1978, p. 148, footnote 21, notes the principal holdings of Julien's sketch-models and emphasizes that, characteristically, Julien's surfaces are richly textured and not smooth. M. Gaborit in his letter to the author also remarked that the smooth surface of the terra-cotta here is unusual for a work by Julien.
7. Royal Academy, *Age of Neo-Classicism* (exhibition catalogue), London, 1972, no. 342 (not illus.).

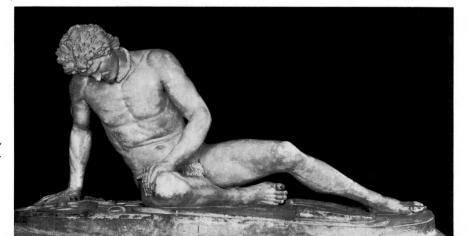

Fig. 1.
Roman, *Dying Gaul*, marble,
Capitoline Museum, Rome.

89. *Bust of a Woman*

Terra-cotta, ca. 1795-1800.
H. 10⅝ in. (27.0 cm.) W. 6⅛ in. (15.5 cm.) D. 4⅜ in. (11.1 cm.)
Condition: small chip on nose; paint cracks on face and neck.
Accession no. 77.5.30

ALTHOUGH UNSIGNED, this bust is typical of the small-scale terra-cotta portrait-busts and medallions in which Chinard specialized after his return to Lyons. For *petite nature* busts of a similar kind, one can compare it with the pair of busts of Prince Bacciocchi and Elisa Bonaparte, formerly in

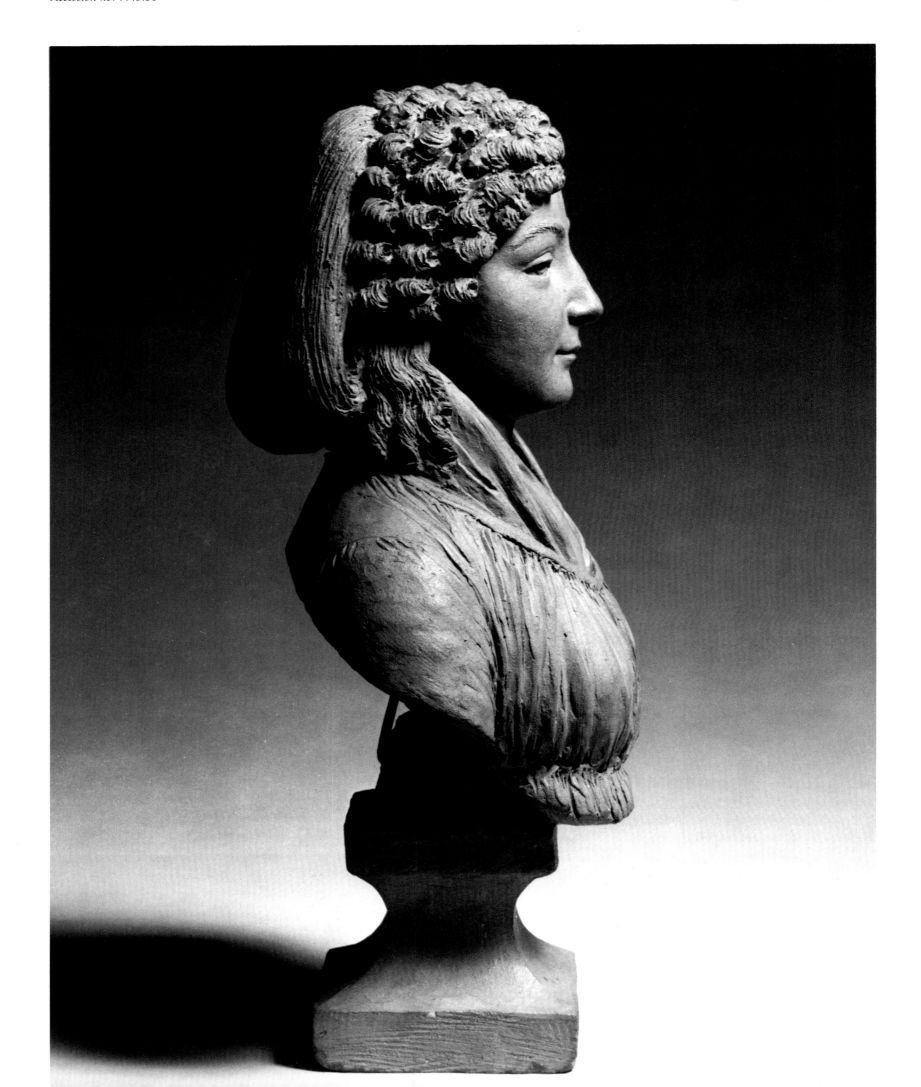

the collection of the comte de Penha Longa.[1] But for period, dress, and a comparable approach to a female sitter, one should compare this *petite nature* terra-cotta with the life-size marble bust of the marquise de Jaucourt, executed in Lyons in 1796.[2]

1. Union centrale des arts decoratifs. *Exposition d'oeuvres du sculpteur Chinard de Lyon* (exhibition catalogue). Pavillon de Marsan (Louvre), 1909, pl. facing p. 48.
2. M. Tourneux, "La collection de M. le comte de Penha Longa: bustes, médaillons et statuettes de Chinard," *Les Arts*, vol. VIII, no. 95, November, 1909, pl. on p. 21.

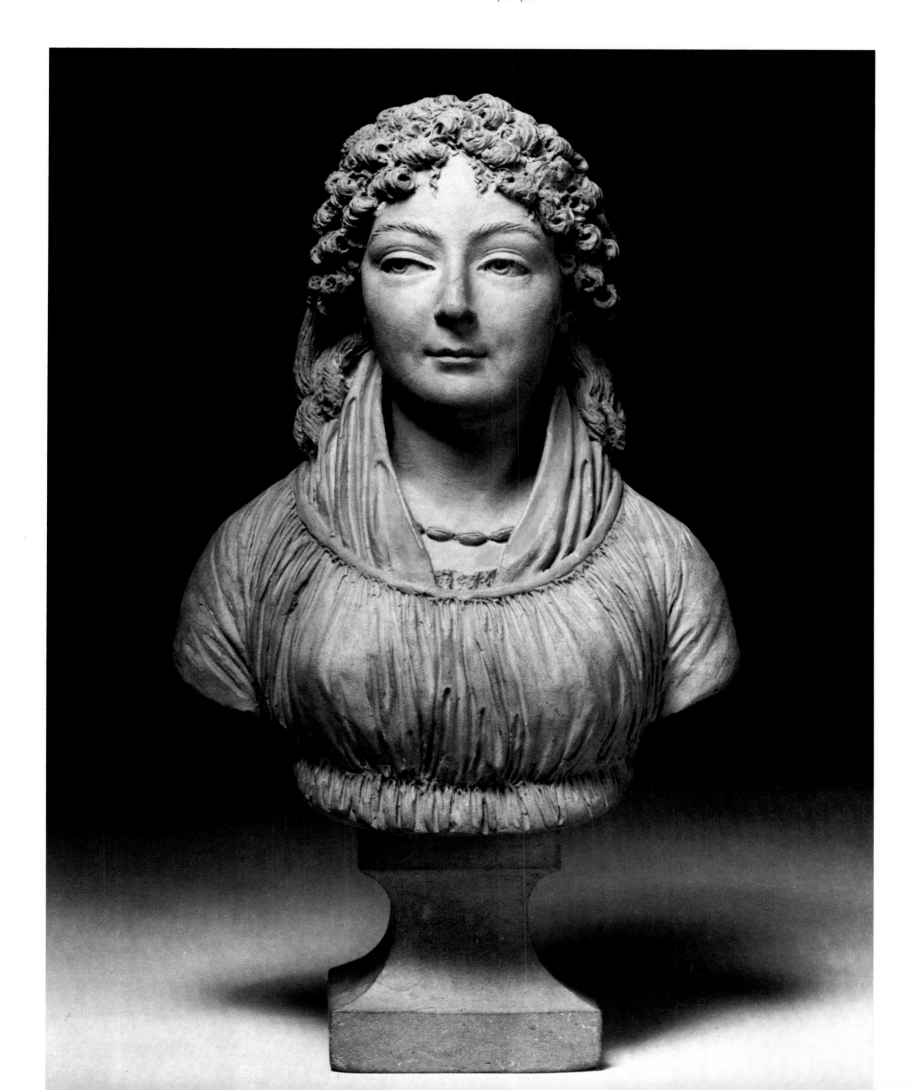

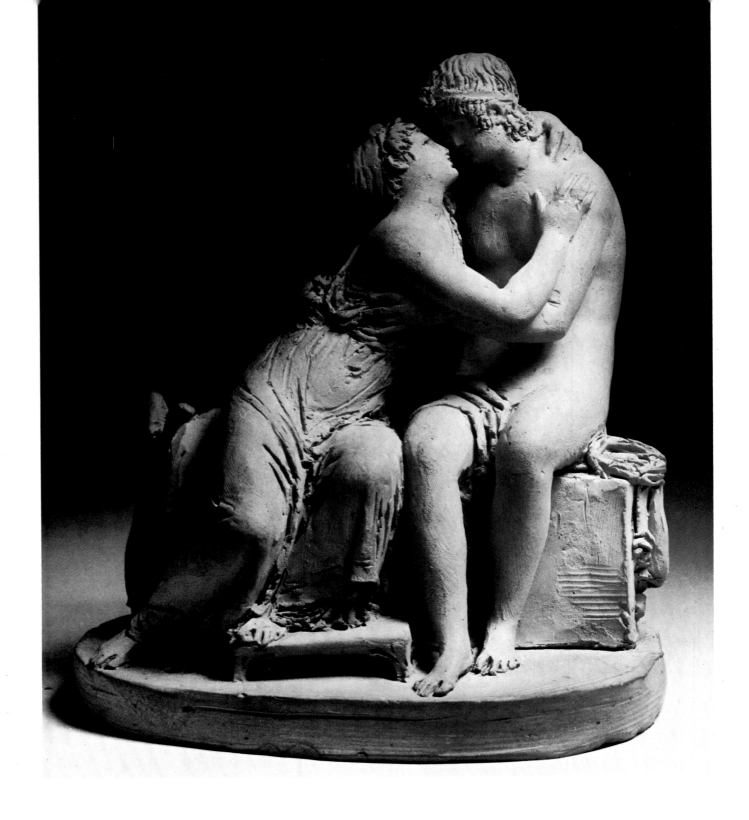

Attributed to JOSEPH CHINARD

90. *Sappho and Phaon*

Terra-cotta, ca. 1800-1810.
H. 6¼ in. (15.8 cm.) W. 6¼ in. (15.8 cm.) D. 4 in. (10.2 cm.)
Condition: excellent except for small chips on base.
Accession no. 77.5.27

T HE STYLE OF THIS WORK strongly suggests that it is by
Chinard. In mood it comes close to his early group
of *Perseus and Andromeda*, which exists in a number
of versions,[1] but the neoclassical stylization of the figures is
here much more advanced. That it is unsigned is unusual for
this self-advertising sculptor, but the lack of signature may
result from the fact of its being a *maquette*. In all likelihood it
dates from the Empire period, when Chinard was no longer
compelled to imbue his works with political significance and
could again model amorous subjects from antiquity. This

dating would also be appropriate to the subject matter of the
piece, because it was only Mme. Pipelet and Martini's popular
opera *Sapho* (1794), and Lantier's chapters in his *Voyages
d'Antenor* (1797), devoted to the poetess Sappho's suicidal
infatuation with the fisher-boy Phaon, that launched the
literary and artistic vogue for Sappho as a subject that swept
through the first decades of the 19th century.

Vien[2] appears to have initiated the vogue for pictorial depictions
of Sappho with his painting of *Sappho singing her verses while
accompanying herself on the lyre* in the Salon of 1787, and in
the 1795 Salon she was the subject of five exhibits, one of which
was the terra-cotta sketch of *Sappho addressing her verses to
the bust of Phaon* by Jacques-Philippe Lesueur.[3] This was the first
sculptural representation, followed by Ramey's marble statu-
ette of *Sappho holding a letter to Phaon* (for which the terra-cotta
was exhibited in 1796),[4] and the anonymous "Citoyen ****'s"
terra-cotta *Sappho*, in the Exposition de l'Elysée of 1797.

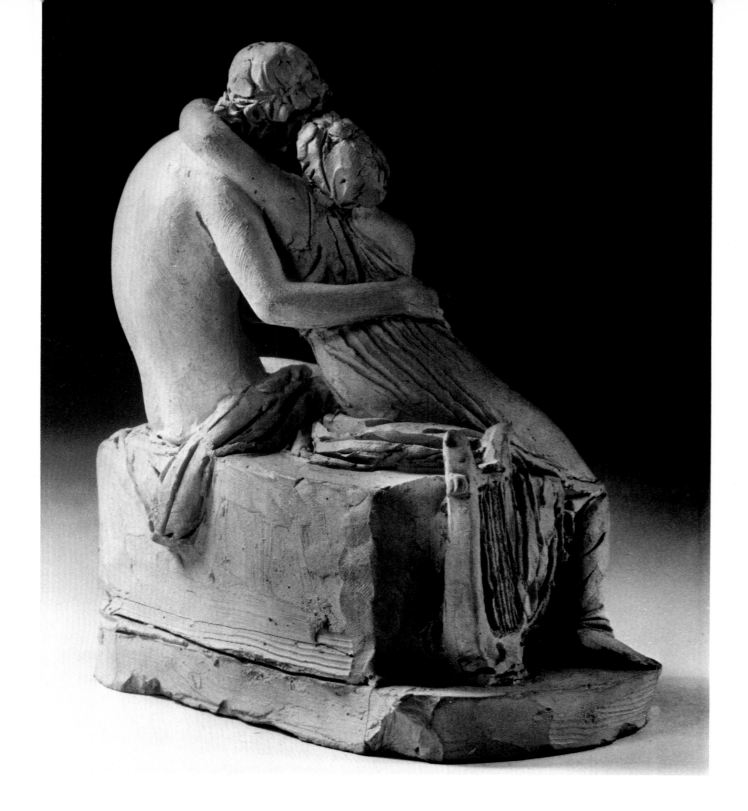

Chinard himself exhibited a bust of *Mme. Alb. de Mar[seille] as Sappho playing the lyre* in the Salon of 1808.[5] In the present group, following his native bent, Chinard emphasizes the lyrical aspect of Sappho's supposed passion for Phaon, rather than the tragic aspect opened up by Taillasson (1791)[6] and Gros (1801),[7] with their depictions of her alleged suicide.

"Images of both Sappho and her legendary lover Phaon are the exception rather than the rule in the period of her fresh popularity, 1775-1875. Sappho, who was known in the Renaissance, sleeps with little disturbance through the Baroque and makes a fresh and dramatic appearance in the period of romantic classicism, beginning with engraved book illustrations in the 1760s and culminating in a virtual Sapphomania in Salon paintings and sculptures of the 1790s and 1800s. In the nineteenth century Sappho became a stock heroine in countless academic examples. More than likely, Phaon is there only by implication. Many assumed that the verses she was frequently

depicted writing were addressed to Phaon. In the Lesueur terra-cotta, Sappho addresses her lyrics to a bust of the young man. In a watercolor attributed to Maria Cosway, Sappho sits in front of a tree with Phaon's name carved into the bark.[8] Jacques-Louis David's *Sappho and Phaon* (1809) is probably the best known image of both the poet and her muse/lover.[9]

An image quite close in feeling to the terra-cotta here is Girodet-Trioson's watercolor *Paysage avec Sapho* (1793).[10] In it a nude Phaon, lounging in the pose of a river god, rests behind the poet. Surely this muse is Phaon himself and not a cupid."[11]

1. M. Rocher-Jauneau, "Chinard and the Empire Style," *Apollo*, September, 1964, figs. 1, 2 and 5, pp. 220-222.
2. Joseph-Marie Vien (1716-1809).
3. 1757-1830.
4. Claude Ramey (1754-1838).
5. Wernher Collection, Luton Hoo, Luton Bedfordshire, exhibited in Royal Academy and Victoria and Albert Museum, *The Age of Neoclassicism*, London, 1972, no. 343.
6. Jean Joseph Taillasson (1745-1809).
7. Baron Antoine-Jean Gros (1771-1835).
8. Maria Cosway (1745 or 1759-1838); the watercolor is in a private collection, New Haven, Conn.
9. Jacques-Louis David (1748-1825); painting, now in the Hermitage, Leningrad.
10. Anne-Louis Girodet-Trioson (1767-1824); painting in a private collection, see Musée Municipal, Montargis (France), *Girodet, 1767-1824, exposition du deuxième centenaire*, Montargis, 1967, no. 60.
11. Personal communication from Judith Stein, doctoral candidate, the University of Pennsylvania, Department of Art History, currently completing her thesis on *The Iconography of Sappho, 1775-1875*.

FRENCH, late 18th to mid-19th century

JACQUES-EDME DUMONT
(1761-1844)

Son of Edme Dumont, Jacques-Edme belonged to a dynasty of artists who had moved from Valenciennes to Paris in the 17th century. His father having died when he was only fourteen, Jacques was admitted as a pupil by Edmé's friend Pajou. He had already obtained a number of ecclesiastical commissions (including sculpture for the pulpit of St. Sulpice) when he won the first prize for sculpture in 1788 and left for Rome. Returning to France in 1793, he began making models of Revolutionary subjects, but by the time of the Exposition de l'Elysée in 1797, he was already exhibiting more winning themes. In 1806 he won the favour of the Empress Josephine with a small wax medallion of *Love in a Chariot Drawn by Butterflies*, and at the same time began to win monumental commissions for sculpture: on the Colonne de la Grande Armée, L'Arc de Triomphe du Carrousel, the Louvre, and elsewhere. At the Restoration he was commissioned to execute statues of *Malesherbes* (1815-19) and *Pichegru* (1816-24), but after that, nothing. The remainder of his life was heartened by the success of his son Augustin as a sculptor.

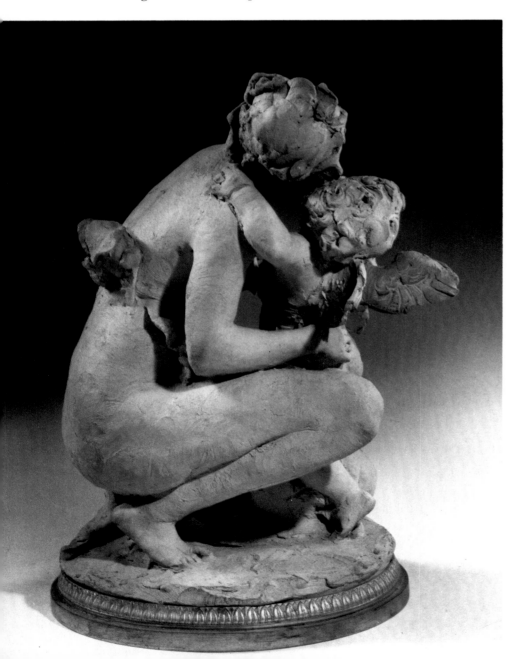

91. *Venus Comforting Cupid*

Terra-cotta, ca. 1797.
H. 9¾ in. (24.7 cm.) W. 6¾ in. (17.1 cm.) D. 5½ in. (14.0 cm.)
Condition: repairs to both figures.
Provenance: M. Jules Thomas.
Exhibited: Exposition de l'Elysée, Paris, 1797, no. 12; Exposition Universelle, *Exposition Centennale de l'Art Français de 1800 à 1889*, Paris, 1900, no. 1623.
Accession no. 77.5.35

LAMI'S ASSERTION that the group entitled *Vénus et l'Amour* in the 1900 Exposition Centennale was previously exhibited at the Exposition de l'Elysée, in 1797 may be given some credence.[1] Guiffrey's abstract of the catalogue of that exhibition includes among several other works by Dumont "no. 12. *L'Amour se plaignant à Vénus de la piqûre d'une abeille*," which could plausibly be identified with the group exhibited in 1900, if its title was shortened, as well as with the present terra-cotta.[2]

Lami was incorrect, however, in asserting that the group *Vénus et l'Amour* belonged to Mme. Ginain.[3] The catalogue of the 1900 Exposition Centennale clearly indicates M. Jules Thomas, a French sculptor and student of Augustin Dumont, as its owner.[4] M. Thomas had replaced Augustin Dumont as Professor at the Ecole des Beaux-Arts after the latter's death in 1884. It is nowhere stated, but the existence of the *Vénus et l'Amour* together with a small, square relief, *Portrait of Mlle. C. Dumont*, also exhibited in 1900, in the possession of Jules Thomas strongly suggests that they were acquired directly from the artist's descendants, either by inheritance or purchase. Indeed, Mme. Ginain was also the owner of a number of small terra-cottas done by Jacques-Edme Dumont in that exhibition. As a matter of fact the pieces in Mme. Ginain's collection probably were acquired in the same way, since Mme. Ginain appears to have been the widow of the painter Louis Ginain or of his brother, the architect Paul Ginain, and close to the sculptor's family.

If *Vénus et l'Amour* and *l'Amour se plaignant à Vénus de la piqûre d'une abeille* are indeed one and the same, then M. Jules Thomas may have been the former owner of the Sackler terra-cotta. A similar group by Simon-Louis Boizot (see no. 84) entitled *Le Baiser de Vénus*, modelled for Sèvres in 1787, may have been the inspiration for the group by Dumont here.[5]

1. S. Lami, *Dictionnaire des sculpteurs de l'Ecole française au dix-huitieme siècle*, Paris, 1910 (Reprint, Liechtenstein, 1970), p. 304.
2. J. Guiffrey, Exposition de l'Elysée, 1797, abstract of catalogue, Paris, 1875.
3. Lami, *op. cit.*
4. Exposition Universelle (see *Exhibited* above). He is also known as Gabriel-Jules Thomas.
5. E. Bourgeois, *Le biscuit de Sèvres*, Paris, 1913, no. 96, pl. 32.

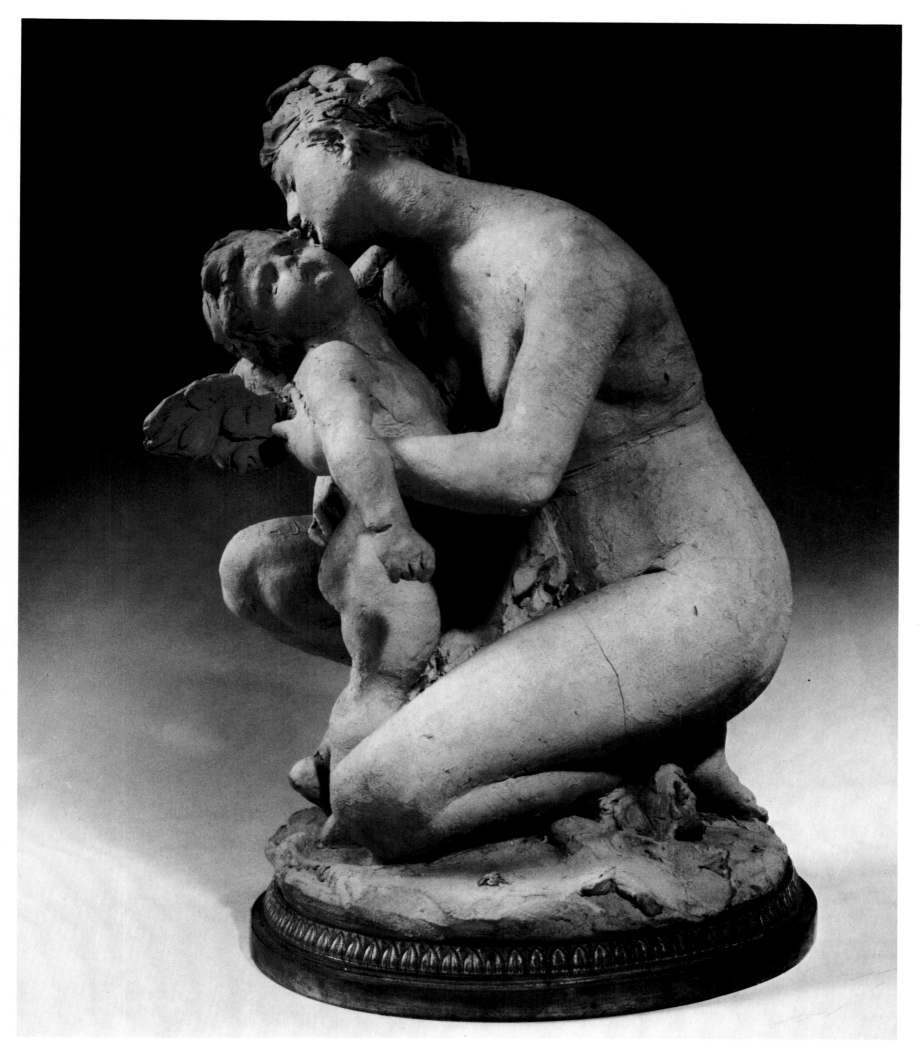

FRANÇOIS-DOMINIQUE-AIMÉ MILHOMME
(1758-1823)

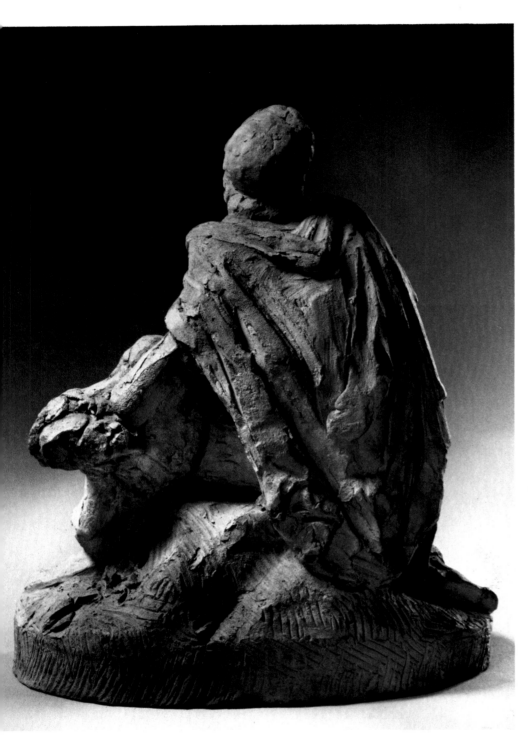

Milhomme was born in Valenciennes, the son of the *intendant* of the Governor of Hérault. He received his earliest training in his native city from Pierre-Joseph Gillet, and then went to Paris where he became the pupil of Allegrain.[1] In the dearth of sculptural commissions occasioned by the Revolution, he supported himself by making models for the goldsmith Auguste. Returning to sculpture, he belatedly won the second prize for sculpture in 1797, and shared the *prix de Rome* with Marin in 1801. He left for Italy the next year, and remained there until 1809. On his return he made his debut at the Salon of 1810 with a marble statue of *Psyche*, carved in Rome in 1806, now in the Louvre. While in Rome he had also carved a statue of *Hoche* (1808), intended for the Temple de la Gloire (Madeleine), now in the Musée de Versailles. More official commissions followed in the Restoration, including the relief of *Louis XIII* (1818) for the pediment of the *hôtel de ville* at Rheims and a statue of *Colbert* (1819-20) intended for the Pont Louis XVI (de la Concorde), also now in the Musée de Versailles. His last works were for the Orléans funerary chapel at Dreux.

92. *Brutus Lamenting Over the Dead Lucretia*

Terra-cotta, ca. 1795-1800.
*Signed: D. *ilhomme* (mutilated signature).
H. 10 in. (25.5 cm.) W. 8⅛ in. (20.7 cm.) D. 6 ⅛ in. (15.8 cm.)
Condition: repairs throughout both figures.
Accession no. 79.1.18

THIS LITTLE *maquette* would appear to be an early work by Milhomme, executed at a time when Brutus was regarded as a Revolutionary paragon. It is probably contemporaneous with the relief for which the sculptor won the *prix de Rome* in 1801: *Caius Gracchus leaving his wife Licinia to oppose the Consul Opimius in the Forum*, now in the Musée de Valenciennes.

1. Gabriel Allegrain (1733–1799).

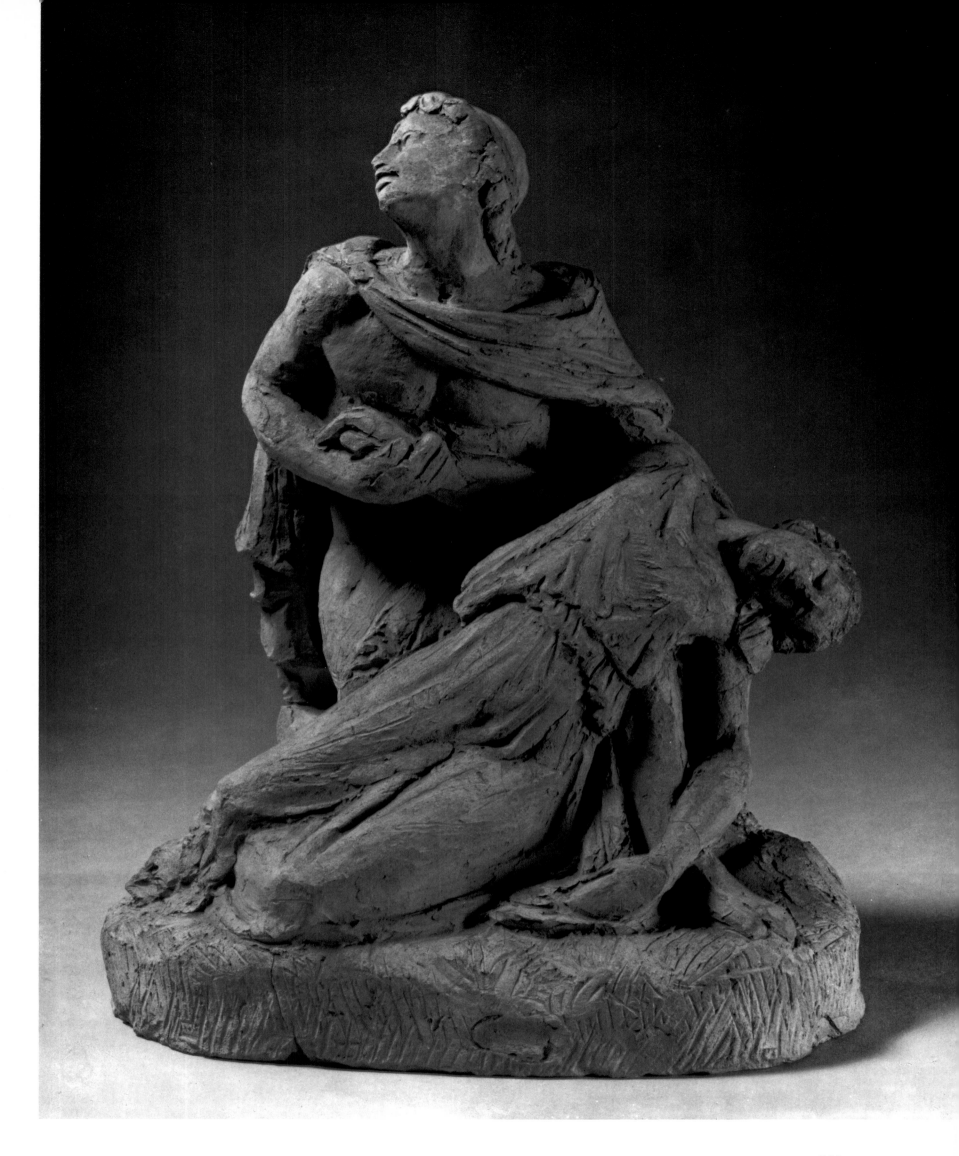

JOSEPH-CHARLES MARIN
(1759-1834)

Of Parisian bourgeois stock, Marin is first recorded working in Clodion's studio as one of a team producing terra-cotta statuettes in that sculptor's manner, as he was later to do on his own. He was also a pupil of the Academy schools, and competed for the *prix de Rome* six times between 1782 and 1787; but, perhaps because his master did not belong to the Academy, he was always unsuccessful. Marin's first known work, the *Reclining Girl With a Rose,* is dated 1778, when he was only nineteen, but as a non-Academician he could not start exhibiting at the Salons until the suppression of the jury in 1791. During the Revolution, he produced a number of patriotic busts, as well as *Bacchantes* in the manner of Clodion. In 1796, he was attached to the commission set up to select works of art from conquered Italy; he remained there until 1798. Eager to go back after his return to Paris, he competed yet again for the *prix de Rome,* which he belatedly won in 1801. This time he remained in Italy, from 1802 until 1810, producing statues and reliefs of classical subjects in marble, plaster, and terra-cotta. He did a series of busts and tombs for the exiled Lucien Bonaparte, as well as the *Tomb of Pauline de Beaumont* (1803/5; S. Luigi dei Francesi) for Chateaubriand. On his return to France, he was patronized by maréchal Gouvion de Saint-Cyr, and made *maquettes* for a number of sculptures for unexecuted public monuments. He twice eloped with one of Clodion's daughters, but did not marry her. In 1813, he succeeded Chinard as professor at the Ecole des Beaux-Arts of Lyons, but gave this up to return to Paris in 1818. He won a few public commissions under the Restoration, but it was reported that the sculptor eked out his last years modelling figurines for a few *sous.* Marin initially passed into oblivion, and has since been overshadowed by Clodion; but his terra-cottas in the vein of his master, although often deliberately hastier in execution, have a charm all their own.

Fig. 1. Marin, *Vestal,* terra-cotta, Los Angeles County Museum.

93. *Vestal Holding a Vase*

Terra-cotta, ca. 1790.
Signed: under the base, inscribed in ink: "PEROT"; and a fragment of an old auction label reading: "F. Pérot, Entrepreneur de Menuiserie, rue Jeu de Paume."
H. 12⅛ in. (30.8 cm.) W. 4 in. (10.2 cm.) D. 3½ in. (8.9 cm.)
Condition: right arm broken off at elbow; nose broken; repair at neck; chipped on edge of shawl and back of base.
Accession no. 77.5.68

THE ONLY *menuisier* called "Pérot" listed in Vial, Marcel & Girodie's *Les Artistes Décorateurs du Bois*[1] is a joiner who received a trivial payment for repairs to panelling in the church of Saint-Michel in Bonneval (Eure-et-Loire) in 1779, a field of activity very different from that of an *entrepreneur,* as named on the label here. Nor was there any *ébéniste* of that name, even if it were possible or likely for a cabinetmaker to have become a contractor-cum-dealer in joinery. The initial and his reputed profession also preclude his being identified with either of the Jean-Jacques Pérots recorded as master-sculptors belonging to the Academy of St. Luke between 1749 and 1786. In any case, Pérot was not the author of this statuette, but only the dealer through whose hands it passed. In view of this terra-cotta having once belonged to an *entrepreneur de menuiserie,* it is quite possible that it was originally intended as the model not for a statuette in its own right, but for a piece of sculpture to be incorporated into some such item of furniture as a clock.[2]

Perhaps, however, it was a *maquette,* with slight variations, for a signed but undated statuette of a *Vestal* by Marin now in the Los Angeles County Museum (fig. 1).[3] Undoubtedly, Marin took the inspiration for the subject from his former master, Clodion. The technique is also similar to Clodion's in his preliminary *maquettes,* particularly in two formerly attributed to Marin but now associated with his master.[4]

Marin made a *Vestal* in plaster, 35 cm. high, signed and dated, in 1790. She held an oval flower basket in both hands, and a column at her side, decorated with a bas-relief, was surmounted by an overturned amphora of flowers. A similar terra-cotta, not signed, and one varying slightly, but signed and uncertainly dated 17—, both 33 cm. high, are also known.[5] *Une Vestale* is listed among his eleven pieces of sculpture in the 1791 Salon,[6] and a *Vestale, Modèle en terre* in the 1795 Salon.[7] The former may be either the plaster or one of the two terra-cottas mentioned above, while the latter may either be one of the two terra-cottas or another entirely. Neither, however, can be identified with the one here or the Los Angeles piece.

1. H. Vial, A. Marcel and A. Girodie, *Les Artistes Décorateurs du Bois,* vol. II: M à Z and Supplément, Paris, 1922, p. 75.
2. For instance, the *Vestal Virgin* and the *Pontifex* flanking the clock in *biscuit de Locre,* of which there was an example in a sale at the Galerie Jean Charpentier, Paris, June 20, 1933, lot 73 (illus.).
3. Formerly in the Gaston Le Breton collection and exhibited Galerie Heim, Paris, *Le choix de l'amateur,* 1975, no. 41.
4. See Clodion's *Une Vestale* and *Une Pretesse* in Galerie Cailleux, Paris, *Autour du Néoclassicisme,* 1973, nos. 55 and 56.
5. M. Quinquenet, *Une élève de Clodion: Joseph-Charles Marin, 1759–1834,* Paris, 1948, p. 54. The plaster was in the M. Dubois-Chefdebien sale, hôtel Drouot, Paris, February 13, 1941, lot 60, pl. XXVIII; one terra-cotta was in a hôtel Drouot sale, Paris, May 13, 1947; and the uncertainly dated terra-cotta was in the Emile Strauss sale, Galerie Georges Petit, Paris, June 4, 1929, no. 93.
6. Quinquenet, *op. cit.,* p. 55.
7. *Ibid.,* p. 56 and no. 1061 in the 1795 Salon as indicated in *Corrections des Livrets des Anciennes Expositions depuis 1673 jusqu'en 1800,* Paris, 1871, p. 69.

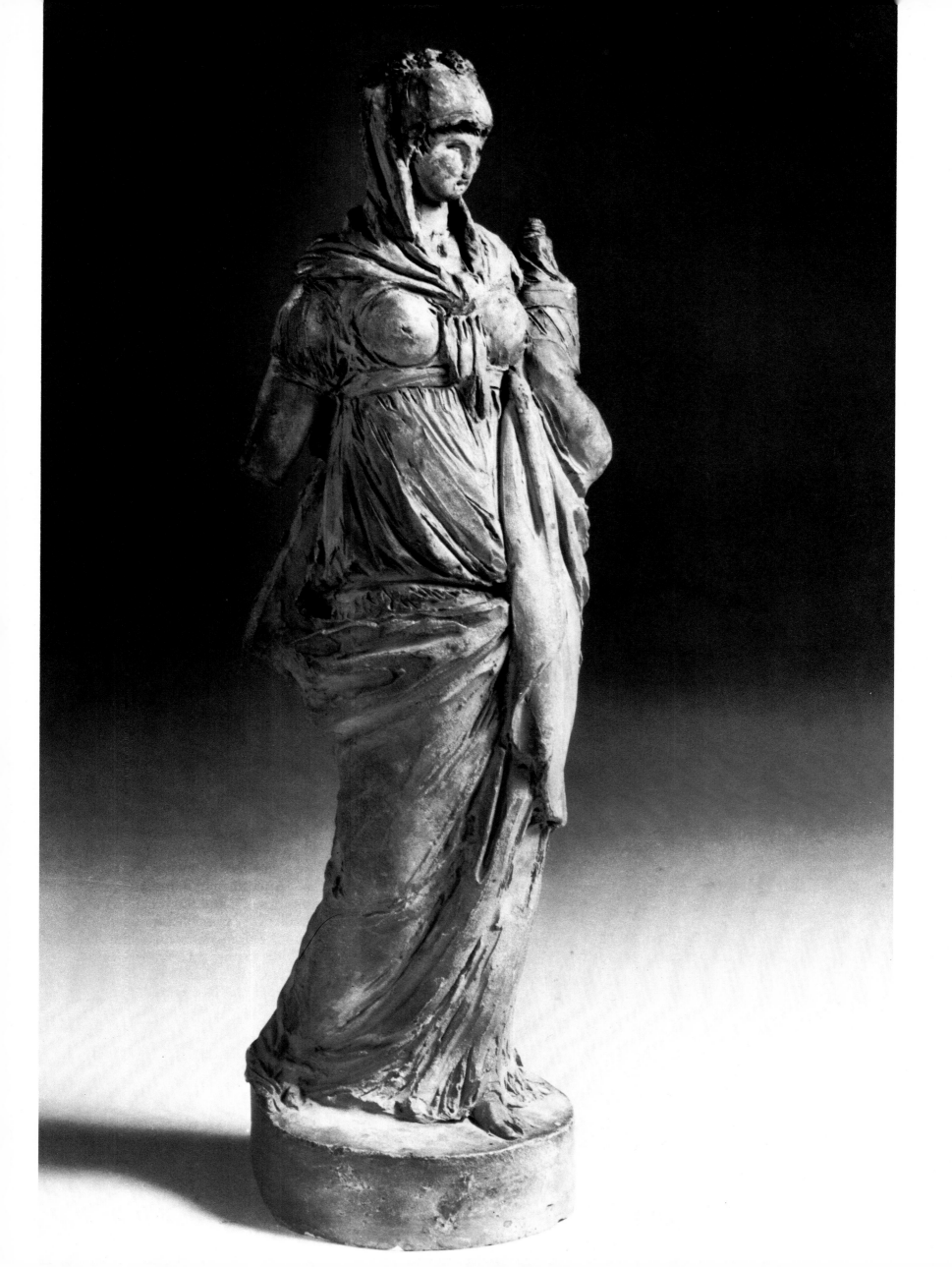

FRANCISQUE-JOSEPH DURET
(1804-1865)

Son of the sculptor François-Joseph Duret (1729-1816), Francisque, after his father's death, at first decided to become an actor. Later, having elected to become a sculptor after all, he entered the Ecole des Beaux-Arts and became a pupil of François-Joseph Bosio (1769-1845) in 1818. In 1823 he shared the *prix de Rome* with Augustin Dumont, another precocious son of a sculptor. He executed a number of works in Italy, notably the marble *Mercury Inventing the Lyre,* which, exhibited in the Salon of 1831, won him a first-class medal. Purchased by King Louis-Philippe, it was destroyed in the sack of the Palais-Royal in 1848, just as the original replacement bronze was burned with the old Opéra. On a visit to Naples, Duret conceived what was to be his most popular work, the *Fisherboy Dancing a Tarantella,* which, with the *Neapolitan Fisherboy* (1831), by François Rude (1784-1855), initiated the vogue for *genre* sculpture. The original bronze, also acquired by the king and now in the Louvre, was exhibited in the Salon of 1833. A steady succession of official commissions followed.* He also executed a number of works for Parisian churches. Duret was made a *chevalier* of the *Légion d'honneur* in 1833 and an *officier* in 1853; he was elected to the Institut de France in 1843; won the medal of honour at the Exposition Universelle of 1855; and succeeded Ramey as professor at the Ecole des Beaux-Arts in 1852. Unspoiled by this brilliant record of orthodoxy and success, Duret was greatly valued as a teacher for the painstaking but undogmatic nature of his instruction.

*These included statues of *Molière* (1830-34, Institut de France), *Casimir-Périer* (1833, Chambre des Députés), *Richelieu* (1836, Musée de Versailles), *Chateaubriand* (1849-54, Institut de France), and *Rachel* (1862-65, Théâtre-Français); the figures of *Tragedy* and *Comedy* for the vestibule of the Théâtre-Français (1855-57); and sculpture for the crypt of Invalides, the Louvre, and the Fontaine Saint-Michel (*St. Michael Crushing the Devil,* 1860-61).

94. *Sketch for a Figure of François Chateaubriand*

Terra-cotta, ca. 1849.
H. 8¾ in. (22.3 cm.) W. 5⅛ in. (13.1 cm.) D. 5½ in. (14.0 cm.)
Condition: repairs to right ankle, front of base, left foot, neck and left arm at shoulder and wrist.
Accession no. 79.1.19

THIS IS THE *première pensée* for Duret's celebrated statue of Chateaubriand (1768-1848) in the Institut de France. Commissioned by the State in 1849, when Charles Blanc was *directeur des beaux-arts,* the marble was completed in 1853 and allocated to the Institut, after it had helped Duret to win his medal of honour at the Exposition Universelle in 1855. The final marble shows the writer seated, supporting himself on a rock beside a wave-battered shore. According to Charles Blanc the aim of the sculptor, forced by the restrictions imposed on him by modern dress to express his subject through pose and gesture, was to show Chateaubriand the traveller, *"le poête de l'Itinéraire."*[1] Whereas Théophile Gautier praised the head of the marble for its likeness and for being impressed with "that stamp of deep melancholy and incurable *ennui* which were characteristic of the author of *René,"*[2] Blanc criticized its lack of life, and suggested that Duret had been intimidated by working from a cast of David d'Angers' mask of the writer.

As with the Carpeaux sketch of *Flore* (no. 96), and for many of the same reasons, Duret's terra-cotta sketch has a vividness that the final marble lacks. Blanc supplies the reasons when he explains that Duret was a statuary rather than a sculptor.[3] By this he means that Duret was far happier when modelling in clay or wax, whose every nuance could be reproduced by casting in bronze, than in carving marble, which was for him a mechanical task executed with tools at one remove, and which he therefore preferred to leave to his *practiciens* (craftsmen), hardly even touching up the finished product himself: "Any instrument except the modelling tool seemed to burn his fingers."[4] By contrast, Blanc describes Duret, when modelling a work, as first using the clay to fix a pose that satisfied him, "After turning it this way and that in a hundred different attitudes..."; and then, making a third-size model, "he took every possible care to refine the forms, select the folds for the drapery, calculate the effects of light and shade...in a word, to implant spirit into brute matter."[5] Yet such was Duret's modesty that his studio contained nothing of his own but his *Chactas* (the hero of Chateaubriand's *Atala*), and his plaster models were relegated to a dim vestibule.

1. C. Blanc, "Francisque Duret," in *Gazette des Beaux-Arts,* XX, February, 1866, p. 112.
2. *"Ce cachet de mélancolie profonde et d'incurable ennui qui caractérisait l'auteur de René."* T. Gautier, *Les Beaux Arts en Europe,* second series, Paris, 1856, p. 165.
3. Blanc, *op. cit.,* pp. 103-104.
4. *Ibid.: "Tout autre instrument que l'ébauchoir semblait lui brûler les doigts,"* p. 104.
5. *Ibid.: "Après l'avoir tourné et retourné de cent manières...et il ne négligeait rien alors pour châtier les formes, choisir les plis, ménager les effets de lumière et d'ombre...en un mot faire entrer l'esprit dans la matière."* p. 105.

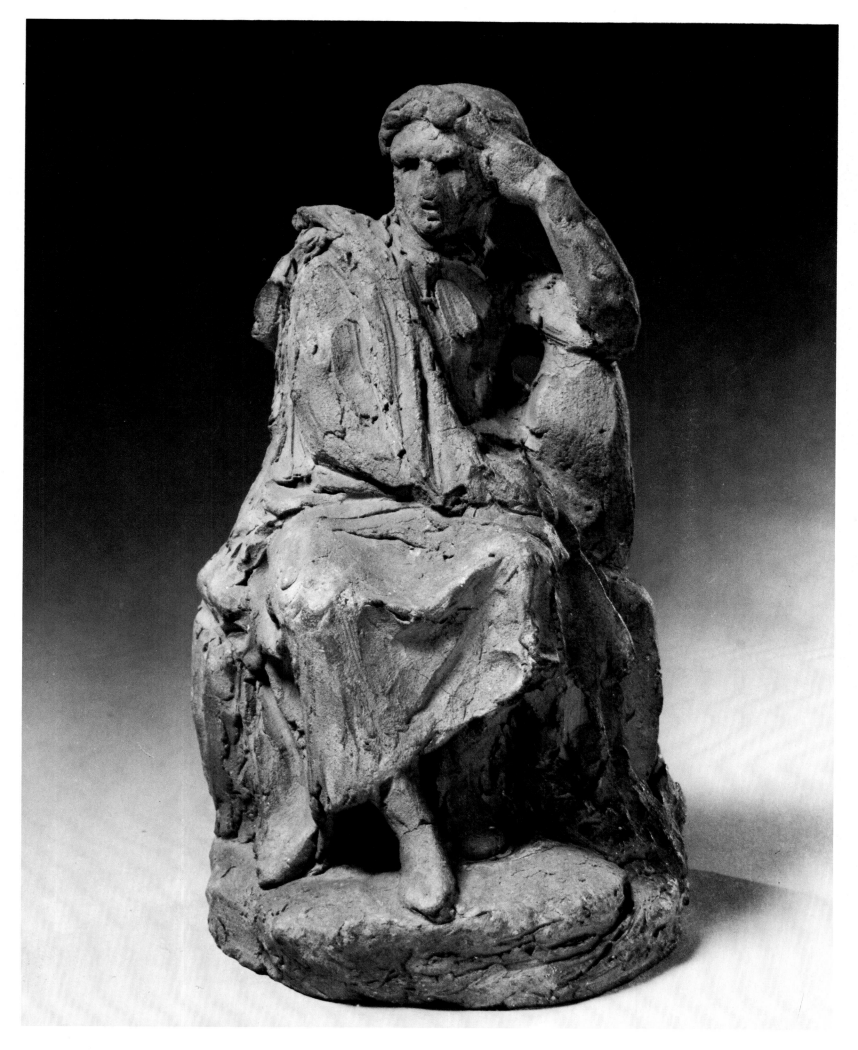

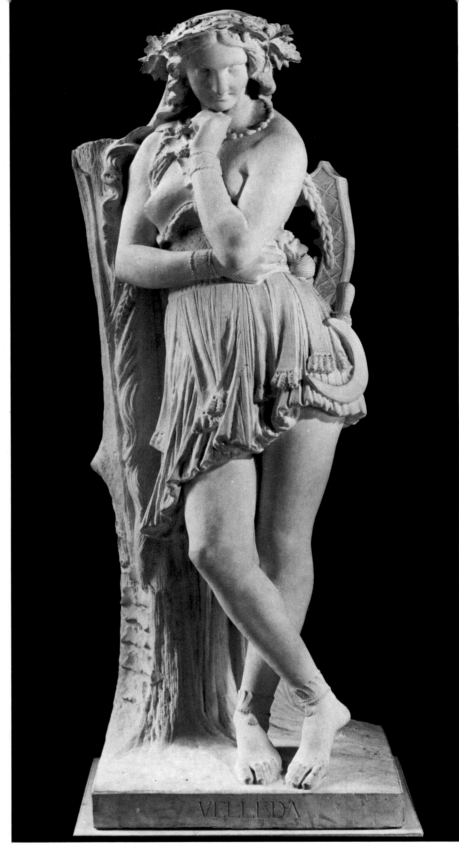

Fig. 1. Maindron, *Velléda*, marble, Louvre, Paris.

FRENCH, 19th century

ETIENNE-HIPPOLYTE MAINDRON
(1801-1884)

Son of a former soldier, Maindron was born at Champtoceaux and received his earliest training at the Ecole des arts et métiers in Angers from 1818 to 1823. To earn his living, he first worked for a business in Nantes, and then as a *surveillant* (supervisor) in his old school at Angers from 1824 to 1826. Feeling his true vocation to be a sculptor, in 1827 he obtained a three-year scholarship from the Department of Maine-et-Loire to study in Paris. He was admitted to the Ecole des Beaux-Arts, and accepted as an assistant by David d'Angers, whom he helped to carve the pediment sculpture of the Panthéon. He made his debut at the Salon of 1834 with a statue of *A Young Shepherd Bitten by a Snake*, of which the marble is in the Museum of Angers. He won a third-class medal in 1838, and second-class medals in 1843, 1848, and 1859; but public recognition did not come until his *Velléda*, which he first exhibited in 1839. Numerous commissions from the State ensued, notably those for the two groups of *St. Rémy Baptizing Clovis* (plaster, 1848; marble, 1854-58) and *Ste. Geneviève Halting Attila* (plaster, 1862; marble, 1864-66), placed on either side of the portal of the Panthéon. He also made a number of busts, medallions and statues of great men of the past, partly in emulation of his fellow countryman and former master David d'Angers. Made *chevalier* of the *Légion d'honneur* in 1874, he continued to exhibit at the Salons until 1880.

95. *Velléda*

Terra-cotta, ca.1844.
Signed: "MAINDRON" on base and inscribed "VELLEDA."
H. 17½ in. (44.5 cm.) W. 5½ in. (14.0 cm.) D. 6½ in. (16.5 cm.)
Condition: old repairs on drapery at back of head, legs at thighs and ankles, left arm just below shoulder, tip of nose.
Accession no. 77.5.46

I T WAS WITH his sculptures of this heroine of Gallic resistance to the Romans that Maindron made his name. He exhibited a plaster model in the Salon of 1839.[1] In 1843 he received a commission from the Ministre de l'Intérieur to carve it in marble. Exhibited in the Salon of 1844, this version is now in the Luxembourg Gardens. A plaster *maquette* connected with it and dated 1844, is in the Musée de Rennes. A marble replica commissioned in 1869 for the Musée du Luxembourg, after a period in the Tuileries Gardens, was placed in the Louvre. The present terra-cotta was probably also a by-product of this major public commission.

The ultimate inspiration for this statue was the tale of Eudore in Chateaubriand's *Les Martyrs*[2] in which, taking great liberties with the account of Velléda found in Tacitus, Chateaubriand portrayed a tragic love affair between the Christian convert Eudore and Velléda, the last of the Druid priestesses. The real Velléda was a priestess of the Bructeri and the chief ally in the revolt of Claudius Civilis (A.D. 69-70) until, deserted by him, she was delivered up to the Romans to adorn Domitian's triumph in Rome. Chateaubriand, however, placed her in the time of Diocletian, and had her commit suicide for breaking her vows of virginity with her Romano-Greek captor, Eudore. Maindron, although taking his inspiration from Chateaubriand, and particularly from the description of her appearance in the middle of Book IX, nonetheless presents Velléda more as a patriotic figure contemplating her fateful destiny as an enemy of Rome, than as Chateaubriand's lovelorn fury.

1. Museé royal, Paris, Salon of 1839, no. 2238, re-exhibited at the Exposition Universelle Paris in 1855, no. 4480; now in the Musée d'Angers.
2. François Chateaubriand, *Les Martyrs*, Paris, 1809; revised edition, 1839, Books IX and X.

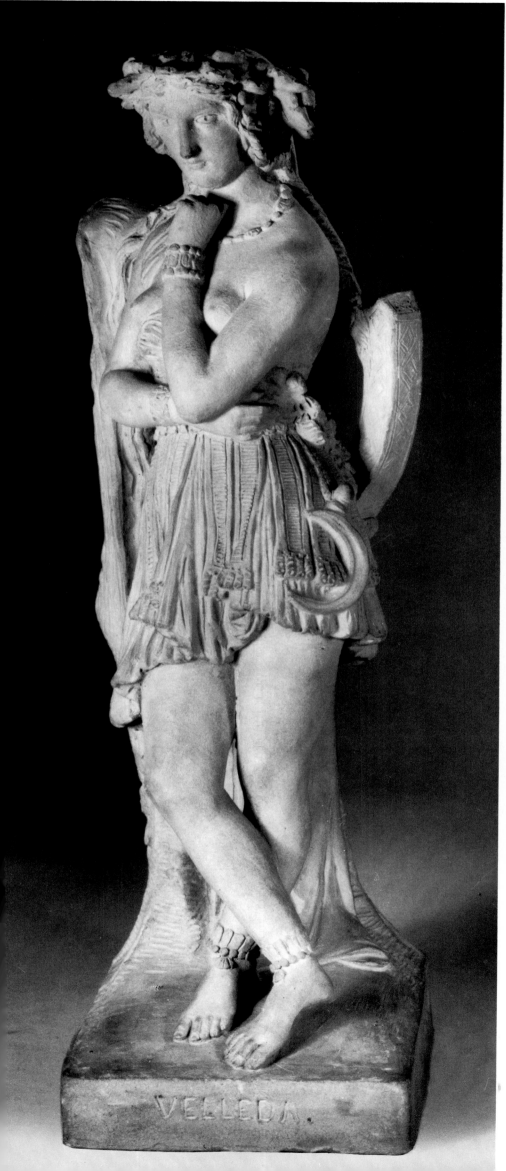

VELLEDA.

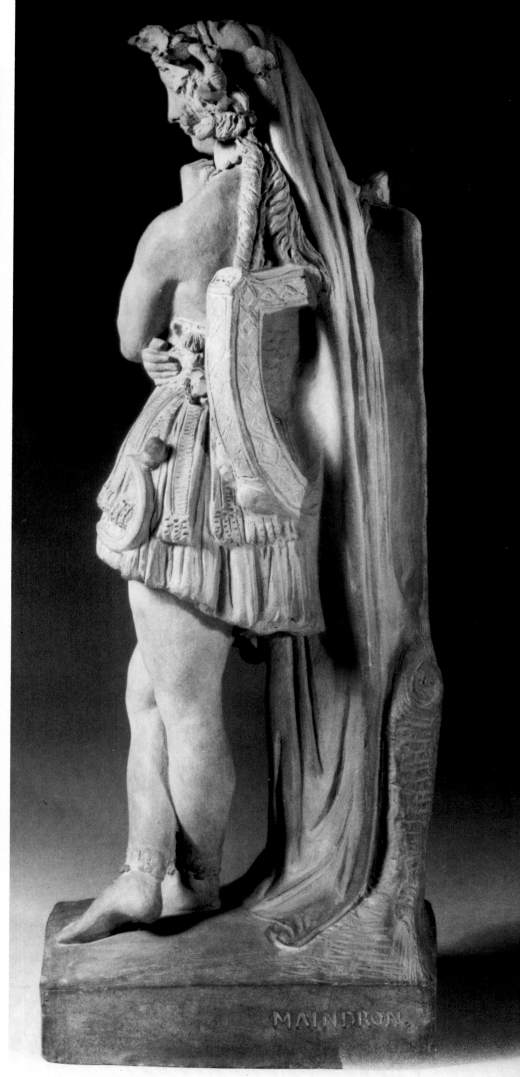

MAINDRON.

217

FRENCH, 19th century

JEAN-BAPTISTE CARPEAUX
(1827-1875)

Of poor parents (his father was a mason), Carpeaux
received an elementary education in his birthplace,
Valenciennes, before entering the so-called "Petite
Ecole" in Paris in 1842. Rejected by his compatriot,
the sculptor Henri Lemaire, he was taken on as a
student by Victor Liet. After acceptance by the Ecole
des Beaux-Arts in 1844, he entered the studios
first of Abel de Pujol, then of Rude, and, finally,
in order to win the *prix de Rome*—which he did in
1854—of the more orthodox Duret. From 1846
on he had been subsidized by his native city. After
making his debut at the 1853 Salon with a plaster
relief of *The Submission of Abd-el-Kader,* Carpeaux
persuaded Napoleon III to order its execution in
marble. It is now in the Musée de Valenciennes.
He stayed in Italy from 1854 to 1862 and dispatched
from there two of his most celebrated works, the
Pêcheur à la Coquille and *Ugolino.* Patronage from
imperial and governmental circles nullified the
academic hostility that was manifested over such
official commissions as the relief *Triomphe de Flore*
(1866) for the Pavillon de Flore and *The Spirit of the
Dance* (1866-69) for Garnier's new Opéra. After
retreating to London during the Paris Commune,
Carpeaux returned to Paris to complete his last
major commission, the fountain group for the
Observatory (1867-74). Thereafter, he increasingly
concentrated on making a distinguished series
of portrait-busts. Weakened by stomach cancer
and feeling persecuted by his wife, he spent his
last years under the protection of Prince Stirbey.
Carpeaux was the most influential figure in
French sculpture of the mid-19th century.

96. *Flore Accroupie (Crouching Flora)*

Terra-cotta, ca. 1863.
H. 8½ in. (21.6 cm.) W. 3¾ in. (9.5 cm.) D. 4¼ in. (10.8 cm.)
Condition: front of base broken; right arm broken off above elbow,
left arm at shoulder; locks of hair broken off at top of head.
Accession no. 77.5.23

218

Fig. 1. Carpeaux, *Crouching Flora*, plaster, Louvre, Paris.

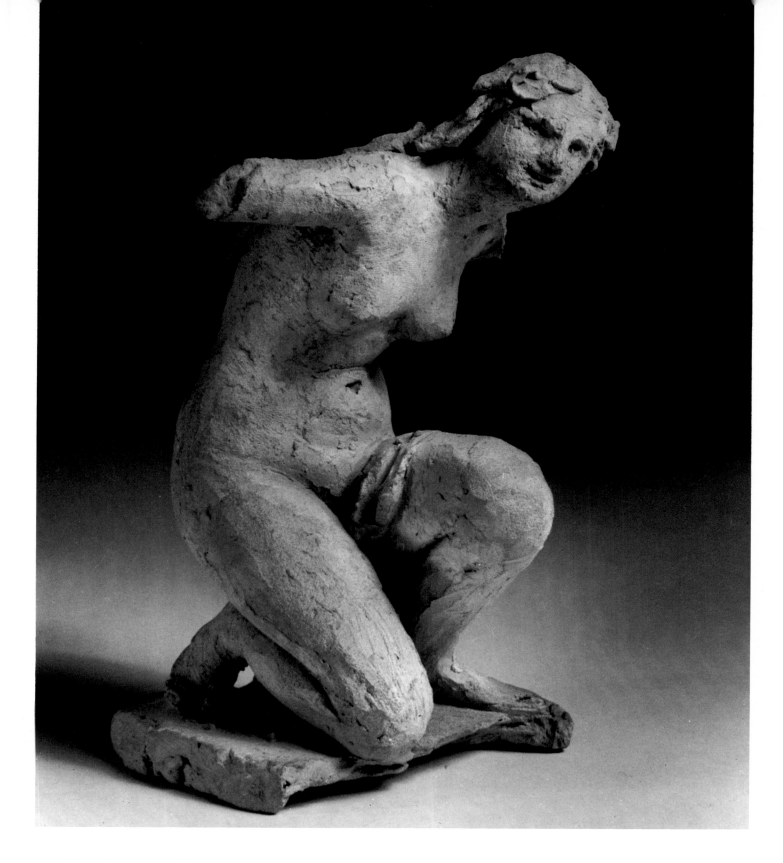

T HIS IS ONE of the sketch-models for Carpeaux's final idea for the *Flore Accroupie* in the *Triomphe de Flore* (1863-66) on the attic of the river front of the Pavillon de Flore of the Louvre. One of his earlier ideas, recorded in a sketch-model in the Musée des Arts Décoratifs in Paris, was for a reclining nymph reminiscent of the work of the Mannerist sculptor Jean Goujon.[1] After opting instead for a pose inspired by the Antique *Crouching Venus*, as shown in this and other sketches,[2] Carpeaux had to twist Flore's head and knees to bring them parallel to the front plane, in order to integrate Flore, her accompanying *putti* and the surrounding architecture. Even so, he enraged the architect Lefuel by the extent of the sculpture's protrusion and plasticity.

In 1864, the sculptor's model was approved, and, working in Chauvigny stone from a half-size plaster model (fig. 1),

Carpeaux had virtually completed the group by the end of 1865. On August 5, 1866, the scaffolding was taken down and the *Flore* stood revealed. The approbation of the Emperor, who is reputed to have mounted the scaffold to inspect the work, protected the artist from Lefuel and ensured its success.

The vivid immediacy of Carpeaux's technique in this sketch (his fingerprints can be seen on its characteristically roughened surface) is typical of the preliminary *maquettes* in which he elaborated his first thoughts for a composition.[3]

It is likely that the present *Flore* was among the contents of the artist's studio after his death, but the identifications in the sale and exhibition catalogues are too imprecise to make this certain.

1. Grand Palais, Paris, *Sur les traces de Jean-Baptiste Carpeaux* (exhibition catalogue), 1975, no. 268.
2. *Ibid.*, no. 266.
3. J. L. Wasserman, ed., *Metamorphoses in Nineteenth-Century Sculpture* (exhibition catalogue), Fogg Art Museum, Cambridge, 1975-1976, fig. 9, p. 118, fig. 17, p. 124 and fig. 29, p. 135.

FRENCH, second half of the 19th century

ALBERT-ERNEST CARRIER-BELLEUSE
(1824-1887)

Albert-Ernest was one of the children of Louis-Joseph Carrier de Belleuse, a notary at Anizy-le-Chateau, who deserted his family, leaving the children to be brought up by their cousins, the Aragos. Since Albert had to earn his own living, he first became an apprentice of the engraver Bauchery and then, through the influence of David d'Angers, went to work for the goldsmith Fauconnier and his successors, the Fannières. Concurrently, after a brief period at the Ecole des Beaux-Arts, he went to night classes at the more craft-oriented "Petite Ecole." He was soon greatly in demand as a modeller for manufacturers and, in 1850, after making his debut at the Salon with some medallions, left for Stoke-on-Trent to work for the Minton China works and teach in the local schools of design, while still sending back drawings to *bronziers* in France.

Returning to Paris in 1855, Carrier-Belleuse was tirelessly active in the artistic life of the city, modelling and making bronzes, exhibiting at the Salons, carving sculpture on the Louvre, and helping to found the Union Centrale des Arts Décoratifs, at whose first exhibition in 1863 he was unique in setting up a stall of his own, winning in the process the Gold Medal. He made about 200 busts of his friends and contemporaries, many of which he exhibited at Martinet's gallery. In the 1863 Salon, he began to win acclaim for pure sculpture with his *Bacchante* which was acquired by the Emperor and placed in the Tuileries Gardens; even so, some of Carrier-Belleuse's most successful commissions were for architectural sculpture, notably for the Casino at Vichy (1864-66), the Opéra (1864-66), and the hôtel de Päiva (1864-65). To avoid dependence upon patronage, he initiated a series of sales of his own work at the hôtel Drouot in 1868.

During the Franco-Prussian War and the Paris Commune, Carrier-Belleuse went to Brussels to work on the Bourse. After his return he was greatly in demand to adorn the rebuilt Paris with sculpture, and in 1875 he was appointed Director of Works of Art at Sèvres, for which he copiously produced exquisite chalk-drawn designs. These were realized in the round by modellers such as his son-in-law, Joseph Chéret, and, above all, Rodin. Carrier-Belleuse was not only one of the most prolific artists of his day, but he also did more than anyone, since the eighteenth century, to straddle the rift that had developed between pure and applied art.

220

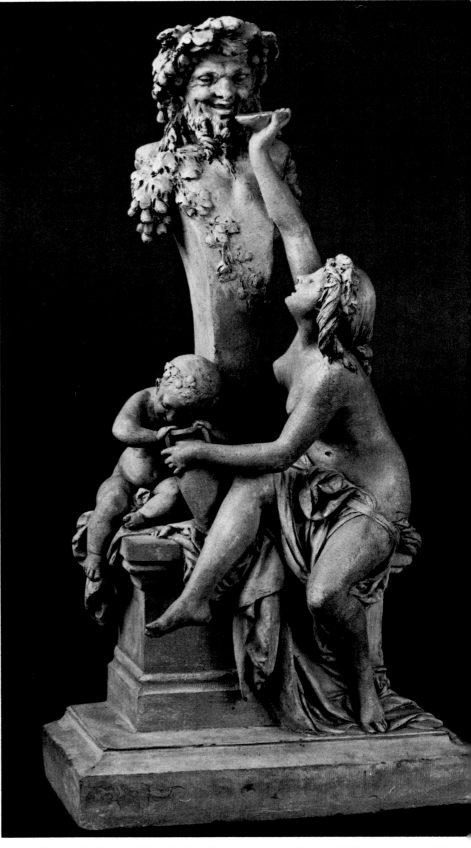

Fig. 1. Carrier-Belleuse, *Offrande à Bacchus*, terra-cotta, Bruton Gallery, Somerset, Engla

97. *Bacchante Offering a Libation to a Bacchic Term*

Terra-cotta, ca. 1868-1871.
Signed: "A CARRIER.B."
H. 24¼ in. (61.6 cm.) W. 11⅟₁₆ in. (28.1 cm.) D. 6 in. (15.2 cm.)
Condition: right arm of Bacchante restored from elbow; repairs to Bacchante and child throughout.
Accession no. 77.5.24

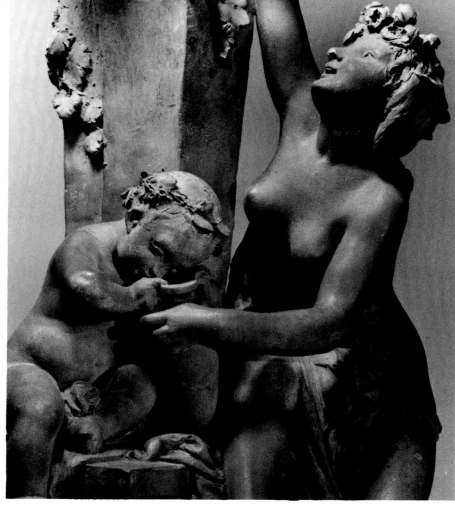

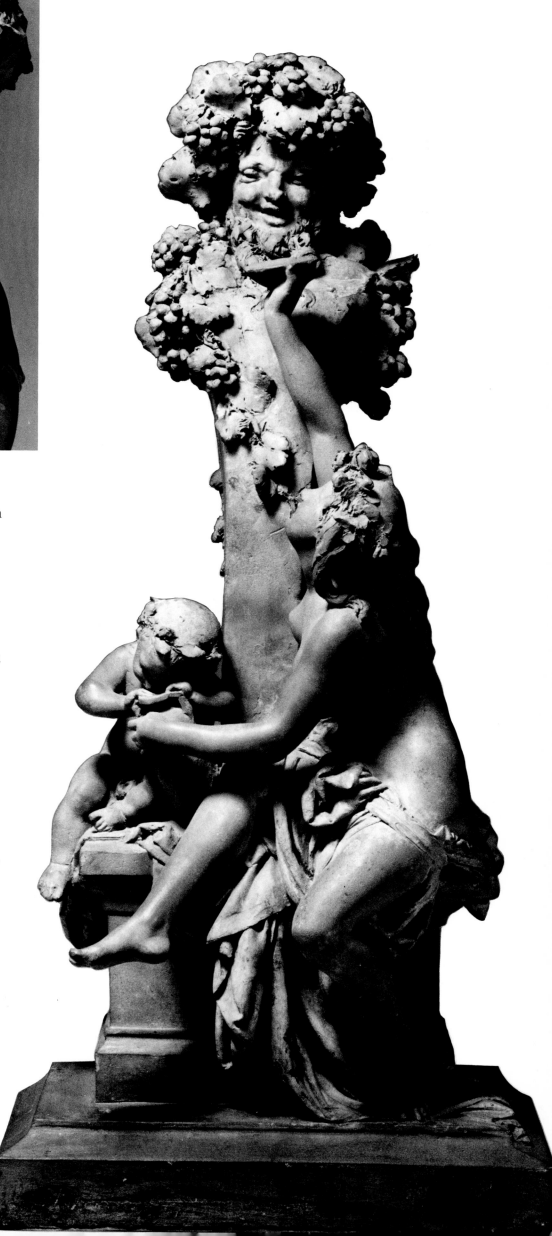

I N 1863, CARRIER-BELLEUSE achieved his first major success as a pure sculptor at the Salon with a *Bacchante Pouring a Libation Over a Bacchic Term.* He had begun carving it from a block of marble supplied by the State in June 1861, after a plaster model completed in September 1860. The finished statue was purchased by the Emperor and presented to adorn the Tuileries Gardens.[1] Such was the sculptor's own fondness for this work that the original model for it was, at his request, posthumously exhibited in the 1888 Salon.[2] A terra-cotta of this *Bacchante* made in 1863 was one of the first reductions that Carrier-Belleuse offered for sale in the Union Centrale exhibition of the same year. Another terra-cotta of this piece, an example of which is in the collection of David Barclay in London (H.65 cm.; signed "CARRIER"), was included in Carrier-Belleuse's first sale at the hôtel Drouot 1868 and listed as *Bacchante.*[3] One was also cast in bronze.[4]

The success of *Bacchante Pouring a Libation Over a Bacchic Term* prompted Carrier-Belleuse to produce a second and yet more Clodionesque version of the theme. The first record of the second version is of a terra-cotta model included in the hôtel Drouot sale in Paris in 1868 as *Offrande à Bacchus, Groupe—Hauteur, 50 cent.* and described as "a young nymph, half seated on an altar surmounted by a figure of Bacchus to whom she is offering a libation; a small child seated beside her is looking into an amphora which he holds in his two hands."[5] This second version, the description of which so clearly applies to the group seen here, seems to appear a few years later in smaller size under the heading *Reproductions of Various Models in Terra-cotta,* as Lots 24 and 25, and entitled *A Sacrifice to Bacchus—A Group—1 ft. 3 in. high* (37.5 cm.), in the sculptor's exclusive sale at Christie's in London on November 1, 1871. At this same sale, and under the same heading of *Reproductions...,* there also appeared *A Terminal Figure and A Bacchante—A Group—2 ft. high* (61 cm.).[6] In his

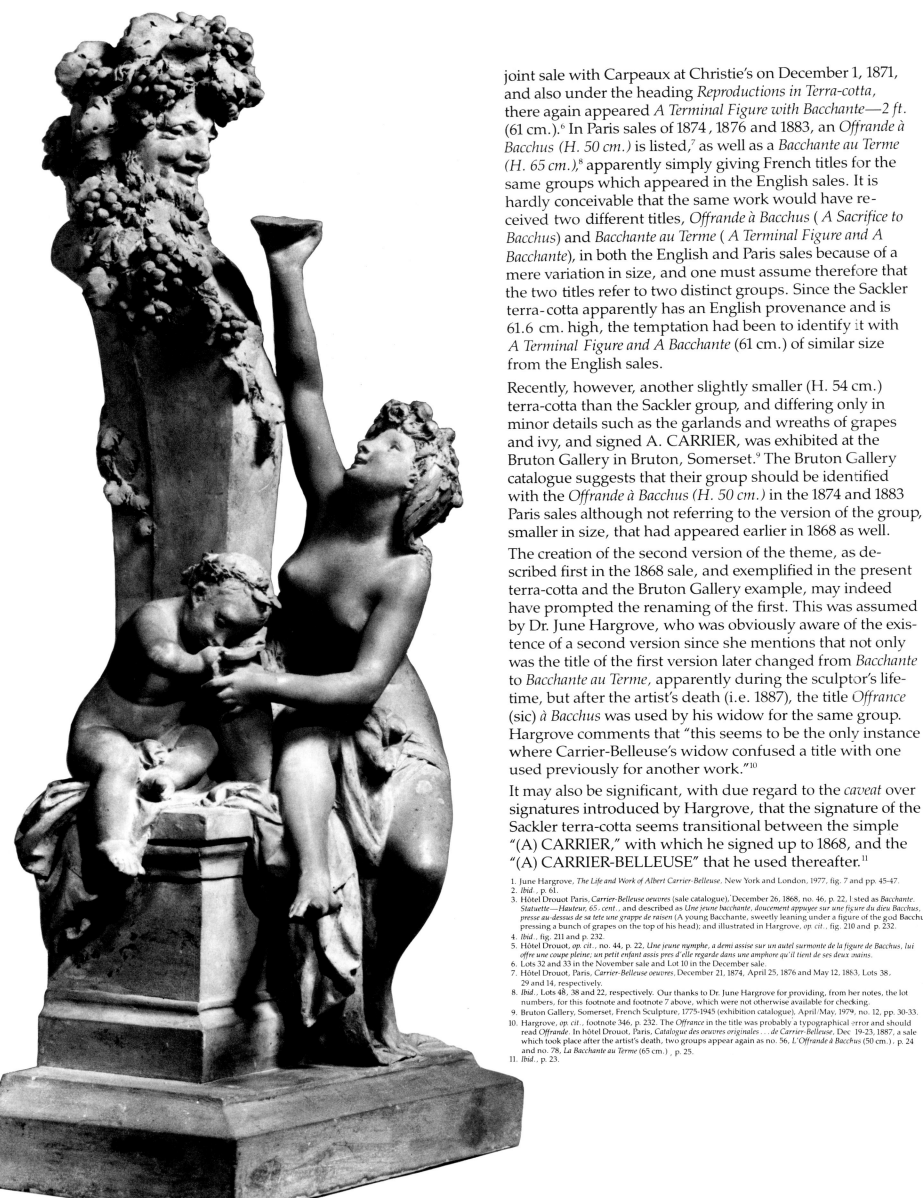

joint sale with Carpeaux at Christie's on December 1, 1871, and also under the heading *Reproductions in Terra-cotta*, there again appeared *A Terminal Figure with Bacchante—2 ft. (61 cm.)*.[6] In Paris sales of 1874 , 1876 and 1883, an *Offrande à Bacchus (H. 50 cm.)* is listed,[7] as well as a *Bacchante au Terme (H. 65 cm.)*,[8] apparently simply giving French titles for the same groups which appeared in the English sales. It is hardly conceivable that the same work would have received two different titles, *Offrande à Bacchus* (*A Sacrifice to Bacchus*) and *Bacchante au Terme* (*A Terminal Figure and A Bacchante*), in both the English and Paris sales because of a mere variation in size, and one must assume therefore that the two titles refer to two distinct groups. Since the Sackler terra-cotta apparently has an English provenance and is 61.6 cm. high, the temptation had been to identify it with *A Terminal Figure and A Bacchante* (61 cm.) of similar size from the English sales.

Recently, however, another slightly smaller (H. 54 cm.) terra-cotta than the Sackler group, and differing only in minor details such as the garlands and wreaths of grapes and ivy, and signed A. CARRIER, was exhibited at the Bruton Gallery in Bruton, Somerset.[9] The Bruton Gallery catalogue suggests that their group should be identified with the *Offrande à Bacchus (H. 50 cm.)* in the 1874 and 1883 Paris sales although not referring to the version of the group, smaller in size, that had appeared earlier in 1868 as well.

The creation of the second version of the theme, as described first in the 1868 sale, and exemplified in the present terra-cotta and the Bruton Gallery example, may indeed have prompted the renaming of the first. This was assumed by Dr. June Hargrove, who was obviously aware of the existence of a second version since she mentions that not only was the title of the first version later changed from *Bacchante* to *Bacchante au Terme*, apparently during the sculptor's lifetime, but after the artist's death (i.e. 1887), the title *Offrance* (sic) *à Bacchus* was used by his widow for the same group. Hargrove comments that "this seems to be the only instance where Carrier-Belleuse's widow confused a title with one used previously for another work."[10]

It may also be significant, with due regard to the *caveat* over signatures introduced by Hargrove, that the signature of the Sackler terra-cotta seems transitional between the simple "(A) CARRIER," with which he signed up to 1868, and the "(A) CARRIER-BELLEUSE" that he used thereafter.[11]

1. June Hargrove, *The Life and Work of Albert Carrier-Belleuse*, New York and London, 1977, fig. 7 and pp. 45-47.
2. *Ibid.*, p. 61.
3. Hôtel Drouot Paris, *Carrier-Belleuse oeuvres* (sale catalogue), December 26, 1868, no. 46, p. 22, l sted as *Bacchante. Statuette—Hauteur, 65 , cent.*, and described as *Une jeune bacchante, doucement appuyée sur une figure du dieu Bacchus, presse au-dessus de sa tete une grappe de raisen* (A young Bacchante, sweetly leaning under a figure of the god Bacchus, pressing a bunch of grapes on the top of his head); and illustrated in Hargrove, *op. cit.*, fig. 210 and p. 232.
4. *Ibid.*, fig. 211 and p. 232.
5. Hôtel Drouot, *op. cit.*, no. 44, p. 22, *Une jeune nymphe, a demi assise sur un autel surmonte de la figure de Bacchus, lui offre une coupe pleine; un petit enfant assis pres d'elle regarde dans une amphore qu'il tient de ses deux mains.*
6. Lots 32 and 33 in the November sale and Lot 10 in the December sale.
7. Hôtel Drouot, Paris, *Carrier-Belleuse oeuvres*, December 21, 1874, April 25, 1876 and May 12, 1883, Lots 38, 29 and 14, respectively.
8. *Ibid.*, Lots 48, 38 and 22, respectively. Our thanks to Dr. June Hargrove for providing, from her notes, the lot numbers, for this footnote and footnote 7 above, which were not otherwise available for checking.
9. Bruton Gallery, Somerset, French Sculpture, 1775-1945 (exhibition catalogue), April/May, 1979, no. 12, pp. 30-33.
10. Hargrove, *op. cit.*, footnote 346, p. 232. The *Offrance* in the title was probably a typographical error and should read *Offrande*. In hôtel Drouot, Paris, *Catalogue des oeuvres originales . . . de Carrier-Belleuse*, Dec 19-23, 1887, a sale which took place after the artist's death, two groups appear again as no. 56, *L'Offrande à Bacchus* (50 cm.), p. 24 and no. 78, *La Bacchante au Terme* (65 cm.) , p. 25.
11. *Ibid.*, p. 23.

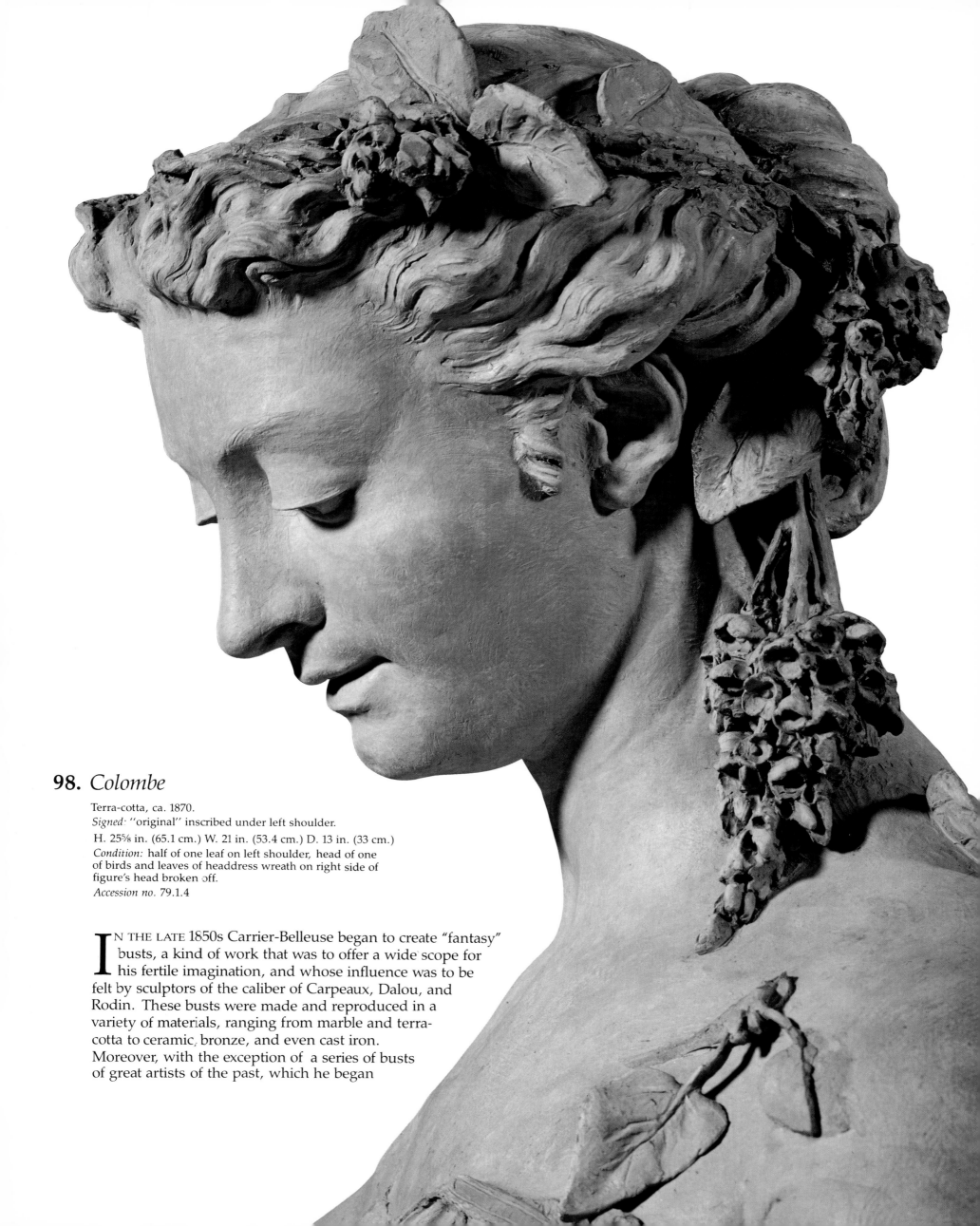

98. *Colombe*

Terra-cotta, ca. 1870.
Signed: "original" inscribed under left shoulder.
H. 25⅝ in. (65.1 cm.) W. 21 in. (53.4 cm.) D. 13 in. (33 cm.)
Condition: half of one leaf on left shoulder, head of one
of birds and leaves of headdress wreath on right side of
figure's head broken off.
Accession no. 79.1.4

IN THE LATE 1850s Carrier-Belleuse began to create "fantasy"
busts, a kind of work that was to offer a wide scope for
his fertile imagination, and whose influence was to be
felt by sculptors of the caliber of Carpeaux, Dalou, and
Rodin. These busts were made and reproduced in a
variety of materials, ranging from marble and terra-
cotta to ceramic, bronze, and even cast iron.
Moreover, with the exception of a series of busts
of great artists of the past, which he began

to issue in the early 1860s, they were almost invariably of women, sometimes disguised portraits, and with some sculpted detail to justify their symbolical or fanciful titles. Dr. June Hargrove has given her oral opinion that this bust, although unsigned, is by Carrier-Belleuse, and should be dated about 1870, although no bust titled *Colombe (Dove)* seems to appear in any of the sculptor's own sales prior to 1887. It therefore may be a somewhat later work. However, the *Fantasy Bust after Mlle. Sophie Croizette* in the Los Angeles County Museum is dated ca. 1874 by Dr. Hargrove, and it certainly seems close in feeling and style of modelling to the one here.[1] As in the Los Angeles bust, the features here are generalized, but there is the same small, round, dimpled chin, the same ears, high forehead, pointed nose and straight, striated brows. These similar features may relate to the way in which Carrier-Belleuse worked, creating ornamental busts of limited editions under the inspiration of a particular sitter. The basic form of a given model was apparently cast from molds and then carefully reworked with accessories varying radically enough so that each new bust was virtually another composition.[2] It is just possible

that this so-called *Colombe* was also inspired by Sophie Croizette, an actress in the Comédie Française, whose bust in plaster Carrier-Belleuse had sent to the Salon of 1874. Carrier-Belleuse had also sculpted Théo and Céline Chaumont, other actresses of the period, and Marguérite Bellanger, the circus performer.

A bust called *Colombe (Dove)* appeared in Carrier-Belleuse's posthumous sale at the hôtel Drouot in 1887. Its height was given as 60 cm., but then such heights were only approximations. In view of the quality of the present bust and of the fact that it is unsigned, but inscribed "original" it may well be the terra-cotta from which molds were taken to cast reproductions for sale. Shrinkage in firing would inevitably make the reproductions slightly smaller.

This bust has the subtle interplay of contrasted diagonals in the truncation and the turn of the head also favored, albeit in a more pronounced form, by Carpeaux in his "fantasy" busts, for example, *La Fiancée*.[3]

1. J. Hargrove in P. Fusco and H.W. Janson, eds., *The Romantics to Rodin* exhibition catalogue), The Los Angeles County Museum of Art, 1980, no. 53, pp. 168-169.
2. *Ibid.*, p. 169.
3. J. Hargrove, *The Life and Work of Albert Carrier-Belleuse*, New York and London, 1977, fig. 164.

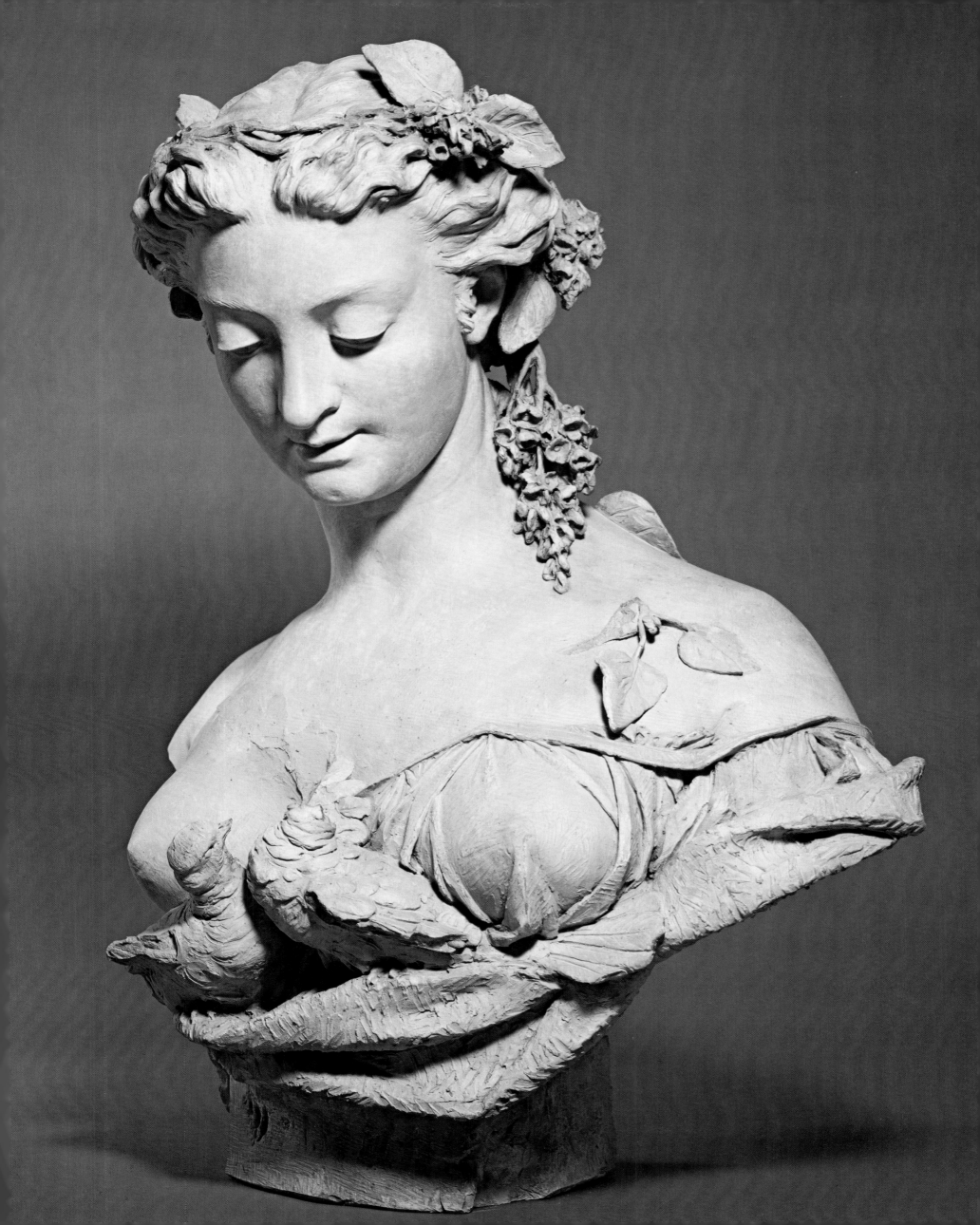

FRENCH, late 19th and early 20th century

AUGUSTE RODIN (1840-1917)

Auguste Rodin was born in Paris, the son of a simple clerk. Rejected three times by the Ecole des Beaux-Arts, he learned to sculpt instead at the "Petite Ecole" and from Antoine-Louis Barye (1796-1875) in the Jardin des Plantes. At first he earned his living by modelling small ornamental figurines for the manufacturers of "art" bronzes; then, through a recommendation of Jules Dalou (1838-1902), he became one of the "ghost" sculptors working in Carrier-Belleuse's industrially run studio (1864-1870). After service in the Franco-Prussian War, Rodin joined his employer in Brussels in 1871, working on sculpture for the Bourse by day and modelling busts and figurines for the Compagnie des Bronzes by night. After a falling-out with Carrier-Belleuse over working on his own account, Rodin continued to work in Brussels with the Belgian sculptor Antoine-Joseph van Rasbourg, with whom he entered into a partnership from 1873 to 1877. In 1874, he went with van Rasbourg to Antwerp to work on a monument commemorating the Burgomaster J. F. Loos, for a wealthy shipowner, Jules Pecher. Rodin was to work under Carrier-Belleuse again at Sèvres, from 1879 to 1882. He stayed in Brussels until 1877, with the exception of a visit to Italy in 1875.

Working in Brussels, Rodin paved the way for his return to Paris with the statue representing *The Age of Bronze*, submitted to the Salon of 1877. This piece won him his first notoriety, because of the accusation that it was a cast from a live model.

From then on, the major works in Rodin's career were marked by controversy: *The Gates of Hell* (1880 on), for which Rodin was paid in full, yet which he was never to complete in their definitive form, despite over a quarter of a century of work on them; the *Burghers of Calais* (1885-1889), commissioned by that city, which then failed to place them where the artist had stipulated; the *Monument to Balzac* (1891-1898), which was not set up in public, as intended, until forty-one years after its completion; and the *Monument to Victor Hugo* (1886-1901), which was denied its projected place in the Panthéon. However, at the Exposition Universelle of 1900, Rodin was permitted to erect a pavilion, within which he exhibited virtually his entire *oeuvre*, thus achieving a worldwide reputation that he has never since forfeited. His supreme ability, ultimately, was as a modeller; he never learned to carve stone, leaving it to his assistants to work up marbles from his sketch-models. It was into these that he poured his creative energy.

Rodin's private life only enhanced his notoriety as a sculptor. His mistresses included Claudel's sister Camille and the American-born duchesse de Choiseul. The poet Rainer Maria Rilke was, for a brief and tempestuous period, his secretary, while Rilke's wife, Clara Westhoff, studied with Rodin. After the sculptor's death, his house and studios in Meudon and the hôtel de Biron, and the contents of both, were left to the State as a Rodin museum.

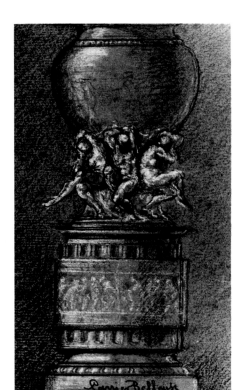

Fig. 1. Carrier-Belleuse, *Design for a jardinière with Titans*, drawing in charcoal, red chalk and white heightening, Musée de Calais.

226

AUGUSTE RODIN
and
ALBERT-ERNEST CARRIER-BELLEUSE

99. *Vasque des Titans*

Terra-cotta, ca. 1880.
Signed: "A. CARRIER BELLEUSE."
H. 15¾ in. (40 cm.) W. 11¾ in. (29.8 cm.)
Condition: all protruding limbs of figures and draperies repaired.
Accession no. 77.5.77

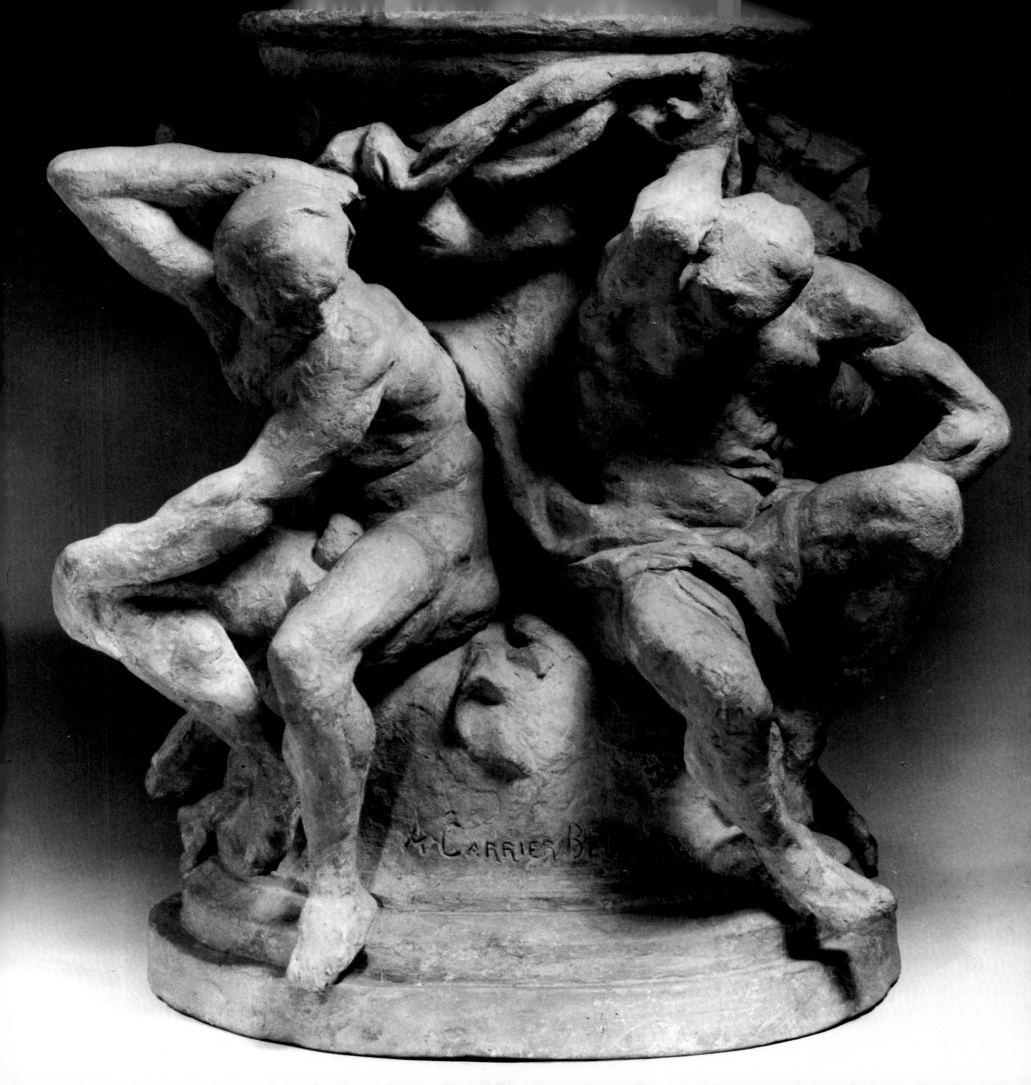

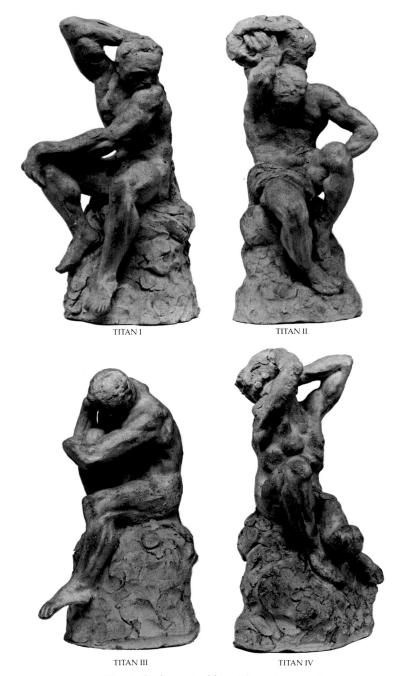

TITAN I TITAN II

TITAN III TITAN IV

Fig. 2. Rodin, set of four *Titans*, terra-cotta, Maryhill Museum, Goldendale, Washington.

Fig. 3. Rodin, set of four *Titans*, bronze, The Israel Museum, Jerusalem.

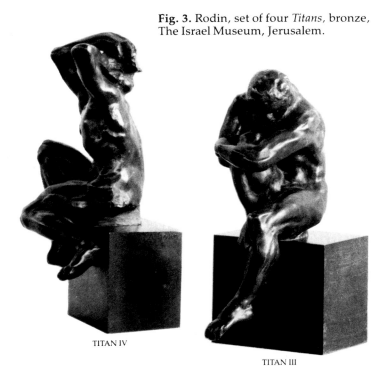
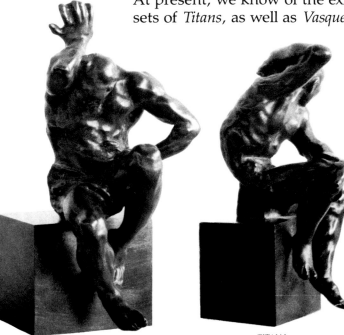

TITAN IV TITAN III TITAN II TITAN I

THE HISTORY of this so-called *Vase* or *Vasque des Titans* is a complex one, because of the respective roles of Rodin and Carrier-Belleuse in its creation.[1] The story apparently begins with four independently conceived terra-cotta *maquettes* of seated *Titans* made by Rodin. These figures were purportedly made under the influence of Michelangelo's *ignudi* from the Sistine Chapel ceiling shortly after Rodin's trip to Italy in 1875. Rodin was, however, drawing and making models from works by Michelangelo while he was still a student in the Petite Ecole.

Rodin had a wide visual education and the individual *Titans* "reflect not only Michelangelo, but the *Slaves* by Pietro Tacca (1577–1640) on the fountain in Leghorn and a famous antique seated statue, the *Ludovisi Ares*. These nudes are a foretaste of things to come, antedating, as they probably do, his earliest full-scale sculpture, the *Age of Bronze*."[2] The *Titans* have also been associated with his earlier caryatids made for an elegant house on the Boulevard Anspach and the Bourse in Brussels, between 1871–1874.[3] There is, as well, some suggestion of their relationship to Rodin's work on the Loos Monument in Antwerp in 1874.[4]

At some point, it was decided to incorporate the individual *Titans* as a group on a stand for a vase. Since the signature on four of the known stands is "A CARRIER BELLEUSE," it is apparent that the vases were made while Rodin was employed by Carrier-Belleuse, for whom he worked intermittently between 1864, the year he entered Carrier-Belleuse's workshop, and 1879–1882, when he worked under the general supervision of Carrier-Belleuse at the Sèvres factory. Sometime during this period, Carrier-Belleuse had made a drawing for a faience *jardinière* on a terra-cotta stand composed of *Titans*, with a stone and bronze base. This drawing, unfortunately undated, is now in the Calais Museum, and was reproduced in 1884 by Carrier-Belleuse in his *Application de la figure humaine à la decoration et à l'ornementation industrielle* (fig. 1).[5] It seems that Rodin's four figures were reworked so that casts of them could be taken and amalgamated into the model of the stand Carrier-Belleuse had drawn. Although much has been written about Rodin's *Titans* and the *Vasque* and its reproductions, no documentation to date, about either Rodin or Carrier-Belleuse, indicates exactly when or how the *Titans* were incorporated as a part of Carrier-Belleuse's design. Dating of the *Titans* and the *Vasque* has therefore varied.[6]

At present, we know of the existence of a certain number of sets of *Titans*, as well as *Vasques des Titans*. There are two

known sets of four *Titans* and two partial sets of two *Titans* each, all in terra-cotta. A set of four bronze *Titans* also exists, purportedly from an "original" mold, perhaps of terra-cotta.[7]

One complete set in terra-cotta is in the Maryhill Museum of Fine Arts, Washington, and shows the four *Titans* seated on rounded, roughly modeled bases (fig. 2). The figures themselves have unfinished backs and except for drapery across the right leg of *Titan* II, there is no drapery beneath or above them.[8] The Maryhill figures were acquired between 1915 and 1923 by Samuel Hill, founder of the

museum, who received them either from Rodin himself or Löie Fuller.[9] The other known set of four *Titans* was on the London art market in 1967.[10] The latter figures do not sit on bases at all.

In 1958, two terra-cotta *maquettes* were sold at Parke Bernet Galleries, New York, and according to the catalogue were cast "in Paris from an original mold during Rodin's lifetime."[11] These, *Titans* II and IV, are now in the Houston Museum of Fine Arts.[12] Unlike the Maryhill *Titans*, they sit on rectangular bases. The second set of two, also *Titans* II and IV, were sold

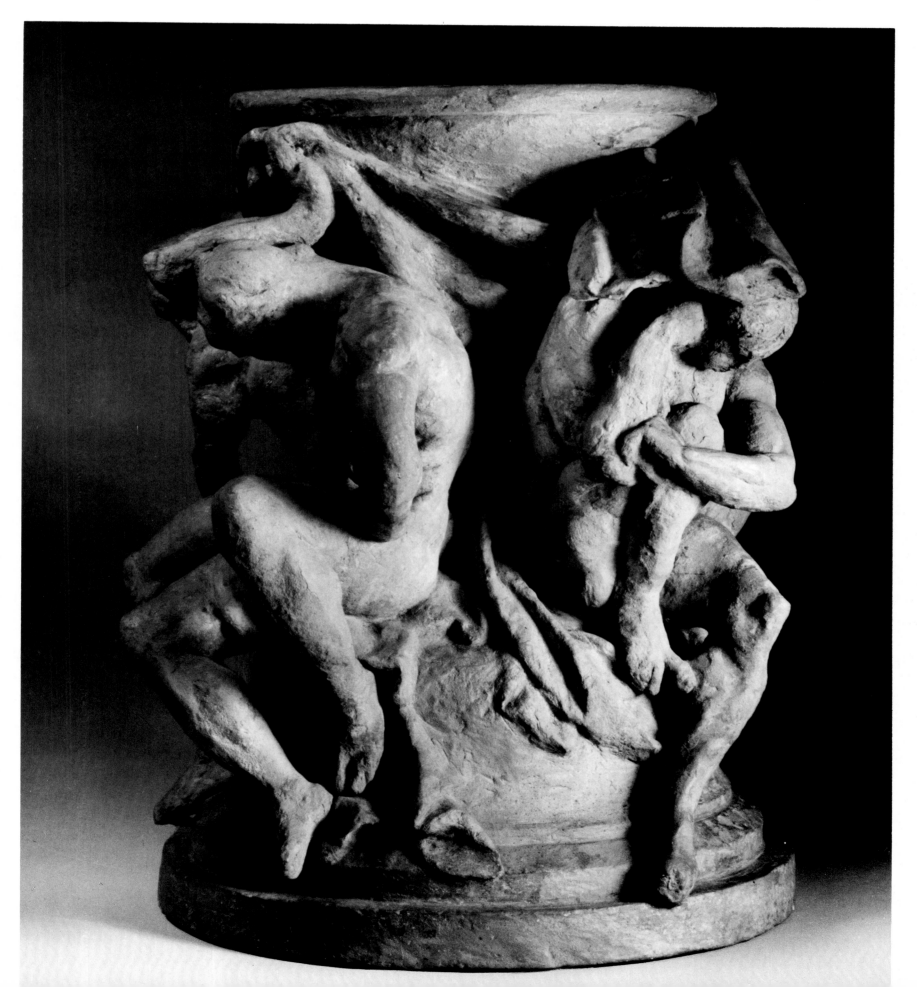

at Sotheby's, London, in 1967.[13] These "were said to come from Othilo Pesci, one of Rodin's assistants, who received them from the master as a parting gift."[14] However, the four bronze *Titans* in The Israel Museum (fig. 3), also seated on rectangular bases, are documented as being cast from the original "terres" given by Rodin to another assistant, Legendre, who died in 1935 and whose son-in-law cast the bronze *Titans* in 1937.[15]

Of the *Vasques des Titans*, there are four signed terra-cotta versions: one in the Maryhill Museum acquired along with their *Titans*; one in the Rodin Museum, Paris (fig. 4);[16] one of lead-glazed earthenware in the Bethnal Green Museum (a branch of the Victoria and Albert Museum), London;[17] and the one here. Two others, made of plaster and sand, were in the David Barclay collection, London, although one of them was sold at Sotheby's in 1971.[18] The latter two were unsigned. In the four signed versions, the location of the signature is slightly different on the bases. On one, the initial "A." appears clearly behind the leg of *Titan* I, while entire signatures appear higher or lower on the base or on the

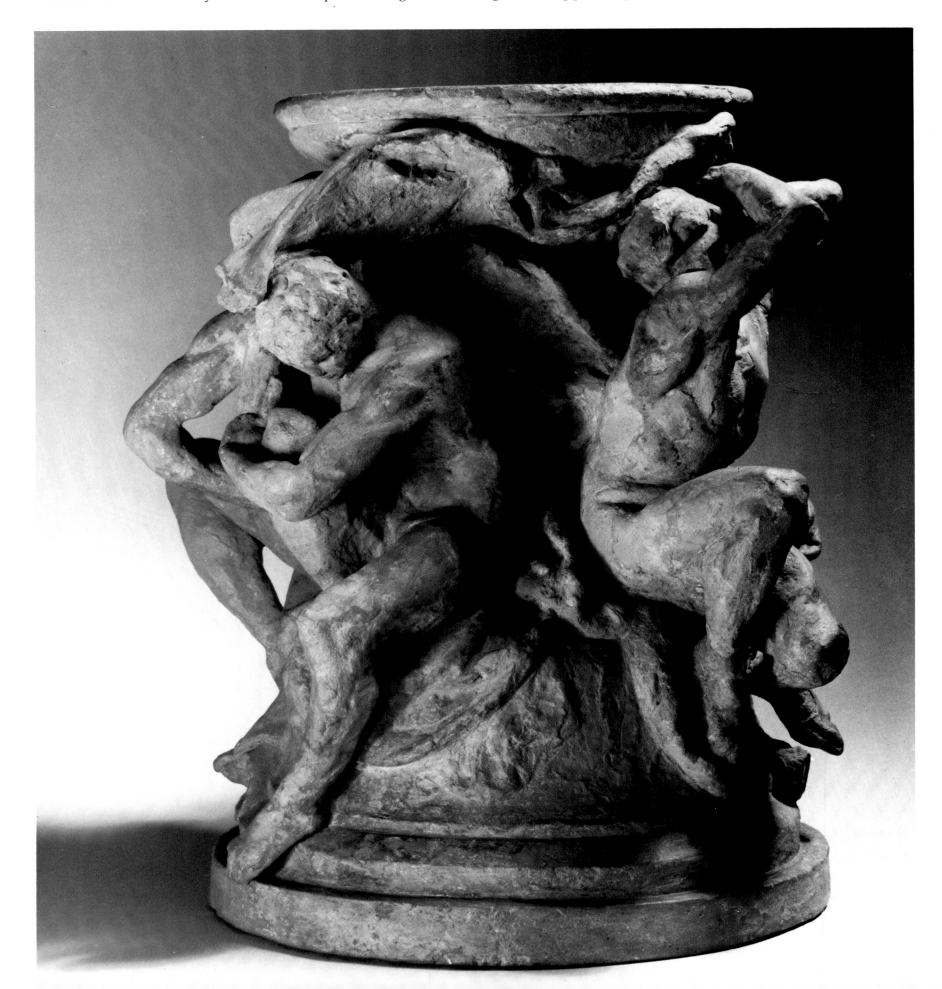

plinth.[19] The bases themselves vary somewhat as in the glazed earthenware stand in the Bethnal Green Museum which has a rolled tier between the steps of the plinth. The positioning of the *Titans* also differs slightly on each.

Two sets of *jardinières*, described as *Les Titans*, were in an exclusive Carrier-Belleuse sale under the heading—*Terre cuites patinées, groupes* in 1884.[20] Two others were included in Carrier-Belleuse's posthumous sale in 1887.[21] They may be a repeat of the listing in 1884, or they may be others which were still in Carrier-Belleuse's atelier at his death. The listings

in the 1887 sale were under the major heading *Terre Cuite*, subheading *Groupe*, sub-subheading *Patiné*. They were given as *Les Titans* (*Jardinières*) with a height of 80 cm., more than twice the size of the known stands.

Patiné may have referred to the glazed vases only, while the stands and bases were possibly of other material, as indicated for Carrier-Belleuse's drawing in his 1884 publication.[22] The stands in the Maryhill and Rodin Museums, and in the Sackler collection, may therefore have been the terra-cotta stands for glazed vases. Conceivably, the lead-glazed Bethnal

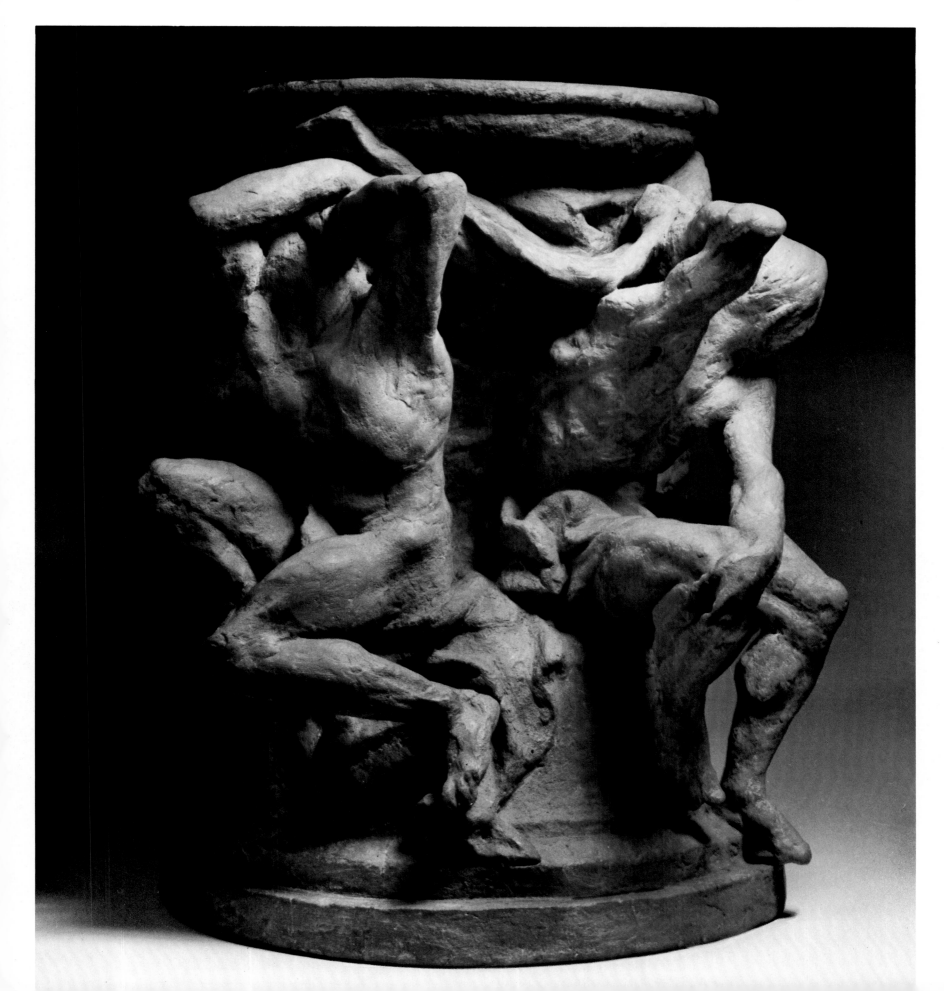

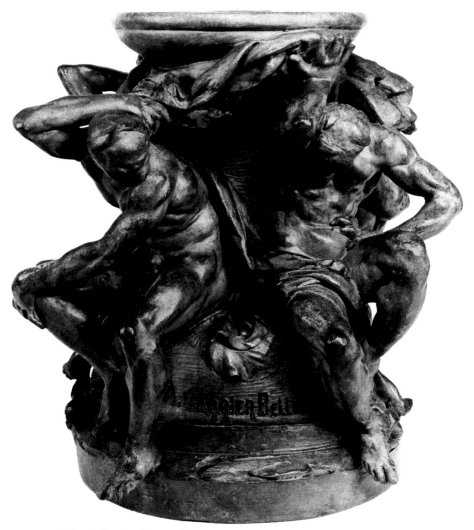

Fig. 4. Rodin, *Vasque des Titans*, terra-cotta, Rodin Museum, Paris.

Fig. 5. Quellinus, model for a water pump, terra-cotta, 1651, Rijksmuseum, Amsterdam.

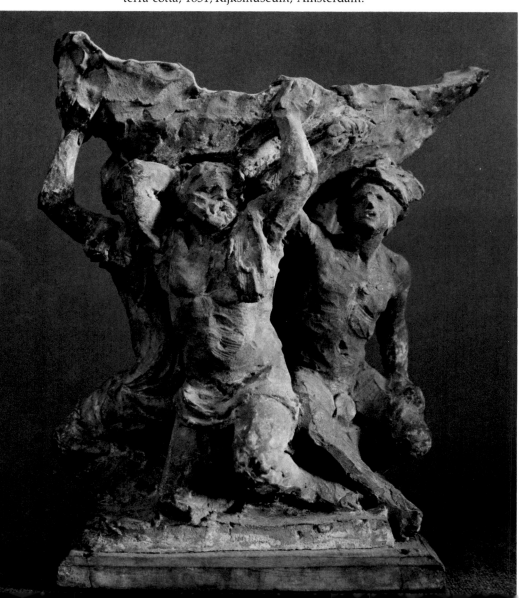

Green Museum stand may be the fourth one of the groups listed in the 1884 and 1887 sales, but the only one to have been glazed (possibly at some later date).

It is interesting to note a similar design (fig. 5) by the Belgian sculptor Artus Quellinus in 1651 for a water pump for the South Court of the Amsterdam Town Hall then being constructed.[23] Having come from Antwerp to work on the sculptures for the Town Hall, Quellinus designed two terra-cotta models for water pumps which were meant to stand in the center of each of two courtyards. The terra-cotta model for the South Court has the form of a ship borne on the shoulders of four allegorical figures: Minerva, Hercules, Mercury, and Jupiter or Poseidon. Although the pump itself was never made, the model for it is presently in the Rijks-museum, Amsterdam.[24] This terra-cotta model has a strong affinity to the *Vasque des Titans* in the modelling of the forms, their moving poses and the connecting draperies from figure to figure. Quellinus had spent some years in Italy, returning from Rome to Antwerp in 1639, and, like many other artists of his time working in Northern Europe, was strongly influenced by the Italian Renaissance and the works of Michelangelo. There is no indication that Rodin or Carrier-Belleuse were ever in Amsterdam, or that they actually saw Quellinus' terra-cotta model, but undoubtedly they were familiar with his works in Belgium.

1. The most pertinent information appears in the following: A. Alhadeff, "Michelangelo and The Early Rodin," *The Art Bulletin*, vol. XLV, no. 4, Dec. 1963, pp. 363–367, Alhadeff and figures 1–12; H.W. Janson, "Rodin and Carrier-Belleuse: The *Vase des Titans*," *The Art Bulletin*, vol. L, no. 3, Sept. 1968, pp. 278–280 and figures 1–28; C. Avery, "From David d'Angers to Rodin: Britain's National Collection of French Nineteenth-Century Sculpture," *The Connoisseur*, vol. 179, no. 722, April, 1972, pp. 230–239; J. Hawkins, *Rodin Sculptures*, Victoria and Albert Museum, London, 1975; J. Hargrove, "Sculptures et dessins d'Albert Carrier-Belleuse au Musée des Beaux-Arts de Calais," *La Revue du Louvre*, 1976, pp. 411–424 and *The Life and Work of Albert Carrier-Belleuse*, London and New York, 1977, figs. 227 and 228, pp. 246 and 272–273; J. Tancock, *The Sculpture of Auguste Rodin*, The Collection of the Rodin Museum, Philadelphia Museum of Art, 1976, pp. 238-240.
2. Avery, *op. cit.*, p. 239.
3. Tancock, *op. cit.*, p. 65 and A. Elsen, *Rodin*, Museum of Modern Art, New York, 1963, p. 16.
4. Alhadeff, *op. cit.*, p. 36; J. Hawkins, *op. cit.*, p. 32.
5. Paris, 1884, fig. 173.
6. For example, Avery, *op. cit.*, dates the Bethnal Green Museum vase ca. 1875; I. Jianou and C. Goldscheider, *Rodin*, Paris, 1967, p. 93, assigns two of the *Titans* to the year 1887.
7. Documents in the Israel Museum, Jerusalem, cited by M. Weyl, "Four Bronze Casts of *The Titans* by Auguste Rodin," *The Israel Museum News*, no. 12, Jerusalem, 1977, p. 128. One of these, dated 1943, although the hand-writing is difficult to read, refers to "des terres du Maitre Rodin quatre figures...pour...les cariatides..."
8. Also illustrated in Janson, *op. cit.*, figs. 7, 9, 10, 11, 16, 17, 20. Janson uses a numbering system for the Titans with *Titan I* to the viewer's left of the signature, *Titan II* to the viewer's right of the signature, *Titan III* counterclockwise from *Titan II* and *Titan IV* counterclockwise from *Titan III*.
9. *Ibid.*, p. 278, footnote 9; and Tancock, *op. cit.*, p. 240.
10. Janson, *op. cit.*, figs. 8, 14, 18, 19, 25.
11. Hume Cronyn and Jessica Tandy collection, Parke Bernet Gallery, New York, Jan. 15, 1958, lots 41 and 42.
12. Robert Lee Blaffer Memorial collection, accession nos. 58-20a, 58-20b; illus. in Janson, *op. cit.*, figs. 13, 15, 23, 24.
13. June 28, 1967, lots 17 and 18, although the catalogue illustrates the Houston figures, not those being sold; the ones sold at Sotheby's are illustrated in Janson, *op. cit.*, figs. 12, 21.
14. *Ibid.*, p. 278.
15. Weyl, *op. cit.*, p. 128, footnote 1, and documents in the Department of Sculpture, the Israel Museum.
16. The Maryhill Museum of Fine Arts, Washington, illustrated in Janson, *op. cit.*, figures 1 and 2, and in Peter Fusco and H. W. Janson, eds., *The Romantics to Rodin* (exhibition catalogue), Los Angeles County Museum, California, 1980, no. 194, pp. 333-334; the Rodin Museum vase was illustrated in Weyl, *op. cit.*, fig. 7, p. 125, but incorrectly labeled as being from the Maryhill Museum. The photograph here was provided by Dr. Weyl.
The Rodin Museum vase is also illustrated in Hargrove, *op. cit.*, 1976, fig. 18 as well as in the exhibition catalogue, *Rodin, ses collaborateurs et ses amis*, Rodin Museum, Paris, 1957, no. 6. Hargrove, *op. cit.*, 1976, p. 424, footnote 32, indicates that the Rodin Museum vase came from Roland Levy who described to her in a letter of May 31, 1974 that the *Vase des Titans* was in three pieces: the four *Titans* placed on a fluted socle of black wood and surmounted by a vase also in terra-cotta.
17. Avery, *op. cit.*, and Hawkins, *op. cit.*, p. 32, describe the piece as lead-glazed earthenware although Tancock, *op. cit.*, lists it as porcelain. Ruth Butler in her entry for the Los Angeles exhibition catalogue, *op. cit.*, describes the stand in the Bethnal Green Museum as porcelain, following Tancock's description, and therefore ascribes it to the period of 1879-82 when Rodin was working under the general supervision of Carrier-Belleuse at Sèvres. The Bethnal Green Museum stand however is *not* porcelain but *earthenware* covered with a lead glaze and would not have been produced at Sèvres even if Judith Cladell (*Rodin: sa vie glorieuse, sa vie inconnue*, Paris, 1936 [definitive ed. 1950], p. 238) claimed that Rodin worked at Sèvres on a *surtout de table* (centerpiece for a table) ornamented with figures.
18. Janson, *op. cit.*, p. 278 and figs. 3, 4, 5 and 6 and Sotheby's, London, July 7, 1971, lot 4.
19. One with "A " behind *Titan I* in the Rodin Museum; one with the signature lower on the base in the Maryhill Museum; one with the signature on the step of the plinth in the Bethnal Green Museum, London.
20. Hôtel Drouot, Paris, sale of December 22, 1884, no. 19 and 22 cited in Hargrove, *op. cit.*, 1976, p. 422.
21. Hôtel Drouot, Paris, sale of December 19–23, 1887, with an introduction by Paul Mantz, no. 69 and 70, p. 24. Janson, *op. cit.*, footnote 13, indicates these were *terre cuite* although the auction catalogue lists them under *terres cuites, Patinés*.
22. See footnote 5 above.
23. K. Fremantle, *The Baroque Town Hall of Amsterdam*, Utrecht, 1959, p. 40, and footnote 2, and p. 173, illus. 189.
24. J. Leeuwenberg and W. Halsema-Kubes, *Beeldhouwkunst in het Rijksmuseum*, Amsterdam, 1973, cat. 282, pp. 220–221.

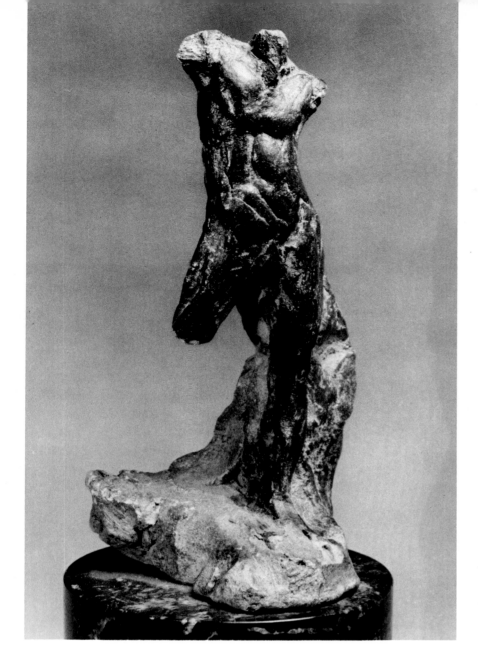

Attributed to AUGUSTE RODIN

100. *Torso Standing on One Leg*

Grey terra-cotta, ca. 1900.
H. 5⅜ in. (13.7 cm.) W. 3 in. (7.6 cm.) D. 1⅞ in. (4.8 cm.)
Condition: right leg missing; possible repair across left foot extending to base and to crack across knee where torso may have separated from base.
Accession no. 77.5.78

THIS EXPRESSIVE little torso has been attributed to Rodin on the basis of its resemblance to a very similar terra-cotta study in the Rodin Museum at Meudon.[1] The essential attitude of both figures is the same, but in the Meudon terra-cotta it is the left leg that is broken off at the thigh, while the right leg is broken off at the knee, and there is no supporting mass.

Rodin has a good claim to be considered the first sculptor deliberately to have created a torso as an independent and finished work of art.[2] He progressed from the incorporation of the *Belvedere Torso* as an ornamental element into the crest of one of the wall posts of the Académie des Sciences et des Beaux-Arts in Brussels (ca. 1873)—in emulation of one of the pediments of the Louvre carved about 1855[3]—to the formation of autonomous torsos illustrated and exhibited (notably in 1900) in their own right. J. A. Schmoll

maintained that Rodin arrived at his torsos by a process of amputation, in a series of works produced from 1896-97 onwards, beginning with the *Voix Intérieure*.[4] But Albert Elsen appears to have demonstrated that Rodin—inspired by Michelangelo's *non finito* ("uncompleted") works during his visit to Italy in 1875—had already made a torso for its own sake. Later cast in bronze by the artist, and illustrated in the February 1888 issue of *L'Art Français*, it is now in the Musée du Petit Palais. Nonetheless, Schmoll seems right in maintaining, in contradistinction to Herbert von Einem,[5] that not only should Rodin's torsos not be seen as the sculptural equivalent of sketches, but that there is also a clear difference of intention between Michelangelo and Rodin; that whereas the former was afraid of falsifying his original Platonic idea by particularity, the latter sought expressive and symbolic ends in shaping the amputated or deliberately incomplete human body.

According to Ambroise Vollard, Rodin replied to a critic of his headless *Walking Man* (ca. 1900), "Does one really need a head to walk with?" This could be taken as relating to the torsos that Rodin created by the amputation of essentials. Vollard also records Rodin producing torsos by laying about unsuccessful enlargements with a sword.[6]

While the creation of the armless *Voix Intérieure* (ca. 1896/7), from the figure of *Méditation* on the Victor Hugo monument, exemplifies the process of subtraction for symbolic ends, his pure torsos, on the other hand, reflect a belief in the expressive power of the limbless and headless human body. This belief was best expressed by the remark recorded by Paul Gsell, *à propos* the torso known as the *Periboëtos* in the Louvre: "This young headless torso seems to smile at the light and the Spring better than eyes and lips could do."[7] This must surely have helped to inspire the sonnet "Archäischer Torso Apollos" by Rilke.

It was only in the latter part of the 19th century that classical torsos came to be seen as having expressive qualities in their own right, and attempts to "complete" them seen as misguided. Rodin himself possessed a collection of classical torsos[8] and, in the case of the present *maquette*, he would appear to have taken such a torso, probably that of the Praxitelean *Farnese Eros* in the Louvre, which had been discovered only in 1862, as his starting point. He then added to it, most likely, as in his new creations, out of the reconstituted *disjecta membra* of his own sculptures, a leg and the mass from which it emerges. In this latter element—and illogically for a sculptor who did not release a figure from the stone by *carving*, but rather built up a figure by *modelling*—Rodin appears to have been emulating the *Slaves* of his revered Michelangelo.

1. R. Descharnes and J.-F. Chabrun, *Auguste Rodin*, London, 1967, figure on pp. 242-43, third torso from the right.
2. J. A. Schmoll gen. Eisenwerth, *Der Torso als Symbol und Form*, Baden-Baden, 1954, and "Zur Genesis des Torso-Motivs und zur Deutung des Fragmentärischen Stils bei Rodin," in *Das Unvollendete als Künstlerische Form*, Berne and Munich, 1959, pp. 117-139; and Albert E. Elsen, "Rodin and the Partial Figure," in *The Partial Figure in Modern Sculpture* (exhibition catalogue), Baltimore Museum of Art, 1969, pp. 16-28.
3. Schmoll, *Das Unvollendete*, figs. 47-53.
4. Schmoll, *Der Torso*, pp. 56-65.
5. Herbert von Einem, "Der Torso als Thema der bildenden Kunst," in *Zeitschrift für Asthetik und allgemeine Kunstwissenschaft*, XXIX, 1935.
6. A. Vollard, "Une visite de Rodin," *Le Correspondant*, Paris, December 10, 1917, pp. 919-930.
7. "Ce jeune torse sans tête semble sourire à la lumière et au printemps mieux que des yeux et des lèvres ne le pourraient faire." A. Rodin, *L'Art entretiens réunis par Paul Gsell*, Paris, 1911, p. 276.
8. Schmoll, *Der Torso*, fig. 5.

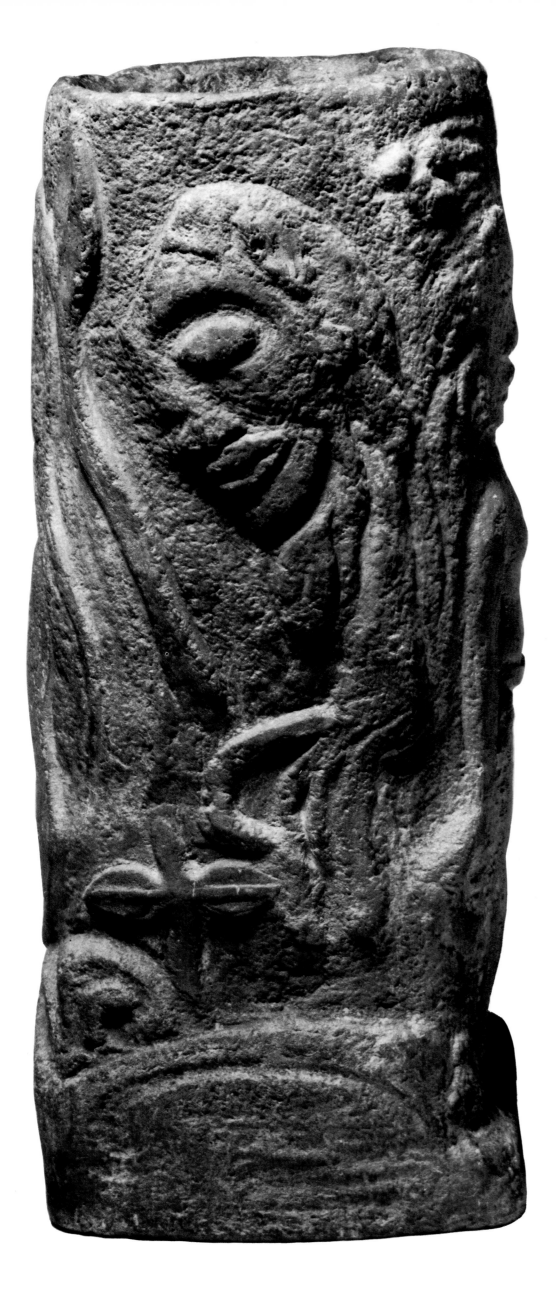

FRENCH, late 19th century

PAUL GAUGUIN
(1848-1903)

Gauguin's career is sufficiently well-known (if only in the fictionalized form of Somerset Maugham's *The Moon and Sixpence*), and his *oeuvre* as a painter well enough established, not to need repeating here. It is only in more recent years, however, that his work as a wood-carver and ceramic artist has come to be studied and appreciated. His beginnings as a sculptor were conventional enough, and go back to his first steps as an artist. He met his future wife through the wife of the sculptor Aubé in 1873, and after their marriage the same year, they became her lodgers. Four years later they became tenants of the academic sculptor Bouillot, under whose guidance Gauguin immediately executed his first sculptures, and the only work he ever did in marble: one of his wife Mette and one of his son Emile.[1]

Thereafter, his preferred medium for sculpture was wood, which was not expensive to procure, and required no elaborate studio or tools for its working. Self-taught, he carved figures in the round and in relief. He even carved furniture, staining and painting his works to achieve the same deliberately "barbaric" effects as in his later paintings. In 1883 he gave up his job as a banker to make his living as an artist, and it was as a result of the struggle to make ends meet that in 1886 he resorted to Aubé's device for augmenting his income, and entered into an agreement to make artistic vases for the potter Ernest Chaplet, who continued to let him use his pottery studio and kilns whenever he was in Paris. Violently hostile to *"l'éternel vase grec,"* Gauguin derived a significant part of his inspiration from pre-Columbian pottery: he turned away from vases smoothly turned on the wheel, to create hybrid forms, half-sculpture and half-jug or pot, which vigorously reflected their creation by the modeller's hand. Once he finally settled in Polynesia, he took the inspiration for the primitive figures of his sculpture from there, translating figures from its mythology into a symbolic language of his own.

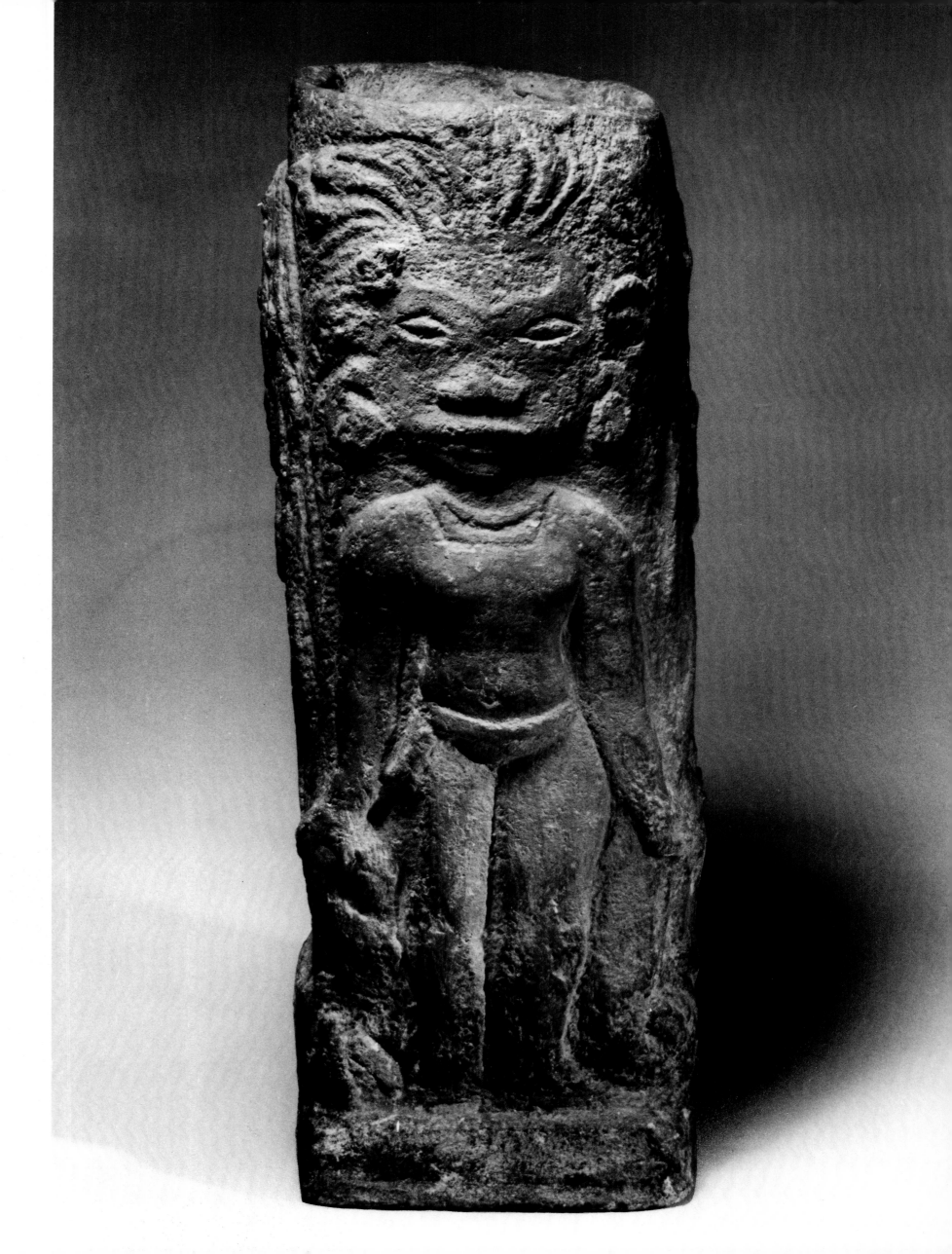

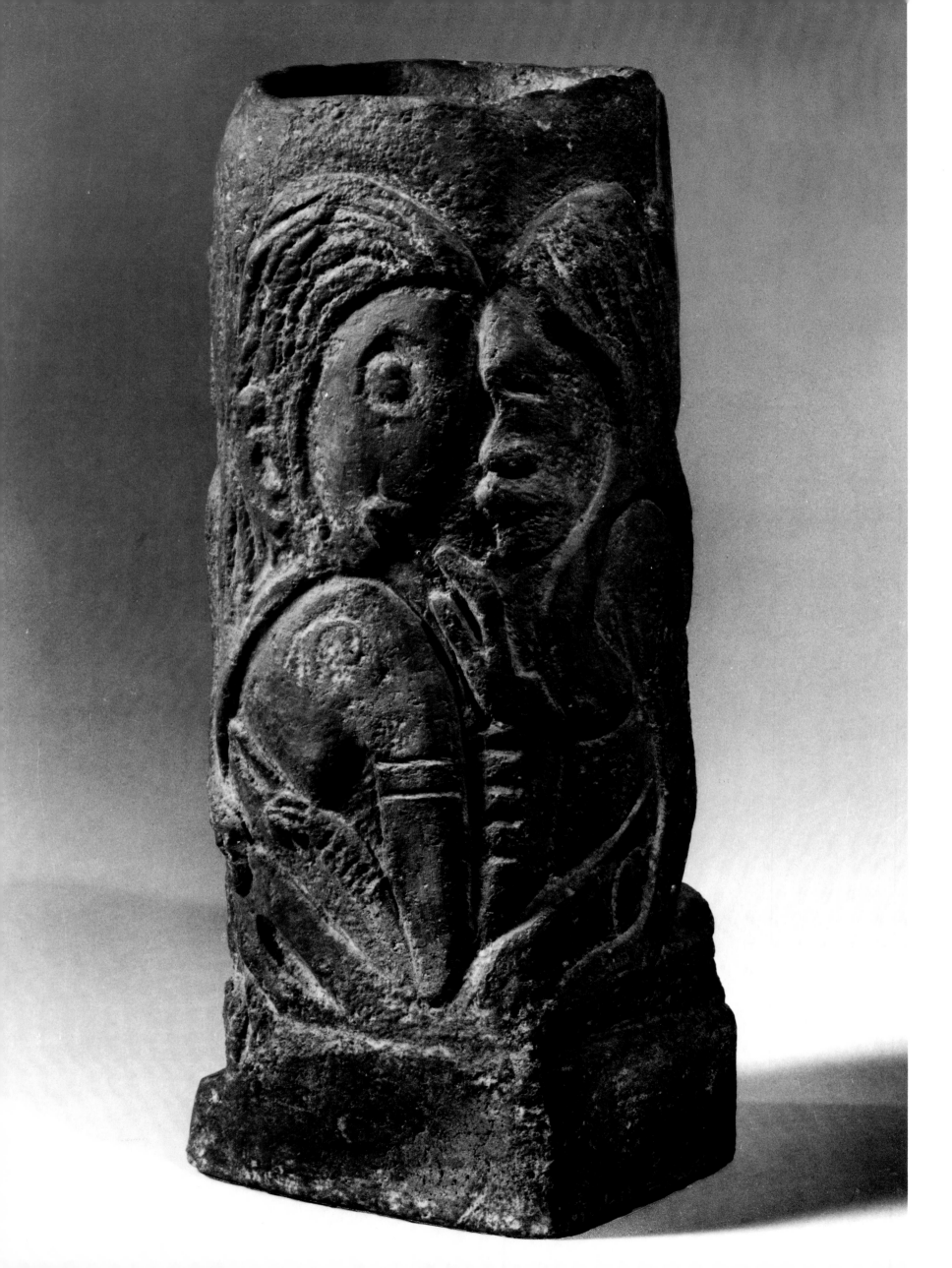

102. *Square Vase Adorned with Tahitian Gods*

Terra-cotta, 1893-95.
H. 13 in. (33 cm.) W. 5¼ in. (13.4 cm.)
Provenance: Ambroise Vollard, Paris; Arnold Haskell, London; Sidney Burney, London; Stephen Hahn, New York.
Exhibited: , Art Institute of Chicago and The Metropolitan Museum of Art, *Gauguin*, Chicago/New York, 1959, no. 123.
Accession no. 72.10.1

THIS VASE is almost unique in Gauguin's ceramic *oeuvre*, in that it exists in three virtually identical versions, suggesting that for the first time Gauguin was using molds to create a, albeit limited, *production de série*. The other two versions are in the Louvre and the Kunstindustrimuseet in Copenhagen.[2]

Although the native figures and the primitive execution might suggest that the vases were executed in Tahiti, the absence of suitable clay made pottery there impossible and they must have been executed on Gauguin's last visit to France, from August 1893 to February 1895. Merete Bodelsen believes that these vases were produced in an ordinary potter's workshop,[3] despite the fact that the most important piece of sculpture that Gauguin produced on this return visit (and indeed in his whole career), the figure called *Oviri*,[4] was made in Ernest Chaplet's pottery.

Each side of the vase is adorned with a figure of one of the Tahitian spirit-deities, such as occur in works in several other media of this period—drawing, watercolor, woodcut, and carved wood. The erect female figure on one side of the vase is *Hina*, the Spirit of the Moon, who appears most frequently of all the members of the Tahitian spirit world in Gauguin's *oeuvre*.[5] In the form that she takes here, she derives from a figure carved by Gauguin on one side of a double-sided relief in Tamanu wood now in the collection of Alden Brooks.[6] The two seated figures are *Hina* talking to *Te Fatou* (the Spirit of the Earth), and similarly derive from two figures on a wooden cylinder in the collection of Mme. Huc de Monfried.[7] The fourth figure, which

Bodelsen tentatively identifies with *Ta'aroa*, the spirit made manifest in matter, or *Hina*, derives more loosely from one of the two figures on the other side of the cylinder. In front of *Ta'aroa* here, there appears the same germinating plant seen on the cylinder. This may represent the first plant given life by *Ta'aroa* and *Hina*.

Although all three vases appear to have been cast from the same molds, there are minor differences in detail and surface treatment between them. The Copenhagen vase is made of a fairly fine-grained light red terra-cotta, with some darkening due to absorbed lead glazes, whereas the Louvre version is made of a coarse greyish cement-like material with traces of paint. The Copenhagen version shows evidence of a considerable amount of hand-finishing on the interior, whereas the Paris version is quite rectangular—probably a result of its having been molded around a block of wood. The present version is closer to the Louvre vase, except that it too shows signs of hand work on the interior and has a bottom.

1. Now in Courtauld Institute, London and The Metropolitan Museum of Art, New York, respectively.
2. M. Bodelsen, *Gauguin Ceramics in Danish Collections*, Copenhagen, 1960, no. 11, pp. 30-32 & figs. 15, 20 & 23; C. Gray, *Sculpture and Ceramics of Paul Gauguin*, Baltimore, 1963, no. 115, pp. 64 & 249-251 in which one view of the Sackler vase is illustrated (see p. 249a); Bodelsen, *Gauguin's Ceramics*, London & Copenhagen, 1964, pp. 143-146 and 235, and figs. 98 and 104.
3. Bodelsen, *op. cit.*, 1960, p. 18 and 1964, p. 143.
4. Jacques Ulmann collection, Paris.
5. Hina was the deity of the Tahitian pantheon that made the greatest impression on Gauguin. An ancient Polynesian myth retold by Gauguin in his *Ancien Culte Mahorie* (Paris, 1951, p. 13) describes a dialogue between Hina, the Spirit of the Moon, and Te Fatou, the Spirit of the Earth. Hina had begged Fatou to grant man life after death, but had been refused. "Hina replied, 'Do as you like, but I shall call the moon to be reborn.' And all that Hina possessed continued to exist, that which Fatou possessed perished, and man had to die." A drawing showing the two gods seated facing each other was used to illustrate this myth in Gauguin's manuscript and was apparently his first thought for the treatment of the theme seen here and which also appears in other media.
6. Gray, *op. cit.*, no. 97, p. 223.
7. *Ibid.*, no. 96, p. 222.

237

ARISTIDE MAILLOL
(1861-1944)

Born of modest origins in the Pyrenees, after a
hard childhood Maillol was sent by his *département*
to study art at Perpignan. In 1881 he went to Paris
and, in 1883, succeeded in gaining admission to
the Ecole des Beaux-Arts. Although he had begun
by sculpting, he now studied painting, at first
briefly under Gérome, and then under Cabanel.
For a time he shared lodgings with Bourdelle.
After making the acquaintance of Gauguin, Maillol
was inspired by the example of his paintings to
take up a new art and to experiment with recreat-
ing the vivid directness of medieval tapestry in a
modern idiom, opening a tapestry workshop in his
native Banyuls-sur-Mer in 1893. Gauguin's essays
in wood carving, however, convinced Maillol
that his own true vocation was for sculpture,
which he began to exhibit alongside his tapestries
in 1896. Having attracted attention with his terra-
cottas and ceramic cisterns, he found an influen-
tial patron in the diplomat and connoisseur Harry
Kessler. In 1908 he accompanied Kessler and Hugo
von Hofmannsthal on what proved to be a
revelatory voyage to southern Italy and Greece.
From that time on, in his studio at Marly-le Roi,
Maillol concentrated with single-minded determi-
nation upon the one theme of the female nude,
evolving in the process his own canon of ponder-
ous, earthbound, womanly beauty. His *Young
Cyclist,* now in the Musée de l'Art Moderne, Paris,
was one of his rare essays in the male nude. He
also executed a limited number of portrait-busts
(notably that of *Renoir*) and monuments, and was
highly sought after as a draughtsman and illus-
trator. In recognition of Maillol's stature as the
most important French sculptor of the twentieth
century, André Malraux, in 1964, took the novel
step of creating a kind of open-air museum of his
major works in bronze in the Jardins du Carrousel
in front of the Louvre.

102. *Head of a Young Woman*

Terra-cotta, ca. 1900-1914.
H. 5 5/16 in. (13.5 cm.) W. 3 7/8 in. (10 cm.) D. 4 1/4 in. (10. 8 cm.)
Condition: ridged mold lines on hair, face, jaw and neck; part of ear
lobe missing.
Accession no. 76.3.17

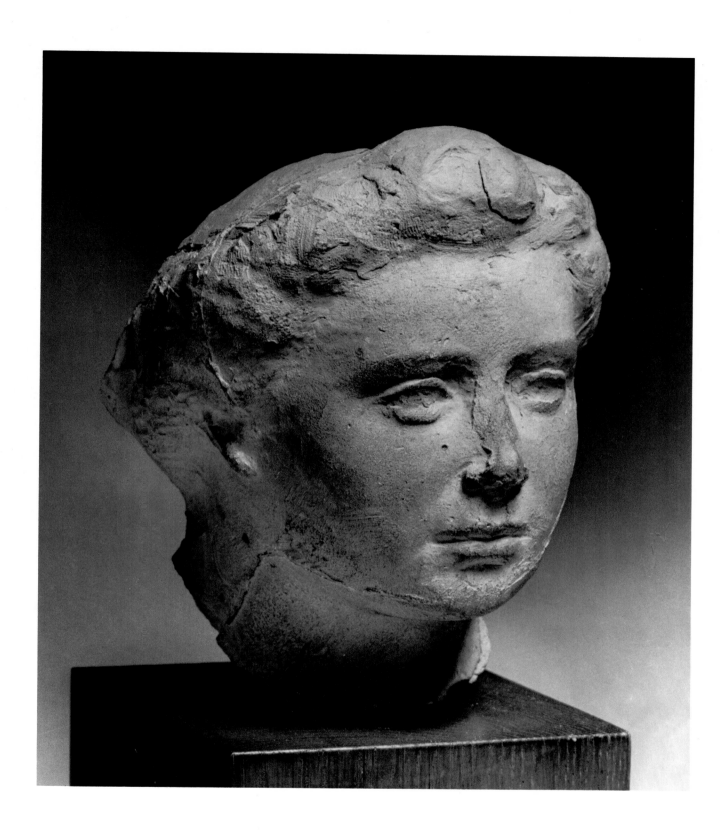

THIS MINIATURE HEAD, although typical, in its
smoothed and boneless features, of Maillol's
sculptures—and exhibiting the characteristic
late nineteenth-century rolled hairstyle to which he
remained faithful throughout his career—is difficult
to date with any precision. Its slightly feline character
is reminiscent of the later nudes painted by Renoir,

whom Maillol sculpted at Cagnes-sur-Mer in 1907, and
the indications are that it dates from before the First
World War.[1] Although Maillol adhered very much to the
same style of the female face and figure throughout his
career, his later faces became heavier and less delicate;
while in his last years they were clearly evocations of
his faithful companion and artistic executor, Dina Vierny.

1. Cf. the heads of Maillol's sculptures from this period in Waldemar George, *Aristide Maillol
 et l'âme de la sculpture*, Neuchâtel, 1977, among the plates on pp. 129-169.

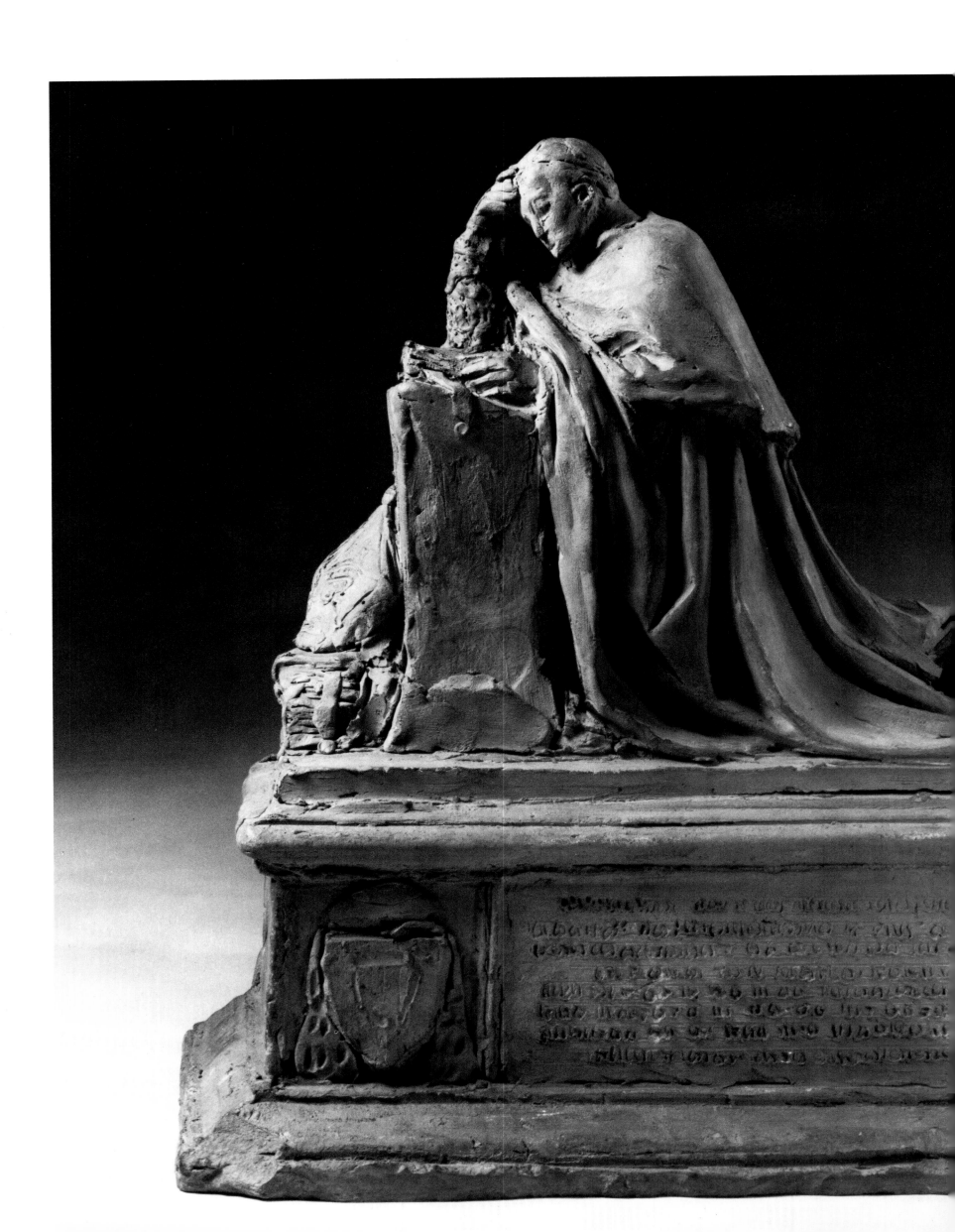

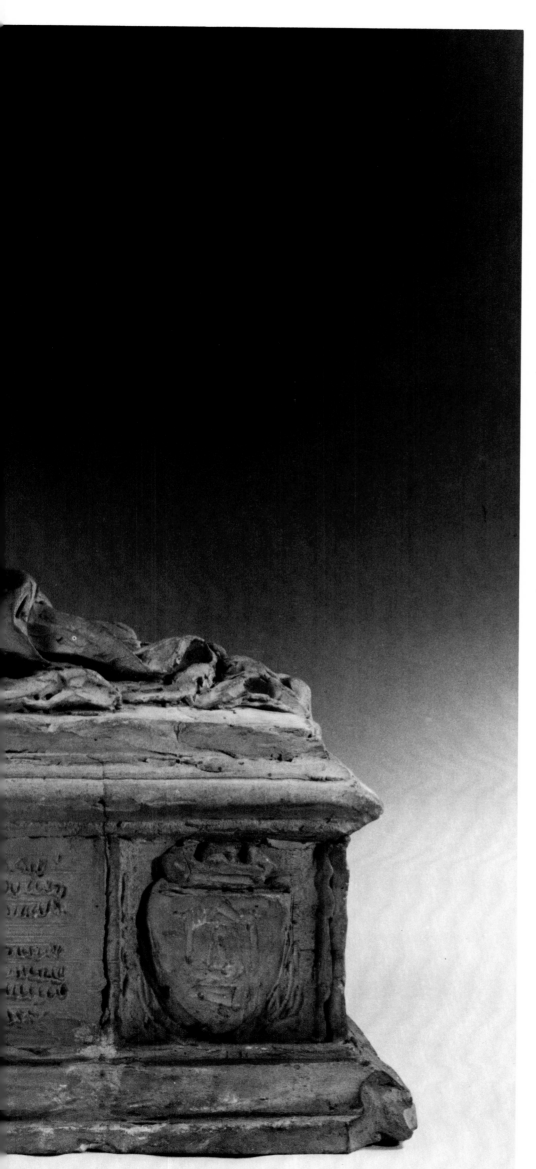

JEAN-MARIE-JOSEPH MAGROU
(1869-1945)

Magrou, born in Béziers, was the pupil of Gabriel-Jules Thomas at the Ecole des Beaux-Arts in Paris, and of his fellow townsman Jean-Antoine Injalbert. He made his debut at the Salon of 1893 with a portrait-bust and medallion, and won a third-class medal at the 1895 Salon with the *Chanson de Silène*. Thereafter, he exhibited regularly at the official Salons until the Second World War in 1939, ultimately becoming a member of the selecting committee for sculpture. Magrou's main specialities were portrait-busts and tomb statues; and after the First World War he made a number of war memorials. In 1911 he received two commissions from Brazil—for a statue of the ex-Emperor Pedro II, erected at Petropolis, and for a bust of the president, Marshal Hermès de Fonseca. At the 1926 Salon, Magrou exhibited elements of his most important works: the figures for the tombs of Cardinal de Cabrières in Montpellier Cathedral, and of Prince Louis d'Orléans in the Orléans family mausoleum at Dreux; he won the gold medal with them.

103. *Maquette for the Tomb of Cardinal de Cabrières*

Terra-cotta, ca. 1925.
Signed: "J. MAGROU"; inscription in red ink under base.
H. 11⅝ in. (29.5 cm.) W. 13¼ in. (33.7 cm.) D. 6 in. (15.2 cm.)
Condition: chipped left and right front corner of base.
Accession no. 77.5.45

THIS IS THE *maquette* for the marble tomb of Cardinal de Cabrières (1830-1921), Bishop of Montpellier and intransigent opponent of the separation of Church and State, erected in his former cathedral (fifth chapel on the right). Magrou exhibited the marble figure of the kneeling cardinal at the 139th Salon, in 1926, in which he won the gold medal for sculpture.[1] Montpellier is in the Hérault, the *département* of Magrou's native Béziers, and the commission for the tomb evidently went to him as the most distinguished traditional sculptor from the region. Two years later, Magrou made a very similar tomb of Monseigneur Bonnet, for his former cathedral of Viviers, with the deceased also shown praying at a *prie-dieu*.

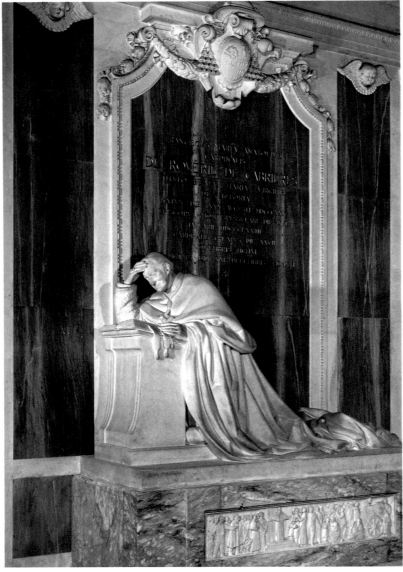

Fig. 1. Magrou, *Tomb of Cardinal de Cabrières,* marble, Montpellier Cathedral.

In making these two tombs, Magrou shows himself to have been perhaps the last exponent of a tradition in funerary sculpture that reached back into the mid-fifteenth century. The idea of carving the deceased upon tombs as if they were still alive and kneeling at their devotions originated in northern Europe, probably in France itself. It was a fusion of the customary medieval mode of depiction showing the *gisant* (recumbent figure), with his hands folded in prayer, and with the relief or painted image of the kneeling figure of a donor or the deceased presented to the Virgin and Child, or presented at some religious event, by his patron saint.[2]

The earliest depiction on an original tomb of unpresented figures kneeling in prayer, found in the collection of drawings of tombs made for Roger de Gaignières, appears to have been on the tomb of Jean Jouvenel des Ursins (†1431) and his wife (†1456) in Nôtre-Dame de Paris, in which husband and wife are both shown praying at *prie-dieus* on their joint tomb, one behind the other.[3] There are various earlier kneeling figures with

their hands clasped in prayer, for example, Arnoul de Puisieux (†1417), and Hémon Raguier (†1420) and his wife,[4] as well as Antoine des Essarts (1442/3) and Agnès Sorel (1450),[5] but none is at a *prie-dieu*, and all but Antoine des Essarts, who kneels on the truncated shaft of a pillar in Nôtre-Dame, are presented by their patron saints.

Tombs with praying figures of the deceased continued to be made in France up until the later 17th century, when they were superseded by more dramatic conceptions of the dead.[6] In the 19th century there was a revival of the kneeling posture for figures of the deceased in both England and France. When first evolved in the 15th century, the posture was used for laymen and women, including the kings and queens of France, beginning with Charles VIII, and only belatedly extended to the clergy. In the revival, possibly under the influence of Canova's kneeling figure on the tomb of Pope Clement XIII (1787-92) in St. Peter's, it seems primarily to have been reserved for bishops, and only secondarily (because of their supposed natural piety) for women.[7] In France, the use of such a pose for prelates was doubtless reinforced by such 17th-century monuments as Coysevox's tomb of Cardinal Mazarin.

It is noteworthy that, while Magrou's tombs of both Cardinal de Cabrières and Bishop Bonnet incorporated *priants* (praying figures), his tomb of Prince Louis d'Orléans, executed in the same year as the former (1926), employed the medieval alternative of a *gisant*. When he reverted to the image of the deceased praying at a *prie-dieu* at the very end of this revived tradition, Magrou nonetheless introduced a more intimate note, characteristic of his time, by showing the cardinal as if discovered, not actually with his hands folded in prayer, but supporting his head on one hand while reading his breviary or bible.

1. No. 3504, illustrated in the Salon catalogue on pl. 191; the tomb is illustrated in Augustin Fliche, *Guidebook to Montpellier,* Paris, 1935, p. 35.
2. E. Panofsky, *Tomb Sculpture,* London, 1964, pp. 76-81; Philippe Ariès, *L'homme devant la mort,* Paris, 1977, pp. 246-255.
3. J. Adhémar and G. Dordor, "Les tombeaux de la collection Gaignières à la Bibliothèque Nationale," part II, *Gazette des Beaux-Arts,* sixth series, vol. LXXXVIII, July/August 1976, no. 1160, p. 15.
4. Adhémar and Dordor, "Les tombeaux, etc.," part I, *Gazette des Beaux-Arts,* sixth series, vol. LXXXIV, July/September, 1974, no. 1046, p. 186 and no. 1064, p. 189.
5. Adhémar and Dordor, part II, *op. cit.,* nos. 1128, p. 10 and 1149, p. 13.
6. F. Ingersoll-Smouse, *La sculpture funéraire en France au XVIIIe siècle,* Paris, 1921, pp. 11 and 20.
7. N. Penny, *Church Monuments in Romantic England,* New Haven and London, 1977, pp. 66-80.

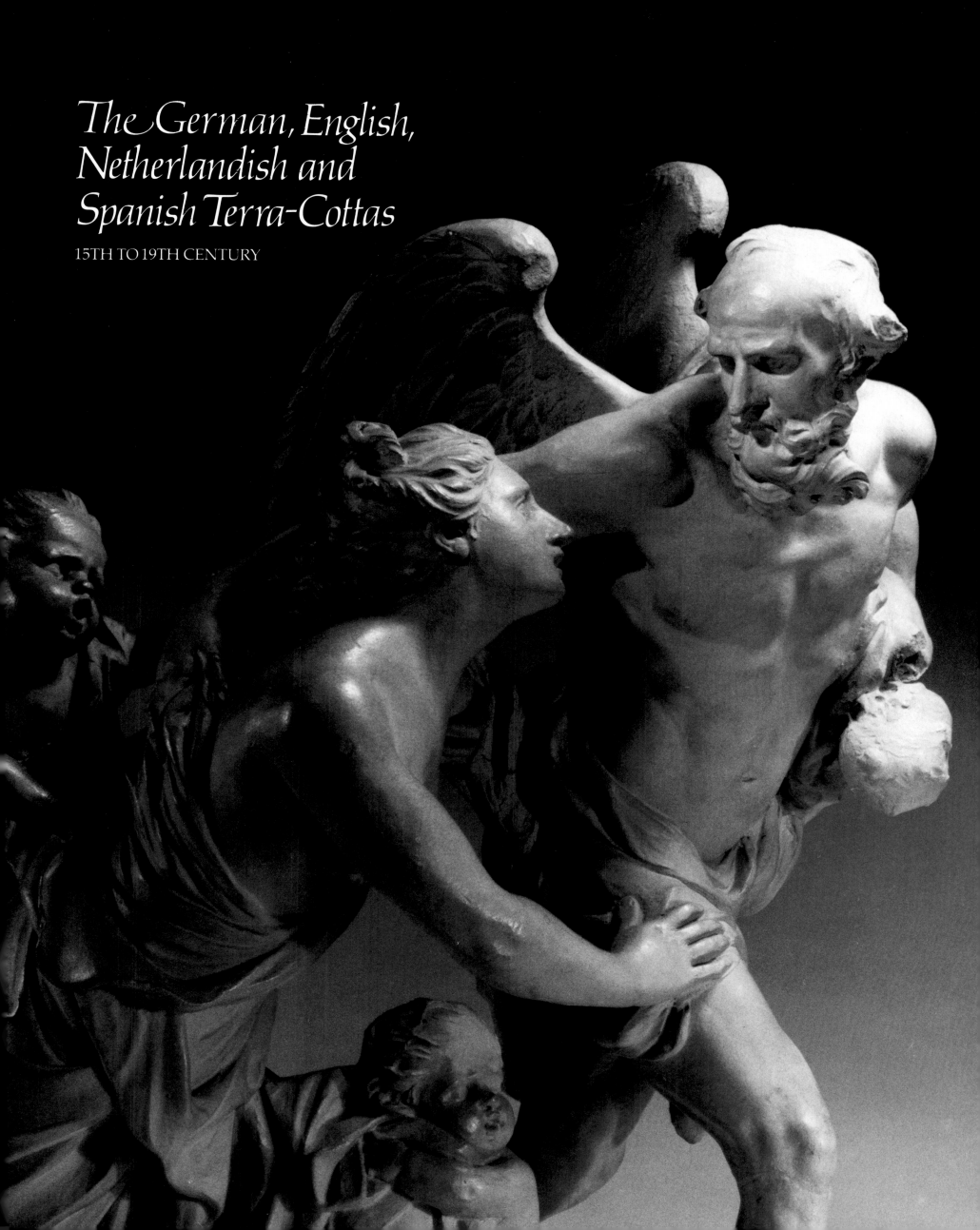

The German, English, Netherlandish and Spanish Terra-Cottas

15TH TO 19TH CENTURY

SOUTH GERMAN, late 15th century

ANONYMOUS

104. *Christ Kneeling*

Polychrome terra-cotta, late 15th century.
H. 40 in. (101.6 cm.) W. 26¼ in. (66.6 cm.) D. 12 in. (30.5 cm.)
Condition: hands missing; figure's left sleeve broken on inner sides;
paint chipped and flaking throughout; former repairs throughout.
Accession no. 77.5.10

THIS STATUE presumably formed part of a tableau showing the *Agony in the Garden*. Its style is unmistakably South German but the medium is unusual, for limewood was the preferred material at the time for large-scale religious sculpture. While the massiveness and angularity of the figure are impressive, it lacks aesthetic cohesion and is clearly the work of a minor sculptor in a provincial centre.

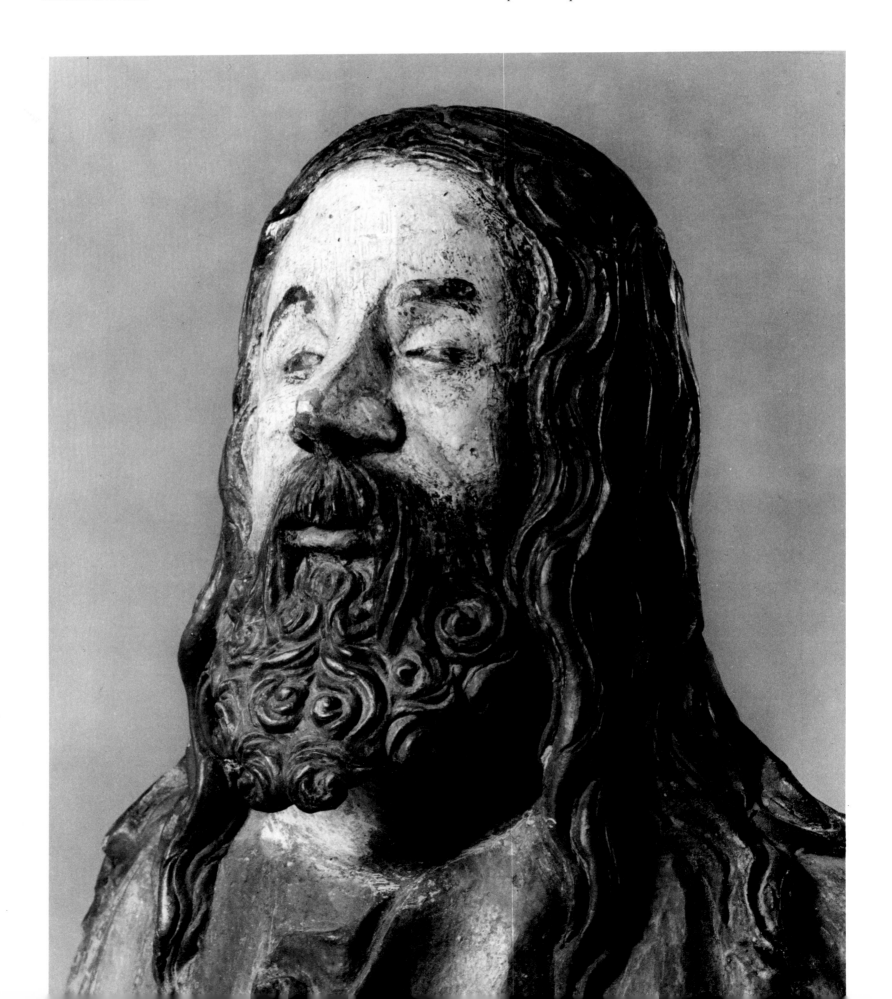

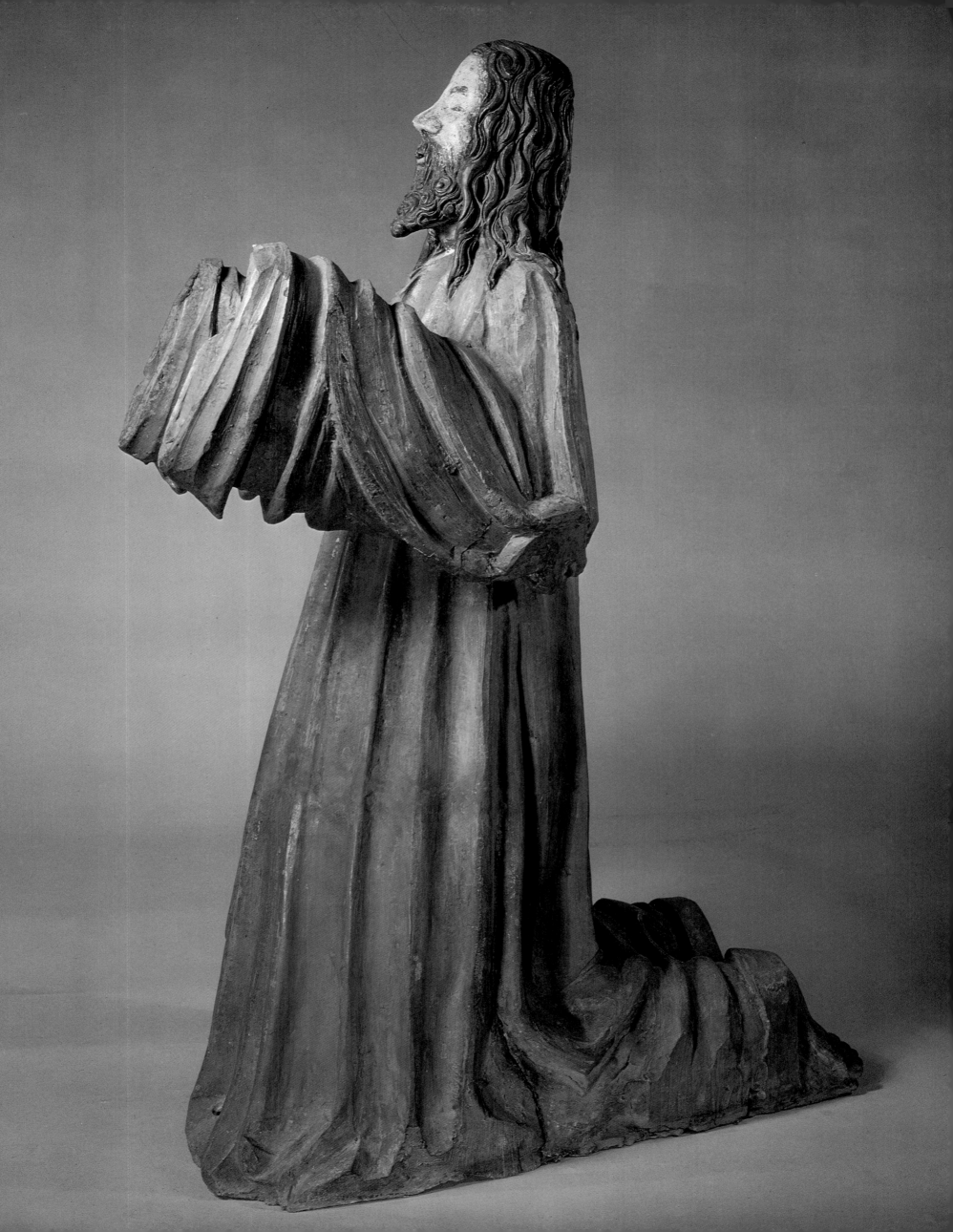

FLEMISH, early 17th century

FRANÇOIS DIEUSSART
(ca. 1600-1661)

Born in Arquinghem near Armentières (French Hennegau), at a date which can be calculated as around 1600, Dieussart was proud of his French-speaking origins, often calling himself "Vallone" ("Walloon") in Italian documents, instead of using his surname. First recorded at Rome when he was entered in the statute books of the Flemish brotherhood there in 1622, he rose to prominence in the expatriate colony during that decade and may have remained there until 1636. He was probably familiar with his fellow-countryman François Duquesnoy (see cat. no. 19) and is documented as having worked especially for the Barberini family on minor decorative sculptures. In 1636 he went to England in the employ of the Earl of Arundel and is known thereafter from a series of competent, and occasionally inspired, portrait-busts of crowned or noble heads resident in capitals of northern Europe.*

A number of figure-sculptures and decorative projects are recorded, but only one has so far been identified: a small marble *Pietà*, dated 1660, in the Convent of the Byloke in Ghent (fig. 1).[1] In any case it is clearly as a portraitist that Dieussart deserves a position in the history of European sculpture.[2]

*Included among these are: King Charles I and (?) Queen Henrietta Maria; Prince Rupert of the Rhine and his brother Charles Louis of the Palatinate; the "Winter" King and Queen of Bohemia; King Christian IV of Denmark; Prince Frederick Hendrick and other members of the House of Orange; Friedrich Wilhelm, the "Great" Elector of Brandenburg; Leopold Wilhelm, the Hapsburg Regent of the Netherlands; and King Charles II of England, when Prince of Wales and in exile.

105. *Holy Family with St. John the Baptist*

Terra-cotta, gilded, in an 18th-century ormulu frame, 1634.
Signed: François Flamand
H. 15 in. (38.0 cm.) W. 12¼ in. (31.0 cm.) D. 2⅝ in. (6.8 cm.)
Condition: excellent on surface of oval field, outer flange chipped.
Exhibited: Heim Gallery (London), *Forty Paintings and Sculptures from the Gallery's Collection,* Autumn 1966, no. 38 (as Duquesnoy).
Accession no. 79.1.23

Fig. 2. Detail, *François flamand,* artist's signature.

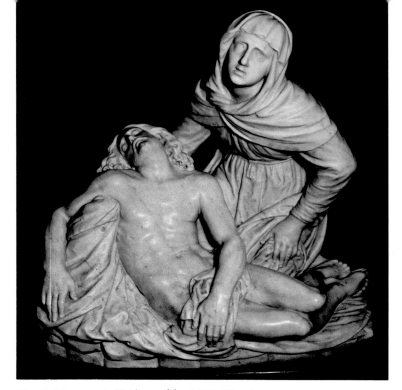

Fig. 1. Dieussart, *Pietà*, marble, 1660, Ghent.

THE GENERAL STYLE of the relief, coupled with the date 1634 inscribed on the block on which the Virgin rests her right foot, suggested the attribution to François Duquesnoy which is engraved on the brass back-plate of the frame. However, the style is not fluent enough either in handling of the drapery or in the modelling of the two children to be associated with the great Duquesnoy directly. Removal from the later frame and cleaning have now revealed at the lower periphery of the oval field a clear signature "François flamand" (fig. 2). The author must therefore be a French-speaking Fleming with the Christian name François and with a good knowledge of the Roman Baroque style of sculpture, particularly that of Duquesnoy.

François Dieussart is the most likely candidate, but the attribution is at present hard to verify on stylistic grounds, owing to the paucity of comparable figurative sculpture. Comparison with his much later *Pietà* of 1660 (fig. 1), is inconclusive. The style of drapery and the facial types of his marble portrait-busts, all of which are later, are not inconsistent with those in the present relief. Furthermore, one of the few specific subjects of marble sculpture recorded during Dieussart's Roman period by J. Sandrart in 1675 was *The Infant St. John kneeling before Christ and receiving the Cross* —a symbolic representation of the passion.[3] While such a subject is not uncommon in painting, at least with the Virgin Mary also present at the meeting of the infant cousins, it is rare in sculpture. The concentration on infants is also reminiscent of Duquesnoy, whose specialty they were, and it may be significant that the basic subject of the present relief is St. John holding a lamb (the symbolic Lamb of God) up to the Baby Jesus, while St. John's cross, with its ribbon usually inscribed *Ecce Agnus Dei* ("Behold the Lamb of God") lies on the ground in front. The language employed in the signature suggests that the relief was made for a Frenchman, as one would have expected Dieussart's more customary "Francesco Vallone," had the piece been destined for a Roman patron. It is matter for speculation whether any confusion with François Duquesnoy, who was normally called in Italy "Francesco Fiammingo," was intended.

1. Musée de l'Art Ancien, Brussels, *La sculpture au siècle de Rubens* (exhibition catalogue), 1977, no. 36.
2. C. Avery, "François Dieussart, Portrait Sculptor to the Courts of Northern Europe," *Victoria and Albert Museum Yearbook,* 4, 1974, pp. 63-99.
3. "*Wie das Kind S. Johannes vor Christo kniend das Cruetz empfänget,*" J. Sandrart, from a brief biography of François Dieussart in *Teutsche Akademie,* 1675.

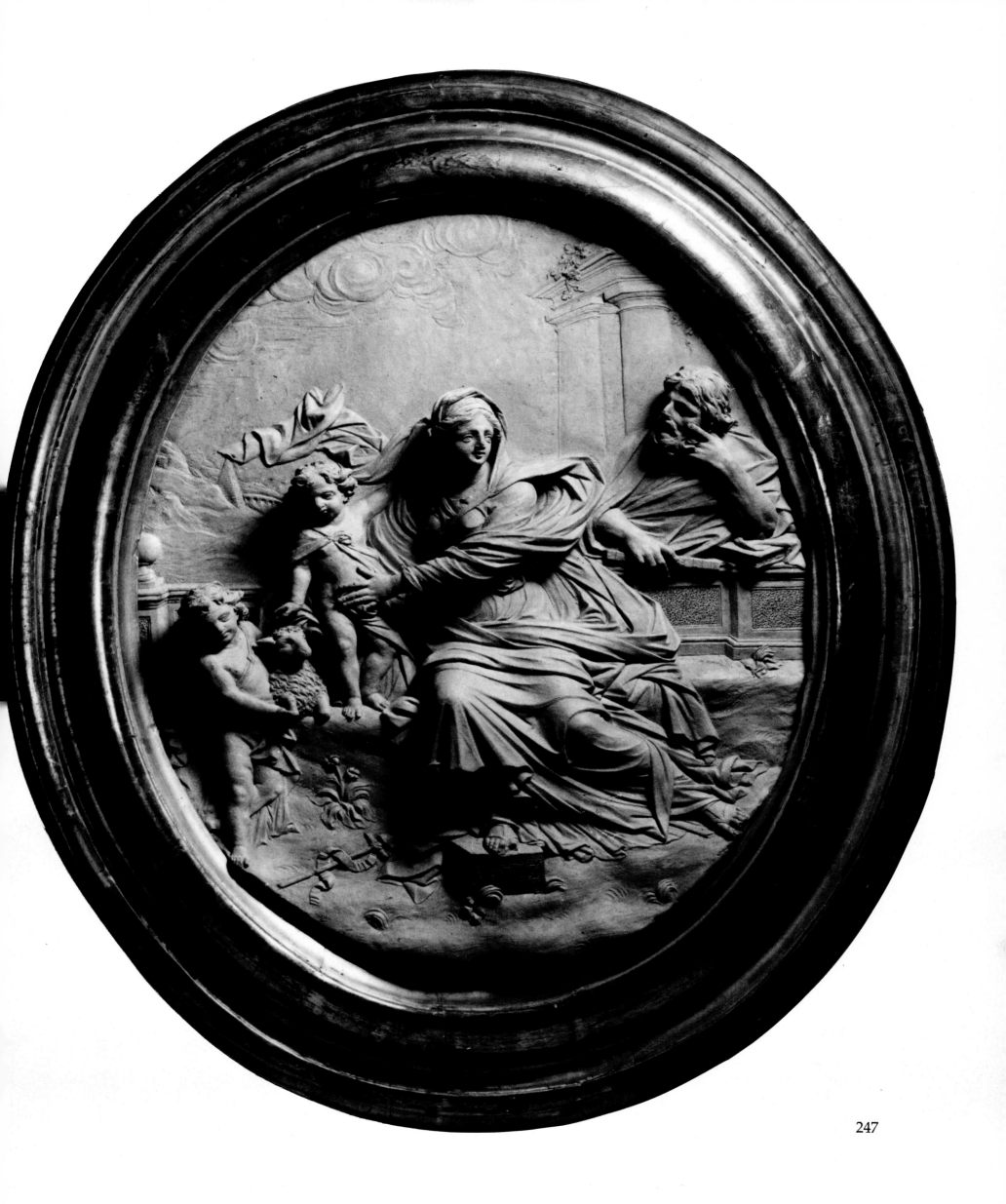

247

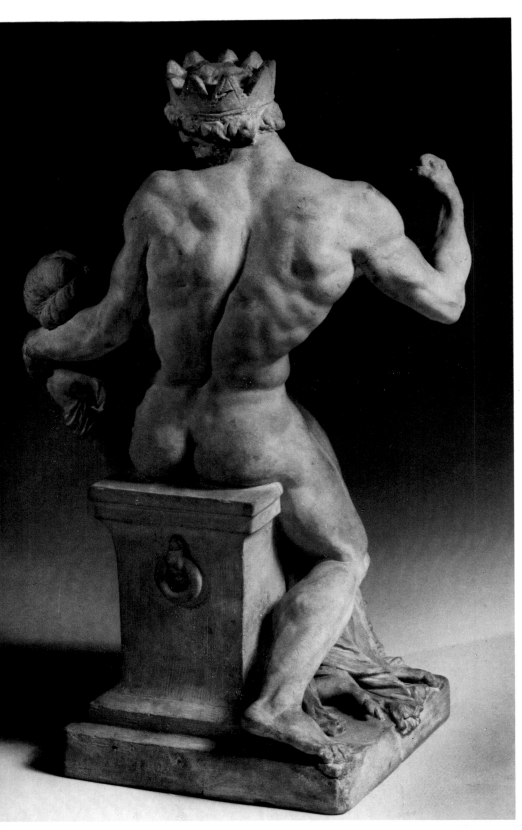

NETHERLANDISH, 17th century

Circle of
ARTUS QUELLINUS THE ELDER
(1609-1668)

Trained by his father, a sculptor, in Antwerp, Artus'
first major works were paid for by the Stateholder of
the Northern Netherlands in 1634. He then spent
five years in Rome, probably working with François
Duquesnoy, whose style he adopted, rather than the
more pronounced baroque of Bernini.

By 1639 he was back in Antwerp, where he was
strongly influenced by Rubens, and in 1646 he was
engaged on the projected Town Hall for Amsterdam,
where he stayed from 1650 to 1664. This was his major
commission and he modelled and carved a large
amount of relief sculpture for the interior and exterior,
still the glory of what is now the Royal Palace.

His original models preserved in the Rijksmuseum,
Amsterdam betray a Rubensian amplitude and tactility
in the modelling of naked flesh, while the drapery is
derived via Duquesnoy from late Hellenistic Roman
sculpture. He also carved excellent portrait busts.

106. *Tarquin and Lucretia*

Terra-cotta, ca. 1650.
H. 13⅝ in. (34.6 cm.) W. 5¾ in. (14.6 cm.) D. 6 in. (15.2 cm.)
Condition: right forearm of Lucretia has been restored; Tarquin's
right foot, right hand at wrist and upper arm repaired. Tarquin's
crown and hair are modelled in plaster, either as the result of a
change of design by the artist, or an early repair.
Accession no. 77.5.13

THE CLASSICIZING depiction of the subject and treatment
of drapery, combined with the naturalistic rendering
of nude anatomy—especially in the muscular figure
of Tarquin—suggest that this group originates from the
circle of Artus Quellinus the Elder when he was working
on sculpture for the Amsterdam Town Hall.[1] The sinuous
contrapposto of Lucretia's body and the sharply twisting
movement of her head are to be found frequently among
the terra-cotta sketch-models for the sculpture of the Town
Hall, notably in the model for the pediment at the front
of the building, which shows *Sea-Gods Paying Homage to
Amsterdam.*[2] The carefully rendered architectural pedestal
with a ring on the back is also consistent with a Dutch
origin.

1. K. Fremantle, *The Baroque Town Hall of Amsterdam*, Utrecht, 1959; J. Leeuwenberg and W. Halsema-Kubes,
 Beeldhouwkunst in het Rijksmuseum, Amsterdam, 1973, nos. 273-298.
2. Leeuwenberg and Halsema-Kubes, *op. cit.*, nos. 276a and b.

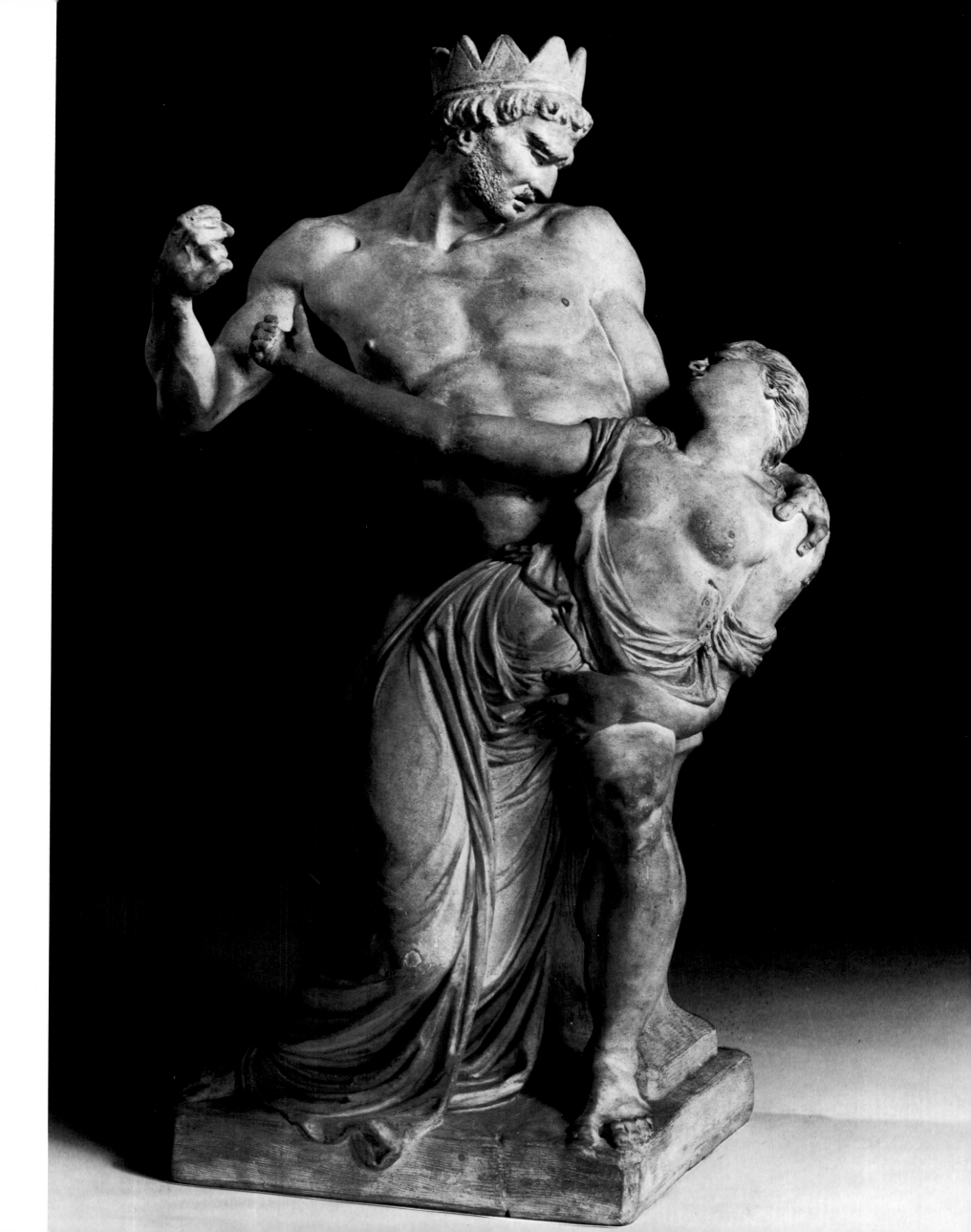

NETHERLANDISH, mid-17th century

ANONYMOUS

107. *Bust of a Man Screaming*

Terra-cotta.
H. 5½ in. (14.0 cm.) W. 4¾ in. (12.1 cm.) D. 3 in. (7.6 cm.)
Condition: excellent.
Accession no. 77.5.6

T HE BUST is clearly not intended to be a portrait, but rather a study of physiognomy in a mature man under great physical or emotional stress. Both the idea and the emaciated type of face portrayed recall on the one hand, prototypes from the Florentine High Renaissance, Pollaiolo, Verrocchio and especially Leonardo da Vinci; and on the other, Bernini's early self-portrait study entitled *Anima Dannata* (*Damned Soul*), Palazzo di Spagna, Rome (fig. 1),[1] which is clearly the source for the dishevelled hair and deeply excavated eyes. Leonardo had based his quasi-scientific studies of physiognomy on the artistic work of his immediate predecessors and embodied some of his findings in his sketches for the great fresco depicting the *Battle of Anghiari* which he painted for the Hall of the Five Hundred in the Palazzo della Signoria, Florence, at the beginning of the 16th century. His warriors shouting in battle found sculptural expression both in his own and his pupil Rustici's terra-cottas (see no. 9), as well as in four similar heads cast in

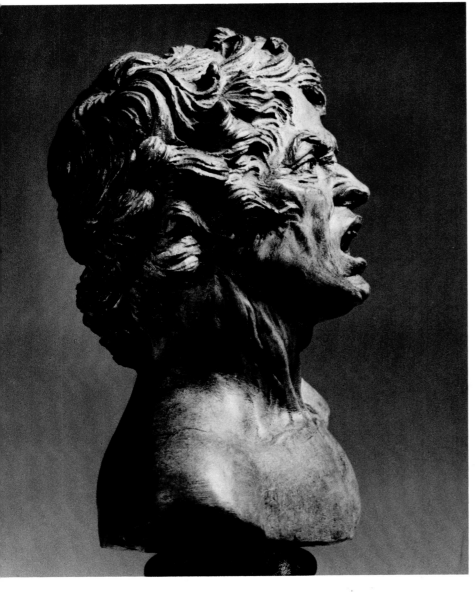

bronze, by a follower, for a fountain formerly in Cowdray Castle, Sussex, later in Woolbeding House, and currently on loan from the National Trust to the Victoria and Albert Museum (fig. 2).[2]

Both these Italian sources were in some degree subsumed in the studies of maniacs that were modelled probably from the life in lunatic asylums by the Netherlandish sculptors Hendrick de Keyser (1565-1621), Artus Quellinus the Elder (1609-1668) and Pieter Xavery (ca. 1647-1674). The most celebrated example is the statue dating from about 1650 of a woman known as *Frenzy* attributed to Quellinus, which is now in the Rijksmuseum in Amsterdam (fig. 3):[3] at least one of the four faces of lunatics peering through their cell windows that are set into the pedestal below this alarming statue resembles to a certain extent the present study.

1. R. Wittkower, *Gian Lorenzo Bernini*, London, 2nd ed., 1966, cat. no. 7, plate 6.
2. J. Pope-Hennessy, "Some newly acquired Italian sculptures: A Fountain by Rustici," *Victoria and Albert Museum Yearbook*, 4, 1974, pp. 21-37.
3. J. Leeuwenberg and W. Halsema-Kubes, *Beeldhouwkunst in het Rijksmuseum*, Amsterdam, 1973, pp. 228-29, no. 302.

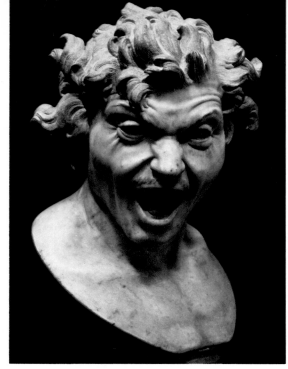

Fig. 1. Bernini, *Anima Dannata*, marble, Palazzo di Spagna, Rome.

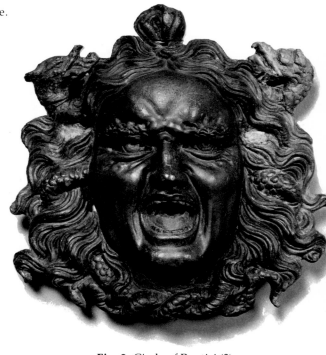

Fig. 2. Circle of Rustici (?), *Fountain*, bronze, Victoria and Albert Museum, London.

Fig. 3. Attributed to Artus Quellinus the Elder, *Frenzy*, sandstone, Rijksmuseum, Amsterdam.

251

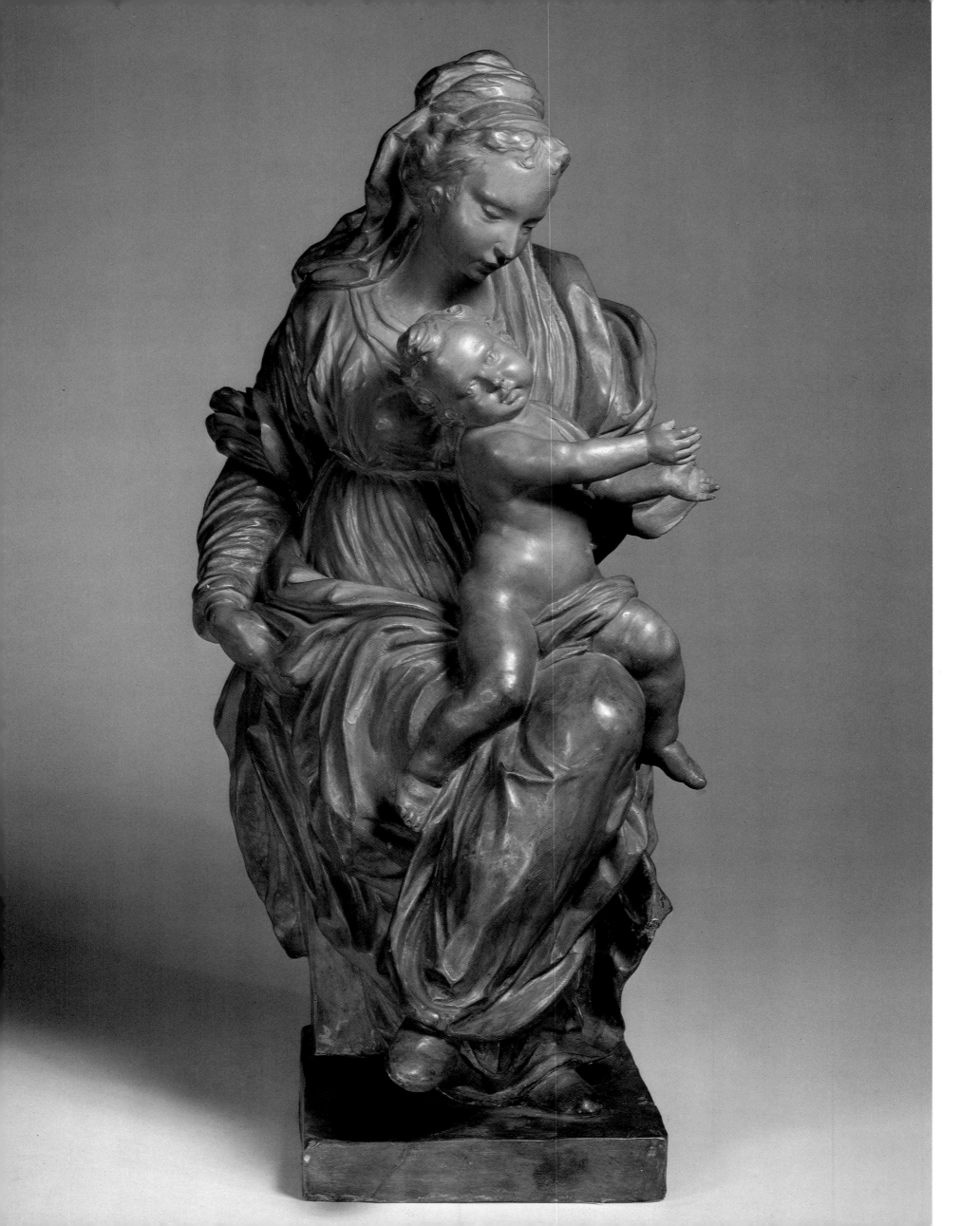

FLEMISH, late 17th or early 18th century

ANONYMOUS

formerly attributed to
Artus Quellinus the Younger
(1625-1700)

108. *Virgin and Child*

Terra-cotta, ca. 1700.
H. 20¾ in. (57.7 cm.) W. 6¼ in. (15.8 cm.) D. 7¼ in. (18.4 cm.)
Condition: a few minor repairs to both figures.
Accession no. 77.5.74

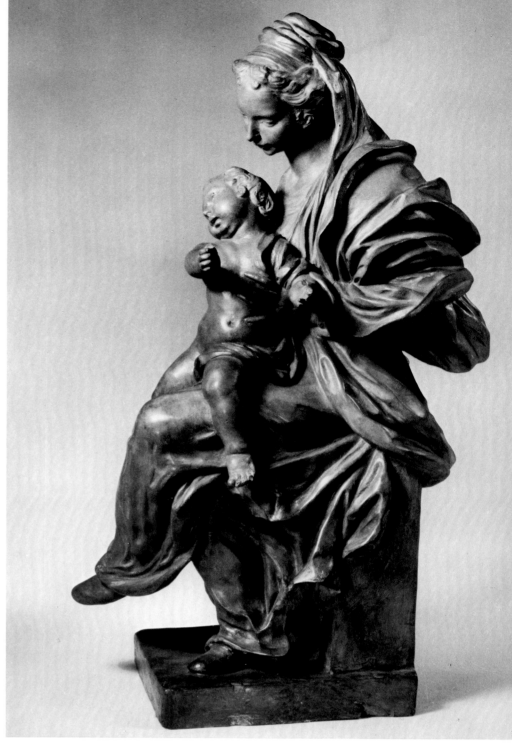

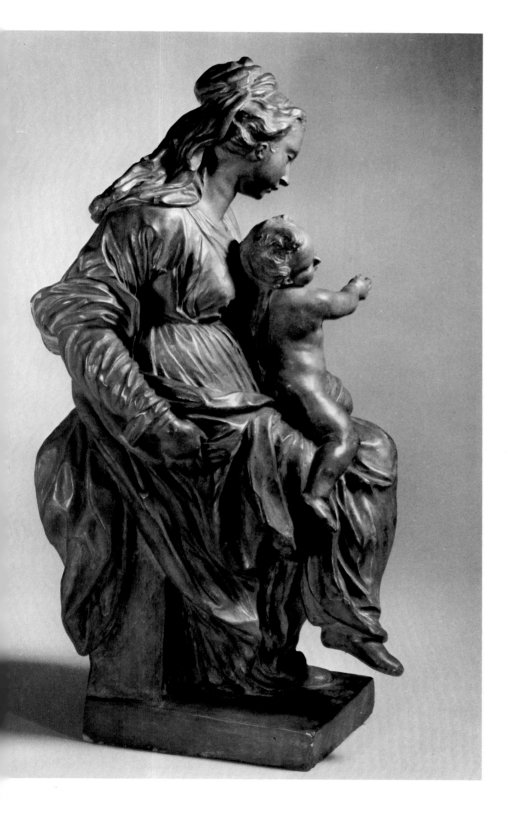

LIKE SO MANY obviously Flemish 17th- or 18th-century terra-cottas, this group is difficult to attribute, for it shares so many of the generic features of religious sculpture of the period. The slightly unusual, crossed-legged pose of the Virgin is distantly derived from Michelangelo's *Madonna* in the New Sacristy at San Lorenzo, Florence. The girlish features of the Virgin—the tiny, pointed nose and chin, plump cheeks, small ears, and lightly waving hair—point away from the fleshier, broad-faced woman depicted by Rubens and his sculptural associates early in the 17th century and towards the daintier type popularized by Artus Quellinus the Younger (1625-1700) at the end of the century. The busy folds of drapery in both the lighter material of the dress and the heavier cloth of the mantle are also characteristic of numerous sculptors during the late 17th and early 18th century. Nevertheless, no precise parallel for the style and handling has as yet been identified.

253

FLEMISH (BRUSSELS), early 18th century

JAN-BAPTISTE VAN DER HAEGHEN
(1688–1738/40)

Born in Brussels, Van der Haeghen matriculated in the Corporation des Quatre Couronnés in 1715, but does not seem to have executed any sculptures before 1723. In that year he delivered two statues, *St. Joseph and the Christ Child* (fig. 1), and *St. James the Great* for altars in the church of Notre-Dame de Bon Secours. Between 1728 and 1730 he carved the high altar, two side altars, three statues of saints, the communion rail and the organ loft in the abbey-church of Ninove. He is best known for his statues of *Thetis* and *Leda* for the royal park of Brussels.

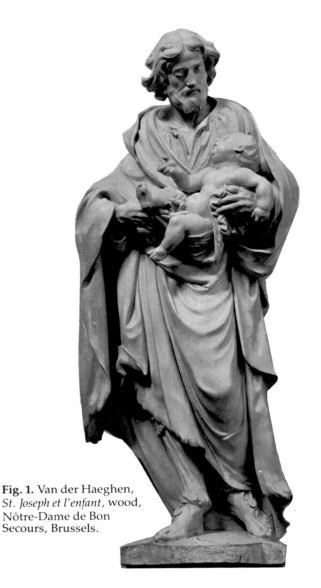

Fig. 1. Van der Haeghen, *St. Joseph et l'enfant*, wood, Nôtre-Dame de Bon Secours, Brussels.

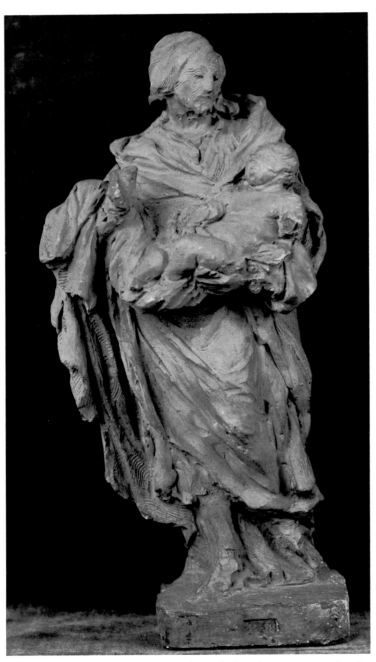

Fig.2. Van der Haeghen, *St. Joseph*, terra-cotta sketch-model, Musées royaux des Beaux-Arts, Brussels.

109. *St. Joseph Holding the Christ Child*

Terra-cotta, ca. 1723.
H. 19¾ in. (50.1 cm.) W. 8⅜ in. (21.3 cm.) D. 6⅝ in. (16.8 cm.)
Condition: head of St. Joseph broken off and repaired, legs and right arm of Christ Child as well as swaddling draperies missing; chips in drapery edges throughout; tip of St. Joseph's nose broken off; chips off fingers of both hands.
Accession no. 77.5.75

THIS CHARMING and sensitive group is characteristic of Flemish late Baroque sculpture for churches in the age of the Counter-Reformation. It is a preliminary model for a wooden statue 1.65 m. high in Nôtre-Dame de Bonsecours in Brussels and presumably dates from 1723 or just before, when the statue is documented in position. Its pendant, *St. James the Great*, dates back from the following year. The altars which they decorated were built by François Custers to a commission from Thomas de Fraula and are known from engravings by François Harrewijn (1700–1764).[1] Another terra-cotta sketch-model for *St. Joseph* (fig. 2), is in the Musées royaux des Beaux- Arts, Brussels.

St. Joseph is the earliest known work by Van der Haeghen and demonstrates how, as in the case of his contemporary Laurent Delvaux, the classical spirit and the Baroque could be amalgamated. The calm and relaxed pose sets the mood of religious adoration as Joseph contemplates the divine being wriggling naked in his arms.[2]

1. J. Le Roy, *Grand théâtre sacre du Duché de Brabant*, The Hague, 1938, p. 246.
2. The information in this entry is drawn from the catalogue of the exhibition held in Notre-Dame de la Chapelle, Brussels, in 1979, *Trésors d'art des églises de Bruxelles*, constituting vol. 56 of the *Annales de la Société royale d'archéologie de Bruxelles*, 1979, no. 132, pp. 175-76.

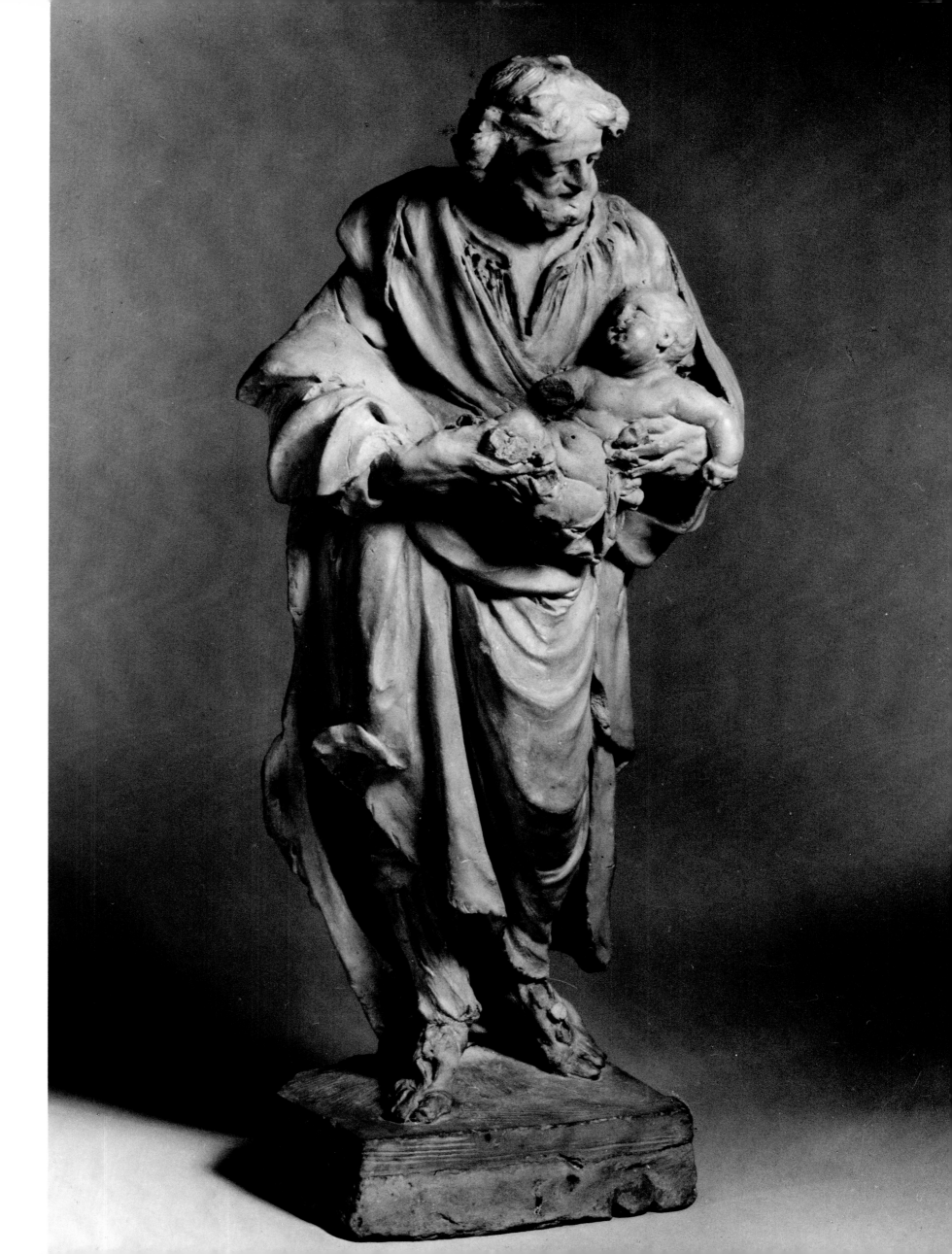

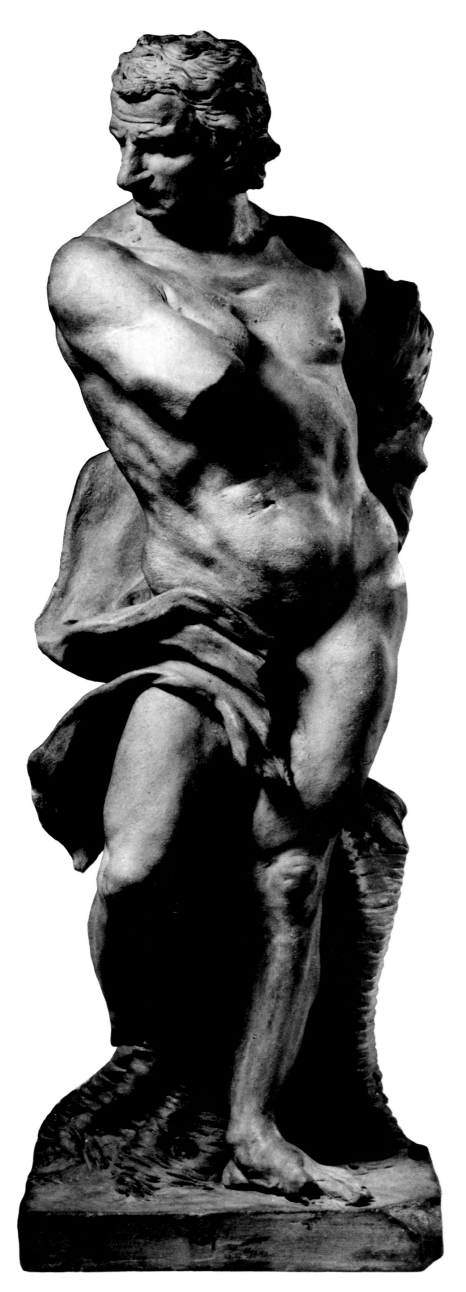

NETHERLANDISH, late 17th or early 18th century

ANONYMOUS

110. *Meleager or Hercules*

Terra-cotta, ca. 1700.
H. 18⅝ in. (46.9 cm.) W. 6½ in. (16.5 cm.) D. 6½ in. (16.5 cm.)
Condition: right foot broken off; right arm broken off above elbow; left arm broken off just below elbow; big toe of left foot broken off; front and back edges of drapery broken off; left side of boar's head broken off.
Accession no. 77.5.89

THE STATUETTE is unusual inasmuch as the face appears to be a portrait—and is quite unlike any ideal classical hero— while the rest is mythological in inspiration.[1] The complex pose and extremely naturalistic handling of the mature, male anatomy suggest a late Baroque sculptor working in the Netherlands. Such an origin might also explain the unorthodox iconography.

It is, however, difficult to determine by stylistic criteria alone which of the many competent sculptors in the Low Countries, who were used to modelling in terra-cotta, was responsible.

1. For a description of the legend of Meleager, see no. 78, footnote 5.

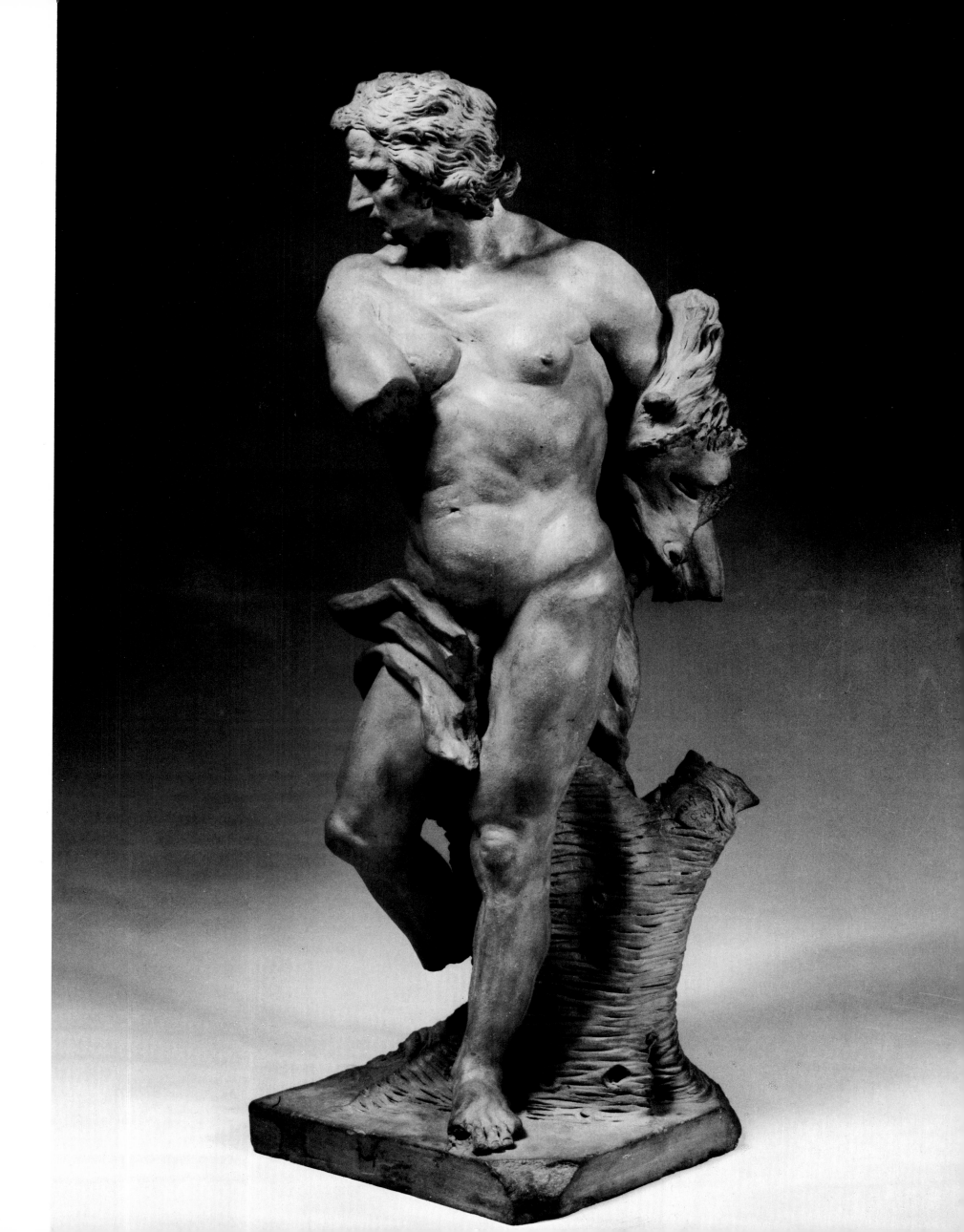

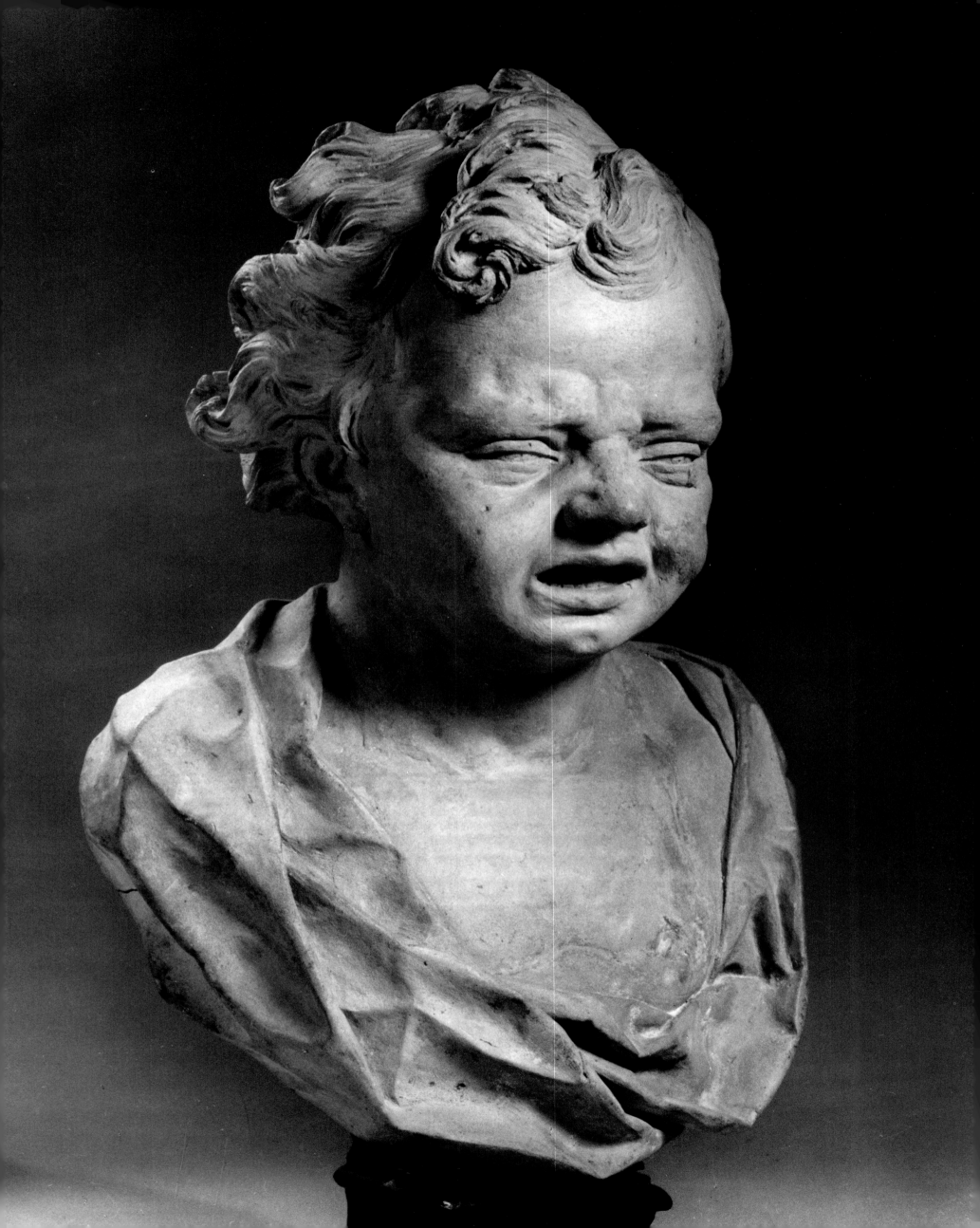

NETHERLANDISH, late 17th or early 18th century

Circle of JAN CLAUDIUS DE COCK
(1667-1735)

Born in Brussels, Jan Claudius was apprenticed in 1682-83 to the Antwerp sculptor Pieter I Verbruggen, who died in 1686. He matriculated into the guild of sculptors in 1688-89, and after the death of Pieter II Verbruggen in 1691, de Cock appeared in 1692 as an independent sculptor in Breda, employed by King William III of England, Stateholder of the United Provinces, to decorate the Court of the Princes. From about 1697 on, he is mentioned regularly in Antwerp, where he seems to have settled down, establishing a flourishing workshop with many apprentices passing through its doors. De Cock also wrote a handbook of sculptural practice.

111. *Crying Boy*

Terra-cotta.
H. 16 in. (40.6 cm.) W. 12 in. (30.5 cm.) D. 8 in. (20.3 cm.)
Condition: old repairs at neck, shoulders, cheeks, forehead, nose and around chest.
Accession no. 77.5.9

THE BUST HAS some characteristics of a portrait, but the extreme pain or sorrow registered on the countenance suggests that it is rather an allegorical representation. There had been a tradition in the Netherlands—at least since the time of Hendrick de Keyser, who produced a bronze bust of a child screaming (fig. 1)[1]—of quasi-scientific interest in physiognomy and expression. Jan Claudius de Cock made something of a speciality of sculptures of children, in the tradition of Duquesnoy, and was, for example, interested in portraying distinct racial types, such as the Negro.[2] A very similar terra-cotta bust of a chubby little boy weeping, recently on the art market in Amsterdam (fig. 2), bore the name "de Cock" inscribed in ink. Nevertheless, an ascription may be made only with a cautionary note, for the present bust also has similarities with a terra-cotta fragment showing the face and hand of a crying boy (fig. 3), now in Lakenhal Museum, Leiden, which was modelled by a local doctor, Petrus Camper (1722-1789). Similarities with the work of Walter Pompe may also be noted (see no. 113).

1. C. Avery, "Hendrick de Keyser as a sculptor of small bronzes," *Bulletin van het Rijksmuseum,* XXI, 1973, pp. 16-22.
2. Musée d'Art Ancien, Brussels, *La sculpture au siècle de Rubens* (exhibition catalogue), 1977, nos. 5, 6.

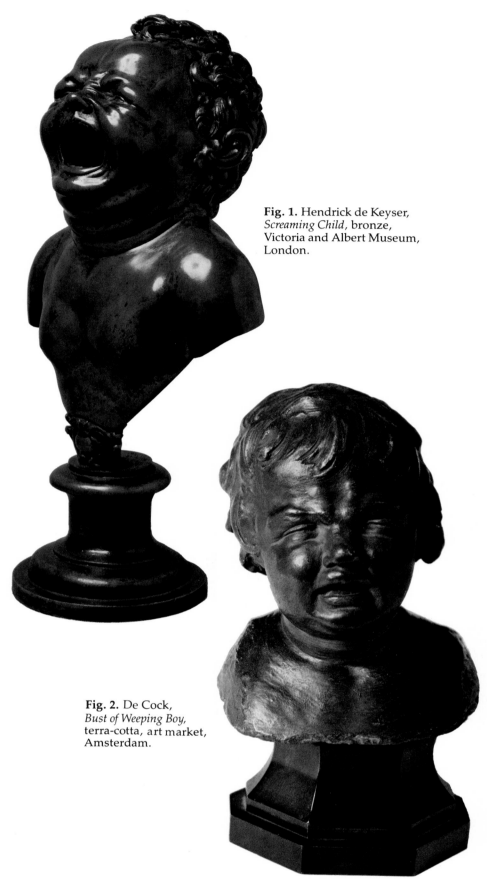

Fig. 1. Hendrick de Keyser, *Screaming Child,* bronze, Victoria and Albert Museum, London.

Fig. 2. De Cock, *Bust of Weeping Boy,* terra-cotta, art market, Amsterdam.

Fig. 3. Petrus Camper, fragment of terra-cotta showing face and hand of crying boy, Lakenhal Museum, Leiden.

Attributed to WALTER POMPE (1703-1777)

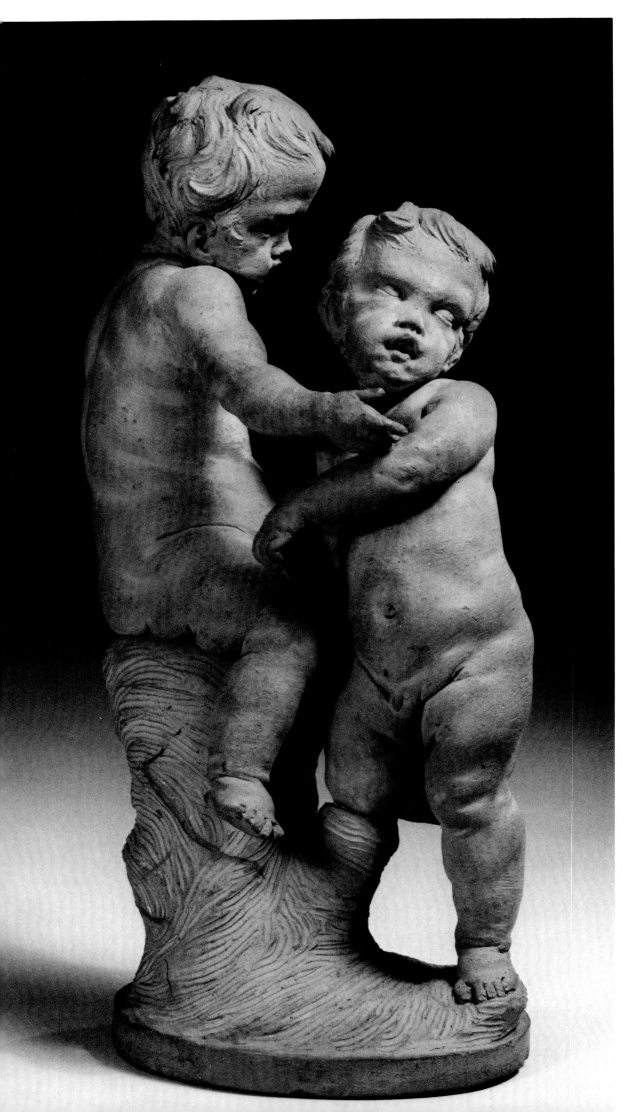

Pompe was born at 's-Hertogenbosch in 1703, but worked and died in Antwerp. He sculpted in terra-cotta, wood, ivory and stone, and had the obliging habit of usually signing his work and dating it with the day, month and year. His style recalls that of Duquesnoy and Artus Quellinus the Elder in combining classical subjects with extremely naturalistic handling, and it sometimes verges on the Rococo.[1]

112. *Putti Bird's-Nesting*

Terra-cotta.
Signed: initial "P" on the base.
H. 10¾ in. (27.3 cm.) W. 4¼ in. (10.8 cm.) D. 3¾ in. (9.5 cm.)
Condition: crack running down tree stump; repair in right upper arm of seated putto; repairs around ankle and right arm of standing putto; repaired heads at neck of both figures.
Accession no. 77.5.72

THIS CHARMING GROUP, so reminiscent of the *putti* at play in the garden sculpture at Versailles, is clearly Netherlandish in origin, when the extremely naturalistic rendering of the soft flesh of the infants is taken into account. The appearance of a cursive initial "P" on the base, first remarked by the present writer, has prompted a tentative attribution to Pompe.[2] But James Draper of the Metropolitan Museum has pointed out that "the delicately spiralling composition here may in fact be too good to be by Pompe who was a rather hack sculptor of Antwerp."[3]

The types of children, in facial features and plump anatomy, are taken from François Duquesnoy, who specialized in such *putti* (see no. 19) and whose work was known all over Europe through bronze, ivory, clay or wax statuettes in private collections, especially those of other sculptors.

Judging from its subject, bird's-nesting, the group may well be a model for a garden sculpture, which was a field much exploited by Pompe and his contemporaries. Terra-cotta models of this scale and type, so suitable for domestic ornaments, were the prototypes for the emergent production of statuettes in glazed ceramic or *biscuit*, which were to be such a feature of 18th-century interiors.

1. C. van Herck, "Walter Pompe en zijn Werk," *Jaarboek Antwerpen's Oudheidkundige Kring*, XI, 1935.
2. The *putti* here may be compared with other Pompe infants: the Christ Child in a terra-cotta statuette of the *Virgin and Child* made February 19, 1728, now in the Rijksmuseum, Amsterdam, illustrated in J. Leeuwenberg and W. Halsema-Kubes, *Beeldhouwkunst in het Rijksmuseum*, Amsterdam, 1973, no. 408, p. 292; a pair of *putti* clad as *Mars* and *Mercury* in the Mayer van den Bergh Museum, Antwerp, illustrated in Museum Mayer van den Bergh, *Catalogus 2, Beeldhouwkunst*, Antwerp, 1969, nos. 2334, 2335; two terra-cotta groups of children, one of a small child playing with a dog, the other with a small child giving a drink to a swan, and with statuettes of *putti* representing the *Four Seasons*, formerly in a Dutch private collection, illustrated in van Herck, *op. cit.*, no. 226, repro. pl. IV.
3. Personal communication to the author.

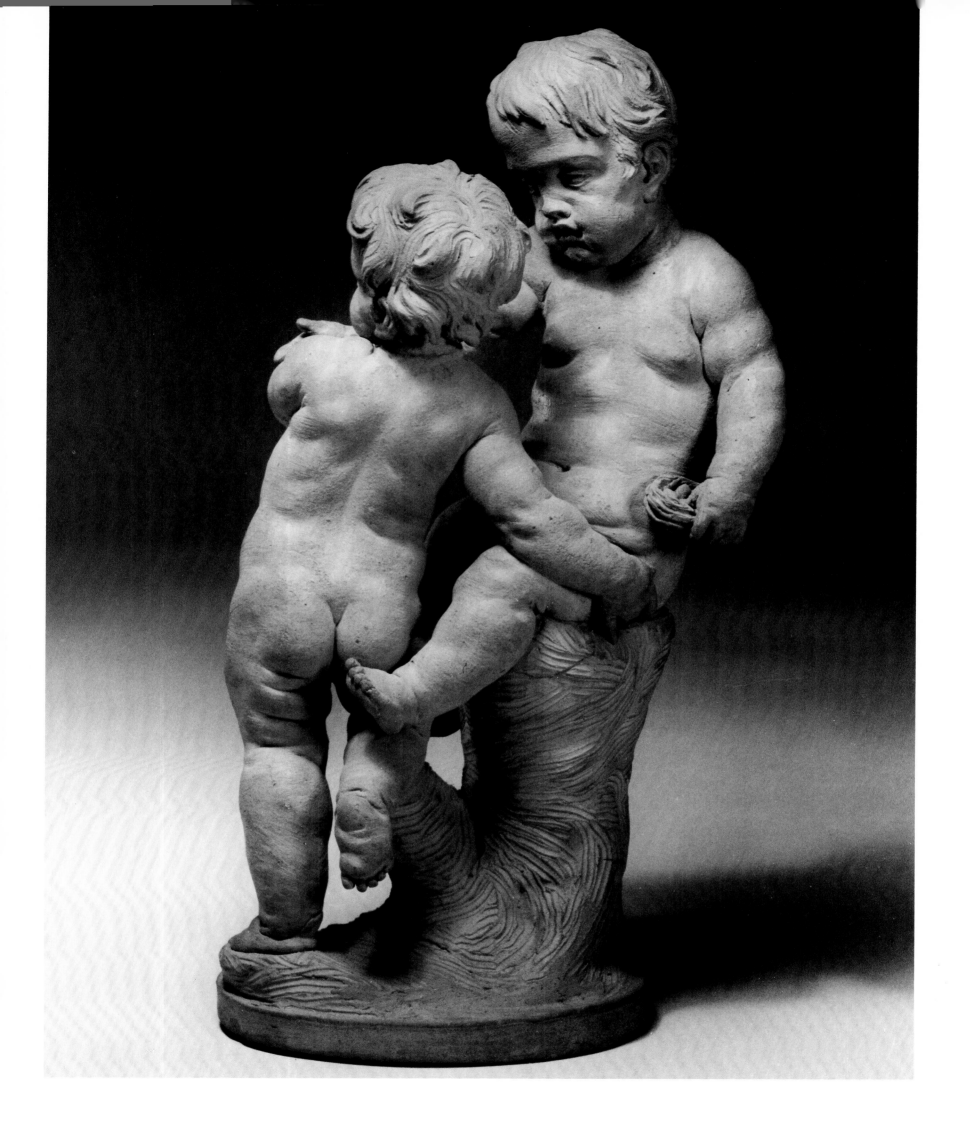

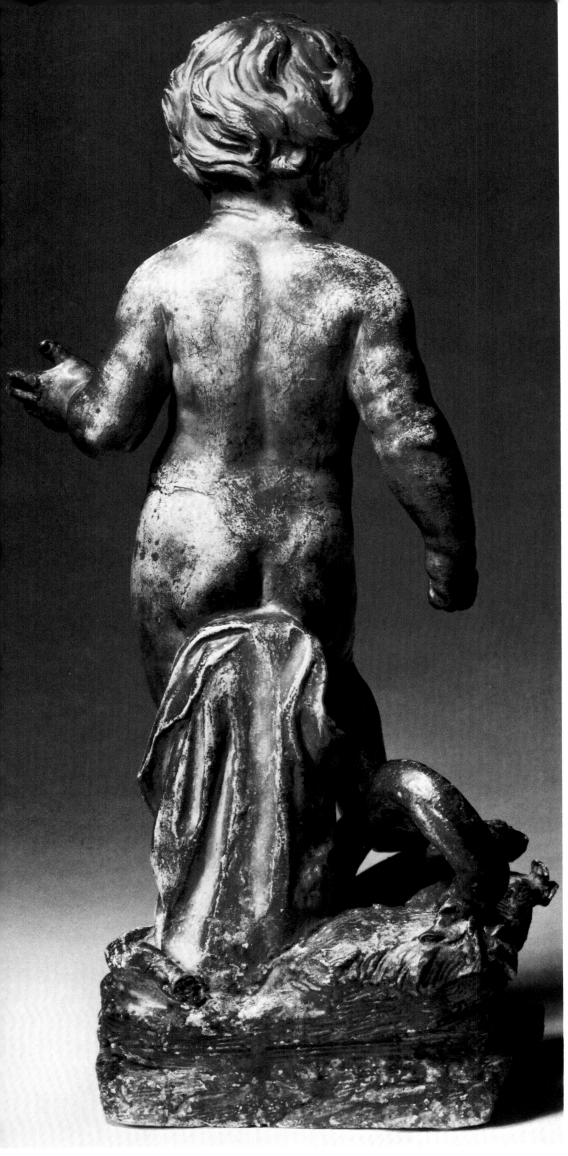

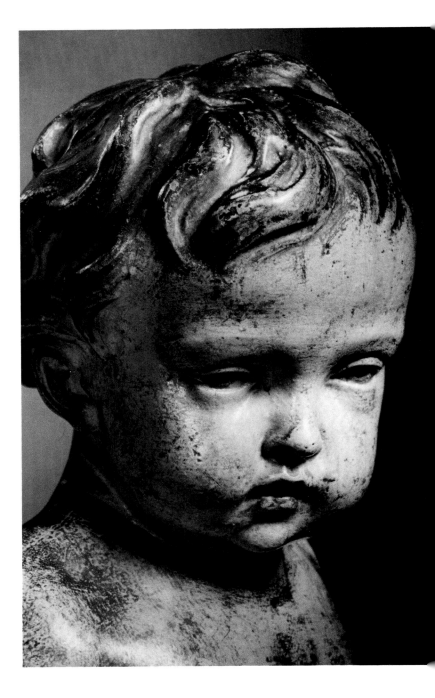

DUTCH or FLEMISH, 19th century

ANONYMOUS, Style of Walter Pompe

113. *The Christ Child as Saviour*

Polychrome terra-cotta.
H. 21¾ in. (55.2 cm.) W. 9¼ in. (23.5 cm.) D. 6¼ in. (15.9 cm.)
Condition: repairs throughout.
Accession no. 79.1.20

THE STATUETTE is cast from molds which were probably taken from an authentic original. The polychromy was not unusual during the 18th century and served to disguise any traces of molding marks on the surface. The devotional subject matter explains the motive for reproducing the sculpture—for use on another altar. The original has not been identified, but the realistic rendering of infant flesh points to the Low Countries and to an artist such as Pompe (see no. 112).

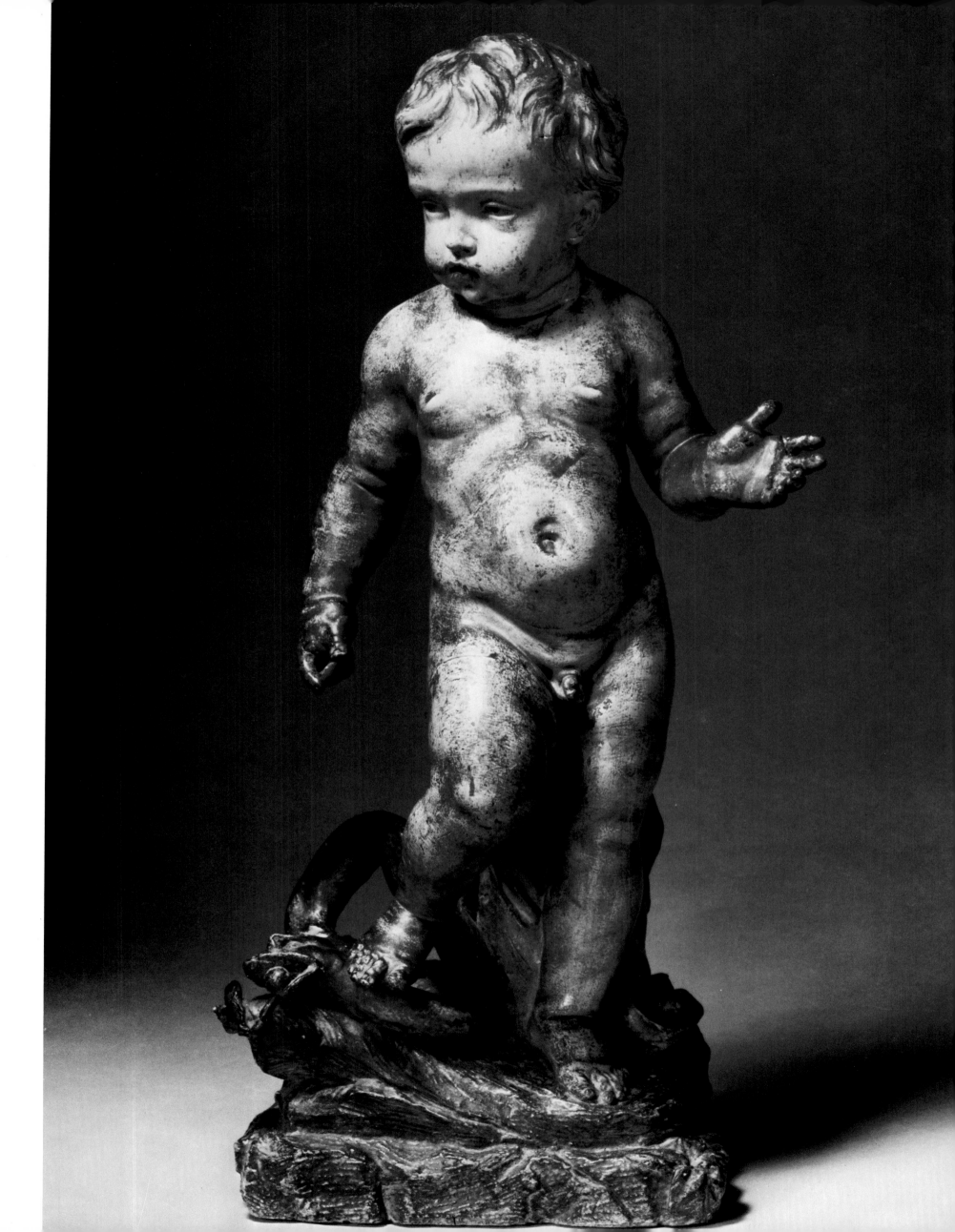

FLEMISH or ENGLISH, early 18th century

Attributed to PIERRE-DENIS PLUMIERE
(1688-1721)

formerly attributed to Laurent Delvaux (1696-1778)

Born in Antwerp, Plumière (or Plumier) studied
sculpture there under Willemssens (1698-99),
and later in Rome and Paris, where, in 1708,
he won a first prize at the Académie. After a
career in Antwerp and Brussels, engaged in
executing allegorical sculpture (such as the river-
gods for a fountain in the courtyard of Brussels
Town Hall) and funereal statuary (the Spinola
family monument in Nôtre-Dame de la Chapelle,
1715), Plumière went to London to try his fortune,
accompanied by two assistants, Laurent Delvaux
and Peter Scheemakers the Younger. Plumière's
untimely death in 1721 interrupted the production
of his masterpiece, the tomb of John Sheffield,
Duke of Buckingham, in Westminster Abbey,
which was finished by his assistants.

114. *Father Time Carrying Off a Dead Infant*

Terra-cotta, ca. 1710-1720.
H. 20⅞ in. (53.0 cm.) W. 18 in. (45.7 cm.) D. 8⅛ in. (20.7 cm.)
Condition: extensive repairs throughout; limbs of child broken off;
chips on figures and drapery; restored areas: wings (of molded
wood), left foot and lower leg of Father Time, support under left
arm of woman, center section at back of base.
Provenance: Sotheby, London, April 17, 1969, no. 159 (illustrated);
Heim Gallery (London), *Paintings and Sculptures of the Baroque,*
Autumn 1970, no. 85.
Accession no. 79.1.22

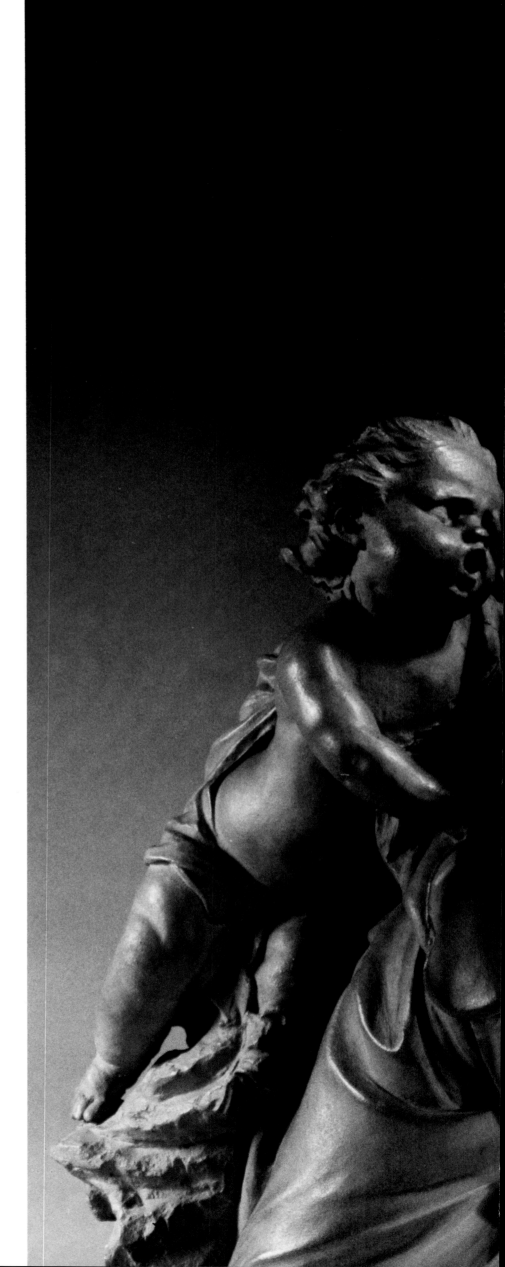

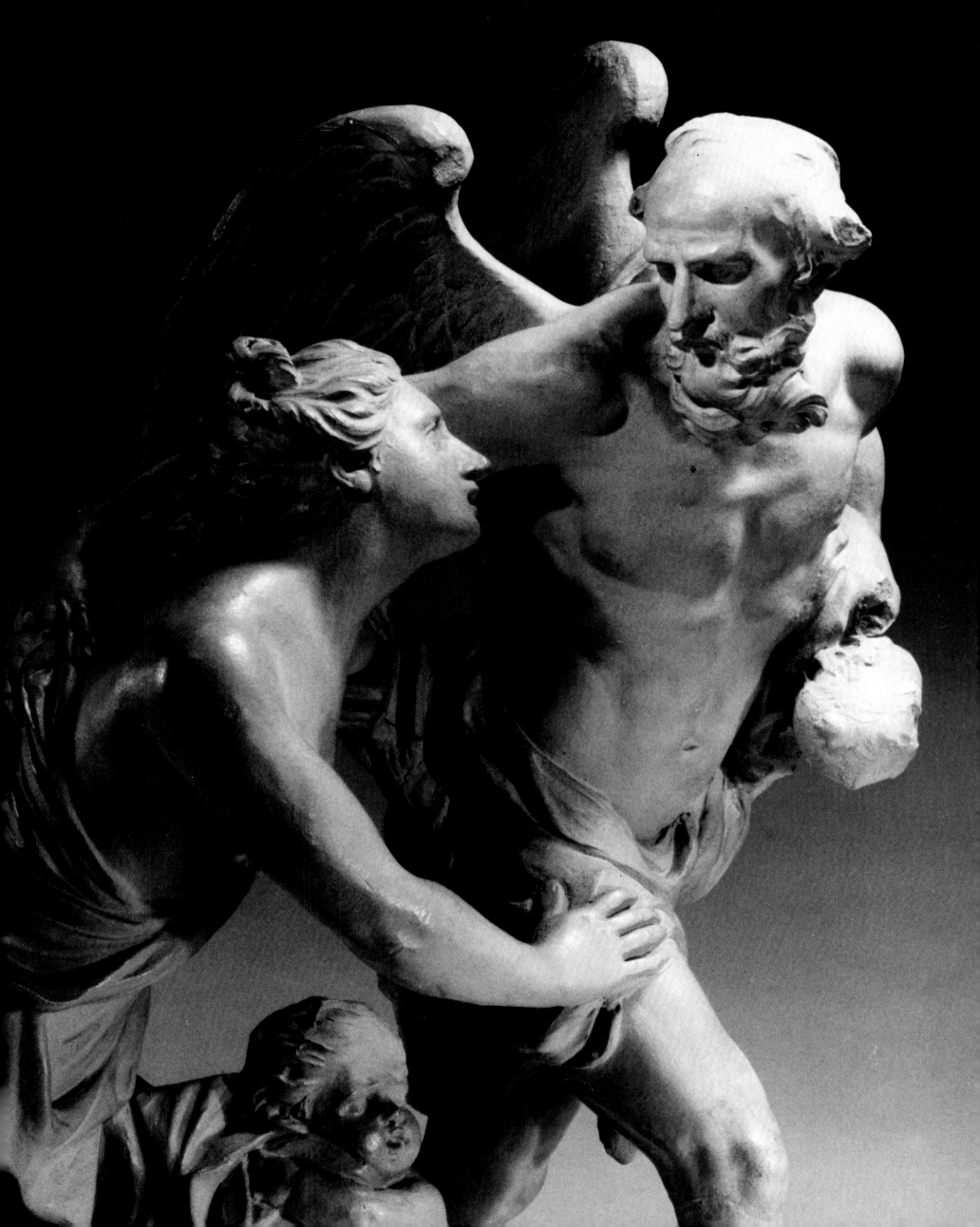

Fig. 1. Plumière and Scheemakers, *Monument to the Duke of Buckingham,* Westminster Abbey.

THIS GROUP was formerly attributed, on stylistic grounds, to Laurent Delvaux, but does not seem absolutely consistent with his many corresponding terra-cotta models.[1] Its subject—Father Time carrying off a dead infant from a distraught mother and two other weeping children—corresponds with the iconography for late Baroque funereal monuments popular ca. 1700, and notably with that of the Buckingham and Spinola monuments (figs. 1 and 2), which were masterminded by Plumière. In each case, the prominent figure of Father Time, at the apex of a pyramidal composition including the deceased and a mourning wife, is close to the present model.[2]

While there are few surviving sketch-models by Plumière, many are known to have existed, and the present terra-cotta may well be an example of his work. Its apparently English provenance corroborates the attribution.

1. Georges Willame, *Laurent Delvaux,* Brussels, 1914.
2. Charles Avery, "Laurent Delvaux's Sculpture in England," in *National Trust Studies,* II, 1980, pp. 150-170.

Fig. 2. Plumière, *Spinola Family Monument,* Nôtre Dame de la Chapelle, Brussels.

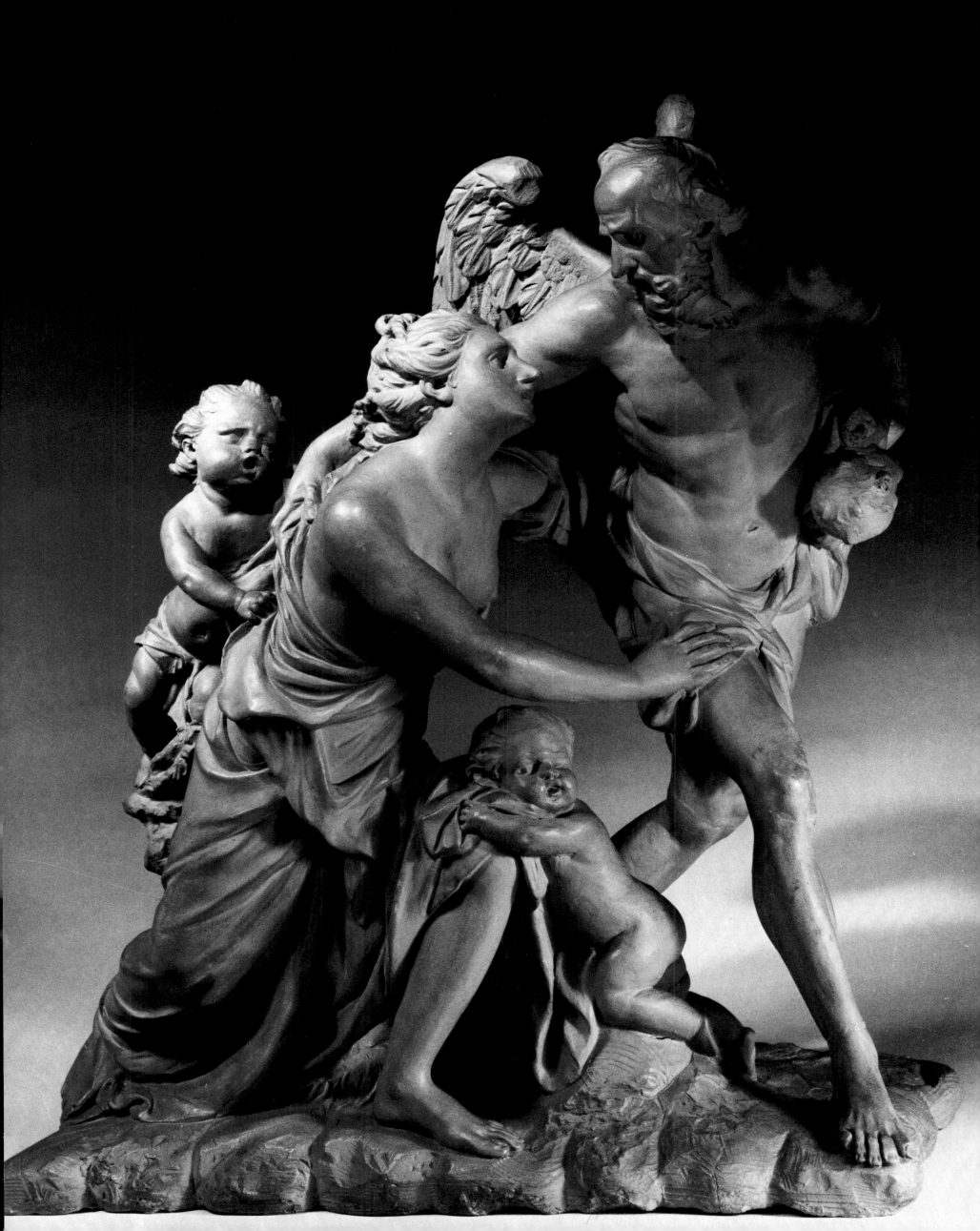

ENGLISH, mid-18th to early 19th century

JOSEPH NOLLEKENS
(1737-1823)

Nollekens, son of a London painter who came from Antwerp, was apprenticed in 1750 to Peter Scheemakers. From 1760, he spent a decade in Rome restoring and copying Antique statuary and carving a few portrait-busts for the English market. After his return, he was made an Associate of the Royal Academy in 1771 and a full Academician a year later. Nollekens specialized in portrait-busts and monuments, although he personally preferred allegorical and mythological subjects. His taste was for Classical costume and he spans the change in taste from the Rococo to Neo-Classicism.

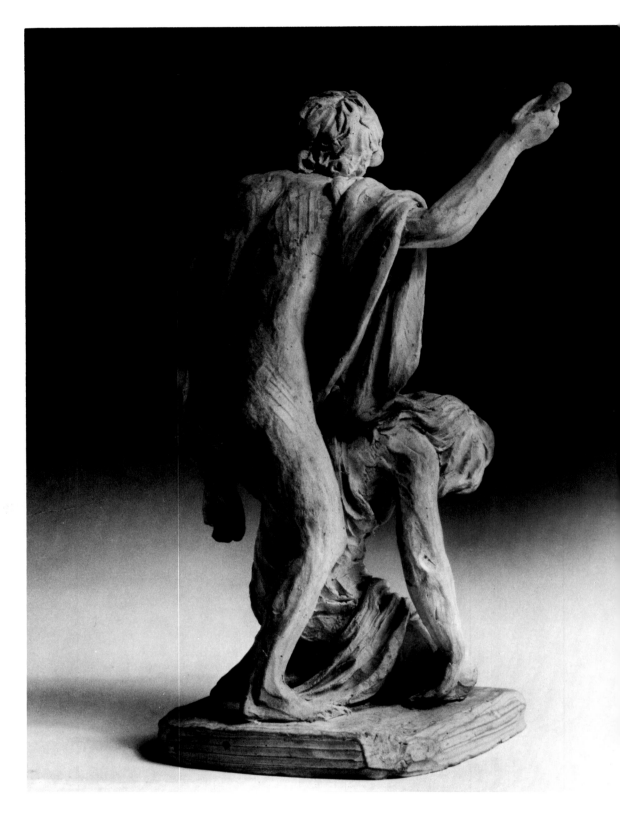

Fig. 1. T. Rowlandson, *Nollekens Modelling Venus*, drawing, Widener Memorial Collection, Harvard University, Cambridge, Mass.

115. *Paetus and Arria* *

Terra-cotta, ca. 1770.
H. 7⅜ in. (18.7 cm.) W. 3⅛ in. (8.0 cm.) D. 3⅛ in. (8.0 cm.)
Condition: excellent, except for Paetus' nose, which is broken off, and missing fingers on left hand of Arria.
Exhibited: Royal Academy, London, 1771, **no. 141**(?).
Provenance: Sotheby's, London, March 18, 1976, no. 197; Heim Gallery, London.
Accession no. 77.5.59

THE BOXWOOD STAND which was sold at Sotheby's with this group bears an old label inscribed "Virginius and his daughter, modelled by Flaxman." On stylistic grounds, however, the group can confidently be attributed to Nollekens, and its relatively complex composition suggests it was an early work.[1]

This work is here identified as the model which Nollekens exhibited at the Royal Academy in 1771 (no. 141): *A model, Paetus and Arria; a groupe.*[2] The exhibition opened just four months after the sculptor had returned from his eight years in Italy, so possibly it had been made in Rome. It is related, and very closely so in the expiring figure of the woman, to an ancient marble group the *Gaul Killing Himself and His Wife,* formerly at the Villa Ludovisi and now in the Terme Museum, Rome. However, in the 18th century the ancient group was known as *Paetus and Arria.*

Caecina Paetus was condemned by Claudius for his part in the conspiracy of Camillus Scibonianus (A.D. 42). His wife, Arria, who professed Stoicism, stabbed herself and handed the dagger to Paetus saying, *"Paete, non dolet"* ("Paetus, it doesn't hurt").[3]

This historical subject, though obscure today, was familiar in London at the time because a plaster cast of the Ludovisi marble had come from Rome in 1756, and was in the Duke of Richmond's Gallery at Whitehall (1758-ca. 1765) where many young artists, including Nollekens himself, had been encouraged to study. By 1770 this plaster cast seems to have belonged to the Incorporated Society of Artists of Great Britain,[4] and it is interesting that it appears in the background of a drawing by Thomas Rowlandson of *Nollekens Modelling Venus* (fig. 1).[5]

1. For a discussion of Nollekens' terra-cotta models, see K. Esdaile in the *Burlington Magazine,* September 1944.
2. See J.T. Smith, *Nollekens and His Times,* London, 1828, vol. II, p. 79.
3. Pliny, *Epistles* 3, XVI: Martial, 1, XIII.
4. Others from the Richmond Gallery were acquired by the Royal Academy.
5. Widener Memorial Collection, Harvard University, Cambridge, Mass.
 * Entry written by John Kenworthy-Browne.

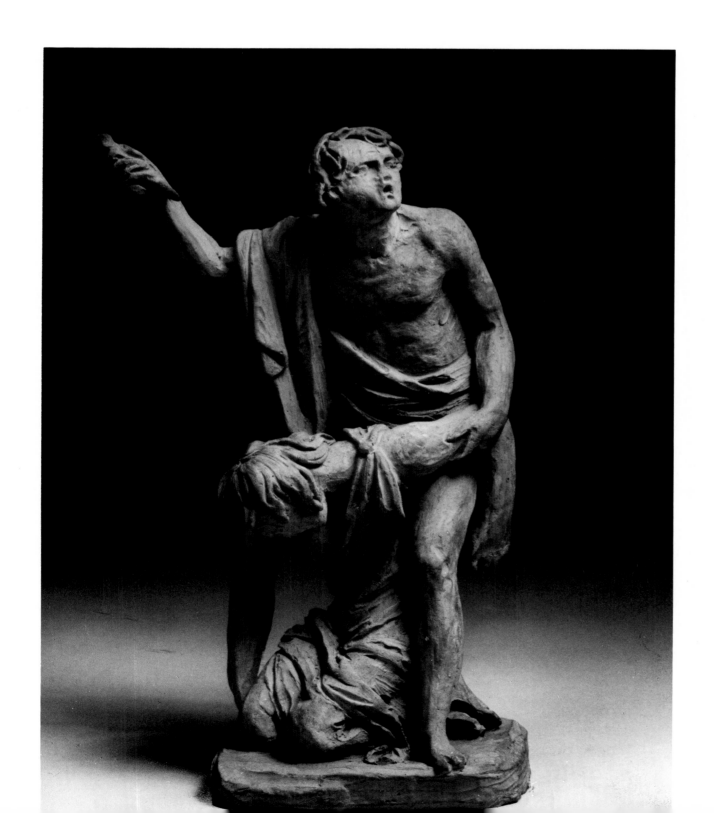

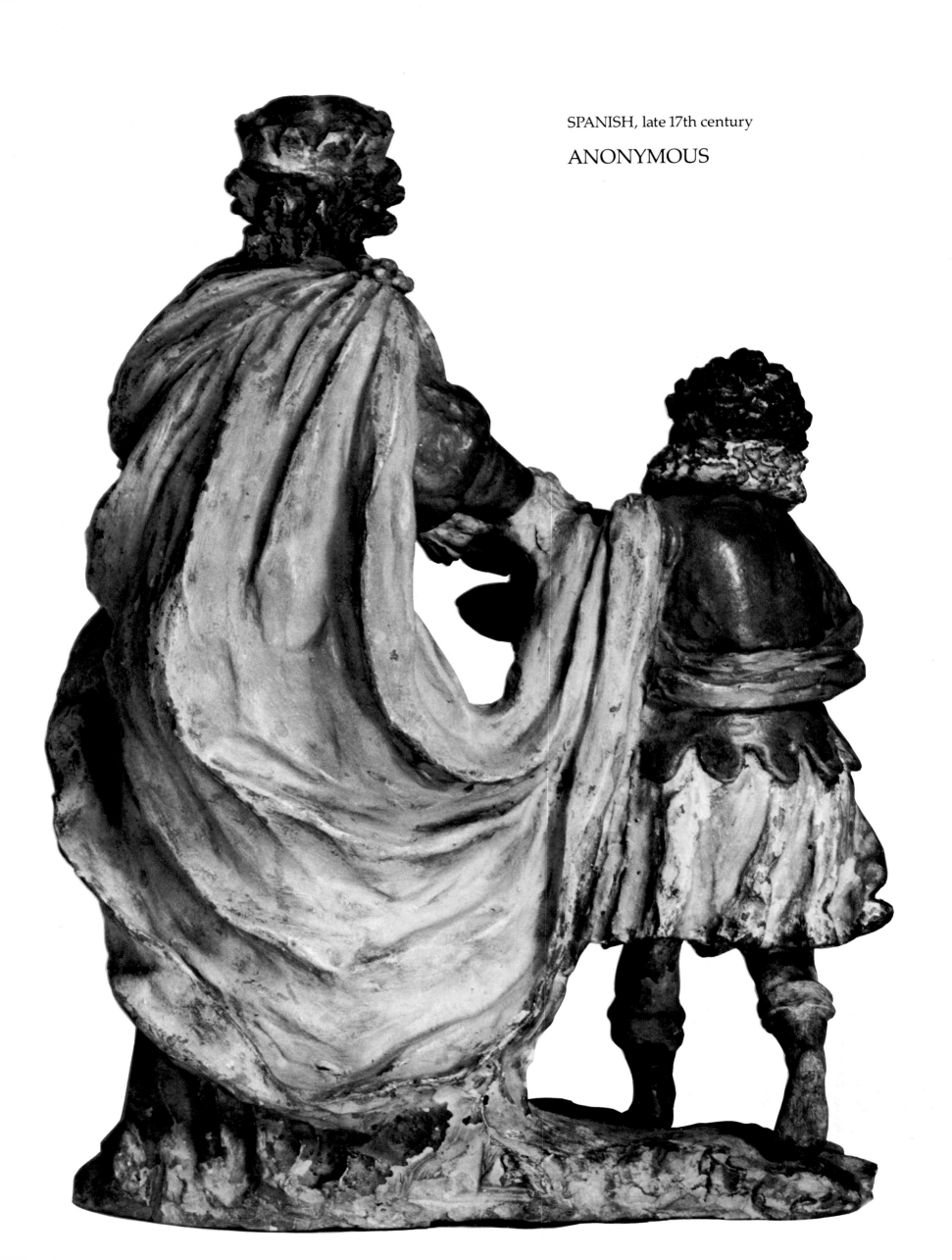

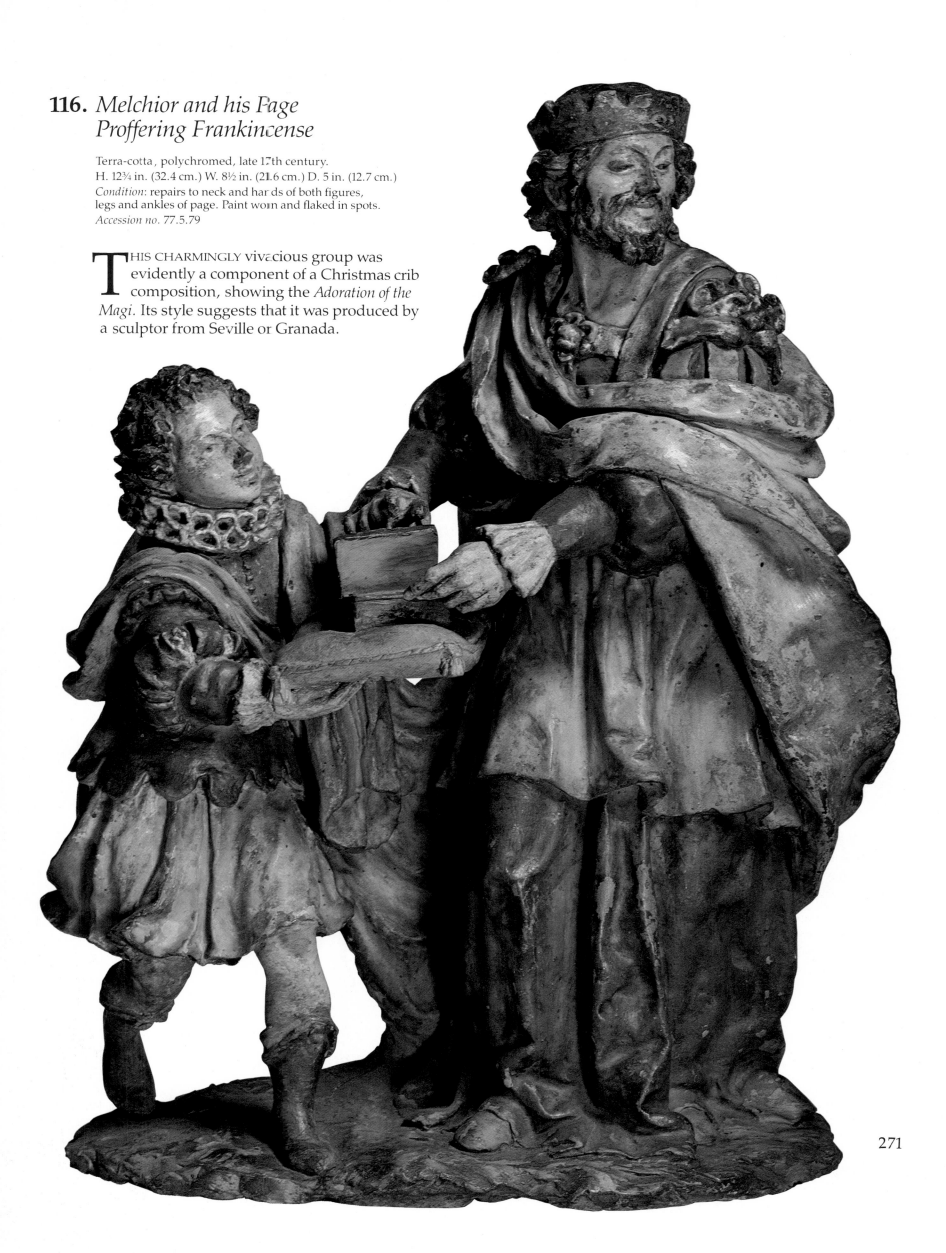

116. *Melchior and his Page Proffering Frankincense*

Terra-cotta, polychromed, late 17th century.
H. 12¾ in. (32.4 cm.) W. 8½ in. (21.6 cm.) D. 5 in. (12.7 cm.)
Condition: repairs to neck and hands of both figures, legs and ankles of page. Paint worn and flaked in spots.
Accession no. 77.5.79

THIS CHARMINGLY vivacious group was evidently a component of a Christmas crib composition, showing the *Adoration of the Magi.* Its style suggests that it was produced by a sculptor from Seville or Granada.

271

SPANISH, late 19th century

VENANCIO VALLMITJANA
(1828-1919)

V ENANCIO VALLMITJANA Y BARBANY, was born in
Barcelona, Spain, in 1828, the son of a modest
weaver whose trade he and his brother Agapito
(1833-1905) followed in their youth. Eventually, both
brothers became prolific sculptors widely renowned in
Spain, and abroad. They produced works, primarily
in a Romantic mode, in terra-cotta, stone and bronze,
and collaborated on many large commissions. From the
middle of the 19th century Venancio was recognized for
his independent conceptions and original techniques.

In 1883, he was named professor at La Escuela Superior
de Artes y Oficios y Bellas Artes of Barcelona and
taught many generations of young artists. He died
September 3, 1919 in Barcelona, at the age of 91.[1]

117. *Torero Herido (Wounded Bullfighter)*

Terra-cotta.
Signed: "V.V." initialled on left top of base.
H. 4⅛ in.(10.5 cm.) W. 14 in.(35.5 cm.) D. 4½ in. (11.4 cm.)
Condition: repairs throughout; right leg broken off below knee;
right arm restored in plaster.
Accession no. 79.1.8

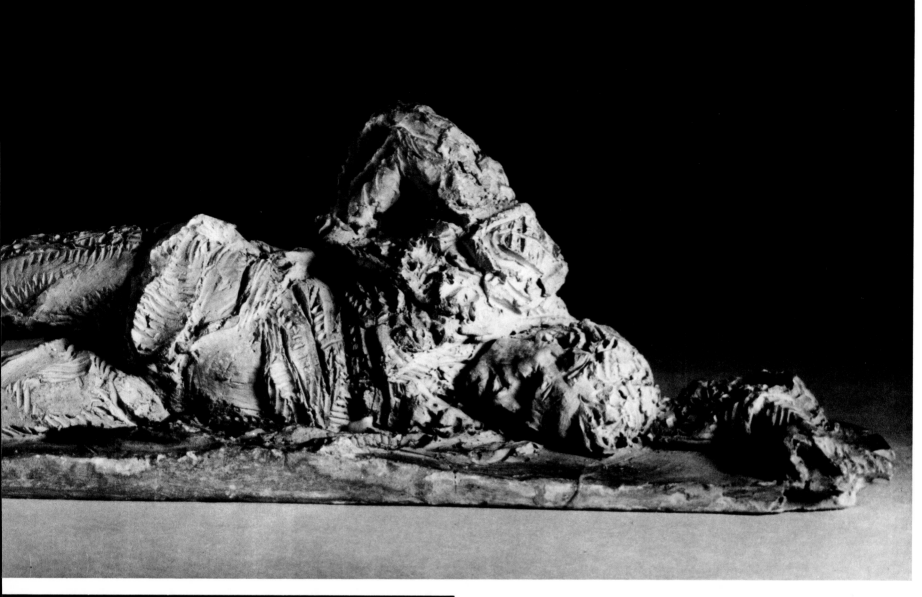

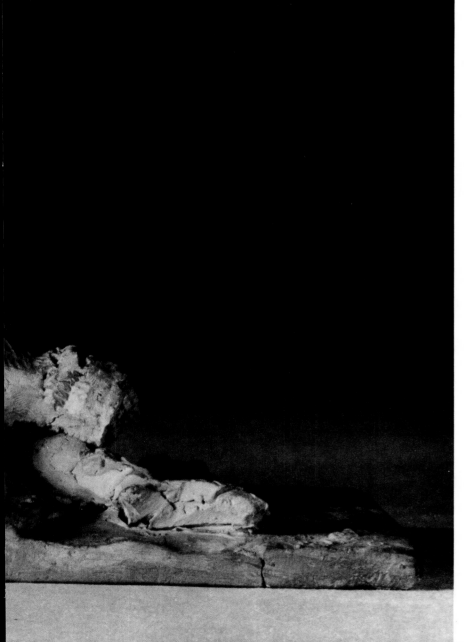

T HE SUBJECT AND POSE are characteristic of Romantic
sculpture as it emerged during the 19th century.
The pathos of the recumbent figure is increased by
the hatching with a modelling tool on the drapery of the
traje de luces (suit of light).

When this small sculpture was acquired for the Sackler
collection, it was titled *Dying Soldier* and attributed to the
19th century Italian artist Vincenzo Vela (1820-1891). The
attribution was based on the initials V.V. inscribed on
the base at the feet of the figure and, as reported by the
dealer from whom it was purchased, a purported Italian
provenance. Comparison, however, with other published
sculptures by Vincenzo Vela made the attribution
untenable,[2] while closer examination of the figure itself
revealed that the subject was not a dying soldier, but rather
a wounded bullfighter wearing the traditional costume, a
traje de luces. With new appreciation of the subject matter,
and at the suggestion of James Draper of the Metropolitan
Museum, Spain was considered a more suitable place of
origin. Searching among names of Spanish sculptors of the
19th century who would fit the initials V.V., Mr. Draper
came up with that of Venancio Vallmitjana, the popular and
prolific 19th- and early 20th-century sculptor from Barcelona.

A review of the sculptures ascribed to Venancio Vallmitjana
revealed that he did in fact produce a work entitled *Torero
Herido* before 1883-84,[3] although no information about size
or material is recorded for it. However, a photograph of

273

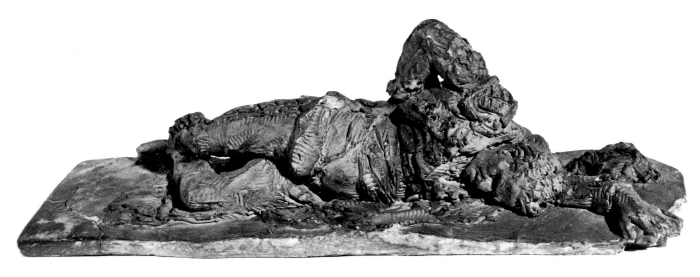

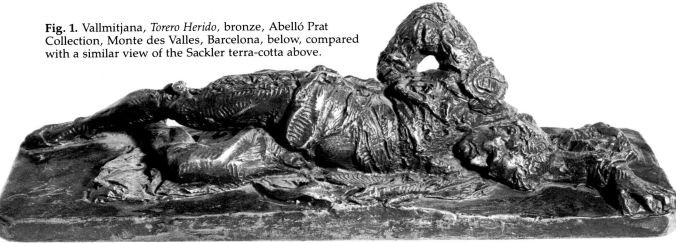

Fig. 1. Vallmitjana, *Torero Herido*, bronze, Abelló Prat Collection, Monte des Valles, Barcelona, below, compared with a similar view of the Sackler terra-cotta above.

a *Torero Herido* by Vallmitjana was found in MAS, the photographic archives in Barcelona (fig. 1).[4] The piece is in fact a bronze version of the Sackler terra-cotta, but with the extended right leg of the torero still intact. A comparison of the two works leaves no doubt that the terra-cotta was a sketch-model for the bronze, the dimensions of the latter are: H. 10.5 cm., W. 35 cm., D. 11.5 cm. The bronze also carries the initials V.V. in exactly the same position on the plinth as the terra-cotta. It seems possible to assume that the bronze *Torero Herido* was indeed the one produced sometime before 1883-84 and the terra-cotta can be dated accordingly. It is recorded, however, that Vallmitjana, between working on more monumental sculptures, spent his time reproducing his larger compositions in smaller terra-cotta versions, which purportedly were then acquired in Paris, London, Venice, and the United States.[5] But the *Torero Herido* here is not a smaller version of its bronze counterpart.

Although no other sculpture by Vallmitjana with the initials V.V. has so far been identified, signatures on published sculptures by him demonstrate in the initial "V" of each name a definite relationship to the "Vs" found on the base of the figure here.[6] Another work by Venancio, *Shepherd and Goat* (fig. 2), evidently in terra-cotta, demonstrates an identity in the handling of the clay which reveals a spontaneity in the quick, deft tooling with abrupt, uneven surfaces that reflect the play of light.[7] The work is signed V. Vallmitjana, using the same characteristic "Vs" found in the two *Torero Heridos* and other signed works.

Among published sculptures by Venancio, two statuettes of *Figaro* have facial features which are perhaps those of the same model for the *Torero Herido*, but at a younger age.[8]

274

1. M. Ossorio y Bernard, *Galeria Biographica de Artistas Españoles del Siglo XIX*, Madrid, 1883-84, pp. 684-685; *Enciclopedia Universal Ilustrada Europo-Americana*, tomo LXVI, Madrid, 1929, pp. 1123-1126; M. R. Codola, "Els Escultors Vallmitjana," *Butlleti dels Museus d'Art de Barcelona*, vol. VI, 1936, pp. 136-151; Codola, *Venancio y Agapito Vallmitjana Barbany*, Madrid, 1946.
2. R. Manzoni, *Vincenzo Vela*, Milan, 1906. F. Sapori, *I Maestri dell' Arte, Monographie d'artisti italiana moderni, no. 8, Vincenzo Vela*, Torino, 1919; M. Calderini, *Vincenzo Vela*, Torino, 1920; Museo Vela, Ligornetto, *Catalogo della opera de scultura e di pittori*, Bellinzona, 1925.
3. Mention in the 1883-1884 edition of Ossorio y Bernard, *op. cit.*, p. 685, gives a date after which it could not have been made. It is also mentioned in the *Enciclopedia, op. cit.*, p. 1125.
4. The Abelló Prat collection, Mollet des Valles, Barcelona, MAS reference Abelló 274. Mary thanks to Señora Blanch and her associates at MAS in Barcelona for sending the illustrations of and information about Venancio Vallmitjana from their archives, and to Lydia Dufours of the Hispanic Society, New York, for her help in locating information about the artist.
5. *Enciclopedia, op. cit.*, p. 1125.
6. For example, *Donya Maria Christina i Alfonso XIII* in the Museo d'Art de Catalunya, and *Estatua yacente de Doña Maria Auter*, illustrated in Codola, *op. cit.*, p. 45 and *Enciclopedia, op. cit.*, p. 1125, respectively.
7. Present location unknown, but the photograph of it was furnished by MAS, Barcelona, MAS reference C-7397.
8. Codola, *Butlleti, op. cit.*, p. 141, illustrates both, while Codola, *op. cit.*, p. 39, illustrates one, but in larger size, which is the one apparently done in 1873 for the contest sponsored by *Le Figaro*, Paris (see pp. 18-20).

Fig. 2. Vallmitjana, *Shepherd and Goat*, terra-cotta, present location unknown.

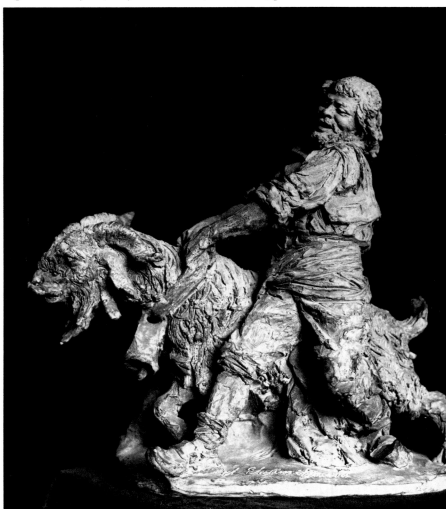

Appendix

sculptures with negative dating derived
from thermoluminescence analysis*

*Further study is intended in order to determine if restorations
and repairs undertaken during the last 150 years may have prevented
proper dating by thermoluminescence analysis.

ITALIAN, 19th or 20th century

ANONYMOUS
formerly attributed to Andrea di Lazzaro,
called Il Buggiano (1412-1462)

A. *Pietà*

Terra-cotta, hollow relief plaque, post-1830.[1]
H. 25¾ in. (65.4 cm.) W. 19⅜ in. (49.2 cm.) D. 4 in. (10.2 cm.)

Condition: old repairs to heads of the Virgin and Christ, along lower right side and outer left; the back, which acts as a support for the front of this hollow relief plaque, seems to be a later addition with the terra-cotta having turned a light pinkish hue in the firing.

Accession no. 77.5.39

THE FORMER ATTRIBUTION of the relief to a Florentine associate of Brunelleschi, called 'Il Buggiano' (after his native village), was tentative. In fact, this type of composition of the *Pietà* is related to northern European Gothic sculpture and appears frequently in Italy or north of the Apennines, but rarely in Tuscany.[2] The emphatic modelling of facial features, musculature and drapery folds resembles late 15th-century sculpture in Padua and Ferrara, and these must have been the sources of inspiration for the author of the present relief.

1. Oxford Research Laboratory for Archaeology and the History of Art, *Report of Thermoluminescence Analysis*, sample no. 281p45, 1979: last fired less than 150 years ago. The last firing indicated in the analysis may be a result of the later addition of the back support. Further examination is necessary to determine old repairs and if the back is indeed of a later date than the front relief.
2. Cf. **Palazzo della Ragione**, *Dòpo Mantegna* (exhibition catalogue), Padua, 1976, nos. 81, 82, 84.

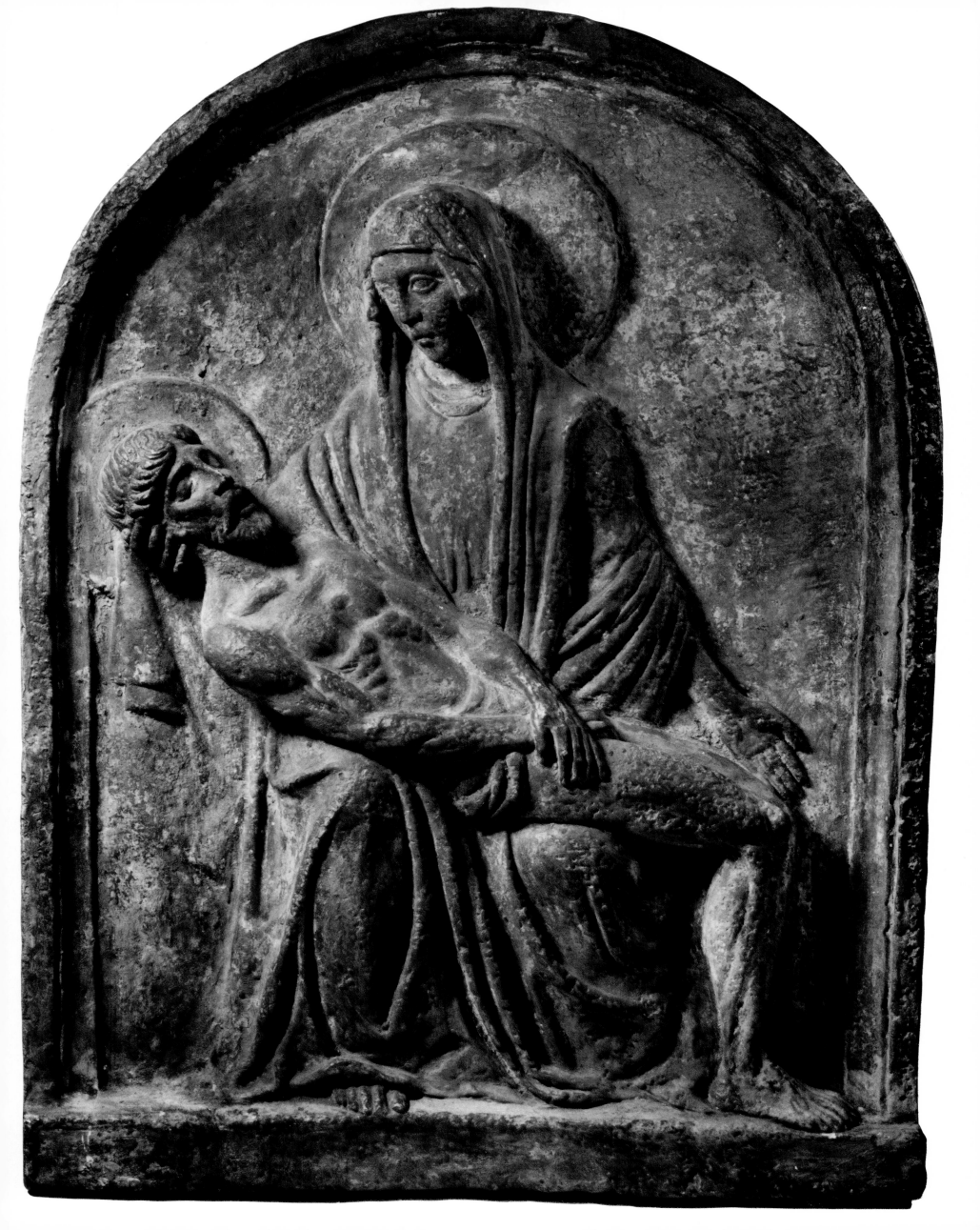

ITALIAN, 19th century (?)[1]

ANONYMOUS

B. *Virgin Annunciate*

Polychrome terra-cotta.

H. 25⅝ in. (65.1 cm.) W. 18 in. (45.7 cm.) D. 23 in. (58.4 cm.)

Condition: repairs to neck, wrists, hands and fingers; chips on edge of mantle; repaired at the hairline. Paint stained, flaked, chipped and worn, with evidence of retouching.

Accession no. 77.5.7.

THE BUST doubtless formed a pair with one of the Angel Gabriel. The type of the Virgin and the handling of anatomy and drapery suggest a dating in the middle of the 16th century. The half-length figure, including arms and hands, and the modelling in terra-cotta and lifelike polychromy would be typical of Bolognese sculpture of the period.[2] The surface has been vitiated with repairs and over-painting, which does not allow a proper appreciation of its original quality, even though this may have been provincial.

The bust exhibits no traits that are specifically 19th century, and its origin in that period would be curious, for it is not a forgery of any particularly sought after type of Renaissance sculpture, unlike the alluring 'Madonnas' or portrait-busts of Bastianini or Dossena. The piece may have been repaired with clay and re-fired during the period indicated by thermoluminescence analysis, while being essentially of 16th century origin.

1. Oxford Research Laboratory for Archaeology and the History of Art, *Report of Thermoluminescence Analysis,* sample no. 281p49, 1979: last fired less than 170 years ago.
2. Cf. J. Pope-Hennessy, *Catalogue of Italian Sculpture in the Victoria and Albert Museum,* London, 1964, vol. II, nos. 528, 537.

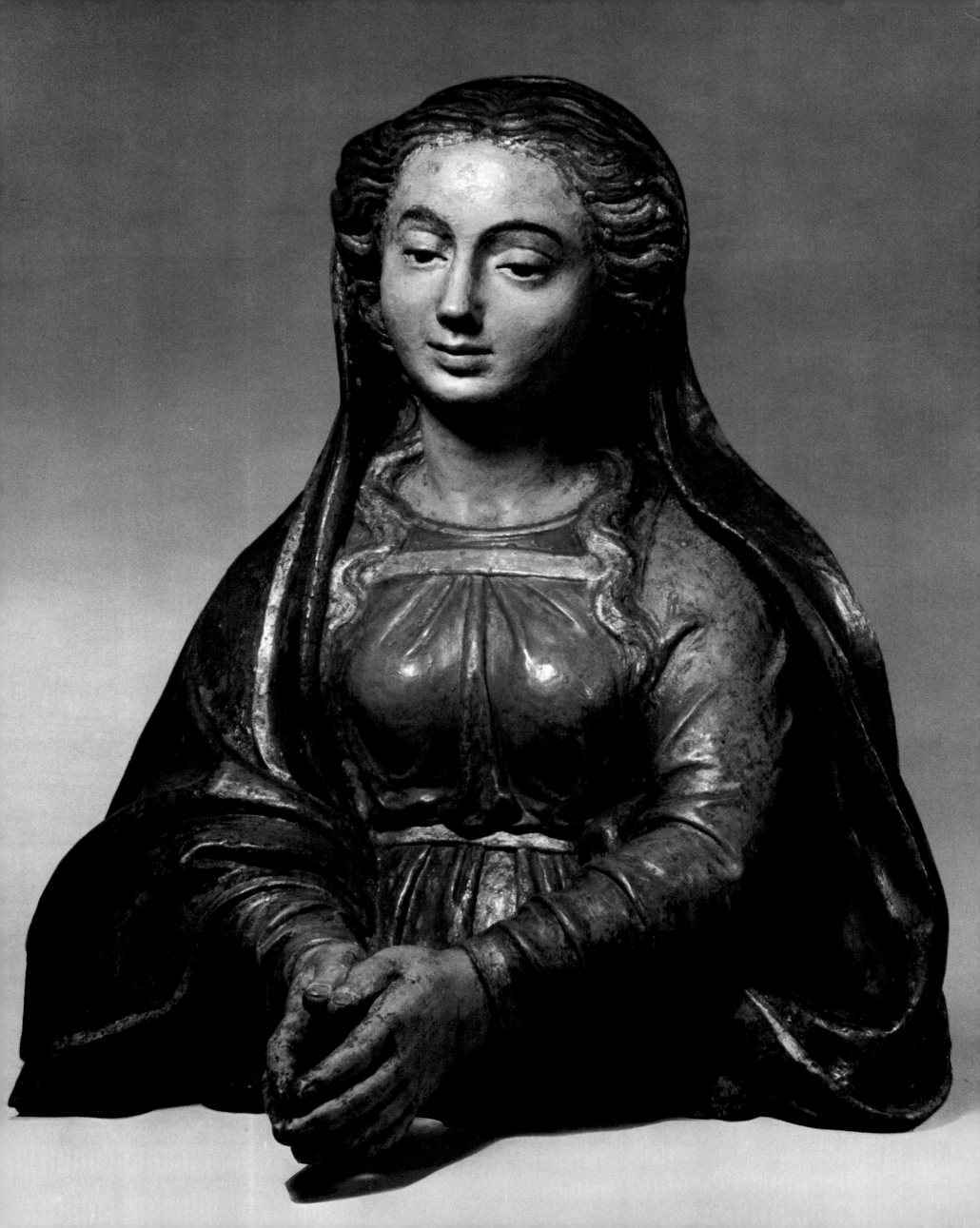

LIST OF FIGURES IN TEXT

Introduction: Fig. 1. Leone Leoni, *Michelangelo,* silver medal, 1563, Victoria and Albert Museum. London.

Fig. 2. *Female Figurine,* terra-cotta, Anatolia, ca. 3rd millenium B.C., the Arthur M. Sackler Collections, New York.

Fig. 3. *Medusa-mask,* decorative terra-cotta roof-tile, Etruscan, 6th century B.C., Museo Nazionale di Villa Giulia, Rome.

Fig. 4. *Woman,* terra-cotta, Tanagra, late 4th or early 3rd century B.C., Bowdoin College Museum of Art, Brunswick, Maine.

Fig. 5. Giambologna, *Florence Triumphant Over Pisa,* wax, ca. 1565, Victoria and Albert Museum. London.

Fig. 6. Andrea del Verrocchio, *Forteguerri Monument,* terra-cotta, ca. 1476, Victoria and Albert Museum. London.

Fig. 7. Jacopo Sansovino, *St. Paul,* terra-cotta, ca. 1515, Musée Jacquemart-André, Paris.

Fig. 8. Michelangelo, *Hercules and Cacus,* terra-cotta, ca. 1525-28, Casa Buonarotti, Florence.

Fig. 9. Niccolò della Casa, *Baccio Bandinelli With Models,* engraving, mid-16th century, Museum of Fine Arts, Boston.

Fig. 10. Giambologna, *Florence Triumphant Over Pisa,* terra-cotta, 1565, Victoria and Albert Museum, London.

Fig. 11. Detail of statuette in Fig. 10, during conservation, showing hollow modelling of torso.

Fig. 12. Detail of statuette in Fig. 10, showing imprint of wood-grain on underside.

Fig. 13. Giambologna, *Florence Triumphant Over Pisa,* clay with admixtures, 1565, Galleria dell'Accadèmia, Florence.

Fig. 14. Giambologna, *River-god,* terra-cotta, ca. 1585, Victoria and Albert Museum, London.

Fig. 15. Gianlorenzo Bernini, *Angel Holding the Scroll,* terra-cotta, ca. 1668, Fogg Art Museum, Harvard University, Cambridge, Mass.

Fig. 16. Luca della Robbia, *Virgin and Child,* tin-glazed terra-cotta, third quarter of the 15th century, Edith A. and Percy S. Straus Collection, Museum of Fine Arts, Houston, Texas.

Fig. 17. Luca della Robbia, *Visitation,* detail showing upper part of Virgin Mary, tin-glazed terra-cotta, pre-1445, San Giovanni Furocivitas, Pistoia.

Fig. 18. Florentine School, *Madonna and Child,* terra-cotta, painted and gilded, ca. 1435, Samuel H. Kress Collection, National Gallery of Art, Washington, D.C.

Fig. 19. Andrea del Verrocchio, *Giuliano de' Medici,* terra-cotta, Andrew Mellon Collection, National Gallery of Art, Washington, D.C.

Fig. 20. Pietro Torrigiano, *King Henry VII,* pigmented terra-cotta, ca. 1510, Victoria and Albert Museum, London.

Fig. 21. Niccolò dell'Arca, *Lamentation,* detail showing upper part of the Virgin Mary, pigmented terra-cotta, 1463, Santa Maria della Vita, Bologna.

Fig. 22. Alessandro Vittoria, *Self-portrait,* terra-cotta, late 16th century, Victoria and Albert Museum, London.

Fig. 23. Alessandro Algardi, *Cardinal Paolo Emilio Zacchia,* detail, terra-cotta, ca. 1652, Victoria and Albert Museum, London.

Fig. 24. Clodion, model for *Poetry and Music,* terra-cotta, Loula D. Lasker Fund, National Gallery of Art, Washington, D.C.

No. 1: Fig. 1. Mazzoni, *Head of Christ,* pigmented terra-cotta, fragment from a *Lamentation* for Sant'Antonio di Castello, Venice, 1585-1589, now in the Museo Civico, Padua.

No. 2: Fig. 1. Ghiberti, *The Nativity of Christ,* bronze, ca. 1410, north door of Baptistry, Florence.

Fig. 2. Michele da Firenze, *The Nativity of Christ,* terra-cotta, ca. 1436, Pellegrini Chapel, Sant'Anastasia, Verona.

Fig. 3. Ghiberti, *Adoration of the Magi,* bronze, ca. 1410, north door of Baptistry, Florence.

Fig. 4. Michele da Firenze, *Adoration of the Magi,* terra-cotta, ca. 1436, Pellegrini Chapel, Sant'Anastasia, Verona.

Fig. 5. Michele da Firenze, *Altare delle Statuine,* terra-cotta, ca. 1441, Cathedral, Modena.

Nos. 3/4: Fig. 1. Attributed to Minelli (but probably by Pizolo), *St. Catherine of Siena,* terra-cotta, 15th century, Musée des Arts Décoratifs, Paris.

Fig. 2. Attributed to Minelli (but probably by Pizolo), *St. Catherine of Alexandria,* terra-cotta, 15th century, Musée des Arts Décoratifs, Paris.

Fig. 3. Pizolo, *Altar Relief,* terra-cotta, ca. 1450, Ovetari Chapel, Church of the Eremitani, Padua.

No. 6: Fig. 1. Minelli, *Entombment of Christ with Carlotta of Lusignan,* painted terra-cotta, 1483-87, The Isabella Stewart Gardner Museum, Boston.

Fig. 2. Anonymous, *Madonna and Child,* terra-cotta with traces of paint, ca. 1525, Philbrook Art Center, Tulsa.

No. 7: Fig. 1. Style of Rustici, *St. Jerome,* stucco, Victoria and Albert Museum, London (possibly a reproduction of a lost bust by Verrocchio).

Fig. 2. Style of Verrocchio, *St. Jerome,* terra-cotta, Victoria and Albert Museum, London.

Fig. 3. Master of the David and St. John Statuettes, *St. Jerome Kneeling,* terra-cotta, Heim Gallery, Paris.

Fig. 5. Ferrucci, *St. Jerome,* marble in a niche in an altarpiece, 1490-1500, Victoria and Albert Museum, London.

No. 8: Fig. 1. Master of the David and St. John Statuettes, *David,* terra-cotta, Victoria and Albert Museum, London.

Fig. 2. Verrocchio, *David,* bronze, before 1469, Museo Nazionale, Florence.

Fig. 3. Donatello, *David,* bronze, Museo Nazionale, Florence.

Fig. 4. Master of the David and St. John Statuettes, *St. Sebastian,* terra-cotta, Victoria and Albert Museum, London.

No. 9: Fig. 1. Master of the Unruly Children, *Charity,* terra-cotta, formerly Kaiser-Friedrich Museum, Berlin.

Fig. 2. Master of the Unruly Children, *Charity,* terra-cotta, Victoria and Albert Museum, London.

Fig. 3. Master of the Unruly Children, *Virgin and Child,* painted terra-cotta, Rijksmuseum, Amsterdam.

Fig. 4. *Group of Warriors,* terra-cotta, Donazione Loeser, Palazzo della Signoria, Florence.

Fig. 5. *River God,* terra-cotta, Italian, 16th century, Museum of Art, Rhode Island School of Design, Providence.

No. 10: Fig. 1. Beccafumi, *Angel Holding a Candlestick,* bronze, 1548-1551, for chancel of Siena Cathedral, Siena.

Fig. 2. Beccafumi, *Angel Holding a Candlestick,* wood, gilded, Opera del Duomo, Siena.

No. 11: Fig. 1. Vincenzo Onofri, *Beroaldo,* terra-cotta, San Martino, Bologna.

No. 13: Fig. 1. Danti, *Pope Julius III Enthroned,* bronze, Perugia Cathedral.

Fig. 2. Detail of clasp with profile of Christ.

No. 14: Fig. 1. Del Duca, *Sacramental Tabernacle,* bronze, Museo di Capodimonte, Naples.

Fig. 2. Detail of Fig. 1 with panel depicting the deposition of Christ.

Fig. 3. Della Porta, *Flagellation,* bronze cast from a preliminary model Victoria and Albert Museum, London.

No. 15: Fig. 1. Bellini, *Portrait of Doge Leonardo Loredan,* painting on wood, National Gallery, London.

Fig. 2. Cattaneo, *Bust of Lazzaro Bonamico,* Museo Civico, Bassano.

No. 16: Fig. 1. Palma, *Ecclesiastic,* marble, Victoria and Albert Museum, London.

No. 18: Fig. 1. Algardi, *Baptism of Christ,* gilt bronze, the Arthur M. Sackler Collections, New York.

No. 19: Fig. 1. *Altar of Filomarino Chapel,* marble, 1640-1642, S.S. Apostoli, Naples.

Fig. 2. Duquesnoy, detail of marble relief above the altar of Filomarino Chapel.

281

No. 19: Fig. 3. Monari, Detail of a still life, oil on canvas, ca. 1700, private collection.

Fig. 4. Duquesnoy, *Study Relief,* wax on figwood, Staatliche Museen Preussischer Kulturbesitz, Berlin.

No. 21: Fig. 1. Mazzuoli, preliminary model for the *Lamentation,* clay, Kunsthistorisches Museum, Vienna.

No. 22/23: Figs. 1/2. Mazzuoli, *Angels,* marble, ca. 1695, altar of San Donato, Siena.

No. 25/26: Figs. 1-4. Rusconi, *Putti Personifying the Four Seasons,* Royal Collection in Windsor Castle.

No. 27/28: Fig. 1. Attributed to Jean-Baptiste Théodon, *St. Peter,* terra-cotta, Staatliche Museen, Berlin-Dahlem.

No. 29/30: Fig. 1. Monnot, *St. Peter,* marble, St. John Lateran, Rome.

Fig. 2. Monnot, *St. Paul,* marble, St. John Lateran, Rome.

Fig. 3. J. J. Kaendler, *St. Peter,* porcelain, Museo Diocesano, Urbino.

Fig. 4. J. J. Kaendler, *St. Paul,* porcelain, Museo Diocesano, Urbino.

No. 32/33: Fig. 1. Giovanni Baratta, *Hercules and the Nemean Lion,* marble, 1709, Rosenborg Castle, Copenhagen.

Fig. 2. Cristoforo Stati, *Samson and the Lion,* marble, 1604-07, Jardin de la Isla, Aranjuez, Spain.

Fig. 3. Giambologna, *Hercules and the Nemean Lion,* bronze, National Gallery of Ireland, Dublin.

Fig. 4. Giovanni Battista Foggini, *Apollo Flaying Marsyas,* bronze, Victoria and Albert Museum, London.

No. 45: Fig. 1. Agostino Corsini, *Worship of the Golden Calf,* terra-cotta, Victoria and Albert Museum, London.

No. 52: Fig. 1. Vaccaro, *King David,* marble, San Ferdinando, Naples.

No. 53: Fig. 1. Papaleo, *St. Luke,* carved wood, National Museum, Valletta, Malta.

No. 56: Fig. 1. Luca della Robbia, *Via della Scala Madonna,* glazed terra-cotta, Florence.

Fig. 2. School of A. della Robbia, *Madonna and Child,* terra-cotta, white glaze, Museum of Fine Arts, Boston.

Fig. 3. Replica, terra-cotta, white glaze, Wallace Collection, London.

Fig. 4. Replica, polychrome terra-cotta, Pinacoteca Comunale, Faenza.

No. 59: Fig. 1. Ferrari, full-size model for bronze caryatids, *Monument to Terenzio Mamiani della Rovere,* Pesaro.

No. 66: Fig. 1. Zawiejski, *Czas,* terra-cotta, National Museum, Warsaw, Gift of Arthur M. Sackler.

No. 67: Fig. 1. Attributed to Pilon, *Dead Christ,* painted stone, Louvre, Paris.

Fig. 2. Pilon, *Sketch for Tomb of Henri II,* terra-cotta, Louvre, Paris.

No. 68: Fig. 1. Lecomte, *Nature,* marble, Versailles.

No. 70: Fig. 1. Coustou, *The Seine and the Marne,* marble, Garden of the Tuileries, Paris.

No. 71/72: Fig. 1. Adam, *Putti with Military Trophies,* terra-cotta, Heim Gallery, London.

Fig. 2. Adam, *Putti with Military Accoutrements,* terra-cotta, Musée Historique de Lorrain, Nancy.

No. 73: Fig. 1. Vassé, *Sorrow,* plaster, study for figure on tomb of Feydeau de Brou, Saint-Merry.

No. 77: Fig. 1. Attributed to Puget, *Resting Mars,* terra-cotta, Musée des Arts Décoratifs, Paris.

Fig. 2. Charpentier, *Death of Meleager,* marble, Louvre, Paris.

No. 79: Fig. 1. Pajou, *Venus and Cupid,* marble, formerly in the Rothschild Collection.

Fig. 2. Pajou, *Venus Receiving the Apple from the Hands cf Love,* drawing, ink on paper, the Arthur M. Sackler Collections, New York.

No. 80: Fig. 1. Pajou, *Bust of the marquis de Montferrier,* terra-cctta, ca. 1781-82, Montreal Museum of Fine Arts.

Fig. 2. Pajou, *Bust of Hubert Robert,* terra-cotta, Ecole des Beaux-Arts, Paris.

No. 85: Fig. 1. Dardel, *Charity,* terra-cotta, 1785, Heim Gallery, London.

No. 88: Fig. 1. Roman, *Dying Gaul,* marble, Capitoline Musem, Rome.

No. 93: Fig. 1. Marin, *Vestal,* terra-cotta, Los Angeles County Museum.

No. 95: Fig. 1. Maindron, *Velléda,* marble, Louvre, Paris.

No. 96: Fig. 1. Carpeaux, *Crouching Flora,* plaster, Louvre, Paris.

No. 97: Fig. 1. Carrier-Belleuse, *Offrande à Bacchus,* terra-cotta, Bruton Gallery, Somerset, England.

No. 99: Fig. 1. Carrier-Belleuse, *Design for a jardinière with Titans,* drawing in charcoal, red chalk and white heightening, Musée de Calais.

Fig. 2. Rodin, set of four *Titans,* terra-cotta, Maryhill Museum, Goldendale, Washington.

Fig. 3. Rodin, set of four *Titans,* bronze, The Israel Museum, Jerusalem.

Fig. 4. Rodin, *Vasque des Titans,* terra-cotta, Rodin Museum, Paris.

Fig. 5. Quellinus, *model for a water pump,* terra-cotta, 1651, Town Hall, Amsterdam.

No. 103: Fig. 1. Magrou, *Tomb of Cardinal de Cabrières,* marble, Montpellier Cathedral.

No. 105: Fig. 1. Dieussart, *Pietà,* marble, 1660, Ghent.

No. 107: Fig. 1. Bernini, *Anima Dannata,* marble, Palazzo di Spagna, Rome.

Fig. 2. Circle of Rustici (?), *Fountain,* bronze, Victoria and Albert Museum, London.

Fig. 3. Attributed to Artus Quellinus I, *Frenzy,* sandstone, Rijksmuseum, Amsterdam.

No. 109: Fig. 1. Van der Haeghen, *St. Joseph et l'enfant,* wood, Nôtre-Dame de Bon Secours, Brussels.

Fig. 2. Vander Haeghen, *St. Joseph,* terra-cotta sketch-model, Musées royaux des Beaux-Arts, Brussels

No. 111: Fig. 1. Hendrick de Keyser, *Screaming Child,* bronze, Victoria and Albert Museum, London.

Fig. 2. De Cock, *Bust of a Weeping Boy,* terra-cotta, art market, Amsterdam.

Fig. 3. Petrus Camper, Fragment of terra-cotta showing face and hand of crying boy, Lakenhal Museum, Leiden.

No. 114: Fig. 1. Plumière and Scheemakers, *Monument to the Duke of Buckingham,* Westminster Abbey, London.

Fig. 2. Plumière, *Spinola Family Monument,* Nôtre-Dame de la Chapelle, Brussels.

No. 115: Fig. 1. T. Rowlandson, *Nollekens Modelling Venus,* drawing, Widener Memorial Collection, Harvard University, Cambridge, Mass.

No. 117: Fig. 1. Vallmitjana, *Torero Herido,* bronze, Abelló Prat Collection, Barcelona.

Fig. 2. Vallmitjana, *Shepherd and Goat,* terra-cotta, present location unknown.

ALPHABETICAL LIST OF ARTISTS

ADAM, Jacob-Sigisbert (1670-1747), attributed to,
Putto Playing A Drum Before Armour, no. 71.
Putti Trying Out Armour, no. 72.

ALGARDI, Alessandro (1598-1654)
Torso of the Resurrected Christ, no. 17.
St. John the Baptist, no. 18.

BARATTA, Count Giovanni (1670-1747), after,
Hercules Slaying the Nemea Lion, no. 32.
Apollo Flaying Marsyas, no 33.

BECCAFUMI, Domenico (1486-1551), circle of,
Candelabrum-bearing Angel, no. 10.

BOCCALARO, Domenico (documented 1495), attributed to,
Judith, no. 5.

BOIZOT, Simon-Louis (1743-1809),
Bust of a High Priest, no. 84.

BOLOGNESE, late 15th or early 16th century,
Bust of a Monk, no. 11.

BOLOGNESE, 18th century,
The Education of the Virgin, no. 43.
Two Bishop Saints Receiving the Palm of Martyrdom, no. 44.

CARPEAUX, Jean-Baptiste (1827-1875),
Flore Accroupie (Crouching Flora), no. 96.

CARRIER-BELLEUSE, A. E. (1824-1887)
Bacchante Offering a Libation to a Bacchic Term, no. 97.
Colombe, no. 98.

CATTANEO, Danese (ca. 1509-1573),
Head of Doge Leonardo Loredan, no. 15.

CHINARD, Joseph (1756-1813),
Lion Supporting an Armorial Cartouche, no.
Phryne Emerging from Her Bath, no. 87.
Othryades Expiring on His Shield, no. 88.
Bust of a Woman, no. 89.

CHINARD, Joseph (1756-1813), attributed to,
Sappho and Phaon, no. 90.

CLODION (1738-1813), Claude Michel called,
Vestal Bearing Wreaths on a Platter, no. 81.
Vestal Holding Sacred Vessels, no. 82.

COCK, Jan Claudius de (1667-1735), circle of,
Bust of a Crying Child, no. 111.

CORNACCHINI, Agostino (1686-1754), attributed to,
Continence of Scipio, no. 37.

CORSINI, Agostino (1688-1772),
St. Anthony of Padua, St. Lawrence and St. Peter Adoring the Christ Child, no. 45.

COUSTOU, Nicolas (1658-1733), attributed to,
A River God and Goddess, no. 70.

DANTI, Vincenzo (1530-1576), attributed to,
Pope Julius III del Monte, no. 13.

DARDEL, Robert-Guillaume (1749-1821),
Equestrian Statuette of the Grand Condé, no. 85.

DIEUSSART, François (ca. 1600-1661),
The Holy Family with St. John the Baptist, no. 105.

DUCA, Jacopo del (ca. 1520-post 1592),
The Deposition of Christ, no. 14.

DUMONT, Jacques-Edme (1761-1844),
Venus Comforting Cupid, no. 91.

DUQUESNOY, François (1597-1643),
Two Angel Musicians, no. 19

DURET, Francisque-Joseph (1804-1865),
Sketch for a Figure of François Chateaubriand, no. 94.

EMILIAN, late 17th century,
St. Blaise (San Biagio), no. 38.

FERRARI, Ettore (1845-1929),
Monument with Angel and Two Mourners, no. 58.
Standing Draped Man Representing Fatherland, no. 59.

FERRUCCI, Andrea (1465-1526), attributed to,
St. Jerome, no. 7.

FLEMISH, ca. 1700,
Virgin and Child, no. 108.

FLORENTINE, mid-19th century,
Sketch-model for a Wall Monument with a Figure of Charity, no. 54.
Sketch-model for a Wall Monument with a Male Portrait-Bust, no. 55.

FRENCH, ca. 1700-1715,
A Study of a Fallen Man in Agony, no. 77.

GANDOLFI, Ubaldo (1728-1781), circle of,
St. Romuald (?), no. 47.
St. Petronius (?), no. 48.

GERMAN, South, late 15th century,
Christ Kneeling, no. 104.

HAEGHEN, Jan-Baptiste van der (1688-1738/40),
St. Joseph Holding the Christ Child, no. 109.

HARDY, Pierre-Jean (1653-1731),
Virgin and Child, no. 69.

ITALIAN, mid-16th century,
Roman Emperor, no. 12.

ITALIAN, North, mid-to-late-15th century.
The Nativity of Christ and the Annunciation to the Shepherds, no. 2.

ITALIAN, 19th century,
Virgin Annunciate, no. A.
Pietà, no. B.

LECOMTE, Louis (1639-1694),
Nature, no. 68.

LEMOYNE, Jean-Baptiste (1704-1778),
Bust of Henri-Claude, comte d'Harcourt, no. 74.
François Boucher, no. 75.
Mme. Boucher, no. 76.

MAGROU, Jean-Marie-Joseph (1869-1945),
Maquette for the Tomb of Cardinal de Cabrières, no. 103.

MAILLOL, Aristide (1861-1944),
Head of a Young Woman, no. 102.

MAINDRON, Etienne-Hippolyte (1801-1884),
Velléda, no. 95.

MARIN, Joseph-Charles (1759-1834), attributed to,
Vestal Holding a Vase, no. 93.

MARINALI, Angelo (1654-1701), attributed to,
Venetian Senator, no. 51.

MARTINI, Arturo (1889-1947),
Girl Kneeling and Dressing Her Hair, no. 60.
Girl Seated and Drying Her Foot (?), no. 61.
Wrestlers, no. 62.
Man on Horse, no. 63.
Horse Tamer, no. 64.
Pair of Clothed Figures, no. 65.

MASTER of the David and St. John Statuettes, late 15th century,
David, no. 8.

MASTER of the Unruly Children, early 16th century,
Virgin and Child, no. 9.

MAZZA, Giuseppe (1653-1741),
David Triumphant Over Goliath, no. 39.
Walking Cupid (?), no. 40.

MAZZA, Giuseppe (1653-1741), attributed to,
Virgin Mary (?) Wearing a Veil, no. 41.

MAZZONI, Guido (active 1473-1518), circle of,
Bust of Christ, no. 1.

MAZZUOLI, Giuseppe (1644-1725),
Lamentation, no. 21.
Kneeling Angels, nos. 22, 23.

MAZZUOLI, circle of, late 17th or early 18th century,
The Virgin in Adoration or Annunciate, no. 24.

MICHEL, Claude (see CLODION)

MILHOMME, François-Dominique-Aimé (1758-1823),
Brutus Lamenting Over the Dead Lucretia, no. 92.

MINELLI, Giovanni (ca. 1440-1527), attributed to,
St. Catherine of Alexandria, no. 6.

MONNOT, Pierre (1657-1733), attributed to,
St. Peter, no. 29.
St. Paul, no. 30.

NETHERLANDISH, mid-17th century,
Bust of a Man Screaming, no. 107.

NETHERLANDISH, ca. 1700,
Meleager or Hercules, no. 110.

NOLLEKENS, Joseph (1737-1823),
Paetus and Arria, no. 115.

PAJOU, Augustin (1730-1809),
Silenus, no. 78.
Venus Receiving the Apple from the Hands of Love, no. 79.
Bust of Corbin de Cordet de Florensac, no. 80.

PALMA, Felice (1583-1625), attributed to,
Bust of a Cleric, no. 16.

PANTANELLI, Sebastiano (n.d.-1792),
Statue of Pope Clement XIV Ganganelli, no. 49.

PAPALEO, Pietro (ca. 1642 - ca.1718),
St. Luke, no. 53.

PARODI, Filippo (1630-1702), attributed to,
Genoese Senator, no. 50.

PIGALLE, Jean-Baptiste (1714-1785),
Mercury, no. 83.

PILON, Germain (ca. 1506-1565), circle of,
Dead Christ, no. 67.

PIÒ, Angelo Gabriello (1690-1769),
Christ on the Road to Emmaus, no. 46.

PIZOLO, Nicolo (active 1438-1453), attributed to,
St. Francis, no. 3.
St. Clare, no. 4.

PLUMIÈRE, Pierre Denis (1688-1721),
Father Time Carrying Off a Dead Infant, no. 114.

POMPE, Walter (1703-1777), attributed to,
Putti Bird's-nesting, no. 112.

POMPE, style of, 19th century,
The Christ Child as Saviour, no. 113.

QUELLINUS, Artus, the Elder (1609-1668), circle of,
Tarquin and Lucretia, no. 106.

ROBBIA, Andrea della (1435-1528), after,
Virgin and Child, no. 56.

RODIN, Auguste (1840-1917) and Albert Carrier-Belleuse
(1824-1887), *Vasque des Titans*, no. 99.

RODIN, Auguste (1840-1917), attributed to,
Torso Standing on One Leg, no. 100.

ROMAN, third quarter of 17th century,
Ascension of St. Catherine of Siena, no. 20.

ROMAN, early 18th century,
St. Peter, no. 27.
St. Andrew, no. 28.
Pope Clement XI Albani, no. 31.

ROSA, Ercole (1846-1893),
Genius of the Papacy, no. 57.

RUSCONI, Camillo (1658-1728),
Putto Personifying Summer, no. 25.
Putto Personifying Winter, no. 26.

SOLDANI-BENZI, Massimiliano (1656-1740),
Apotheosis of Grand Master Fra Antonio Manoel de Vilhena, no. 34.

SOLDANI, circle of, early 18th century,
Adoration of the Magi, no. 35.
Preaching of St. John the Baptist, no. 36.

SPANISH, late 17th century,
Melchior and his Page, no. 116.

TOSELLI, Ottavio (1695-1777) and Nicola (1706-1782),
The Miracle of the Cranes, no. 42.

VACCARO, Lorenzo (1655-1706),
King David, no. 52.

VASSÉ, Louis Claude (1716-1772),
Mourning Woman and Putto, no. 73.

VALMITJANA y Barbany, Venancio (1829-1919),
Torero Herido (Wounded Bullfighter), no. 117.

ZAWIEJSKI, Mieczylslaw Leon (1856-1933),
La Vedetta: La Gazzetta del Popolo (The Lookout: The People's Gazette), no. 66.

BIBLIOGRAPHY

A

Adhémar, Jean, and Gertrude Dordor, "Les tombeaux de la collection Caignières à la Bibliothèque Nationale (Tome I)," *Gazette des Beaux-Arts*, 6ᵉ pér., 84 (July/September, 1974), pp. 1-192.
———, and Gertrude Dordor, "Les tombeaux de la collection Caignières à la Bibliothèque Nationale (Tome II)," *Gazette des Beaux-Arts*, 6ᵉ pér., 88 (July/August, 1976), pp. 1-88.
———, see Jean Seznec.

Alhadeff, Albert, "Michelangelo and the Early Rodin," *The Art Bulletin*, XLV, no. 4, December, 1963, pp. 363-367 and figs. 1-12.

American Art Galleries and Plaza Hotel, *Raoul Tolentino Collection* (sale catalogue), New York, April 21-24 and April 26-27, 1920.

Arcade Gallery, *Sculpture* (exhibition catalogue), London, November, 1957.

Ariès, Philippe, *L'homme devant la mort*, Editions du Seuil, Paris, 1977.

The Art Institute of Chicago and The Metropolitan Museum of Art, *Gauguin* (exhibition catalogue), Chicago/New York, 1959.

Ashbee, Charles Robert (trans.), *The Treatises of Benvenuto Cellini on Goldsmithing and Sculpture*, London, 1898, Dover Publications, New York, 1967.

Avery, Charles, *Florentine Renaissance Sculpture*, Harper & Row, London/New York, 1970.

———, "From David d'Angers to Rodin: Britain's National Collection of French Nineteenth-Century Sculpture," *The Connoisseur*, 179, no. 722, April, 1972, pp. 230-239.

———, "Hendrick de Keyser as a sculptor of small bronzes," *Bulletin van het Rijksmuseum*, XXI, 1973, pp. 3-24.

———, "François Dieussart, Portrait Sculptor to the Courts of Northern Europe," *Victoria and Albert Museum Yearbook*, 4, Phaidon, London, 1974, pp. 63-99.

———, "Three Marble Reliefs by Luca della Robbia," *Museum Studies 8*, The Art Institute of Chicago, Chicago, 1976, pp. 7-37.

———, "Bernardo Vecchietti and the wax models of Giambologna," *Atti del I Congresso Internazionale sulla Ceroplastica nella scienza nell'arte*, Florence. 1975 (Florence, Alschki, 1977), II, pp. 461-474.

———, "Benvenuto Cellini's bronze bust of Bindo Altoviti," *The Connoisseur*, 198, May, 1978, pp. 62-72.

———, "Giambologna's sketch-models and his sculptural technique," *The Connoisseur*, 199, Sept., 1978, pp. 3-11.

———, "Laurent Delvaux's Sculpture in England," *National Trust Studies*, II, 1980, pp. 150-170.

———, "La cera sempre aspetta: wax sketch-models for sculpture," *Proceedings of the Second International Congress on Wax-modelling*, London, 1978 (in press, 1980).

———, and Anthony Radcliffe, *Giambologna, Sculptor to the Medici* (exhibition catalogue), Arts Council of Great Britain, London, 1978.

Azzopardi, Canon Reverend John, "Il-Krisja Ta'S. Pawl tar-Rabat fis-1680," *Il Festa Taghna*, Malta, 1980.

B

Babelon, Jean, *Germain Pilon*, Les Beaux-Arts, edition d'études et de documents, Paris, 1927.

Baldinucci, Filippo, "Camillo Rusconi, Scultor Milanese," *Archivi d'Italia*, edited by Sergio S. Ludovici, series 2, no. 17, 1950.

———, *Notizie dei professori del disegno da Cimabue in qua*, Florence, 1631-88; reprinted. F. Ranalli, ed., V. Batelli, 5 volumes, Florence, 1845-1847.

Baudouin, J. (trans.), *Iconologia* by Cesare Ripa, L. Villaine, Paris, 1677.

Becker Dr. Felix, see Dr. Ulrich Thieme.

Bellori Giovanni Pietro, *Le vite de'pittori, scultori, e architetti moderni*, Rome, 1672.

Bibliotheca Sanctorum, 12 volumes and Index, Istituto Giovanni XXIII della Pontificia Università Lateranense, Rome, 1961-1970.

Black-Nardeau Gallery, Monte Carlo, *Sculpture and Works of Art 1500 to 1900* (exhibition catalogue), Monaco, 1980.

Blanc, Charles, "Francisque Duret," *Gazette des Beaux-Arts*, XX, February, 1866, pp. 97-118.

Bodelsen, Merete, *Gauguin's Ceramics, a study in the development of his art*, Faber and Faber, in association with Nordisk Sprog-og Kulturforlag, London and Copenhagen, 1964.

Borghini, Raffaello, *Il Riposo*, Giorgio Marescotti, Florence, 1584.

Bottari, Giovanni, and Stefano Ticozzi, *Raccolta di lettere sulla pittura, scultura ed architettura*, Milan, 1822.

Bourgeois, Emile, *Le Biscuit de Sèvres au XVIIIᵉ Siècle*, Goupil, Paris, 1913.

Brinckmann, Albert E., *Barock-Bozzetti*, 4 volumes, Frankfurter Verlagsanstalt, Frankfurt A. M., 1923-1925.

Broeder, Frederick den, "The Lateran Apostles," *Apollo*, LXXXV, May, 1967, pp. 360-365.

Bruton Gallery, *French Sculpture: 1775-1945* (exhibition catalogue), Somerset, April/May, 1979.

Bunnett, F. (trans.), *Life of Michael Angelo* by Herman Grimm, 2 volumes, London, 1865.

C

Cahn, Walter, see Cornelius C. Vermeule, III.

Calderini, Marco, *Vincenzo Vela scultore*, Edizioni d'Arte E. Celanza, Turin, 1920.

Carrier-Belleuse, Albert, *Application de la figure humaine à la décoration et à l'Ornamentation industrielles*, A. Guerinet, Paris, 1884.

Cellini, Benvenuto (trans. C. R. Ashbee), *Treatises of Benvenuto Cellini on Goldsmithing and Sculpture*, London, 1898; Dover Publications, New York, 1967.

Cellini, Benvenuto (trans. J. A. Symonds), *The Life of Benvenuto Cellini, written by himself* (intro. and illus. John Pope-Hennessy), Phaidon, London, 1949.

Chabrun, Jean-François, see Robert Descharnes.

Chapelle, Salomon de la, "Catalogue des oeuvres de Chinard," *Revue du Lyonnais*, XXIII, 1897.

Charageat, Marguerite, "Vénus donnant un message à Mercure," *La Revue des Arts*, no. 4, 1953, pp. 217-222.

Chateaubriand, François, *Les Martyrs*, Pourrat Brothers, Paris, 1809; revised edition, 1839.

Christie, Manson and Wood, Sale Catalogue, London, November 1, 1871.

———, Sale Catalogue, London, December 1, 1871.

———, Sale Catalogue, London, July 1, 1976.

Ciechanowiecki, Andrew, "A Bozzetto by Lorenzo Vaccaro," *The Burlington Magazine*, CXXI, April, 1979, pp. 252-253.

Cladell, Judith, *Rodin: sa vie glorieuse, sa vie inconnue*, Bernard Grasset, Paris, 1936 (definitive ed., 1950).

Clarke, T. H., "Die 'Römische Bestellung'-Die Meissener Altar-Garnitur Die August III. Dem Kardinal Annibale Albani Im Jahre 1736 Schenkte," *Keramos*, 86, October, 1979, pp. 3-52.

Collections des Livrets des Anciennes Expositions depuis 1673 jusqu'en 1800, (Salon of 1795), Paris, 1871.

Colnaghi and Company, P. & D., Ltd., *Exhibition of Seventeenth and Eighteenth Century Italian Sculpture*, London, February/March, 1965.

Coural, Jean, "Note sur le tombeau de Paul-Esprit Feydeau de Brou par Louis-Claude Vassé," *Revue de l'Art*, 40/41, 1978, pp. 203-208.

D

Davies, Martin, *The Earlier Italian Schools,* National Gallery, London, 1961, 2nd ed. (rev.).

Descharnes, Robert, and Jean-François Chabrun, *Auguste Rodin,* Viking Press, New York/London, 1967.

Detroit Institute of Art, *The Twilight of the Medici: Late Baroque Art in Florence 1670-1743* (exhibition catalogue), Detroit/Florence, 1974.

Dominici, Bernardo dé, *Vite de'pittori, scultori, ed architetti napoletani,* 3 volumes, Naples, 1742.

Dordor, Gertrude, see Jean Adhémar.

Draper, James David, "New Terracottas by Boizot and Julien," *Metropolitan Museum Journal,* 12, 1977, 141-149.

E

Einem, Herbert von, "Der Torso als Thema der bildenden Kunst," *Zeitschrift für Asthetik und Allgemeine Kunstwissenschaft,* XXIX, 1935.

Elsen, Albert E., *Rodin,* Museum of Modern Art, New York, 1963.

————, "Rodin and the Partial Figure," *The Partial Figure in Modern Sculpture* (exhibition catalogue), The Baltimore Museum of Art, Baltimore, 1969.

Enciclopedia Italiana di scienze, lettere ed arti, 35 volumes, Istituto Giovanni Treccani, Rome, 1929-37.

Enciclopedia Universal Illustrada Europeo-Americana, 70 volumes, Espasa-Calpe, Madrid/Barcelona, n.d., vol. I–vol. XXXIX, 1920-1930, vol. XL–vol. LXX.

Enggass, Robert, *Early Eighteenth Century Sculpture in Rome,* 2 volumes, The Pennsylvania State University Press, University Park and London, 1976.

Esdaile, Katherine, "Group of Terra-cotta Models by Joseph Nollekens, R.A.," *The Burlington Magazine,* LXXXV, September, 1944, pp. 220-223.

Exposition Universelle, *Catalogue Général Officiel, oeuvres de l'art, Exposition Centennale de l'art française (1800-1889),* Paris, 1900.

Exposition Universelle de 1855, *Explication des ouvrages de peinture, sculpture, gravure, lithographie et architecture,* Paris, 1855.

F

Fabriczy, Cornelius von, "Giovanni Minnello," *Jahrbuch der Königlich Preuszischen Kunstsammlungen,* vol. 28, G. Grote'sche Verlagsbuchhandlung, Berlin, 1907, pp. 53-89.

Fiocco, Giuseppe, "Michele da Firenze," *Dedalo,* XII, 1932, pp. 542-562.

————, *L'arte di Andrea Mantegna,* Neri Pozza, editore, Venice, 1959.

Fliche, Augustin, *Les Villes d'Art célèbres: Montpellier,* Librairie Renouard, Paris, 1935.

Fremantle, Katherine, *The Baroque Town Hall of Amsterdam,* Haentjens Dekker and Gumbert, Utrecht, 1959.

Fusco, Peter, and H.W. Janson, eds., *The Romantics to Rodin* (exhibition catalogue), Los Angeles County Museum of Art, Los Angeles, 1980.

G

Gaborit, Jean-René, "L'Adoration du Christ mort, Terre cuite ferraraise du Musée du Louvre," *Fondation Eugène Piot, Monuments et Mémoires,* vol. 59, Paris, L'Académie des Inscriptions et Belles-Lettres, 1974, pp. 209-229.

Galerie Cailleux, *Autour de Néoclassicisme* (exhibition catalogue), Paris, March, 1973.

Galerie Georgès Petit, *Emile Strauss Collection* (sale catalogue), Paris, June 3-4, 1929.

Galerie Jean Charpentier, Sale Catalogue, Paris, June 20, 1933.

Gauguin, Paul, *Ancien culte mahorie* (facile edition, Commentary by René Huyghe), La Palme, Paris, 1951.

Gautier, Théophile, *Les Beaux-Arts en Europe,* second series, Michel Lévy Frères, Paris, 1856.

George, Waldemar, *Artistide Maillol et l'âme de la sculpture,* Editions Ides et Calendes, Neuchâtel, 1977.

Gilbert, Creighton, ed., *Renaissance Art,* Harper & Row, New York, 1970.

Girodie, André, see Henri Vial.

Goldscheider, Cecile, see Ionel Jianou.

Goldscheider, Ludwig, *A Survey of Michelangelo's Models in Wax and Clay,* Phaidon, London, 1962.

Gramberg, Werner, *Die Düsseldorfer Skizzenbücher des Guglielmo della Porta,* 3 volumes, Gebr. Mann Verlag, Berlin, 1964.

Grand Palais, *Sur les traces de Jean-Baptiste Carpeaux* (exhibition catalogue), Éditions de la Réunion des Musées nationaux, Paris, 1975.

————, *Chardin* (exhibition catalogue), Editions de la Réunion des Musées nationaux, Paris, 1979.

Grand Palais des Champs-Elysées, *Explication des ouvrages de peinture, sculpture, architecture, gravure, et lithographie des Artistes vivans* (Salon of 1926), Imprimerie Georges Lang, Paris, 1926.

Gray, Christopher, *Sculptures and Ceramics of Paul Gauguin,* Johns Hopkins Press, Baltimore, 1963.

Grimm, Herman (trans. F. Bunnett), *Life of Michael Angelo,* 2 volumes, London, 1865.

Gronau, Georg, *Documenti Artistici Urbinati,* G. C. Sansoni, Florence, 1936.

Guiffrey, Jules, *Livret de l'exposition du Colisée (1776) suivi de l'analyse de l'Exposition ouverte à Elisée en 1797 et précedé d'une histoire du Colisée après les mémoires du temps avec une table des artistes qui prirent part à ces deux expositions,* Baur, Paris, 1875.

————, publisher, *Comptes des bâtiments du roi sous le règne de Louis XIV,* 5 volumes, Paris, 1881-1901.

H

Hadley, Rollin van N., see Cornelius C. Vermeule, III.

Hager, Werner, *Die Ehrenstatuen der Päpste,* Buchdruckerei Poeschel and Trepte, Leipzig, 1929.

Halsema-Kubes, Willy, see Jaap Leeuwenberg.

Hamburger Kunsthalle, *Johan Tobias Sergel* (exhibition catalogue), Hamburg, May/September, 1975.

Hargrove, June, "Sculptures et dessins d'Albert Carrier-Belleuse au Musée des Beaux-Arts de Calais," *La Revue du Louvre,* 1976, pp. 411-424.

————, *The Life and Work of Albert Carrier-Belleuse,* Garland Press, New York and London, 1977.

Hawkins, Jennifer, *Rodin Sculptures,* Victoria and Albert Museum, London, 1975.

Heim Gallery (London), *Italian Paintings and Sculptures of the 17th and 18th Centuries,* Summer Exhibition, 1966.

————, *Forty Paintings and Sculptures from the Gallery's Collection,* Autumn Exhibition, 1966.

————, *Baroque Sketches, Drawings and Sculptures,* Autumn Exhibition, 1967.

————, *Baroque Paintings, Sketches and Sculptures for the Collector,* Autumn Exhibition, 1968.

————, *French Paintings and Sculptures of the 18th Century,* Winter Exhibition, 1968.

————, *Baroque Art for the Collector,* Autumn Exhibition, 1969.

————, *Paintings and Sculptures of the Baroque,* Autumn Exhibition, 1970.

————, *Faces and Figures of the Baroque,* Autumn Exhibition, 1971.

————, *Sculptures of the 15th and 16th Centuries,* Summer Exhibition, 1972.

————, *Paintings and Sculptures of the Italian Baroque,* Summer Exhibition, 1973.

————, *Italian Paintings and Sculptures of the 17th and 18th Centuries,* Tenth Summer Exhibition, 1976.

————, *Aspects of French Academic Art: 1680-1780,* Summer Exhibition, 1977.

———, *The Baroque in Italy: Paintings and Sculptures 1600-1720*, Summer Exhibition, 1978.

———, *Recent Acquisitions: French Paintings and Sculptures of the 17th and 18th Centuries*, Summer Exhibition, 1979.

———, *From Tintoretto to Tiepolo*, Summer Exhibition, 1980.

Heim Gallery (Paris), *Le choix de l'amateur*, March/April, 1974.

———, *Le choix de l'amateur*, June/July, 1975.

Herck, Charles van, "Walter Pompe en zijn Werk," *Jaarbock Antwerpen's Oudheidkundige Kring*, XI, Antwerp, 1935, pp. 145-186.

Herding, Klaus, *Pierre Puget*, Gebe Mann Verlag, Berlin, 1970.

Hill, G. F., *The Medallic Portraits of Christ*, Clarendon Press, Oxford, 1920.

———, and C. Pollard, *Renaissance Medals from the Samuel H. Kress Collection at the National Gallery of Art* [U.S.], Phaidon for the Samuel H. Kress Foundation, London, 1967.

Hodgkinson, Terence, "A Clodion Statuette in the National Gallery of Canada," *The National Gallery of Canada Bulletin*, 24, Ottawa, 1974, pp. 13-21.

Honour, Hugh, "Count Giovanni Baratta and his Brothers," *The Connoisseur*, 142, December, 1958, pp. 170-177.

———, "English Patrons and Italian Sculptors," *The Connoisseur*, 141, June, 1958, pp. 220-226.

Hôtel de Bullion, Paris, *Paillet Collection* (sale catalogue), Catalogue des tableaux de feu Alex Paillet, June 2, 1814.

Hôtel de la Monnaie, *Louis XV: un moment de perfection de l'art français* (exhibition catalogue), Paris, 1924.

Hôtel Drouot, *Carrier-Belleuse oeuvres* (sale catalogue), December 26, 1868.

———, *Carrier-Belleuse oeuvres* (sale catalogue), December 21, 1874.

———, *Carrier-Belleuse oeuvres* (sale catalogue), April 25, 1876.

———, *Carrier-Belleuse oeuvres* (sale catalogue), May 12, 1883.

———, *Carrier-Belleuse Collection* (sale catalogue), December 19-23, 1887.

———, *Dubois-Chefdebien Collection* (sale catalogue), Paris, February 13, 1941.

I

Impruneta, *La Civiltà del Cotto: Arte della terracottta Nell'area Fiorentina dal XV al XX secolo* (exhibition catalogue), Impruneta, Italy, May/October, 1980.

Ingersoll-Smouse, Florence, *La sculpture funéraire en France au XVIIIᵉ siècle*, Schemit, Paris, 1921.

J

Jacquot, Albert, "Les Adam, Les Michel, et Clodion," *Réunion des Sociétés des Beaux-Arts des Départments*, 1897, pp. 650-739.

Janson, H.W., "Rodin and Carrier-Belleuse: the *Vase des Titans*," *The Art Bulletin*, volume L, September, 1968, pp. 278-280.

Janson, H.W., see Peter Fusco.

Jianou, Ionel, and Cecile Goldscheider, *Rodin*, Editions d'Art, Paris, 1967.

Jones, H. Stuart, *The Sculptures of the Museo Capitolino*, VI of a Catalogue of the Ancient Sculptures preserved in the Municipal Collections of Rome, by member of the British Museum School at Rome, Clarendon Press, Oxford, 1912-1926.

K

Kalnein, Wend Graf and Michael Levey, *Art and Architecture of the Eighteenth Century in France*, Penguin Books, Harmondsworth, 1972.

Keller, Ulrich, *Reitermonumente absolutischer Fürsten*, Schnell and Steiner, Munich, 1971.

Keutner, Herbert, "Critical Remarks on the Work of Agostino Cornacchini," *North Carolina Museum of Art Bulletin*, I, Winter, Raleigh, 1957-1958, nos. 4-5, pp. 13-22.

———, "The Life of Agostino Cornacchini by Francesco Maria Gabburri," *North Carolina Museum of Art Bulletin*, II, Summer, Raleigh, 1958, no. 1, pp. 37-42.

L

Lami, Stanislas, *Dictionnaire des sculpteurs de l'Ecole française sous le règne de Louis XIV*, Paris, 1906 (Kraus Reprint, Liechtenstein, 1970).

———, *Dictionnaire des sculpteurs de l'Ecole française au dix-huitième siècle*, Paris, 1910 (Kraus Reprint, Liechtenstein, 1970).

Lankheit, Klaus, *Florentinische Barockplastik*, Verlag F. Bruckmann, Munich, 1962.

Lavin, Irving, "Bozzetti and Modelli: Notes on sculptural procedure from the early Renaissance through Bernini," *Stil und Überlieferung in der Kunst des Abendlandes, Akten des 21. Internationalen Kongresses für Kunstgeschichte in Bonn 1964*, Verlag Gebr. Mann, Berlin, 1967, pp. 93-104.

Le Corbeiller, Clare, "Mercury, Messenger of Taste," *The Metropolitan Museum of Art Bulletin*, XXII, Summer, 1963, pp. 22-28.

Le Pausanias français, ou Description du Salon de 1806, F. Buisson, Paris, 1806.

Leeuwenberg, Jaap, and Willy Halsema-Kubes, *Beeldhouwkunst in het Rijksmuseum*, Amsterdam, 1973.

Lemprière, John A., *A Classical Dictionary*, London, n.d., new edition, New York, 1949.

Le Roy, Jacques, baron, *Grand théâtre sacré du Duché de Brabant* (trans. from A. Sanderus [1586-1664] *Chorographia Sacra Brabantiae*), 2 volumes in 4, The Hague, 1734.

Levey, Michael, "The Pose of Pigalle's 'Mercury'," *The Burlington Magazine*, CVI, October, 1964, pp. 462-463.

Levey, Michael, see Wend Graf Kalnein.

Litta, Pompeo, *Celebri Famiglie Italianae*, 12 volumes, L. & F. Bassadonna, Milan, 1819-1911 (vol. I, 1819, *sub voce* Acciaioli).

Loeser, Charles, "Gianfrancesco Rustici," *The Burlington Magazine*, LII, June, 1928, pp. 260-272.

Lugt, Frits, *Répertoire des catalogues de ventes publiques*, 3 volumes, Martinus Nijhoff, The Hague, 1938-1964.

M

Maclehose, Louisa S. (trans.), *Vasari on Technique*, London, 1907; Dover Publications, New York, 1960.

Mallet at Bourdon House, *Sculptures in Terracotta* (exhibition catalogue), London, 1963.

Mann, J.G., *Wallace Collection Catalogues: Sculptures*, His Majesty's Stationery Office, London, 1931.

Manzoni, Roméo, *Vincenzo Véla, L'Homme, le patriote, l'artiste*, Ulrico Hoepli, Milan, 1906.

Marcel, Adrien, see Henri Vial.

Mariani, Valerio, "Bozzetti Berniniani," *Bollettino d'Arte*, IX, 1929-30, pp. 59-65.

Marie, Alfred, and Jeanne Marie, *Marly Editions "Tel,"* Paris, 1947.

Marquand, Allan, *Luca della Robbia*, Princeton Monographs in Art and Archaeology, vol. 3, Princeton, 1914.

———, *Benedetto and Santi Buglioni*, Princeton University Press, Princeton, 1921.

———, *Andrea della Robbia and His Atelier*, 2 volumes, Princeton University Press, Princeton, 1922.

Matzulevitsch, Giannetta, "Tre bozzetti di G. L. Bernini all'Ermitage di Leningrado," *Bollettino d'Arte*, XLVIII, 1963, pp. 67-74.

The Metropolitan Museum of Art, see The Art Institute of Chicago.

Middeldorf, Ulrich, *Sculptures from the Samuel H. Kress Collection: European Schools, XIV-XIX Century*, Phaidon for the Samuel H. Kress Foundation, London, 1976.

Montagu, Jennifer, *"Le Baptême du Christ* d'Alessandro Algardi,*" Revue de l'Art*, 15, 1972, pp. 64-78.

———, "Some Small Sculptures by Giuseppe Piamontini," *Antichità Viva*, 13/3, 1974, pp. 3-21.

Morazzoni, Giuseppe, *Le porcellane italiane*, 2 volumes, Görlich, Milan, new edition, 1960.

Moureyre, Françoise de la, see Souchal, François.

Moureyre-Gavoty, Françoise de la, *Institut de France—Musée Jacquemart—André: Sculpture Italienne*, Paris, 1975, no. 136.

Musée municipal, Montargis (Fr.), *Girodet, 1767-1824, exposition du deuxième centenaire*, Montargis, 1967.

Musée Napoléon, Paris, *Explication des ouvrages de peinture, sculpture, architecture et gravure, des Artistes vivans* (Salon de 1810), Dubray, Imprimeur du Musée Napoléon, November 5, 1810.

Musée royal, Paris, *Explications des ouvrages de peinture, sculpture, architecture, gravure et lithographie des Artistes vivans* (Salon de 1839), Yinchon fils, Paris, March 1, 1839.

Musées royaux des Beaux-Arts de Belgique, *La sculpture au siècle de Rubens*, Exhibition held at Musée d'Art Ancien, Brussels, 1977.

Museo Vela in Ligornetto, *Catalogo della opere di scultura e di pittura*, Tipo-Litografia Cantonale Grassi & Co., Bellinzona, 1925.

Museum Mayer van den Bergh, *Catalogus 2, Beeldhouwkunst*, Antwerp, 1969.

N

Nagler, Georg Kaspar, *Neues Allgemeines Künstler-Lexikon*, 22 volumes, Munich, 1835-52, reprint Verlagsbuchhandlung, Buch- und Kunstdruckerei, E. Mareis, Linz a.D., 1905.

Nava Cellini, Antonia, "Stefano Maderno," *I Maestri della Scultura*, no. 60, Fratelli Fabbri Editori, Milan, 1966.

———, "Per il Borromini e il Duquesnoy ai SS. Apostoli di Napoli," *Paragone*, no. 329, 1977, pp. 26-38.

Norton, Richard, *Bernini and Other Studies in the History of Art*, The Macmillan Co., New York, 1914.

Nôtre-Dame de la Chapelle, Brussels, *Trésors d'art des églises de Bruxelles*, in *Annales de la société royale d'archéologie de Bruxelles*, vol. 56, no. 132, 1979.

O

Opdycke, Leonard, "A Group of Models for Berninesque Sculpture," *Bulletin of the Fogg Museum of Art*, VII, Harvard University, March, 1938, pp. 26-30.

Ossorio y Bernard, M., *Galería Biografica de Artistas Españoles del Siglo XIX*, Libreria Gaudi, Madrid, 1883, reprinted 1975.

P

Paccagnini, Giovanni, "Il Mantegna e la plastica dell'Italia settentrionale," *Bollettino d'Arte*, January-June, 1961, pp. 65-100.

Palazzo della Ragione, *Dopo Mantegna* (exhibition catalogue), Electa Editrice, Padua, 1976.

Palazzo Pretorio, *Lorenzo Bartolini* (exhibition catalogue), Prato, 1978.

Panofsky, Erwin, *Tomb Sculpture*, ed. H. W. Janson, H. N. Abrams, London/New York, 1964.

Pansecchi, Fiorella, "Contributi a Giuseppe Mazzuoli," *Commentari* X, 1959, pp. 33-43.

Parke-Bernet, *Hume Cronyn and Jessica Tandy Collection* (sale catalogue), New York, January 15, 1958.

———, Sale Catalogue, New York, November 1, 1958.

———, *French & Co.* (sale catalogue), New York, November 14, 1968.

Parronchi, Alessandro, "Felice Palma: Nascita del barocco nella scultura Toscana," in *Festschrift: Luitpold Düssler*, Deutscher Kunstverlag, Munich, 1972, pp. 275-298.

Pascoli, Lione, *Vite de'pittori, scultori ed architetti moderni*, 2 volumes, Rome, 1730-1736.

Patte, Pierre, *Monumens érigés en France à la gloire de Louis XV*, Guerinet, Paris, 1765.

Penny, Nicholas, *Church Monuments in Romantic England*, Yale University Press, New Haven and London, 1977.

Perocco, Guido, "Arturo Martini," *I Maestri della Scultura*, no. 68, Fratelli Fabbri Editori, Milan, 1966.

Phillips, John G., "A Sculpture by Agnolo di Polo," *The Metropolitan Museum of Art Bulletin*, October-November, 1971, pp. 80-86.

Planiscig, Leo, *Andrea Riccio*, Anton Schroll and Co., Vienna, 1927.

———, *Venezianische Bildhauer der Renaissance*, Anton Schroll and Company, Vienna, 1921.

Pollard, G., see G.F. Hill.

Pope-Hennessy, John, *Italian Gothic Sculpture*, Phaidon, London, 1955.

———, *Italian Renaissance Sculpture*, Phaidon, London, 1958.

———, *Catalogue of Italian Sculpture in the Victoria and Albert Museum*, 3 volumes, Her Majesty's Stationery Office, London, 1964.

———, "Foggini and Soldani: Some Recent Acquisitions," *Victoria and Albert Museum Bulletin*, III/4, October, 1967, pp. 135-144.

———, *Italian High Renaissance and Baroque Sculpture*, Phaidon, London/New York, 1970.

———, "Some newly acquired Italian sculptures: A Fountain by Rustici," *Victoria and Albert Museum Yearbook*, 4, Phaidon, London, 1974, pp. 21-37.

———, "Thoughts on Andrea della Robbia," *Apollo*, CIX, March, 1979, pp. 176-197.

Q

Quinquenet, Maurice, *Un élève de Clodion: Joseph-Charles Marin, 1759-1834*, Lacoste, Paris, 1948.

R

Radcliffe, Anthony, "Two Bronzes from the Circle of Bernini," *Apollo*, CVIII, December, 1978, pp. 418-423.

Radcliffe, Anthony, see Charles Avery.

Raggio, Olga, "Review of John Pope-Hennessy, *Catalogue of Italian Sculpture in the Victoria and Albert Museum, 1964,*" *The Art Bulletin*, vol. L, March, 1968, pp. 98-105.

Réau, Louis, *Une dynastie de sculpteurs aux XVIIIe siècle: Les Lemoyne*, Les Beaux-Arts, Edition d'études et de documents, Paris, 1927.

———, "Un sculpteur oublié du XVIIIe siècle: Louis-Claude Vassé, 1716-1772," *Gazette des Beaux-Arts*, 6e pér., IV, 1930, pp. 31-56.

———, "Les maquettes des sculpteurs français du XVIIIe siècle," *Bulletin de la société de l'Histoire de l'Art Français*, 1936, pp. 7-28.

———, *J.-B. Pigalle*, P. Tisné, Paris, 1950.

———, *Houdon—sa vie, son oeuvre*, 4 parts in 2 volumes, De Nobele, Paris, 1964.

Riccòmini, Eugenio, *Mostra della Scultura Bolognese del Settecento* (exhibition catalogue), Museo Civico, Bologna, 1965/6.

———, "Guido Mazzoni," *I Maestri della Scultura*, no. 66, Fratelli Fabbri Editori, Milan, 1966.

———, *Ordine e Vaghezza: scultura in Emilia nell'età barocca*, Zanichelli, Bologna, 1972.

Rigoni, Erice, "Il Pittore Nicolò Pizolo," *Arte Veneta*, II, 1948, pp. 141-147.

———, *L'Arte Rinascimentale in Padova, studi e documenti*, Editrice Antenore, Padua, 1970.

Ripa, Cesare, *Iconologia*, J. Baudouin (trans.), L. Villaine, Paris, 1677.

Rocher-Jauneau, Madeleine, "Chinard and the Empire Style," *Apollo*, LXXX, September, 1964, pp. 220-225.

Rodin, Auguste, *L'Art. Entretiens réunis par Paul Gsell*, Bernard Grasset, Paris, 1911.

Rodin Museum, *Rodin, ses collaborateurs et ses amis* (exhibition catalogue), Paris, 1957.

Rodriguez Codolá, Manuel, "Els Escultors Vallmitjana," *Butlleti dels Museus d'Arte de Barcelona*, VI, May, 1936, pp. 136-151.

————, *Venancio y Agapito Vallmitjana Barbany*, Ediciones Patrocinades por la Direccion General de Bellas Artes, Madrid, 1946.

Rosasco, Betsy, "New Documents and Drawings Concerning Lost Statues from the Château of Marly," *Metropolitan Museum Journal*, 10, 1975, pp. 79-96.

Rossi, Filippo, *Il Museo Horne a Firenze*, Electa, Milan, 1967.

Rossi, Paola, "Vicende biografiche de Giralamo Campagna," *Vita Veronese*, XIX, March/April, 1966, pp. 90-100.

Royal Academy and Victoria and Albert Museum, *The Age of Neoclassicism* (exhibition catalogue), Arts Council of Great Britain, London, 1972.

S

Sandrart, Joachim von, *Joachim von Sandrarts Academie der Bou-Bild und, Mahlerey-Kunste von 1675*, Munich, 1925.

Sanminiatelli, Donato, *Domenico Beccafumi*, Bramante Editrice, Milan, 1967.

Sapori, Francesco, *Vincenzo Vela*, no. 8 of *I maestri dell'Arte, monografie d'Artisti italiani moderni*, Edizioni d'Arte E. Celanza, Turin, 1919.

Schlegel, Ursula, "Per Giuseppe e Bartolomeo Mazzuoli: nuovi contributi," *Arte Illustrata*, V, number 47, 1972, pp. 6-8.

————, *Die italienischen Bildwerke des 17, und 18, jahrhunderts*, Mann, Berlin, 1978.

Schmoll gen. Eisenwerth, Josef Adolf, *Der torso als symbol und form*, Bruno Grimm, Baden-Baden, 1954.

————, "Zur Genesis des Torso-Motivs und zur Deutung des Fragmentärischen Stils bei Rodin," *Das Unvollendete als Künstlerische Form*, Francke, Berne and Munich, 1959, pp. 117-139.

Schottmüller, Frida, *Bildwerke der Kaiser-Friedrich-Museums, Die italienischen und spanischen Bildwerke der Renaissance und des Barock*, I, Verlag von Walter de Gruyter & Company, Berlin/Leipzig, first edition, 1913, second edition, revised, 1933.

Semenzato, Camillo, *La Scultura Veneta del Seicento e del Settecento*, Alfieri, Venice, 1966.

Seznec, Jean, and Jean Adhémar, eds., *Diderot, Salons*, 4 volumes, Clarendon Press, Oxford, 1957-1967.

Smith, John T., *Nollekens and his Times*, 2 volumes, London, 1828.

Sotheby & Company, Sale Catalogue, London, June 28, 1967.

————, Sale Catalogue, London, April 17, 1969.

————, Sale Catalogue, London, June 7, 1971.

————, Sale Catalogue, London, November 16, 1972.

Souchal, François, *Les Slodtz*, Editions E. de Boccard, Paris, 1967.

————, *French Sculptors of the 17th and 18th Centuries, The Reign of Louis XV*, vol. A-F, Cassirer, Oxford, 1977.

————, with Françoise de la Moureyre, "Les statues aux façades du Château de Versailles," *Gazette des Beaux-Arts*, 6ᵉ per., 79, February, 1972, pp. 1-110.

Stein, Henri, *Augustin Pajou*, Librairie Centrale des Beaux-Arts, Paris, 1912.

Suboff, von Valentin, "Giuseppe Mazzuoli," *Jahrbuch der Preuszischen Kunstsammlungen*, XLIX, G. Grote'sche Verlagsbuchhandlung, Berlin, 1928, pp. 33-47.

Summers, John David, "The Chronology of Vincenzo Danti's First Works in Florence," *Mitteilungen des Kunsthistorischen Institut in Florenz*, XVI, 1972, pp. 185-198.

Symonds, John Addington (trans.), *The Life of Benvenuto Cellini, written by himself* (intro. and illus. John Pope-Hennessy), Phaidon, London, 1949.

T

Tancock, John, *The Sculpture of Auguste Rodin*, The Collection of the Rodin Museum, Philadelphia Museum of Art, Philadelphia, 1976.

Thieme, Dr. Ulrich, and Dr. Felix Becker, et al., *Allgemeines Lexikon der Bildenden Künstler*, 37 volumes, Veb. E.A. Seemann, Leipzig, 1907-1950.

Thirion, Henri, *Les Adam et Clodion*, A. Quantin, Paris, 1885.

Timofiewitsch, Wladimir, *Girolamo Campagna*, Fink, Munich, 1972.

Tolnoy, Charles de, *Michelangelo, V, The Final Period*, Princeton University Press, Princeton, 1960.

Touring Club Italiano, *Guida d'Italia: Marche*, 3rd edition, Milan, 1962.

Tourneax, Maurice, "La collection de M. le comte de Penha Longa: bustes, médaillons, et statuettes de Chinard," *Les Arts*, 8, no. 95, November, 1909, pp. 1-32.

U

Union centrale des arts decoratifs, *Exposition d'oeuvres du sculpteur Chinard de Lyon* (exhibition catalogue), Pavillon de Marsan (Louvre), 1909/1910.

V

Vaccaj, Giulio, *Pesaro, Italia artistica*, vol. 42, Collezione de monografie illustrate, Bergamo, 1909.

Vasari, Giorgio, *Le vite de' più eccellenti pittori, scultori ed architettori scritte da Giorgio Vasari pittori Aretino con nuove Annotazioni e commenti di Gaetano Milanesi*, 9 volumes, G. C. Sansoni, Editore, Florence, 1906.

————, (trans. Louisa S. Maclehose), *Vasari on Technique*, London, 1907; Dover Publications, New York, 1960.

Venturi, Adolfo, *Storia dell'Arte Italiana*, 11 volumes, U. Hoepli, Milan, 1901-1940.

Verdon, Timothy, *The Art of Guido Mazzoni*, Garland Publishing, Inc., New York/London, 1978.

Vermeule, Cornelius C., III; Walter Cahn; and Rollin van N. Hadley; *Sculpture in the Isabella Stewart Gardner Museum*, Boston, 1977.

Vial, Henri; Adrien Marcel; and André Girodie; *Les artistes décorateurs du bois*, 2 volumes, Jean Schemit, Paris, 1922.

Vitry, Paul, *Musée national du Louvre: Catalogue des sculptures du Moyen âge, de la Renaissance, et des Temps modernes*, I, Paris, 1922.

————, *Musée national du Louvre: Catalogue des sculptures du Moyen âge, de la Renaissance, et des Temps modernes, Supplement*, Paris, 1933.

Vollard, Ambroise, "Une visite de Rodin," *Le Correspondant*, Paris, December 10, 1917, pp. 919-930.

W

Wark, R. R., *Sculpture in the Huntington Collection*, Henry E. Huntington Library and Art Gallery, San Marino, California, 1959.

Wasserman, Jeanne L., ed., *Metamorphoses in Nineteenth Century Sculpture* (exhibition catalogue), Fogg Art Museum, Cambridge, 1975-1976.

Weyl, Martin, "Four Bronze Casts of *The Titans* by Auguste Rodin," *The Israel Museum News*, no. 12, Jerusalem, 1977.

Wildenstein & Co., *French XVIIIth Century Sculpture* (exhibition catalogue), New York, April, 1940.

Willame, Georges, *Laurent Delvaux*, Librairie Nationale d'Art et d'Histoire, G. Van Oest and Cie, editeur, Brussels/Paris, 1914.

Wittkower, Rudolf, *Gian Lorenzo Bernini*, Phaidon, London (2nd ed.), 1966.

PHOTO CREDITS:

A.C.L. BRUXELLES: no. 109, fig. 1; *Alinari:* no. 1, fig. 1, no. 2, figs. 1, 2, 3, 4; nos. 3/4, fig. 3, no. 8, figs. 2, 3, no. 56, figs. 1, 4 (Courtesy of Pinacoteca Comunale, Faenza); *Alinari/Editorial Photocolor Archives:* no. 10, figs. 1, 2, no. 11, fig. 1, no. 107, fig. 1; *Anderson,* Roma: no. 2, fig. 5; *James Austin,* Cambridge, England (Courtesy of Musée Jacquemart André, Paris): Introduction, fig. 7; *Kunsthistorisches Museum,* Wien: no. 21, fig. 1; *Provided by the author, Charles Avery:* Introduction, figs. 3, 17; nos. 29/30, figs. 1, 2, 3, 4; no. 9, fig. 1; no. 13, fig. 1; nos. 32/33, fig. 2; no. 52, fig. 1; no. 73, fig. 1; no. 105, fig. 1, no. 109, fig. 2; *C. Baldarini,* Milano (Courtesy of Victoria and Albert Museum, London): Introduction, fig. 10; *F. Barsotti,* Firenze (Courtesy of Palazzo della Signoria, Florence): no. 9, fig. 4; *Bowdoin College Museum of Art:* Introduction, fig. 4; *Giacomo Brogi,* Firenze (Courtesy of Casa Buonarotti, Florence): Introduction, fig. 8; *Bruton Gallery,* Somerset, England: no. 97, fig. 1; *Caisse Nationale des Monuments Historiques et des Sites:* no. 70, fig. 1; *John Del Campa,* Amsterdam: no. 111, fig. 2; *Cera,* Paris (Courtesy of Ecole Nationale Supérieure des Beaux-Arts, Paris): no. 80, fig. 2; *A. Ciocci:* no. 19, fig. 3; *Courtauld Institute of Art:* no. 114, figs. 1, 2; nos. 25/26, figs. 1, 2, 3, 4; *Ed. Croci:* Introduction, fig. 21; *Prudence Cuming Assoc., Ltd.,* London (Courtesy of Heim Gallery, London): nos. 71/72, fig. 1; *De Danske Kongers Kronologiske Samling Rosenborg,* Copenhagen: nos. 32/33, fig. 1; *A. Dingjan* (Courtesy of Stedelijk Museum "De Lakenhal," Leiden): no. 111, fig. 3; *Famiglia de Vecchi:* nos. 22/23, figs. 1, 2; *Fogg Art Museum,* Harvard University: Introduction, fig. 15; *Gabinetto Fotografico, Soprintendenza beni artistici e storici di Firenze* (Courtesy of Galleria dell'Accademia, Florence): Introduction, fig. 13; *Gabinetto Fotografico, R. Soprintendenza alle Antichata della Campania e del Molise,* Napoli (Courtesy of Museo di Capodimonte, Naples): no. 14, figs. 1, 2; *Isabella Stewart Gardner Museum,* Boston: nos. 5/6, fig. 1; *Heim Gallery,* London: no. 18, fig. 1, no. 66, fig. 1, no. 80, fig. 1, no. 85, fig. 1; *Heim Gallery,* Paris: no. 7, fig. 3; *Robert Houette* (Courtesy of Musée de Calais): no. 99, fig. 1; *The Israel Museum,* Jerusalem: no. 99, fig. 3; *Laboratorio fotografico della soprintendenza alle gallerie Napoli:* no. 19, figs. 1, 2; *Los Angeles County Museum of Art:* no. 93, fig. 1; *Maryhill Museum of Art,* Goldendale, Washington: no. 99, fig. 2; *A. Mewbourn* (Courtesy of Museum of Fine Arts, Houston): Introduction, fig. 16; *Musée des arts décoratifs,* Paris: nos. 3/4, figs. 1, 2; *Musée Historique Lorrain à Nancy:* nos. 71/72, fig. 2; *Musées Nationaux:* no. 67, figs. 1, 2, no. 77, fig. 2, no. 95, fig. 1, no. 96, fig. 1; *Museo Capitolino,* Roma: no. 88, fig. 1; *Museo Civico,* Bassano: no. 15, fig. 2; *Museum of Art, Rhode Island School of Design,* Providence: no. 9, fig. 5; *Museum of Fine Arts,* Boston: Introduction, fig. 9, no. 56, fig 2; *National Gallery,* London: no. 15, fig. 1; *National Gallery of Art,* Washington, D.C.: Introduction, figs. 18, 19, 24; *National Gallery of Ireland,* Dublin: nos. 32/33, fig. 3; *National Museum of Fine Arts,* Valletta, Malta: no. 53, fig. 1; *Otto E. Nelson,* New York: Introduction, fig. 2, no. 13, fig. 2, no. 79, fig. 2, nos. 1-117, Appendix A & B, and all details of Sackler terra-cottas; *Michael Nedzweski,* no. 98 (color); *Claude O'Sughrue,* Montpellier, no. 103, fig. 1; *Philbrook Art Center,* Tulsa: nos. 5/6, fig. 2; *Rijksmuseum,* Amsterdam: no. 9, fig. 3; no. 99, fig. 5; no. 107, fig. 3; *MAS:* no. 117, figs. 1, 2; *Sotheby Parke Bernet,* no. 79, fig. 1; *Staatliche Museen, Preussischer Kulturbesitz, Skulpturengalerie,* Berlin: no. 19, fig. 4, nos. 27/28, fig. 1; *M. Thierry, PRAT:* no. 68, fig. 1; *Victoria and Albert Museum,* London: Introduction, figs. 1, 5, 6, 11, 12, 14, 20, 22, 23, no. 7, figs. 1, 2, 4; no. 8, fig. 1, 4, no. 9, fig. 2; no. 14, fig. 3, no. 16, fig. 1, nos. 32/33, fig. 4, no. 45, fig. 1, no. 107, fig. 2, no. 111, fig. 1; *Wallace Collection,* London: no. 56, fig. 3; *Martin Weyl,* The Israel Museum: no. 99, fig. 4; *Widener Memorial Collection,* Harvard University: no. 115, fig. 1; *Walter Yee,* no. 39 (color).

290

A

abbé Gougenot, Louis (d. 1767), 189
Abbey-church of Ninove, 254
Abbey of St. Denis, funerary chapel of Catherine de'Medici, 158
Abel de Pujol, Denis (1785-1861), 218
Académie des Sciences et des Beaux-Arts, Brussels, 233
Académie royale de peinture et de sculpture, Paris (also in text as Académie, Académie royale, Academy and Royal Academy, Paris), 193, 194; Lecomte 160; Hardy, 162; Coustou, 164; Vassé, 168; Lemoyne, 170; reception pieces, 174, 174 n2; Pajou, 176; Clodion, 184; Pigalle, 188, 189; Boizot, 191; Julien, 202, 203 n4, Sergel, 203 n3; Plumière, 264
Academy of Fine Arts, Rome, 142
Academy schools, 212
Accademia del Disegno, Florence, 64
Accademia di Belle Arti, Venice, 146
Accademia di San Luca, Rome (also in text as Academy of St. Luke, Rome, and Roman Academy of St. Luke), 96, 132; Papaleo, 132; Ferrari, 142; Chinard, 196; two Jean-Jacques Perots, 212
Accademia, Florence 5
Acciaioli, Donato (1622-1704); Ottaviano di Donato (1664-1735); Roberto di Donato di, 76
Acton Collection, Florence, 36
Adam, François-Gaspard (1710-1761),
ADAM, Jacob-Sigisbert, 12, 24, 166, 184; no. 71, Putto Playing a Drum Before Armour, 12, 12, 166, 167; no. 72, Putti Trying Out Armour, 167, 167; Putti with Military Trophies, 166 fig. 1, 167 Putti with Military Accoutrements, 167, 167 fig. 2
Adam, Lambert (17th century); Lambert-Sigisbert (1700-1759); Nicolas-Sébastien (1705-1778), 166
Adeane, Jane; Lord, 78
Adhémar, J., 242 n3, Biblio.
L'Adoration du Christ Mort, 30 n4
Adoration, from life of Christ, 23, 80
Adoration of the Magi (Michele da Firenze), 31, 35 fig. 4; (Ghiberti), 31, 35 fig. 3; no. 35 (Circle of Soldani), 100, 101, 103; no. 115, from composition of, 270, 271, 271
Age of Absolutism, 163
The Age of Bronze (Rodin), 226, 228
Age of Mannerism, 55
Agony in the Garden, 244
Agostini Collection, Bologna, 112 n1
Aldoviti, Bindu, 19
d'Alemagna, Giovanni (1421-1460/61), 36
Allen Memorial Museum, Oberlin College, Ohio, 201
ALGARDI, Alessandro, 24, 66, 108; Cardinal Paolo Emilio Zacchia, 24 fig. 23; Meeting of Attila and Pope Leo the Great, 66; tomb of Pope Leo XI, 66; no. 17, Torso of the Resurrected Christ, 66, 66, 67; no. 18, St. John the Baptist, 68, 68, 69; Baptism of Christ, gilt bronze, 68, 68 fig. 1
Alhadeff, A., 232 n1, n4, Biblio.
Allegrain, Gabriel (1733-1799), 210
Altar Relief (Pizolo), 38, 38 fig. 3
Altare delle Statuine (Michele da Firenze), 31, 35 fig. 5
Altman bequest, The Metropolitan Museum of Art, 189
Ammanati, Bartolomeo (1511-1592), 64
L'Amour se plaignant à Vénus de la piqûre d'une abeille (Dumont), 208
Amsterdam, Rijksmuseum, 49 fig. 3, 232, 248, 251, 251 fig. 3, 261 n2
Amsterdam Town Hall, 232, 248
Anatolia, 6, 17; clay figure, 17 fig. 1
Ancien Culte Mahorie, Gauguin, 237 n5, Biblio.
Angel Gabriel, 80, 87
Angel Holding a Candlestick (Beccafumi), 50, 50 fig. 1, fig. 2
Angel Holding the Scroll (Bernini), 21, 21 fig. 15
Angels (Mazzuoli), 77, 78, 79 figs. 1 and 2
Angers, Ecole des arts et métiers 216
d'Angers, David (1788-1855), 216, 220; Condé Throwing His Bâton into the Enemy's Lines, 194 n3; d'Angiviller commissions, 194
Anima Dannata (Damned Soul) (Bernini), 250, 251 fig. 1
Anizy-le-Château, 220
Annunciate, The Virgin in Adoration or, no. 24 (Circle of Mazzuoli), 80, 80, 81
Annunciation (Calandra), 70, 70 fig. 1, 72
ANONYMOUS, no. 2, 31; no. 11, 52; no. 12, 55; no. 20, 73; no. 27/28, 86; no. 31, 92; no. 33, 106; no. 43, 116; no. 44, 118; no. 54, 134; no. 55, 136; no. 77, 174; no. 104, 244; no. 107, 250;

no. 108, 253; no. 113, 262; no. 116, 270; App. A, 276, App. B, 278
Antique, 164, 184, 188, 203, 219, 228; statues, 196, 202, 268
Antiquity, 14, 17, 206
Antwerp, 226, 228, 232, 248, 258, 260, 264, 268; Mayer van den Bergh Museum, 260, 260 n2, Apennines, 21, 23, 30, 276
Apollo Flaying Marsyas, no. 33 (after Baratta), 94, 95, 96, 96 n8, 97; (Foggini), 96, 97 fig. 4
Apostles, Basilica of S. Giovanni Laterano, Rome, 82, 87
The Apotheosis of Grand Master Fra Antonio Manoel de Vilhena, no. 34 (Soldani-Benzi), 98, 99; other versions, 98
Application de la figure humaine à la décoration et à l'ornementation industrielle, Carrier-Belleuse, 228
Aragos family, 220
Arc de Triomphe, Bordeaux, 196
L'Arc de Triomphe du Carrousel, Paris (also referred to as Arc du Carrousel), 184, 193, 196, 208
dell'Arca, Niccolò (ca. 1435-1494), 23; detail from Lamentation, 23 fig. 21; Circle of, 30
Arcade Gallery, London, 46
"Archaischer torso Apollos," Rainer Maria Rilke, 233
Archbishop Fisher (Torrigiano), 23
Arezzo, 31
Argives, 203 n1
Ariès, P., 242 n2, Biblio.
Armentières, 246
Arquinghem, 246
Art (Lecomte), 161, 161 n3
The Art Institute of Chicago, 11, 237
Arte dei Maestri di Pietra e Legname (Guild of Stonemasons and Carpenters), 138
Arts Council of Great Britain, 25 n5
The Ascension of St. Catherine of Siena, no. 20 (Anonymous), 73, 73
Aspetti, Tiziano (1565-1607), 64
Atala, Chateaubriand (1768-1848), 214
Athenian funeral stelae, 136
Les attributs des art et les Récompenses qui leur sont accordées (Chardin), 189
Aubé, Jean-Paul (1837-1916), 234
d'Aubusson de la Feuillade (Lemoyne), 170
Auguste, Robert Joseph (1725-1795), 210
Augustus III of Saxony, 91
Autumn (Rusconi), 82 fig. 3, 84
Auvergnat family arms, 196
Avery, Charles, 25 n3, n5, n8, n10, n15, n22, 44 n2, 49 n8, 96 n5, 134 n2, 186 n5, n9, 232 n1, n2, n6, n17, 246 n2 and 259 n1, 266 n2, Biblio.
Azopardi, Canon Reverend J., 132 n3, Biblio.

B

Babelon, J., 158 n1, n2, n3, n4, Biblio.
Bacchanale (Titian), 70
Bacchante, Bacchante au Terme (Carrier-Belleuse), 220, 221, 222; Bacchante statuette, 222 n3, n10
Bacchantes (Marin), 222
Bacchante Offering a Libation to a Bacchic Term, no. 97 (Carrier-Belleuse), 24, 25, 220, 221, 221, 222, 222
Bacchus, 221, 222 n3
Baccio Bandinelli with Models (della Casa), 19 fig. 9
Bacciocci, Prince, bust (Chinard), 204
Bachelier, Jean-Jacques (1724-1806), 191
Baedeker, Karl (1801-1859), 51
Bagard, César (1639-1709), 166
Baldinucci, F. (ca. 1624-1696), 19, 24 n14, 72, 84, 84 n5, Biblio.
Balzac, Honoré de (1799-1850), statues (Rodin), 153
Bandinelli, Baccio (1493-1560), 19; Duke Cosimo I de'Medici, 55
Banyuls-sur-Mer, 238
Baptism (Palma), 64
Baptism of Christ (Algardi), gilt bronze, 68, 68 fig. 1; bronze, 68
Baptistry of Pietrasanta, 64
Baptistry, Florence, 31, 34 fig. 1, 35 fig. 3
BARATTA, Giovanni, Pope Clement XI Albani, 92; Tobias and the Angel, 94; no. 32, Hercules Slaying the Nemean Lion (after), 94, 94; no. 33, Apollo Flaying Marsyas (after), 94, 95, 96, 97; Hercules and the Nemean Lion, marble, Orpheus, Eurydice, 96
Barberini family, 246
Barbieri, Giacomo (active 1680-90), 106
Barcelona, Spain, 272, 273, 274 274 n4, n7
Barclay, David, Collection, London, 221, 230
Bargello, see Museo Nazionale
Baroque, 5, 14, 17, 24, 116, 207, 254, 256; Italian, 80, 82; Florentine, 103, 104, 266; Roman, 246

du Barry, Madame Jeanne Béçu, comtesse (1743-1793), 168
Barye, Antoine-Louis (1796-1875), 226
Bartolini, Lorenzo (1777-1850), 134, 136; La Carita Educatrice, 134; Fiducia in Dio, 147
Basilica of the Santo (Sant' Antonio), Padua, 36
Basilica of St. John Lateran, Rome, 87, 88
Bassano, Italy, 62, 62 fig. 2, 63
Bastianini, Giovanni (1830-1868), 278
Battle of Anghiari (Leonardo da Vinci), 48, 250
Bauchery (mid-19th century), 194
Baudoin, J., 116 n2, Biblio.
BECCAFUMI, Domenico, no. 10 (Circle of), Candelabrum-bearing Angel, 50, 51; Angel Holding a Candlestick, bronze, 50, 50 fig. 1; Angel Holding a Candlestick, gilded wood, 50, 50 fig. 2
Begarelli, Antonio (ca. 1499-1565), 23
Beheading of St. John the Baptist (Danti), 56
Belanger, François-Joseph (1745-1818), 176
Belfiore, Church of, Ferrara, 31
Belgium, 232
Bellanger, Marguerite (mid-19th century), 224
Bellano, Bartolomeo (ca. 1434-1496/7), 35
Bellerophon and Pegasus (di Giovanni), 152
Bellini, Giovanni (ca. 1430-1516), Portrait of Doge Leonardo Loredan, 62 fig. 1, 63; Bellinesque, 63
Bellini, Giovanni (ca. 1430-1516), Portrait of Doge Leonardo Loredan, 62 fig. 1, 63; Bellinesque, 63
Bellinzona, 274 n2
Bellori, Giovanni Pietro (ca. 1615-1696), 72
Belvedere Torso, 233
Bergamo, 144 n1
Berlin, 11, 72 fig. 4, 73, 87, 92, 96; Deutsches Museum, 72; Kaiser-Friedrich Museum, 46, 46 fig. 1; (or Berlin-Dahlem), Staatliche Museen (also referred to as Staatliche Museen Preussischer Kulturbesitz), 12, 42 n5, 49, 72 fig. 4, 73, 86 fig. 1, 189
Berlin, East, Bode Museum, 96
Bernardo (16th century), 20
Bernini, Gianlorenzo (1598-1680), 12, 18, 20, 21, 24, 66, 75, 80, 82, 112, 128; Angel Holding the Scroll, 21 fig. 15; Baldacchino, 70; Constantine, 104; Anima Dannata, 250, 251 fig. 1
Beroaldo (Onofri), 52, 52 fig. 1
Berruer, Pierre-François (1733-1797), 170
Berzighelli, Camillo, 64
Bethnal Green Museum, London, 230, 231, 232 n6, n17, n19
de Bézenval, Pierre-Victor, baron (1722-1791), 203
Béziers, 241
Biblioteca Fabbroniana, Pistoia, 104
Biblioteca Olivierianna, Pesaro, 126
Bishop Bonnet, tomb (Magrou), 242
Blaise, Barthélémy (1738-1819), 196
Blanc, Charles (1813-1882), 214, Biblio.
Blanch, Señora, MAS, Barcelona, 274 n4
Blessed Pietro da Pisa (Vaccaro), 128
BOCCALARO, Domenico, no. 5, Judith, 39, 39; St. John the Evangelist and St. Peter, 39
von Bode, Wilhelm, 46
Bode Museum, East Berlin, 96
Bodelsen, Merete, 237, 237 n.2, 239 n2, Biblio.
du Bois-Guerin, M., 160
Boizot, Antoine (1702-1782), 191
BOIZOT, Simon-Louis, 180 n6; no. 84, Bust of a High Priest, 190, 191, 191; Bust of a High Priestess, Bust of Calchas, 191; Le Baiser de Vénus, 208
Böhler, J., 49
Bologna, 23, 30, 66, 108, 112, 114, 120, 122, 125; Santa Maria della Vita, 23; Church of San Domenico, 30 n4; San Martino, 52; Agostino Collection, 112 n1; A. Boschi Collection, 112 n1; Church of S. Giovanni in Persiceto, 122
BOLOGNESE, late 15th or early 16th century, 52; late 17th or early 18th century, 108, 112; early 18th century, 111; 18th century, 116, 120, 122; middle of the 18th century, 114, 124; or ROMAN 18th century, 118
Bolognese terra-cotta schools of sculpture, 55; painting, 70; medium, 114
Bolsvert, S.A. (ca. 1581-1659), 189 n3
Bonaparte, Elisa (1777-1820) bust (Chinard), 204; Lucien (1775-1820), 212
Bonnassieux, Jean-Marie (1810-1892), 212
Bontemps, Pierre (1505/10-1568/70), 158
Borghini, R., 25 n4, Biblio.
Borromini, Francesco (1599-1667), 72
Boschi, A., Collection, Bologna, 112 n1
Bosio, François-Joseph (1768-1845), 214
Boston: 11, 40; Isabella Stewart Gardner Museum, 40, 40 fig. 1; Museum of Fine Arts, 19 fig. 9; 138 fig. 2
Bottari, Monsignore G. (1689-1775), 82, 84 n3, Biblio.

Bouchardon, Edme (1698-1762), 24, 168, 188, 193, 194 n2
Boucher, Mme., Bust of, no. 76 (Lemoyne), 172, 173
Boucher, M. François, Bust of, no. 75 (Lemoyne), 13, 14, 172, 173, 173
Boucher, M. François (1703-1770), 173, 184, 186 n2
Bouillot, Jules-Ernest (active 1888-1895), 234
Boulevard Anspach, 228
Boulogne, 160
Bourbon, prince de (1736-1818), equestrian statue (Pilon), 193, 194
Bourdelle, Emile-Antoine (1861-1929), 238
Bouret, Etienne-Michel (1709-1777), 189
Bourgeois, E., 191 n2, 208 n5, Biblio.
Bourse, Brussels, 220, 226, 228
Bowdoin College, Museum of Art, Brunswick, Maine, 17 fig. 4
de B(oynes), Mme., Sale, 186 n11
bozzetti, bozzetto, 17, passim
Breda, Holland, 259
Brescia, Palazzo dei Rettori, 129
Brinckman, A.E., 25 n2, 49, 49 n11, Biblio.
Briosco, Andrea, called Il Riccio (ca. 1470-1532), 35
den Broeder, F., 87 n2, 91 n3, Biblio.
Brompton Oratory, London, 75
Brooks, Alden, Collection, 237
Brunelleschi, Filippo (1377-1446), 276
Bruno, Giordano (1548-1600), statue (Ferrari), 142
Brussels, 70, 220, 226, 228, 254, 259, 264, 266 fig. 2; Académie des Sciences et des Beaux-Arts, 233; Musée royaux des Beaux-Arts, 254; Royal Park, Town Hall, 264
Brutus Lamenting Over the Dead Lucretia, no. 92 (Milhomme), 210
Bruton Gallery, Somerset, England, 220, 220 fig. 1, 222, Biblio.
Buddhistic sculptures of China, 5
Il Buggiano, Andrea di Lazzaro (1412-1462) called, 276
Buglioni, Santi (1494-1576), 48
Bunnet, F., 16, Biblio.
Burghers of Calais (Rodin), 226
Burghley House, England, 88
Burney, Sidney, London, 237
Buonarotti, Leonardo, 58
Busseto, 82
Bust of a Cleric, no. 16 (Palma), 13, 13, 64, 64, 65
Bust of a High Priest, no. 84 (Boizot), 190, 191, 191
Bust of a High Priestess (Boizot), 191
Bust of a Man Screaming, no. 107 (Anonymous), 250, 250, 251, 251
Bust of a Monk, no. 11 (Anonymous), 52, 53
Bust of a Woman, no. 90 (Chinard), 13, 14, 204, 204, 205, 205
Bust of Bishop Pietro Usimbardi (Palma), 64
Bust of Bishop Usimbardo Usimbardi (Palma), 64
Bust of Christ, no. 1 (Circle of Mazzoni), 28, 28, 29, 29
Bust of Corbin de Cordet de Florensac, no. 80 (Pajou), 180, 181, 182, 183, 183
Bust of Henri Claude, comte d'Harcourt, no. 74 (Lemoyne), 170, 170, 171
Bust of Hubert Robert (Pajou), 183, 183 fig. 2
Bust of Lazzaro Bonamico (Cattaneo), 62 fig. 2, 63
Bust of the marquis de Montferrier (Pajou), 183, 183 fig. 1
Bust of Weeping Boy (de Cock), 259, 259 fig. 2
Butler, R., 232 n17, Biblio.

C

Cabanel, Alexandre (1823-1889), 238
Ca'd'Oro, Venice, 96
Caffà, Melchiore (1631-1667), 73, 75
Caffieri, Jean-Jacques (1725-1792), 173, 174 n3
Cagnes-sur-Mer, France, 239
Cailleux Collection, Paris, 184
Caius Gracchus leaving his wife Licinia to oppose the Consul Opimius in the Forum (Milhomme), 210
Calais Museum, 228
Calandra, Giovanni Battista (1586-1644), Annunciation, 70, 70 fig. 1, 72
Calchas (Boizot), 191
Calderini, M., 274 n2, Biblio.
Calmet, Dom Augustin (1672-1757), 166
Calydonian Boar, 174 n5
Cambridge, Massachusetts, 9, 12, 20, 21, 138, 268 fig. 1 269 n5
Camelio (Vittore Gambello, called) (1460-1537), 63
Campagna, Girolamo (1549/50-1625?), figure of Doge, 63
Camper, Petrus (1722-1789), fragment of Crying Boy, 259, 259 fig. 3
Campo dei Fiori, Rome, 142

Canova, Antonio (1757-1822), tomb of Pope Clement XIII, 242
Candelabrum-bearing Angel, no. 10 (Circle of Beccafumi), 50, *51*
Caponnori Villa, Pisa, 64
Capitoline Museum, Rome, 184, 202, 203 fig. 1
Capodimonte Museum, Naples, 56
Ca'Pesaro, Venice, 146
Capponi, Marchese Alessandro, 96
Cardinal Francesco Alidosi (1455-ca. 1511) portrait relief (Francesco Francia), 52
Cardinal Alpheron Collection, 98
Cardinal Annibale Albani, 91
Cardinal Pietro Bembo (1470-1547), 63
Cardinal de Cabrières (1830-1921), 241, 242
Cardinal Carlo A. Fabbroni, 104
Cardinal Ascanio Filomarino, (1583-1666), 72
Cardinal Forteguerra (1419-1573), 18 fig. 6, 19
Cardinal Giuseppe Renato Imperiale (1651-1737), 70, 72
Cardinal Jules Mazarin (1602-1661), 242
Cardinal Benedetto Pamphili, 87
Cardinal of York, 84
Cardinal Virtues (Rusconi), 82
Cardinal Paolo Emilio Zacchia (d. 1605), (Algardi), 24 fig. 23
Carioli brothers, monument (Rosa), 140
La Carita Educatrice (Bartolini), 134
Carnegie Institute, Pittsburgh, 184
CARPEAUX, Jean-Baptiste, 222, 223; no. 96, *Flore Accroupie* (*Crouching Flora*), 214, 218, *218*, 219, *219*; *Crouching Flora*, plaster, 218 fig. 1; *The Submission of Abd-el-Kader, Pêcheur a la Coquille, Ugolino, The Spirit of the Dance*, 218; *La Fiancée*, 224
Caracci, Annibale (1560-1609), 66
Carrara, Italy, 64, 94, 146, 196
CARRIER-BELLEUSE, Albert-Ernest, 21, 24, 220, 226, 232, 232 n1, n17; *Design for a jardiniere with Titans*, drawing, 226 fig. 1, 228; *Offrande à Bacchus*, 220 fig. 1; no. 97, *Bacchante Offering a Libation to a Bacchic Term*, 220, 221, *221*, 222, *222*; no. 98, *Colombe*, 223, *223*, 224, *224*, 225, *225*; no. 99, *Vasque des Titans* (with Rodin), 226, 227, *227*, 228, *229*, 229, 230, *230*, 231, *231*, 232
Carrier-Belleuse, Louis-Joseph, 220
Carthage, 104, 118
della Casa, Niccolò (active 1543-1547), 19 fig. 9
Casa Buonarotti, Florence, 19 fig. 8
Casa Rudolfi, Florence, 49 n6
Casimir-Périer (Duret), 214
Catherine de'Medici (1519-1589), 158
Catherine, II, the Great, of Russia (1729-1796), 189
CATTANEO, Danese, 24, 60, 62, 64; *Bust of Lazzaro Bonamico*, 62 fig. 2; no. 15, *Head of Doge Leonardo Loredan*, 50, 61, *61*, 62, *62*, 63, *63*; bust of Alessandro Contarini, 63; *Venezia armata, Peace, Dovizia, The League of Cambrai*, 63
Cauchi, John A., 132
de Caylus, comte (1692-1765), 168
Cefalù, Sicily, 58
Cellini, Benvenuto (1500-1571), 19, Biblio.
Certosa di San Martino, 130
Certosa di Pavia, 30
di Cesnola, General Luigi Palma (1832-1904), 11
Chabrun, J.F., 233 n1, Biblio.
Chactas, 214
Chambers of Deputies, Italy, 142
Chambre des Députés, Paris, 214
Champtoceaux, 216
Chanson de Silène (Magrou), 241
Chantilly, 162, 193
Chapel of St. Ignatius, Gesù di Roma, 132
Chapel of St. Roch, Nôtre-Dame de Versailles, 160
de la Chapelle, Salomon, 201, 201 n1, Biblio.
Chaplet, Ernest (1835-1909), 234, 237
Charageat, M., 189 n7, Biblio.
Chardin, Jean-Baptiste (1699-1779), 189
Charlemagne (Cornacchini), 104
Charles VIII, King of France, 28, 242
Chárles IX (1550-1574), King of France, 158
Charles Louis of the Palatinate (r. 1632-1680), portrait-bust (Dieussart), 246
Charity (Master of the Unruly Children), 46, 46 fig. 1, fig. 2, 48, 49; for *Seven Corporal Works of Mercy*, 48; *bozzetto* (Caffà), 73; (Mazzuoli), 75; no. 54 (Anonymous), 134; (Dardel), 193 fig. 1
Charpentier, René (1680-1723), 174 fig. 2
château d'Anet, 189
château de Millemont, 189
château de Saint Eusoge, 170
château de Sassy, Orne, 189 n6
château de Thury, 170
Chateaubriand, François (1768-1848), 212, 216, 216 n2;

no. 94, *Sketch for a Figure of* (Duret), 214, *215*; (Duret), marble, 214;
Chaumont, Céline (ca. 1845-after 1885), 224; Théo, 224
Chauvigny, 219
Chéret, Gustave-Joseph (1838-1894), 220
Chicago, 11
Chigi Collection, Chigi Palace, 92
Chigi-Saracini Collection, Siena, 76
China, 5, 6, 7, 11
CHINARD, Joseph, 24; no. 86, *Lion Supporting An Armorial Cartouche*, 196, *196*, *197*; no. 87, *Phryne Emerging From Her Bath, 12, 157*, 198, *198*, *199*, 200, 201, *201*; *Innocence Taking Refuge in the Bosom of Justice, Madame Récamier*, 196; *Perseus and Andromeda*, 196, 206; *Pygmalion*(?), *Perseus Delivering Andromeda*, 201; no. 88, *Othryades Expiring on His Shield*, 202, *202*, 203, *203*; no. 89, *Bust of a Woman, 13*, 204, *204*, 205, *205*; bust of marquise de Jaucourt, 205; no. 90 *Sappho and Phaon, 206, 206*, 207, *207*; bust of *Mme Alb. de Mar (seille) as Sappho playing the lyre*, 207; *Femme Couvert de Draperies* by (?), 201 n2
Ching Dynasty (A.D. 1644-1911), China, 7
de Chiverny, comtesse, 170
de Choiseul, duchesse, 226
Choisy, gardens, 189 n1
Chou Dynasty (1027-221 B.C.), China, 7
Choux, l'abbé, 167 n1
Christ on the Road to Emmaus, no. 46 (Piò), 122, *123*
Christ, 23, 30; bust, 30 n4, 103; profile in no. 13, 56, 56 fig. 2; head (Mazzoni), 30, 30 fig. 1; (Algardi), 68; *Christ* (Palma); 64; (Pilon), 158
Christ Child, 80; 120, 163, 261 n2
The Christ Child as Savior, no. 113 (Anonymous), 262, *262*, *263*
Christ Kneeling, no. 104 (Anonymous), 244, *244*, *245*
Christ in Limbo, 24
Christian festivals, 28 ; Christian Virtues, 48
Christie's, London, 172, 221, 222, Biblio.
Christina, Queen of Sweden (1626-1689), 98
Christmas, 28, 80, 140, 271
Church of the Madonna di Monte Berico, Vicenza, 129
Church of St. John, Valletta, Malta, 98
Church of Holy Apostles, Naples, 72
Ciehanowiecki, A.A., 130, 130 n1, Biblio.
City Museum and Art Gallery, Birmingham, U.K., *Judith and Holofernes* (Cornacchini), 104
Civilis, Claudius, 216
Civitavecchia, 118
Cladell, Judith, 232 n17, Biblio.
Clarke, T.H., 91 n4, Biblio.
Claudel, Camille (1856-ca. 1920), 226; Paul (1868-1955), 226
Claudius, Emperor of Rome (10 B.C.-A.D. 54), 269
van Clève, Corneille, *The Loire and the Loiret*, 164
Cleveland Museum of Art, *Baptism of Christ* (Algardi), bronze, 68
CLODION, Claude Michel called, 12, 21, 24, 25, 166, 167, 184, 186, 186 n6, 212; model for *Poetry and Music*, 25; *Vestal*, 184; no. 81, *Vestal Bearing Wreaths on a Platter*, 184, *184*, 185, *185*; no. 82, *Vestal Holding Sacred Vessels*, 86, *86*, 87, *87*; *Une Vestale and Une Pretesse*, 212 n4; Clodionesque, 221
de COCK, Jan Claudius, no. 111, *Crying Boy* (Circle of), *258*, 259; *Bust of Weeping Boy*, 259, 259 fig. 2
Codola, M.R., 274 n1, n8, Biblio.
Codroipa, Italy, 129
Colbert, Jean-Baptiste (1619-1683), 188 ; bust (Coustou), 164
Colbert (Milhomme), 210
Colnaghi, Messrs., London, 44, 101, 103, Biblio.
Colombe, no. 98 (Carrier-Belleuse), 24, 223, *223*, 224, *224*, *225*
Colonne de la Grande Armée, Paris, 184, 208
Comedy (Duret), 214
Commerce, 142
Compagnie des Bronzes, Brussels, 226
Comptes des bâtiments du roi, 163
Concours, 193, 203
Condé, house of, 162, 164; prince de Bourbon, 193; prince Louis-Joseph (1736-1818), 193, 194
Condé Throwing His Baton into the Enemy's Lines (d'Angers), 194 n3
Conforti, Dr. Michael, 90
Congrega dei Morticelli at Fogga, 130
Congregazione dei Virtuosi, 132
Constantine, Alessandro, bust (Cattaneo), 63
Conte degli Alessandri Collection, Empoli, 101, 103
Conte Annibale degli Abati-Olivieri Giordani, portrait-bust (Pantanelli), 126

The Continence of Scipio, no. 37 (attributed to Cornacchini), 104, *104*, *105*
Convent of the Byloke, Ghent, 246
Coolidge, Professor John, 14, 64 n2
Copenhagen, Rosenborg Castle, 96, 96 fig. 1; Kunstindustrimuseet, 237
CORNACCHINI, Agostino, Pope Clement XI Albani, 92; no. 37, *The Continence of Scipio* (attributed to), 104, *104*, *105*; *Charlemagne, Judith and Holofernes, Fortitude*, 104
Corporation des Quatre Couronnés, 254
Corsini Chapel, San Giovanni in Laterano, Rome, 104
CORSINI, Agostino, no. 45, *St. Anthony of Padua, St. Lawrence and St. Peter Adoring the Christ Child*, 120, *121*; *Worship of The Golden Calf*, 120 fig. 1; *St. Peter, Immaculate Conception*, 120
Cortona, Italy, 142
Cosimo I de'Medici (1551-1573), Grand Duke of Florence, 56, 193
Cosimo II de'Medici (1590-1621), 64
Cosway, Maria (1745/59-1838), 207, 207 n8
Counter-Reformation, 116, 254
Coural, J., 168 n1, Biblio.
Court, French, Louis XV and XVI, 176; of Savoy, Italy, 142; of the Princes, United Provinces, 259
Courtauld Institute, London, 237 n1
Coustou, François (1657-1690), 164
Coustou, Guillaume I, (1677-1746), 164; *Hercules on The Funeral Pyre*, 174 n2
COUSTOU, Nicolas, no. 70, *A River God and Goddess*, 164, 165, *164*, *165*; *The Emperor Commodus as Hercules, Meléager, Descent from the Cross, The Recovery of Louis XIV, bust of Villars, Les Nappes, Grand Pièce d'Eau*, 164, *The Seine and The Marne*, 164 fig. 1
Cowdray Castle, Sussex, 251
Coysevox, Antoine (1640-1720), 164; *Fame, Mercury* and two pairs of *River Gods*, 165; tomb of Cardinal Mazarin, 242
Cracow, Poland, 154
Crema, Italy, 28
de Créqui, François, 164
Crécy, 168
Cronyn, Hume and Jessica Tandy Collection, 232 n11
Crouching Aphrodite (Diodalsas), 147
Crouching Venus, Antique, 219
Crying Boy, no. 111 (Circle de Cock), *258*, 259
Cum Spartaco Pugnavi (Ferrari), 142
Cupid, 111, 179, 180
Cupid and Psyche (Pajou) 180 n4
Custers, François, 254
Cybele, 98
Cyprus, 11
Czas (Zawiejski), 154 fig. 1

D

Dagencourt Collection, Paris, 189 n4
Dalou, Jules (1838-1902), 223, 226
Dancers (Degas), 147
DANTI, Vincenzo (1530-1576), no. 13, *Pope Julius III del Monte, 13*, 14, 56, 56 fig. 2, *57*; *Pope Julius III Enthroned*, bronze, 56 fig. 1; *Beheading of St. John the Baptist*, 56
DARDEL, Robert-Guillaume, no. 85, *Equestrian Statuette of the Grand Condé, 192*, 193, 194, *194*, *195*; *Charity*, 193, 193 fig. 1; *Peace of Amiens, Grenadier, The Grand Condé, Louis XIV and the Ashes of Louis XIII, Descartes Piercing the Clouds of Ignorance*, 194, 194 n4
David, Jacques-Louis (1748-1825), 193; *Sappho and Phaon*, 207, 207 n9
David (Michelangelo), 5; (Donatello) 44, 44 fig. 3; (Master of the David and St. John Statuettes), 44, 44 fig. 1; no. 8 (Master of the David and St. John Statuettes), 44, *45*; (Verrocchio), 44, 44 fig. 2
David Triumphant over Goliath, no. 39 (Mazza), 109, *109*
David-Weill Collection, 186, n5, n7
Davies, M., 63 n7, Biblio.
De Vecchi Collection, Siena, 77
Dead Christ (Mazzuoli), 75; *bozzetti* (Bartolomeo Mazzuoli), 76; (attributed to Pilon), 158 fig. 1; no. 67 (Circle of Pilon), 158, *158*, *159*
Death of Hippolytus (Lemoyne the Elder), 174
Death of Meleager (Charpentier), 174, 174 fig. 2
Degas, Edgar Hilaire Germain (1834-1917), 18, 147, 148, 152
Delacroix, Eugène (1798-1863), 25
Delvaux, Laurent (1696-1778), 254, 264, 266
Denmark, 12, 94
Deposition (Sansovino), 18; (Cornacchini), 104

The Continence of Scipio, no. 37 (attributed to
The Deposition of Christ, no. 14 (del Duca), 14, *14*, 58, *59*
Descartes Piercing the Clouds of Ignorance (Dardel), 194, 194 n4
Descent From the Cross (Coustou), 164
Descharnes, R., 233 n1, Biblio.
Desmarais, Lucien M., Collection, Paris, 186, 186 n12
Desmarest, 186 n11
Design for a jardinière with Titans (Carrier-Belleuse), drawing, 226 fig. 1
Detroit Institute of Arts, 49, 104 n4, 109 n2, Biblio.
Deutsches Museum, Berlin, 72
Diana (Vassé), 168
Diderot, 180
DIEUSSART, François, no. 105, *Holy Family with St. John the Baptist*, 246, *247*; *Pietà*, 246, 246 fig. 1; Portrait busts, 246
Diocletian, 216
Divine Grace (Vaccaro), 130
Doge Leonardo Loredan, *Head of*, no. 15 (Cattaneo), 60, *60*, 61, *61*, 62, *62*, 63, *63*; (Campagna), 62; (Bernini), 62 fig. 1
Doidalsas, *Crouching Aphrodite*, 147
de' Dominici, B., 130 n2, Biblio.
Domitian, 216
Donatello (ca. 1386-1466), sculptures of Virgin and Child, 22, 36, 38; *David*, 44, 44 fig. 3
Donya Maria Christina i Alfonso XIII (Vallmitjana), 274 n6
Dordor, B., 242 n3, Biblio.
Dossena, Alceo (1878-1937), 278
Dovizia (Cattaneo), 63
Draper, James, 118 n1, 203, 203 n6, 260, 273, Biblio.
Drury-Lowe, Captain P.J.B., Locko Park Collection, 56
Dubois-Chefdebien sale, 212 n5
del DUCA, Jacopo, no. 14, *The Deposition of Christ*, 14, *14*, 58, *59*; *Sacramental Tabernacle*, 58, 58 figs. 1, 2
Duchy of Modena, 94
Due Rettori (Marinali Brothers), 129
Dufours, Lydia, 274 n4
Duke of Lerma, Francesco (1553-1625), 96 n4
Duke of Marlborough, John 1st (1650-1722), England, 94, 98
Duke of Richmond's Gallery, Whitehall, 269
Duke of Urbino, Francesco Maria II (1548-1631), 63
Dumont, Augustin (1801-1884), 214; Edme (1722-1775), 208; François (1688-1726), *Falling Titan*, 174, 174 n2
DUMONT, Jacques-Edme, no. 91, *Venus Comforting Cupid*, 208, *208*, *209*; *Pichegru, Love on a Chariot Drawn by Butterflies, Malesherbes, Venus et l'Amour, L'Amour se plaignant a Vénus de la piqûre d'une abeille, Portrait of Mlle. C. Dumont*, 208
Dupré, Giovanni (1817-1882), 140
DUQUESNOY, François, 24, 82, 84, 246, 259, 260; no. 19, *Two Angel Musicians, 14, 15*, 70, *71*; marble relief, 70 fig. 2; *St. Andrew, St. Susannah*, 70; study relief, after, 72 fig. 4; tomb of Vryburch and Van den Eynde
Duquesnoy, Jérôme the Younger (1602-1654); Jérôme the Elder (ca. 1570-1641/2), 70
DURET, Francisque-Joseph, no. 94, *Sketch for a Figure of François Chateaubriand*, 214, *215*; *Mercury Inventing the Lyre, Fisherboy Dancing a Tarantella, Molière, Casimir-Périer, Richelieu, Chateaubriand, Rachel, Tragedy, Comedy , St. Michael Crushing the Devil*, 214; 218
Duret, François-Joseph (1729-1816), 214
Dutch, 11, 248, 260 n2
DUTCH, or FLEMISH, 19th century, 262
Duveen's, 138
Dying Gaul, Antique, 203 fig. 1
Dying Gladiator (Julien), 202

E

Earl of Arundel, England, 246
Easter, 28, 66; Sepulchres, 23, 158
Ecclesiastic (attributed to Palma), 64, 64 fig. 1
Ecoles des arts et métiers, Angers, 216
Ecole des Beaux-Arts, Lyons, 212
Ecole des Beaux-Arts, Paris, 183 fig. 2; 214; 216, 218, 220, 226, 238, 241
Ecole de dessin, Paris, 196
Ecole des élèves protégés, 176, 184, 193
Ecole Militaire, 194 n3
The Education of the Virgin, no. 43 (Anonymous), 116, *116*, *117*
von Einem, H., 233, n5, Biblio.
Elsen, A., 232 n3, 233, 233 n2, Biblio.
Emanuele II, King Vittorio, equestrian monument (Ferrari), 140, 142

Emilia, Italy, 30 n4, 106
EMILIAN, late 17th century, 106
Emilian school, 52
Emmaus, 122
Emperor Gallus, 118
Emperor Pedro II of Brazil, statue (Magrou), 241
Emperor Valerian, 118
The Emperor Commodus as Hercules (Coustou), 164
Emperor Constantine (Vaccaro), 130
Empire period in France, 196, 206
Empress Josephine, 208
Enggass, R., 84 n4, 87 n2, 91 n3, 132 n1, Biblio.
England, 23, 24, 82, 84, 88, 94
ENGLISH, mid-18th to early 19th century, 268
Entombment of Christ with Carlotta of Lusignan (Minelli), 40, 40 fig. 1
equestrian monuments, 140, 193, 194, 194 n2
Equestrian Statuette of the Grand Condé, no. 85 (Dardel), *192*, 193, 194, *194*, *195*
Eremitani, Church of the, Padua, 36, 38, 38 fig. 3, 39
Escorial, Spain, 58
La Escuela Superior de Artes y Officios y Belles Artes, Barcelona, 272
Esdaile, Katherine, 269 n3, Biblio.
d' Espeuilles, marquis, 183
L'Espion Anglais, 170, 170 n5
Esquiline Hill, Rome, 152
Estatua Yacente de Doña Maria Auter (Vallmitjana), 274 n6
Eternity (Soldani-Benzi), 98
Etruscan terra-cottas, 12, 17, 17 fig. 3
L'Etude du Dessin (Chardin), 189
Eudore, 216
Eurydice (Baratta), 96
Evangelists (Sansovino), 49; (Mazza), 108
Exeter, Earl of, 88
Exposition de l'Elysée, 206, 208
Exposition Universelle, Paris, 208, 208 n4, 214, 216 n1, 226

F

Fabbretti monument, 84
Fabbroniana, Biblioteca, Pistoia, 104
Fabriczy, C. von, 40 n3, Biblio.
Faenza, 138, 138 fig. 4, 138 n5
Falconet, Etienne-Maurice (1716-791), *Baigneuses*, 148; 191
Falling Titan (François Dumont), 174, 174 n2
Fame (Coysevox), 165
"Fantasy" busts (Carrier-Belleuse), 223, 224; (Carpeaux), 224
Fantasy Bust After Mlle. Sophie Croizette (Carrier-Belleuse), 224
Fanzago, Cosimo (1591-1678), 130
Farnese Eros, Antique, 233
Father Time Carrying Off a Dead Infant, no. 114 (attributed to Plumière), *243*, 264, *265*, *266*, *267*
Fauconnier, Jacques Henri (1776-1839), 220
Femme Couvert des Draperies (Chinard), 201 n2
Fernando I of Tuscany, 96 n4
Ferrara, 30 n4, 31, 142, 276
FERRARI, Ettore, equestrian monument, 140; no. 58, *Monument with Angel and Two Mourners*, 142, *142*; *Cum Spartaco Pugnavi*, *Return of the Prodigal Son*, Equestrian monument of King Vittorio Emanuele II, Giordano Bruno, Garibaldi memorials, President Lincoln, Monuments to Giuseppe Verdi, and A. Meucci, 142; no. 59, *Standing Draped Man Representing Fatherland*, 144, *144*, *145*; model for *Monument to Terenzio Mamiani della Rovere*, 144 fig. 1
Ferrari, Filippo (1819-1897), 142
Ferrata, Ercole (1610-1686), 75, 82, 88
Ferri, Ciro (1634-1689), 22
FERRUCCI, Andrea, *St. Jerome*, 42, 42 fig. 4; no. 7, *St. Jerome*, attributed to, 42, *43*
Il Fiammingo, 70
La Fiancée (Carpeaux), 224
Fiducio in Dio (Bartolini), 147
Fiesole, Cathedral 42; Church of San Girolamo, 42
da Fiesole, Mino (1429-1484), 134
Figaro (Vallmitjana), 274
Le Figaro, Paris, 274 n8
Fighting Horsemen (Rustici ?), 49 n8
Filomarino Chapel, 14, 70, 70 fig. 1
Fiocci, G., 31, 35, 35 n1, n2, 38, 38 n7, Biblio.
Fisherboy Dancing a Tarantella (Duret), 214
Flagellation, from della Porta's model, 58, 58 fig. 3
Flamen, Anselme (1647-1717), 165
FLEMISH, early 17th century, 246; late 17th or early 18th century, 253; early 18th century, 253; or DUTCH, 19th century, 262; or ENGLISH, early 18th century, 264

Flemish 19, 24, 246
Fliche, Augustin, 242 n1, Biblio.
Flore Accroupie (*Crouching Flora*), 214; no. 96 (Carpeaux), 218, *218*, 219, *219*; by Carpeaux, for *Triomphe de Flore*, Pavillon de Flore, Louvre, Paris, 219
Florence, 5, 17, 18, 22, 23, 42, 49, 55, 56, 58, 64, 76, 94, 98, 104, 154; Acton Collection, 36; Baptistry, 34 fig. 1, 35 fig. 3; Casa Buonarotti, 19; Casa Rudolfi, 49 n6; Cathedral, 19, 42; S. Trinita, 64; Church of Santa Croce, 19, 19 fig. 8; Church of SS. Michele e Gaetano degli Antinori, 103; Church of Santo Spirito, 94; Galleria dell' Accàdemia, 5, 21, 21 fig. 3; Pitti Palace, 134; Grand Ducal Drawing School, 98; Museo Horne, 42 n5; Museo Nazionale, 19, 44, 44 figs . 2, 3, 49 n8, 56 n4, 64 n2; Or San Michele, 32; Palazzo della Signoria, 48, 49 fig. 4; Palazzo Ruscellai, 49 n6; Palazzo Vecchia, 21; San Lorenzo, 253; Uffizi Gallery, 184
Florence Triumphant Over Pisa (Giambologna), wax, 18, 18 fig. 5; terra-cotta, 20, 20 fig. 10, fig. 11, fig. 12; full-scale model, 21, 21 fig. 13; marble, 21
FLORENTINE, late 15th century, 42, 44; early 16th century, 46; early 16th century style, 138; first quarter of the 17th century, 64; first half of the 18th century, 104; early 18th century, 98, 103; early 18th (or 19th) century, 94; mid-19th century, 134, 136
Florentine, 30, 31, 49, 55, 94, 98, 103, 134, 276
Florentine School, *Madonna and Child*, 22 fig. 18
Fogg Art Museum, 9, 12, 20; *bozzetti* (Bernini), 20; *Angel Holding the Scroll* (Bernini), 21
Foggini, Giovanni Battista (1652-1725), 94, 104; *Apollo Flaying Marsyas*, 96, 97 fig. 4; *David Triumphant Over Goliath*, 109
Folie Saint-James, Neuilly, 176
Fontainebleau, 158
Fontaine Saint-Michel, 214
Fontaine (Cornacchini), 104
Fortitude (Circle of Rustici), 51 fig. 2
Fortezza (Cornacchini), 104
da Forli, Ansuino (1406-1469), 36
Fort Manoel, Malta, 98
de Fortier, M., sale, 186 n3
Four Continents (Vaccaro), 130
Fountain (Circle of Rustici), 51 fig. 2
Four Seasons (Pompe), 261 n2
Fracastoro, Girolamo (ca. 1478-1553), bust (Cattaneo), 63
France, 17, 23, 24, 28, 30, 70, 87 n3, 158, 164, 180, 188, 194, 208, 220, 237, 242
Francia, Francesco (1450/53-1517/18), 52
Franciscan Order, 138
Franco-Prussian War, 220, 226
"François Flamand", 246
de Fraula, Thomas, 254
Frederick IV, King of Denmark, 96
Frederick the Great of Prussia (1712-1786), 168, 189
Frederick Hendrick, Prince, portrait-bust (Dieussart), 246
Freemantle, K., 232 n23, 248 n1, Biblio.
FRENCH, late 16th century, 158; late 17th century, 160; late 17th to mid-18th century, 162; first quarter of the 18th century, 174; 18th century, 176; mid-18th century, 168; mid-18th to early 19th century, 212; mid- to late-18th century, 188; late 18th to early 19th century, 191, 193, 196, 210; late 18th to mid-19th century, 208; 19th century, 214, 216, 218; second half of the 19th century, 220; late 19th century and early 20th century, 226; late 19th century, 234; late 19th to mid-20th century, 238, 241
French, 11, 17, 21, 24, 82, 88, 148, 163, 164, 170, 202
French Academy, Rome, 168, 184, 186, 202
French & Co., New York, 184, 186 n4
Frenzy (attributed to Artus Quellinus I), 251 fig. 3
Friedrich Wilhelm, the "Great" Elector of Brandenburg (1620-1688), portrait-bust (Dieussart), 246
Frileuse (Houdon), 1781, 201
Fuller, Loie, 229
Fusco, Peter, 224 n1, 232 n16

G

Gabburri, Francesco (1675-1742), 104
Gaborit, J.-R., 30 n4, 203, 203 n4, 203 n6
Gaddi, Giovanni, 19
de Gaignières, Roger (1642-1715), 242
Galatea, 201
Galerie Cailleux, Paris, 186 n7, 212 n 4, Biblio.
Galerie Heim, Paris, 42, 42 n1, n5, 42 fig. 3, 55, 212 n3, Biblio.
Galerie Georges Petit, Paris, 167 n1, n5
Galerie Jean Charpentier, Paris, 212 n2
Galitzin monument, 168
Galleria dell' Accàdemia, Florence, 21; Galleria delle

Carte Geografiche, Vatican, Rome, 132; Galleria Palatina, Pitti Palace, Florence, 134
Gandolfi, Ubaldo, Circle of, no. 47, *St. Romuald (?)*, no. 48, *St. Petronius (?)*, 124, *124*, 125, *125*, 126
Garibaldi memorials (Ferrari), 142
Garnier, Charles (1825-1898), 218
The Gates of Hell (Rodin), 226
Gates of Paradise (Ghiberti), 44
GAUGUIN, Paul, 234, 238 ; no. 101, *Square Vase Adorned with Tahitian Gods*, *234*, *235*, *236*, 237; *Tamanu Wood Relief*, 237; *Ancien Culte Mahorie*, 237 n5, Biblio.; and Maillol, 238
Gaul Killing Himself and His Wife, Antique, 269
Gautier, Theophile, 214, 214 n2, Biblio.
Genius of the Papacy, no. 57 (Rosa), *140*, 141, *141*
Genoa, Genoese, 128
Genoese Senator, no. 50 (attributed to Parodi), 128, *128*
Genre sculpture, 154, 214
George II, King of England (1683-1760), 84
George III, King of England (1738-1820), 84
George, Waldemar, 239, n1, Biblio.
Gérôme, Jean-Léon (1824-1904), 238
Gesù di Roma, Chapel of St. Ignatius, 132
Ghiberti, Lorenzo (1378-1455), Virgin and Child, 22; *The Nativity of Christ*, 31, 34 fig. 1; *Adoration of the Magi*, 35, 35 fig. 3, 44
Giambologna (1529-1609), *Mercury*, 18; *Florence Triumphant Over Pisa*, wax, 18, 18 fig. 5, clay with admixtures, 21, 21 fig. 13, terra-cotta, 20, 20 figs. 10, 11, 12; *Rape of a Sabine*, 21; *River-God*, 21, 21 fig. 14; *Cosimo I*, 193; *Hercules and the Nemean Lion*, 96, 96 fig. 3
Gilbert, C., 38 n6, Biblio.
Gillet, Pierre-Joseph (1734-1810), 211
Ginain, Louis (1818-1886), 208; Mme., 208
Ginori, Marchese Carlo (1851-1905), 98
di Giorgio, Francesco (1439-1501/1502), 50
di Giovanni, Bertoldo (ca. 1420-1491), *Bellerophon and Pegasus*, 152
Gipsoteca, Prato, 134
Girl Kneeling and Dressing Her Hair, no. 60 (Martini), *11*, 146, *146*, 147, *147*
Girl Seated and Drying Her Foot, no. 61 (Martini), 148, *148*
Girodet-Triosan, Anne-Louis (1767-1824), 207, 207 n10
Giuliano de'Medici (Verrochio), 23, 23 fig. 19
Goldendale, Washington, 228, 228 fig. 2
Goldscheider, C., 232 n6, Biblio.
Goldscheider, L., 25 n12, Biblio.
Golfieri, Ennio, 138 n5
Goliath, 44, 109
Gordon, Vivian, 35 n4
Gothic, 30, 31, 163, 276
Goujon, Jean (d. ca. 1567), 219
Gramberg, W., 58 n3, Biblio.
Granada, Spain, 271
Grand Condé (1621-1686), 193, 194, 194 n3
The Grande Condé, Louis XIV and the Ashes of Louis XIII (Dardel), 193
Grand Degré, Chantilly, 162
Grand Ducal Court, Florence, 20; Grand Ducal drawing school, Ducal mint, 98
Grand Master of the Order of Malta, 98
Grand Pièce d'Eau (Coustou), plaster, 164
Gray, C., 237 n2, Biblio.
Great Men of France, 194, 194 n3
Grecian, 136
Greco-Roman, 147
Greece, 17, 174 n5
Greeks, 191
Grenadier (Dardel), 193
Grimm, H., 25 n1, Biblio.
Gronau, G., 63 n1, Biblio.
Gros, Baron Antoine-Jean (1771-1835), 207, 207 n7
Group of Warriors (attributed to Master of the Unruly Children), 49, 49 fig. 4
Gruaria, Italy, 114
Gsell, Paul, 233, 233 n7
Guiard, Laurent (1723-1788), 193
Guiffrey, J., 208 n2, Biblio.

H

Hadley, R. van N., 40 n4, Biblio.
Hadrian, 161
Hager, W., 126 n1, Biblio.
The Hague, 186 n2, 254 n1
Hahn, Stephen, 237
Hall of the Five Hundred, Palazzo della Signoria, Florence, 250
Halsema-Kubes, W., 49 n3, 232 n24, 250 n1, 251 n3, 261 n2, Biblio.

Hamburg Kunsthalle, 203 n3
d'Harcourt, Anne-Pierre (1701-1784), (Lemoyne), 170
HARDY, Pierre-Jean, no. 69, *Virgin and Child*, 162, *162*, *163*; *Religion Crushing Idolatry*, 162
Hardouin-Mansart (1646-1708), 161
Hare, Augustus, 58
Hargrove, Dr. June, 222, 222 n1, 224 n1, 224 n3, 232 n1, n20, Biblio.
Harrewijn, François (1700-1764), 254
Haskell, Arnold, London, 237
Hawkins, J., 232 n1, 237 n17, Biblio.
Head of Doge Leonardo Loredan, no. 15 (Cattaneo), 60, *60*, 61, *61*, 62, *62*, 63, *63*
Head of a Young Woman, no. 102 (Maillol), 238, *238*, 239, *239*
Hébé, Déesse de la Jeunesse (Pajou), 180
Heim Gallery, London, 28, 30 n3, 36, 40, 40 n3, 55, 60, 64, 68 n2, 70, 75, 76, 76 n4, 77, 82, 84 n4, 86, 87 n1, 89, 91 n2, 98, 103 n2, 104, 112, 120, 122, 129, 130, 166 fig. 1, 167, 173 n3, 176, 179, 180, 183 n1, 184, 186, 193 fig. 1, 195, 246, 264, 268; Galerie Heim, Paris, 42, 42 n1, n5, 42 fig. 3, 55, 212 n3, Biblio.
Hellenistic , 149
Henri II, King of France (1519-1559), 158, 158 fig. 2
Henrietta Maria (?), portrait-bust (Dieussart), 98
Hérault, 210, 183, 241
Herck, van C., 261 n1, 261 n2, Biblio.
Hercules, 162, 232
Hercules (or Meleager), no. 110 (Anonymous), 256, *256*, *257*
Hercules and Cacus (Michelangelo), 19, 19 fig. 8
Hercules on the Funeral Pyre (Guillaume Coustou the Elder), 174, 174 n2
Hercules and the Nemean Lion (Baratta), 96, 96 fig. 1; (Giambologna), 96, 96 fig. 3
Hercules Slaying the Nemean Lion, no. 32 (after Baratta), 94, *94*, 96
Herding, K., 174 n3, Biblio.
Hermitage, Leningrad, *bozzetti* (Bernini), 12, 20; *Winter* (Rusconi), 84; *Sappho and Phaon* (David), 207, 207 n9
Herodotus, 203 n1
von Hildebrand, Adolf (1847-1921), 146
Hill, G. F., 56, 56 n2, 63 n10, Biblio.
Hill, Samuel, 229
Hina, Spirit of the Moon, 237, 237 n5
Hoche (Milhomme), 210
Hodgkinson, T., 186 n4, Biblio.
Hofmannsthal, Hugo von, 238
Holy Family with St. John the Baptist, no. 105 (Dieussart), 246, *247*
Honour, H., 91 n1, 96 n2, Biblio.
Horse-Tamer (Martini), *11*, 151, *151*, 152, *152*
Horse-Tamers (Antique), 152
Hôtel: de Biron, Paris, 226; de Bullion, 203 n5, Biblio.;Drouot, Paris, 212 n5, 220, 221, 222 n3, n5, n10, 224, 232 n20, n21, Biblio.; de la Monnaie, Paris, 174 n3, Biblio.; de Päiva, 220; de Ville, Rheims, 210
Houdon, Jean-Antoine (1741-1828), 184; *Frileuse*, 201
House of Orange, portrait-busts (Dieussart), 246
Houston Museum of Fine Arts, Texas, *Titans* (Rodin), 226; *Virgin and Child* (Luca della Robbia), 22, 22 fig. 16
Humphris, Cyril, Ltd., London, 46, 56
Huntington Collection, San Marino, Calif., 148 n1
Hurtrelle, Simon (1648-1724), *Nymphs*, 165

I

Iconologia, Cesare Ripa, 161 n2
Ignudi (Michelangelo), 228
Immaculate Conception (Corsini), 120
Imperator, 55
Impruneta, Italy, 64 n2, Biblio.
Incorporated Society of Artists of Great Britain, 269
The Infant St. John Kneeling Before Christ and Offering Him the Cross (Dieussart), 246
Ingersoll-Smouse, F., 168 n2, 169, 247 n2, Biblio.
Injalbert, Jean-Antoine (1845-1933), 241
Innocence Taking Refuge in the Bosom of Justice (Chinard), 196
Institut de France, 196, 214
Invalides, 160, 163, 164, 214
Iran, 6
The Isabella Stewart Gardner Museum, Boston, *The Entombment of Christ with Carlotta of Lusignan* (Minelli), 40, 40 fig. 1
Israel Museum, Jerusalem, *Titans* (Rodin), 228 fig. 3, 230, 232 n7
Istituto dei Buoni Fanciulli, Verona, 31
Istituto Italia-Oriente di Cultura, Rome, 146

ITALIAN, mid-16th century, 54; late 19th century, 154; 19th or 20th century, 278; early 20th century, 146
Italian, 20, 21, 89, 128, 246, 273
Italo-Flemish, 146, 148
Italy, 12, 17, 84, 142, 154, 158, 164, 170, 176, 188, 210, 212, 214, 218, 228, 232, 233, 276

J

Jacquot, A., 167 n2, Biblio.
James III Stuart, 84
Janson, H. W., 224 n1, 232 n1, n8, n13, n16, n18, n21
Jardin de la Isla, Aranjuez, Spain, 96, 96 fig. 2
Jardin des Plantes, Paris, 226
Jardins du Carrousel, Paris, 238
de Jaucourt, Marquise, Bust of (Chinard), marble, 207
Jerusalem, 122; Israel Museum, 228, 228 fig. 3, 232 n7
Jianou, I., 232 n6, Biblio.
Johann Adam, Prince of Liechtenstein (d. 1712), 98, 108
Jones, Lady Anna Maria, 58
Jones, H.S., 203 n2, Biblio.
Jordaens, Jacob, *Mercury and Argus*, 189 n3
Josephine, Empress, 208
Joseph's Dream (Giuseppe Mazzuoli), 80
Journal, Delacroix, 25
The Judgment of an Unknown Saint (Piamontini), 103 n1
Judith, No. 5 (attributed to Boccalaro), 39, *39*
Judith and Holofernes (Cornacchini), 104
Jula, 114
Julien, Pierre (1731-1804), *Dying Gladiator*, 202, 203 n4, n6
de Jullienne, M., sale, 186 n6, 189
Jupiter, 232
Jupiter Tonans (Palma), 64

K

Kaendler, J.J., *Saint Peter* and *Saint Paul*, 90, 91, 91 figs. 3 and 4
Kaiser-Friedrich Museum, Berlin, 46, 189, 189 n5
Kalnein, W. G., 180 n10, 183 n2, 189 n2, 196 n1, Biblio.
Keller, U., 194 n1, Biblio.
Kensington Palace, 84
Kenworthy-Brown, John, 269 n1
Kessler, Harry, 238
Keutner, H., 104 n1, n3, n4
de Keyser, Hendrick (1565-1621), *Screaming child*, 259, 259 fig. 1
King David, no. 52 (Vaccaro), 130, *130*, *131*; marble (Vaccaro), 130 fig. 1
Kress, Samuel H., Collection, 22, 22 fig. 18, 40, 40 fig. 2, 184, 186 n7
Kunstindustrimuseet, Copenhagen, *Square Vase Adorned with Tahitian Gods* (Gauguin), 237
Kunsthistorisches Museum, Vienna, *Bust of Fracastoro (?)* (Cattaneo), 63; *Lamentation*, preliminary model (Mazzuoli), 75, 75 fig. 1, 76; *Bellerophon and Pegasus* (di Giovanni), 152

L

Lakenhal Museum, Leiden, fragment of a crying boy (Camper), 259, 259 fig. 3
Lamentation (dell'Arca), 23 fig. 23; (Mazzoni), 28, 30, 30 fig. 1; no. 21 (Mazzuoli), *74*, 75, 75, 76, 76; preliminary model, 75, 75 fig. 1, 76
Lami, S., 163, 163 n1, n3, 186, 186 n3, n8, n10, n12, 193, 208 n1, Biblio.
Lankheit, K., 76 n2, 98 n1, n2, n3, n5, Biblio.
de Lantier, Etienne François (1734-1826), 206
Lasker, Loula D., Fund, 25
Lateran Commission, 87, 91
Lavia, I., 25 n2, n7, Biblio.
Lazzari, Dionisio (d. 1690), 130
di Lazzaro, Andrea (1412-1462), called Il Buggiano, 276
Le Breton, Gaston, Collection, 212 n3
Lecomte, Félix (ca. 1737-1817), mausoleum of Stanislas Leszczynski, 168; *Grand Condé*, 193, 194 n3
LECOMTE, Louis, no. 68, *Nature*, 24, 160, *160*, 161, *161*; *St. Bartholomew, Louis XIV Trampling Heresy Underfoot*, 160
Lecomte Picard (1650-1681), 160
Leda (Van der Haeghen), 254
Leeuwenburg, J., 49 n3, 232 n24, 248 n1, 251 n3, 261 n2, Biblio.
Lefuel, Hector Martin (1810-1880), 219
Legendre (d. 1935), 230

Leghorn (Livorno), 228
Leiden, Lakenhal Museum, 259, 259 fig. 3
Leithe-Jasper, Dr. Manfred, 62
Lemaire, Henri (1798-1880), 218
LEMOYNE, Jean-Baptiste, 176, 188; no. 74, *Bust of Henri-Claude, comte d'Harcourt*, 170, *170*, *171*; no. 75, *M. François Boucher*, *13*, 14, 172, *172*; no. 76, *Mme. Boucher* 172, 173, *173*,
Lemoyne, Jean-Baptiste I, or the Elder (1679-1731), 170; *Death of Hippolytus*, 174, 174 n2
Lemoyne, Jean-Louis (1665-1755), 170; Pierre Hippolyte (1748-1828), 173
Le Moyne, Yves, sale, 173 n1
Lemprière, J., 104 n5, Biblio.
Le Nôtre, Andre (1613-1700), 162
Leningrad, Hermitage, 12, 20, 84, 207 n9
Leonardo da Vinci (1452-1519), *Battle of Anghiari*, 48, 250; *Fighting Horsemen*, 49 fig. 8
Leonardesque, 49
Leoni, Leone (1509-1590), 19; *Michelangelo*, 16 fig. 1
Leopardi, Alessandro (d. 1522/1523), 63
Leopold, Duke of Lorraine (r. 1697-1729), 166
Leopold Wilhelm, portrait bust, (Dieussart), 246
Leroy, Jacques, 254 n1, Biblio.
Lescot, Pierre (1500/1515-1578), 158
Lesueur, Jacques-Philippe (1757-1830), *Sappho addressing her verses to the bust of Phaon*, 206, 207 n3
Leszczynski, Stanislas (1677-1766), 168
Levey, Michael, 180 n10, 183 n2, 188, 189 n2, n3, 196, 196 n1, Biblio.
Le Voyer, M., 180 n6
Levy, Roland, 232 n16
Liet, Victor, 218
Lincoln, President Abraham (Ferrari), 142
Lion Supporting an Armorial Cartouche, no. 86 (Chinard), 14, 196, *196*, 197, *197*
Lipparini, Giovanni (d. 1788), 125
Lippi, Filippo (1457-1504), 36
Lisci, Marchese Ginori, Collection, 98
Litta, Pompeo (1781-1852), 76
Loeser, Charles, 48, 49, 49 n6, Biblio.
The Loire and the Loiret (van Clève), 164
Lombardi, Alfonso (1487/1497-1537), 23
Lombardo, Pietro (ca. 1435-1515), 40
London, 23 fig. 20, 28, 36, 40, 44, 46, 55, 56, 60, 63, 64, 68, 70, 75, 76, 77, 82, 86, 89, 91 n2, 96, 97, 98, 101, 104, 112, 120, 122, 129, 130, 166 fig. 1, 167, 176, 179, 180, 184, 186, 191, 193 fig. 1, 218, 221, 237, 246, 251, 264, 268, 269, 274; Arcade Gallery, 46; National Gallery, 62 fig. 1, 63; Brompton Oratory, 75; Wallace Collection, 138 fig. 3; David Barclay Collection, 221, 230; Bethnal Green Museum, 230, 232 n6, n17, n19; Courtauld Institute, 237 n1; Victoria and Albert Museum (see separate listing)
The Lookout (La Vedetta), no. 67 (Zawiejski), 14, *14*, 154, *154*, *155*
Loos, J. F., 226, 228
Loredan monument (Cattaneo), 60
Lorraine, France, 163
le Lorrain, Robert (1666-1743), 170, 188
Los Angeles County Museum, 232 n16, Biblio.; *Vestal* (Marin), 212; *Fantasy Bust after Mlle. Sophie Croizette* (Carrier-Belleuse), 224
Louis XII, 28
Louis XIII, 70, 164, 194
Louis XIII (Milhomme), 210
Louis XIV, 24, 163 n2, 164, 165
Louis XIV Trampling Heresy Underfoot (Lecomte), 160
Louis XV, 170, 176, 188, 189, 193
Louis XVI, 176
Louveçiennes, France, 168
Louvre, Musée du, Paris, 189 n1, 238; "unfinished figures" (Michelangelo), 5; bust of Christ, 30 n4; *Warriors* (Rustici?), 49, 49 n6; portrait-relief of Cardinal Alidosi (Francia), 52; *Risen Christ* (Pilon), 158 fig. 1; *Dead Christ* (attributed to Pilon), 158 fig. 2; Sketch for Tomb of Henri II (Pilon), 158 fig. 2; Relief (Hardy), 162; *The Recovery of Louis XIV* (Coustou), 164; *Sorrow* (Vassé), 168; *Death of Meleager* (Charpentier), 174 fig. 2; *River God* (Caffieri), 174 n3; Pajou, 176; *Mercury* (Pigalle), 189; *morceau de réception* (Julien), 203 n4; Dumont 208; *Psyche* (Milhomme), 210; *Fisherboy Dancing a Tarantella* (Duret), 214; *Velléda* (Maindron), 216; *Crouching Flora* (Carpeaux), 218 fig. 1; *Triomphe de Flore* (Carpeaux), 219; Carrier-Belleuse, 220; *Periboëtos*, 233; *Farnese Eros* (Praxitelian), 233; *Square Vase Adorned with Tahitian Gods* (Gauguin), 237
Love on a Chariot Drawn by Butterflies (Dumont), 208
Low Countries, 256, 262

Ludovisi Ares, 228
Lugt, F., 186, 188, Biblio.
Luxembourg Gardens, 189, 216
de Luynes, duc, 170
Lyons, 164, 188, 189, 196, 198, 204

M

Macerata, Italy, 142
Maclehose, L. S., 25 n20, Biblio.
Madame Récamier, bust (Chinard), 196
Maderno, Stefano (ca. 1576-1636), 96
Madonna (Michelangelo), 253
Madonna and Child, (Florentine School), 22 fig. 18; (School of Andrea della Robbia), 138 fig. 2
Madonna col Bambino (Mazza), 112 n1
Madonna di Fonte Nuova, Monsummano, 64
Madonna Immacolata col Bambino (Mazza), 112 n1
MAGROU, Jean-Marie-Joseph, *Chanson de Silène*, bust of Emperor Pedro II, bust of Marshal Hermès de Fonseca, 241; no. 103, *Maquette for the Tomb of Cardinal de Cabrières*, 240, 241, *241*, 242; *Tomb of Cardinal de Cabrières*, 242 fig. 1
da Maiano, Benedetto (1405-1465/69), 19, 22, 46
MAINDRON, Etienne-Hippolyte, 24; no. 95, *Velléda*, 216, *217*; *Velléda*, marble, 216 fig. 1; *Velléda*, plaster, 216 n1; *A Young Shepherd Bitten by a Snake*, *St. Remy Baptising Clovis*, *Ste. Geneviève Halting Attila*, 216
MAILLOL, Aristide, no. 102, *Head of a Young Woman*, 238, *238*, 239, *239*; *Young Cyclist*, *Renoir*, 238
de Mairobert, Pidansat, *Mémoires secret par Bachaumont*, 180 n1
Malesherbes (Dumont), 208
Mallet at Bourdon House, London, 191
Malraux, André, 5, 238
Malta, 68, 98, 132, 132 fig. 1
Mamiani della Rovere, Terenzio (1799-1885), monument (Ferrari), 144
Mann, J. G., 194 n1, Biblio.
Manneken-Pis (Jérôme Duquesnoy the Elder), 70
Man on Horse, no. 63 (Martini), 150, *150*
Mantegazza, Cristoforo (active 1464-1482), 28, 30
Mantegna, Andrea (1431-1506), 36, 39; Mantegnesque, 40
Mantua, 39, 66
Mantz, Paul, 232 n21
Manzoni, R., 274 n2, Biblio.
Maquette for the Tomb of Cardinal de Cabrières, no. 103 (Magrou), *240*, 241, *241*
maquettes, 17, *passim*
Maratta, Carlo (1625-1713), 82, 84, 87, 87 n3
Marcel, A., 212 n1, Biblio.
Marches, Italy, 23, 108, 158
Marchigian school, 52, 55
maréchal Gouvion de Saint-Cyr, 212
Marian cult, 111
Mariani, V., 25 n16, Biblio.
Marie, I. and A., 165 n1, Biblio.
Mariette, Pierre-Jean (1694-1774), 166
Marin, Joseph-Charles, *prix de Rome*, 210; no. 93, *Vestal Holding a Vase*, 212, *213*; *Vestal*, 212, 212 fig. 1; *Reclining Girl with a Rose, Tomb of Pauline de Beaumont*, 212
MARINALI, Angelo, no. 51, *Venetian Senator*, 129, *129*; *Rappresentante Veneto, Due Rettori*, 129
Marin, Joseph-Charles, *prix de Rome*, 210
Marlborough, Duke of, England, 94, 98
Marly-le-Roi, 180, 238
Marmorbad in Kassel, 88
Marquand, A., 25 n21, 49 n5, 138, 138 n3, Biblio.
Marquis de Monferrier, bust (Pajou), 183, 183 fig. 1
Mars (Pompe), 261 n2
Marseilles, 196, 201
Marsyas, 96
Martinet's Gallery, 220
MARTINI, Arturo, 21, 25, 146, 147; no. 60, *Girl Kneeling and Dressing Her Hair*, 11, *11*, 146, *146*, 147, *147*; no. 61, *Girl Seated and Drying Her Foot (?)*, 148, *148*; no. 62, *Wrestlers*, 149, *149*; no. 63, *Man on Horse*, 150, *150*; no. 64, *Horse-Tamer*, 11, *11*, 151, *151*, 152, *152*; no. 65, *Pair of Clothed Figures*, 153, *153*
Martini family, 42
de Martrais, Marie-Magdeleine Thibert, comtesse de Chiverny, 170
The Martyrdom of Bartholomew (Piamontini), 103 n2
The Martyrdom of Sts. Simon and Judas Thaddeus (Piamontini), 103 n2
The Martyrdom of an Unknown Saint, 103 n1
Maryhill Museum of Fine Arts, Goldendale, Washington, 232 n16, n19; *Titans* (Rodin), 228 fig.

2, 229; *Vasques des Titans* (Rodin and Carrier-Belleuse), 230, 232 n16
Marzia Scorticato da Apollo (School of Baratta), 96
MAS, photographic archives, Barcelona, 274, 274 n4, n7
MASTER OF THE DAVID AND ST. JOHN STATUETTES, 22, 44; *St. Jerome*, 42, 42 fig. 3; *St. Jerome* (kneeling), 42 n5; no. 8, *David*, 44, 45; *David*, 44, 44 fig. 1; *St. Sebastian*, 44, 44 fig. 4
MASTER OF THE UNRULY CHILDREN, 22; no. 9, *Virgin and Child*, 46, *46*, 47, 48, *48*, 49; *Charity*, 46 fig. 1; *Charity*, 46, 46 fig. 2; *Two Boys Quarreling*, 48; *Warriors*, (?), 48, 49 fig. 4; *Virgin and Child*, 49, 49 fig. 3; *River God*, 49, 49 fig. 5; *St. John the Baptist as a Child*, (?), 49 n4
Matzulevitch, G., 25 n17, Biblio.
Maugham, Somerset, 234
Mausoleum of Stanislas Leszczynski (Vassé), 168
Mayer van den Bergh Museum, Antwerp, *Mars and Mercury* (Pompe), 260, 261 n2
MAZZA, Giuseppe Maria, 24; *Rest on the Flight into Egypt*, 108; *Evangelists*, 108; no. 39, *David Triumphant over Goliath*, 108, 109, *109*; no. 40, *Walking Cupid (?)*, *110*, 111, *111*; no. 41, *Virgin Mary (?) Wearing a Veil* (attributed to), 112, *112*, *113*; *Madonna col Bambino*, *Vergine Annunciata* and *Madonna Immacolata col Bambino*, 112 n1
MAZZONI, Guido, 23, 30 n4; no. 1, *Bust of Christ* (Circle of), 28, *28*, *29*, 30; *Lamentation* groups, 28, 30, 30 fig. 1
Mazzuoli, Bartolomeo, *bozzetti* for *Dead Christ*, 76
MAZZUOLI, Giuseppe, 75, 112; no. 21, *Lamentation*, *74*, 75, *75*; preliminary model for *Lamentation*, 75 fig. 1, 76; *Dead Christ*, *Charity*, *Twelve Apostles*, Pallavicini-Rospigliosi tombs, 75; nos. 22 and 23, *Pair of Kneeling Angels*, 77, *77*, 78, *79*; *Angels*, 78, 79 figs. 1, 2; *Vision of the Blessed Ambrogio Sansedoni*, 77; *Joseph's Dream*, 80; Pope Clement XI Albani, 92
McCarthy, William J., 114
de' Medici, 19, 20, 44, 98; Cosimo I, 56, 56 n4; Anna Maria Luisa, 104; Lorenzo, 138; Nannina, 138
Medici Villa, Pratolino, 21
Meditation (Rodin), 233
Medusa-mask, 17, 17 fig. 3
Meeting of Attila and Pope Leo the Great (Algardi), 66
Meissen, 90, 91, 91 figs. 3, 4
Melchior and His Page Proffering Frankincense, no. 116 (Anonymous), 270, *270*, 271, *271*
Meleager (Coustou), 164
Meleager, 174 n5
Meleager or Hercules, no. 110 (Anonymous), 256, *256*, *257*
Mellini, Giovanni, 19
Mellon, Andrew, Collection, 23 fig. 19
Mercure (Pigalle), plaster, 189
Mercurio, Che Uccide Argo (Mercury Killing Argus) (School of Baratta), 96
Mercury (Pompe), 261 n2; (Coysevox), 165; (Giambologna), 18; (Pigalle), 189, 189 n5; (Artus Quellinus), 232
Mercury and Argus (Jordeans), 189 n3
Mercury Attaching His Wings to His Ankles, no. 83 (Pigalle), 188, *188*, 189, *189*
Mercury Inventing the Lyre (Duret), 214
Merlini, Lorenzo (1666-after 1739), 76
The Metropolitan Museum of Art, New York, 11, 118 n1, 189, 203, 237, 237 n1, 260, 273; *King Henry VIII and Archbishop Fisher*, portrait-busts (Torrigiano), 23; *President Lincoln* (Ferrari), 142; *Mercury Attaching His Wings to His Ankles* (Pigalle), 189
Metz, Germany, 166
Meudon, France, 162, 226, 233
Meucci, A., monument (Ferrari), 142
Mexican art, 11
Michelangelo, 5, 14, 16, 18, 19, 23, 56, 228, 233, 234; *David*, 5; *Pietà*, 5, 58; *Hercules and Cacus*, 19, 19 fig. 8; *Hercules and Antaeus*, 19; tomb of Pope Paul III, 56; *Sacramental Tabernacle*, 58; *ignudi*, 228; *Madonna*, 253
Michelangelo (Leoni), 16 fig. 1
Michele da Firenze (active 1436-1441), also referred to as Michele di Niccolò della Scalcagna and Michele di Niccolò Dini, 31, 35 n2, n4; tomb for Dr. Francesco Rosselli (attributed to), 31; *The Nativity of Christ*, 31, 34 fig. 2, 35; *The Adoration of Christ*, 31, 35, 35 fig. 4; *Altare della Statuine* (attributed to), 35, 35 fig. 5, 35 n4
Middle Ages, 17, 116
Middeldorf, U., 40 n6, 42, 64 n1, 186 n5, n9, Biblio.
Milan, Cathedral Square, 140, 146
MILHOMME, François-Dominique-Aimé; no. 92, *Brutus Lamenting Over the Dead Lucretia*, 24, 210,

294

210, 211, *211*; *Psyche, Hoche, Louis XIII, Colbert, Caius Gracchus leaving his wife Licinia to oppose the Consul Opimius in the Forum*, 210
Minelli, Maestro Antonio (15th century), 40
MINELLI, Giovanni, 36, 37, 38, 39; no. 6, *St. Catherine of Alexandria* (attributed to), 40, *40*, 41, *41*; *Entombment of Christ, with Carlotta of Lusignan*, 40, 40 fig. 1
Minerva, 232
Ming Dynasty, China (A.D. 1368-1644), 7
Minton China works, 220
The Miracle of the Cranes, no. 42 (Ottavio and Nicola Toselli), 14, *14*, 114, *114*, *115*
Mme. Alb. de Mar(seille) as Sappho Playing the Lyre (Chinard), 207
modello, 20, *passim*
Modena, Italy, 28, 30, 94, 126; Modena Cathedral, 31, 35, 35 fig. 5; San Domenico, 108
Molière (Duret), 214
Monari, Cristoforo (d. 1720), Still Life, 72, 72 fig. 3
de Monfried, Mme. Huc, Collection, 237
MONNOT, Pierre-Etienne, monumental tomb, 88; *St. Peter* and *St. Paul* 87, 90, 90 figs. 1, 2; no. 29, *St. Peter* (attributed to), 88, *88*, 89, 90; no. 30, *St. Paul* (attributed to), 89, *89*, 90
Monseigneur Bonnet, tomb (Magrou), 241
Montagu, J., 66, 68, 68 n1, 96, 103 n2, 104 n4, 109 n2, 132, Biblio.
Monte di Pietà, 120
Montegufoni Castle, Tuscany, 75; chapel, 76
da Montelupo, Baccio (1469-1535), 42 n5
de Montesquiou, Robert, comte, 176
Montpellier, France, 183, 241; Cathedral, 241, 242 fig. 1
Montreal, Canada, Museum of Fine Arts, 183, 183 fig. 1
Monument to Balzac (Rodin), 226
Monument to Terenzio Mamiani della Rovere (Ferrari), 144, 144 fig. 1
Monument to Victor Hugo (Rodin), 226
Monument with Angel and Two Mourners, no 58 (Ferrari), 142, *143*
Morazzone, G., 84 n6, Biblio.
Mort d'Othryades, 203
Moses (Michelangelo), 5; (Vaccaro), 130
de la Moureyre-Gavoty, F., 25 n11, Biblio.
Mourning Woman and Putto, no. 73 (Vassé), 24, 168, *169*
Munich, 49, 146
Musée Condé, Chantilly, 193
Musée d'Angers, *A Young Shepherd Bitten by a Snake* (Maindron), 216; *Velléda* (Maindron), plaster, 216 n1
Musée d'Art Ancien, Brussels, 246 n1, 259 n2
Musée de Calais, *Design for a jardinière with Titans*, drawing (Carrier-Belleuse), 226 fig. 1
Musée de l'Art Moderne, Paris, *Young Cyclist* (Maillol), 228
Musée de Rennes, *Velléda* (Maindron), plaster maquette, 216
Musée de Valenciennes, *Caius Gracchus leaving his wife Licinia to oppose the Consul Opimius in the Forum* (Milhomme), 210; *The Submission of Abd-el Kader* (Carpeaux), 218
Musée de Versailles, 193; *Colbert* (Milhomme), 210; *Hoche* (Milhomme), 210; *Richelieu* (Duret), 214
Musée des Arts Décoratifs, Paris, altar panels (attributed to Minelli), 36, 37 figs. 1, 2, 38; *Resting Mars* (attributed to Puget), 174, 174 fig. 1; sketch-model for Pavillon de Flore (Carpeaux), 219
Musée du Louvre, Paris (see Louvre)
Musée du Luxembourg, *Velléda* (Maindron), replica, 216
Musée du Petit Palais, Paris, torso (Rodin), 233
Musée Girodet, Montargis, Portrait, self-portrait (Chinard), 203
Musée Historique Lorrain, Nancy, *Putti with Military Accoutrements* (Jacob-Sigisbert Adam), 167 fig. 2
Musée Jacquemart-André, Paris, *St. Paul* (Sansovino), 19 fig. 7
Musée Napoleon, Paris, 198
Musée royale, 226 n1
Musées royaux des Beaux-Arts, Brussels, *St. Joseph* and *St. James* (Van der Haeghen), 254
Museo Civico, Bassano, Italy, *Bust of Lazzaro Bonamico* (Cattaneo), 62, 62 fig. 2
Museo di Capodimonte, Naples, *Sacramental Tabernacle* (del Duca), 58, 58 figs. 1, 2
Museo Civico, Padua, *Lamentation* (Mazzoni), 30, 30 fig. 1; *St. John the Evangelist* and *St. Peter* (Boccalaro), 39
Museo Diocesano, Urbino, *St. Peter* and *St. Paul* (J.J. Kaendler), 91, 91 figs. 1, 2
Museo Horne, Florence, *St. John* (Anonymous), 42 n5

Museo Nazionale (Bargello), Florence, *Perseus and Medusa* (Cellini), 19; *David* (Verrocchio), bronze, 44, 44 fig. 2; *David* (Donatello), bronze, 44, 44 fig. 3; *Warriors* (attributed to Rustici), terra-cotta, 48, 49 n6, n8; facade sculpture for Uffizi (Danti), 55; Sportello for Cosimo I, de'Medici, 56 n4; *Portrait of a Cleric* (attributed to Palma), 64 n2
Museo Nazionale di Villa Giulia, Rome, *Medusa-mask*, 17, 17 fig. 3
Museum of Art, Rhode Island School of Design, Providence, *River God* (Master of the Unruly Children ?), 49, 49 fig. 5
Museum of Fine Arts, Boston, *Baccio Bandinelli with Models* (Anonymous), 189 n6; *Madonna and Child* (School of Andrea della Robbia), 138, 138 fig. 2
Museum of Fine Arts, Houston, *Virgin and Child* (Luca della Robbia), 22, 22 fig. 16

N

Nagler, George K., 163, 163 n4, Biblio.
Nancy, France, 162, 166, 184; Musée Historique Lorrain, 167; Notre-Dame de Bonsecours, 168
Nantes, France, 216
Naples, Italy, 28, 30, 120, 214; Filomarino Chapel, SS. Apostoli, 14, 70, 70 figs. 1 and 2, 72; Capodimonte Museum, 56, 58 fig. 1; Cathedral, 130; church of S. Ferdinando, 130, 130 fig. 1
Napoleon, busts (Chinard), 196
Napoleon, III, 218
Les Nappes (Coustou), 164
National Gallery, London, *Portrait of Doge Leonardo Loredan* (Bellini), 62 fig. 1, 63
National Gallery of Art, Washington, D.C., 9, 25, 114 n2; *Madonna and Child* (Florentine School), 22, 22 fig. 18; *Giuliano de'Medici* (Verrocchio), 23 fig. 19; *Vestal* (Clodion), 184
National Gallery of Canada, 186 n4
National Gallery of Ireland, Dublin, *Hercules and the Nemean Lion* (Giambologna), 96 fig. 3
National Museum, Paris, 193
National Museum, Stockholm, *Othyrades* (Sergel), 203 n3
National Museum, Valletta, Malta, figure of Christ (Algardi), 68; *St. Luke* (Papaleo), 132, 132 fig. 1
National Trust, London, 251
Nativity (Mazzoni); 28; (Cornacchini), 104
The Nativity of Christ (Ghiberti), 31, 34 fig. 1, 35; (Michele da Firenze), 31, 34 fig. 2, 35
The Nativity of Christ and the Annunciation to the Shepherds, no. 2 (Anonymous), 14, *15*, 31, *31*, *32*, *33*, *34*, 35
Nâtoire, Charles (1700-1777), 186
Nature, no. 69 (Lecomte), 24, *160*, 161, *161*; marble, Versailles, 161, 161 fig. 1
Nava Cellini, A., 72, 72 n2, Biblio.
NEAPOLITAN, late 17th to early 18th century, 130
Neapolitan Fisherboy (Rude), 214
Neo-Classic, 24, 134, 142, 206, 268
Neolithic, 7
NETHERLANDISH, 17th century, 248; mid-17th century, 250; late 17th or early 18th century, 256, 258; mid-18th century, 260
New Carthage, 104
New York, 9, 11, 17, 23, 35 n4, 142, 179, 184, 229, 232 n11, 237, 237 n1, 274 n4
Newmark, Dr. Carolyn, 114 n2, 132 n3
Niederwiler, Nancy, 184
Noah (Palma), 64
NOLLEKENS, Joseph, no. 115, *Paetus and Arria*, 268, *268*, 269, *269*
Nollekens Modelling Venus (Rowlandson), 268 fig. 1, 269
NORTH ITALIAN, late 15th century, 28; (VERONA), mid- to late- 15th century, 31; second half of the 18th century, 126
Northern Europe, 116, 232, 242
Norton, R., 25 n16, Biblio.
Nôtre-Dame de Paris, 164, 170, 242
Nôtre-Dame de Bonsecours, Nancy, 168
Nôtre-Dame de Bonsecours, Brussels, 254
Nôtre-Dame de la Chapelle, Brussels, 254 n2, 264, 266 fig. 2
Nôtre-Dame-la-Rotonde, St. Denis, 158
Nôtre-Dame de Versailles, 160
Novatian schism, 118
Nymphs (Flamen and Hurtrelle), 165

O

Observatory, Paris, 218
Oeneus, 174 n5
Offrance à Bacchus (Carrier-Belleuse), 222, 222 n10

Offrande à Bacchus (Carrier-Belleuse), 220, 220 fig. 1, 221, 222, 222 n10
d'Oigny, baron, 189
Onofri, Vincenzo (active 1503-1524), *Beroaldo*, 52, 52 fig. 1
Opdycke, L., 25 n16, Biblio.
Opera del Duomo, Siena, 50, 50 fig. 2
Opéra, Paris, burning of, 214; 218, 220
Or San Michele, Florence, 30
Oratory of St. Lucy, Parma, 106
Order of Malta, 98
Orient, Oriental, 6, 7
d'Orléans, Prince Louis, tomb (Magrou), 241, 242
Orne, château de Sassy, 189 n6
Orpheus (Baratta), 96
Ospedale del Ceppo, Pistoïa, 48
Ossorio y Bernard, M., 274 n1, n3, Biblio.
Othryades (Sergel), 202, 203 n3; *Otriades, (O)trianidas*, 202
Othryades Dying, 202, 203 n1
Othryades Expiring on His Shield, no. 88 (Chinard), 202, *202*, 203, *203*
Ovetari Chapel, Church of the Eremitani, Padua, 36, 38, 38 fig. 3
Oviri (Gauguin), 237
Oxford Research Laboratory for Archaeology and the History of Art, Report on Thermoluminescence Analysis, 28, 38 n1, 39 n2, 40 n2, 52 n1, 55 n1, 56 n3, 60, 96 n8, 138 n1, 176 n1, 276 n1, 278 n1

P

Paccagnini, G., 39 n3, Biblio.
Padua, 36, 39, 40, 60, 128, 276; Basilica of the Santo, Cappella del Podestà, 36; Church of the Eremitani, 38; San Nicola da Tolentino, 39; Museo Civico, 30, 30 fig. 1
PADUAN, middle of the 15th century, 36; late 15th century, 39; late 15th or early 16th century, 40; *Paetus and Arria*, no. 115 (Nollekens), 268, *268*, 269, *269*
Paetus, Caecina, 269
Paillet, 186 n10, 203 n5
PAJOU, Augustin, 176, 193, 208; no. 78, *Silenus*, 176, *176*, *177*; no. 79, *Venus Receiving the Apple from the Hands of Love*, 178, 179, *179*, 180; no. 80, *Bust of Corbin de Cordet de Florensac*, 180, *181*, 182, *182*, 183, *183*; *Satyr Playing the Flute*, 176; *Venus and Cupid*, marble, 179, 179 fig. 1; *Venus Receiving the Apple from the Hands of Love*, drawing, 180, 180 fig. 2; *Bust of the marquis de Montferrier*, 183, 183 fig. 1; *Bust of Hubert Robert*, 183, 183 fig. 2
Palace of Justice, Paris, 158
Palais-royale, 214
Palazzo Comunale, Bassano, 129
Palazzo dei conservatori, 66
Palazzo dei Rettori, Brescia, 129
Palazzo della Signoria, Florence, 48, 49, 49 fig. 4, 250
Palazzo di Spagna, Rome, 250, 251 fig. 1
Palazzo Ruscellai, Florence, 49 n6
Palazzo Sansedoni, Siena, 76, 77, 80
Palazzo Vecchio, Florence, 21, 55
Palazzo Venezia, Rome, 84
Palazzo Widmann, Venice, 111 n1
Palermo, Sicily, 132
Pallavicini, Marchese Niccolò Maria, 82, 84
Pallavicini-Rospigliosi Tombs (Mazzuoli), 75
Palma, Felice, 64; no. 16, *Bust of a Cleric*, 13, *13*, 64, *64*, *65*; *Ecclesiastic* (attributed to), 64, 64 fig. 1; *Portrait of a Cleric, Jupiter Tonans, Busts of Bishop Pietro and Usimbardo Usimbardi, Noah, Baptism, Risen Christ*, finials of *Christ* and *St. John the Baptist*, 64
Panofsky, E., 242 n1, Biblio.
Pansecchi, F., 76 n3, n5, 77 n2, Biblio.
PANTANELLI, Sebastiano, no. 49, *Statue of Pope Clement XIV Ganganelli*, 11, 126, *126*, *127*; Bust of Conte Annibale degli Abati-Olivieri Giordani, 126
Panthéon, 216, 268
Papal museums, Rome, 202
PAPALEO, Pietro, no. 53, *St. Luke*, 132, *132*, *133*; *St. Luke*, wood, 132, 132 fig. 1; *St. John of the Cross, St. Fabianus*, 132
Paris, 42, 42 fig. 3, 55, 96, 98, 158, 160, 162, 164, 166, 167 n1, 168, 170, 170 n2, 179, 183 n2, 183 fig. 2, 184, 186, 186 n2, n6, n7, n11, 188, 189 n4, 191, 193, 196, 198, 203, 203 n2, n3, 208, 210, 212, 212 n2, n3, n5, 216, 218, 219, 220, 221, 222, 226, 229, 234, 237, 237 n4, 238, 241, 242, 264, 274, 274 n8; Musée des Arts Décoratifs, 36, 37 figs. 1, 2, 219; Musée du Louvre, 5, 49 n6, 158, 158 figs. 1, 2, 218,

fig. 1, 219, 233, 237; Musée du Petite Palais, 233; Musée Jacquemart-André, 19; Rodin Museum, 226, 230, 231, 232, 232 fig. 4, 233
Parke Bernet Galleries, New York, 180 n4, 186 n4, 229, 232 n11
Parma, Italy, 23, 106
PARODI, Filippo, no. 50, *Genoese Senator* (attributed to), 128, *128*
Parronchi, A., 64 n1, n3, Biblio.
Pascoli, E., 82, 84, 84 n1, n7, Biblio.
Passion of Christ, 23, 58
Patria, 144
Patte, P., 194 n2, Biblio.
Pavillon de Flore, Louvre, 218, 219
Paysage avec Sapho (Girodet-Trioson), 207
Peace (Cattaneo), 63
Peace of Amiens (Dardel), 193
Pêcheur à la Coquille (Carpeaux), 218
Pecher, Jules, 226
Pellegrini Chapel, Sant'Anastasia, Verona, 31, 34 fig. 2, 35, 35 fig. 4
Penha Longa, comte de, Collection, 205
Penny, N., 242 n7, Biblio.
Periboëtos, 233
Perocco, G., 147 n1, Biblio.
Perot, Jean-Jacques, 212
Perpignan, France, 238
Perseus and Andromeda (Chinard), 196, 206
Perseus Delivering Andromeda (Chinard), 201
Perseus and Medusa (Cellini), 19
Perugia Cathedral, 56, 56 fig. 1
Pesaro, Italy, 126, 144, 144 fig. 1
Pescia, Italy, 104
"Petite Ecole," Paris, 218, 220, 226, 228
Phaon, 206, 207
Philbrook Art Center, Tulsa, Oklahoma, 40, 40 fig. 2
Philip V (Vaccaro), 130
Phillips, J.G., 30 n2, Biblio.
Philosophie (Chinard), 201
Philosophy (Ferrari), 144
Phryne (Pradier), 201
Phryne Emerging from Her Bath, no. 86 (Chinard), 12, 24, *157*, 198, *198*, *199*, 200, 201, *201*; *Phrine Sortant du Bain*, 198
Piamontini, Giuseppe (1664-1742), 103
Piazza del Municipio, S. Angelo in Vado, 126
Piazza dell'Unità, 138
Piazza della Stazione, Pesaro, 144
Piazza San Marco, Venice, 63
Pichegru (Dumont), 208
Pietà (Michelangelo), 5, 58; (Dieussart), 246, 246 fig. 1; Appendix A (Anonymous), 276, *277*
Pietrasanta, 64
PIGALLE, Jean-Baptiste, 184, 194 n2; no. 83, *Mercury Attaching His Wings to His Ankles*, 188, *188*, 189, *189*; *The Tomb of Maréchal de Saxe, Louis XV*, 188; *Venus Charging Mercury with the Education of Love*, 189
PILON, Germain, no. 67, *Dead Christ* (Circle of), 158, *158*, *159*; *Dead Christ*, painted stone (attributed to), 158, 158 fig. 1; *Statue for Tomb of Henri II*, 158, 158 fig. 2; *Risen Christ*, 158
Pilon, Louis-Jacques (1741-after 1806), equestrian statue of the prince de Bourbon, 194
Pinacoteca Comunale, Faenza, 138, 138 fig. 4, 138 n5
Pincian, Rome, 140
PIÒ, Angelo Gabriello, no. 46, *Christ on the Road to Emmaus*, 122, *123*
Pisa, Italy, 64, 142
da Pisa, Giovanni (d. ca. 1460), 36, 38
Pisano, Andrea (d. 1348/49), 31
Pistoia, Italy, 22, 22 fig. 17, 104; Cathedral, 19; Ospedale dell Ceppo, 48
Pitti Palace, Florence, 134
PIZOLO, Nicolò, no. 3, *St. Francis* (attributed to), 36, *36*, 38, *38*; no. 4, *St. Clare* (attributed to), 36, 37, *37*, 38, *38*; *St. Catherine of Siena* (probably by), 36, 37 fig. 1; *St. Catherine of Alexandria* (probably by), 36, 37, 37 fig. 2, 38; *Altar Relief*, 38, 38 fig. 3
Place de Vosges, 194
Place Royale, Rheims, 188
Planiscig, L., 38 n3, 63 n4, Biblio.
Pliny, 269 n3
PLUMIÈRE, Pierre-Denis, no. 114, *Father Time Carrying Off a Dead Infant* (attributed to), 242, *243*, 264, *264*, 265, *265*, 266, *267*, *Monument to the Duke of Buckingham*, 264, 266, 266 fig. 1; *Spinola Family Monument*, 264, 266, 266 fig. 2
Po Valley, 23, 30
Poetry (Ferrari), 144
Poetry and Music (Clodion), 25 fig. 24
Poggio Imperiale, Florence, 64

Poland, 154
Pollaiolo, Piero (1443-1496), 19, 250
Pollard, G., 63 n10, Biblio.
di Polo, Agnolo, 42 n5
Polynesia, 234
du Pompadour, Mme., 168, 172, 188
POMPE, Walter, 259; no. 112, *Putti Bird's-Nesting*
(attributed to), 24, 260, *260*, 261, *261*; no. 113, *The
Christ Child as Saviour* (style of), 262, *262*, *263*
Pontifex, 212 n2
Pope Alexander VII, tomb, 75
Pope Clement XI Albani, Gian Francesco, 90, 91,
92, 92 n1
Pope Clement XI Albani, no. 11 (Anonymous), 12,
12, 92, *92*, 92 figs. 1, 2, *93*
Pope Clement XIII, tomb, 242
Pope Clement XIV Ganganelli, Statue of, no. 49
(Pantanelli), *11*, 126, *126*, *127*
Pope Cornelius, 118, 118 n1
Pope Gregory XIII (Rusconi), 82
Pope Innocent X (Algardi), 66
Pope Innocent XI, 98
Pope Julius II, tomb, 58
Pope Julius III Enthroned (Danti), 56, 56 fig. 1
Pope Julius III del Monte, no. 13 (attributed to Danti),
13, 14, 56, 56 fig. 2, *57*
Pope Leo XI, tomb (Algardi), 66
Pope Paul III (della Porta), 56
Pope-Hennessy, J., 25 n6, n9, n13, 30 n1, n4, 35 n1,
42 n2, n6, 44 n1, n3, 49 n2, 50 n1, n4, 63 n2, 64
n4, 98 n4, n6, 104 n2, 120 n1, 251 n2, 278 n2,
Biblio.
Porte Désilles, Nancy, 167
della Porta, Guglielmo (d. 1577), 56, 58
Porte Saint-Clair, Lyons, 196
Portrait of a Cleric (attributed to Palma), 64, 64 n2
Portrait of Doge Leonardo Loredan (Bernini), 62 fig. 1
Portugal, 94
Poseidon, or Jupiter, 232
Potsdam, Sans Souci, 189
Poussin, Nicholas (1593/94-1665), 70
dal Pozzo, Cassiano, 70
Pradier, Jean-Jacques (1792-1852), 201
Prat, Abelló, Collection, Mollet des Valles, Barcelona,
274 fig. 1, 274 n4
Praxiteles, *Farnese Eros*, 233
Preaching of St. John the Baptist, no. 36 (Circle of
Soldani), *102*, 103, *103*
pre-Columbian civilizations, 17, 234
Priestess Carrying a Vessel, Antique statues, 184
Prieur, Barthélémy (1536-1611), 148
Primaticcio, Francesco (1504-1570), 158
prix de Rome, 164, 188, 193, 210, 212, 214, 218
Providence (Vaccaro), 130
Prudence (Cornacchini), 104
Prussia, 94, 168
Psyche (Milhomme), 210
Puget, Pierre (1620-1694), 174, 174 fig. 1
de Puisieux, Arnoul (d. 1417), tomb, 242
Putti Bird's-Nesting, no. 112 (attributed to Pompe),
260, *260*, *261*
Putti with Military Trophies (Adam), 166, 166 fig. 1
Putti with Military Accoutrements (Adam), 167, 167
fig. 2
Putti Personifying the Four Seasons (Rusconi), marble,
82, 82 figs. 1, 2, 3, 4, 84
Putto Personifying Summer, no. 25 (Rusconi), 82, *83*,
84
Putto Personifying Winter, no. 26 (Rusconi), 82, 84,
85, marble, 82, 82 fig. 4, other versions, 84
Putto Playing a Drum Before Armour, no. 71 (Adam)
12, *12*, *166*, 167
Putto Trying Out Armour, no. 72 (Adam), 167, *167*
Pygmalion (Chinard ?), 201
Pyrenees, 238

Q

Quattrocento, 134
Quellinus, Artus, the Elder (1609-1668), 260; model
for water pump, 232, 232 fig. 5; *Tarquin and
Lucretia* (Circle of), 248, *248*, *249*; *Sea Gods Paying
Homage to Amsterdam*, 248; studies of maniacs, 251,
251 fig. 3
Quellinus, Artus, the Younger (1625-1700), 253
Quinquenet, M., 212 n5, n6, Biblio.

R

Rabat, Malta, 132
Rachel (Duret), 214
Radcliffe, A., 25 n5, 96 n4, n5, Biblio.
Raggio, O., 104 n2, Biblio.
Ramey, Claude (1754-1809), *Sappho holding a letter to
Phaon*, 206, 207 n4, 214

Rape of a Sabine (Giambologna), 21
Rappresentante Veneto (Marinali), 129
van Rasbourg, Antoine-Joseph (1831-1902), 226
Raucher-Jauneau, M., 207 n1, Biblio.
Raguier, Hémon (d. 1420), tomb, 242
Réau, L., 24, 25 n2, n23, 168, 168 n2, 170 n1, n6, n7,
n8, 173, 186 n1, 189 n1, n4, n6, n8, Biblio.
Reclining Girl with a Rose (Marin), 212
Reggio Emilia, Italy, 23
The Recovery of Louis XIV (Coustou), 164
Religion Crushing Idolatry (Hardy), 162
Renaissance, 5, 14, 17, 19, 20, 22, 23, 24, 40, 116,
134, 136, 149, 207, 250, 278
Reni, Guido (1575-1642), 72
Renoir (Maillol), 238
Rest on the Flight into Egypt (Mazza), 108
Resting Mars (attributed to Puget), 174, 174 fig. 1.
Restoration of the French Monarchy, 193, 210, 212
Resurrection, tableau (Pilon), 158
Return of the Prodigal Son (Ferrari), 142
Revolution, French, 176, 184, 193, 194, 196, 208, 210,
212
Riban, Jean-Baptiste, bust (Pajou), 183
Il Riccio, appellation for Andrea Briosco (ca. 1470-
1532), 35, 40, 40 n6
Riccòmini, E., 30 n4, n5, 109, 109 n1, 112 n1, 114
n1, 122 n2, 125 n1, Biblio.
Richelieu (Duret), 214
Richmond Gallery, 269 n5
Rigoni, E., 38 n6, 40, 40 n1, 63 n1, Biblio.
Rijksmuseum, Amsterdam, *Virgin and Child* (Master
of the Unruly Children), 49 fig. 3; model for a
water pump (Artus Quellinus the Elder), 232,
Frenzy (Artus Quellinus the Elder), 251, 251 fig. 3;
Virgin and Child (Pompe), 261 n2
Rilke, Rainer Maria (1875-1926), 226, 233
Ripa, Cesare (fl. 1600), 161, 161 n2
Risen Christ (Palma), 64; (Pilon), 158
River-God (Giambologna), 21 fig. 14; (Master of
the Unruly Children ?), 49, 49 fig. 5; (Caffieri),
174 n3; *River Gods* (Coysevox), 165
A River God and Goddess, no. 70 (Coustou), 164, *164*,
165
della ROBBIA, Andrea, 22; no. 56, *Virgin and Child*
(after), 138, *139*
della Robbia, Luca (1399/1400-1482), *Virgin and
Child*, 22, 22 fig. 16;
Visitation, detail, 22, 22 fig. 17;
Via della Scala Madonna, 138,
138 fig. 1
Rocco, Francesco, monument (Vaccaro), 130
Rococo, 82, 196, 260, 268
RODIN, Auguste, 13, 24, 25, 153, 220, 223; *Gates of
Hell, Burghers of Calais, The Age of Bronze*, Loos
Monument, 226, 228; *Monument to Balzac,
Monument to Victor Hugo*, 226, 233; *Titans*, terra-
cotta, 228, 228 fig. 2, 229, 230; *Titans*, bronze, 228,
228 fig. 3, 229, 230; no. 99, *Vasque des Titans* (with
Carrier-Belleuse), 226, *227*, 228, 229, *229*, 230, *230*,
231, *231*, 232, other versions, 228, 230, 231, 232
fig. 4, 232 n16, n19; no. 100, *Torso Standing on One
Leg*, 233, *233*; *Walking Man*, 233
Roland, Philippe-Laurent (1746-1816), 194 n3
Romagna, Italy, 106
ROMAN, third quarter of the 16th century, 56; 16th
century, 58; first half of the 17th century, 66, 70;
third quarter of the 17th century, 73; early 18th
century, 82, 86, 88; 92; late 19th century, 140; late
19th century to early 20th century, 142; (or
SIENESE), late 17th or early 18th century, 80; (or
BOLOGNESE), 18th century, 118
Roman, Ancient, 22, 44, 104, 118, 152, 203 fig. 1
Roman Emperor, no. 12 (Anonymous), *54*, 55, *55*
Romantic, 21, 24, 207, 273
Rome, 19, 21, 24, 60, 66, 70, 72, 75, 82, 84, 88, 90,
98, 104, 108, 112, 118, 120, 122, 132, 140, 142, 146,
176, 186, 186 n2, 188, 189, 191, 196, 201, 203, 203
fig. 1, 208, 210, 232, 246, 264, 268, 269; Museo
Nazionale di Villa Giulia, 17; Istituto Italia-Oriente
di Cultura, 146; Santa Caterina a
Montemagnanapoli, 73; Esquiline Hill, 152; French
Academy, 168, 186, 202; Papal Museums, 202;
Capitoline Museum, 184, 202; Palazzo di Spagna,
250
ROSA, Ercole, no. 57, *Genius of the Papacy*, 140, *140*,
141, *141*; Monument to the Cairoli brothers, 140
Rosasco, B., 165 n2, Biblio.
Rosenborg Castle, Copenhagen, 96, 96 fig. 1
Rosselli, Dr. Francesco (d. 1430), tomb (attributed to
Michele da Firenze), 31
Rossellino, Antonio (1427-1479), 42
Rossellino, Bernardo (1409-1464), 134

de Rossi, Angelo, 92
Rossi, P., 63 n1, Biblio.
Rothschild Collection, Vienna, 179
Rowlandson, Thomas, *Nollekens-Modelling Venus*, 268
fig. 1, 269
Royal Academy, London, 268, 269, 269 n5
Royal Collection, Windsor Castle, 82, 82 figs. 1-4
Rubens, Peter Paul (1577-1640), 24, 253
Rucellai, Bernardo, 138
Rude, François (1784-1855), *Neapolitan Fisherboy*, 214,
218
RUSCONI, Camillo, 94, 104, 108, 130; no. 25, *Putto
Personifying Summer*, 82, *83*, 84; no. 26, *Putto
Personifying Winter*, 82, 83, 84; *Putti Personifying
the Four Seasons*, marble, 82, 82 fig. 1, 2, 3, 4, 84;
putti on Fabbretti monument, 84; *St. Andrew*,
marble, 87
Russia or Russian, 11, 168, 184
Rustici, Giovanni Francesco (1474-1554), 250;
St. Jerome, (style of), 42, 42 fig. 1; *Warriors*
(attributed to), 49, 49 n8; *Fountain* (Circle of), 251
fig. 2

S

Sackler, Arthur M., 3, 7, 9, 11, 12, 13, 14, 17 fig. 2,
24, 36, 38, 68, 68 fig. 1, 76, 154, 154 fig. 1, 180, 180
fig. 2, 186, 194 n4, 203, 222, 231, 273, 274
Sacramental Tabernacle (del Duca), 58, 58 figs. 1, 2
Sacrifice to Bacchus (Carrier-Belleuse), 221
Sant'Agostino, Padua, 40; Siena, 77
Sant'Anastasia, Verona, 31, 34 fig. 2, 35 fig. 4
St. Andrew, 56, *57*
St. Andrew (Ferrucci); 42; (Duquesnoy); 70; no. 28
(Anonymous), 86, 87, *87*; (Rusconi), 87
Sant'Angelo in Vado, near Urbino, 126
Sant'Anna dei Lombardi, Naples, 28
St. Anne, 116, *116*, *117*
St. Anthony of Padua, 120, *121*
St. Anthony of Padua (attributed to Pizolo), 38,
38 fig. 3
Sant'Antonio (Minelli), 38
Sant'Antonio, Padua, (also referred to as the Santo),
36, 38, 40, 63, 128
Sant'Antonio di Castello, Venice, 30, 30 fig. 1
SS. Apostoli, Naples, 70, 70 fig. 1, 72
St. Augustine (Marinali), 129
St. Bartholomew (Lecomte), 160
St. Blaise (San Biagio), no. 30 (Anonymous), 106, *106*,
107
Santa Caterina a Montemagnanapoli, Rome, 73
St. Catherine (attributed to Minelli), 40 n3; (Caffà), 73
St. Catherine of Alexandria, (Pizolo?), 36, 37 fig. 2;
no. 6 (attributed to Minelli), 40, *41*
St. Catherine of Siena (Pizolo?), 36, 37 fig. 1
St. Clare, no. 4 (attributed to Pizolo), 36, 37, *37*, 38, *38*
Santa Croce, Florence, 19
St. Cyprian, 118
St. Denis, 158
San Domenico, Bologna, 30 n4
San Domenico, Modena, 108
San Donato, Siena, 77, 78 fig. 1, 79 fig. 2
St. Etienne-du-Mont, 158
St. Fabianus (Papaleo), 132
San Ferdinando, Naples, 130, 130 fig. 1
San Francesco, Arezzo, 31
San Francesco a Ripa, Rome, 75
St. Francis, no. 3 (attributed to Pizolo), 36, *36*, 38, *38*;
(Pizolo), Acton Collection, Florence, 36
St. Geneviève Halting Attila (Maindron), 216
SS. Giovanni e Paolo, Venice, 62
San Giovanni Furocivitas, Pistoia, 22 fig. 17
San Giovanni in Laterano, Rome, 82, 104
San Giovanni in Persiceto, Bologna, 122
San Giovanni Maggiore, 130
San Girolamo, Fiesole, 42
Santa Giustina (Minelli), 38
Santa Giustina, Padua, 128
St. Helena (Vaccaro), 130
Sant'Ignazio, Cappella Ludovisi, Rome, 82
St. James (Sansovino), 19
St. James the Great (Van der Haeghen), 254
St. Jerome (Torrigiano), 23; no. 7, (attributed to
Ferrucci), 42, *43*; (style of Rustici), 42 fig. 1; in
meditation (style of Verrocchio), 42, 42 fig. 2;
(Master of the David and the St. John Statuettes),
42 fig. 3; (Ferrucci), 42 fig. 4; (Vaccaro), 130
St. John, 30, 246, *247*
St. John (Sansovino), 49
St. John, Valletta, Malta, 98
St. John Lateran, Basilica, Rome, 87, 88, 90 figs. 1, 2
St. John of the Cross (Papaleo), 132
St. John the Baptist (Pizolo), 36; (Palma), 64; no. 18
(Algardi), 24, 68, *68*, *69*

Saint John the Baptist as a Child (attributed to Master
of the Unruly Children), 49 n4
St. John the Evangelist (Boccalaro), 39
St. Joseph (Van der Haeghen), 254 fig. 2
St. Joseph et l'enfant (Van der Haeghen), 254 fig. 1
St. Joseph Holding the Christ Child, no. 109 (Van der
Haeghen), 254, *255*
St. Lawrence, 120
San Lorenzo, New Sacristy, Florence, 253
St. Lucy, Oratory, Parma, 106
San Luigi dei Francesi, 212
St. Luke, no. 53 (Papaleo), 132, *132*, 133, *133*;
(Papaleo), carved wood, 132 fig. 1
Santa Maria degli Angeli, 58
Santa Maria dell'Anima, 70
Santa Maria delle Grazie a Caponapoli, Naples, 130
Santa Maria della Scala, Siena, 75, 76; Rome, 132
Santa Maria della Vita, Bologna, 23 fig. 21
Santa Maria della Vittoria, Rome, 77
Santa Maria di Loreto, Rome, 58, 70
Santa Maria di Montesanto, Rome, 132
Santa Maria in Campitelli, Rome, 77
Santa Maria Sopra Minerva, Rome, 84
St. Mark's, Venice, 49, 60
San Martino, Bologna, 52, 52 fig. 1
St. Martin's, Stamford, England, 88
St. Mary Magdalene, 66
Saint-Merry, 168
St. Michael Crushing The Devil (Duret), 214
Saint-Michel, Bonneval, 212
SS. Michele e Gaetano degli Antinori, Florence, 103
San Nicola da Tolentino, Church of the Eremitani,
Padua, 39
San Nicolo di Lido, Venice, 129
St. Paul (Sansovino), 19, 19 fig. 7; (attributed to
Théodon), 87; (Monnot), marble, 88, 90, 90 fig. 2;
no. 30 (Monnot), 89, *89*, 90; (J.J. Kaendler),
Meissen porcelain, 90, 91, 91 fig. 4; (Marinali), 129
St. Paul's Grotto, Rabat, 132
St. Peter (Boccalaro), 39; no. 27 (Anonymous), 86, *86*,
87; (attributed to Théodon) 86 fig. 1, 87; (Monnot),
marble, 87, 88, 90, 90 fig. 1; no. 29 (attributed to
Monnot), *88*, 89, 90; (J.J. Kaendler), Meissen
porcelain, 90, 91, 91 fig. 3; (Corsini), 120
St. Peter's, Rome, 66, 70, 104, 242
San Petronio, 120
St. Petronius, 125
St. Petronius(?), no. 48 (Circle of Gandolfi), 124, 125, *125*
San Pietro in Montorio, 56
San Prosdocimo (Minelli), 38
St. Remy Baptizing Clovis (Maindron), 216
St. Romuald(?), no. 47 (Circle of Gandolfi), 124, *124*, 125
St. Sebastian (Master of the David and St. John
Statuettes), 44, 44 fig. 4
San Sebastiano fuori le mura, Rome, 132
Santo Spirito, Ferrara, 30 n4; Florence, 94
St. Sulpice, Paris, 208
St. Susannah (Duquesnoy), 70
St. Thomas, 66
St. Thomas, Strasbourg, 188
Santa Trinita, Florence, 64
Salons, Paris, 168, 170, 176, 179, 180, 180 n1, n3, 183,
184, 189, 191, 193, 198, 201, 203, 203 n3, 206, 207,
210, 212, 212 n7, 214, 216, 218, 220, 221, 224, 226,
241, 242 n1
Salons de la Correspondance, Dardel (1771-1787), 193
Salviatti family, 42
Samson and the Lion (Stati), 95, 96 fig. 2
Sandrart, Jakob, 246, 246 n3
Sanminiatelli, D., 50 n2, Biblio.
Sansovino, Jacopo (1486-1570), 24, 60; tableau of
the Deposition, wax on wood, 18; *St. James*, 19; *St.
Paul*, terra-cotta, 19, 19 fig. 7; *Evangelists, St. John*, 49
Sappho, opera, 206
Sapori, 274 n2, Biblio.
Sappho, 24, 206, *206*, 207, *207*, 207 n3
Sardou Collection, 180
Satyr Playing the Flute (Pajou), 176
Scheemakers, Peter, the Younger (1691-1781), 264,
266 fig. 1, 268
Schlegel, U., 72, 72 n4, 73 n1, 76 n6, 77 n3, 80 n1,
87 n4, 92 n1, 96 n1, n3, Biblio.
Schluter, Andreas, 194
Schmoll, J.A., 233, Biblio.
Schottmüller, F., 42 n5, 49 n1, Biblio.
Scipio, Publius Cornelius (called Africanus), 104
Screaming Child (de Keyser), 259, 259 fig. 1
Scribonianus, Camillus, 269
Sea-Gods Paying Homage to Amsterdam (Artus
Quellinus the Elder), 248
The Seine and the Marne (Coustou), 164 fig. 1, 165
Self-Portrait (Vittoria), 24, 24 fig. 22
de Selle, M., 189

296

Semenzato, C., 39 n1, 111 n1, 129, Biblio.
Sergel, Johan Tobias (1740-1814), *Othryades*, 202, 203 n3
da Settignano, Desiderio (ca. 1430-1464), 134
Seven Corporal Works of Mercy, 48
Seville, 271
Sèvres Manufactory, 180 n6, 208, 220, 226, 228, 232 n17
Seznac, J., 180 n1, n2, Biblio.
Shang Dynasty, China (ca. 1600-1027 B.C.), ritual bronzes, 5, 7
Sheffield, John (Duke of Buckingham), tomb, 264, 266, 266 fig. 1
Shepherd and Goat (Vallmitjana), 274, 274 fig. 2
Sicily, 58, 132
Siena, 112; Opera del Duomo, 50, 50 fig. 1; Cathedral, 50, 50 fig. 2; bronze, 75; Santa Maria della Scala, 75, 76; Chigi-Saracini Collection, 76; De Vecchi Collection, 77; San Donato, 77, 78, 79 figs. 1, 2; Palazzo Sansedoni, 80
SIENESE, 16th century, 50; late 17th century, 75; (or ROMAN), late 17th or early 18th century, 80
Silenus, no. 78 (Pajou), 176, *176*, *177*; plaster, 176
Sirigatti, Ridolfo (active 1594-1601), 20
Sistine Chapel, Rome, 228
Sketch for a Figure of François Chateaubriand, no. 94 (Duret), 214, *215*
Sketch-model for a Wall-Monument with a Figure of Charity, no. 54 (Anonymous), 14, *14*, 134, *134*, *135*
Sketch-Model for a Wall-Monument with a Male Portrait-Bust, no. 55 (Anonymous), 136, *136*, *137*
Slaves (Tacca), 228; (Michelangelo), 233
Sleeping Shepherd (Vassé), 168
Slive, Seymour, 9
Slodtz, Michel-Ange (1705-1764), 191
Smith, John T., 269 n2, Biblio.
Soentgen, Joseph (n.d.-1788), 167
SOLDANI-BENZI, Massimiliano, 94; no. 34, *The Apotheosis of Grand Master Fra Antonio Manoel de Vilhena*, 98, *99*; tombs for Manoel de Vilhena, medals for Christina, Queen of Sweden, 98; no. 35, *Adoration of the Magi* (Circle of), *100*,*101*, 103; no. 36, *Preaching of St. John the Baptist* (Circle of), *102*, 103, *103*
Solimena, Francesco (1657-1747), 130
Sorel, Agnes (d. 1450), tomb, 242
Sorrow (Vassé), 168, 168 fig. 1
Sotheby, London, 56, 230, 232 n18, 264, 268, 269
Souchal, François, 161, 161 n1, 163 n2, 174, 174 n1, n2
SOUTH GERMAN, late 15th century, 244
SOUTH ITALIAN, late 17th century, 132
Spain, 23, 58, 94, 96 fig. 2, 96 n4, 104, 130, 272, 273
SPANISH, late 17th century, 270; late 19th century, 272
Sparta, 202, 203 n1
Spinola Family Monument (Plumière), 264, 266, 266 fig. 2
Spirit of the Dance (Carpeaux), 218
Spring (Rusconi), marble, 82, 82 fig. 1
Square Vase Adorned with Tahitian Gods, no. 101 (Gauguin), *234*, *235*, *236*, 237
Staatliche Museen, Berlin (or Berlin-Dahlem, also given as Staatliche Museen Preussischer Kulturbesitz), *St. Jerome* (Anonymous), 42 n5; *St. John* (Sansovino), 72, 72 fig. 4; *Study Relief* (after Duquesnoy), 72, 72 fig. 4; *Charity* (Caffà), 73; *St. Peter* (attributed to Théodon), 86 fig. 1; *Mercure and Venus* (Pigalle), 189
Standing Draped Man Representing Fatherland, no. 59 (Ferrari), 14, *144*, 144, *145*
Stanza del Gladiatore, 203 n2
Stati, Cristoforo (1556-1619), *Samson and the Lion*, 96, 96 fig. 2
Stein, H., 176 n2, 180 n1, n3, n5, n6, 183 n1, Biblio.
Stein, Judith, 207 n11, Biblio.
Still Life (Monari), 72, 72 fig. 3
Stirbey, Prince, 218
Stockholm, Sweden, 203 n3
Stoke-on-Trent, England, 220
Strasbourg (or Strassburg), 11, 188
Straus, Edith A. and Percy S., Collection, Museum of Fine Arts, Houston, 22 fig. 16
Study of a Fallen Man in Agony, no. 77 (Anonymous), 24, 174, *175*
Study Relief (after Duquesnoy), 72, 72 fig. 4
von Stumm, Baron Friedrich 104
The Submission of Abd-el Kader (Carpeaux), 218
Suboff, V., 77 n1, Biblio.
Summer, no. 25 (Rusconi), 82, *83*, 84; marble, 82, 82 fig. 2, 83
Summers, D., 56 n1, Biblio.
Sung Dynasty, China (A.D. 960-1279), ceramics, 7
Symonds, J., 25 n13, Biblio.

T
Ta'aroa, 237
Tacca, Pietro (1577-1640), 64; *Slaves*, 228
Tacitus, 216

Tahiti, 237
Taillasson, Jean-Joseph (1745-1809), 207, 207 n6
Tancock, J., 232 n1, n3, n17
Tanagra, Greece, 17, 17, fig. 4
Tao-chi (ca. 1641-1717?), 7
Tarquin and Lucretia, no. 106 (Circle of Artus Quellinus the Elder), 248, *248*, 249
Te Fatou and Hina, 237, 237 n5
Temple de la Gloire (Madeleine), 210
Terme Museum, Rome, 269
A Terminal Figure with Bacchante (Carrier-Belleuse), 222
terra-cotta, 17 and *passim*
terra-cruda, 128, 146, 148, 149, 150, 151, 152
Théâtre-Français, 214
Théodon, Jean-Baptiste (1646-1713), 86 fig. 1, 87, 87 n3
Thetis (Van der Haeghen), 254
Thieme-Becker, 84 n4, 106 n1, 114 n1, 132 n1, 141 n1, 142 n1, Biblio.
Thirion, H., 186, 186 n6, n8, n10, n11, n13, Biblio.
Thomas, M. Gabriel-Jules (1824-1905), Collection, 208, 208 n4, 241
Thyria, 132 n1
Ticozzi, S., 84 n3, Biblio.
Timofiewitsch, G., 62, 63 n2, Biblio.
Titans (Rodin), 226 fig. 1, 228, 228 figs. 2, 3, 229, 230, 231, 232 n6, n7, n8, n16, n19 (see also *Vasque des Titans*)
Titian (1477-1576), *Bacchanals*, 70
Tobias and the Angel (Baratta), 94
Toledo Cathedral, 130
Tolentino, Raoul, Collection, 138
de Tolnay, C., 58 n2, Biblio.
Tomb of Cardinal de Cabrières (Magrou), 241, 242, 242 fig. 1
Tomb of Maréchal de Saxe (Pigalle), 188
Tomb of Pauline de Beaumont (Marin), 212
Tondu, Eugene, sale, 186
Torero Herido, no. 117 (Venancio Vallmitjana y Barbany), 272, *272*, 273, *273*, 274 fig. 1 (above); bronze, 274, 274 fig. 1 (below)
Tourneax, M., 201 n3, 205 n2, Biblio.
Toulouse-Lautrec, Henri de (1864-1901), 154
Townsend, H., 138 n6
Tragedy (Duret), 214
Treatises (Cellini), 19
Trevi Fountain, 120
Treviso, Northern Italy, 146
Trianon, 162, 164
Triomphe de Flore (Carpeaux), 218, 219
Troy, 191
Troyes, France, 158
Tuileries Gardens, 164, 164 fig. 1, 216, 221
Turin, 142; Torino, 274 fig. 2, n2
Tuscany, 22, 23, 96 n4, 138, 276; Montegufoni Castle, 75, 76
Twelve Apostles (Mazzuoli), 75
Two Angel Musicians, no. 19 (Duquesnoy), 14, *15*, 70, *71*
Two Bishop Saints Receiving the Palm of Martyrdom, no. 44 (Anonymous), 118, *119*
Two Boys Quarreling (attributed to Master of the Unruly Children), 48

U
Udine, Italy, 129
Uffizi Gallery, Florence, 55, 184
Ugolino (Carpeaux), 218
Ulmann, Jacques, Collection, Paris, 237 n4
Une Vestale (Marin), 212
Union Centrale des Arts Décoratifs, exhibition, 220, 221
United States, 11, 14, 142, 274
United States, Baedeker, 11
Urbino, Museo Diocesano, 91
des Ursins, Jean Jouvenel (d. 1431), 242
Usimbardi busts (Palma), 64

V
Vaccaj, G., 144 n1, Biblio.
Vaccaro, Domenico Antonio (1680-1750), *Moses*, 130
VACCARO, Lorenzo, no. 52, *King David*, 130, *130*, *131*; *King David*, marble, 130, 130 fig. 1; *Divine Grace, Providence, Emperor Constantine, St. Helena, Four Continents*, 130
Valenciennes, France, 208, 210, 218; Musée de, 210
della Valle, Filippo (1698-1768), 82, 84
Valletta, Malta, National Museum, 68, 132; Church of St. John, 98; Cathedral, archives, 132

Vallmitjana y Barbany, Agapito (1833-1905), 272
VALLMITJANA y Barbany, Venancio, no. 117, *Torero Herido* 272, *272*, 273, *273*, 274, 274 fig. 1; *Torero Herido*, bronze, 273, 274, 274 fig. 1; *Shepherd and Goat*, 274, 274 fig. 2
Van den Eynde, tomb (Duquesnoy), 70
VAN DER HAEGHEN, Jan-Baptiste, no. 109, *St. Joseph Holding the Christ Child*, 254, *255*; *St. Joseph et l'enfant*, 254, 254 fig. 1; *St. Joseph*, 254, 254 fig. 2; *St. James the Great, Leda and Thetis*, 254
Vasari, Giorgio, 17, 20, 35 n2, 42, 49, 49 n9, 56
Vasques des Titans (also in text as *Vase des Titans* or *Vasques*), no. 99 (Rodin and Carrier-Belleuse), 25, 226, *227*, 228, *229*, 230, *230*, 231, *231*, 232; other versions, 230, 231, 232, 232 fig. 4, 232 n16, n17
VASSÉ, Louis-Claude, no. 73, *Mourning Woman and Putto*, 168, *169*; *Sorrow*, 168, 168 fig. 1; *Diana, Venus Directing The Darts of Love, Sleeping Shepherd, Woman Weeping Over an Urn*, mausoleum of Stanislas Leszczynski, 168; tomb of Feydeau de Brou, 168, 168 n1
Vassé, François-Antoine (1681-1736), 168
Vatican, Rome 132; Museum, 68
Vecchietti, Bernardo, 20
La Vedetta: La Gazzeta del Popolo, (The Lookout: the People's Gazette) no. 66 (Zawiejski), 14, *14*, 154, *154*, 155
Vela, Vincenzo (1822-1891), 140, 273
Velléda, no. 95 (Maindron), 24, 216, *217*; marble, 216, 216 fig. 1
VENETIAN, 16th century, 60; second half of the 17th century, 129
Venetian, 30, 64
Venetian Senator, no. 51 (Marinali), 129, *129*
Venezia armata (Cattaneo), 63
Venice, 24,108, 128, 129, 142, 146, 274; Sant' Antonio di Castello, 30, 30 fig. 1; St. Mark's, 49, 60; SS. Giovanni e Paolo, 62; Piazza San Marco, 63; Ca d'Oro, 96; Palazzo Widmann, 111 n1; Accàdemia di Belle Arti, 146
vente après décès, 184 and *passim*
Venturi, A., 52 n2, 58 n1, 63, 63 n2, n6, n8, n9, Biblio.
Venus (Pigalle), marble, 189, marble reduction, 189 n5; *Venus Charging Mercury with the Education of Love* (Pigalle), 189; *Venus Comforting Cupid*, no. 92 (Dumont), 208, *208*, 209, *209*; *Venus Directing the Darts of Love*, 168; *Venus Receiving the Apple from the Hands of Love* (Pajou), no. 79, 178, *178*, 179, *179*, marble, 179, 179 fig. 1, drawing, 179, 180 fig. 2
Verbruggen, Pieter I (d. 1686), Pieter II (d. 1691), 259
Verdi, Giuseppe, monument (Ferrari), 142
Verdon, T., 30 n4, Biblio.
Vergine Annunciata (Mazza), 108 n1
Verona, 31, 34 fig. 2, 35 fig. 4, 60, 129
VERONA (see NORTH ITALIAN)
del Verrochio, Andrea (1435-1488), 46, 250; *Forteguerri Monument*, 18 fig. 6, 19; reliefs and statuettes of Virgin and Child, 22; *Giuliano de'Medici*, 23, 23 fig. 19; Group with Christ and "Doubting Thomas," 30; *St. Jerome*, in meditation (style of), 42, 42 fig. 2; *David*, 44, 44 fig.2
Versailles, 162, 170, 260; Nôtre-Dame de, 160; château de, 161, 161 fig. 1; park, 164; Academy, 193; Musée de, 193, 210
Vestal (Marin), 212, 212 fig. 1
Vestal Bearing Wreaths on a Platter, no. 81 (Clodion), 24, 184, *184*, 185, *185*
Vestal Holding a Vase, no. 93 (Marin), 212, *213*
Vestal Holding Sacred Vessels, no. 82 (Clodion), 24, 186, *186*, *187*
Vestal Virgin, biscuit de Locre, 212 n2
Une Vestale (Clodion), 212 n4
Vestale, Modele en terre (Marin), 212
Vial, H., 212 n1, Biblio.
Vicenza, Italy, 129, 142
Vichy, Casino, 224
Victoria and Albert Museum, London, 189; *Michelangelo* (Leoni Leone), silver medal, 16 fig. 1; *Forteguerri Monument* (Verrocchio), 18 fig. 6, 19; *Florence Triumphant Over Pisa* (Giambologna), wax, 18, 18 fig. 5; *Florence Triumphant Over Pisa* (Giambologna), terra-cotta, 20, 20 fig. 10; *River-God* (Giambologna), 21, 21 fig. 14; *King Henry VII* (Torrigiano), 23, 23 fig. 20; *Self-portrait* (Vittoria), 24, 24 fig. 22; *Cardinal Paolo Emilio Zacchia* (Algardi), 24, 24 fig. 23; *St. Jerome* (style of Rustici), 42, 42 fig. 2; *St. Jerome* (Ferrucci), 42, 42 fig. 4; *St. Sebastian* (Master of the David and St. John Statuettes), 44, 44 fig. 4; *David* (Master of the David and St. John Statuettes), 44, 44 fig. 1;

Charity (Master of the Unruly Children), 46, 46 fig. 2, 47; *Flagellation* (della Porta), 58, 58 fig. 3; *Ecclesiastic* (attributed to Palma), 64, 64 fig. 1; *Apollo Flaying Marsyas* (Foggini), 96, 97 fig. 4; *The Apotheosis of Manoel di Vilhena, Grand Master of the Order of Malta* (Soldani-Benzi), 98; *Nativity* (Cornacchini), 104; *Worship of the Golden Calf* (Corsini), 120, 120 fig. 1; *Vasque des Titans* (Rodin and Carrier-Belleuse), 230; *Fountain* (Circle of Rustici ?), 251, 251 fig. 2; *Screaming Child* (de Keyser), 259, 259 fig. 1
Vien, Joseph-Mario (1716-1809), *Sappho singing her verses while accompanying herself on the lyre*, 206
Vienna, Kunsthistorisches Museum, *Fracastoro ?* (Cattaneo), 63; *Lamentation* (Mazzuoli), 75 fig. 1, 76; *Bellerophon and Pegasus* (di Giovanni), 152
Vierny, Dina, 239
de Vilhena, Manoel, 98
Villa Capannori, 64
Villa dei Massoni, 64
Villa Ludovisi, 269
Villa Rusciano, Florence, 104
Villard, M., Collection, Lyons, 198
Villars, bust (Coustou), 164
Virgin and Child, (Luca della Robbia), 22, 22 fig. 16; (Torrigiano), 23; reliefs (attributed to Michele da Firenze), 31; (Anonymous), 40, 40 fig. 2; no. 9 (Master of the Unruly Children), 46, *46*, 47, 48, *48*; (Master of the Unruly Children), 49, 49 fig. 3; no. 56 (after Andrea della Robbia), 138, *139*; (Hardy), *162*, 163, *163*; no. 108 (Anonymous), *252*, 253, *253*; (Pompe), 260 n2
The Virgin in Adoration, or Annunciate, no. 24 (Circle of Mazzuoli), 80, *80*, *81*
Virgin Annunciate, Appendix B (Anonymous), 278, *279*
The Virgin Mary (?) Wearing a Veil, no. 41 (attributed to Mazza), 112, *112*, *113*
Vision of the Blessed Ambrogio Sansedoni (Mazzuoli), 77
Visitation (Luca della Robbia), detail, 22, 22 fig. 17
Vitry, P., 158 n1, n4, Biblio.
Vittoria, Alessandro (1525-1608), 64; *Self-Portrait*, 24, 24 fig. 22
Vivarini, Antonio (ca. 1415-1476/84), 36
Viviers, France, 241
Voix Interieure (Rodin), 233
Vollard, Ambroise, 233
Voyages d'Antenor, Lantier, 206
Vryburch Tomb (Duquesnoy), 70

W
Waddesdon, 189 n5
Walking Cupid, no. 40 (Mazza), *110*, 111, *111*
Walking Man (Rodin), 233
Wallace Collection, London, 138, 138 fig. 3
Warburg Institute, London, 96
Ward-Jackson, Peter, Collection, 46
Wark, R.R., 148 n1, Biblio.
Warrior, also given in text as *Warriors, Fighting Horsemen, mêlée* of soldiers, etc. (attributed to Rustici), 48, 49, 49 n6; (Master of the Unruly Children ?), 49, 49 n6, n10
Washington, D.C., 11; National Gallery of Art, 9, 22 fig. 18, 23 fig. 19, 25 fig. 24, 184, 186 n7
Wasserman, J.L., 219 n3
Weiner Collection, Paris, 170 n2
Wernher Collection, Luton Hoo, Bedfordshire, 207 n5
Westhoff, Clara, 226
Westminster Abbey, London, 264, 266 fig. 1
Weyl, Martin, 232 n7, n15, n16
Widener Memorial Collection, Harvard University, Cambridge, 268 fig. 1, 269 n5
Wildenstein Gallery, New York, 186 n7, Biblio.
Wilkins Collection, Florence, 138 n6
Willame, G., 144 n1, Biblio.
Willemssens, Louis (1630-1702), 264
William III, King of England, 259
Windsor Castle, Royal Collection, 82 figs. 1-4, 84
Wittkower, R., 251 n1, Biblio.
Woman, Tanagra, Greece, 17, 17 fig. 4
Woman Weeping Over an Urn (Vassé), 168
Worship of the Golden Calf (Corsini), 120, 120 fig. 1
Wrestlers, no. 62 (Martini), 149, *149*

X Y Z
Xavery, Pieter (1647-1674), 251

A Young Shepherd Bitten by a Snake (Maindron), 216
Young Cyclist (Maillol), 238
Zawiejski, Mieczylslaw Leon, no. 66, *La Vedetta: la Gazzeta del Popolo*, 14, *14*, 154, *154*, 155; *Czas*, 154, 154 fig. 1

PRODUCTION NOTES:

This catalogue was designed and its production supervised by Victor Trasoff. Production coordinator was Edward Tuntigian. It was printed in limited editions of cloth and paper covers in four-color process and four duotone colors by Rapaport Printing Corp., New York in its Stonetone process on Warren 80 lb. LOE dull-coated text stock and 10 pt cover stock. End papers were printed on 100 lb. Mohawk Superfine offset stock.

The type face is *Palatino*, designed by Hermann Zapf. Photo composition by Empire Typographers, New York. Both editions were bound by Sendor Bindery, New York. Case binding is in Hollistan natural record buckram dyed terra-cotta brown.

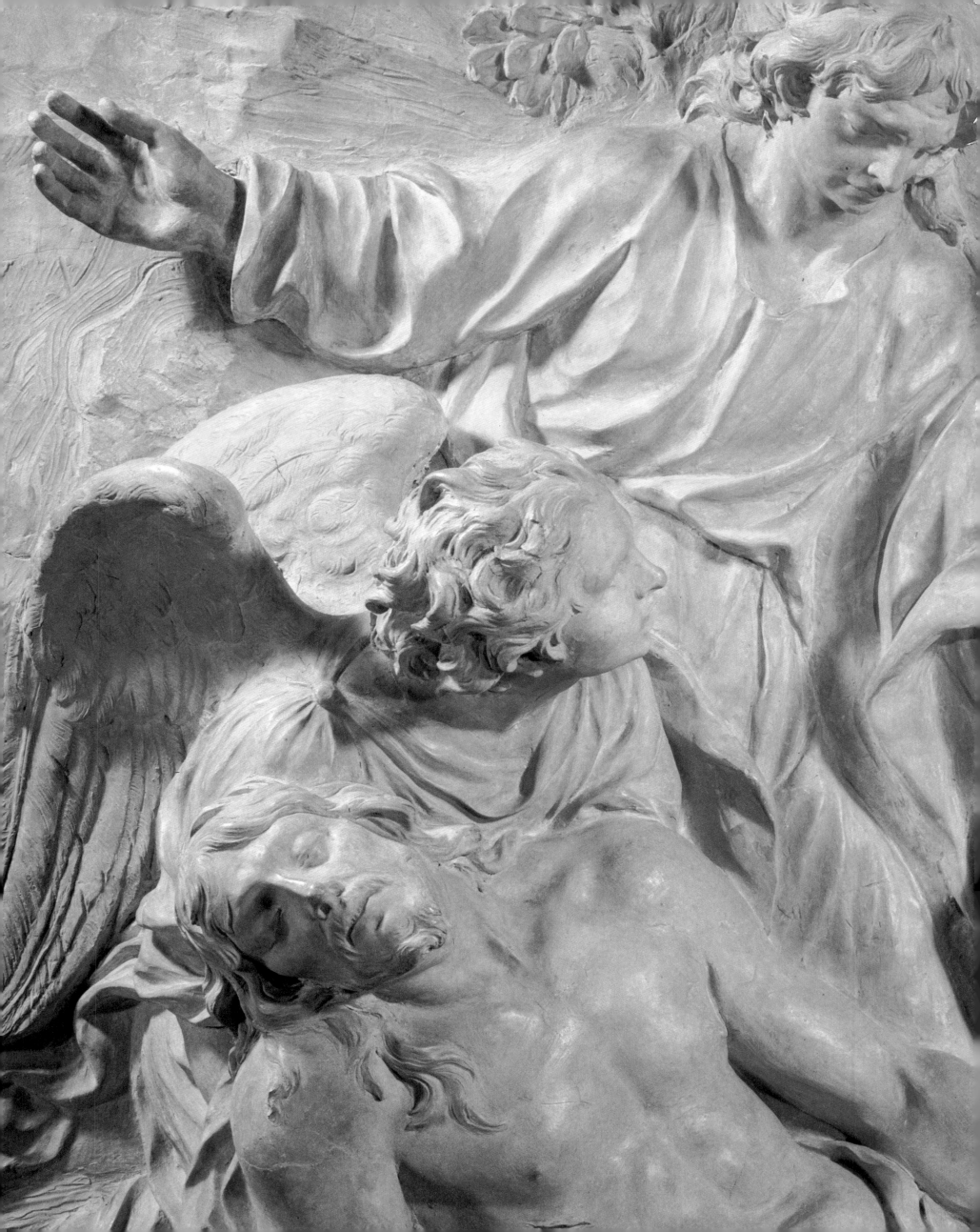